ART TREASURES OF ENGLAND

THE REGIONAL COLLECTIONS

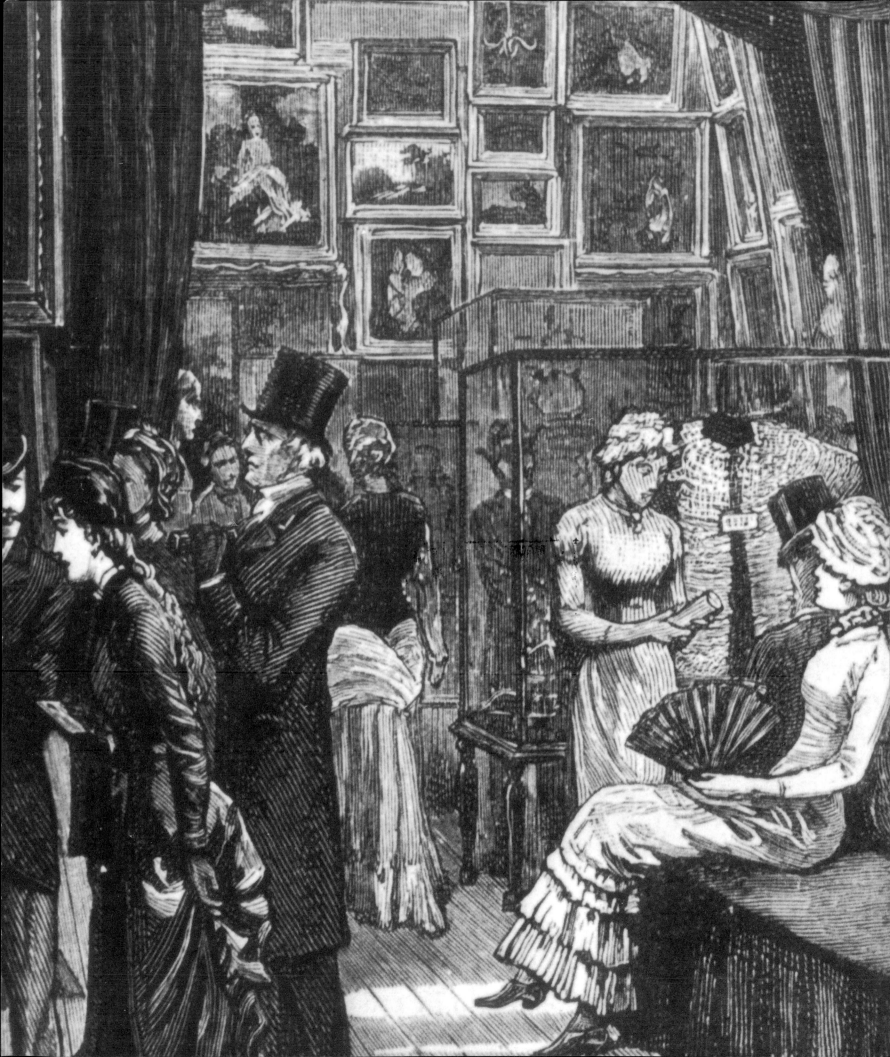

Art Treasures

of England

The Regional Collections

Merrell Holberton

PUBLISHERS LONDON

First published on the occasion of the exhibition
'Art Treasures of England: The Regional Collections'
Royal Academy of Arts, London 22 January – 13 April 1998

The Exhibition was organised by the Royal Academy of Arts, London

Sponsored by Peterborough United FC

Football meets Art

Exhibition Curators:
Jane Martineau, Norman Rosenthal,
Richard Verdi, Giles Waterfield
Exhibition Organiser: Susan Thompson
Exhibition Assistant: Harriet James
Research Assistants: Sophie Chessum, Laura Tayler

Text Editor: Michael Foster
Photographic and Copyright Coordinator:
Miranda Bennion
Assistant Photographic Coordinator:
Roberta Stansfield
Editorial Coordinator:
Sophie Lawrence

The Royal Academy of Arts is grateful to Her Majesty's Government for its help in agreeing to
indemnify the exhibition under the National Heritage Act 1980, and to the Museums and Galleries
Commission for their help in arranging this indemnity.

British Library Cataloguing-in-Publication Data
A catalogue record for this book is available from the British Library

Copyright © 1998 Royal Academy of Arts, London
ISBN: 0 900946 59 8 (Royal Academy paperback)
ISBN: 1 85894 047 8 (hardback)

Designed by Roger Davies

Produced by Merrell Holberton Publishers
Willcox House, 42 Southwark Street, London SE1 1UN

Printed in Italy

Cover illustrations
Front: Ford Madox Brown, *Work* (cat. 130, detail)
Back: Richard Deacon, *Let's not be Stupid* (cat. 411)

Frontispiece
A loan exhibition at the Fine Art Institution, York, in 1879, later to become the York City Art Gallery,
wood engraving from *York Illustrated*, 1879 (detail) York City Art Gallery

Contents

Sponsor's Preface

As a small child I was taken to Peterborough Museum where I marvelled at the intricate carvings of the French prisoners of the Napoleonic war who worked wonders with old cow bones at nearby Norman Cross.

In my travels around the country I have always been intrigued by museums and the treasures sitting in these monuments of our heritage. I only wish that more of them could be open longer to cope with the increased amount of leisure time available to us.

A museum is a positive element in a city, reminding citizens and visitors alike of its great heritage, a reminder that the culture of a city is not something which can be wiped at will off a floppy disc.

Regional museums are often unknown to the nation at large, unless they show their treasures in London. This superb exhibition *Art Treasures of England: The Regional Collections* at the Royal Academy of Arts will make many thousands more aware of the riches of our country.

Peterborough United Football Club – the "Posh" to its many fans – is pleased to respond to the call for sport to become more involved with the culture of our land. It is pleasing to see that we now have a Minister for Culture, Media and Sport and we hope that our initiative, in World Cup Year, will help strengthen the strong link between the three.

PETER BOIZOT MBE

Chairman, Peterborough United FC

President's Foreword

The exhibition *Art Treasures of England* is a celebration of our regional art galleries. Together with libraries, many of these were founded in the mid-19th century as freely accessible institutions, born of a mixture of civic pride and belief in the civilising and educational power of the arts. They contain great treasures, and each treasure has its own local associations. With this exhibition and its catalogue we wish to bring these treasures to the attention of as wide a public as possible, and to pay tribute to the far-sighted founders and benefactors who established the galleries and their collections as well as to their present-day custodians, striving against great financial odds to keep the galleries alive and accessible to the public.

The exhibition was first proposed at a meeting of the English National and Regional Museums Directors' Committee, and conveyed to the Royal Academy by its chairman, Richard Foster, Director of the National Museums and Galleries on Merseyside, and by Professor Richard Verdi, Director of the Barber Institute of Fine Arts in Birmingham.

In the past year a selection committee comprising Jane Martineau, Curator and Editor at the Royal Academy, Norman Rosenthal, Exhibitions Secretary of the Royal Academy, Richard Verdi and Giles Waterfield, freelance curator, has travelled the length and breadth of England visiting the regional galleries. We thank the staff of the museums and galleries who have lent their works. We also salute the National Arts Collections Fund, the Contemporary Art Society, the Heritage Lottery Fund, and the Museums and Galleries Commission, all of whom have encouraged the exhibition, seeing it as an extension of their task to support the regional museums.

Besides this catalogue, one million copies of a brochure describing the various institutions have been produced which we hope will be widely circulated and will encourage people to visit galleries and museums outside London and explore for themselves the riches which can only be hinted at in this exhibition.

The Academy is particularly happy to welcome Peterborough United Football Club as its sponsor and to thank the Club's Chairman, Peter Boizot – himself a long-standing supporter of the Royal Academy – for his help and encouragement with this great exhibition. Arts and Sport share a Secretary of State, and it is therefore particularly appropriate that they should combine forces on this occasion.

SIR PHILIP DOWSON CBE
President, Royal Academy of Arts

Acknowledgements

The Royal Academy wishes to thank the following who in many ways helped in the
preparation of this exhibition and catalogue:

Maureen Attrill
Adrienne Avery-Gray
Caroline Bacon
Christopher Baker
Andrew Barlow
Christian Barnes
Janet Barnes
Don Bashforth
Hugh Belsey
John Benington
Amanda Beresford
John Bernasconi
Hazel Berriman
Susan Bourne
Annette Bradshaw
John Brazier
George Breeze
Xanthe Brooke
G. John Brooks
Christopher Brown
Charlotte Bryant-Fenn
Ann Bukantas
Erik Burnett-Godfree
Richard Burns
The late Hazel Burston
Martyn Cadds
Katharine Chant
Ruth Charity
Ronald A. Clarke
David Coke
Elizabeth Conran
Linda Coode
Abbie Coppard
Alison Cowling
Mary Cowling
Tim Craven

Melva Croal
Sandra Cruise
Tamsin Daniel
Su Davies
Richard Deacon
Hillary Diaper
Robert Dickinson
Jo Digger
Ian Duckworth
Caroline Dudley
Sally Dummer
Jane Farrington
Brendan Flynn
Richard Foster
Celina Fox
David Fraser
Anne French
Nicola Frost
Melanie Gardner
Catherine Gibson
Anne Goodchild
Andrew Gorczycki
Cherry Gray
Richard Gray
Christopher Green
Richard Green
Francis Greenacre
Andrew Greg
Janet Gunn
Robert Hall
Steven Halls
Camilla Hampshire
Dennis Harrington
Michael Harrison
Francis Haskell
Gill Hedley

Julian Herbert
Nigel Herring
Matt Hervey
Victoria Hollows
Christine Hopper
Juliet Horsley
Richard Hurley
David James
Peter Jenkinson
Nichola Johnson
Penny J. Johnson
Louise Karlsen
Laura Kidner
Edward King
Caroline Krzesinska
Alan Leigh
Andrew Lewis
Yvonne Locke
Mark Lomas
James Lomax
Sarah Macdonald
Sheila MacGregor
Vera Magyer
Sandra Martin
Patrick Matthiesen
Emeline Max
David McNeff
John Millard
Corinne Miller
Julie Milne
Andrew Moore
William Mostyn-Owen
Edward Morris
Nicola Moyle
Susan Newell
Charles Nugent

Sam Oakley
Tony O'Connor
Simon Olding
Godfrey Omer-Parsons
Alison Plumridge
Geoff Preece
Simon Reed
Kenneth Reedie
Chris Reeve
Jennifer Rennie
Michael Rhodes
Alex Robertson
Duncan Robinson
Barley Roscoe
Mark Rowland-Jones
Michael Rowlands
Francis Russell
Jessica Rutherford
Richard Rutherford
Christina Sanderson
Judith Sandling
David Scrase
Jane Sedge
Tim Shadla Hall
Richard Shone
Evelyn Silber
Maggy Simms
Colin Simpson
Helen Simpson
Michael Simpson
Elizabeth Smallwood
Alistair Smith
Emma Smith
Thyrza Smith
Stephen Snoddy
Paul Spencer-Longhurst

Christina Stansfield
Timothy Stevens
Andrew Stewart
Brian Stewart
Sheena Stoddard
Christine Stokes
Ann Sumner
Annabel Taylor
Nick Tite
Veronica Tonge
Penny Thompson
Julian Treuherz
Antonino Vella
Michael Vickers
Neil Walker
Catherine Wallace
Philip Ward-Jackson
Anthony Wells-Cole
Lucy Whetstone
Christopher White
Lucy Whitaker
Jane Whittaker
Stephen Whittle
Timothy Wilcox
Alan Wilson
Catherine Wilson
Carolyn Wingfield
Richard Wood
Claire Woodage
Robert Woof
Caroline Worthington
Anthony Wray
Joanne Wright
Peter Young
Mary Yule

Lenders to the Exhibition

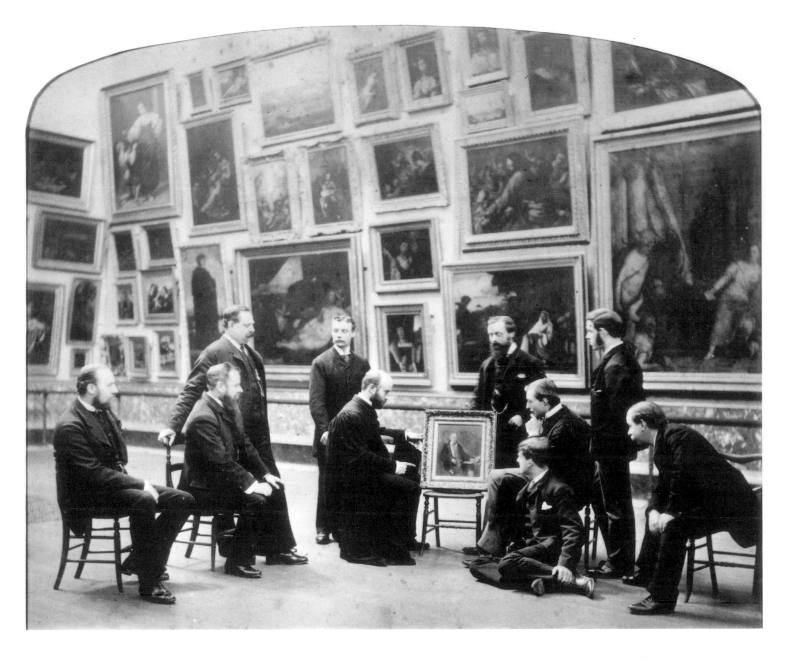

Fig. 1 The staff of the Fitzwilliam Museum, Cambridge, contemplating a portrait of the founder, Richard, 7th Viscount Fitzwilliam, in Gallery III, 2 November 1887

Art Galleries and the Public: A Survey of Three Centuries

GILES WATERFIELD

Most foreign visitors to Great Britain will scarcely be aware of the museums and art galleries outside the capital. Visits to Oxford, Stratford and Bath, to Edinburgh and Glasgow, to such appealing towns as Cambridge, York and Brighton feature regularly on the tourist schedule. Yet numerous art collections, especially those in Northern and Midland towns, fail to attract many visitors from abroad, or indeed British people from outside their own region, on account of the (largely false) reputation which the cities acquired during the 19th century as ugly and forbidding places. Relatively few lovers of art will travel to enjoy the paintings and sculpture in Liverpool or Manchester, Leeds or Birmingham, all cities with more than one notable gallery. Still fewer will travel to the smaller towns of the North West to taste the extraordinary concentration of galleries created at a time when much of the industrial wealth of the richest country in the world was concentrated in Lancashire; or sample the distinctive collections in such ancient cities as Bristol and Norwich, with their celebration of local pride and broad cultural inheritance; or seek out the smaller university museums which distinguish this country.*

The aim of this exhibition is to convey the variety and individuality of public collections outside the capital. While the exhibition is confined to England, this essay studies such collections throughout Britain and suggests how they differ from their equivalents elsewhere. It traces their development from the 17th century to the present, looking at the foundation of institutions, at changing types of collection, at temporary exhibitions and at the educational role of galleries.

Galleries and the State

The history of art acquisition in Britain, the wealth of the country's private collections, the debates about the aims of its museums and the nature of the British school are reflected in the variety of our regional galleries. Yet the reflections are unexpected, and limited. British museums have scarcely profited from the country's political continuity. In no other European state of any size has the throne been continuously occupied for

*In Britain, 'gallery' is used in opposition to 'museum' to indicate an institution dedicated to the display of works of art as compared to historical or scientific specimens. Among European languages, only Italian also observes this distinction, and it is not usually applied in the United States. In this essay, 'gallery' is generally used in the conventional British sense, although 'art museum' will also be employed.

such an extended period. Elsewhere royal possessions have been given as the basis for state galleries, as in Austria, or confiscated, as in France: not so in Britain. The Hermitage in St Petersburg, the Kunsthistorisches Museum in Vienna and many other major Continental galleries are essentially enlarged versions of monarchical holdings: by contrast, the National Gallery and the British Museum in London started on the basis of private collections purchased by the state.

The resistance to invasion since the 14th century, the sustained wealth and dexterity of the aristocracy and the law of primogeniture have ensured that, in spite of many losses, aristocratic country houses retain notable works of art, whether in private hands or, since the 1940s, in the possession of the National Trust. Internationally, this situation is rare. If Gustav Waagen, the German chronicler of British art collections, were to visit Britain today, he would recognise numerous works in the houses where he saw them between 1835 and 1862.[1] For public galleries, which have rarely received works of art from the aristocracy, this continuity has not been helpful. Nor has the avoidance of revolution: whereas the 1640s led to the dispersal of the collections of Charles I and his courtiers, and ruined many of the holdings of the Church, no subsequent event has allowed the state to confiscate noble or ecclesiastical possessions for deposit in museums, as was the case in revolutionary France and elsewhere.

Nor has the system of government in Britain encouraged public collecting or ambitious museum building programmes. The arts have seldom been engaged in the public discourse of power in the way that has for centuries applied in France, Italy and Germany: if the nation had had to rely on governments, which almost without exception have been ungenerous towards the arts, Britain would have a pretty negligible group of public collections or buildings. The expectation that a parliamentary government should keep its expenditure as low as possible has encouraged the view that, while the acquisition for the public benefit of works of art, books or scientific specimens might be justified, they should be accommodated as modestly as possible. When, in 1753, the government set up the British Museum, the first national museum in Europe, money to buy Sir Hans Sloane's core collection were raised through a lottery. Seventy years later, the foundation of the National Gallery was funded by the unexpected repayment of a government loan. As the 19th century progressed, public provision for the arts became more common, but had to be justified on grounds of social or economic

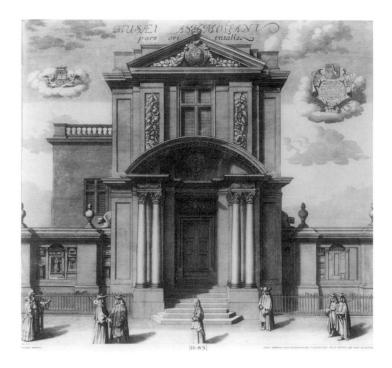

Fig. 2 The east front of the Old Ashmolean Building, Oxford, master mason Thomas Wood (?), 1673–83, shortly after its construction; engraving by Michael Burghers, 1685

improvement and was applied to buildings and instruction rather than to purchases. 'Voluntaryism', the idea that charitable activities were best conducted by associations of private individuals rather than by a state which might impose its wishes in areas where it had no right to interfere, was a deep-seated principle. As a result, state support (and the same applies in most cases to municipal support) for the arts has been limited and arbitrary, in contrast to the centralised system of, say, France. The two approaches can produce wildly different results: on the one hand, the outwardly dignified but illogically planned and cramped British Museum, standing among homely streets with not a vista to boast of; on the other, the Musée du Louvre, a former palace and a masterpiece of urban planning, but (to some eyes) nightmarishly over-large and impersonal, expressing through every stone the power of the state.

Museums hardly existed in Britain before the second half of the 17th century, and even then the fine arts were barely represented until around 1900. Some of the earliest private collections were opened to visitors in the first half of the 17th century. The Ark in Vauxhall, which contained the possessions of John Tradescant, father and son, botanists and travellers, could be seen from the 1630s, but painting and sculpture played a limited

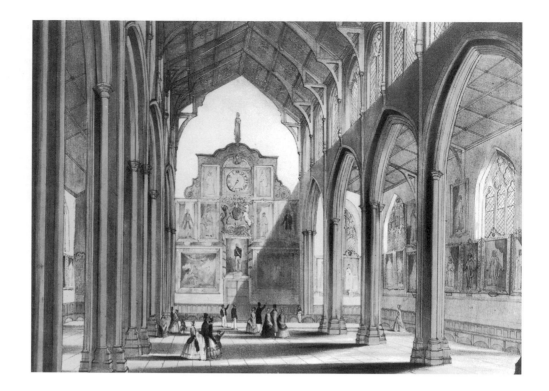

Fig 3. St Andrew's Hall, Norwich, hung with portraits of civic dignitaries; hand-coloured lithograph by C.J. Greenwood, *c.* 1850; Castle Museum, Norwich

role there. In the most prominent early public museums – the Ashmolean in Oxford, founded in 1683 (fig. 2), or the British Museum – the collection's purpose was to facilitate study of the natural world, to provide a microcosm of creation in which the universe would be embodied. In such a scheme artifice – the works of human creation – held an important place, but the role of art was generally restricted to portraiture and to works on paper, often documentary in character.

The relationship between the fine arts on the one hand and scientific and historical specimens on the other remains complex until the late 19th century. The two were often closely associated, as in the Victorian civic museum and art gallery. The idea that the art gallery or exhibition should exist in isolation, with works of art divorced from records of the natural world, emerges only gradually in the course of the 19th century. Today this isolation may once again seem a questionable good.

Commemorative, High and Popular Art

Broadly speaking, works of art in public ownership fall into three overlapping categories: commemorative, high and popular. The relationship between 'high' and 'popular' art is central to museum history, but commemorative art – including portraiture, topography and depictions of military and naval engagements as

well as of such public occasions as official visits by a royal personage – is also a constant factor.

The value of portraiture as a historical tool, already recognised in the 14th century,[2] engendered publications and galleries containing images of the famous. Portraits were regularly used as instruments of political propaganda: Charles II, for example, demonstrated his dynasty's longevity and continuity through the Line of Kings at the Tower of London and the gallery of Scottish kings at Holyroodhouse. Paintings also found their way into early scientific and historical collections as documents. In the Ashmolean Museum the portraits of the founders and their associates dominated the (relatively few) paintings.[3] Equally, visitors to the Chelsea house of Sir Hans Sloane in the early 18th century recorded the room containing portraits of 'kings, learned men and others',[4] later transferred to the British Museum.

The celebratory and documentary use of portraiture was adopted by the increasingly wealthy professional and merchant classes in the 18th century. As early as 1670 the City of London aldermen had commissioned 22 portraits of the Fire Judges from J.M. Wright.[5] The first major enterprise of this sort outside London had been undertaken in Norwich, the leading regional city in England until the 1730s, when it was overtaken by Bristol. In 16th-century Norwich portraits of notable citizens, especially mayors and sheriffs, benefactors and magistrates, were

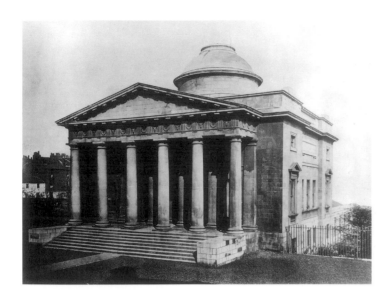

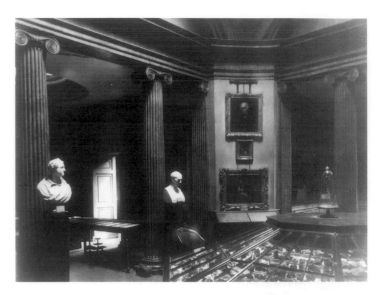

Fig. 4 Hunterian Museum, Glasgow, designed by William Stark, opened in 1806

Fig. 5 Interior of the Hunterian Museum, photograph by Thomas Annan, c. 1871

assembled by city dignitaries for display in the Guildhall. The custom was formalised in 1732 by the decision to acquire, generally by subscription, a series of full-length depictions of civic dignitaries for St Andrew's Hall, a place of assembly belonging to the city (fig. 3).[6] Norwich here anticipated the 19th-century accumulation of municipal portraits, a form of collecting given official approval by the foundation in 1856 of the National Portrait Gallery in London and by the three huge 'special exhibitions of national portraits' held at South Kensington from 1866 to 1868.

The role of 'high art' is very different. The expression generally denotes paintings, sculpture and works on paper that have been assembled on the understanding that a gallery's purpose is to celebrate the intrinsic importance of the work of art. Prototypes of the 'high' or 'sacred' gallery existed in the collections of the sovereign, the aristocracy and the wealthy in 17th and 18th-century Britain. During the latter century the assembly of paintings and Classical sculpture (the constant pendant to Old Master paintings in early collections) became a regular activity in sophisticated houses. An aristocratic country seat such as Wilton House in Wiltshire, a villa such as Chiswick in Middlesex or the London house of a collector such as Dr Richard Mead were intended as settings for works of art and were accessible to the 'polite' visitor. At Wilton, regarded virtually as a museum by connoisseurs on account of the sculpture collection of the 8th Earl

of Pembroke, guidebooks-cum-catalogues, the first of their type, were produced in the 1720s.[7] Seen in such settings, Classical sculpture and Italian and Dutch paintings came to be associated with the aristocracy, anticipating the 19th-century prejudice – which persists, unfortunately – that Old Masters form part of the cultural capital of the educated and socially privileged.

'High art' collections were biased towards works produced in the past and towards works with ideal subjects. Such collections were primarily didactic, intended to instruct the artist and inspire the layman. In the public museum dedicated to high art (at least in the 19th and early 20th centuries) the permanent collection prevailed over temporary exhibitions, which had a subordinate role, if any; education was directed at the initiated; and the provision of comforts for visitors was scarce, although cheap catalogues were considered essential, since labelling did not become common until the 1860s. The external and internal architecture of these galleries was inspired by the models of temple and palace, and it was as temple or palace that they were conceived. Their function was to suggest that the collection would exist eternally and purely, the works of art dissociated from commercial value. In Britain a number of galleries could be placed in this category, though changing attitudes have modified their character: the National Gallery in London and that in Edinburgh, the Ashmolean and Fitzwilliam museums, the Hunterian Museum (fig. 4, 5) and Dulwich Picture Gallery, the

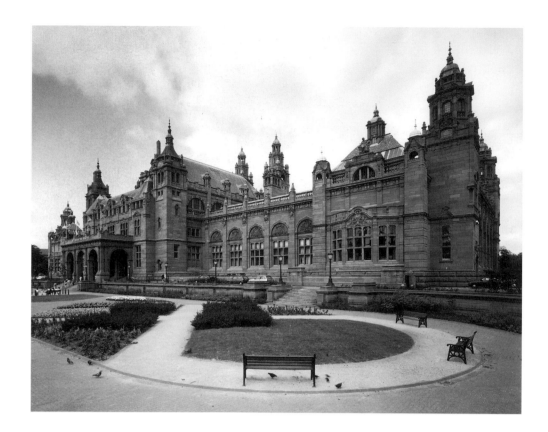

Fig. 6 Glasgow Art Gallery and Museum, Kelvingrove, designed by John Simpson and Milner Allen, opened in 1902

Fig 7 Glasgow Art Gallery and Museum, the Natural History Gallery, looking east

Bowes Museum, and several later university galleries, such as the Barber Institute of Fine Arts in Birmingham and the Courtauld Institute Galleries in London.

The 'popular art' collection, as developed in the 19th century, was directed at enjoyment, though also at practical instruction; it was easily understandable; it concentrated on modern, notably British, art, which was admired for its representation of national achievement and for its accessibility; and it maintained closer links with the marketplace. Such collections were typically more responsive to the contemporary world than was the temple museum. In the popular museum, the temporary exhibition played a crucial part; the educational aspect tended to be directed primarily at the craftsman; the provision of public amenities, such as a refreshment room, was important; and the audience was as inclusive as possible. While the building might use the Classical vocabulary, this language was often replaced by a semi-vernacular style without learned associations. Rather than the temple, such galleries recall the temporary exhibition space, and even the market hall and, towards the end of the century, the department store (fig. 6, 7).

It is to this second type that the majority of British galleries, notably the South Kensington Museum, belong, or belonged.

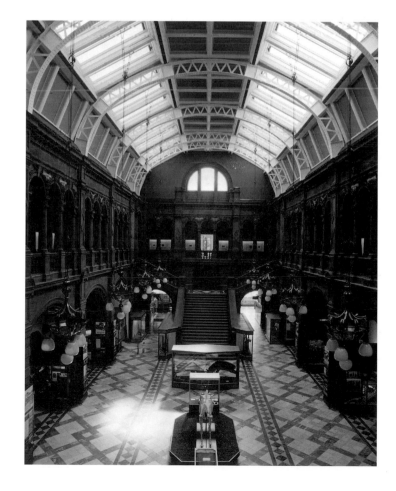

They followed in the tradition of the 18th century when, in London, art and money were allied at the Foundling Hospital in Bloomsbury, Vauxhall Gardens and Boydell's Gallery in Pall Mall. The Royal Academy of Arts, founded in 1768, aimed to promote the dignity of the British artist and to provide the earliest large-scale art-teaching establishment. It received no government funding, although the King underwrote the early exhibitions: such things were better done privately, it was thought. For the public its principal function was to organise annual displays of works by living artists, mostly for sale. Throughout the following century a crucial element in the development of artistic enterprises in British cities was to be the exhibition of contemporary art for sale. This combination of entrepreneurial activity and intellectual ambition in the creation of a validating frame for the work of art connects the enterprises of the 18th and early 19th centuries to the Great Exhibition of 1851, to its offshoot, the South Kensington Museum in London, and to the municipal galleries of the last third of the century.

Early University Collections

A recurring feature of cultural history in Britain is the way in which the lead has been taken by private or by semi-public bodies. Over the past century the National Trust, the wonder of foreigners, has done so in the preservation of the countryside and of historic houses. In the 17th and 18th centuries universities fulfilled a similar function, especially Oxford and Cambridge, but also such old Scottish universities as Glasgow and Aberdeen. Outside the private realm, universities became repositories for works of art and for scientific and historical specimens. England and Scotland in the 17th century resembled other European countries in developing university collections, which included botanical gardens and libraries. As at Pisa and Leiden, where anatomical and natural history specimens were being assembled in the 1590s,[8] many British colleges or universities acquired curiosities and scientific specimens, while the creation of a physic garden (a phenomenon closely related to the museum) became a regular enterprise. In 18th-century Oxford the university's portraits, largely of documentary interest, were assembled at the Bodleian Library, where they were displayed in rooms known as the Bodleian Picture Gallery.[9]

Where Britain was unusual was in the subsequent expansion or establishment of university or college museums, particularly those dedicated to Classical archaeology and to the fine arts.

There is scarcely any parallel in Europe to such large institutions as the Fitzwilliam, the Ashmolean and the Hunterian (Glasgow) museums or to the numerous 20th-century university galleries, of which the Barber Institute in Birmingham, the Sainsbury Centre in Norwich and the Courtauld Institute Galleries in London (founded in 1931) are among the most remarkable. Comparable collections in Italy are related much more closely to academies of art, such as the Accademia in Venice, which began to assemble paintings on its foundation in 1756. In spite of Italian influence on the development of 18th-century cultural institutions in Britain, there is no reason to suppose that donations to British universities were inspired by such exemplars. The closest analogy is to be found later, in the United States of America, whose many college galleries were based, as were their counterparts in England, on the generosity of individuals in a political climate that viewed state patronage with suspicion.

Early donations of works of art in Britain were almost all made to academic institutions. The process was initiated in 1677, when the Arundel Marbles, the remains of the outstanding collection of Antique statuary assembled by the 2nd Earl of Arundel and Surrey, were given in part to the University of Oxford by the Earl's grandson.[10] This example possibly stimulated a gift, not to the university, but to an individual college: the donation of paintings and drawings to Christ Church in 1765 by General John Guise, a former member of the college.[11] Subsequent donations to universities or colleges included the Hunterian collection, bequeathed in 1783 to the University of Glasgow by the surgeon William Hunter and containing scientific specimens as well as 17th and 18th-century paintings; some 300 Old Master paintings left to Dulwich College in 1811 by the art-dealer and painter Sir Francis Bourgeois; and Lord Fitzwilliam's collections, bequeathed to the University of Cambridge in 1816.

Although donors did not generally explain their choice of beneficiary in the deeds of gift, their reasons for selecting colleges seem not to have been determined by intellectual factors. While the Ashmolean Museum, certainly in its earliest days, reflected the intellectual life of late 17th-century Oxford in offering a model academic collection with the display of objects upstairs matched by a School of Natural History and a chemistry laboratory on the lower floors, no sustained didactic role was considered for the works of art given to Christ Church or to Cambridge, at least until the late 19th century. Art, after all, formed no part of the university curriculum.

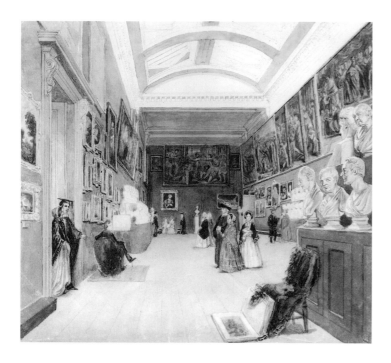

Fig. 8 Ashmolean Museum, Oxford, designed by C.R. Cockerell, the Picture Gallery; pencil and watercolour view by Joseph Fisher, *c.* 1850; Bodleian Library, Oxford

These gifts appear to have been pragmatically motivated. Universities had replaced monasteries as repositories for precious objects, and they possessed libraries which, with their holdings of manuscripts and curiosities, resembled early museums. They could be expected (not always reliably) to preserve collections intact in the founder's name. They held an established position within the political, religious and intellectual structures of England and Scotland, notably through the exclusion of non-adherents of the established religion. While the British Museum, from its earliest days, attracted donations including Classical sculpture and paintings, it had the disadvantage of absorbing collections into a larger whole in which donors became indistinguishable – one reason why Bourgeois decided against a bequest to the museum. Equally, the Royal Academy had been given numerous works of art since its foundation, yet, with such startling exceptions as the Leonardo cartoon and the Michelangelo tondo, most of them were prints and plaster casts, intended as tools of study for young artists.

These early museums belonging to educational institutions could only to a limited extent be described as 'public', in the generally accepted modern sense of communal, or state, ownership and availability. The history of their accessibility illustrates changing attitudes towards the admission of general, non-initiated, visitors to places of learning from the 17th century onwards. The Ashmolean was open to all from the start, and educated early visitors described with revulsion the crowds of ignorant country people who crowded in with no understanding of what they were looking at: an early indication of the dilemma over whether to present museums as science or as spectacle (fig. 8).[12] Such openness did not apply during the 18th century, when museums and universities found a discrepancy between their purported intention to show their collections to visitors and the practicalities of admitting people into spaces containing precious objects and dedicated to abstruse knowledge. Thus, although the British Museum was always open to the public, from its earliest days entry could be achieved only by appointment. Visits were conducted in groups at great speed and with the communication of little information, an effective way of excluding, while not actually banning, the outsider. Nor did the Christ Church holdings, kept in the college library and shown only to privileged visitors, function as a publicly accessible museum. The 'public' museum was a 19th-century phenomenon. Even then, in reaction to the Chartist demonstrations of the 1840s, the danger of admitting the working classes to such places, and the subsequent relief that no misdemeanour had been committed, were constant subtexts in discussions about the control of cultural provision.

The notion of a canon of taste dominated the early collections. General Guise was praised by his contemporary George Vertue for his 'excellent Taste collecting those peices [*sic*] of the greatest Italian Masters only, & chiefly pictures in their best manner'.[13] Guise tended towards correctness, avoiding Flemish and Dutch paintings or French 18th-century art. When he could not find originals he acquired copies, a usual practice until the early 19th century, when the worship of the original work of art took sway. William Hunter's slightly later art collection, though smaller, with only 54 pictures, reflected personal loyalties in the depictions of celebrated anatomists (Hunter was one himself), such as Vesalius and Dr Radcliffe, and an interest in natural history and anatomy, as in Stubbs's animal studies. Hunter also showed a sophisticated awareness of contemporary French art by acquiring three Chardins. Lord Fitzwilliam concentrated on Dutch and Flemish paintings, although in addition he purchased spectacular Italian Renaissance works, including pictures by Titian and Veronese. Ambitiously, the founders of the Bourgeois collection intended to create a national gallery in miniature, in

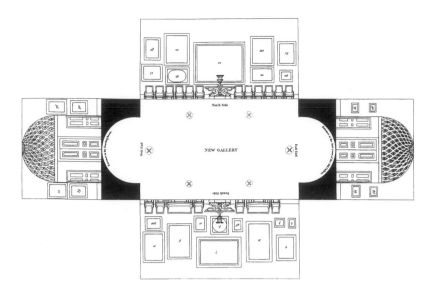

Fig 9 The Marquis of Stafford's gallery, Cleveland House (later Bridgewater House), London, designed by C.H. Tatham; from W.Y. Ottley and P.W. Tomkins, *The Stafford Gallery*, London, 1818

which the most admired artists of the past and a select group of current artists were represented.

Works on paper played an important part in some of these early collections. Guise's paintings were supplemented by almost 2000 Italian (and rather fewer Northern) drawings, which offered an almost encyclopaedic representation of Italian artists up to the late 17th century. Assembling comprehensive drawing collections had become established in England in that century, especially by artists (such as Sir Peter Lely), who were joined in the 18th century by aristocrats and private individuals. An encyclopaedic approach was also embodied in Fitzwilliam's 187 volumes of prints, neatly categorised by artist.

The Growth of Regional Identity

These 'college collections' depended on a traditional selection of works by famous foreign names of the past. The growing confidence of the native school in the late 18th century was checked by the political events of the 1790s, which encouraged the French aristocracy to send their paintings for sale to London and led to the dispersal of important Italian and Spanish works from disestablished religious institutions. The availability in London of rich holdings of Old Master paintings sent collectors back to 16th and 17th-century art just when they were beginning to show an interest in more recent work – a tendency that has been described as 'entirely retrograde ... as far as English taste was concerned'.[14] It was not just modern works that were no longer in demand: a rising interest in the early schools, in Italian and Northern art prior to 1500, was interrupted for more than a

generation. The impact of the sale in London of works from the Orléans and other collections was to improve greatly the quality of Old Master paintings in Britain.

The growing Continental enthusiasm for public museums in the late 18th century encouraged the opening to at least a cultivated audience, and sometimes to all, of princely galleries, including the Uffizi Gallery in Florence and the Belvedere Palace in Vienna. This process reached a climax in 1793, when the French revolutionary government opened a museum in the Louvre to display the former King's possessions. It was the sight of the Louvre which persuaded the British aristocracy, in the absence of a British National Gallery, to make their collections more accessible. In 1806 a group of noblemen, led by the wealthy Marquis of Stafford, decided to show the galleries in their London houses to a limited public, including artists provided with letters of introduction from members of the Royal Academy (fig. 9). This decision was reflected in the opening to visitors of country collections, such as that of Henry Blundell at Ince Hall in Lancashire. Also in 1806 aristocratic initiative formed the British Institution in Pall Mall, London, which presented an innovative exhibition programme, the first in Britain outside the Royal Academy (fig. 10). This included a show devoted to contemporary art as well as an annual display of Old Master paintings lent by private owners and, until 1813, reserved for artists. Despite the pressure exerted on government by such examples, and although comparable institutions already existed all over Europe, a National Gallery was not established until 1824.

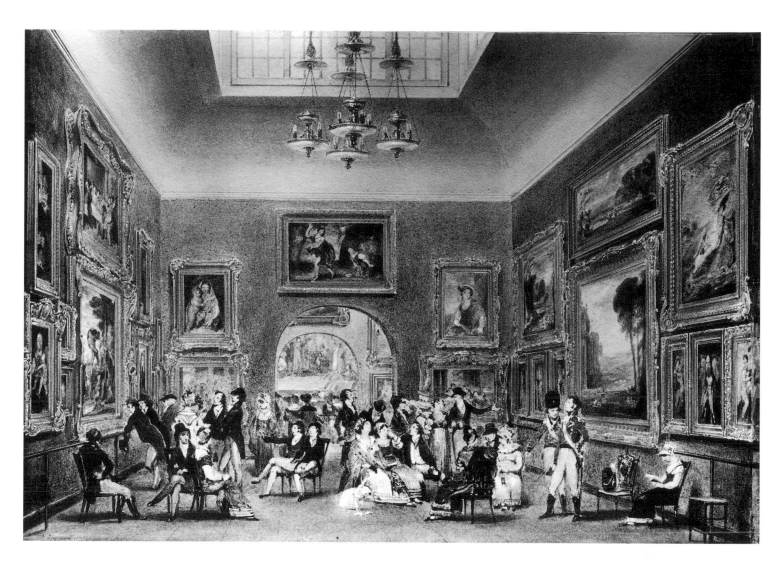

Fig. 10 The British Institution, London, designed by George Dance II, 1788; pen and watercolour view in 1816 by James and F.P. Stephanoff, 1817; Victoria and Albert Museum, London

Outside the capital, such developments had relatively little influence. The establishment of museums and galleries in regional cities could hardly be much assisted by a National Gallery which existed for its first fifteen years in former private houses, minimally staffed and dependent on a tight-fisted Treasury. Whereas Napoleon in 1801 decreed the foundation of fifteen provincial museums (primarily to house works of art confiscated from the aristocracy and the Church), central government in Britain took no interest in creating cultural institutions in the regions, and this in spite of the rapid urbanisation of the country. The regional cities, notably Liverpool and Manchester, Leeds and Sheffield, Birmingham and Nottingham, and Glasgow, as well as many smaller towns, were already growing rapidly in population and wealth by 1800; yet they expanded most vigorously during the first half of the new century, when the populations of Manchester and Glasgow quadrupled, and those of Liverpool, Leeds and Birmingham increased by a factor of eight.

These newly rich cities were excluded during the first third of the century from the political establishment and the universities. Until the Reform Bill of 1832, they were largely unrepresented in Parliament; they possessed no universities (except in Scotland); and many of their inhabitants, as Nonconformists or Catholics, were unable to attend university. Moreover, they were prevented

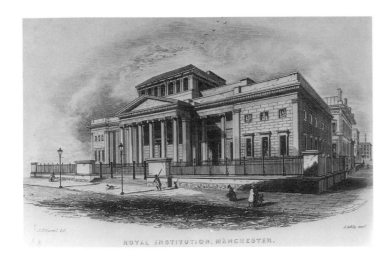

Fig. 11 The Royal Manchester Institution, designed by Charles Barry, 1824–5, home of Manchester City Art Gallery from 1883; engraving by J.F. Burrell

from organising any proper representative systems or municipal services by the chaotic system of local government which prevailed until the 1830s and beyond. By the early 19th century there were 25,000 instruments of government (legally constituted bodies with defined powers) in England and Wales. Many of the most important towns, including Manchester and Birmingham, were governed by minor local bodies, often medieval in origin. Even the Municipal Corporations Act of 1835, which set up elected bodies in place of the self-perpetuating corporations, initiated municipal reform only slowly.

In these circumstances the men of wealth and influence who wished to create a cultural and social identity, and a sense of achievement, for the cities of the Midlands and the North were forced to operate outside official institutions. Their task was made even more difficult by an extended period of social unrest from the late 18th to the mid-19th century. This is illustrated by the extreme case of the 1791 burning of Birmingham Library and the sacking of the house of its secretary, Joseph Priestley, by a mob fearful of the revolutionary activities supposedly conducted at the library. The history of 19th-century regional museums and galleries is often closely linked with Liberal political sympathies: the cultural aspirations of Manchester, for instance, should be seen in the context of the establishment in 1821 of *The Manchester Guardian*, dedicated to liberty and parliamentary reform. In the institutional sphere, initiatives included the encouragement of local schools of artists and the establishment of scientific,

philosophical and literary societies. The latter were distinguished by their imposing classical buildings, by their collections of scientific and historical specimens, by the organisation of temporary exhibitions and by intellectual activity in the form of meetings, lectures and publications. Belief in the power of cultural institutions was central to the development of regional cities up to World War I.

The history of cultural life in the great regional cities can only be touched on here.[15] Learned societies had been established in some numbers in the late 17th century, following the foundation in 1662 of the Royal Society in London. They assembled collections intended to support the academic research and experiments carried out by members. Of these early groups few survive: the Gentlemen's Society of Spalding in Lincolnshire is a rare example.[16] Further organisations of this kind were established in the 18th century, for example the Foulis Academy in Glasgow (1754) and the Royal Society of Arts in London (1760). Societies in large regional cities, generally founded without suitable premises or substantial collections, allowed individuals interested in scientific research and new ideas to meet for discussion and experiments: the Lunar Society of Birmingham developed from the late 1760s, while similar establishments (both, unusually, surviving) followed in Manchester in 1781 and in Newcastle upon Tyne in 1793.

At the end of the Napoleonic Wars more ambitious and lasting bodies were founded. In Liverpool and Manchester, Leeds and York, as well as in such smaller towns as Whitby and Scarborough, learned societies came into existence, all between 1817 and 1823. These organisations were based entirely on private initiative. They often erected impressive premises, of which Manchester City Art Gallery, a building designed by the young Charles Barry in the 1820s, is a prime example (fig. 11; cat. 13). Such establishments would house a lecture room, a library and collections of stuffed birds, fossils and archaeological remains. Resources were raised by membership subscription, usually high enough to exclude the less privileged. Access was confined to members, their families (admission for women was restricted) and their friends. Private as these institutions may seem, they represented a statement of pride by people excluded from national structures of power and debate. For this reason, the societies tended to be regarded, if not necessarily with hostility, at least with indifference by the established orders. When that generous promoter of British art Sir John Leicester undertook to raise money in the 1820s for the erection of the Royal Manchester

Institution, he found almost none of his wealthy aristocratic friends prepared to contribute. Furthermore, conflicts were not confined to that between urban power and landed interest. At Manchester, the idea of an institution to organise temporary exhibitions and teaching had originally been mooted by a group of artists, inspired by the Northern Society in Leeds. The notion was taken up by 'a certain number of opulent Gentlemen of Manchester enthusiastic admirers of Art'[17] with such determination that they assumed sole responsibility for the new institution and, on the model of the British Institution, excluded artists from its administration.

Artists needed, and to an extent achieved, their own arena for exhibiting and selling their work at a time when commercial outlets for the sale of contemporary art were limited. Both in London and elsewhere, the provision of temporary exhibition spaces for this purpose was central to 19th-century cultural politics. Part of the problem for artists lay in finding venues that would bestow respectability on a profession which was uncertainly defined within society, especially outside the capital. In Liverpool, already wealthy by the later part of the 18th century, an art society (dedicated to the promotion of good design) had been founded as early as 1769. Five years later it held an exhibition of contemporary art largely by Liverpool artists – the first art display in a regional city in England.[18] Throughout the 19th century, artists regularly organised themselves into groups to mount exhibitions, inspired by the Royal Academy and by the British Institution. These events, generally annual, included mostly local artists, but also some nationally known names, in order to increase attractiveness. The Norwich Society of Artists (one of the strongest, associated with probably the most important of all locally based schools of artists in England) held its first exhibition in 1805, the Edinburgh Society in 1808, the Northern Society in Leeds in 1809. They were followed by many others, so that by 1830 such displays had been arranged in some twenty cities and towns. The life of these groups was extremely precarious, especially when they built their own premises. Few lasted for long without interruption – a warning of the vulnerability of art institutions without public funding. It was only in the second half of the century that artists' societies found a home in municipal galleries. There they could organise regular exhibitions in a spacious setting, given respectability by municipal status, and free of financial anxieties. The determination with which they occupied this territory, and the efforts of curators to dispossess them, were to form an important narrative a century later.

Even when the fine arts were not central to private societies, the encouragement, if not the collection, of painting and sculpture often featured among the objectives of such institutions: indeed, one of their interesting features was the way in which they allowed the fine arts to co-exist with other products of human ingenuity. In Bristol, whose tradition of collecting natural history and geological specimens had been

Fig. 12 The Bristol Philosophical Institution, designed by C.R. Cockerell, opened in 1823

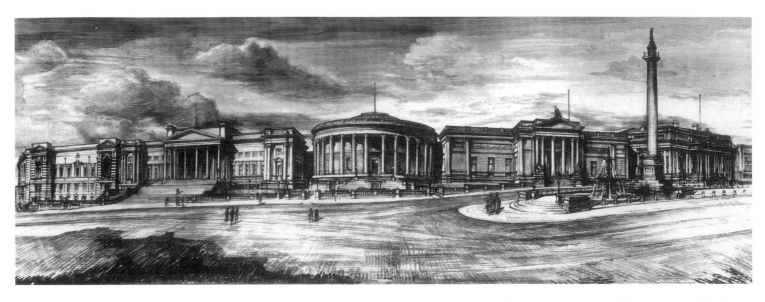

Fig. 13 North Side of William Brown Street, Liverpool, showing (left to right) Liverpool Museum and Library by Thomas Allom, 1857–60; the Picton Reading Room by Cornelius Sherlock, 1875–9; Walker Art Gallery by Cornelius Sherlock and Henry Hill Vale, 1874–7; Sessions House by F.G. Holme, 1882–4; and the Wellington Monument by A.P. Tankard, 1946; Liverpool Libraries and Information Services

encouraged by the richness of the native flora and rock formations and by the curiosities brought to the city by sea captains, art collecting was relatively sluggish, in spite of the energy of the Bristol school of artists. The Philosophical and Literary Society, established in the early 1790s, erected in the 1820s the Bristol Philosophical Institution to the designs of Charles Robert Cockerell (fig. 12). In this building, with its celebration of Classical architecture and its frieze depicting Apollo and Minerva introducing the Arts and Sciences and Literature to the City of Bristol, zoological and anatomical specimens were to co-exist with 'The exhibitions of Pictures, Statues, Casts, and other objects of the Fine Arts, and of Antiquities'.[19] The Institution was to act both as an academy for the artists of Bristol, for which a teaching collection was required, and as a site for annual exhibitions which, following the example of the British Institution, would alternate between displays of Old Master paintings and contemporary work. The first exhibition by the Bristol school was held there in 1824.[20] The Institution's collecting efforts were negligible, however. An account of 1835 lists few contemporary works and some portraits, shown pell-mell in the Great Room with Classical casts and 'various reptiles, fish, and mollusca, in spirits'.[21] Bristol may stand for the majority of such institutions: at the Royal Manchester Institution or at the Literary and Philosophical Society of Newcastle upon Tyne only a handful of paintings and sculptures, mostly by local artists and

collected by subscription or by random gifts and bequests, was assembled in contrast to the rich holdings of scientific specimens. One area in which collecting works of art was encouraged was topography: in Newcastle, for example, the stated aims of the Society included the encouragement of paintings inspired by the beautiful local scenery. This was to be a constant theme in late Victorian art galleries.

Within this rather dispiriting picture, Liverpool shines out (fig. 13). The city had grown rich as foreign, and especially colonial, trade (not least in slaves) doubled in the last fifteen years of the 18th century. Of the counties of Britain which flourished at this period, Lancashire, led by Liverpool and Manchester, but including many other important manufacturing and trading centres, rose most dizzily: 35th in wealth among English counties at the end of the 17th century, it had become the third richest a century later and the second (after London) by 1843.[22] Lancashire was to sustain this wealth into the 20th century and many of the most impressive Victorian collections and museums were created there. Well before 1800 Liverpool was known for its collectors of both Old Masters and contempory works. Art exhibitions were only one feature of its cultural life, since various cultural institutions were created from the mid-18th century onwards in a city determined to justify the motto 'Liverpool gentleman, Manchester merchant'. These included a subscription library (set up in the 1750s), a College of Arts and Science, an

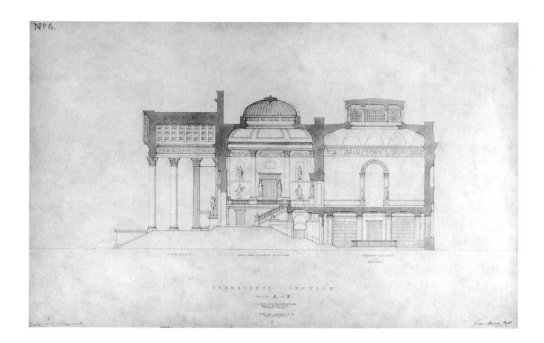

Fig. 14 Fitzwilliam Museum, Cambridge, designed by George Basevi, 1837–48, transverse section; pen and ink; Fitzwilliam Museum, Cambridge

Athenaeum (with a library) and a botanic garden, and culminated in the foundation in 1814 of the Liverpool Royal Institution, which was to house both a learned society and an art collection.

Even more than early 19th-century Manchester, Liverpool possessed an influential group of men eager to set up cultural bodies and collections in the service of public education. Thus the Classical antiquities (with a few modern pieces) assembled in the late 18th century by the Catholic landowner Henry Blundell at Ince Hall,[23] a few miles from the city, reflected the aristocratic collections of contemporary London in being regularly open to visitors, in spite of the difficulty of accommodating an untrained public in a 'polite' setting. After troubles with 'large parties, which often occasioned no small trouble and inconvenience, particularly when there was company in the house',[24] the sculpture collection was opened one day a week in a purpose-built Pantheon. Blundell, interested in public education, produced in 1803 a guidebook 'to obviate the daily questions of those visitors who are not much versed in history or heathen mythology, and … by no means intended to meet the eye of the learned antiquarian'.[25] It anticipated the production of easily comprehensible catalogues for a mass market which flourished in 19th-century Britain.

William Roscoe (1753–1831)

A leading contributor to this cultivated atmosphere in late 18th-century Liverpool was one of the most remarkable early collectors, William Roscoe. Roscoe, largely self-taught and a passionate believer in general education, made his fortune as a banker but devoted as much time as possible to social reform (he was a passionate supporter of the abolition of slavery) and to collecting.

Roscoe kept his works of art in his house at Allerton, outside Liverpool, where he also created a botanical garden. From the 1780s he bought prints with the aim of illustrating the development of art from the earliest times, in Italy and in the North. He gained a considerable reputation from his historical publications, notably his lives of Lorenzo de' Medici (1795) and Leo X (1805), and acquired paintings in the spirit in which he assembled material for his books.

Roscoe was crucial to the development of museums in this country for several reasons. First, he advanced the fashion for buying Italian and Northern paintings of the period before Raphael, a taste that had already developed in Italy, Germany and France. Although he was not the first collector of this type in Britain, his was the first historically conceived collection to enter semi-public ownership (and it survives in part at the Walker Art Gallery). Roscoe was far ahead of the National Gallery, which continued until the 1840s to conform to traditional taste by buying 17th-century paintings. For relatively small sums, he purchased 'primitive' (that is, pre-1500) paintings in the salerooms as well as later paintings. As he explained in 1816: 'The following works … have been collected during a series of

years, chiefly for the purpose of illustrating, by a reference to original and authentic sources, the rise and progress of the arts in modern times, as well in Germany and Flanders as in Italy. They are therefore not wholly to be judged of by their positive merits, but by a reference to the age in which they were produced. Their value chiefly depends on their authenticity, and the light they throw on the history of the arts.'[26]

In 1816 the bank in which Roscoe was senior partner went into liquidation and his collections were sold at auction. Thirty-seven of the 'primitive' paintings, for which there was little demand, were bought by a group of subscribers, who presented them to the Liverpool Royal Institution (cat. 270, 276). There they were shown to the public from 1819. As Edward Morris has written: 'For the first time a group of important old master paintings had been bought and placed on permanent exhibition with the avowed intention of improving public taste.'[27] This was a methodical display, with paintings arranged by school and chronology for the first time in Britain. The catalogue was laid out correspondingly. In his reflection of the growth of art historical studies Roscoe anticipated the development of university galleries in the 19th century and of municipal collections in the 20th.

In the short term Roscoe had few imitators. In the 1840s the carriage-builder Alexander McLellan, whose collection in Glasgow had been admired by Waagen, bequeathed it to his native town with the intention that it be shown to the public. Sadly, his generosity was premature and, though the works of art were accepted, inadequate arrangements were made for their display. Only in Oxford, where a fine Neoclassical building by C.R. Cockerell was erected to hold the university's art collections in the 1840s, and in Cambridge, where a museum was finally built for the Fitzwilliam and other collections in the same decade, were substantial new galleries based at least to some extent on historical principles (fig. 14). The construction of the Oxford University Galleries encouraged various acquisitions. In 1850 the Hon. William Fox-Strangways, who in 1828 had already given similar paintings to Christ Church, presented to the galleries a group of what he called 'the very old Masters', Italian pictures by, among others, Filippo Lippi and Paolo Uccello. The Ashmolean's most important acquisitions during this period were the Raphael and Michelangelo drawings from Sir Thomas Lawrence's collection, bought by subscription in 1842 through the efforts of one of the curators, Henry Wellesley (cat. 76, 77). Wellesley believed that, while the museum could no longer hope to obtain

major paintings, it could represent the Old Masters through drawings. They were exhibited permanently in the museum's Great Gallery and attracted many other gifts of prints and drawings.

Roscoe was important not only for the historical basis of his collecting. For this historian of Renaissance Florence, the Italian banking and commercial city was directly comparable to Liverpool. The newer city, proud of its independence and its cultural life, should, he felt, emulate the older one in patronage of the arts, an essential element of urban life. The value of the arts, for Roscoe, was not that, in the usual formula of 19th (and 20th) century Britain, they would bring financial prosperity, but that they were capable of 'educating, humanizing, and finally ennobling society'.[28] Just as Florence had had its Lorenzo the Magnificent, Liverpool, he believed, benefited from its merchant-princes, and just as Italian streets were admired for their Renaissance palaces, the English ones boasted theirs. The idea that the great commercial towns of Victorian England should be compared to, and be inspired by, Venice and Florence was to become a commonplace in Victorian urban debate.

Art Education and the State

The activities of the learned societies suffered from the danger faced by all private initiatives, whether cultural or economic: dependence on a few individuals and the risk of decline when those individuals cease to be involved. Unfortunately, public support was limited. Although the French wars necessitated the creation of numerous public offices, in 1815 the role of the British government was again reduced: in 1819 the staff of the Home Office numbered 30. Traditionally, social legislation was not regarded as an obligation of the state, a view which extended to the provision of public education. Thus, while in Austria compulsory public education had been introduced by Joseph II at the end of the 18th century, similar legislation was not approved in Britain until the 1870s.

In the 1820s expectations of government began to change: many people no longer found domination by a small élite tolerable and the need for social and political reform came to be expressed with increasing vigour. The advocates of Utilitarianism and of Evangelical religion, with their emphasis on the need for general education and on the state's obligation to provide educational institutions, exercised a powerful influence on public discussion of social issues. From the 1820s until the 1840s, a series of Parliamentary Select Committees investigated with

remarkable thoroughness such subjects as the role of historic buildings, the need for art education, the future of the National Gallery and the purpose of public art. The necessity of rebuilding the Houses of Parliament, burned down in 1834, lit up the discussion of British art and of a possible revival of history painting, and led to the appointment in 1841 of the Fine Arts Commission, charged with investigating how the new building could be used for 'the encouragement of British art'.[29] This Commission, which numbered among its members many leading figures in the early Victorian art world and public affairs, including Prince Albert (as President) and Charles Eastlake (as Secretary), with Thomas Babington Macaulay to represent recent historical scholarship, instituted a series of competitions for frescoes for the new Palace of Westminster. The results were exhibited in Westminster Hall, arousing huge popular interest, and some of the schemes were ultimately executed.

Although the decoration of the Palace was a magnificent failure in terms of painting technique, it encouraged the expectation that depictions of British history and heroes should be central to works of art displayed in public. Through the example of Westminster Palace, emergent municipalities and other local authorities were encouraged to express civic pride. In the Great Hall of Manchester Town Hall, from 1876 to 1888, Ford Madox Brown executed a programme of wall paintings celebrating the antiquity of the city, its Christian values and its educational and commercial traditions, from the Romans building a fort to the Mancunian chemist John Dalton collecting marsh-fire gas (on his way to discovering atomic theory).[30] In many instances, allegorical sculpture and statues of famous citizens in town halls and other public buildings, including museums, reflected the sculptural programme devised for Westminster. Just as the rebuilt Palace had been seen as a gallery of British art for the benefit of the whole nation, and for many years could be visited with the help of guidebooks that explained the paintings, so one purpose of the Victorian town hall, and by extension the art gallery, was to function as a public display of locally inspired works of art.

An artist and administrator such as William Dyce (1806–64), the Scottish historical and religious painter, believed that public education in the arts at any level below the academies should be severely pragmatic. Dyce and his allies, among them Henry Cole, Director of the new South Kensington Museum, founded in 1852, argued that public instruction in the fine arts must be aimed at education in design and botanical drawing. The

problem with British education in the arts, they claimed, was that it did not teach manufacturers and artisans to produce objects of artistic quality, so that British products were less saleable than those from France and Germany. These countries' highly developed art education should be emulated. Training in ornament for manufactured objects, rather than academic life drawing, must be the purpose of the new art schools.

Dyce and Cole stimulated the establishment in 1838 of a School of Design at Somerset House, with Dyce as its first Superintendant. In the following decades similar schools were set up in towns all over Britain through the publicly funded Department of Science and Art (which had been responsible for the foundation of the South Kensington Museum). In these schools, art education was organised on the strict principles laid down in manuals by Dyce and his colleagues. By 1864 Cole could point to 90 art schools throughout the country teaching 16,000 students, with many more children also being instructed. In practice these schools were less than satisfactory: many suffered administrative and ethical problems as well as invasion by middle-class ladies, an oppressed group in their own way, but not the official target of art education.

An art collection for the benefit of students was an integral part of the aims of the schools of design. As the Report of the 1836 Parliamentary Select Committee on Arts and Manufactures put it, government should investigate an arrangement for 'the formation of open PUBLIC GALLERIES or MUSEUMS OF ART in the various towns willing to undertake a certain share in the foundation, and to continue the maintenance, of such establishments'. Claiming that foreign countries possessed a notable advantage over Britain in 'their numerous public galleries devoted to the Arts, and open gratuitously to the people', the Report lamented the lack of such places in Britain and the exclusion – because of the fees charged – of poorer people from such exhibitions as were organised. [31] It also recommended that new museums should be open after working hours and should include reproductions of famous works for teaching purposes. Crucial to the Report was the belief that artistic instruction for all should be central to state education.

In fact, galleries were not set up as speedily as the schools of design had been: although art schools could be funded by the Department of Science and Art, there was no such provision for galleries. Not until 1845 did the first Museums Act allow towns with populations exceeding 10,000 to devote money from the rates to museums. This legislation, known popularly as the

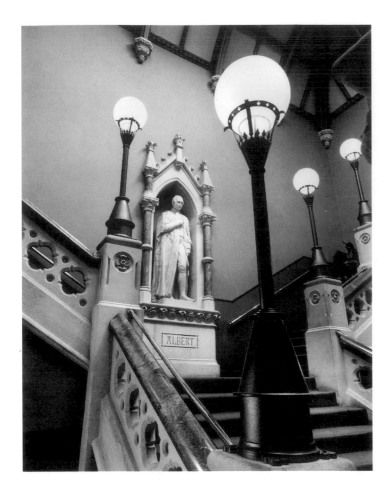

Fig. 15 Royal Albert Memorial Museum, Exeter, designed by John Hayward, the entrance staircase with the statue of Prince Albert by E.B. Stephens (1968)

Fig. 16 Wolverhampton Art Gallery, designed by Julius Chatwin, opened in 1884

'Beetle Act' because of its emphasis on natural history, had little effect on corporations: by 1850 only six towns had established museums. Most of these were based on the collections of declining Literary and Philosophical societies, and none was dedicated to the fine arts. Even the 1850 Public Libraries and Museums Act, which allowed corporations to set up libraries – frequently co-existing in the same buildings as museums, as some do to this day, often in forced marriages – did not immediately stimulate the foundation of galleries. From the 1870s, however, they were regularly established in the same building as an art school, just as the National Gallery had initially occupied the same premises in Trafalgar Square as the Royal Academy. At the Royal Albert Memorial Museum in Exeter, founded in 1868 and one of the earliest new art museums, and at the Wolverhampton Art Gallery of 1884 gallery and school of art co-existed (fig. 15, 16). At Wolverhampton, the imposing classical building by the Birmingham architect Julius Chatwin was characteristic in containing an art school on the ground floor and the new gallery above. Much of the metalwork and woodwork was intended to demonstrate the excellence of the local craftsmen, creating a building that was in itself an exhibit. In many galleries the provision of materials, in particular casts, from which artists could copy formed an important element of the exhibits. Comparable art schools-cum-museums were set up at Leicester, where an art gallery was built next to the existing art school from 1880 to 1885, and at the Grosvenor Museum and Schools of Science and Art in Chester (1885–6).

The delay in establishing municipal galleries was understandable. Whereas the learned societies often accumulated significant scientific collections, they seldom owned paintings or sculpture of interest. Nor did the newly constituted municipal authorities, often faced with major housing and sanitation problems, consider establishing art museums to be a priority at a time when public education, too, was extremely limited (in 1850 only one child in eight in Britain attended school).

International Exhibitions

Public interest in the visual arts was transformed by one of the most important cultural innovations of the 19th century: the international exhibition. Here, as it seemed to contemporaries, evidence of the growth of trade and improvements in communications were combined with an exalted view of the possibilities of human endeavour. The Great Exhibition of 1851, the first great international exhibition, which was held in Hyde

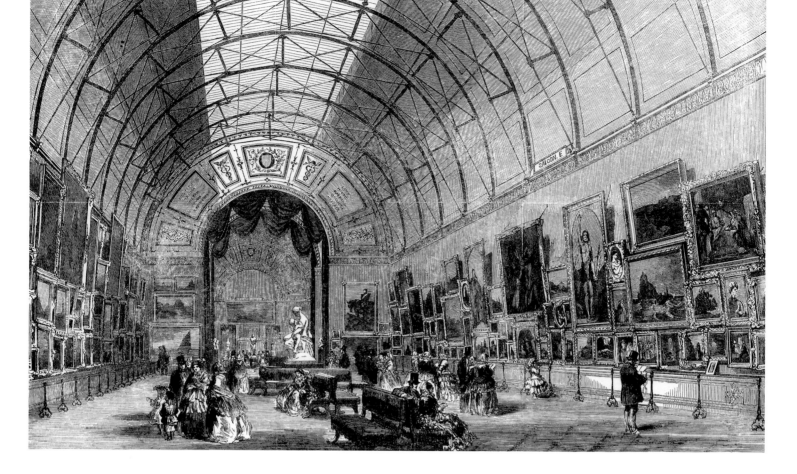

Fig. 17 Manchester Art Treasures Exhibition, the gallery of modern painters; from *The Illustrated London News*, 4 July 1857

Park, was a commercial enterprise which made a substantial profit, yet it was inspired by elevated ideals. As Prince Albert declared during the planning, the world was approaching a period of the 'most wonderful transition ... the realization of the unity of mankind'. The exhibition would 'give us a true test and a living picture of the point of development at which the whole of mankind has arrived in this great task, and a new starting-point from which all nations will be able to direct their further exertions'.[32]

In the Great Exhibition and its heirs, the Crystal Palace at Sydenham and the South Kensington Museum, in the Manchester Art Treasures Exhibition of 1857 and the International Exhibition of 1862 held at South Kensington, a new mass public was regaled with an intoxicating blend of instruction and entertainment. The crowds were enormous: six

million people visited the Great Exhibition in 140 days, while the much more recondite and art-based Manchester exhibition attracted well over a million. The displays were housed in huge iron and glass constructions, which were capable of containing exhibitions on a scale never previously contemplated. They were hailed by their admirers as the architecture of the future but not regarded as architecture at all by their detractors.

Perhaps the greatest influence on the municipal galleries which emerged in the 1860s and 1870s was the Manchester Art Treasures Exhibition (fig. 17). This extraordinary event, organised in one year by a group of leading citizens, reasserted the effectiveness of private initiative and commercial enterprise in the pursuit of noble aims. It also celebrated the more parochial truth, acknowledged by Waagen in his *Treasures of Art in Great Britain*, published shortly before, that the private collections of

Fig. 18 Harris Museum and Art Gallery, Preston, designed by James Hibbert, 1882–93, the first-floor landing

Britain contained the richest assembly of works of art in the world. This statement of the nation's cultural riches represented an early example in Britain of that attachment of nationalistic values to works of art which was to assume greater force a generation later. The aristocracy was expected to lend to the exhibition and in many cases they obliged, apparently out of a sense of duty. Furthermore, the exhibition proved that Manchester, often despised as a commercial centre with no pretensions to cultivated life, was capable of bringing together the most impressive collection of works of art ever seen in Britain – and at a time when the National Gallery was still small and badly accommodated. The message was not lost on the great regional cities.

In a triple-tiered glass basilica, thousands of objects were displayed in carefully organised sections, devoted to works on paper, British portraits, glass, enamels, porcelain, Oriental china, majolica, goldsmiths' work, bronzes and terracottas, medallions and glyptics, ivories, arms and armour, clocks and furniture, sculpture (largely modern), watercolours (almost 1000 of these), photographs and prints (some 2000, arranged by technique). The tone of the proceedings is suggested by a note on the ivories. They deserved, one of the catalogues admonished, 'particular notice, inasmuch as there is certainly no other branch of the Art

which can to an equal degree afford us a knowledge of the different styles of successive epochs, of the guiding spirit, dominant ideas, customs, and manners of past ages, from the commencement of the Christian era down to the 17th century'.[33] Equal weight was attached to the fine and the decorative arts, although the best places were accorded the paintings. The climax, both for the organisers and, one must assume, for visitors whose spirits must have wilted at the prospect of the clocks and line-engravings, was the display of 'Ancient Masters'. Over 1000 of these were shown, along with works from Lord Hertford's collection which, before its donation to the nation as the Wallace Collection in 1897, was assuming a semi-public role through frequent loans to exhibitions.

The display of Ancient Masters was arranged by the young George Scharf, later to be the first Keeper and Director of the National Portrait Gallery, an indefatigable student of British collections and, along with Sir Alfred Eastlake, Director of National Gallery and President of the Royal Academy, Antonio Panizzi of the British Museum and a few others, a hero of Victorian museums. Scharf wished to give a comprehensive history of art from ancient times (he started with Classical and Byzantine objects, though sparingly) by illustrating 'the choicest specimens of every master in the history of art, as far as I

remembered their existence in this country'.[34] This was an aim which the National Gallery had begun to pursue under the leadership of Eastlake but that had otherwise been explored only in the Crystal Palace at Sydenham. There the opening displays had been organised so as to present an encyclopaedic range of learning, science and art, making the Palace into a School of Fine Art, not just for the privileged but for the whole mass of the people – although at Sydenham this objective was achieved largely by means of reproductions. Late Victorian museums found that, by using casts and photographs, they could follow a similar route. At the Harris Museum and Art Gallery in Preston, from 1883 to 1892, a magnificent central hall was created which contained in reproduction a survey of art from the Assyrians to the Renaissance (fig. 18). The modern British school offered the logical culmination of this progress.

As Scharf explained, he 'adopted one leading principle ... I desired not only to arrange them [the works of art] in chronological order, but to mark as far as possible the contemporaneous existence of opposite schools'.[35] Accordingly, he showed Italian paintings on one wall of the principal saloon opposite works of the Northern school from equivalent periods. Although Scharf was far from undermining the traditional respect shown to Italian art, he wished to assert the comparable excellence of the Northern schools, which might have as much to offer to contemporary artists as Italian art. Scharf's approach anticipates the recurring enthusiasm for Northern art shown by early municipal collections and their unwillingness to acquire Italian Renaissance paintings.

The British School

The Manchester exhibition and the comparably enormous 1862 International Exhibition at South Kensington contributed another important feature to the development of public galleries: they celebrated the history and the contemporary excellence of the British school. The frustrated efforts of artists and critics at the beginning of the century to assert the potential of British painting and sculpture had stimulated a shift of taste by the 1830s. In such innovative publications as Allan Cunningham's *The Lives of the Most Eminent British Painters, Sculptors and Architects*, published in six volumes from 1829 to 1833, the qualities of British art were asserted. 'Our shrewd Scottish Vasari'[36] declared, in an influential version of events, that before the time of Hogarth British art had relied excessively on foreign skills, that such exceptions as the miniaturists and the native

followers of Van Dyck could 'have little right to be classed among masters' and that true art was established in England by the founding fathers: Hogarth, Reynolds, Wilson and Gainsborough. For Cunningham, the strength of the English school lay in 'the truest nature and the purest fancy',[37] as well as in the 'moral sentiment, nervous satire, sarcastic humour, and actual English life' to be found in Hogarth.[38] English art was led astray by foreign study: British artists lost 'their own island originality in gazing upon the splendid works of Michel Angelo and Raphael; they come home bringing with them all that is weak and leaving all that is strong'.[39] Cunningham's vigorous assertion of the native genius, natural, virtuous, humorous, independent and non-academic, was extended in later publications, of which Richard and Samuel Redgrave's *A Century of Painters of the English School*, first published in 1866, was the most extensive.

These publications were reinforced by several important donations to British museums, such as the 1847 gift to the National Gallery of British paintings belonging to Robert Vernon, which presented the newly defined canon of British art in comprehensive form.[40] In this discourse, the great exhibitions played an important role. At Manchester, British culture was represented both by the 'British Portrait Gallery', with its presentation of national history, and by a survey of British art. This began with British portraits (with Scottish work well represented) of around 1700, followed by a large selection of pictures by the heroes of the British school, notably Reynolds (with 37 works in this section alone), and a good showing of early 19th-century artists, including Turner, Landseer, Etty and Wilkie, before sweeping into a display of post-1830 British art. Even more ambitiously, the fine-art section of the 1862 exhibition placed British art in competition with that of other nations. In a vast hall in South Kensington, some 6000 works of art (along with numerous other artefacts) were assembled. British objects slightly outnumbered those from abroad.[41] In his introduction to the catalogue, F.T. Palgrave explained that the exhibition would present the development of the indigenous school, unique in that its roots lie in modern times.[42] As he put it: 'The best art is that which best represents the mind of a race, and we may read ourselves as a nation in the independence and vigorous individuality of our artists.'[43] This new-found confidence in British painting was to be a key factor in the creation of municipal collections.

These exhibitions also influenced municipal museums by evidently considering enjoyment and comfort to be of prime

Fig. 19 Walker Art Gallery, Liverpool, designed by Sherlock and Vale, 1874–7, the Refreshment Room in 1888

importance. Although admission was charged at all the exhibitions, prices were adjusted to allow poorer people to attend when they enjoyed leisure time. At Manchester, for example, admission was halved to 6*d* on Saturday afternoons, when many workers were free; while on some days entrance fees were high, in order to encourage those seeking privacy. Transport to the events revolutionised mass pleasure travel. It was through his organisation of railway excursion tours from all over the country to the Great Exhibition that Thomas Cook gained his reputation, and new omnibus services to Kensington were instituted. Other needs were catered for, too. Public amenities were introduced, proving both popular and profitable (fig. 19). At Manchester, the visitor who had summoned the strength to see the whole exhibition would certainly have earned the comfort provided by the variously priced refreshment rooms: 'and oh! how he will enjoy that marbled section of Aberdeen beef – those plump thighs of Dorking chickens – and a cool and sparkling bottle of Moet, topped up with a becoming share of that '40 port now piled up in fabulous numbers of dozens under the floor of Mr Donald's strong room'.[44] The exhibitions also offered musical entertainment, such as the concerts organised and conducted by Charles Hallé at Manchester and those arranged at the Crystal Palace. This regular provision of musical diversion for a mass audience was, again, frequently followed in municipal museums.

In a society in which money for commercial enterprises was relatively easy to find, but in which funding supposedly non-commercial cultural enterprises was difficult, temporary displays frequently provided the stimulus for a permanent gallery. One of the most important and earliest instances of this development was the foundation in 1854, initially by a private society, of the National Gallery of Ireland following the Dublin Exhibition of Art and Art-Industry the previous year.[45] In some cases, as at York City Art Gallery in 1892 or, on a more ambitious scale, at Glasgow, where the International Exhibition of 1888 led to the founding of the Kelvingrove Museum and Art Gallery, a profitable temporary display paid for the building and sometimes the grounds of a permanent gallery. At Leeds, it was the organisation of the National Exhibition of Works of Art in the newly built city infirmary in 1868[46] which led to the foundation of a municipal collection, happily on another site.

In many instances, a gallery which opened with a building but no collection sustained itself by means of changing displays. Often they showed exhibitions sent from the Department of Science and Art and intended to educate local craftsmen. Thus, in the early days of Birmingham City Art Gallery displays of metalwork were presented, while at Nottingham workers in the local lace industry were regaled with surveys of historic lace. Initially, Henry Cole saw both Birmingham and Nottingham as outposts of the South Kensington Museum and envisaged that similar museums would eventually spread across the whole country so that every town with a population of more than 10,000 would have its own museum of science and art. It was not long, however, before local curators rebelled against this régime in the interests of putting togther an art collection of their own, a process similar to developments at South Kensington itself.

Temporary exhibitions also dominated the programme at Liverpool where, as already noted, those organised by local artists were the main purpose of the new institution. On opening in 1904, the Laing Art Gallery in Newcastle filled its empty spaces with a 'Special Inaugural Exhibition of Pictures by British and Foreign Artists, Collections of Decorative and Industrial Art' from private individuals and museums. The walls were crammed with portraits, uplifting local landscapes and such thrilling scenes as that depicted in Millais' *The Rescue* which, according to 'a critic' quoted in the catalogue, 'is one of those pictures which illustrate our ideal of the proper functions of art. A fireman has ventured into a burning house, and brought from their sleeping places three children, whose mother, in an ecstasy of joy, receives

Fig. 20 Warrington Museum and Art Gallery, designed by John Dobson, 1855–7, the Botany and Geology Galleries

them kneeling on the staircase.'[47] At these new galleries, the rooms would be occupied by changing displays until the permanent collection was sufficiently large to dominate the display area.

The Rise of Municipal Galleries

Although it was not until the late 1860s that municipal art galleries were set up in any appreciable numbers, the process soon became almost unstoppable. The advent in 1868 of Gladstone's reforming Liberal government, the ministry which made the first attempt to provide universal education, seems to have encouraged a considerable increase in the number of new foundations. These included donated collections, such as the museum and gallery in Brighton, founded in 1873 for the Willett collection; entirely new buildings with nugatory contents, such as the Walker Art Gallery, opened in Liverpool in 1877 (fig. 21); the conversion of an art academy at Carlisle into a

museum in 1877; and, in the same year, at Warrington (fig. 20) the addition of a wing to the existing museum to show the work of the local sculptor John Warrington Wood. The rate quickened in the 1880s, with new galleries established all over the country, but with a concentration in Yorkshire (Sheffield and Leeds) and Lancashire (Oldham and both the City Art Gallery and the Whitworth in Manchester). In the same decade galleries were created in Scotland (Inverness and Aberdeen), Wales (Newport) and the Midlands, while in the 1890s some of the longer established cities, such as York, Norwich, Portsmouth and Worcester, prodded themselves, often under the impact of a single donor, into establishing what had become an almost compulsory attraction for a city or town of any consequence.

The process continued until World War I. From the turn of the century to 1915 some 26 new galleries were founded. They included shrines to artists (the Watts Gallery at Compton near Guildford in Surrey and Leighton House in London, part of the

Fig. 21 The opening of the Walker Art Gallery, Liverpool; *The Graphic*, 15 September 1877

Fig. 22 Maidstone Museum and Art Gallery, cover of a guide to the collection, 1919

growing campaign to place British artists within the canon of greatness), the rehousing of older collections, such as Kelvingrove Art Gallery in Glasgow, and the establishment of galleries in seaside resorts, for example Hastings, as well as in more conservative, older towns, such as Bristol. Nevertheless, the bulk of the new foundations was still concentrated in the newly wealthy towns of Lancashire and Yorkshire: Bury, Stalybridge, Bradford, Doncaster, Hull, Blackpool, Rochdale, Barnsley. Almost all survive to this day, testimonials, like the town halls which often stand beside them, to vanished wealth and (perhaps less perishable) civic pride, and the homes of collections which once seemed the acme of taste but now are viewed with a more sceptical eye.

A traditional approach to the architecture of newly established museums and galleries was sometimes imposed by a decision to adapt an older building. The earliest museums, biased towards art rather than science (to adopt the official dichotomy of the 1850s), tended to occupy historic houses and to celebrate 'Olden Times', an important aspect of British culture from the 1820s until late in the century. Just as Hampton Court Palace had been restored in a historicist style in the 1830s and 1840s[48] and was opened to the public on a regular basis by Queen Victoria, a few boroughs set about acquiring historic buildings. These included Brighton, where in 1851 the Borough bought the Royal Pavilion, threatened with demolition; Maidstone, where in 1858 Chillington Manor, the house of a local collector and benefactor, was acquired for the town (fig. 22); and Birmingham, where the Jacobean Aston Hall was bought in 1864. The process continued after 1870: at Nottingham Castle (essentially 17th-century) in 1878, at Norwich Castle in 1894, at Towneley Hall in Burnley in 1902 and, in the 1920s, at Christchurch Mansion in Ipswich and Temple Newsam near Leeds. Naturally, the character of the historic building was often irrelevant to the collections being assembled there. As a result, these conversions sometimes induced tension between the expectations stimulated by the building and the purposes to which it was to be put. The associations of Nottingham Castle, where Charles I had raised his

Fig. 23 Cartwright Hall Art Gallery, Bradford, designed by Simpson and Allen, 1902–4

standard in the Civil War and which had a long history of aristocratic habitation before its gutting by fire in 1831, encouraged a largely historical display concentrating on the 17th century. By contrast, half a century later, at Temple Newsam, the Director of Leeds Art Galleries and Museums, Philip Hendy, was influenced by modernist ideas to the extent of feeling that the Jacobean house could be made suitable as a gallery only if its historic features were obliterated as far as possible. This tension has not diminished today, particularly as the appeal of a 'heritage site' is often held to be stronger than that of a traditional museum collection.

The prevailing architectural language for museums and art galleries in early 19th-century Britain, as for most buildings associated with culture or learning, was classicism.[49] This applied in the British capitals and in the universities, which erected sophisticated Greek Revival buildings for the Hunterian, the Fitzwilliam and the Ashmolean museums. The Literary and Philosophical societies also felt their aspirations to social and intellectual status to be best expressed through classical elevations: the Royal Manchester Institution and the Bristol Literary and Philosophical Society were designed in the Greek Revival manner by, respectively, Charles Barry and C.R. Cockerell. When municipal building began, this language

continued to be used. The Walker Art Gallery of 1874–7, the Mappin Art Gallery in Sheffield of 1887 and the Harris Museum and Art Gallery, completed in Preston in 1893, employed a strict Neoclassical style which was not generally in use even for public buildings at the time. In the early 20th century a more fashionable, Beaux-Arts manner tended to be adopted, in such buildings of the 1920s as the Lady Lever Art Gallery at Port Sunlight and the Williamson Art Gallery at Birkenhead.

As the 19th century advanced, divergences from classicism appeared. In some cases these were Gothic, particularly the Venetian Gothic language advocated by John Ruskin and applied at the Royal Albert Memorial Museum in Exeter and the Albert Institute in Dundee, both of the 1860s. These two institutions housed scientific collections as well as works of art and there are few examples of pure art galleries in the Gothic manner, perhaps because it had come to be especially associated with places of worship. Numerous galleries were designed in an eclectic manner known as the Free Style, of which Glasgow Art Gallery at Kelvingrove (1897–1901) is an ambitious example. Also popular, around the turn of the century, was a sort of Ginger Beer Baroque, cheerful and not particularly correct, as at the swaggering Cartwright Hall at Bradford (fig. 23, 24). A comparison might be made with developments in theatre

Fig. 24 Cartwright Hall Art Gallery, Bradford, the first floor

architecture in the course of the century, and an analogy with the music hall is far from irrelevant: the late Victorian museum and art gallery, and the music hall (also increasingly prominent in the second half of the century), were both examples of a primarily popular culture.

Much thought was given to the design of these buildings. Gallery interiors were discussed at length in the proceedings of the Parliamentary Select Committees, in the *Art Journal* and in such books as *Museums, Libraries and Picture Galleries* of 1853 by the architects J.W. and Wyatt Papworth and Thomas Greenwood's *Museums and Art Galleries* of 1888. Foreign models were often cited, usually German (especially Munich, Berlin and Dresden) in the earlier part of the century and often American towards 1900, the Boston Museum of Fine Arts being particularly admired. Later Victorian galleries contained a number of recurring internal features. These include an imposing entrance hall, a top-lit upper storey (fig. 25) for the display of pictures (the sculpture or museum collections would be shown on the ground floor) and a tribuna, or great gallery, as the climax of the upper level. Planning was generally based on the enfilade, with a succession of regularly proportioned rooms arranged on axis.

The spate of construction from 1870 to 1914 represents the most active period of museum creation in the history of Britain. The structures erected constitute the main museum building

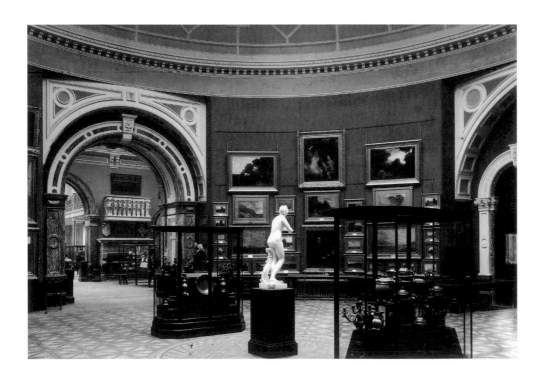

Fig. 25 Birmingham Museum and Art Gallery, designed by Henry Yeoville Thomason, 1881–5, the Round Room, *c.* 1890

Fig. 26 Mappin Art Gallery, Sheffield, designed by Flockton & Gibbs, 1887

stock in Britain. This is an important legacy. It is also one that has posed many problems during this century and that threatens to create more, since attitudes to the visual arts will no doubt continue to change in the 21st century. Traditional galleries, frequently restored in recent years to their original appearance in the vogue for historical reconstruction, often ill suit contemporary visual art or the relaxed style of today's approach to the public.

Most galleries, whether built by universities or by public bodies, were sited in the centre of town. Sometimes, as at the Walker Art Gallery or the National Museum of Wales in Cardiff (founded in 1907), the buildings were seen as part of an ambitious urban ensemble. More often, the museum and gallery were close to the town hall, but in a mean building, as with Leeds City Art Gallery; or placed to the side of the principal civic buildings, as at Birmingham, where a site above the offices of the Gas Corporation was thought appropriate; or given a niche above the public library, as at Walsall.

By contrast, a number of galleries, generally towards the end of the century, were sited in parks on the outskirts of town, reflecting the growing faith, from the 1840s onwards, in the

desirability of providing urban parks. Surviving examples are Cartwright Hall, Bradford; Kelvingrove, Glasgow; Queen's Park, Manchester; and the Mappin, Sheffield, where museum and park, always open free of charge, were intended to delight and improve the visitor's mind and body (fig. 26). Successful as these ensembles are, they lack the civic ambition of the City Beautiful projects in the United States which, between 1893 and 1928, gave Philadelphia its great art gallery, approached by avenues and mounted on an acropolis,[50] or, in the early 1890s, sited the Art Institute of Chicago in a Renaissance palazzo at the heart of the developing urban scheme.[51]

Although many of the buildings were paid for by private donors, municipal museums tended to be less ambitious architecturally than their foreign counterparts and to be accommodated wherever space could be found with a minimum of effort. As Thomas Greenwood summarised the situation in 1888: 'The only adjuncts to a Municipality which are at present ... in too many instances, unfortunately, looked upon as absolutely indispensable, beyond street improvements, drainage, lighting, and waterworks, are a gaol and a workhouse, with their concomitants of police, magistrates, and a share in a lunatic asylum and the national hangman. We are most lavish in our expenditure under these heads, but when we come to the expenditure for education, with the institutions which should necessarily spring from the parent stem, our national niggardliness becomes painfully apparent, and we resort to rigid retrenchment ... let the object [of expenditure] be a few extra thousands for the British Museum, the endowment of research, Board Schools, or Free Libraries, down go the thumbs, and strangulation forthwith proceeds.'[52]

The Collections

What collections were assembled in these newly formed galleries? Only a few public galleries were established on the basis of 'high art' collections late in the century. In London one of the few national museums set up at the time was the Wallace Collection, opened in 1900, which offered a spectacularly novel type of collection, with paintings, sculpture, furniture, porcelain and bronzes shown together and with French art of the 17th and 18th centuries in a dominating position. A comparable collection was the Bowes Museum at Barnard Castle in County Durham, opened in 1892, with its rich holdings of Spanish, French and Italian art from the 16th to the 19th century. The Bowes Museum was exceptional, having been set up as a private trust by

Fig. 27 *Portrait of John Bowes* (1811–85) by Eugene Feyen, 1863; The Bowes Museum, Barnard Castle

Fig. 28 *Portrait of Josephine Bowes* (1825–74) by Antoine Dury (retouched by Eugene Feyen in 1865); The Bowes Museum, Barnard Castle

wealthy individuals (fig. 27–9), and in general Old Masters were thinly represented in municipal collections. The only historic schools to appear with any regularity are the Dutch and Flemish, notably in the familiar and cheerful field of genre painting. While most of the larger galleries had some representation of the older European schools, this was usually the result of chance bequests and almost never of acquisitions policy. Such bequests might occasionally be of high quality, as with the collection, primarily of Dutch and Flemish paintings, given to Glasgow by the portraitist John Graham-Gilbert in 1877, or could at least include remarkable paintings, such as the *Hercules and Diomedes* by Charles Lebrun given to Nottingham Castle by an otherwise unknown colonel in 1893. Collecting Old Masters was not usually among the aims of these galleries, still less assembling a systematic historical collection. The Walker Art Gallery was prevented by the conditions attached to its Autumn Exhibitions

from applying funds from the exhibition profits to purchase 'the works of the old masters and of the old English school',[53] and this approach was symptomatic of most of the new institutions.

For many municipal galleries, acquiring portrayals of famous citizens was an important element of their early activities. Influential local bodies, and councillors, regarded the new institutions as suitable recipients of worthies' portraits. Glasgow, for example, acquired in the early days, in addition to a group of depictions of monarchs from James I to George III, portraits of the Lord Provost and of the Police Commissioner for 24 years (presented by the Magistrates and Council for the Police), a bust of John Carrick, the City Architect, bought by the Parks and Galleries Trustees, as well as further local notables presented by the artist N. Macbeth.[54] At Manchester, the collection included, alongside the almost obligatory councillors, such artistic luminaries as the Lancashire poet Edwin Waugh. Liverpool

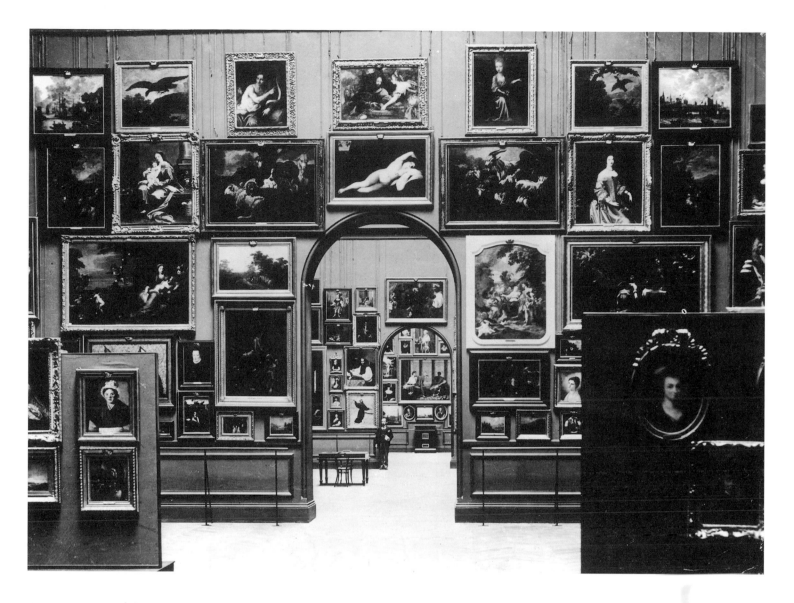

Fig. 29 The Bowes Museum, Barnard Castle, designed by Jules Pellechet, opened 1892, the main picture galleries, looking east, before 1914

offered a selection of role models: not only Wellington (a regular favourite) and Charles James Fox, but also such recent writers as Dickens and Scott, national rather than local heroes.[55] These galleries were partly intended to serve as local versions of the national portrait galleries in London and Edinburgh.

A further role for the galleries was as industrial showplaces. Such was the case at Birmingham. In addition to numerous loans from South Kensington, the gallery benefited at its reopening in 1885 from gifts by members of the Elkington family, metal manufacturers specialising in the electrotypes that adorned many public collections, and from loans made available by the Royal Worcester Porcelain Works. Also on display were such improving

objects as a model of the first locomotive steam engine and medals and coins of the Soho Mint.[56] The gallery also reflected Birmingham's position as a Liberal stronghold notable for its vigorous municipal improvements. The 1885 catalogue of the collection includes, among objects associated with the Liberals, loans or gifts from Gladstone and the Birmingham MP Joseph Chamberlain.

The essential point is that the role of these institutions, established with no collections of any significance, exceeded that of a fine-art gallery. At a time when many of the great industrial towns had only relatively recently acquired a fully fledged system of local government, the galleries proclaimed the good

administration, the wealth, the cultural value and the national significance of this new system.

On the artistic front it was primarily British paintings that these galleries wanted. From mid-century national identity had begun to find expression in the cultural arena, through the foundation of the National Portrait Gallery in 1856 and the initiation of the *Dictionary of National Biography* in 1882, as well as through the search for an English and Scottish vernacular idiom in architecture. Paintings and watercolours had their own contribution to make, and this was thought especially desirable at a time when the British were increasingly confident about their own artistic achievement: from the 1870s until at least the end of the century the native school enjoyed unparalleled admiration and financial support. In this endeavour to replicate the history of British art laid down by Cunningham and other historians, the 18th century was lightly represented. This may have been because from the 1870s works by Reynolds and Gainsborough were fetching very large sums of money, especially from American buyers, and could hardly be afforded by municipal museums – which, in any case, would scarcely have been attracted by the predominantly aristocratic subject-matter. More frequently acquired was work by the less expensive 18th and early 19th-century artists, who appealed to collectors of the late Victorian age for their humorous genre scenes and their innovatory but recognisably British landscapes: Fuseli, Opie, Morland (a particular favourite), Mulready, Maclise, Turner and Constable. Yet it was principally contemporary works, bought from Agnew's, from the Royal Academy and from local artists' exhibitions, which filled the new galleries.

The early days of Manchester City Art Gallery, established in 1883, exemplify how collections were amassed in the absence of large bequests or gifts. In 1894 the gallery recorded a large group of paintings that had been bought at its Autumn Exhibitions and, less frequently, at other sales (in 1888 at the fashionable New Gallery in London, for instance).[57] These included works by the most revered artists of the time, such as Watts; landscape paintings by John Brett, Alfred East and J.C. Hook; genre scenes, such as Marcus Stone's *Lost Bird* (Autumn Exhibition, 1884); historical paintings, such as Yeames's *Prince Arthur and Hubert*; social realist works, such as Herkomer's *Hard Times* (cat. 182), acquired from the 1885 Autumn Exhibition; historical paintings, such as Poynter's *Ides of March*, acquired in 1883; and remarkable Pre-Raphaelite works by Rossetti, Millais (*Autumn Leaves,* bought in 1893), Burne-Jones, Holman Hunt and Ford Madox Brown

(cat. 130). The Newlyn School was also represented, with the purchase of a Stanhope Forbes in 1893. A major painting, *The Last Watch of the Hero*, was commissioned by the Corporation in 1887 – characteristically, from the President of the Royal Academy, Lord Leighton. British watercolours were strongly represented, a recurring feature in these collections: as John Rothenstein later remarked, 'it is a curious fact about British provincial art galleries that the water colours are almost always conspicuously superior to the oil paintings'.[58]

Although Manchester City Art Gallery was exceptional in belonging to an outstandingly rich city, which was eager to buy the most expensive and glamorous paintings of the year, its approach was characteristic of the larger galleries. In its attention to Pre-Raphaelite painting it was typical of some, but by no means all, of its peers: while sophisticated collections, such as that being accumulated by Whitworth Wallis at Birmingham City Art Gallery, vigorously bought Pre-Raphaelite pictures, others, such as Preston and Leeds, were considerably less interested in this controversial area. On the other hand, fondness for social realism and the Newlyn School, as well as for appealing landscapes, scenes of British history and attractive subject paintings, was fairly widespread.

To enhance the sense of local identity was an aim crucial to these galleries. The catalogues reiterated the information that the works on view were by the sons (and occasionally the daughters) of that particular town or that the artists had trained in its schools or at least lived in the town, proving that it was capable of fostering the practice of fine art and that its art teaching was of high quality. One might cite Leeds, where the 1898 catalogue by the curator, George Birkett, constantly referred to the birthplace and training of the artists in the collection: if not all from Leeds, it revealed, many of them were at least of good Yorkshire stock. Thus, Atkinson Grimshaw was born in Leeds and the gallery was fortunate in possessing *Iris*, 'in every way his masterpiece';[59] J.W. Inchbold, praised in his youth by Ruskin, was the son of a local newspaper proprietor;[60] and so forth. The process of producing a picture was also discussed in the catalogue, reflecting the early relationship between galleries and art schools. The training – or lack of training – of the artist was emphasised: David Murray, represented by *Driving Cows, Hampshire,* had received his only training, visitors were told, at nightclass at the Government Art School in Glasgow.[61] The message at Leeds and at other galleries was that, with application, the assiduous student–visitor could also achieve artistic success. This applied

especially to men: relatively few women found a place in the collections, though many were active artists.

There was also a place for foreigners. The French, who exerted a powerful influence on the development of British art during this period, were especially favoured, both the academic heavyweights, such as Bouguereau (cat. 163), and the Barbizon school. They were well known through the ample representation accorded them in major art exhibitions, through the touring displays organised by Ernest Gambart of an artist such as Rosa Bonheur (cat. 139) and through such events as the loan exhibition of the modern French school held at Birmingham in 1898. This last featured the Barbizon school, Fantin-Latour and Bastien-Lepage, as well as such narrative painters as Eugène Isabey and Constant Troyon – but no Impressionists, of course.[62] It was especially appreciated if the foreigner had shown the good sense to settle in England, like Alphonse Legros (cat. 19), Professor at the Slade School of Art in London, whose brilliant teaching was widely admired. Better still was the foreigner who had been lucky enough to be born in this country. Thus, in introducing the work of James Aumonier, the Leeds catalogue commented reassuringly (in the style of *HMS Pinafore*) that, although the artist was spoken of as French, he 'has never studied out of England, nor indeed has he ever been out of the country'.[63] Even those French (and, to a lesser extent, German, Italian and Scandinavian) painters who had been deprived of such advantages might be included in the nascent collections, as long as their work was realistic, evocative of foreign climes or socially improving.

Classical sculpture was hardly collected by municipal galleries, although some acquired casts of Antique works for their art schools (casts which were mostly deliberately destroyed in the 20th century). Historic English sculpture was seldom bought, but there was some interest in modern work, even though the physical problems associated with the medium – strengthening floors and providing adequate space for viewing – militated against the acquisition of many pieces. Sculpture galleries were built at Cartwright Hall and at the Mappin, while the Walker accumulated work by Canova and by Liverpool's son John Gibson. By the end of the century more advanced taste was being shown: Glasgow acquired a Rodin in 1888 and the Harris Art Gallery pursued a policy of buying the New Sculpture.

Donors

The new galleries were heavily dependent on donations, but seldom profited from largesse on the part of the aristocracy or the Crown (although Albert and Victoria gave generously to national museums). A few people with noble associations donated works of art or created museums, but these tended to be illegitimate scions of great families (such as John Bowes of the Bowes Museum), relatively low in the aristocratic hierarchy (Sir William Holburne of the Holburne of Menstrie Museum, Bath) or foreign (such as Baron de Ferrieres of the Cheltenham Art Gallery). Although the nobility frequently loaned works of art, setting up municipal galleries was not a course of action that appealed to them in the late Victorian period any more than it had at the beginning of the century. Nor did artists frequently establish or give collections, though some served as advisers to civic galleries and sat on committees. The most prominent examples of artists' involvement in new museums were posthumous: Leighton House, opened after Leighton's death in 1896, and the Watts Gallery, built in 1903–4.[64]

Altruism was not always the prevailing motive among other donors. In several cases, major financial donations for new buildings were made by people interested primarily in a show of benevolence and in the aura of respectability conferred by art. Most prominent of these, perhaps, was Alderman Walker of Liverpool, whose munificence to the city of Liverpool in 1873 paid for the Walker Art Gallery. Walker was a brewer at a time when the temperance movement was strong in the city: his advance to the mayoralty of the second largest city in England was forwarded by his well-timed generosity. Walker was not the only brewer to behave in this way: the Mappins of Sheffield, who were enthusiastic collectors, did so, as did Alexander Laing, founder of the Laing Art Gallery in Newcastle but no lover of art, who derived his wealth not only from beer, but also from selling wine and spirits.

Lists of donations to galleries can induce confusion, since the gifts were so numerous and eclectic. Yet certain styles of donor do emerge. Some were representatives of long-established local families, such as the Holts of Liverpool, who had made their fortune in the shipping industry. In 1944 their descendant, Emma Holt, bequeathed to the city the family home, Sudley House, and its pictures, characteristic of a number of large art collections in Liverpool. More often, donors were men who, having amassed large fortunes, regarded it as their duty to endow their place of birth with art galleries or museums. They might also endow hospitals or schools: indeed, the endowment of cultural institutions should be seen within the much broader context of a philanthropism inspired by Liberal and

Fig. 30 Thomas Wrigley (1808–80)

Fig. 31 Thomas Kay (1841–1914)

Nonconformist ideals. This style of giving was especially strong in the North and is seen in such men as Thomas Wrigley of Bury and Thomas Kay of Stockport.[65] Wrigley (fig. 30), who had made his fortune in the paper trade, banking and railways, and was an ardent advocate of universal education, assembled a collection of contemporary British art which his children presented to the town of Bury. Kay (fig. 31), whose wealth came from patent medecines, was active in promoting education in Stockport: his collection, originally donated to be shown in a library, ultimately found its way to Rochdale Art Gallery. From a rather different background, the art-dealing Agnew family, and especially William Agnew, a Liberal MP for many years, not only gained a fortune from selling art to private owners and to galleries, but also made numerous gifts to institutions in the North West, notably of Holman Hunt's *A Shadow of Death* to Manchester in 1883.

Many of these men were inspired by the idealistic approach to education and the visual arts advocated by John Ruskin. Ruskin believed passionately in the usefulness of art museums and art education. It was a principle he expounded in various publications[66] and which is embodied both in the museums that

he and his supporters established in and around Sheffield (at Walkley in 1875 and at Meersbrook Park in 1890) and in his donations to the Ashmolean Museum and his establishment there of a school of art. For Ruskin, the industrial Britain he saw around him represented a corrupted society, ugly both physically and morally. To those unfortunate enough to live in it should be revealed what he called 'Typical Beauty', beauty which reflected God's creativity in the external forms of natural life, of animals and of human beings. Such beauty could also be studied via art, whose purpose was to express as clearly as possible the universal truths potentially visible in the physical world. Hence, it must be the mission of museums – and Ruskin hoped that many would be sited in villages and towns all over the country – to provide examples of such Typical Beauty for general study. Drawings and specimens of natural forms (rocks, minerals, dried plants), reproductions of the finest art of the past, views of beautiful countryside in this country and abroad for those unable to travel, depictions of stirring historical scenes to encourage in the uneducated a sense of history and national pride – all were considered suitable for a gallery organised on Ruskinian principles.

Ruskin's ideas appealed to many. The most obvious instances of his influence were the philanthropic galleries, by means of which high-minded men and women, such as T.C. Horsfall of the Ancoats Art Gallery in Manchester and Samuel and Henrietta Barnett of the Whitechapel Art Gallery in London, attempted to implement Ruskin's ideas in the poorest urban districts.[67] Ruskinian notions were applied at many of the municipal galleries, too. In Sunderland, Thomas Dixon, an associate and correspondent of Ruskin, persuaded the great man to give drawings and regular support to a gallery created with his ideals in mind. Another friend of Ruskin, Henry Willett of Brighton (fig. 32), a passionate Liberal and an advocate of public ownership of land who regularly organised political meetings for working men, was persuaded by his Ruskinian sympathies to assemble art collections which he intended ultimately to make available to all. He lent works of art to galleries all over the country and made numerous donations, most notably to Brighton Museum and Art Gallery, to which in 1905 he bequeathed his collection of British popular ceramics. Organised in such categories as monarchs, criminals, soldiers and sailors, this was intended to appeal to and educate as broad an audience as possible.[68] The character of most municipal galleries did not closely resemble the highly organised didactic displays of Ruskin's museums, yet the belief that Ruskin inspired in the morally improving effect of art on society, and especially on the urban poor, was a constant theme in the creation of these institutions. As George Birkett wrote in celebrating the increasing number of visitors to the Leeds gallery, especially those who did not have to pay for admission, the art displays were arousing curiosity in many, while 'the Art leaven is already fermenting and gradually increasing for good increasing numbers of the community'.[69]

The expansion of the new galleries was due not only to donors: in some cases the impetus came from councillors or curators. Among the most active councillors were Aldermen Philip Henry Rathbone and Edward Samuelson of Liverpool, political opponents but allies from the 1870s to the 1890s on the city's Arts and Exhibitions Sub-committee. They set up the Autumn Exhibitions (which they saw, unusually for the time, as national rather than local events) and acquired major examples of contemporary British art.[70] The ability, and influence, of directors and curators varied considerably. In the early days, continuing in a tradition which went back to royal households of the 17th century, they were generally painters, who were required to care for the physical condition of the works in their charge. The most

Fig. 32 Henry Willett (1823–1905) with his granddaughter Joyce, *c.* 1890

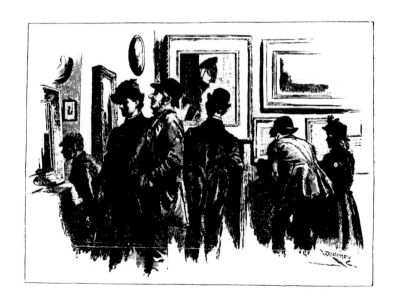

33. *In the Picture Gallery*; engraving, *c.* 1890

distinguished and active of these curators included a number of men (there were few women in the senior positions, though increasing numbers worked as assistants) associated with the South Kensington Museum. Notable among them were Whitworth Wallis, Keeper of Birmingham City Art Gallery from 1885 to 1927, and G.H. Wallis, appointed Curator of the museum at Nottingham Castle in 1878. Whitworth Wallis was respected and allowed independence by councillors who had the sense to realise that their gallery was better run by a man with a practical knowledge of art than by ill-informed politicians or administrators. He organised the progressive enlargement of the building, initiated an ambitious exhibition programme, published successive catalogues of the expanding collection and, most importantly for later generations, presided over the accumulation, through purchases and gifts, of the Pre-Raphaelite collection. In this enterprise he was assisted by such influential figures as the artist and dealer Charles Fairfax Murray, who made numerous donations of works by Burne-Jones and others, and the ubiquitous William Agnew. Wallis also worked in collaboration with J.C. Robinson, formerly an official at the South Kensington Museum (and creator of many of its collections). Like Wallis, Robinson believed that collections in provincial museums should be as strong as those in London and undertook a series of foreign tours to obtain works of art for the gallery.[71] Together they formed one of the most remarkable collections in the country.

The Victorian Public

The new art galleries were astonishingly popular. They generally attracted many more people annually than they were to do in the 20th century. This seems particularly remarkable since in many cases they were closed on Sundays, thanks to the endeavours of the Lord's Day Observance Society. Only toward the end of the century did the energetic efforts of the National Sunday League persuade most Councils to change this policy. In 1881, shortly after its completion, the Walker Art Gallery was visited by over 610,000 people on the 260 days it was open, with almost 80,000 attending the Autumn Exhibition.[72] Birmingham City Art Gallery in the first year of its new building (1886) welcomed 1,165,000 people and the annual numbers remained at over half a million until the end of the century,[73] even though the city's population was still only just over half a million in 1901. Many of these visitors were local but, inspired by the example of the Great Exhibition, people were prepared to travel to visit museums. As early as 1854 it was reported of the Derby Museum

in Liverpool, which contained the Earl of Derby's natural history collection: 'A considerable proportion of the visitors have consisted of excursionists, chiefly from the manufacturing districts, the conduct of whom has been orderly and respectable.'[74] Comments both on the willingness to travel and on the excellent behaviour of visitors were recurring features of the galleries' annual reports.

What drew visitors in such large numbers? Significant factors were the lack of other attractions in great cities, where only the music hall, the public house and the church provided competition; the popular interest in education and self-improvement; and the universal principle of free admission, which applied to these galleries as to the public libraries and municipal parks set up in many cities at the same time. In addition, many working people, relatively well paid by the last third of the century, could afford to enjoy the growing leisure which the success of the Saturday Half-Holiday Movement (founded in 1843 in Manchester) brought them: they increasingly undertook day excursions and longer holidays. Museums and galleries still needed to work hard, not so much to attract their public for a first visit (novelty saw to that) as to ensure that visitors returned. Although the annual artists' exhibitions became gradually less appealing, they brought large numbers in the early days, especially since the work of local artists was often boosted by paintings previously shown at the Royal Academy. These exhibitions were supplemented by regular programmes of activities. Birmingham, for instance, organised improving displays of 'industrial art', such as that in 1885 of 'The Tangye Collection of Old Wedgwood' (owned by one of the gallery's principal supporters). It also provided a showplace for modern painting: in a series no doubt inspired by the winter exhibitions organised at the Royal Academy, it displayed in 1885–6 paintings by Watts and Burne-Jones (attended by over 400,000 people, Watts being a revered name), a year later work by Walter Langley, and so forth. In 1895 there followed an exhibition of 'tapestries and laces; designs for stained glass and wall decorations: and examples of bookbinding and topography', which included work by Ford Madox Brown, Burne-Jones, William Morris and the like. In many cases the exhibitions were devoted to private collections, sometimes in anticipation of a major gift to the institution. The exchange of works of art between galleries was also popular: in its early years Bury Art Gallery, for instance, borrowed paintings from Birmingham and lent works of its own to Rochdale and Brighton.[75]

In addition to exhibitions, public education, in the tradition of the Working Men's College established in London in 1854, formed a crucial element in the life of the museums and galleries. Activities included popular lectures and entertainments, generally for the benefit of working people. Such events were especially frequent at those institutions, like the Whitworth Institute and Art Gallery in Manchester, established in 1889, which had been set up to provide both technical and artistic instruction for working people. At Liverpool in 1894 an average attendance of 1240 was recorded for the 48 autumn and winter lectures organised by the museum and gallery, and it was noted that these events were particularly popular among the ill-educated.[76] Instruction for children was not neglected. As early as 1874 pupils from Liverpool schools were brought to see the annual exhibition at the Walker, which was regarded as 'fostering a love of art at a time when habits are being formed'.[77] Interest in art education for children burgeoned under the influence of the philanthropic 'slum museums' set up late in the century at Ancoats in Manchester and Camberwell in London. In these Ruskin-inspired museums for the poor, teaching in art, music and other subjects for all ages, but especially the young, was crucial to the programme, and the success of the initiative prompted the Board of Education in 1895 to allow museum and gallery visits to be included in the curriculum. The encouragement and organisation of such excursions became frequent before World War I: thus, Bradford City Art Gallery introduced a system in 1912 by which visiting schoolchildren were given an introductory talk by the Director and a representative of the Municipal School of Art.[78] In that first year 30,000 children attended, which may have diminished the Director's enthusiasm.

The impact of the museum collections was enhanced by the organisation from an early date of loan collections of works of art (and of natural history and other specimens) for circulation to adult institutes and schools. One impressive result of this was the collection of modern British work (especially of 1900 to 1925) assembled by Charles Rutherston and presented to the city of Manchester for distribution to art schools in 1925. In addition, new reproductive techniques were used to encourage the broadest possible distribution of art: photographs of famous works, generally supplied by the South Kensington Museum, were sold as cheaply as possible by museums. In present-day vocabulary, access was the keynote.

Edwardian Innovations

In the first decade of the 20th century a number of institutions began to move away from the gallery presentation and the type of art which had characterised the late Victorian period. Under the influence of the Aesthetic movement and of a new approach to showing pictures, made familiar to a broad public in London in the 1880s by the exhibitions of the Grosvenor Gallery and the New Gallery, increasing thought was given to the character of gallery interiors. The typical Victorian art museum – probably by necessity rather than choice, at least as regards the crowding of exhibits – had displayed paintings and sculpture in large halls, frequently painted dark red or maroon, with bare wooden floors and railings guarding the works from the crowd. Now, more visually sympathetic rooms were sought. At the Walker, the success of the Autumn Exhibition of 1899 was due partly, it was suggested, to the fact that 'The Galleries presented an appearance of sumptuousness not previously seen, the floors being for the first time completely covered with blue-green felt, with Turkey runs in the doorways; while commodious and elegant Morocco leather covered ottomans afforded great ease and comfort to visitors'.[79] The hanging of the paintings was also carefully considered. A few years later the Exhibition of English Art at Cartwright Hall strove, under the influence of the Director, Butler Wood, 'to show the works of Art in some natural and harmonious arrangement with one another The formalised and irritating effect of the prevailing method of picture exhibition is familiar. The typical picture gallery with its crowded unspaced paintings, whose exhibits crush and jostle each other, is very much the counterpart of a mob.' It was generally agreed, Butler Wood continued, that this situation needed to be improved and that congruity between objects should be sought. At Bradford, the committee had striven to achieve a less formal atmosphere, including furniture and ceramics in the display so that the collection should 'wear the air of being at home in a somewhat natural combination'.[80] The creation of carefully balanced and exquisite interiors reached its peak at the Fitzwilliam Museum, where Sydney Cockerell, appointed Director in 1908, transformed the interior and built the new Marlay and Courtauld galleries. In these well-proportioned spaces, Cockerell, friend of Morris, Ruskin and the painters Charles Ricketts and Charles Shannon, initiated a new approach. The rooms were decorated in cool colours with an emphasis on varied textures; furniture and ceramics were displayed with the paintings and sculpture; rugs and (a significant innovation)

Fig. 34 Fitzwilliam Museum, Cambridge, the Marlay Gallery, designed by A. Dunbar Smith, opened in 1924

flowers were introduced to the galleries; and minute thought was applied to the relationship of objects to one another (fig. 34). All these features gave the Fitzwilliam a refined luxury which public galleries had never exhibited before.[81]

The innovative approach to display was sometimes reflected in new types of show. Exhibition programmes in the 19th century had tended towards 'industrial art' and towards British painting and sculpture. In the Edwardian period, under the influence of a sophisticated interest in the visual arts of which the foundation of the *Burlington Magazine* in 1903 was symptomatic, some galleries began to demonstrate a more cosmopolitan attitude. At Brighton Art Gallery, Henry Roberts, appointed Curator in 1906, organised a series of avant-garde shows. These included, in 1910, *Modern French Artists*, which opened earlier in the year than Roger Fry's much better known exhibition at Grafton Galleries in London. For the first time in Britain, not only the Impressionists, but also such artists as Matisse, Derain, Vlaminck and Rouault were put on display.[82] Similar innovation was apparent in Leeds, where from 1912 to 1917 the art critic Frank Rutter, an advocate of advanced contemporary art, experienced a difficult reign as Director. On bad terms with the City Councillors – he was 'appalled at their grossness, their ignorance and general lack of manners'[83] – he combined with the Vice-Chancellor of Leeds University, the noted collector Sir Michael

Sadler, to organise a series of exhibitions in the brief period of his directorship before World War I. Like Roberts at Brighton, Rutter demonstrated a sophisticated awareness of contemporary developments on the Continent, notably in the 1913 Loan Exhibition of Post-Impressionist Pictures and Drawings. This showed works by Cézanne, Gauguin and Van Gogh, as well as by the still relatively unfamiliar Camden Town group. In the Constable exhibition mounted the same year, Rutter organised, at Sadler's suggestion, an innovative event for a regional (or, indeed, a national) museum by bringing together paintings and drawings by a single historical artist from numerous sources, supported by etchings and accompanied by a scholarly catalogue.

Cockerell in Cambridge was not to be outdone, though his style was rather different. He instituted a series of exhibitions based on loans from private and public collections, notably the royal collection and Chatsworth. Such ideas as the loan of a single work to compare with a painting in the permanent collection (in this case Hogarth's *Servants* from the National Gallery in London to set alongside the Fitzwilliam's own Hogarth) seem to have been initiated by Cockerell.[84] Inevitably, such innovations tended to be less in evidence during World War I, although some galleries did maintain a reduced programme. Many were obliged to organise exhibitions with a stirring patriotic theme, such as the War Cartoons by Louis Raemaekers shown at Birmingham in

1916 or 'What German Invasion Means', a display of photographs, proclamations and relics which stiffened the resolve of the citizens of Leeds in 1914–15.

Sadly, the innovations discussed above made little impact on purchases in the first two decades of the new century. Councillors knew what they liked, and they did not like anything new; and although the National Art-Collections Fund had been set up in 1903 to preserve works of art for the nation, its grants were directed in its early years almost exclusively towards the national museums. Exhibitions of new styles of art had little effect on purchases at a time when most of the British were lamentably parochial in their attitude to the visual arts. Thus, the 1910 Brighton exhibition was not liked locally and from it the councillors bought not the modestly priced Monet or Cézanne but a Gaston La Touche. Rutter received no help with acquisitions from his councillors. Orpen, Sargent, William Nicholson were excessively strong meat for them, purchases that did not justify the use of public funds, and Rutter was forced in 1912 to set up, with Michael Sadler, the Leeds Art-Collections Fund to make acquisitions possible. This was one of the earliest examples of the Friends organisations that have since flourished at many museums. Elsewhere purchases tended to continue after World War I as in the early days, with a disposition to buy unadventurous British works, supported by numerous bequests.

The Interwar Years

At the beginning of the 20th century, and still more after World War I, municipal galleries and museums faced growing problems. First, they were becoming less popular. A decline in the number of visitors seems to have been common in the Edwardian period. At Sheffield in 1909 it was remarked: 'The small diminution in the number of visitors … appears to have been common to all the museums throughout the kingdom.'[85] Three years later, at Liverpool, the continuing decrease in visitors to the Autumn Exhibition was attributed to 'the inducement offered in other directions, notably the attraction of the numerous picture palaces, and the tendency on the part of many to spend their leisure time motoring'.[86] As the century advanced, these municipal galleries steadily lost their hold over the poorer urban community: the narrative pictures that had enthralled late Victorian audiences were supplanted by the moving picture. Second, Victorian painting began to plummet in critical esteem and in market value after World War I. John Rothenstein (fig. 35), Director at Leeds in the early 1930s, wrote in his memoirs

Fig. 35 John Rothenstein (1901–92) while Director of the Tate Gallery, c. 1940

that, while many of his councillors privately preferred the Victorian paintings of their youth, 'the average member of the local art gallery committee … could not remain unaffected by their fate in the sale-room and by the evident determination of persons not always otherwise distinguished by civic spirit to present or bequeath them to civic institutions'.[87] For those curators interested in progressive movements in art, it seemed essential to consign most of the 'popular-academic' Victorian paintings and sculptures to the basement, as Rothenstein did at Sheffield in 1933 to much applause. While some institutions continued in the old ways, with annual visits to the Royal Academy to select a work for the collections (a practice which persisted at Bury and Preston until the 1960s), buying such art became increasingly unpopular. Finally, the older museum buildings entered a period of decline, as Rothenstein's account of

Fig. 36 *Portrait of Lady Barber* (1869–1933) by James
Jebusa Shannon, exhibited at the Royal Academy in 1912;
The Barber Institute of Fine Arts, The University of
Birmingham

result of private philanthropy, and were generally located in
smaller towns. Civic galleries were founded at Stockport, Hove,
Lincoln, Birkenhead and Luton in the 1920s, and at Harrogate,
Darlington, Perth, Middlesborough and Southampton in the
1930s. Lancashire and industrialised Yorkshire, hit by the
Depression and already well supplied with cultural institutions,
were less active than in the past. Meanwhile, the adaptation of
country houses as museums rather than as furnished interiors
continued, as at Temple Newsam near Leeds and Torre Abbey in
Torquay. A strong impact was made by a small number of
wealthy individuals setting up charitable trusts, notably Lord
Leverhulme at the Lady Lever Art Gallery in Port Sunlight and
Lady Barber at the Barber Institute at Birmingham University
(fig. 36, 37).

In spite of purchases of historic British painting, and
notwithstanding the growing interest in acquiring contemporary
British art (discussed in this volume by Angela Summerfield), the
interwar period was not one of major expansion or activity for
regional museums. The few innovative acquisitions were largely
due to the energy and knowledge of such figures as William
Rothenstein, art adviser at the Tullie Art Gallery at Carlisle and
at Bradford; Kenneth Clark, briefly curator at the Ashmolean and
adviser for Southampton; and Sir Michael Sadler, benefactor of
Leeds and other galleries. These men demonstrated once again
the crucial role played by individuals, whether as patrons and
curators, in establishing collections and enlivening institutions.

In terms of collecting, a significant shift of taste can be
detected in the interwar period. Interest in 18th-century British
art, accompanied by enthusiasm for 18th-century furniture and
architecture and reflected in numerous publications on artists of
the period, had been growing since the late Victorian period and
now began to influence purchases by municipal galleries. Older
works of the native school became increasingly popular. The Lady
Lever Art Gallery, opened in 1922 but assembled by Lord
Leverhulme since 1896, offers the outstanding example, with its
rich holdings of Reynolds, Gainsborough and Romney, genre
paintings by Morland and Wheatley, as well as Neoclassical
sculpture and 18th-century English furniture.[89] In nearby
Liverpool, Colonel Vere Cotton, Chairman of the Libraries,
Museums and Arts Committee from 1939 to 1955, instituted a
policy (which he had already advocated in 1931) of buying classic
British paintings of the past on a systematic basis. Extended to
include Old Masters, this programme inspired the Director of the
Walker, Frank Lambert, and members of the Council to embark

Leeds City Art Gallery in 1932 suggests. He described the
gloomy impact of the Victorian paintings on finer works and
quoted from an article in the *Yorkshire Post*: 'The condition of the
Gallery within doors is deplorable ... it ranges from dingy to
dirty, from dilapidated to dangerous.'[88] Such galleries no longer
appealed to Councils as expressions of civic competitiveness and
often lost the sense of purpose that had informed their early
activities.

Compared to the explosion in the creation of new art galleries
between 1870 and 1914, the interwar years proved relatively
quiet. Nevertheless, the rate of foundations remained steady
throughout the period, in spite of international economic and
political problems. In both the 1920s and the 1930s around ten
public galleries were set up in Britain, on a pattern established in
the late Victorian period. The majority were municipal, often the

Fig. 37 The Barber Institute of Fine
Arts, Birmingham, designed by
Robert Atkinson, opened in 1939;
photograph, 1936

on a sustained policy of acquisitions. They were to endow the gallery with one of the finest art collections in the country: their purchases included work by Stubbs, Wilson and Henry Moore, as well as by Rembrandt and Rubens.[90]

A similar taste was to be found in other institutions. The cause of the regional galleries was pleaded in 1920 by the Vice-Chairman of the National Art-Collections Fund, Sir Robert Witt: he asked for support from the Fund for 'the provincial museums which are ... carrying on under the greatest possible difficulties, and doing splendid work notwithstanding'.[91] The grants instituted four years later were awarded primarily for the acquisition of 18th and early 19th-century British art. Thus, between 1924 and the outbreak of World War II, the Fund supported several purchases of such works, often in accordance with a mission to send paintings or watercolours to towns associated with a particular artist.[92] Those favoured included Wright of Derby (for Derby Art Gallery; cat. 49), Bonington (for Nottingham, near which he was born), Richard Wilson (for Cardiff), Crome (for Norwich), Anthony Devis (for Preston, whence the Devis family hailed), Thomas Patch (for Exeter, his native town) and Zoffany (his portrait of Charles Townley, for Towneley Hall in Burnley; cat. 8). The Fund also assisted in the acquisition of numerous works on paper with a historic British emphasis. The leading recipients were the Fitzwilliam and the Ashmolean, where Karl Parker began in the 1930s to build up one of the finest printrooms in the country.

Apart from these grants towards purchasing historic British

art, the Fund's assistance of regional museums was relatively unfocused – necessarily so, since it was able only to react to requests, not to initiate them. In this period its rare examples of support for more recent art included a Gauguin gouache for the Whitworth (in 1926), a Wilson Steer for Liverpool (in 1936) and an Alfred Stevens for Sheffield (in 1937). Acquisitions of foreign work included a Sebastiano Ricci, a Patenier and an Ingres drawing, all for the Ashmolean, and for Bristol the *Withypool Altarpiece*, a painting by the Venetian Renaissance artist Antonio da Solario executed for a Bristol merchant. Significantly, these four purchases, indicative of a broader historical perspective, were all made in the later interwar years. They anticipated the changes in acquisition style of the post-1945 period.

Some construction activity did take place. Many of the new gallery buildings, such as the Williamson Art Gallery in Birkenhead, the Usher in Lincoln and the Lady Lever at Port Sunlight, were designed in a sophisticated Beaux-Arts style, their interiors reflecting contemporary concerns with good circulation and top-lighting. Equal care was accorded the galleries which formed part of the civic centres fashionable in the 1930s. Such buildings were erected for the Graves at Sheffield in 1934 and at Southampton just before World War II, while a similar arrangement was proposed for Leeds. Internally, these galleries tended to move away from the rich wall coverings and the dense picture hangs of the Victorian gallery towards a lighter, sparer look, influenced both by Cockerell (as Rothenstein was at the Graves) and by the modernist aesthetic.

Fig. 38 Hans Hess (1908–75), Curator of Leicester Museum and Art Gallery and later of York City Art Gallery

In a number of ways the ground was laid, especially in the 1930s, for the changes of the postwar period. Although the first degree in art history in Britain had been offered at Edinburgh University as early as 1880, this precedent had encouraged little emulation. Political events in Germany and Austria during the 1930s, however, brought to Britain a number of brilliant scholars from the countries where the discipline of art history was practised most intensively, among them Ernst Gombrich, Nikolaus Pevsner, Edgar Wind and Rudolf Wittkower. These men transformed art historical studies in this country. Particularly significant for the postwar development of regional museums were other immigrants, including Hans Hess (fig. 38) and Fritz Grossmann. The exodus also brought art historical institutions to Britain, stimulating the creation of the Warburg and the Courtauld institutes in the 1930s. All this exercised a decisive influence on a small group of galleries set up before the war but not to blossom until after 1945. Although Leicester Art Gallery had been founded in the 19th century, it was transformed by the bold decision, taken in the midst of World War II by the Director, Trevor Thomas, and his Curator, Hans Hess, to exhibit and collect in a field hitherto almost entirely ignored in this

country: German Expressionism. The enthusiasm of these men for German 20th-century art initiated a collection which was to become one of the most remarkable in the country. Most significant of all, perhaps, was the Barber Institute, set up at Birmingham University in 1932 by the wealthy Lady Barber to teach and encourage the visual arts and music. The Barber's policy of collecting art worthy of the National Gallery on principles that reflected an academic interest in art history brought to regional museums an approach previously unknown outside the national and the old university collections.

New Galleries after World War II

The period after World War II, when many galleries were emptied of their collections for safekeeping and a number suffered bomb damage, was marked by changes of emphasis. Following the foundation of municipal galleries at Swindon and Scarborough in the 1940s, few towns needed to establish municipal galleries. Most of the new foundations resulted from important donations. These included the Berwick-on-Tweed Art Gallery of 1949, set up to accommodate the 'second Burrell collection', bequeathed by Sir William Burrell; the Beecroft Art Gallery in Southend-on-Sea, established in 1953; and, most spectacularly, the Burrell Collection, in a building finally erected in Glasgow in 1983 to display the gift made to the city by Burrell in the 1940s and 1950s. In several cases, historic houses were acquired by the borough or by private trusts and turned into galleries and community centres. This applied at Cannon Hall, Barnsley; Abbot Hall in Kendal; and at Lotherton Hall, an Edwardian house on the outskirts of Leeds given to the city in 1970 by the descendants of the original owners.

One major change of emphasis was the increase in university collections, of both European and Asiatic art. As the number of universities expanded in the 1960s, and as numerous art history departments were set up, art galleries for permanent collections and temporary exhibitions were often established. Beginning with the Durham University Oriental Museum, which opened in 1960, the list includes galleries (or at least collections) at the universities of Hull, Cambridge, Edinburgh, Liverpool, Norwich, Warwick, Essex, East Anglia and Lancaster, as well as a new building in the 1970s for the Hunterian Art Gallery in Glasgow. Another long-established type of museum – that devoted to an individual artist and often accommodated in his or her former house and studio – also gained in popularity. Such galleries were set up in buildings associated with Gainsborough

Fig. 39 The Sainsbury Centre for the Visual Arts, Norwich, designed by Norman Foster Associates, opened in 1977

(the first of this group, in 1961), Stanley Spencer, Alfred Munnings and Barbara Hepworth.

While some existing art museums expanded – notably Leeds, which in 1993 was augmented by the Henry Moore Institute for the study and display of sculpture – extensions to older buildings tended to be modest compared to those undertaken by the national museums. In one respect, the postwar period did witness a major development in the relationship between the national museums and the regions. The decision by the Tate Gallery to create outstations to show works from its collections in new, purpose-built galleries resulted in the Tate of the North in Liverpool, opened in 1988, and the Tate Gallery, St Ives, of 1995.

The long history of private patronage of galleries by no means closed after 1945, and some of the most memorable collections are those made by private collectors which retain a highly individual character. One of the most distinctive is the Sainsbury Centre, donated to the University of East Anglia in 1973 (fig. 39). It contains the collections assembled by Sir Robert and Lady Sainsbury from 1933 onwards. Abandoning the traditional tendency to separate Western from non-Western art, the Sainsburys brought together works of art from all over the world in a way that previously had hardly been attempted. The Western collections include works by Bacon and Giacometti, Henry Moore and Picasso.[93] Equally personal in its own way was the collection of the visionary educator Jim Ede, arranged at Kettle's Yard, his house in Cambridge (fig. 40).[94]

Impressive though the list of new art galleries may seem, many were on a modest scale and dependent on the generosity of private patrons. Few were comparable in ambition to the art museums established in Germany, France or the United States in the postwar period. It was in other fields that the greatest expansion took place in Britain: the National Railway Museum in York and the National Museum of Photography, Film and Television at Bradford, social history museums of a new type, such as the Ironbridge Museum at Coalbrookdale, and military museums, including the Royal Air Force Museum at Hendon. This emphasis on museums rather than galleries contrasts strikingly with the situation a century earlier.

Types of expansion other than the physical did take place after the war: notably of the resources that became available for

Fig. 40 Kettle's Yard, Cambridge, extension by Leslie Martin, 1966–71

staffing and new activities. The increasing professionalism required of the institutions was reflected in additional funding at both the national and the regional level, especially from the late 1960s onwards, with much support coming from Jennie Lee, first Minister for the Arts (1964–70). The considerable increase in the staff of the National Gallery, and the foundation there of departments for conservation, education and exhibitions, was reflected all over the country. The late 19th-century prejudice that what was good enough for London was too good for the regions weakened as the large regional museums and galleries, and many smaller ones, were for the first time encouraged to function to a fully professional standard. It is instructive to look at the style of staffing recorded in 1928 by the Miers Report, which investigated the condition of museums throughout the country.[95] The full curatorial and professional provision both at Leeds and at Bradford City Art Gallery was a director and a secretary; at Birmingham only five people were employed in professional positions.

Post-war Collecting

For the acquisition of Old Master and foreign 19th-century paintings, this was the heroic age. A group of art historians, trained in many instances at the Courtauld Institute, and influenced by those German immigrants who assumed important institutional positions, joined the staff of regional museums with the aim of buying not just contemporary British art, but also a range of European masterpieces. Among those in larger institutions who contributed strongly to the development of collections, and to the organisation of scholarly catalogues and exhibitions, the following are particularly noteworthy: Trenchard Cox, Director of Birmingham City Art Gallery from 1944 to 1955, and his colleagues John Woodward and Mary Woodall; Hugh Scrutton, Director of the Walker Art Gallery from 1952 to 1970; Loraine Conran, Director of Manchester City Art Gallery from 1962 to 1976, and his deputy, Fritz Grossmann, and the later Director, Timothy Clifford; Frank Constantine, Director of Sheffield City Art Galleries from 1964 to 1982; a series of distinguished directors and keepers at the Fitzwilliam Museum, including Carl Winter (Director 1946–66) and Michael Jaffé (Director 1973–90; cat. 27); and, at the Ashmolean, K.T. Parker (at the museum from 1934 to 1962). Long as the list may seem, the ease with which it could be extended indicates the talent involved, especially when contrasted with the relative scarcity of distinguished names in earlier periods.

These people put together remarkable collections. Although the acquisitions reflected the exigencies of the market as well as

the 'heritage' element of potential purchases (support for an acquisition was more likely to be forthcoming if the work had British associations), they covered a considerable range. It was during this period that Birmingham assembled its distinguished Italian and Northern 17th-century paintings (schools generally out of fashion at the time), including pictures by Claude, Guercino, Subleyras and Orazio Gentileschi (cat. 296, 322). The Walker added works by Poussin (cat. 298), Rembrandt, Ruisdael, Rubens, Van Dyck, Murillo, Courbet, Monet and Seurat to what had already been one of the most remarkable collections of painting and sculpture in the British Isles. Manchester and Sheffield, which previously had owned very small holdings of Old Masters, acquired notable works from the 17th century and earlier. The Ashmolean, by purchase and gift, brilliantly enhanced its collection of works on paper, laying particular emphasis on 16th and 17th-century Italian drawings: some 3000 drawings were acquired during Parker's keepership. Moreover, work by the Impressionists, Cézanne and Seurat began to appear in regional collections, even if not in great numbers.

A similar development took place in smaller institutions. These included the Barber Institute, which acquired works of art of outstanding quality and range under the directorship of Thomas Bodkin and later of Ellis Waterhouse. Southampton City Art Gallery was fortunate in enjoying a generous purchase fund from Robert Chipperfield, a Southampton councillor, and, with the advice of a succession of experts, put together a collection stretching from early Italian works to the French Impressionists and the Camden Town group. At Hull, the endowment left by a local philanthropist, T.R. Ferens, permitted the assembly of an equally wide-ranging collection, with the emphasis on 17th-century paintings from the Netherlands. York City Art Gallery, under the curatorship of Hans Hess, consigned its Victorian art to the basement and embarked on a vigorous acquisitions policy, assisted by the gift in 1955 (through the National Art-Collections Fund, which played a major part in facilitating such donations) of the Lycett Green collection, a representative group of European and British paintings. Finally, at Northampton and Brighton smaller, but interesting, groups of pictures were bought, reflecting contemporary taste for such fields as Italian 17th and 18th-century oil sketches.

Many galleries maintained their interest in British 17th and 18th-century works at a time when one of the most adventurous collections in this area was being made in the USA by Paul Mellon. Numerous works were acquired, notably by Reynolds,

Gainsborough and Hogarth (who feature infrequently among earlier acquisitions) as well as by the sculptors Rysbrack and Roubiliac. Again, a major bequest assisted this process. On his death in 1955 the rich and varied collection of Ernest Edward Cook, a member of the travel agency family, was distributed through the National Art-Collections Fund to several galleries: the Holburne Museum in Bath, for example, gained a major group of Raeburns and Ramsays.[96] Some Victorian paintings were acquired, with Burne-Jones a particular favourite, but most galleries missed the opportunity they might have enjoyed of buying spectacular Victorian paintings for little money. In the field of works on paper, the Whitworth Art Gallery in Manchester continued to buy watercolours and drawings of the British school, notably by Cozens and Girtin.

In many instances, purchases continued a long tradition by creating or consolidating collections associated with a leading local artist. Plymouth City Art Gallery acquired works by Devon artists, notably Reynolds (who grew up in the county), James Northcote and Benjamin Robert Haydon. At Christchurch Mansion in Ipswich, comparable energy was directed towards the work of Suffolk painters, especially Gainsborough and Constable, while Norwich accumulated notable works by artists of the Norwich school (as well as Dutch painting) to complement two major bequests from the Colman family. The Abbot Hall Art Gallery in Kendal, founded as recently as 1962, concentrated on artists associated with the Lake District and made remarkable purchases, including a fine group of paintings by Romney (cat. 57).

This cheering picture has its limitations. The British public remained for many years stodgily conservative and ignorant in its approach to contemporary developments in Continental art. From the perspective of the late 20th century, when attitudes to modernist art have become rather more enlightened, it seems extraordinary that the 1962 Royal Academy exhibition *Primitives to Picasso* showed the work of Picasso for the first time at Burlington House, an event hailed in the press as sensationally innovative. When the National Gallery bought Cézanne's *Les Grandes Baigneuses* in 1964, popular opposition was intense, many members of the National Art-Collections Fund threatening resignation if the Fund contributed.[97] There is no reason to suppose that the curators mentioned above shared this blinkered view, but their priorities lay elsewhere. Only very few institutions, such as Wolverhampton Art Gallery with its policy of buying American Pop Art, ventured to look at contemporary

Fig. 41 Tate Gallery, St Ives, elevation from Porthmeor Beach, projected design by Evans & Shalev, 1992

art beyond this country. The result is that in the regions – as, to a considerable extent, in the national collections – the representation of 20th-century art is almost exclusively insular. As purchase funds shrink or disappear, prices rise, and private collectors become increasingly cautious and, for the most part, ungenerous, that – apparently – is the way the situation will stay.

And the Future?

If the foreign visitors postulated at the beginning of this essay were to embark on a tour of English regional galleries, what would they find? In terms of buildings, if the visitors were French or German or American and sought postwar museum buildings to compare with those at home, they would be surprised at how few there are. The only new buildings on a major scale that they would see would be the Burrell Collection in Glasgow[98] (ironically, at this gallery, one of the most ambitious projects of the 1980s, funding is currently being severely reduced, entailing the elimination of curatorial staff) and the Sainsbury Centre at Norwich, a redefinition for the 20th century of the 19th-century iron and glass exhibition hall.[99] The enterprise of the Tate Gallery in converting part of Albert Dock in Liverpool into the Tate of the North[100] and in building the Tate at St Ives would illustrate the impact that can be made by a national museum on the regions (fig. 41). Our visitors would also encounter a number of distinctive buildings on a modest scale, such as the gallery at Christ Church, Oxford,[101] and the Hunterian Art Gallery in Glasgow (fig. 42). In general, however, they would find that Britain has been forced by its inheritance of Victorian and early 20th-century galleries, as well as by a

shortage of cash, into 'making do', even if 'making do' has seldom extended to adequate structural maintenance.

The picture would not strike our guests as uniformly bleak. In some instances, they would be impressed by the continuing growth of collections, assisted not only by the long-established National Art-Collections Fund, the Contemporary Art Society and the Purchase Grant Fund (administered by the Victoria and Albert Museum), but also, more recently, by the National Heritage Memorial Fund. They would discover that sometimes the old hegemony of Western art was being questioned, noting that at Cartwright Hall in Bradford and in the Latin American collection being assembled at Essex University curators have been prepared to escape the demands of Western art and explore the creative activities of the rest of the world – not through the safely restricting categories of 'ethnography' or 'Asian art', with their Eurocentric and imperialist connotations, but as a central aspect of modern creativity. Our visitors might still wonder where, outside the national museums, collections of late 20th-century British art were being assembled for present and future generations. Were British public collectors, they might ask, missing the boat?

Were our guests to meet the curators (or 'collections managers' or whatever title they sported), they might encounter what Nicholas Goodison has recently described as 'a level of demoralisation the like of which I do not recall in my lifetime'.[102] The visitors might be dispirited, as was the present writer, on congratulating a director on the achievements of her museums service, to be told that local government reorganisation meant that half a million pounds would have to be cut from the budget

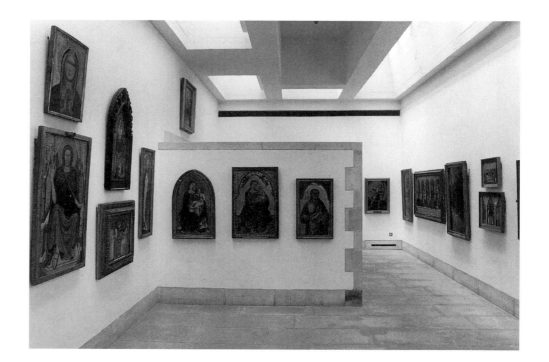

Fig. 42 Christ Church Picture Gallery,
Oxford, designed by Powell & Moya, 1964–7

the following year. Museums and galleries at times of financial constriction are treated as luxuries, so that when a local authority is forced to make cuts, it looks first at the expenditure of such non-statutory services as museums and galleries. Reorganisation of local government has sometimes produced a much smaller tax base on which the museum service can be supported, forcing major cuts on civic services – including museums and galleries – however great their contribution to the region (as in Manchester in the 1980s and Glasgow in the 1990s). University museums, dependent on Special Factor rather than on central university funding, are also placed at risk.

In all too many cases museum services that have long been the pride of their cities are in disarray, with their expert staff reduced to the point where they can scarcely provide an adequate service to the people of their city or to potential outside visitors. Even education services, always a source of pride among local authority museums and galleries, have sometimes been cut to the bone. From time to time the situation is highlighted by a crisis that threatens to end in closure of an institution, as at the Mappin Art Gallery in Sheffield in 1995 and the Hatton Gallery in Newcastle in 1997. Although these threats generally lead to some last-minute solution, crisis management may not seem to our foreign critics to offer a rational or desirable way of dealing with one of the most tangible and permanent elements of the nation's cultural life.

It may be that the country has more museums funded from the public purse than it can support. As our late 19th-century predecessors discovered, it has never been easy to make permanent collections permanently interesting: they are awkward to store and expensive to maintain. Among the most positive features of post-1980 galleries has been the increased interest they have shown in catering to the comfort of the visitor by means of cafés and shops, in ease of access for the disabled and in making the objects they show appealing to a broad public through education and outreach programmes and through sophisticated information technology. Yet this very concern to emphasise the role of galleries as popular institutions may militate against the notion of collecting as a crucial element of their life. It may be that the idea developed in the late 19th century that each town of any substance ought to express its identity by assembling works of art and scientific collections, can no longer be sustained. Perhaps the future lies in the amalgamation of permanent collections either physically or in terms of staffing, so that some can concentrate on looking after, displaying and adding to the objects in their care, while others function primarily as they did a hundred years ago: as exhibition halls and places of entertainment, unburdened by custodial responsibilities.

In the 1990s the advent of the National Lottery, through the Heritage Memorial Fund and the Arts Council, seems to offer the

Fig. 43 Manchester City Art Gallery, model showing the planned extension, designed by Michael Hopkins & Partners, 1997

Fig. 44 Walsall Art Gallery, model of the new gallery, designed by Caruso St John, 1997

opportunity of erecting galleries and museums of high quality, appropriate to current social demands and to the display of late 20th-century art. Manchester City Art Gallery, which for a century has been planning an ambitious extension to accommodate its rich collections, is to have one at last, with the help of a major grant from the Heritage Lottery Fund (fig. 43). The new art gallery at Walsall, largely paid for by the Arts Lottery, will present the Garman-Ryan collection in an entirely innovative way (fig. 44). Equally, the opportunities for purchase grants offered by the Heritage Lottery Fund are, at least currently, on a scale more generous than has ever been known in this country: recent grants have allowed the purchase of Sebastiano del Piombo's *Madonna and Child* by the Fitzwilliam, Batoni's *John Smyth* by York, Plura's *Diana and Endymion* by the Holburne and Derain's *Portrait of Bartolomeo Savona* by the Barber (cat. 43, 45, 280, 361).

Notwithstanding this development, the lack of any overall strategy for the future of our museums and galleries remains glaring. Our foreign visitors might ask how all these problems are viewed by the Ministry of Culture. It may not reassure them to be told that until 1997 no such ministry existed. Yes, we may say, a Ministry of National Heritage was set up in 1992.[103] Although active in encouraging national museums to operate in a businesslike way, this Department was not, despite its name, able to assume any responsibility for non-national institutions. It could provide advice and encouragement and could approve the

registration scheme set up by the Museums and Galleries Commission to encourage good professional practice. In 1996 the Department published *Treasures in Trust,* which outlined various ideas for museums, but its powers remained very limited. One result of *Treasures in Trust*, and a possible acknowledgement that central government might have some responsibility for the future of regional museums, was the designation scheme, introduced as an attempt to recognise that some non-national museums and galleries held collections of national status. And does this mean, our by now perplexed foreign guests might ask, that the designated few will receive money from central government? No, not quite, we would have to answer: but it does mean that funding bodies will be expected to be more generous to designated museums, without being less generous to any of the others.

The current situation of many of our regional art galleries and museums is a major wasted opportunity. They have so much to

offer, through their collections, their buildings, their expertise, their links with local communities. As this essay has tried to demonstrate, art galleries and museums have generally responded to the demands of successive generations. They have reacted to the late 20th century by working to make their collections as accessible and exciting as possible. Sometimes this wish may lead enthusiasts to regard the collections as of secondary importance to the events that can be organised in the public spaces offered by museums, forgetting that it is the objects that they contain which give the galleries and museums their unique character. But that is not the real problem. The real problem is that local authority, and university, galleries and museums are dogged by political uncertainty and financial cuts. Continual cash shortages and incessant restructuring, generally motivated by the need for economy, prevent them from achieving many things of which they are capable and which their public want.

Successive governments have declared that the running of these institutions is the province of local government or of universities and therefore outside their brief. Yet the present situation is unnecessarily negative and, in general, beyond the control of local authorities. It is hard to believe that a Government Department which has instituted the policy of designating museums and galleries of national importance should be unable to consider offering not just encouragement, but also more concrete help to designated, and other, museums to allow them to function as effectively as possible. The role that flourishing museums and galleries can play in the regeneration of our cities, in the education of people of all ages and backgrounds, in the breaking down of traditional barriers, in the enrichment of our lives, is no less strong now than it was in the 19th century. This exhibition, and the publication that accompanies it, demonstrate that the regional galleries own works of art of the highest quality and that they have the will to make these works of art contribute to the life of people throughout the country. Is it unreasonable to ask that they should be given the power to do their job properly?

NOTES

1. Waagen published two versions of his travels, *Works of Art in England,* London, 1838, and *Treasures of Art in Great Britain*, London, 1854. See G. Waterfield with F. Illies, 'Waagen in England', *Jahrbuch der Berliner Museen,* 1995, pp. 47–59.

2. F. Haskell, *History and its Images,* New Haven and London, 1993, esp. chap. 2.

3. A. Macgregor, ed., *Tradescant's Rarities*, Oxford, 1983.

4. P. Kalm, 'Soane's Museum at Chelsea, 1749', in A. Macgregor, ed., *Sir Hans Sloane: Collector, Scientist, Antiquary*, London, 1994, p. 33.

5. I am grateful to Celina Fox for pointing this out.

6. N. Watt, 'The Civic Face', in *Family and Friends,* exh. cat. by A. Moore with C. Crawley, Norwich Castle Museum, 1992, pp. 47–53.

7. A. Tinniswood, *A History of Country House Visiting,* Oxford, 1989.

8. W. Schupbach, in O. Impey and A. Macgregor, eds., *The Origins of Museum,* Oxford, 1985, pp. 169–78.

9. J. Whiteley, 'The University Galleries', in the forthcoming volume of *The History of the University of Oxford*, devoted to the 19th century.

10. D.E.L. Haynes, *The Arundel Marbles,* Oxford, 1975, pp. 11–12.

11. J. Byam Shaw, *Paintings by Old Masters at Christ Church, Oxford,* Oxford, 1967.

12. Macgregor, ed., 1983, p. 62.

13. Quoted in Byam Shaw, 1967, p. 4.

14. F. Haskell, *Rediscoveries in Art,* London, 1976, p. 26.

15. T. Fawcett, *The Rise of English Provincial Art,* Oxford, 1974, summarises the development of cultural institutions.

16. D. Owen, ed., *The Minute-Books of The Spalding Gentlemen's Society 1712–1755,* Lincoln, 1981.

17. Royal Manchester Institution Council Minute Book, 6 August 1823.

18. C.P. Darcy, *The Encouragement of the Fine Arts in Lancashire,* Manchester, 1976.

19. *Laws and Regulations of the Bristol Institution for the Advancement of Science, Literature and the Arts,* Bristol, 1825, p. 18.

20. F. Greenacre, *The Bristol School of Artists,* Bristol, 1973.

21. *West of England Journal of Science and Literature,* January 1835.

22. Darcy, 1976.

23. G. Vaughan, 'Henry Blundell's Sculpture Collection at Ince Hall', in P. Curtis, ed., *Patronage and Practice: Sculpture on Merseyside,* Liverpool, 1989, pp. 13–21.

24. H.B. [Henry Blundell], *An Account of the Statues, Busts, Bass-Reliefs, Sepulchral Monuments, Cinerary Urns, and Other Ancient Marbles, and Paintings, At Ince, Collected by H. B.,* Liverpool, 1803, n.p. (Introduction).

25. [H.B.], *Engravings and Etchings of the Principal Statues, Buists, Bass-Reliefs, Sepulchral Cinerary Urns, &c. in the Collection of Henry Blundell Esq. at Ince,* Liverpool, 1809.

26. *Catalogue of ... Drawings and Pictures, the Property of William Roscoe Esq.,* sale cat., Winstanley, Liverpool, September 1816.

27. E. Morris, 'The Formation of the Gallery of Art in the Liverpool Royal Institution, 1816–1819', *Transactions of the Historic Society of Lancashire and Cheshire,* CXLII, 1992, p. 88.

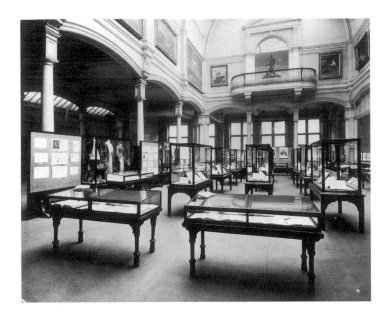

Fig. 45 Leeds City Art Gallery, the Central Court, looking east, 1927

Fig. 46 Leeds City Art Gallery, the Watercolour Room, 1949, created after the partition of the Central Court

28. Fawcett, 1974, p. 94.

29. Sir Robert Peel to Queen Victoria, quoted in D. Robertson, *Sir Charles Eastlake and the Victorian Art World,* Princeton, 1978, p. 325.

30. J. Treuherz, 'Ford Madoz Brown and the Manchester Murals', in J. Archer, ed., *Art and Architecture in Victorian Manchester*, Manchester, 1985, pp. 162–207. Wakefield in the 1890s and Glasgow in 1899 commissioned similar works.

31. *Report of Parliamentary Select Committee on Arts and Manufactures,* London, 1836, p. v.

32. *The Prince Consort: The Principal Speeches and Addresses*, London, 1862, p. 112.

33. *Manchester: Catalogue of the Art Treasures of the United Kingdom*, Manchester, 1857, p. 151.

34. 'On the Manchester Art-Treasures Exhibition, 1857', lecture given by Scharf at Liverpool, quoted in U. Finke, 'The Art-Treasures Exhibition', in Archer, ed., 1985, p. 117.

35. *Ibid.*

36. As Cunningham was called by Mrs Heaton, editor of the expanded, 1879 edition.

37. A. Cunningham, *The Lives of the Most Eminent British Painters, Sculptors and Architects,* 1879 edn, I, p. 258.

38. *Ibid.*, p. 43.

39. Cunningham, 1836 edn, I, p. 19.

40. *Robert Vernon's Gift: British Art for the Nation*, London, 1993.

41. 3023 British as against 2905 foreign; see *Official Catalogue of the Fine Art Department of the 1862 International Exhibition*, London, 1862.

42. *Ibid.*, p. 3.

43. F.T. Palgrave, *Handbook to the Fine Art Collections in the International Exhibition of 1862* , London, 1862, p. 8.

44. Manchester Guardian, *A Handbook to the Paintings ... Prefatory and General Introduction to the British Paintings*, Manchester, 1857, p. 12.

45. C. de Courcy, *The Foundation of the National Gallery of Ireland*, Dublin, 1985.

46. *National Exhibition of Works of Art, at Leeds, 1868: Official Catalogue,* Published by the Executive Committee, Leeds, 1869.

47. C. Bernard Stevenson, *Catalogue of the Special Inaugural Exhibition of Pictures by British and Foreign Artists ...*, Newcastle upon Tyne, 1904–5.

48. S. Thurley, 'Hampton Court, Middlesex', *Country Life*, 1 June 1995; P. Mandler, *The Fall and Rise of the Stately Home*, New Haven and London, 1997.

49. For discussions of gallery architecture in Britain, see J. Summerson, 'The Architecture of British Museums and Art Galleries', in J. Chapel and C. Gere, *The Fine and Decorative Art Collections of Britain and Ireland*, London, 1985, and *Palaces of Art*, exh. cat. by G. Waterfield, London, Dulwich Picture Gallery, and Edinburgh, National Gallery of Scotland, 1991–2.

50. D. Brownlee, *Building the City Beautiful: The Benjamin Franklin and the Philadelphia Museum of Art*, Philadelphia, 1989.

51. 'The Art Institute of Chicago', *Museum Studies*, XIV/1, 1988, pp. 28–45.

52. T. Greenwood, *Museums and Art Galleries,* London, 1888, p. 2.

53. Liverpool Museums and Art Gallery, *Fifty-fourth Report*, Liverpool, 1906.

54. J. Paton, *Illustrated Catalogue of Pictures and Sculpture, Corporation Galleries of Art, Glasgow,* Glasgow, 1892.

55. C. Dyall, *Walker Art Gallery: Descriptive Catalogue of the Permanent Collection of Pictures*, Liverpool, 1902.

56. Borough of Birmingham, *Handbook to the Art Exhibition at the Inauguration of the Museum and Art Gallery,* Birmingham, 1885–6.

57. W. Stanfield, *Catalogue of the Permanent Collection of Pictures in Oil and Water Colours with Descriptive Notes and Illustrations,* Manchester, 1894.

58. J. Rothenstein, *Summer's Lease* , London, 1965, p. 193.

59. G. Birkett, *Catalogue of Paintings and Drawings in the Permanent Collection, Leeds City Art Gallery,* Leeds, 1898, no. 57.

60. *Ibid.*, no. 65.

61. *Ibid.*, no. 34.

62. *Catalogue of the Loan Collection of Pictures of the Modern French School,* Birmingham City Art Gallery, 1898.

63. Birkett, 1898, no. 9.

64. Regrettably, the Watts Gallery was unable to lend to the present exhibition.

65. *Presents from the Past: Gifts to Greater Manchester Galleries from local Art Collectors*, exh. cat., Bolton Museum and Art Gallery, Oldham Art Gallery, Staleybridge, Astley Cheetham Art Gallery, and Stockport Art Gallery, 1978.

66. Notably *Picture Galleries: Their Functions and Formation* (1857), *Modern Art* (1867) and *A Museum or Picture Gallery: Its Function and Its Formation* (1880).

67. *Art for the People*, exh. cat. by G. Waterfield, London, Dulwich Picture Gallery, 1994.

68. J. Rutherford, 'Henry Willett as a Collector', *Apollo*, March 1982, p. 181.

69. Leeds City Art Gallery, *Annual Report*, Leeds, 1898, p. 4.

70. E. Morris, *Victorian and Edwardian Paintings in the Walker Art Gallery and at Sudley House*, London, 1996, pp. 6–15.

71. S. Davies, *By the Gains of Industry,* Birmingham, 1985.

72. Liverpool Museum and Art Gallery, *Annual Report*, Liverpool, 1881, p. 4.

73. *Birmingham Museum and School of Art Report*, Birmingham, 1914, p. 20.

74. *Second Annual Report of the Committee of the Free Public Library, and The Derby Museum of the Borough of Liverpool*, Liverpool, 1854, p. 3.

75. Bury Public Library and Art Gallery, *Annual Report*, Bury, 1902–3.

76. Liverpool Museum and Art Gallery, *Annual Report*, Liverpool, 1894, p. 10.

77. *Ibid.*, 1874, p. 7.

78. City of Bradford, *Annual Report of the Libraries, Art Gallery and Museum Committee*, Bradford, 1912.

79. Liverpool Museum and Art Gallery, *Annual Report*, Liverpool, 1899, p. 79.

80. City of Bradford, *Catalogue of the Works of Art in the Cartwright Memorial Hall,* Bradford, 1904, 'Prefatory Note' by Butler Wood.

81. W. Blunt, *Cockerell*, London, 1964.

82. P. Vaincker, 'Brighton's Early Art Exhibitions', *The Royal Pavilion & Museums Review*, no. 2, 1988, pp. 3–4.

83. F. Rutter, *Since I was Twenty-Five,* London, 1927, p. 201.

84. Fitzwilliam Museum Cambridge, *Annual Report*, Cambridge, 1913.

85. City of Sheffield, *Report of the Public Museums*, Sheffield, 1908–9.

86. Liverpool Museum and Art Gallery, *Annual Report*, Liverpool, 1912.

87. Rothenstein, 1965, p. 212.

88. *Ibid.*, p. 194.

89. A. Kitson, 'Lever and the Collecting of Eighteenth-Century British Paintings', in E. Morris, ed., 'Art and Business in Edwardian England: The Making of the Lady Lever Art Gallery', *Journal of the History of Collections*, IV/2, 1992, pp. 201–9.

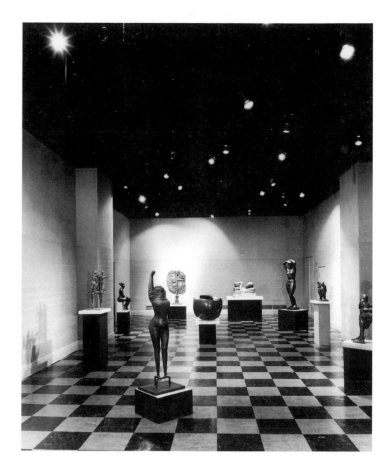

Fig. 47 Leeds City Art Gallery, the Sculpture Room, 1962, formed by the division of the Watercolour Room

90. Merseyside County Council, *Guide to the Pictures in the Walker Art Gallery*, Liverpool, 1980, pp. 1–13.

91. National Art-Collections Fund, *17th Annual Report*, London, 1920, p. 9.

92. Information from the files of the National Art-Collections Fund, Millais House, London.

93. *The Robert and Lisa Sainsbury Collection 1933–1957*, Norwich, 1989. Works from this collection were unfortunately not available for inclusion in the present exhibition.

94. J. Ede, *A Way of Life*, Cambridge, 1984, p. 18.

95. Sir H. Miers, *A Report on the Public Museums of the British Isles (other than the National Museums)*, Edinburgh, 1928.

96. *A Gift to the Nation: Holburne Museum, Bath*, Bath, 1996.

97. H. Rees, 'Thirty-two Years Ago', *Art Quarterly*, Spring 1996, p. 56.

98. By Barry Gasson, 1983.

99. By Norman Foster, 1979 and 1991.

100. By James Stirling, 1985–8.

101. By William Whitfield, 1973–80.

102. N. Goodison, *A New Era for Museums?,* London, 1997, p. 11.

103. The Office of Arts and Libraries had been established within the Department of Education and Science in 1983.

From a Dealer's Viewpoint

D I C K K I N G Z E T T

'Hard is his lot that here by fortune plac'd must watch the wild
vicissitudes of taste'
Samuel Johnson, *The Vanity of Human Wishes*, 1749

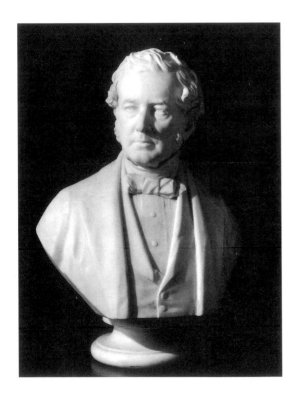

Fig. 48 Bust of Thomas Agnew by Matthew Noble,
marble, 1853; Agnew's

When the Orléans Collection was sold in 1798, the cream of the Old Masters was acquired by an English consortium of two earls and a duke. When the first Thomas Agnew (fig. 48) went into business in Manchester in 1817, two years after the Battle of Waterloo, his clients came from a very different milieu and so did the things they bought. Originally, pictures made up less than half of Agnew's stock, the bulk consisting of objects such as telescopes, opera glasses and girandoles. The firm also sold sweepstake tickets and ran a strong line in instruments ending in the dactyl '-ometer' – barometers, thermometers and hydrometers.[1] By 1850 this incongruous mixture had been refined to a stock of pictures only.[2]

Agnew's first clients, manufacturers and merchants who had made large fortunes in the Industrial Revolution in the North of England, had tastes very similar to their counterparts in 17th-century Holland. They liked well-painted genre pictures by contemporary artists showing events taking place in the comfortable interiors in which they themselves lived, and they liked views of the green English countryside with its still predominantly agricultural life. Their motives were partly patriotic: British was best, whether in worsteds or watercolours, and, by buying contemporary work, they could feel sure that they were getting what they paid for. Not for them the minefield of Old Masters with potentially explosive attributions. It was reassuring to meet David Cox or William Frith when they were invited to Thomas Agnew's home in Salford at the weekend. Some of them responded to the atavistic urge which draws men back to their original homes in old age. In 1865, the year that Scarlett O'Hara yearned to get back to Tara, Agnew's clients were thinking of returning to Pendleton or Rochdale. To have collected was not enough: they must be seen to have collected, and their pictures often formed the nucleus of the regional museums that now sprung into existence. An inscription in the entrance hall of Birmingham Art Gallery proclaims: 'By the gains of Industry we promote Art'.

Richard Newsham (1798–1883), a cotton merchant, first appears in Agnew's books in 1867. His collection of landscapes, including nine pictures by Linnell and ten watercolours by Cox, was bequeathed to his native town of Preston. He wrote: 'if we of this generation were ardent mainly in mercantile pursuits, we also felt and shared in some degree, the loftier passion for beauty and for knowledge, and set store in those things which embellished life, give present dignity to communities, and furnish, as all history teaches, their most enduring title to be held

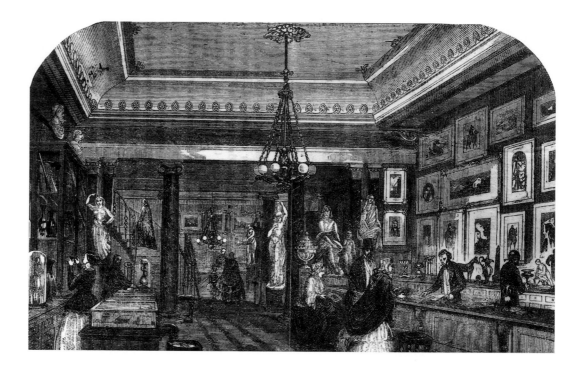

Fig. 49 *Interior of Agnew's in Manchester, c. 1840; engraving*

in future remembrance and good fame'.

Thomas Wrigley (1808–80; fig. 30), papermaker, banker and railway proprietor, bought similar pictures from Agnew's and one blazing masterpiece – Turner's *Calais Sands* (cat. 117). His children presented everything to Bury in the Jubilee year of 1897, conditional to a suitable building being provided. The gallery was duly opened in 1901. Charles Edward Lees (1840–94; fig. 54), spinning and textile manufacturer, was a personal friend of Thomas Agnew, who helped him form a collection of 84 watercolours which Lees presented to Oldham Art Gallery with his pictures. The former includes works by Dante Gabriel Rossetti (cat. 247), Samuel Palmer, J.R. Cozens and J.S. Cotman.

John Frederick Cheetham (1835–1916; fig. 52), owner of the Bankwood Cotton Mills, collected contemporary works and, unusually for his date, early Italian pictures. Agnew's bought five of these for him at the William Graham sale in 1886. He gave Stalybridge its Library and Art Gallery. Thomas Kay (1841–1914; fig. 31), pharmacist and inventor of a particularly stringent throat lozenge, was Agnew's only other client with a taste for early panels, which he gave to Rochdale Art Gallery (cat. 274). Thomas Agnew (1794–1871), a highly principled Swedenborgian, helped to found the Salford Art Gallery in his retirement. Swedenborgians believed that religion was a matter of works rather than faith, and he gave Salford 36 pictures in 1868 and his son, William, added several more.

Agnew's Liverpool branch opened in 1859, sadly arriving when William Roscoe's collecting days were over. He had bought his Old Masters at the start of the century, but financial disasters curtailed his activities after 1816. Roscoe is recorded as having encouraged Thomas Agnew, whom he met through the sculptor John Gibson. Agnew's most prodigious Liverpudlian client was George Holt (1825–96). Son of a cotton broker, he established the Lambert and Holt shipping line and pioneered trade with Brazil. He also found time to buy more pictures from the firm than any other private client except Lord Iveagh, George Salting and Paul Mellon. In 1884 he moved to Sudley, a house with 30 acres of land on the outskirts of Liverpool. He presented Millais' *Martyr of the Solway* to the Walker Art Gallery in 1895, and in her will of 1944 his daughter left Sudley House with 148 of his pictures to the city.

Another great Liverpool buyer was the soap king William Hesketh Lever, later 1st Viscount Leverhulme (1851–1925). Buying his first picture from Agnew's in 1896 (Poynter's *The Breath of Morn*), he continued to collect into the 20th century. His pictures were destined for the Lady Lever Art Gallery in his model industrial village Port Sunlight, where the gallery was opened in 1922. Holt and Lever both changed direction as collectors in midstream.

The third regular entrant in Agnew's Liverpool ledger is Sir Henry Tate (1819–99), the grocer who patented the sugar cube.

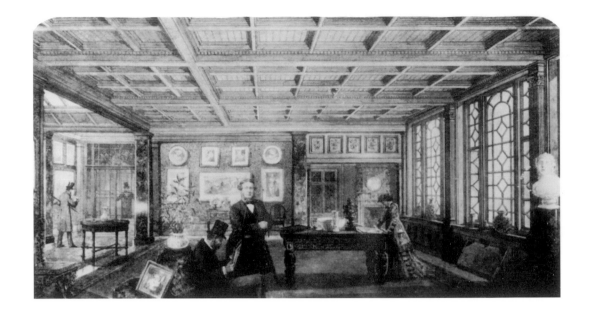

Fig. 50 William Agnew in the newly built gallery at 39 (later 43) Old Bond Street, London, architect E. Salomons, 1877

Although a generous patron to the university and hospitals there, he took his pictures with him – they were all by contemporary British artists – when he moved to London. Today in Millbank, they fall outside the parameters of this exhibition.

The Walker Art Gallery opened in 1877, and Agnew's books show that the gallery concentrated on building up a comprehensive representation of the English school. This embraced such major pictures as Richard Wilson's *Snowdon*, Stubbs's *Molly Longlegs* and Hogarth's *Garrick as Richard III*. The gallery also received a noble bequest from a client of the firm, F.J. Nettlefold, in the shape of Turner's *Linlithgow Palace*.

In Manchester itself, John Edward Taylor (1830–1905; fig. 53), a director of *The Manchester Guardian*, put together one of the finest groups of watercolours for which Agnew's can ever have been responsible. Including several late Turners, they show a taste far in advance of his period. In 1892, he presented 154 of his drawings to the Whitworth Institute, where he and William Agnew served on the original committee. The latter arranged that G.F. Watts should present a large version of *Love and Death*, the first picture to enter the Institute.[3] Sir Joseph Whitworth (1802–87), a brilliant engineer with, according to Jane Carlisle, a face like a baboon, appears only once in Agnew's books, when he bought a river scene by Landseer in 1874. In 1984 the Whitworth bought six stunning drawings by J.R. Cozens, all of which had belonged to the Agnew family.

Sir William Agnew also presented the large version of Holman Hunt's *Shadow of Death* to Manchester City Art Gallery, which

opened in 1883 and has bought regularly from the firm ever since. The most generous of the local collectors featured in Agnew's records was Mrs Assheton Bennett, who donated a fine assembly of Dutch pictures (cat. 307) and English silver. Since World War II, Agnew's has helped the gallery to add items as diverse as the *Cheetah* by Stubbs (cat. 47), a *St Catherine* by Guido Reni and a marble bust by Algardi (cat. 295). When rain stops play at Old Trafford the frustrated spectator can find much to console himself in Mosley Street.[4]

Although opened in 1867, Birmingham City Art Gallery received no purchase grant from the Corporation until 1946. Relying on gifts and bequests, it found three good friends among Agnew's clients, Sir William Kenrick, Sir John Middlemore and J.H. Nettlefold. The remarkable Pre-Raphaelite collection owes to the first Millais' *Blind Girl* (cat. 132), Henry Wallis's *Chatterton* and Burne-Jones's *Feast of Peleus*, and to the second Holman Hunt's *Saviour in the Temple*, Ford Madox Brown's *Elijah* and Burne-Jones's Pygmalion series. The Nettlefold family contributed Millais' *Waiting* and *My Second Sermon* and a Guardi among many English landscapes, which included an enormous number of pictures by David Cox. Agnew's had also added to the large collection of English watercolours given to the gallery in 1953 by the industrialist J. Leslie Wright.

The Colman family had been supplying the nation's mustard from their land outside Norwich for 100 years when Jeremiah James Colman MP (1830–98) first visited Agnew's. In 1894 he bought the *Thorpe Water Frolic* by Joseph Stannard, which he

presented to the Castle Museum when it opened that year. He bequeathed twenty more oil paintings to the museum, the remainder passing to his son, Russell James Colman, another ardent collector of the Norwich School (fig. 51). When the latter died in 1943, 228 pictures and 985 watercolours passed to the museum 'In token of my affection for the City of my birth and in acknowledgement of the honour and the unfailing courtesy and kindness I have received from my fellow citizens'.

If Dickens's readers could recognise characters from *Hard Times* among Agnew's Manchester clients, the London records evoke the Disraelian pages of *Coningsby*. The arrival of Agnew's in London was especially fortuitous in its timing. When the Rothschilds came to England in the 1870s and started erecting their enormous homes in the Vale of Aylesbury, Agnew's had found premises first in the Haymarket and later in 39 (now 43) Old Bond Street and built up a more sophisticated stock (fig. 50).

Benjamin Haydon had written in 1824: 'Wilkie by his talent has done great injury to the taste of the nation. I question whether Reynolds would now make the impression he did, so completely is the taste ebbing to a Dutch one.' Agnew's Manchester stock books confirm Haydon's view that Wilkie's pastiches of Dutch paintings enjoyed more popularity than the purely English pictures of an earlier date, but the London ones tell a different story. Reynolds, Gainsborough and Romney feature strongly in their pages and so does the Rothschild family. Baron Ferdinand (1839–95) wrote to William Agnew: 'I should like to see the "Lady and Child" by Sir Joshua on my return. I do not care about children by themselves but accompanied by a good-looking mother I would willingly accept them. I could do with several more busts as well as three-quarters and one full length but all female figures.'

His family set patterns and standards for collectors for the next twenty years. The earliest to follow the trail were the diamond men now arriving in London from South Africa. Alfred Beit bought his magnificent English and Dutch pictures (they included two Rembrandts) largely from Agnew's between 1895 and 1906, and his cousin Otto Beit followed suit in the first decade of the new century. Other 'Randlords' with similar requirements were Sir Julius Wernher and Sir Joseph Robinson. It has been suggested that the first generation of American collectors – men like J.H. Pierpont Morgan, Henry Marquand and Cornelius Vanderbilt – were looking for instant ancestors to hang in their new houses but it is more likely that they were simply responding to 'le gout Rothschild'.[5] English portraits and Dutch

landscapes and interiors were again sought by English clients, Lord Iveagh, Lord Cowdray and Mrs Ronald Greville all buying fine examples and, in Scotland, Lord Leith selected thirteen Raeburns for his new Scottish home, Fyvie Castle. Two Liverpool clients had changes of heart in the nature of their collecting: George Holt, having originally bought only English 19th-century artists, embarked in 1884 on the purchase of a series of fine 18th-century portraits, culminating in his final acquisition, Gainsborough's splendid *Viscountess Folkestone*. Lord Leverhulme changed direction as a collector in exactly the same way a few years later: the Rothschild effect had reached Merseyside.

F.D. (Peter) Lycett Green's grandfather, a Wakefield industrialist, invented a device which recycled steam, and the grandson, a regular visitor to Agnew's in the 1930s and 1940s, made an unusual and varied collection of 120 pictures, given to York City Art Gallery in 1955, which included artists rarely seen in England, such as as Strigel and Menéndez, and a ravishing Bellotto of Lucca from the Agnew family collection.[6]

Louis Clarke, Director of the Fitzwilliam Museum, Cambridge, from 1937 to 1946, was at the University with Colin Agnew, and Louis and his brother, Charles, made their remarkable collection of Old Master drawings through Agnew's; it went to the museum in 1960 and included Raphael, Leonardo, Correggio, Rembrandt, Van Dyck, Watteau, Fragonard and Boucher (see cat. 78, 79, 92, 95). Clarke's successor, the Australian Carl Winter, had a sharp eye for a bargain, buying from Agnew's in 1950 the wonderfully stylish full-length *Portrait of Lord Northampton* by Batoni for £220 and, in 1951, two Constable cloud studies for £240 each.[7] Michael Jaffé (cat. 28) was a superb museum director from 1973 to 1990. All his superabundant energy and persuasive powers were brought into play when he succeeded in securing Van Dyck's *Virgin and Child*, which Agnew's had bought at the Sutherland sale in 1976. We may remember Jaffé for what he wrote about Rubens, but anyone doubting his eye for English landscape painting should look again at two of the last pictures he bought from the firm – Bonington's *Boccadasse and Monte Fascia* and Cotman's *Breydon Water*.

Agnew's helped the Ashmolean to rescue the Allori *Portrait of a Man* from Mentmore,[8] and more recently they bought from the firm an informal self-portrait drawn by Sir Thomas Lawrence. This was an appropriate purchase, their last director, Kenneth Garlick, having devoted his life to studying the artist whose collections of Raphael and Michelangelo drawings have been in

Fig. 51 *Portrait of Russell James Colman* by Oswald Burley; Colman donated his collection to Norwich; Norwich Castle Museum

I have written so far about collectors many of whom I have only met in the faded sepia ink of Agnew's earlier ledgers. Now I can turn to two men whose collections I saw being formed and whose impact on the firm's other clients I could observe at first hand.

Agnew's came of age in the 1850s, the decade in which Ruskin was fulminating against Italian Seicento painting. For the next 100 years, Italian 17th-century painters are almost entirely absent from the firm's records. Then, in 1953, Sir Denis Mahon is mentioned for the first time when he bought Annibale Carracci's *St John* and a large Salvator Rosa landscape. Shortly afterwards he added Guido Reni's *Sibyl* and, from then on, these names and those of Domenichino, Guercino and Luca Giordano recur with increasing frequency and at increasing prices. Most of these pictures went to museums in the United States, where the Italian Baroque was virtually unrepresented, except at Sarasota and Hartford, Connecticut.[10]

the museum since 1846. Christopher White, during his last years as director, made another apposite acquisition – Rubens's portrait drawing of Thomas Howard, 2nd Earl of Arundel, the greater part of whose celebrated collection of Antique sculpture had long been owned by the Ashmolean.

In 1984 Agnew's negotiated the sale to Birmingham Museum and Art Gallery of a lively sketch for the section of Rubens's Whitehall ceiling representing James I uniting the Kingdoms of England and Scotland. Birmingham University can boast another Rubens in their landscape in the Barber Institute of Fine Arts. During World War II, thanks to the generosity of Sir William and Lady Barber, the Institute found itself in the agreeable position of being able to spend money when nobody else could. Their first Professor of Fine Art, Thomas Bodkin, Shavian in appearance, wit and broad brogue, shared with Colin Agnew a deep dislike of Picasso's work.[9] In 1939 Agnew's made the first of their many purchases from the Cook Collection at Doughty House, and Colin was able to steer such masterpieces as Signorelli's *Portrait of Lorenzo Vitelli* and Mabuse's *Hercules and Dejaneira* in Bodkin's direction. His other purchases included the early Bellini of St Jerome in the wilderness with an apprehensive looking rabbit.

Fig. 52 The Rt. Hon. John Frederick Cheetham in his study at Eastwood House; he donated the Astley Cheetham Library and Art Gallery to Stalybridge

The first Gentileschi to enter an English regional museum was *The Rest on the Flight into Egypt* (cat. 296) which Birmingham bought in 1947 for £450. The gallery's brilliant postwar Keeper of Pictures, John Woodward, bought major works by Castiglione, Carlo Dolci, Renieri and Guercino (*Erminia in the Shepherd's Hut*). Woodward's guru was Sir Ellis Waterhouse, Director of the Barber Institute from 1952 to 1970, whose book *Baroque Painters in Rome* sent British tourists scurrying round many hitherto unvisited churches. Sir Anthony Blunt and Philip Pouncey[11] worked extensively on the period, but it was Mahon, above all, who inspired this change in taste.

In the 1930s, Andrew Mellon had bought full-length portraits by Reynolds and Gainsborough of aristocratic ladies strolling in ancestral parks. Forty years later his son Paul bought a small portrait by Reynolds of an actress sucking her thumb. Paul Mellon loved Turner and Constable too, but these artists had always figured in English collections. Such half-forgotten 18th-century painters as Samuel Scott, J.H. Mortimer and Henry Walton, and 19th-century Romantics such as Francis Danby and John Martin, were the artists he rescued from temporary oblivion. Above all, he awoke enthusiasm for Wright of Derby and Stubbs.[12] His taste for the latter's sporting subjects was extended to include a bashful zebra, a shivering poodle, a somnolent tiger and two deserted rubbing down houses on Newmarket Heath – the latter *plein air* oil sketches that anticipate Seurat.

In 1875 Stubbs was omitted from the eight great names in British art inscribed on the dome of the octagonal entrance to Agnew's new Bond Street Gallery. Restoring the ceiling 80 years later, it was felt that the time had come to include him in the octet. This meant jettisoning Sir Augustus Wall Callcott, a charming artist but one unlikely to catch the selectors' eye if the firm redecorates in 50 years' time.

One should add that the regional museums have always cherished their indigenous heroes. Liverpool and Stubbs, York and Etty, Bristol and Danby, Norwich and Crome, and Ipswich

Fig. 53 John Edward Taylor, who donated his watercolour collection to the Whitworth Art Gallery, Birmingham

and the early Gainsborough – these are the loyal couplings constantly registered in Agnew's books down the years.

I apologise to our many friends in the regions whom lack of space has prevented me from mentioning and will end on a warning note. We all need godparents. They should be rich but not over indulgent, have no favourites and always be around in moments of stress. The National Heritage Memorial Fund and the Heritage Lottery Fund have filled the role for our museums in recent years, and it is of fundamental importance that they should be encouraged by any government in power to continue to do so. The barbarians are always at the gates.

Fig. 54 Charles Edward Lees, who presented his collection to Oldham Art Gallery in 1888

NOTES

1. A popular item was the saccharometer, an instrument designed to measure the quantity of sweetness in a substance. It is tempting to see a connection between the Victorian love of sweet puddings and the saccharine nature of some of their literary heroines. Little Nell was dying in the weekly instalments of *The Old Curiosity Shop* in 1841.

2. It is at about this time that Agnew's stock books become coherent.

3. In mellifuous words typical of the man and his period, William Agnew wrote to Watts in 1885: 'Your generosity has already sent a thrill through the hearts of those who are first and noblest in Manchester City. Dear Mr Watts, accept my grateful acknowledgments and the expression of my earnest belief that no words of mine can express how I feel towards you.' D.H. Lawrence, who admired the picture, wrote more succinctly about it at a later date.

4. If he marvels at the variety of the collection he should remember that its directors included that exuberant acquisitor, Tim Clifford.

5. The Vanderbilt residences both in New York and North Carolina were designed in the late French Gothic style which the Rothschilds had introduced to the English Home Counties.

6. Where it was inevitably know as 'the Canaletto'.

7. If these prices seem incredible today, one should remember that Agnew's held annual exhibitions of pictures by Old Masters at under £200 until 1961.

8. Where it was hopefully called Benvenuto Cellini by Bronzino.

9. When the Victoria and Albert Museum mounted an exhibition of Picasso and Matisse in 1946, Colin said: 'I suppose that sort of thing's all right at the Tate but it seems a shame to do it in the poor old V and A.'

10. In Sarasota the German circus proprietor John Ringling bought property in the Gulf of Mexico, where his elephants could winter in warm weather. There he erected an Italianate palace which he filled with large Baroque pictures. Only German and Austrian universities offered the Italian Seicento as an academic subject before the war and Ringling's adviser was a Munich dealer, Julius Böhler. The remarkably prescient curator was 'Chick' Austin, who later moved on to Hartford, where he bought such major works as Caravaggio's *Ecstasy of St Francis* and Salvator Rosa's portrait of his mistress *La Ricciardella* long before these artists were household names in America.

11. Raymond Chandler and P.G. Wodehouse, who were at Dulwich College together, are said to have owed their beautifully lucid prose style to the same English teacher. The art master at Marlborough, which Waterhouse, Blunt and Pouncey attended together, was a retired Colonel who also ran the Officers Training Corps and whose favourite artist was Brangwyn. The three future art historians and their contemporaries Sir John Betjeman and James Mason are remembered as having made life difficult for the Colonel.

12. Mellon supported and encouraged Ben Nicolson and Basil Taylor's work on these artists. Judy Egerton subsequently consummated their researches with the stunning exhibitions of both artists which she arranged at the Tate.

The Royal Academy and Regional Museums, 1870–1900

N I C H O L A S S A V A G E

The rapid spread of municipal art galleries in England from the early 1870s to the late 1890s coincided with what even at the time were recognised as 'the palmy days' of the Royal Academy in London, when its Summer Exhibition regularly attracted well over 300,000 visitors and contemporary British art attained a peak of cultural value in society that was an exact corollary of national pride in the political and economic power of the British Empire.[1] The unprecedented popular success of the Royal Academy exhibition in this period was matched by extraordinarily large numbers of visitors to the new public art museums in the regions.[2] This essay examines the influence of the Academy on these museums in the final decades of the 19th century, highlighting one of the most interesting cases, that of the Walker Art Gallery in Liverpool.

As Giles Waterfield has pointed out, temporary loan exhibitions were a critical factor in attracting large attendances to the municipal galleries, particularly to those which had not been founded in consequence of the donation of existing major private collections. Although the new galleries were the inheritors of long, if somewhat chequered, local traditions of private and institutional patronage of the arts, collectively they represent a departure from those traditions in two major respects. First, it is clear that a new kind of civic pride impelled the creation of these cathedrals of art, one that was no longer tied to mid-Victorian calculations of the moral, social or economic utility of local art collections, but was founded instead on a belief that such

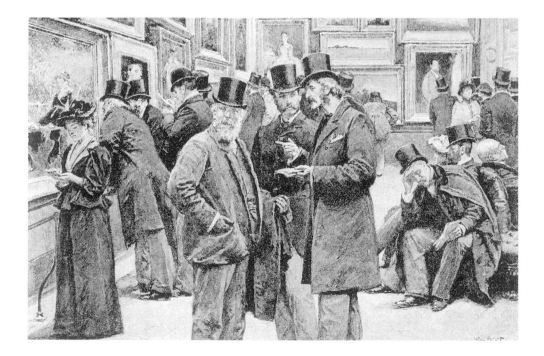

Fig. 55 Press Day at the Royal Academy; from a drawing by Wal Paget, *The Magazine of Art*, March 1892

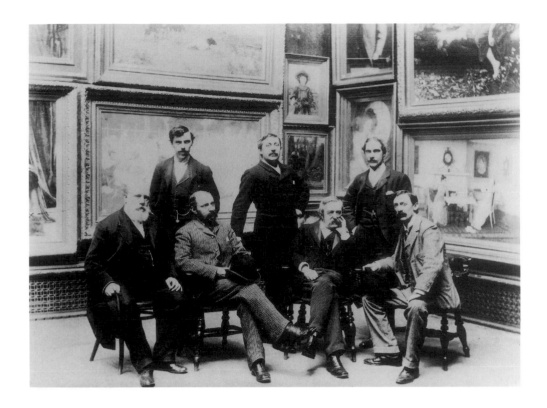

Fig. 56 The Hanging Committee at the 1892 Liverpool Autumn Exhibition; William Stott of Oldham (centre), Stanhope Forbes (far right), P.H. Rathbone, Chairman of the Committee (seated next to Forbes)

collections should be an expression of the importance of a particular city in the cultural life of the nation. Second, in having acquisition funds that were controlled by town or city councils these galleries introduced an important new form of civic art patronage in England, representing a significant development away from the less sophisticated use of artists and sculptors merely to decorate imposing town halls. Both these factors help to explain why the new regional collections were so successful in acquiring, through a process of appropriation from the metropolis, many of the best works of the nation's leading contemporary artists, who were to have no opportunity of being permanently represented in a national public collection of British art until the founding of the Tate Gallery in London in 1897.

The part played by the Royal Academy in this channelling of cultural capital into regional collections, though in no sense an entirely new or controlling one, was none the less critical to its successful outcome. Ever since Reynolds had lent his portrait of Lt.-Col. Tarleton (National Gallery, London) to the 1784 exhibition of the Society for Promoting Painting and Design in Liverpool, Royal Academicians based in London had often contributed to regional art exhibitions, either in the hope of finding buyers or merely to lend support and encouragement to local academies and artists' exhibiting societies. When, therefore,

from 1871 on, the Arts and Exhibitions Sub-committee of Liverpool Town (later City) Council began to send a delegation every March to tour the London studios of prominent artists in order to view forthcoming Royal Academy exhibits, they were simply perpetuating an established practice of the Liverpool Academy: the latter's series of open Autumn Exhibitions, held more or less continuously from 1810 to 1867, had been frequently enriched by contributions from London-based artists, including numerous Royal Academicians.[3] The only difference was that, as an added inducement to London artists to send specific paintings to the Liverpool Autumn Exhibition, the Arts and Exhibitions Sub-committee was able to recommend a selection of such works to the Town Council as suitable purchases for its permanent collection, provided that they had been sent to the Liverpool exhibition, the profits of which (derived from admission charges and commissions on sales) formed the principal source of acquisition funding. An unwritten rule that all purchases of contemporary art for the Walker Art Gallery had to be made directly from the artist, and not through a dealer or other intermediary, may have been unique to Liverpool;[4] it certainly helped to draw London artists to the Liverpool exhibition, encouraging them to follow the example of Frederic Leighton, who showed two major works there in 1872 and 1873

before sending them to the Royal Academy the next year.[5] It also helped to ensure the remarkably early success of the Liverpool Academy exhibition as an annual event: profits accruing from the first exhibition in 1871 were already sufficient to enable the Library, Museums and Arts Committee to 'purchase ... for the Permanent Gallery, Pictures to the value of £500', while the sale of 335 works of art from the 1874 exhibition totalled £9,484 which, according to the exhibition sub-committee's report, was the largest amount ever realised at any regional art exhibition.[6] By 1884 admission receipts had risen to nearly £5000 and paintings worth more than £12,000 were sold from the exhibition, which by now had come to be called colloquially 'the Academy of the North'.[7] As a way of overcoming the reluctance of municipal authorities to fund acquisitions directly from the rates, the Liverpool system had a great deal to recommend it and was soon widely imitated elsewhere, as at Manchester and Leeds which, in 1882 and 1888 respectively, began their own annual exhibitions of contemporary art from which purchases could be made for their collections.

The Royal Academy itself embarked on three important initiatives in the 1870s that involved activities much closer to those of the new regional art galleries than its founders had envisaged. The first of these undertakings – the revival, from 1870 on, of a series of annual winter loan exhibitions of Old Masters (mixed with works by deceased British artists) that had ended with the demise of the British Institution in 1867 – is important here only in that its results reflected the popularity of contemporary British art: all pre-1914 winter exhibitions at the Academy attracted only a fraction of the number of visitors to the summer shows. Even the most popular – the Landseer commemorative exhibition of 1874 – drew less than a third of the total admitted to the Summer Exhibition that year; and although the 1879 winter exhibition filled nine galleries with 1055 works, it was visited by only 34,932 people, less than a tenth of the still unbroken record set that same year for the Summer Exhibition (391,197).[8]

The second important departure for the Academy came in 1877, when the Council made its first purchases of paintings and sculpture for the nation under the terms of the Chantrey Bequest. Sir Francis Chantrey's will had stated that the income from his estate 'shall be devoted to the encouragement of British Fine Art in painting and sculpture only', by means of 'the purchase of Works of Fine Art of the highest merit ... that can be obtained either already executed or which may hereafter be executed by

Fig. 57 *Portrait of Alderman Edward Samuelson* by David Woodlock; Walker Art Gallery, Liverpool, WAG 2423

Artists of any nation provided such artists have actually resided in Great Britain during the executing and completing of such works'.[9] As the selection of works was vested solely in the President and Council of the Royal Academy 'for the time being', and since it was a further requirement of the will that every work 'be publicly exhibited ... in the annual exhibition of the Royal Academy or in some important exhibition of fine art within a year of its purchase', it was perhaps inevitable that the Council's choice should turn out to be restricted largely to contemporary works shown in the Academy's own exhibition.[10] In a sense this merely mirrored the situation at Liverpool, except for one crucial difference: there, successive chairmen of the Arts and Exhibitions Sub-committee, the redoubtable P.H. Rathbone and the powerful local politician Edward Samuelson (fig. 57), had been united 'in preventing Liverpool artists from gaining any special privileged access to the Autumn Exhibitions or any control over them'.[11] It was precisely such 'privileged access' and 'control' that the Royal Academicians enjoyed at the Academy, so the Council's failure to interpret the terms of Chantrey's will to include works not submitted to the Summer Exhibition naturally led to accusations

of partisanship. This was particularly the case in the years following the establishment of alternative, more progressive exhibition venues in London, such as the Grosvenor Gallery in 1877, the New English Art Club in 1886 and the New Gallery in 1888.

The third new venture at the Academy during the 1870s is today the least well known, namely the placing of its own collection of paintings and sculpture on permanent public display at Burlington House for the first time. The opening of the Diploma Galleries on 14 January 1878 seems to have caused remarkably little comment. Even *The Art Journal*, normally an avid follower of Academy affairs, was perfunctory in its report on what was, after all, the only collection in London that covered, if in a rather eccentric fashion, the full continuum of more than a century of British art since Reynolds.[12] Despite this historical sweep, visitors cannot have failed to notice how narrowly living artists were represented. Unfortunately, no attendance figures exist for the Diploma Galleries, which were open daily from 11am to 4pm without charge, but closed on Sundays (as were all Academy exhibitions, even to members). It is unlikely that they were much frequented by the public, since critical notices remained rare and always commented on the Galleries' contents being little known. Their limitation to single works by each Academician meant that they could never be as representative of the current achievements of British artists as the annual displays of contemporary art in the Main Galleries.

These three developments in the Academy's operations in the 1870s each represent an attempt to address its public as a quasi-national institution. They should be seen in the light of the fact that, since 1869, it had occupied handsome new premises at Burlington House, a building granted by the government to the Academy, which undertook to adapt it at its own expense on the understanding that the benefits to the nation accruing from the Academy's activities there were to be made more effective through a reform of both its constitution and its teaching methods. Such reforms as were introduced – in particular, increasing the number of Associates and giving them a voice in the election of new members – were widely perceived to have been obstructed by the old guard under Sir Francis Grant's presidency.[13] Grant's powerful political connections – his wife was a cousin of Lord John Manners, a cabinet minister in both Lord Derby's and Disraeli's administrations – so effectively dampened reverberations of the criticisms made to the 1863 Royal Commission that, by the time Frederic Leighton succeeded him

as President in December 1878, the Academy's social and artistic authority in the eyes of the public probably stood at its highest point since the heady days of its first exhibition at New Somerset House in 1780. Although the founding of the Grosvenor Gallery by Sir Coutts Lindsay sent a shock wave through the art world – news of Lindsay's intention to mount a rival exhibition to the Academy's in May 1877 was condemned by Leighton as 'unpatriotic' – the strong presence in the Grosvenor exhibitions of important works by leading academicians, such as Millais, Leighton, Alma-Tadema, W.B. Richmond and G.F. Watts, effectively obscured direct criticism of the Academy. The Grosvenor shows did draw attention to the way the crowded, heterogeneous Academy exhibition was unsuitable for the display and proper appreciation of new, 'Aesthetic' work by certain eminent living artists, in particular Whistler, Burne-Jones, and Watts.[14] Yet any residual public awareness of the Academy's shortcomings in this respect was to be obfuscated by the Rossetti memorial exhibition, shown at Burlington House in 1882, and by Leighton's success in persuading Burne-Jones, against his better judgement, to become an ARA in 1885. By then, in any case, the Grosvenor summer exhibition had become simply a smaller version of the Academy show.

Another measure of the power of the Academy during the 1880s and early 1890s is the vituperative tone of those few art critics who made it their business to voice the growing anger and frustration of younger, more progressive artists. Although such critics despised the Academy for its conservative pandering to out-moded, popular tastes, they could not ignore the effects of its hold on the art market. A classic example of the distinctive genre of criticism that this situation produced is George Moore's 'The Alderman in Art', which originally appeared in two successive issues of the *Speaker* (15 and 22 October 1892) and was given greater permanence in a revised form as one of the collected essays in his book *Modern Painting* (1897). Moore's determination to attack the pernicious influence of the Academy wherever he could find it led him on occasion to overstate his case. Thus, in reviewing recent purchases made by the new art galleries at Manchester and Liverpool, he saw them as so much 'sowing of evil seed', as evidence that 'the harm occasioned to art by the Academy and its corollary, the Chantrey Fund' did not begin and end in London, but extended 'far and wide' in the regions. There, Moore claimed, art 'is little more than a reflection of the Academy' and the 'majority of the pictures represent the taste of men who have no knowledge of art and who, to disguise their

Fig. 58 George Frederick Cotman, *One of the Family*, 1880; Walker Art Gallery, Liverpool, WAG 1029

ignorance, follow the advice which the Academy gives to provincial England in the pictures it purchases under the terms – or, rather, under its own reading of the terms – of the Chantrey Bequest Fund.'[15] Moore's assumption that the Academy's influence on the formation of regional collections was invariably unmediated by any independent critical awareness on the part of those responsible for selecting works for purchase is belied by his warm tribute to P.H. Rathbone's remarkable achievement at Liverpool: 'Without Mr. Rathbone, Liverpool exhibitions would drop into the ordinary jog-trot of other provincial exhibitions – a mere extension of the commercial system of the Academy. But with Mr. Rathbone the Liverpool exhibition has reached an extraordinarily high level of excellence'.[16] Rathbone's battle to win Liverpool councillors' approval of his contentious purchase in 1892 of 'Glasgow Boy' E.A. Hornel's *Summer* (cat. 204) and William Stott of Oldham's 'impressionist' *Alps by Night* cannot have been helped, however, by Moore's witty denunciation of the artistically minded alderman who 'lets fall from his thick lips those scraps of art-jargon which he has picked up in the studio where he sat for his portrait', who 'goes to the Academy, and dictates the aestheticism of his native town' and who is, all in all, 'the reef which for the last twenty-and-five years has done so much to ruin and to wreck every artistic movement which the enthusiasm and intelligence of individuals have set on foot'.[17]

While Rathbone and his sub-committee needed to attract well-known Royal Academy exhibitors, both members and outsiders, to ensure the continuing popular success of the Liverpool Autumn Exhibition, they were very far from relying on such artists when it came to selecting purchases for the Walker Art Gallery's permanent collection. Of the 150 or so works by living artists acquired for the gallery between 1871 and 1910, mostly directly from the Autumn Exhibitions, about 60 had been exhibited earlier in the year at the Academy – a far lower proportion than would have been the case if Rathbone and his successors had favoured the Royal Academy exhibitors in the way that Moore considered endemic in regional collections. Indeed, what strikes one most forcibly about the pattern of buying at Liverpool is how often paintings which had been badly hung, ignored or disliked by critics at the Academy were bought for the Walker Art Gallery at the Liverpool Autumn Exhibition later the same year. This is as true of some of the earliest of such purchases – F.W.W. Topham's *The Fall of Rienzi, the Roman Tribune* (1872) and Louisa Starr's *Sintram* (1873) – as it is of some major acquisitions in the 1880s, such as Frederick Goodall's *A new Light in the Hareem* (1884), the purchase of which for £1000 was criticised in *The Magazine of Art*,[18] and Walter Dendy Sadler's *Friday* (1882), which had been skied at the Academy but was bought by James Pegram, also for £1000, and presented to the Walker Art Gallery the following year. Again, the four Academy/Liverpool Autumn Exhibition acquisitions made for the Walker Art Gallery in 1880 had all been badly received in London: G.F. Cotman's *One of the Family* (fig. 58) – the first major work by this artist to enter a public collection – had been criticised in *The Times* for showing details of a meal that were

'both obtrusive and vulgar'[19]; Alice Havers's *Blanchisseurs: 'What, no Soap'* and Charles Gregory's *Weal or Woe* had both been scarcely noticed; and Frank Walton's *Down in the Reeds by the River* had been described in the *Athenaeum* as 'much too large', with 'handling marked by pretentious "chic"'.[20] Reviewers in Liverpool had no difficulty in finding qualities to praise in all four works. This suggests a conscious critical independence which, far from hanging on the coat-tails of the London art world, saw such acquisitions as trophies secured for Liverpool in the face of stiff competition, not only from such rival provincial galleries as those at Birmingham, Manchester and Leeds, but also from the Chantrey Bequest itself, which had the advantage of automatic first refusal of any work exhibited at the Academy.

In deploring Manchester City Art Gallery's purchase of Arthur Hacker's *Syrinx* (exhibited at the Royal Academy in 1892) as an instance of the harmful influence of the Chantrey Bequest Fund (which had bought Hacker's other Academy exhibit that year), George Moore rather missed the point of the Manchester committee member's rejoinder that 'our picture is the better of the two', when he replied: 'Poor Mr. Chantrey's money always goes to buy the worst, or as nearly as possible the worst, picture the artist ever painted – the picture for which the artist would never be likely to find a purchaser.'[21] Moore's metropolitan perspective caused him to overlook what really mattered to Manchester, namely that it had beaten the Chantrey Bequest Fund to win a better prize. Moore pleaded that public art collections should not be formed by committees, but by 'competent art directors ... who will deem their mission to be a repudiation of the Anglo-French art fostered by the Academy – a

return to a truer English tradition, and the giving to Manchester and Liverpool individual artistic aspiration and tendency'.[22] However much one may sympathise with Moore's desire to enlist municipal art galleries in the cause of artistic progress, his partisan specification of their directors' proper mission reveals a flaw in his position. In the end it was Rathbone who better understood the role of a public art gallery when he concluded his reply to Moore's criticisms by claiming: 'the great safeguard in our administration is its impartial ignorance, which leads it to seek the very best advice of the very best authorities, and to select according to that advice. This has saved us from being run away with by preconceived prejudices, and has given us the necessary courage to select pictures without regard to name, and by unknown artists who have since risen to unquestioned eminence.'[23]

Any gallery curator today would be justifiably proud to be able to repeat these words (though he or she might well wish to replace 'impartial ignorance' with 'impartial knowledge'), and any number of modern gallery mission statements are in effect paraphrases of Rathbone's Ruskinian belief that 'municipal galleries are not museums, but educational establishments for the citizens generally, and a popular interest is a necessary element of their success in this direction'.[24] Clearly, during Rathbone's forceful and lucid direction of the early acquisition policy of the Walker Art Gallery, the Royal Academy's influence was never so strong there that it could not be accepted or rejected at will on behalf of the citizens of Liverpool as a whole, along with whatever else artists everywhere might have to offer.

NOTES

1. Academy exhibition attendance records and/or receipts can be found in the printed series of *Annual Reports from the Council ... to the General Assembly of Academicians* which began in 1860. These reports were distributed to the members only. The first exhibition at Burlington House in 1869 attracted 314,831 visitors, including 29,796 in the last (13th) week at half-price admission (6d). These figures represented an increase of over 113 per cent on the best previous year ever in the Academy's history (1867). Thereafter Summer Exhibition attendance figures at Burlington House did not fall below the 300,000 mark (except in 1886) until 1896 (the year that the President, Frederic Leighton, died), after which they hovered around 260,000 until 1910 and 1911, when they dropped sharply to 211,043 and 176,257 respectively.

2. In the first few months after the opening of Mappin Art Gallery at Sheffield in July 1887, 6000 visitors would regularly pass through in the space of three hours on a Sunday, while in Leeds, with a population of only 367,000, visitors to the City Art Gallery (founded in 1888) frequently totalled more than 250,000 per year in the 1890s, reaching 420,000 in 1898. M. Tooby, *In Perpetuity and Without Charge: The Mappin Art Gallery 1887–1987*, Sheffield, 1987, p. 18; *Art for the People*, exh. cat. by G. Waterfield, Dulwich Picture Gallery, 1994, p. 35. See also p. 44 of the present volume.

3. E. Morris, *Victorian and Edwardian Paintings in the Walker Art Gallery and at Sudley House*, II, *British Artists born after 1810 but before 1861*, London, 1996, p. 5; C.P. Darcy, *The Encouragement of the Fine Arts in Lancashire 1760–1860*, Manchester, 1976, pp. 31–51. On all matters relating to the Walker collection the present writer is heavily indebted to Morris's catalogue, which sets an entirely new standard for works of its kind.

4. Morris, 1996, p. 16.

5. L. and R. Ormond, *Lord Leighton*, New Haven and London, 1975, pp. 119–20; Morris, 1996, p. 21, n. 9.

6. Morris, 1996, pp. 3–4. In the same year 285 works were sold from the Academy for £24,353 18s. (*RA Annual Report*, 1874, p. 24).

7. Darcy, 1976, p. 58.

8. *RA Annual Report*, 1874, p. 23; *ibid.*, 1879, pp. 30, 33. Precisely the reverse of these attendance figures would be normal today.

9. 'Extract from the Will of Sir F. Chantrey', in *RA Annual Report*, 1875, pp. 49–52.

10. The RA Council was perfectly aware of the possibility of buying works by deceased artists, since its very first purchase was William Hilton's *Christ crowned with Thorns* (destroyed when the Tate Gallery was flooded in 1928), a full-size cartoon for which is extant in the Academy's collection.

11. Morris, 1996, p. 8.

12. *The Art Journal*, February 1874, p. 94. An adjoining gallery, built to display John Gibson's bequest of casts and models of his own works, had opened to the public on 27 November 1876. The delay in setting up the Diploma Galleries was due to the Academy having lent twenty works from its collection to the 1876 Philadelphia International Exhibition.

13. *The Art Journal*, March 1868, p. 58; April 1868, p. 78; January 1869, p. 29; March 1869, p. 94; June 1869, p. 194; June 1870, p. 194. There was an inconclusive debate in the House of Commons on 9 May 1876 on a motion brought by Sir Charles Dilke 'calling attention to the position of art education in England, and to the constitution of the Royal Academy of Arts, and its neglect to carry out the reforms recommended by the Royal Commission of 1863' (*RA Annual Report*, 1876, pp. 7–8).

14. C. Newall, *The Grosvenor Gallery Exhibitions: Change and Continuity in the Victorian Art World*, Cambridge, 1995, p. 32; C. Hallé, *Notes on a Painter's Life*, London, 1909, pp. 142–4.

15. G. Moore, *Modern Painting*, London, 1897, p. 164.

16. *Speaker*, 22 October 1892, p. 498; quoted in Morris, 1996, p. 15.

17. Moore, 1897, pp. 167–8

18. 'The Chronicle of Art [November 1884]', *The Magazine of Art*, 1884, p. vi.

19. *The Times*, 28 June 1880; quoted in Morris, 1996, p. 86.

20. *Athenaeum*, 20 May 1880, p. 702; quoted in Morris, 1996, p. 452.

21. Moore, 1897, p. 164.

22. *Ibid.*, pp. 169–70.

23. *Speaker*, 5 November 1892, p. 563; quoted in Morris, 1996, p. 14.

24. *Ibid.*

Regional Collections of 20th-Century British Art

ANGELA SUMMERFIELD

Fig. 59 Southampton City Art Gallery, designed by B. Webber as part of the civic centre complex, 1929–39

In the popular imagination the Tate Gallery is seen as the natural home of 20th-century British art, where contemporary art is collected as part of a comprehensive historical survey. In contrast, the regional galleries and museums are perceived to be conservative and doggedly provincial.* The story of these institutions, however, reveals a sustained commitment to buying modern and contemporary works of art. When the Tate was opened in 1897 as the first national gallery dedicated exclusively to British art, important public art collections had been in existence for several years at Birmingham, Leeds, Liverpool and Manchester. These galleries were actively acquiring examples of contemporary British art. Regional collections regularly purchased from the Royal Academy's Summer Exhibition and, taking it as model, many galleries and museums established annual Spring and Autumn exhibitions; the first was the Liverpool Autumn Exhibition, held at the Walker Art Gallery from 1877. Regional galleries became the venues for local exhibiting societies' shows, which attracted artists of national and international standing, and also promoted pioneering exhibitions of progressive contemporary art. In 1914 *An Exhibition of the Work of English Post Impressionists, Cubists and Others* was organised at Brighton Art Gallery by its enlightened Curator, Henry Roberts, who had been appointed 1906. In 1931 Jacob Epstein's controversial sculptures *Maternity* and *Genesis* were displayed at Leeds City Art Gallery and Manchester City Art Gallery respectively, and in 1934 the exhibition of the avant-garde Unit One group, which included Barbara Hepworth, Henry Moore, Paul Nash and Ben Nicholson, toured from the Major Gallery in London to the Walker Art Gallery, to Manchester and to four other regional galleries. By 1939 it was the regional collections rather than the Tate Gallery which offered the public the widest representation of progressive contemporary British art in the form of acquisitions and exhibitions.[1] Financial constraints in postwar Britain, however, limited the type of art it was possible to collect for local authority art collections just at the time the Tate was able to expand and consolidate its holdings.[2]

In the postwar years the Tate Gallery was able to establish itself as the foremost collection of modern art because of its London location, its government grant and its independent board

*'Public' and 'regional' galleries and museums refer specifically to those funded by local authorities. The one exception is the Walker Art Gallery in Liverpool, which in 1988 became part of the National Museums and Galleries on Merseyside, funded by central government.

of trustees. Its collecting policy became a model for other galleries. By contrast, postwar regional public collections had inherited disparate and eclectic collecting patterns, and had to contend with the requirements of funding bodies and private trusts. The booming art market for modern and contemporary British art in the 1960s and 1980s compounded their plight. One response to this was the organisation of artist-in-residence schemes and exhibition–competitions from which works have been bought by the galleries. The John Moores Prize, established in 1957 at the Walker Art Gallery, and the Bradford Print Biennale at Cartwright Hall, started in 1969, are two notable examples.

In the 1990s the cultural objectives of museums and art galleries and their collections are being reassessed. Regional public collections need financial support, but local authority purchase grants are not mandatory and legal restrictions on local authority financial support, or even its total absence, mean that galleries have to rely on private benefactors. This includes the establishment of Friends groups, raising public subscriptions and, more recently, finding commercial sponsorship. Before 1934 Birmingham City Art Gallery relied solely on bequest funds, the Public Picture Gallery Fund and the Association of Friends of the Art Gallery; in 1946 the Friends organisation enabled it to purchase works by Harold Gilman, Barbara Hepworth, Ivon Hitchens, Frances Hodgkins, L.S. Lowry, Ruskin Spear and Stanley Spencer. Bequests such as Lord Derby's of £2000 to the Walker Art Gallery in 1892 and endowments such as the £20,000 fund established in 1928 at the Ferens Art Gallery, Hull, have also helped considerably.

The activities of private bodies, such as the National Art-Collections Fund (NACF), the Contemporary Art Society (CAS), the Gulbenkian Foundation and the Henry Moore Foundation, have made substantial nationwide contributions to the purchasing power of public collections. Since its establishment in 1910 the CAS has presented more than 1500 works of art; enough to create a Tate Gallery in itself! In 1985 the CAS and the Arts Council of Great Britain launched a matched-funding collection-building scheme at the Harris Museum and Art Gallery, Preston. The matched-funding of the local authority's contribution by the Museums and Galleries Commission/V & A Purchase Grant Fund greatly increased the value of this scheme, which has since been replicated at the Towner Art Gallery, Eastbourne, Ferens Art Gallery, Hull, and Wolverhampton Art Gallery. The CAS has also been responsible for the regional distribution of large private collections, such as those belonging to Edward Marsh (1872–1953) and Kenneth Clark (1904–83). Currently, some 50 regional public galleries are recipients in the CAS distribution scheme. The NACF's short-lived Modern Art Fund (1989–91) and Contemporary Art Initiative (1992) also made contributions. Regional collecting schemes for contemporary painting and sculpture, from which 37 galleries benefited, were financed and administered by the Gulbenkian Foundation from 1959 to 1979. Modern British sculpture has generally commanded high prices and, in any case, few regional galleries are fortunate to have such purpose-built sculpture galleries as those at Cartwright Hall, Bradford, and Southampton Art Gallery. The Henry Moore Foundation has aimed to redress this situation since its establishment in 1977.

Regional collections have also received support from artists and their estates. Frank Brangwyn's substantial gifts of the 1930s and 1940s, and the Walter Sickert Trust distribution of 1946–50, are notable examples. Since the 1920s independent advisers have helped to initiate, inform and support collecting at, for example, Carlisle Art Gallery and Southampton Art Gallery. Newly established government bodies, such as the Museums and Galleries Commission[3] and the Arts Councils of England, Wales, Scotland and Northern Ireland,[4] have had a major impact on the collecting of contemporary art by museums and galleries.

Central government legislation, private Acts of Parliament and the government-financed Museums and Galleries Commission/V & A Purchase Grant Fund have all affected the growth of regional public collections.[5] The changing culture of local communities has created its own dynamic. In prewar Bradford, for instance, the immigrant German-Jewish community took an active interest in the affairs of the art gallery, while the subsequent establishment of a strong Indian community has expanded the gallery's notion of British art.

One of the great strengths of Leeds City Art Gallery is its collection of painting and sculpture from 1900 to 1920, art of the 1930s and 1940s, and painting and sculpture from the 1960s to the 1990s. The gallery, established in 1888, did not receive its first local authority purchase grant until 1936, but energetic local benefactors and the activities of the Leeds Art-Collections Fund (LACF), set up in 1912, ensured that it thrived.[6] In the mid-1930s two funds set up by Col. Thomas Harding, a committed LACF member, secured the purchase of key paintings, including Harold Gilman's *Mrs Mounter*, Christopher Wood's *Treboul Church, Brittany* and William Roberts's *The Family*

(cat. 394). In 1938 the Director, Philip Hendy, initiated a policy of collecting contemporary art; three years later Henry Moore's sculpture *Reclining Figure* (1929) was purchased. Under Hendy's directorship the gallery bought, and was presented with, paintings, drawings and sculpture by Jacob Epstein, Frank Dobson, Ivon Hitchens, William Roberts, Walter Sickert, Stanley Spencer and Christopher Wood. The Leeds Art-Collections Fund enabled progressive contemporary works to be added to the collection: in 1950 it bought Francis Bacon's *Painting 1950*. Both the Harding Funds and the LACF supported the careers of such local artists as Jacob Kramer and Philip Naviasky; Matthew Smith and Edward Wadsworth, also locals, were collected by Hendy.

In 1927 the gallery received its first gifts from the CAS: *The Red House* on the Hill and the drawing *Nude*, both by Duncan Grant. Later major gifts from the CAS have included Henry Moore's sculpture *Maternity* (1924), presented in 1946, and Ben Nicholson's *Still-life with Guitar*, presented in 1951. The gallery's holdings of 20th-century British sculpture have been significantly extended with the foundation of the Henry Moore Institute in 1993.

In the 1980s the gallery was purchasing works by such artists as Susan Hiller, Gilbert and George, and Richard Long. Its current collecting policy is to develop the strengths of the 20th-century collection by emphasising living British painters and sculptors, and sculptors' drawings and archives. To achieve this, the gallery relies on a 'funding pool'.[7] Acquisitions since 1990 have included works by Andy Goldsworthy, Gillian Ayres, Paula Rego, Leon Kossoff, Adrian Wizniewski, Ken Currie and Lesley Sanderson. The Robert Holmes Bequest of 1992 has helped extend the 20th-century British collection, notably in the area of neo-Romanticism.

Although since its foundation, in 1882, Manchester City Art Gallery had enjoyed a unique annual purchase grant of £2000, it was only by the single gift in 1925 of one private collector, Charles Rutherston (1866–1927), that the gallery came to house the most important public regional collection of modern and contemporary British art.[8] This gift included 50 paintings dating from 1890 to 1925 by, among others, Duncan Grant, Augustus John, Henry Lamb, C.R.W. Nevinson, Lucien Pissarro, William Rothenstein, Walter Sickert and Wilson Steer. There were also over 500 works on paper by such artists as Eric Gill, Paul Nash, William Roberts and Edward Wadsworth, and twelve sculptures by Frank Dobson, Jacob Epstein, Eric Gill and others. Having

supported so many artists, Charles Rutherston hoped that his gift would form the nucleus of a contemporary British art collection to which private gifts and acquisitions could be added. It was intended to form part of Manchester's permanent display and also be available for loan to galleries and schools throughout Lancashire and Yorkshire. In 1928 Rutherston, the Art Gallery Committee, the CAS and other private patrons started to augment the collection. Acquisitions included Robert Bevan's *The Farmhouse*, David Bomberg's *The Tower of London* and Winifred Nicholson's *Primulas*. By 1939 works by artists such as Barbara Hepworth, Ben Nicholson, Graham Sutherland and had also been acquired.

During the 1940s, Manchester City Art Gallery received 53 works by contemporary British artists from the War Artists' Advisory Committee, which distributed over 5500 works to British galleries. The gallery also began to buy wisely, acquiring Paul Nash's *Nocturnal Landscape* in 1948. In the 1950s and early 1960s several contemporary purchases were blocked by the local council; these included Ben Nicholson's *Still-life*, shown in the exhibition *60 Painters for '51*, organised by the Arts Council of Great Britain. In 1976 the gallery received a major bequest of £50,000 from Wilfrid R. Wood for the purchase of works by living British artists, and this has made it possible to buy Howard Hodgkin's *The Hopes at Home* and Bridget Riley's *Zephyr*. In 1979 this fund was wound up when the remaining capital and interest was used to purchase Francis Bacon's *Portrait of Henrietta Moraes* (cat. 408).

Recently, the galleries of Manchester and Birmingham both have had their local authority acquisition funds frozen in response to central government cutbacks, and Manchester has turned to corporate revenue sponsorship to fund the purchase of contemporary art. In 1991 the gallery committed itself to buying contemporary British painting and sculpture, works that relate to the extant collection and ones with an urban theme.

Southampton City Art Gallery (fig. 59) was the last major public gallery containing a significant collection of modern and contemporary British art to open in this country: it has the finest collection of paintings by the Camden Town group outside the Tate. The gallery was constructed as part of an arts centre complex in 1932, was bombed in the war and did not function fully until the 1950s. The purchasing of modern British art had started before it was built. The Chipperfield Trust of 1916 provided funds for the acquisition of works of art selected by the curator subject to the approval of the Director of the National

Gallery. The first adviser was Kenneth Clark, who saw no reason why a regional gallery should concern itself with collecting innovative art.[9] The gallery embarked on a policy of collecting watercolours and drawings, and modern paintings in oils. In 1945 the Chipperfield Trust Fund was used to establish a collection of Victorian and modern British art. In 1925 F.W. Smith, a local alderman, bequeathed a purchase fund to be administered by representatives from the City Council, the University, the Chamber of Commerce, the College of Higher Education and the Royal Academy. The trustees selected works in consultation with the gallery's head curator. One of their first purchases, in 1932, was Sickert's *The Mantel Piece*.

In 1963 the gallery received a major bequest of 20th-century British and foreign art from the dealer–collector Arthur Jeffress. This gift included Lucian Freud's *Bananas*, John Bratby's *Jean and Still-life in front of a Window* and eleven works by Graham Sutherland. In 1964 the Southampton local authority awarded the gallery its own annual purchase grant, which enabled it to make purchases up to a given sum without consultation. The gallery responded quickly in a competitive art market. In 1967 matched-funding from the Gulbenkian Foundation permitted the acquisition of several contemporary works, including Allen Jones's *Pathway*. Since 1976 the gallery has concentrated on acquiring 20th-century paintings, and over 50 per cent of annual purchases have been of contemporary works. In common with many other galleries today, Southampton uses its private funds and local authority grant as part of a collective purchasing pool.[10] The gallery's current acquisition policy is to collect representative works by major British and foreign 20th-century artists, works of regional relevance and works by women and black artists.

Art advisers, usually either artists or museum curators, have played an important role in the development of small public galleries, including those at Bedford, Belfast, Bolton, Carlisle, Huddersfield, Kettering, Middlesborough and Sunderland. Rugby Art Gallery owns a collection of modern British art which is on indefinite loan to the Mead Gallery at the University of Warwick. In 1946 the collection numbered ten works. The art historian and critic Eric Newton was appointed as the gallery's first adviser; he bought several paintings from the early John Moores exhibitions. He was succeeded in the 1970s by Joanna Drew and Monika Kinley, both of whom made good use of the matched-funding available from the Museums and Galleries Commission/V & A Purchase Grant Fund,[11] buying works on paper by Lucian Freud, John Hoyland and R.B. Kitaj. In the

1970s and 1980s works by Leon Kossoff, Maggi Hambling, John Bellany and Paula Rego have been added to the collection.

In 1947 H.J.P. Bomford, an early patron of Francis Bacon, presented some twenty 20th-century British works to the Swindon Art Centre (which had opened in 1944), including Ben Nicholson's *Composition in Black and White*. Lawrence Gowing and Richard Morphet subsequently acted as advisers. In 1964 Swindon opened its present art gallery.

NOTES

1. These key institutions were Birmingham City Art Gallery; Cartwright Hall, Bradford; Ferens Art Gallery, Hull; Leeds City Art Gallery; Leicester City Museum and Art Gallery; Walker Art Gallery, Liverpool; Manchester City Art Gallery; Laing Art Gallery, Newcastle upon Tyne; Oldham Art Gallery; Sheffield City Galleries (Mappin Art Gallery and Graves Art Gallery); and Wakefield City Art Gallery.

2. In 1946 the Tate Gallery was finally voted its first annual central government purchase grant of £2000. Prior to this, it had relied upon private gifts and bequests and several funds. By 1960 the purchase grant amounted to £40,000.

3. Formerly the Standing Committee of Galleries and Museums, established in 1931.

4. The Arts Council of Great Britain was established in 1946 and broken down into four separate bodies in 1997.

5. Although this fund was established in 1881, it was not until 1934 that it became available to regional galleries (in England and Wales only) for the purchase of works on paper. In 1959–60 the fund was extended to cover oil paintings. From 1963 to 1965 specific sums were set aside for purchases of modern painting and sculpture.

6. The LACF was founded by Sir Michael Sadler, Vice-Chancellor of Leeds University and a notable art collector, and Frank Rutter, an art critic who championed modern art and was Curator of Leeds City Art Gallery from 1912 to 1917.

7. This consists of a local authority purchase fund, the Museums and Galleries Commission/V & A Purchase Grant Fund, the Friends, the Henry Moore Foundation, the CAS, the NACF and private donations.

8. Charles Rutherston was the brother of William Rutherston, the painter and educationalist, and Albert Rutherston, the decorative artist.

9. 'Modern work, both English and Continental, which will give the Gallery a freshness as compared with most provincial galleries; very little, if any, of the ultra-modern experimental work need be included.' Southampton Art Gallery Subcommittee Minutes, 2 April 1936.

10. This includes matched-funding from the Museums and Galleries Commission/V & A Purchase Grant Fund and financial help from the NACF, the Pilgrim Trust, the Henry Moore Foundation and the CAS.

11. Drew was an Arts Council of Great Britain curator at the time.

Contributors to the catalogue

JCSB CHRISTIAN BARNES RB RACHEL BARNES WB WENDY BARON HGB HUGH BELSEY

DB DAVID BUSSEL MC MICHAEL CLARKE EC ELIZABETH CONRAN RC RICHARD CORK

RAC ROBIN CRIGHTON CG CHARLOTTE GERE MG MARTIN GREENWOOD CH COLIN HARRISON

RWI RICHARD INGLEBY NK NICOLA KALINSKY DK DICK KINGZETT

JTM JANE MARTINEAU DST DESMOND SHAWE-TAYLOR PS PEYTON SKIPWITH

ECS EDWARD SOUTHWORTH LS LINDSAY STAINTON AS ANN SUMNER

JBT JULIAN TREUHERZ RV RICHARD VERDI PWJ PHILIP WARD-JACKSON

GW GILES WATERFIELD AW ADAM WHITE TW TIMOTHY WILCOX

BIBLIOGRAPHICAL ABBREVIATIONS

Manchester, 1857: *Catalogue of the Art Treasures of the United Kingdom collected at Manchester in 1857*, London, 1857

London, 1962: *Primitives to Picasso: An Exhibition from Municipal and University Collections in Great Britain*, London, Royal Academy, 1962

COLLECTORS AND GALLERIES

The objects shown in this section have been chosen to give an idea of the way museums and galleries in this country have evolved from the institution of university and college collections in the 17th and 18th centuries, via the philosophical and literary societies of the late 18th and early 19th centuries, to the rise of the great municipal gallery in the Victorian period. The selection indicates the types of object that were collected in early museums and galleries, in particular Antique sculpture (cat. 4, 7) and natural specimens, which were sometimes included in a cabinet of curiosities (cat. 1, 2). The portraits, painted and sculpted, represent some of the museum founders and pioneering collectors, such as General Guise (cat. 3), Lord Fitzwilliam (cat. 5) and, of a later generation, William Roscoe of Liverpool (cat. 9). Other galleries were developed from the collections made by learned societies, such as that at Canterbury (cat. 15).

By the mid-19th century temporary public exhibitions of art were visited by thousands of visitors, not least the Summer exhibitions at the Royal Academy (cat. 17, 18); this prompted city fathers to found their own museums and galleries. These were designed as 'palaces for the people', as is demonstrated by two magnificent models from Liverpool and Manchester (cat. 12, 13). The role of the picture dealer was important in the formation of collections both public and private (cat. 16), and connoisseurs were increasingly discerning (cat. 20).

The history of museums and galleries in the 20th century, especially their expansion after World War II, is an important theme of the exhibition and is represented here by portraits of some of the most influential figures, including Kenneth Clark (cat. 25), who played a crucial role in advising museums on their collecting policy and established the War Artists Advisory Scheme, the artist William Rothenstein (cat. 24), who also advised on purchasing, and the museum director Michael Jaffé (cat. 28).

Until fairly recently museums and galleries took scant interest in their own history; even the oldest were scarcely aware that they might have a complex and fascinating identity worthy of investigation. When, in 1962 the Royal Academy held an exhibition, *Primitives to Picasso*, which brought together works of art from regional museums throughout Britain, its catalogue contained no reference to the history of these institutions or to patterns in collecting. All this changed about 30 years ago, when scholars began to study the history of public collections. This exhibition and its catalogue are intended as a contribution to the substantial historical and theoretical research on the subject that has emerged since then. GW, JTM

1

Dutch School

The Yarmouth Collection,
c. 1665

oil on canvas, 165 × 246.5 cm
Norfolk Museums Service (Norwich
Castle Museum), 170.947

This painting was probably
commissioned in the mid-17th
century by Sir Robert Paston
(1631–83), a member of a
distinguished Norfolk family
and a friend of Charles II who
became Earl of Yarmouth in
1679. Both Sir Robert and his
father were enthusiastic
collectors of curiosities, many of
them expensive, which they kept

at their Elizabethan house,
Oxnead Hall (largely demolished
in the 1740s).

This painting was no doubt
intended to celebrate the
Pastons' collection. Though it
was dispersed in the 18th
century, many of the objects
depicted here have been
identified in public collections.
Like many such works, it
contains numerous references to
the vanity of worldly aspirations,
through such symbols as the
hour-glass and the timepiece.
The artist is not known: the
painting has recently been
attributed to Franciscus
Gysbrechts, a little known
Dutch artist who may have

visited England, or Peter Gerritz
van Roestraten (*c.* 1631–1700), a
still-life painter working in
England from the 1660s.

The Yarmouth Collection
illustrates a type of collecting that
preceded the systematic assem-
bling of works of art. According
to the late 17th-century inventory
published by Repton, it was
especially strong in cups, bottles
and shells of exotic materials and
expensively mounted, and little
sculptures. The paintings were
largely portraits, with a few
mythological and religious works
included. Many 16th and 17th-
century collectors accumulated
works of art or nature which were
impressive in terms either of

minute craftsmanship or of exotic
illustration of nature's variety.
The Yarmouth collection
belonged to this tradition rather
than to the concurrent taxonomic
approach, which assembled
specimens in order to illustrate
every example within a certain
species. G W

PROVENANCE Paston family of Oxnead
Hall, Norfolk; 1732: sale, bought by
Buxton of Channonz Hall, Tibenham;
1947: given to the museum by Mrs M.
Buxton
REFERENCES J.A. Repton, 'Oxnead
Hall, Norfolk', *Gentleman's Magazine*,
January–February 1844; A. Moore, *Dutch
and Flemish Paintings in Norfolk*, Norwich,
1988, pp. 90–1; R. Wenley, 'Robert
Paston and the Yarmouth Collection',
Norfolk Archaeologia, XLI/2, 1991, pp.
133–43

3

Sir Joshua Reynolds PRA
(1723–92)
*Portrait of General John
Guise*, 1755–7

oil on canvas, 76.2 × 62.8 cm
The Governing Body, Christ Church,
Oxford, JBS 264

General Guise (1682–1765) was
one of the earliest British donors
of works of art to a public
institution. His bequest of over
200 paintings and a large
collection of drawings to his old
college represented the first
donation of a major art collection
to a college. The paintings were
kept for many years in the
college library, while the
drawings became almost a lost
collection until reassessed and
rescued at the beginning of this
century. In 1968 a new gallery
was built to the designs of
Powell & Moya to accommodate
the college's art collections.

Guise was a professional
soldier but expended much
energy in acquiring paintings
and drawings, especially in his
last five years, generally buying
abroad. He also advised
Frederick, Prince of Wales, on
acquisitions. Guise accumulated
an important representative
group of Italian drawings in the
tradition of English collectors
from Sir Peter Lely onwards.

Guise sat to Reynolds from
1755 and received the painting
in 1757. He was also painted by
Gavin Hamilton (1723–98) and
Antoine Pesne (1682–1757) and
was sculpted posthumously by
John Bacon (1740–99). G W

PROVENANCE Pre-1800: presented to
Christ Church by the 1st Earl of Morley
REFERENCE J. Byam Shaw, *Paintings by
Old Masters at Christ Church, Oxford*,
Oxford, 1967, p. 133, no. 264

2

Attributed to Thomas
(1605–*c*. 1675) or Emanuel
(1605–65) de Critz
*John Tradescant the Younger
with Roger Friend*, 1645

oil on canvas, 107 × 132 cm
inscribed: *Sr. John Tradescant Junr &
his frind Zythepsa of Lambeth 1645*
The Visitors of the Ashmolean
Museum, Oxford, F667

John Tradescant the Younger
(1608–62) succeeded his father
as one of the most distinguished
gardeners, botanists and
scientific collectors of the 17th
century. His gift to Elias
Ashmole of the collection of
natural history specimens,
antiquities and curiosities which
father and son had assembled on
their travels led to the
foundation of the Ashmolean
Museum.

The authorship of this
painting and of the portraits in
the Ashmolean associated with it
remains mysterious. It has been
connected with both Thomas
and Emanuel de Critz, who were
brothers. Tradescant is depicted
with his friend Roger Friend
(identified as 'Zythepsa' ,
meaning 'brewer'). Friend
appears to have given him the
shells shown on the left.

For Tradescant, a museum's
purpose was to assemble natural
specimens and antiquities which
would create a microcosm of
divine and human creation. Such
natural specimens as the shells
seen here would be contrasted
with the productions of art,
which demonstrated the
diversity of human abilities and
cultures.

The portrait establishes
Tradescant's role as a
characteristic 17th-century
collector. Originally hung in the
'old' Ashmolean Museum in
Broad Street, the painting was
moved to the University
Galleries in the 1830s and is
now shown as one of the group
of founders' portraits in the
Founders' Room, a type of
display popular in museums
from their earliest days. G W

PROVENANCE 1645: presumably
commissioned by the sitter; by
inheritance to Elias Ashmole; 1683: given
by him to the University of Oxford with
the Ashmolean Museum
REFERENCE A. Macgregor, ed.,
Tradescant's Rarities, Oxford, 1983,
pp. 295, 303–4, no. 265

4

Metrological Relief
Eastern Greek, possibly
Samos,
mid-5th century BC

marble relief, maximum dimensions
63 × 170 cm
The Visitors of the Ashmolean
Museum, Oxford (Michaelis 83)

This relief represents two systems of measurement – a Samian fathom (the span of a man's arms) and (probably) an Athenian foot. Fernie has argued that it may have served as a lintel above the door of an office regulating weights and measures, and dates from before the Samian revolt against Athens (441–439 BC), since thereafter Athens imposed its own system of measurement on the island.

The piece belonged to Thomas Howard, 2nd Earl of Arundel (1585–1646), the greatest English collector of his age. It may have been collected by his chaplain, William Petty, who, after three years' travel in Asia Minor and the Greek islands, including Samos, by 1626 had 'raked together two hundred pieces, all broken or few entyre' which reached Arundel House,

the Earl's London house on the north bank of the Thames near the Savoy, in January 1627. They included the first ancient Greek inscriptions to come to England. The relief survived the Civil War in the garden of Arundel House, and suffered the indignity of being incorporated into a pastiche folly known as the Tomb of Germanicus in the garden of Easton Neston, Sir William Fermor's new house in Northampton designed by Nicholas Hawksmoor. There it was seen by George Vertue in 1734 and by Horace Walpole in 1736. In 1755 it was donated to Oxford University by the Dowager Countess of Pomfret.
JTM

PROVENANCE 1627: Thomas Howard, 2nd Earl of Arundel (died 1646); by descent to his grandson Henry Howard, 6th Duke of Norfolk (died 1683/4); 1691: bought by Sir William Fermor, 1st Baron Leominster (died 1711), installed at Easton Neston; his son Thomas, 1st Earl of Pomfret (died 1753); his son George, 2nd Earl of Pomfret; from whom bought by his mother, Henrietta Louisa, Dowager Countess of Pomfret; 1755: presented by her to Oxford University

REFERENCES G. Vertue, *Description of Easton Neston in Northumberland*, [1758], pp. 15–22; A. Michaelis, 'The Metrological Relief at Oxford', *Journal of Hellenic Studies*, IV, 1883, pp. 335–50; D.E.L. Haynes, *The Arundel Marbles*, Oxford, 1975; M. Robertson, *A History of Greek Art*, 2 vols., Cambridge, 1975, I, p. 199, pl. 64A; B. Wesenberg, 'Zum metrologischen Relief in Oxford', *Marburger Winckelmann-Programm*, 1975–6, pp. 15–22; E. Fernie, 'The Greek Metrological Relief in Oxford', *Antiquaries Journal*, LXI, 1981, pp. 255–63; H. Ben-Menahem and N.S. Hecht, 'A Modest Addendum to "The Greek Metrological Relief in Oxford"', *Antiquaries Journal*, LXV, 1985, pp. 139–40; M. Vickers, 'Germanicus's Tomb', *The Ashmolean*, XV, 1988–9, pp. 6–8

Netherlands. He had already inherited a group of Dutch paintings from his mother, who was of Dutch descent. Fitzwilliam, who lived at a time when the art market offered extraordinary possibilities, made numerous other acquisitions. Among these were ten pictures bought at the Orléans sales in London in the late 1790s, notably works by Sebastiano del Piombo, Titian and Veronese. Although the collection includes many of the artists most admired at the period, Fitzwilliam does not seem to have tried to create a systematic picture collection.

This portrait was executed for Samuel Hallifax, Fitzwilliam's tutor at Trinity Hall, and shows Fitzwilliam in the robes of a nobleman fellow-commoner. Portraits given by departing pupils to their school instructor were not uncommon in the late 18th and early 19th centuries, but university portraits of this type are extremely rare.

No works from the Founder's Bequest may be lent for exhibition by the museum, and it is therefore unrepresented here. G W

PROVENANCE Collection of Samuel Hallifax, Bishop of St Asaph; 1819: given to the museum by his son, Robert Fitzwilliam Hallifax
REFERENCE J.W. Goodison, *Fitzwilliam Museum Cambridge: Catalogue of Paintings*, Cambridge, 1979, III, pp. 292–3

5

Joseph Wright of Derby
(1734–97)

Portrait of Richard, 7th Viscount Fitzwilliam, 1764

oil on canvas, 74.9 × 62.2 cm
Lent by the Syndics of the Fitzwilliam Museum, Cambridge, 1

This portrait commemorates one of the earliest and most important founders of a museum in this country. Lord Fitzwilliam (1745–1816), an Irish peer who served in parliament but spent much of his life travelling on the Continent, was an avid collector of paintings, illuminated manuscripts and prints (of which he assembled 187 volumes, organised on historical principles), and musical material, including printed music and manuscripts. He bequeathed all these collections, with funds for their accommodation, to the University of Cambridge.

Fitzwilliam left 144 paintings, the bulk of them from the

6

Richard Cosway
(1742–1821)

Group of Connoisseurs,
1771–5

oil on canvas, 84.5 × 105 cm (sight size)
Towneley Hall Art Gallery and Museums, Burnley, Borough Council, 1995

Charles Townley (or Towneley) commissioned this highly individual work from his friend, the young and ambitious Cosway, who experimented here in the popular field of the conversation piece. Its completion was delayed by the patron's extended stay in Italy from 1771 to 1775. Townley was one of the most important early collectors of Classical sculpture and on his two long visits to the Continent assembled what was regarded as an outstanding collection (although many of the works have turned out to be Roman copies of Greek originals). After his death the collection was bought by the government for the British Museum, where a purpose-built gallery was erected to house it.

The painting was conceived in a frivolous spirit: in its first stages it was intended to show the various connoisseurs (Townley is shown second from the left) gaining erotic excitement from seeing one of their number fondling a marble Venus. This element remains evident in the finished picture.

The painting exemplifies Grand Tour taste. While such collecting came to be associated with the early university and national museums, the acquisition of Classical sculpture was almost never a feature of Victorian regional museums. Only through the purchase of casts was Classical art represented in municipal museums, which looked rather to the present than to the past and showed no great interest in the tastes of the traditional aristocracy. G W

PROVENANCE 1771–5: commissioned by Charles Townley; by family descent; 1939: Christie's, London, 3rd Lord O'Hagan's sale; 1956: bought by the gallery through Agnew's
REFERENCE S. Lloyd, *Richard and Maria Cosway*, Edinburgh, 1995, pp. 32, 113

He placed sculpture round his house and heated greenhouses at Ince, but subsequently built a 'Garden Temple' and a replica of the Pantheon to house them. In 1803 and 1810 he published an account and a set of engravings of the collection. The sculpture remained at Ince until 1959, when the majority of it was given to the Liverpool Museum and the Walker Art Gallery, Liverpool.

This is one of a number of Roman marble copies of a famous bronze *Apollo Sauroktonos* (Apollo the lizard-killer) by Praxiteles. The head of the statue does not belong to it but, although it looks female, almost certainly comes from another *Apollo Sauroktonos*. No literary reference exists for the theme, but some lizards were used in folk medicine as antaphrodisiacs. The lizard here, combined with the androgenous head, could therefore be portraying the god as distant from, and unaffected by, mortal sexuality. ECS

PROVENANCE Found near Rome by Gavin Hamilton (1723–98); sold to Robert Heathcote and sent to England; 1803/10: acquired by Henry Blundell; 1959: given to the museum by Col. Weld

7

Roman copy after Praxiteles
Apollo Sauroktonos,
2nd century AD
(original *c*. 350 BC)

marble, 169 × 100 × 90 cm
Board of Trustees of the National Museums and Galleries on Merseyside (Liverpool Museum), 1959.148.558

The collection of Classical and 18th-century sculpture formed by Henry Blundell at Ince Hall in Lancashire between 1776 and 1810 is now regarded as one of the most significant in this country. It has only a limited number of the finest works but, at over 400 ancient pieces, its scale makes it an important resource for the study of 18th-century collecting. Blundell was a close friend of Charles Townley (cat. 6, 8) and the two of them visited Rome together on a number of occasions. Blundell initially purchased from Rome, using the same network of excavators, restorers and dealers as younger English gentlemen on the Grand Tour; later, he bought pieces from English collections.

Catholicism, was one of the most important collectors and patrons of antiquarian learning in the first great era of Classical excavation. Impressed by Zoffany's *Tribuna at the Uffizi* (1772; Royal Collection), exhibited at the Royal Academy in 1780, Townley commissioned the artist to do something similar for his collection of antiquities, which was on show to selected visitors at his house in London's Park Street. The marbles, which formed the basis of the British Museum's collection of Antique statuary, are here impossibly assembled in the Library as the highlights of the Uffizi had been in the Tribuna. The style of the room – dark walls, skylight, Neoclassical decoration, and magpie monumentality – is familiar from the slightly later Sir John Soane's Museum, London.

There is an unexpectedly democratic spirit about this celebration of ownership: Townley himself sits to the side at a lower level than his antiquarian friends, with whom he disputes points of scholarship. Even the statuary, displayed with such casual profusion, is treated with curiosity rather than reverence. It is no accident that behind Townley's chair, beneath a presiding bust of Homer, a hat rests upon a stick – a traditional Roman symbol of Liberty much used in the 18th century. No. 7 Park Street was clearly a species of Liberty Hall, dedicated to the republic of learning. DST

PROVENANCE 1939: purchased by the gallery at Christie's sale of pictures from the collection of the R. Hon. Maurice Townley 3rd Lord O'Hagan
EXHIBITIONS *Johan Zoffany*, London, NPG, 1977, no. 95; *Grand Tour: The Lure of Italy in the 18th Century*, London, Tate Gallery, 1996, no. 215

8

Johann Zoffany RA
(1733–1810)
Charles Townley's Library at 7 Park Street, Westminster,
1781–3

oil on canvas, 127 × 99 cm
Towneley Hall Art Gallery and Museums, Burnley Borough Council, Pa/Oil 120

Charles Townley (1737–1805), a wealthy nobleman debarred from public service by his

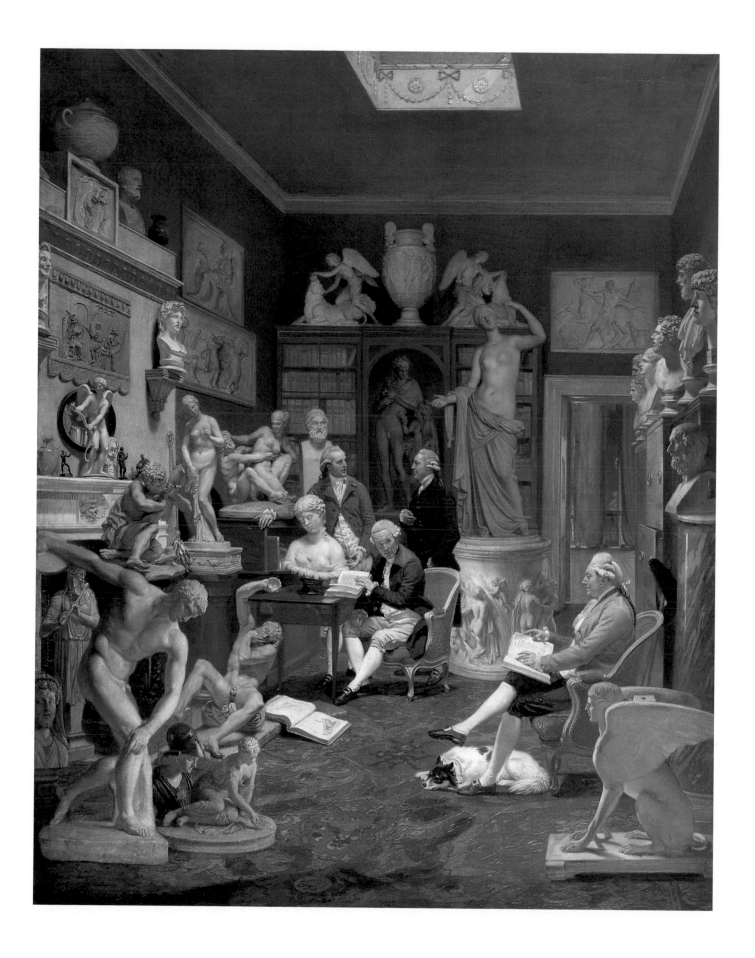

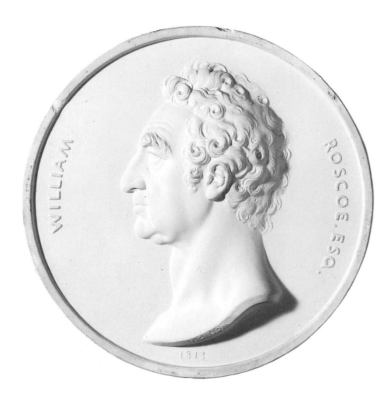

9

John Gibson (1790–1866)

Relief Portrait of William Roscoe, 1813

plaster cast, diam. 22.5 cm
Board of Trustees of the National Museums and Galleries on Merseyside (Walker Art Gallery, Liverpool), WAG 2527

William Roscoe (1753–1831) was a crucial figure in the history of English galleries. A passionate believer in general education, he collected, at his house near Liverpool, paintings and prints, including 'primitive' works, which reflected the growth of art historical studies. Although Roscoe was forced to sell his pictures in 1816, a number were presented to the Liverpool Royal Institution and put on public display as the first art museum organised on historical principles in England (see also pp. 25–6).

This relief testifies to Roscoe's patronage of contemporary art. Among the artists invited to study his collections was the young Gibson, who went weekly to Roscoe's house. They discussed art: Roscoe insisted that the artist must consider 'whether the subject was expressed simply and clearly, whether the figures moved and acted naturally, with truth of character, and just expression'. Commenting later on British sculptors, Gibson remarked: 'If they had followed such advice as I received from Mr Roscoe their works would have acquired a higher character and aim.'

The relief may have been Gibson's first attempt at portraiture. According to an unpublished catalogue entry by Hugh Macandrew, it was widely admired and engraved: one of Roscoe's friends wrote that the medallion 'is Mr Roscoe, as I should wish to remember him'.

In 1817, a year after executing a bust of Roscoe, Gibson moved to London and then Rome. There he settled, becoming one of the most famous sculptors of his day, regarded as the British equal to the Neoclassical sculptors Canova (cat. 333), whose pupil he had become, and Thorvaldsen (1768–1844). G W

PROVENANCE 1952: presented to the gallery by Mrs E.L. Macnaughton
REFERENCE T.S. Traill, *Memoir of William Roscoe Esq.*, ?London, 1832, p. 28

10

Sir Thomas Lawrence PRA (1769–1830)

Portrait of Richard Payne Knight, 1794

oil on canvas, 127 × 101.5 cm
The Whitworth Art Gallery, University of Manchester, O.1975.2

Richard Payne Knight (1750–1824) was the epitome of what was called a 'connoisseur': a noble amateur who made a considerable reputation as an antiquarian, garden designer and artistic theorist. He is best known today for the remodelling of his estate Downton Castle in Herefordshire according to 'picturesque' principles (whereby the rough wildness of Nature is deliberately encouraged) and for the rhyming attack on Capability Brown of 1794 which expounded those principles, *The Landscape – A Didactic Poem*.

Painted for the library at Downton, Lawrence's portrait belongs to the tradition of careless brilliance seen in Gainsborough's *William Wollaston* (cat. 41). In this period learning was never shown by regimented shelves but by lively discussion. Knight turns his flashing eyes to confront some opponent, a vast tome of archaeological learning sliding from his knees as he keeps two further places needed to support his argument. A contemporary seeing it at the Royal Academy said: 'It fills me with the idea of an irascible pedagogue explaining Euclid to a dunce.'

When this portrait was acquired in lieu of death duty in 1970 it was loaned to the Whitworth because of the gallery's holdings of drawings by John Robert Cozens (cat. 214) from Knight's collection. D S T

PROVENANCE By descent from the sitter; 1970: accepted by HM Treasury in lieu of duty from the estate of Major Kincaid-Lennox of Downton Castle, Herefordshire, and placed on loan to the gallery; 1974: allocated to the gallery
EXHIBITION London, RA, 1794
REFERENCES K. Garlick, *Sir Thomas Lawrence*, Oxford, 1989, no. 454a; M. Clarke and N. Penny, *The Arrogant Connoisseur: Richard Payne Knight*, Manchester, 1982

11

William Cowen
(1791–1864)

View of Bradford, 1849

oil on canvas, 71 × 141.5 cm
Bradford Art Galleries and
Museums, Cartwright Hall,
BH 188.1920

This painting illustrates one of
the most important elements of
the traditional municipal gallery,
local history. Topographical
views intended both to record
geographical and architectural
changes and, where appropriate,
to celebrate the antiquity and
beauty of the town and its
environs contributed to the
creation of a sense of local
identity, which was a central
function of these collections.

As a centre for producing
worsted, Bradford expanded
dramatically in the early 19th
century: between 1830 and 1851

its population almost tripled.
This canvas illustrates the
changing character of the town,
surrounded by an agricultural
and moorland landscape but
dominated at its centre by the
technology of industrial
production.

A professional landscape artist,
Cowen was born at Rotherham
in Yorkshire. Sent as a young
man by Lord Fitzwilliam on a
tour of Switzerland and Italy, he
established a reputation as a
topographical painter and
engraver. His visit to Corsica in
1840 stimulated a successful
series of etchings and a book
depicting the island, with
particular reference to the early
days of Napoleon. G W

PROVENANCE 1920: presented to the
gallery by Mrs James Oddy of Moorlands
Hall, Birkenshaw

12

William Goodall and James
Orr Maples (designers)

Elkington & Co. (makers)

Model of Walker Art Gallery

cast and fabricated silver with
porcelain figures, 27 × 66 × 53 cm
Board of Trustees of the National
Museums and Galleries on
Merseyside (Walker Art Gallery,
Liverpool), WAG 3315

This remarkable object
celebrated the gift of money to
the City of Liverpool by Andrew
Barclay Walker (1824–93) for
the purpose of building an art
gallery to house an annual artists'
exhibition. The model was
presented to Walker, a wealthy
brewer and Mayor of Liverpool,
at the opening ceremony in
September 1877.

The model of the gallery was
made by a Liverpool model-
maker after designs by the

architects of the gallery, Sherlock
and Vale, and gives an accurate
impression of the building in its
earliest form. A Liverpool
illuminator, James Orr Marples,
was invited to contribute ideas
for the base, while the work was
carried out by the firm of
Elkington & Co. A contemporary
description conveys the
ambitions associated with this
object: 'At the corners it is
supported by exquisite figures of
mermaids, which combined with
other supports formed of
dolphins, typify the maritime
position of the town. Around the
four sides runs a beautiful
modelled and chased bas-relief
. . . being representations of
children at play with wild beasts,
by which it is intended to
illustrate that happy time of
universal peace.' The shield 'is
surmounted by a figure of the
liver [bird] with outstretched
wings, standing on a shell, from

which spring two rich cornucopiae – the emblems of peace and plenty, and by a happy coincidence, the crest of the mayor'. At each corner statues of the Four Continents 'illustrate the fact that the four corners of the globe contribute to the prosperity of Liverpool'. G W

PROVENANCE 1877: presented to A. B. Walker by his fellow citizens; 1957(?): presented to the gallery
REFERENCE M. Bennett, 'An Art Gallery in Silver', *Country Life*, 5 December 1957

13

George Strutt

Model of Manchester City Art Gallery, 1825

wooden model on wooden base with metal-framed glass cover,
43 × 58.5 × 101.5 cm
Manchester City Art Galleries

In 1824 the Governors of the Manchester Institution (a newly founded private society for the encouragement of the arts) organised a competition for a building. The prize was awarded to Charles Barry (1795–1860), and work was completed in 1835.

This model, commissioned in 1825, shows considerable differences from the executed building, especially in the attic storey and in the surrounding wall, for which railings were substituted. Internally, the proposed top lighting was simplified. When the building became the City Art Gallery in 1882, it was substantially altered, and the lecture theatre shown here was removed.

The Institution originally had a dual function: to provide top-lit upstairs rooms for the Society of Artists' exhibitions and

teaching activities, and to supply accommodation for a learned society – lecture hall, library and rooms for scientific equipment and botanical specimens. Greek architecture seemed to Barry, as his son commented, 'the perfection of beauty and truth', and this commission provided a rare opportunity to work in the

style. It is a grandly austere structure, contrasting strongly with the richer Italianate manner which became Barry's hallmark. G W

PROVENANCE Presented to the gallery by the Manchester Society of Architects
REFERENCE J.H.G. Archer, ed., *Art and Architecture in Victorian Manchester*, Manchester, 1987, pp. 28–45, 52–7

14

Hanson Walker
(*c.* 1844–1933)
Portrait of Baron de Ferrieres, 1898

ebonised carved wood and oil on
canvas, 101 × 218 × 15 cm
Cheltenham Art Gallery and
Museum

Partly of Belgian, partly of
French and English descent,
Charles, third Baron de Ferrieres
(1823–1908) was educated
largely in Britain. He became a
British citizen in 1864 and
played a prominent part in the
affairs of Cheltenham, serving as
Mayor, Justice of the Peace and
(briefly) MP. He was admired for
his advocacy of causes such as the
Free Library Act and for the
stylish hospitality which he
brought to events like the
Cheltenham Cricket Week. At
his death he was applauded for
his 'unbroken devotion to the
interests of the town of his
adoption, with kindly sympathy
with all classes of the
community, and . . . public and
private benevolence'.

In 1864 de Ferrieres inherited
a number of 17th-century Dutch
paintings from his father the
second Baron de Ferrieres (1798–
1864) who died in Cheltenham.
He in turn collected from around

1840 until his death. In 1898
the Baron offered Cheltenham a
number of his paintings, with a
gift of £1000 towards the
erection of a public art gallery.
The new building, consisting
initially of two rooms, was
opened in 1899. The collection
consisted of 43 works including
36 Dutch paintings with a
strong representation of the
19th-century school, of a type
seldom seen in British galleries.

The portrait, by Hanson
Walker, was presented to the
town by a group of subscribers.
It was placed over the entrance
door to the Baron de Ferrieres
Gallery, which was decorated
with care. Above a dado with
panels inlaid with Japanese paper
in gold relief on a gold ground,
the walls were covered in 'a red
striped flock paper', with a
gilded picture moulding and
painted cornice above. G W

PROVENANCE 1898: portrait paid for
subscription and presented to the gallery
REFERENCE C. Wright, *Catalogue of
Foreign Paintings from the de Ferrieres
Collection and other Sources*, Cheltenham,
1987

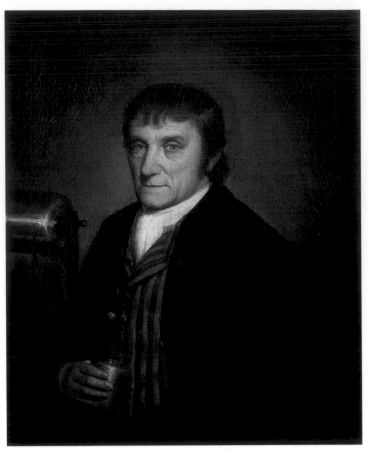

15

Stephen Hewson
(*fl.* 1775–1807)
Portrait of William Goulden,
1805

oil on canvas, 76.5 × 64 cm
The Royal Museum and Art Gallery,
Canterbury, CANCM 3058

William Goulden (1749–1816)
was one of the amateur
enthusiasts who flourished at a
time when the pursuit of
scientific knowledge was a far
more general and less specialised
activity than it has since become.
Like Roscoe (cat. 9), he belonged
to one of the many private
learned societies which
flourished in late 18th and early
19th-century Britain. Goulden,
who was of Huguenot origin,

was a grocer in Canterbury. He
was a founder-member of the
Friendly (later Historical) Society
for the Cultivation of Useful
Knowledge, formed in 1769, and
a Guardian of that Society's
Mathematical, Philosophical
Chemical and Mechanical
Instruments with which
members could conduct
experiments. Here he is shown
with appropriate instruments: he
holds a Leyden jar (a capacitor: a
device for the storage of electric
charge), and behind him is a
friction machine for generating
electricity.

The portrait formed part of
the society's collection, and gives
a vivid impression of the active
intellectual life which flourished
in towns all over Britain at this
time and which led to the

foundation of numerous private society museums, the predecessors of the municipal museums and art galleries of the late 19th century. G W

PROVENANCE Society for the Cultivation of Useful Knowledge, Canterbury; 1825: that Society merged with the Philosophical and Literary Institution, Canterbury; 1847: purchased by Kent County Council when it established the first local authority museum in Kent
EXHIBITION *Paintings Lent by Ladies and Gentlemen of Canterbury and its immediate neighbourhood, for the exhibition at the Museum during the month of September 1840*
REFERENCES *Rules and Orders to be observed by the Historical Society for the Cultivation of Useful Knowledge,* Canterbury, 1816; A.T. Goulden, *The Gouldens of Canterbury 1686–1947,* Tunbridge Wells, 1948

16

Frank Holl RA (1845–88)
Portrait of William Agnew, 1883

oil on canvas, 61 × 51 cm
Thomas Agnew & Sons

William Agnew (1825–1910), eldest son of the founder of the firm of art dealers, moved from Manchester to London, where he opened a branch of Agnew's which established the firm on an international basis. Formidably energetic, immensely charming and ruthlessly ambitious, he possessed the histrionic flair essential to successful salesmanship.

President of the Great Ormond Street Hospital, Chairman of Agnew's, of *Punch* and of the Committee of the Great Loan Exhibition held in Manchester in 1887, he was also Liberal MP for South-East Lancashire and included two Prime Ministers among his friends, Gladstone and Lord Rosebery, the latter making him a Baronet in 1895.

His relationships with Millais, Leighton and Burne-Jones were avuncular. Deeply involved in the development of all English museums, he played a leading role in the founding of the Tate Gallery by his client Sir Henry Tate and he spoke passionately in the House of Commons in support of the Nation's purchase of Raphael's Ansidei Madonna and Van Dyck's *Equestrian Portrait of Charles I* (both in the National Gallery). At Christie's, whether buying all 739 engraved Antique gems of the Marlborough sale or bidding for Hogarth's *Shrimp Girl* for the National Gallery, the flamboyant Victorian always wore a top hat. D K

PROVENANCE Commissioned by the sitter and presented to the firm by his descendants
EXHIBITION *Loan Exhibition of Victorian Painting 1837–1887,* London, Agnew's, 1961
REFERENCES A.M. Reynolds, *The Life and Work of Frank Holl,* London, 1912; Sir Geoffrey Agnew, *Agnew's, 1817–1967,* London, 1967

about art and the education of the underprivileged the guild was able to attract supporters and to survive where other idealistic ventures failed. The gallery established by Ruskin for the guild's collection nearly disappeared after World War II, when visions of the future did not encompass the relics of Victorian philanthropy, but it has been placed on a firm footing again, rather as Ruskin's reputation has been re-established. The painting has been in the gallery since 1892 and is a reminder of Ruskin's key role in establishing Turner's reputation as one of the greatest British artists. C G

PROVENANCE Bramley family, Sheffield; Alderman Herbert Bramley; 1892: presented by him to the guild and museum
REFERENCES *Ruskin in Sheffield: The Ruskin Gallery Guild of St George Collection*, Sheffield, 1985; J. Townsend, *Turner's Painting Techniques*, London, 1993, cover ill.

17

William Parrott (1813–89)

J.M.W. Turner on Varnishing Day at the Royal Academy, 1846

oil on panel, 25.1 × 22.9 cm
inscribed: *W. Parrott from Life*
Collection of the Guild of St George, Ruskin Gallery, Sheffield, R 84

'Varnishing day' provided the Royal Academy exhibitors with a last opportunity to adjust their works to suit the position and conditions of light in which they were hung. Here is Turner, short of stature, in rusty black clothes and unfashionable high-crowned top hat, with his untidy old umbrella on the ground beside him, stabbing away at his canvas with the short-handled brushes he habitually used, to add the striking note of colour that would annihilate the effect of any paintings in the vicinity. The reproductive print, published by George Allen in 1900, is subtitled 'portrait of Turner taken surreptitiously about 1848'. Parrott exhibited at the Royal Academy from 1836 to 1857. Travels in Italy, France and Germany furnished him with Continental views which added variety to his work as a topographical artist.

The painting belongs to the Guild of St George, founded by John Ruskin in 1871. It is almost impossible to overstate the extent of Ruskin's influence in the 19th century. Due simply to the respect for his theories

18

George Bernard O'Neill (1828–1917)

Public Opinion, 1863

oil on canvas, 53.2 × 78.8 cm
inscribed: *G B O'Neill 1863*
Leeds Museums and Galleries (City Art Gallery)

Public Opinion shows the crowds at the annual Royal Academy exhibition pressing to see 'the picture of the year'. Note the railing installed to protect the picture from the crush. The figure skulking at the rear on the right may be a self-portrait of the artist. O'Neill is suggesting that, to be popular, the work must appeal to people of all ages and from all classes of society.

This was in the greatest possible contrast to the élitist 18th-century view of the audience for art, as cultivated, privileged and essentially aristocratic, perfectly exemplified in Johann Zoffany's *Tribuna at the Uffizi* (1772; Royal Collection). A year earlier O'Neill had tackled a similar subject, *Children at the Tower* (exhibited in 1862), showing a mixed crowd of visitors to this famous London tourist attraction, with country bumpkins and gentlefolk mingling amiably together.

O'Neill lived and worked mainly in London, but he rented a house in Kent – within easy reach via the newly built railway – in order to spend time with the artists of the Cranbrook Colony, among them F.D. Hardy (cat. 152). The group specialised in modest, sweet and intimate genre scenes, ultimately derived from Dutch 17th-century painting, but also influenced by David Wilkie (1785–1841). O'Neill exhibited in an almost unbroken succession at the Royal Academy from 1847 to 1893, and his subject-matter remained consistent throughout. C G

PROVENANCE 1888: presented to the gallery by the friends of J.W. Middleton
EXHIBITIONS London, RA, 1863, no. 357; *The Cranbrook Colony*, Wolver-hampton Art Gallery and Newcastle, Laing Art Gallery, 1977, no. 73
REFERENCES *Concise Catalogue*, Leeds City Art Gallery, 1976, no. 42; J. Treuherz, *Victorian Painting*, London, 1993, pl. 96, p. 124

19

Alphonse Legros
(1837–1911)
Portrait of Thomas Dixon,
1879

oil on canvas, 48.3 × 38.1 cm (sight
size)
Sunderland Museum and Art Gallery
(Tyne and Wear Museums),
TWCMS: B9404

This portrait illustrates some important trends in the history of late Victorian municipal galleries. The sitter, who worked as a cork-cutter, was a self-educated man, born in Sunderland. He belonged to a group of advocates of public museums and galleries who, inspired by John Ruskin, believed that the lives of ordinary people could be transformed by the experience of beauty through art. As a member of the Sunderland Museum Committee, Dixon persuaded both Ruskin and Dante Gabriel Rossetti to support the new institution: Rossetti presented two drawings.

This painting was executed in front of an admiring crowd on the day in 1879 that the new gallery opened; it was intended to instruct students in 'laying in' a head. The previous year Legros had painted a head at the Walker Art Gallery, Liverpool, also before 'a large number of art students'. On both occasions, the viewers were amazed by the speed and dexterity of execution. This form of public art production emphasises the role of municipal galleries as schools of art for students at many levels.

A Frenchman by birth and a specialist in sombre depictions of working life, Legros was persuaded to come to England by his friend Whistler in 1876. He was warmly received and was appointed Professor of Fine Art at the Slade School of Art in London. Legros exercised great influence on artistic education throughout the country, and his willingness to become a naturalised British citizen (in 1880) aroused much enthusiasm.
G W

PROVENANCE 1881: given to the gallery by the artist
REFERENCE L. Jessop and N.T. Sinclair, *Sunderland Museum*, Sunderland, 1996, p. 13

20

Henry Herbert La Thangue
RA NEAC (1859–1929)
The Connoisseur, 1887

oil on canvas, 114 × 160 cm
inscribed: *H. H. La Thangue '87*
Bradford Art Galleries and
Museums, Cartwright Hall,
BH11–48

The Bradford art collector
Abraham Mitchell (1828–96)
sits in the picture gallery of his
house, Bowling Park,
contemplating a painting. At the
tea table, sit his wife, Elizabeth,
their son Herbert and one of
their daughters, probably Edith.
Their eldest son, Tom, stands
smoking.

Abraham Mitchell with his
brother, Joseph, expanded the
worsted spinning firm
established earlier in the century
by their father, Thomas. The
company specialised in mohair
for the luxury trade. The
brothers built adjoining houses
in 1864, and Abraham added the
picture gallery to his house in
the 1870s to accommodate his
growing collection. The pictures
shown in La Thangue's painting
have not been identified, but
Mitchell owned works by Faed,

Goodall, Henry Dawson
(1820–1904) and Edwin Hayes
(1811–78). Mitchell was
probably introduced to La
Thangue by the Bradford
merchant and collector John
Maddocks (1842–1924). A
generation younger than
Mitchell, Maddocks formed a
collection of works by more
advanced French and British
artists, including Clausen, Forbes
and Charles, and helped La
Thangue meet local patrons. The
naturalism of *The Connoisseur*
reflects contemporary French art
and typifies the taste of the
merchant and manufacturer

collectors of northern England;
but it is exceptional in La
Thangue's work, most of which
consists of out-of-doors subjects.
J B T

PROVENANCE 1887: Abraham
Mitchell; 1896: Herbert Mitchell; 1948:
presented to the museum by his widow,
Mrs V.H. Mitchell
EXHIBITIONS *A Painter's Harvest:
Works by Henry Herbert La Thangue RA
(1859–1929)*, Oldham Art Gallery, 1978,
no. 7; *The Connoisseur: Art Patrons and
Collectors in Victorian Bradford*, Bradford,
Cartwright Hall, 1989
REFERENCE D. S. Macleod, *Art and the
Victorian Middle Class*, Cambridge, 1996,
pp. 367–8

21

Joseph Durham ARA
(1814–77)

Portrait of Julius Lucius Brenchley, 1873

marble on black and green grained marble pedestal, approx.
70 × 42 × 32 cm (without base)
inscribed: *J. DURHAM A.R.A./1873*
Maidstone Museum and Art Gallery,
24–1974

Born in Maidstone, Brenchley (1816–73) was an explorer, collector and philanthropist. His tour of the Pacific Islands is recorded in his book *The Cruise of the Curaçoa among the South Sea Islands in 1865*. On this trip, which allowed him to study the people of the Solomon Islands, the Ysabel Islands and Fiji, he accumulated great numbers of objects, as much for their aesthetic as for their scientific interest, and brought them back to England. He also made journeys to China and Mongolia. Brenchley retired to Maidstone, where he laid out a public garden. He left the museum many objects from his collections, including 34 Old Master paintings and various watercolours and terracottas. G W

PROVENANCE 1873: given to the museum by the sitter

22

Edward Alfred Briscoe
Drury RA (1856–1944)

Portrait of the Rt. Hon. Samuel Cunliffe Lister, first Baron Masham, 1904

marble, 73 × 63 × 40 cm
Bradford Art Galleries and
Museums, Cartwright Hall

Samuel Cunliffe Lister (1815–1906), created Lord Masham in 1892, was a notable example of the industrialist–philanthropists who embodied the financial and political power of industrial England in the late 19th century. The wool-combing machine had been invented by Edmund Cartwright in 1789 and Lister himself made a fortune by perfecting the Square Motion Comb, which allowed wool-combing to be mechanised.

Lister made a powerful contribution to the emerging wealth of Bradford. In 1898 he offered to build a memorial to Cartwright in the form of a museum and art gallery on the site of his former family house, Manningham Hall. The building, which opened in 1904, was designed in a magnificent neo-Baroque style by Sir John Simpson and E. J. Milner Allen and contained a princely suite for mayoral entertaining, as well as rooms to display paintings and sculpture. G W

PROVENANCE 1904: presented to the gallery by workpeople of Listers Ltd
EXHIBITION London, RA, 1904,
no. 1806 (plaster)
REFERENCE D. Church and P. Lawson,
*Cartwright Hall: A Guide to the Building
and its Architecture*, 1987, pp. 1–2

23

Christian Neuper (1876–?)
Portrait of Alexander Laing,
1905

marble, 73 × 63 × 40 cm
Laing Art Gallery, Newcastle upon
Tyne (Tyne and Wear Museums),
E 1171

Alexander Laing (died 1906) was a Scot by birth, who had moved to Newcastle upon Tyne in 1849 and made his fortune in the wine and spirits business. In 1900 he offered £20,000 to the City of Newcastle in gratitude for 50 years of commercial prosperity. It was decided that the money be spent on building an art gallery, following an extended and unsuccessful attempt to raise the money for this by appeal. The building, designed in the Baroque manner by James Cackett and Robert Burns-Dick, opened in 1904. Laing was not himself a collector, and the gallery originally contained no works of art. G W

PROVENANCE 1906: gift from Alexander Laing Presentation Bust Committee

24

Sir William Rothenstein
(1872–1945)

Self-portrait, 1917

inscribed: *WR, 1917*

oil on canvas, 76.2 × 63.5 cm

Tullie House, City Museum and Art Gallery, Carlisle, 29.1938.19

In 1933 William Rothenstein, then Principal of the Royal College of Art in London, was appointed honorary purchaser for Carlisle Art Gallery. Over the next ten years, initially with an annual sum at his disposal of £100 (later raised to £200), he established the nucleus of a collection of British art from G.F. Watts to Stanley Spencer.

In a letter written in 1937 to the gallery Rothenstein related: 'I have also lately got possession of a painting by myself – a self-portrait painted about 20 years ago – which was bought at the time by John Drinkwater. At the sale of his effects it fetched a moderate price. I hesitate to offer it to the Gallery; but it may be that you would not be averse to having a painting of mine.' Portraits were Rothenstein's forte, and self-portraits punctuate his long career.

Rothenstein's contribution to the history of art in Britain extends far beyond his work as an artist and teacher. His wide-ranging interests and talent for friendship ensured that the three volumes of his memoirs (*Men and Memories*) are an invaluable source of first-hand material on the personalities and politics of the worlds of art and literature over some 50 years. Perhaps most important of all was the

work he did to help his younger contemporaries. Raised in Bradford, the son of a German–Jewish wool merchant, Rothenstein was relatively affluent. Although in adult life he did not practise his religion, he used his influence with the Jewish Educational Aid Society to secure scholarships to enable poor immigrant artists, including Gertler and Kramer, to study at the Slade School of Art. Sculptors, from Epstein when he first came to London to Henry Moore as a student at the Royal College of Art, likewise enjoyed his benevolent patronage. WB

PROVENANCE 1917: John Drinkwater; 1937: bought by the gallery through the agency of the artist

REFERENCE *William Rothenstein: A Unique Collection*, exh. cat., Carlisle City Art Gallery, n.d., no. 46

25

John Stanton Ward RA
(born 1917)

Portrait of Lord Clark of Saltwood, 1980

charcoal and pastel on paper,
48 × 64.5 cm
The Royal Museum and Art Gallery,
Canterbury, CANCM:10225

Kenneth Clark, created Lord Clark in 1969, was one of the most charismatic museum directors of the 20th century as well as an outstanding patron, writer and populist who, by means of his television series *Civilisation*, brought an awareness of art into millions of homes. He was Director of the National Gallery throughout World War II; the collections had been removed for safe storage, but through exhibitions of contemporary art, coupled with lunchtime concerts, he made the gallery a haven for thousands. Through the War Artists Advisory Scheme Clark was responsible for employing artists to cover every field of endeavour, civil as well as military, and there are few artists of his generation and the next who did not benefit from his enlightened patronage. Clark's interest in, and involvement with, such regional galleries as Southampton, of which he drew up the charter, and Canterbury has left an enduring legacy. However, it is by his books *Landscape Into Art*, *The Nude* and *The Romantic Rebellion* and by his television series that future generations will best remember him.

Although born in Hereford, John Ward has lived in Kent for 40 years, near Lord Clark's home, Saltwood Castle. Thus, in 1980,

when the Friends of the Royal Museum and Art Gallery in Canterbury wished to commission a portrait of their patron to celebrate their fifth anniversary, Ward was a natural choice, also in that he and Clark were old friends. The natural sympathy between artist and sitter is evident in this drawing.
PS

PROVENANCE 1980: commissioned by the Friends of the museum and presented to it by them

26

Joseph Southall
(1861–1944)

Portrait of Sir Whitworth Wallis FSA, 1927

tempera on linen laid on panel,
43.5 × 33 cm.
inscribed: *JS 1927*
Birmingham Museums and Art Gallery, 285'27

In 1884 the Art Gallery Purchase Committee of the developing Birmingham City Art Gallery appointed their first Keeper. He was Whitworth Wallis (1854–1927), from a family closely associated with museums (his father was Keeper of the Art Collections at South Kensington). Until he died in 1927 Wallis devoted his energies to establishing the collections in many fields as well as to the expansion of the building and the organisation of a series of successful exhibitions. Although he was responsible for the Industrial Art collections which played an important part in the early life of the museum, it was painting which really engaged him. The formation of Birmingham's outstanding Pre-Raphaelite collection is in great part due to Wallis. He made

numerous journeys abroad, including extended travels in Italy and Egypt, in search of suitable objects for the collection.

Wallis was fortunate in working for a committee which believed that the principal task of a curator was to acquire objects for the collections and to make them as attractive as possible to the public. The happy results have helped to give Birmingham one of the richest art collections in Britain. G W

PROVENANCE 1927: presented to the museum by a group of subscribers
EXHIBITION London, South Kensington, Imperial Institute, 1927, no. 92
REFERENCE S. Davies, *By the Gains of Industry 1885–1985*, Birmingham, 1985, pp. 26–44

27

Graham Sutherland
(1903–80)

Portrait of Arthur Jeffress, 1955

oil on canvas, 145 × 122 cm
inscribed: *Sutherland Venice 1955*
Southampton City Art Gallery, 71/1963

Arthur Jeffress, born in America in 1905, was educated in England. He became a passionate collector of pictures and a director of the Hanover Gallery in London, which launched the career of Francis Bacon. In 1953 Jeffress established his own gallery in London, specialising in Surrealism and Sunday painters. He favoured figurative art of the 19th and 20th century. In later years Jeffress lived in Venice; he committed suicide in 1961.

In 1963 part of Jeffress's collection was bequeathed to Southampton City Art Gallery. The unusual terms of the bequest permitted the gallery to choose

almost at will from both Jeffress's private collection and his commercial stock. With the advice of the Tate Gallery, some 100 items were selected which reflected Jeffress's tastes, including work by Delacroix, Bonnard, Vuillard (cat. 359), Sickert, Sutherland, Piper and Delvaux (cat. 368). The bequest added Lucien Freud and Jeffress's close friend Graham Sutherland to the artists represented in the gallery's collection. This portrait, with its punning reference to Venetian Madonnas of the High Renaissance, and an oil sketch for it dated July 1954, was one of eleven works by Sutherland.

Jeffress's connection with Southampton City Art Gallery started in 1946 when he moved to Owlesbury, just outside the city. Among the many works he lent to the gallery was, in 1947, the first Jackson Pollock to be seen in an English public gallery.

REFERENCE *Southampton Art Gallery Collection*, Southampton, 1980, pp. 6, 81

28

Dame Elisabeth Frink RA
(1930–93)
Portrait of Michael Jaffé,
1992

bronze, patinated green,
height 50 cm (including base)
inscribed: ⅓ *Frink*
Lent by the Syndics of the
Fitzwilliam Museum, Cambridge,
M5-1992

Elisabeth Frink gave the
Fitzwilliam two of her drawings
in 1977 and was patron of the
Friends of the museum in
succession to Kenneth Clark from
1983 until her death. She was a
neighbour and friend of the Jaffés
in Dorset and was therefore a
natural choice to commemorate
Michael Jaffé's directorship of the
Fitzwilliam (1973–90). A bust of
Jaffé's predecessor, Louis Clarke
(1881–1960), had been
commissioned from Jacob
Epstein in 1951 by the Friends of
the Fitzwilliam and funded by
subscription. This precedent was
followed when the head of Jaffé
was commissioned in 1990. In a
letter of 7 December to Jaffé's
successor, Simon Jervis, Frink
wrote: 'It is marvellous when one

does a portrait which pleases
most people – it isn't always very
easy.'

In 1960 Jaffé (1923–97)
persuaded Cambridge University
to institute art history as a
degree subject in its own right
and, under his leadership, the
new department flourished. He
was appointed Director of the
Fitzwilliam in 1973. During his
seventeen-year tenure he raised
the national and international
standing of the museum,
transformed its internal
appearance, enhanced its already
superb collections with astute
purchases and instituted a
programme of major temporary
exhibitions in the Adeane
Gallery, which opened in 1975.
The culmination of Jaffé's
directorship was the exhibition
Treasures from the Fitzwilliam, a
selection of 160 of the museum's
finest objects which was shown
in five American cities from
March 1989 to September 1990.
RAC

REFERENCES *Fitzwilliam Museum
Annual Report*, Cambridge, 1992, p. 16,
pl. 17; *Fitzwilliam Museum News*, Winter
1993, p. 1; *The Times*, 17 July 1997; *The
Guardian*, 18 July 1997; *The Art
Newspaper*, no. 73, September 1997

THE ENGLISH CANON

THE ENGLISH CANON

British paintings form the core of most regional collections in this country. In contrast to the National Gallery, which throughout the 19th century showed a reserved attitude to the native school and made many efforts either to keep such works in the basement or to send them to outposts, galleries outside London have regarded the collecting of works by native artists as a major priority. In particular, they have often specialised in paintings produced by the sons (and, occasionally, daughters) of their town. Many works in this section reflect this tendency, which has produced a number of collections of outstanding quality, including Joseph Wright paintings in the artist's home-town of Derby (cat. 51), Arthur Devis at Preston (cat. 39) and Gainsborough in Sudbury (cat. 53)

Whereas the earliest collections donated to universities and colleges consisted of Antique sculpture and Old Master paintings and drawings, a new confidence in British painting was evident in the acquisitions of galleries founded in the 19th century. Many of these institutions showed temporary exhibitions of contemporary British painting, and such works were incorporated into the collections of learned and artistic societies and into municipal galleries. While many galleries concentrated on collecting contemporary works, they also acquired older British paintings, though generally no earlier than Hogarth. The purchase of works dating from the 17th and early 18th century became more general in the 20th century, while a number of artists who were not at first recognised as part of the central canon of British painting came to be included later. Acquisition patterns were, of course, affected by fashions in the art market. At the end of the 19th century prices for the leading English portrait painters, such as Reynolds and Gainsborough, were exceptionally high and, as a result, portraits of fashionable sitters are rare in regional galleries.

The fact that paintings of the native school were acquired by regional galleries at an early date made it appropriate to place these works near the beginning of the exhibition. Many of the most striking works in this section, for example Stubbs's *Cheetah and Stag with two Indians* (cat. 47), have been acquired by their present owners since World War II. G W

29

Attributed to Daniel Mytens (*c.* 1590–1647)

Portrait of John Cotton,
c. 1626–7

oil on canvas, 123 × 108 cm
inscribed: *Iohn Cotton*
Ipswich Borough Council Museums
and Galleries (Christchurch Mansion,
Ipswich), R1957–124

Formerly ascribed to Cornelius
Johnson (1593–1661), this fine
portrait was attributed to Mytens
in 1985 and is close in style and
quality to the outstanding
portrait of Endymion Porter of
1627 (National Portrait Gallery,
London) also ascribed to Mytens.

John Cotton (*c.* 1590–1655/6)
was the second son of Sir Allen
Cotton, Lord Mayor of London.
He is shown here in his late 30s.
An ambitious man, anxious to
rise above his merchant class
background, Cotton purchased
the manor of Earl Soham in 1625
and became a country
gentleman, subsequently
rebuilding Soham Lodge on the
site of this estate. He married
five times but had children only
by his fourth wife, Anne Cotton
(née Revett) of Brandeston,
whom he married around
1626–7, when this portrait was
probably painted. A pendant
picture of Anne Cotton by an
anonymous English artist is also
at Christchurch Mansion.

Mytens was born in Delft and
trained in The Hague. He is first
recorded in England in 1618
and, from 1621 to 1632, was the
leading portrait painter at the
Stuart Court, his accomplished
style forming a crucial link
between the stiffness of late
Jacobean art and the virtuosity of
Van Dyck, who supplanted him
as the King's First Painter in

1632. Two years later, Mytens
returned to The Hague, where he
died in 1647. Unrestrained by
the formality of the English
Court, he painted some of his
most compelling portraits in his
later years. R V

PROVENANCE John Cotton; by descent
to Allen Cotton; 1957: presented by him
to the gallery
REFERENCE *The Triumphant Image:
Tudor and Stuart Portraits at Christchurch
Mansion, Ipswich*, Ipswich, n.d., no. 25

30

Mary Beale (1632–99)

Portrait of Charles Beale,
c. 1675

oil on bed ticking, 76.2 × 62.3 cm
Manor House Museum
(St Edmundsbury Borough Council),
Bury St Edmunds

Mary Beale portrays her
husband, Charles (1632–1705),
as a poet or scholar laureate. It is
difficult to see how he deserved
such an honour. He may have
practised briefly as a painter, but
made a career managing his
wife's studio. He was friends
with artists, scientists and
churchmen of the day and thus
presumably had pretensions to
scholarship and connoisseurship.
This is the pretext for Mary's

image of melancholy genius.
Charles is dressed with the
extravagant carelessness which
was the exclusive preserve of
poetic inspiration or morbid
meditation: he wears his own
long and unkempt hair, his
doublet is undone, like that of
the distracted Hamlet, and he is
wrapped in a simple dark cloak.
The laurel wreath – the
traditional crown of literary
achievement – tells us that this
is a creative rather than a merely
depressive dishevelment.

It is not surprising that for
many years this portrait was
thought to represent the poet
Thomas Shadwell. Within the
last year it has been correctly
identified by Historical Portraits
Ltd and acquired for Bury St
Edmunds, the birthplace of the

artist, by the Heritage Lottery
Fund. DST

PROVENANCE Duke of Wellington,
Apsley House, London; by descent to the
7th Duke; 1947: sold by him at
Sotheby's; 1996: sold by an American
private collector at Christie's, New York,
to Historical Portraits Ltd; acquired from
them by the museum with assistance from
the Heritage Lottery Fund
REFERENCES D. Piper, *Catalogue of
Seventeenth-Century Portraits in the National
Portrait Gallery*, Cambridge, 1963, no.
1279, p. 23; *The Excellent Mrs Mary Beale*,
exh. cat. by E. Walsh and R. Jeffree,
London, Geffrye Museum, and
Eastbourne, Towner Art Gallery, 1975,
no. 3, p. 21

31

Attributed to Jan van
Belcamp (1610–53)

The Great Picture, 1646

oil on canvas, central panel
254 × 254 cm, side panels
both 254 × 119.4 cm
Abbot Hall Art Gallery, Kendal,
AH2310/81

The content, composition and
detail of the painting were
determined by Lady Anne
Clifford (1590–1676) in
celebration of her family and her
life. The left-hand panel depicts
her aged fifteen. The central
panel shows Lady Anne's parents
– Lady Margaret Russell,

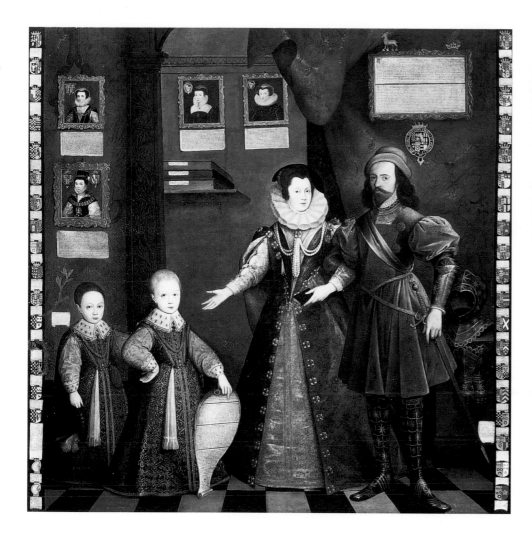

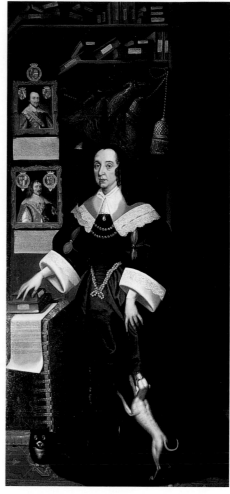

Countess of Cumberland, and George Clifford, Earl of Cumberland – with her elder brothers, Francis and Robert. On the walls hang portraits of her aunts Lady Wharton, Lady Margaret Clifford, Anne, Countess of Warwick, and Elizabeth, Countess of Bath. The right-hand panel shows Lady Anne in her 50s. Behind her hang portraits of her husbands, Richard Sackville, Earl of Dorset, and Philip Herbert, Earl of Pembroke and Montgomery.

Dr Lionel Gust suggested that the painting could be the work of either Belcamp or Remigius van Lemput (1607–75). There was another version (now destroyed). The present work may be a copy, yet it is certainly contemporary, as the handwriting is identical to that of other texts duplicated for Lady Anne in 1649. JCSB

PROVENANCE 1646: commissioned by Lady Anne Clifford; thence by descent in the Tufton and Hothfield families; 1981: purchased by the gallery from the Dowager Lady Hothfield
EXHIBITIONS *Works of Art from Private Collections*, Manchester City Art Gallery, 1960, nos. 72, 105, 115; *Lady Anne Clifford*, Kendal, Abbot Hall, 1976, nos 22, 31; *'Proud Northern Lady'*, Kendal, Abbot Hall, 1990, nos. 21, 33
REFERENCES G.C. Williamson, *Lady Anne Clifford*, Kendal, 1922; M. Holmes, *Proud Northern Lady*, Chichester, 1975; M.E. Burkett, 'Conclusions from the Lady Anne Clifford Exhibition', in *Quarto*, Abbot Hall, Kendal, 1976; V. Slowe, *'Proud Northern Lady': Lady Anne Clifford*, Kendal, 1990

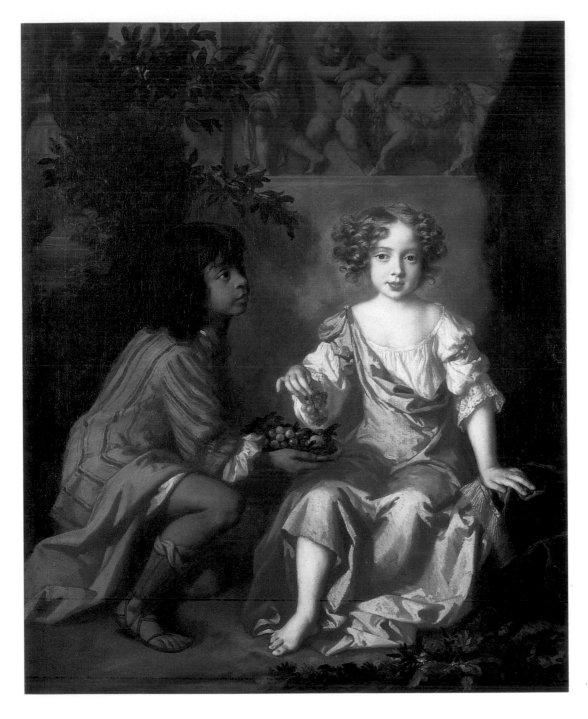

32

Sir Peter Lely (1618–80)
*Portrait of Lady Charlotte
Fitzroy, later Countess of
Lichfield, with her Indian
Page, c.* 1674

oil on canvas, 127 × 101.5 cm
York City Art Gallery, 18

Lady Charlotte (1664–1717/18),
the illegitimate daughter of
Charles II and the Duchess of
Cleveland, was a legendary
beauty who married the Earl of
Lichfield in 1677. She appears
here as a ten-year-old girl in
Arcadian costume and
surroundings – barefoot and
simply draped, among Classical
urns and reliefs. An Indian
servant boy offers her fruit in a
posture of homage which Horace
Walpole read as the tribute paid
to beauty (*Anecdotes*, III, p. 198).
A conventional formula from
Court masques of the 17th
century, this arrangement also
suggests as its 'subtext' the idea
of India offering its riches to the
dominant European trading
nation. DST

PROVENANCE By descent from the
Earls of Lichfield to the 18th Viscount
Dillon; 1933: sold, bought by Vickers;
1948: Sir Bernard Eckstein sale, bought
by Agnew's; 1949: presented to the
gallery by the National Art-Collections
Fund
EXHIBITIONS *Sir Peter Lely*, London,
National Portrait Gallery, 1978; *The New
Child*, Berkeley, California University Art
Museum, 1995

33

Attributed to Jan
Siberechts (1627– *c.* 1703)
*View of Nottingham from the
East, c.* 1700

oil on canvas, 58.5 × 120.7 cm
City of Nottingham Museums,
Castle Museum and Art Gallery,
NCM. 1977–515

In the centre foreground of this
panoramic view of Nottingham,
seen from Colwick Hill, to the
east of the city, is the village of
Sneiton, surrounded by trees. At
the right, is the imposing 14th-
century parish church of St
Mary's, next to the smaller St
Peter's; behind them to the left
is Nottingham Castle, completed
for the 1st Duke of Newcastle in
1679 and now the home of the
city's museum and art gallery.
The prominent red-brick house
in the right middle distance is
the Pierrepont residence, and on
the horizon at the far right is
Wollaton Hall, built to
designs by Robert Smythson
from 1580 to 1588.

The left of the landscape
shows the Trent Valley with the
Trent Bridge and with the
London Road tollhouse and the
town wharf on the Nottingham
side of the river. The river is
depicted as much closer to the
city than it actually is and the

view is further enlivened by the
exaggerated height of the hills.
Although the majority of the
buildings depicted here still
survive, nearly all the area shown
is now built over.

Siberechts was born in
Antwerp and came to England
between 1672 and 1674 at the
invitation of the 2nd Duke of
Buckingham. Here he specialised
in topographical landscapes and
portraits of country houses,
anticipating native developments
in these fields and earning him
some claim to be regarded as the
'father of British landscape'. R V

PROVENANCE 1976, 18 June:
Christie's, London, lot 43 (as Tillemans),
bought by Spink's; 1977: acquired by the
museum (as Jan Griffier the Elder)
EXHIBITION *Prospects of Town and Park*,
London, Colnaghi's, 1988, no. 4
REFERENCE J. Harris, *The Artist and the
Country House*, London, 1985, p. 130,
no. 132

domesticating 'business' within an image of dynastic grandeur. Stone plinth and pilaster make a universal, public and heroic stage. As was the custom with thirteen-year-old noblemen at this date, Orme wears a replica of adult costume, except that he sports his own (powdered) hair, rather than a wig. His feet, shod in fashionable red heels, turn at the angle recommended by manuals of deportment.

The painting was bequeathed to the Holburne Museum as part of a group of family portraits by a descendant of the sitter and trustee of the museum, Sir Harold Orme Garton Sargent (1884–1962). Gifts of this nature (the earliest being the Linley Bequest to Dulwich Picture Gallery in 1832) reveal how family portraits came to be admired as representations of the English school of painting, rather than as merely dynastic records, meaningless outside the family seat. D S T

PROVENANCE By descent to Sir Orme Sargent; 1962: bequeathed by him to the museum
EXHIBITION *Manners and Morals: Hogarth and British Painting 1700–1760*, London, Tate Gallery 1987, no. 6
REFERENCES P. Bishop and B. Roscoe, *Holburne of Menstrie Museum: A Guide to the Collections*, Bath, 1986, pp. 10–11

35

William Hogarth
(1697–1764)
Portrait of George Arnold,
c. 1740

oil on canvas, 90.5 × 70.8 cm
Lent by the Syndics of the Fitzwillian Museum, Cambridge, 21

George Arnold, a London merchant based at St Martin in the Fields, retired to Ashby

34
Jonathan Richardson
(1665–1745)
Portrait of Garton Orme at the Spinet, c. 1709
oil on canvas, 122 × 96.5 cm

The Trustees of the Holburne Museum, Bath, A375

Garton Orme (1696–1758) inherited the Sussex estate of Lavington, half of which he was later forced to sell to pay his

huge debts. This is as much an image of the heir as of the child. The spinet is deceptive: had this been a small-scale portrait it might have accompanied a depiction of a specific interior; on this scale it is little more than

Lodge in Leicestershire and formed a modest collection of Old Master paintings. William Hogarth had a cussed attitude to portraiture, the most lucrative branch of painting in 18th-century England: he shows us the bluff and matter-of-fact earner, rather than the elegant country gentleman and connoisseurial spender. Such an image could never have recommended him as a fashionable portraitist: the pose is too direct, the features too heavy and wrinkles too pronounced. Its 'natural' directness was, however, adopted by Allan Ramsay in his *Lord Drummore* of 1754 (National Portrait Gallery of Scotland, Edinburgh), though with softened features and more elegant play of hands. Hogarth's portraiture may even lie behind Ingres' famously gruff depiction of Monsieur Bertin (Louvre, Paris).

The portrait was bequeathed to the Fitzwilliam Museum in 1865 by a member of the Arnold family, along with two further Hogarths and a portrait by George Knapton (1698–1778).
DST

PROVENANCE George Arnold; by descent to Georgiana Coape (died 1849); 1845: sold by her at Ashby Lodge, bought by Rev. J.W. Arnold of North Manor Place, Edinburgh; 1865: bequeathed by him to the museum (with a life interest for his widow so that it was received in 1873)

REFERENCES R. Paulson, *Hogarth: His Life, Art and Times*, New Haven and London, 1971, I, pp. 445–8; *Fitzwilliam Museum, Cambridge: Catalogue of Paintings*, Cambridge, 1977, III, no. 21

36

Thomas Robins the Elder
(1716–70)

Panoramic View of Charlton Park, 1748

oil on canvas, 104.2 × 134.1 cm
Cheltenham Art Gallery and
Museum

Charlton Park lies a few miles
east of Cheltenham, which is
represented here by the spire of
St Mary's Church in the distance

on the extreme left. The manor
had been acquired in 1716 by
John Prinn, a distinguished local
antiquary, who enlarged the
house to the form seen in the
painting. Prinn's son William
inherited the estate in 1743 and
set about planting the avenue in
front of the house and opening
out the walled garden beyond it.
William may also have been
responsible for the canal which
forms such a prominent feature
in the foreground. This painting

of the house is today chiefly of
interest for the minutely detailed
depiction of the kitchen garden,
which is an important source for
historians of horticulture.

The painting can be dated
with certainty to 1748. The
artist, who was born in the
adjoining village of Charlton
Kings, later became known for
country house views with
fanciful Rococo borders painted
in gouache on vellum. This is a
rare example of a large-scale

painting by him in the earlier
tradition of the bird's-eye view,
which must have been familiar
to him from Johannes Kip's 73
engravings of Gloucestershire
houses, published in 1712. T W

PROVENANCE 1748: commissioned by
William Prinn; by descent to the Russell
family; *c.* 1870: sold to Sir Thomas
Brassey; by descent to Albert Brassey;
1956: purchased from him by the gallery
REFERENCE J. Harris, *Gardens of
Delight*, London, 1978, pp. 8–9

37

Antonio Canale, called
Canaletto (1697–1768)
*Warwick Castle: The East
Front*, 1752

oil on canvas, 73 × 122 cm
Birmingham Museums and Art
Gallery, P.173'78

Always popular with travelling
English patrons for his Venetian
views, Canaletto was tempted to
visit England in 1746 when the
Grand Tour market dried up as a
result of the Wars of the
Austrian Succession. His English
subjects generally celebrate the
wealth and classical style which
seemed to make 18th-century
London a new rival to Rome.
Five views of Warwick Castle
were commissioned in 1752 by
its owner, Francis Greville, Lord
Brooke (later Earl of Warwick),
to hang in his town house in
Grosvenor Square; they represent
a foray into the antiquarian
picturesque, unprecedented in
Canaletto's work.

Owning a venerable medieval
pile was never actually
unfashionable in England, but
around the middle of the 18th
century it became a positive
vogue, with the building of
Horace Walpole's mock-Gothic
Strawberry Hill and other
similar projects. Given the
asymmetrical, medieval character
of his raw material, Canaletto has
here created an image of
astonishingly classical coherence,
clarity and 'neatness'.

Four of this group of
Canalettos made the headlines in
1977 when their sale by David,
Lord Brooke (later 8th Earl of
Warwick), threatened the export
of works which, though painted
by a visitor, seemed integral to
English cultural heritage. One
went to the Paul Mellon Center,
another to the Thyssen-
Bornemisza Collection, but this
example and its pendant entered
the Birmingham Art Gallery,
'rescued from export by a major
appeal to which gallery visitors,
Friends of the Museum,
industry, commerce, charitable
trusts and the West Midlands
County Council responded as
well as Government-funded
grant-making bodies'. DST

PROVENANCE 1752: commissioned by
the Earl of Warwick; by descent; 1978:
bought by the gallery
EXHIBTION *Canaletto and England*,
Birmingham Museums and Art Gallery,
1993, no. 23
REFERENCES D. Buttery, *Canaletto
and Warwick Castle*, Chichester, 1992;
W.G. Constable, *Canaletto*, Oxford, 1976,
no. 446

38

Allan Ramsay (1713–84)

Portrait of James Adam,
1754

oil on canvas, 91.5 × 68.8 cm
Laing Art Gallery, Newcastle upon
Tyne (Tyne and Wear Museums),
C392

This portrait probably came
about through the formation in
1754 of the 'Select Society', one
of the most august debating
clubs of the Edinburgh
Enlightenment, which included
David Hume and Adam Smith as
well as Allan Ramsay and James
Adam as founder-members. The
sitter and painter here are
certainly worthy of this exalted
company. Allan Ramsay, son of
the poet of the same name, was a
philosopher and an antiquarian as
well as a portrait painter. His
Dialogue on Taste of 1752 was an
unprecedented attempt to
demystify aesthetic judgement
according to Hume's methods.
James Adam (1730–94) was a
member of the Adam archi-
tectural dynasty, son of William
(1689–1748) and brother of
Robert (1728–92), for whom he
acted as draughtsman. He is seen
here holding a plan for an
imaginary Palladian-style villa,
the original of which is in Sir
John Soane's Museum, London.

This portrait dates from a
turning-point in Ramsay's career
when he began to experiment
with unforced, 'natural' images
of intelligent elegance. His
model is the pastel portraiture of
his contemporary, Maurice-
Quentin de la Tour, from whom
he has learned to give oil paint a
softness of lighting and a felt-
like texture. DST

REFERENCE A. Smart, *Allan Ramsay,*
New Haven and London, 1992, pp. 59,
107–9

39

Arthur Devis (1712–87)

Portrait of Francis Vincent, his wife, Mercy, and daughter, Ann, of Weddington Hall, Warwickshire, 1763

oil on canvas, 106.5 × 101 cm
inscribed: *Art Devis fc. 1763.*
Harris Museum and Art Gallery, Preston, P1562

Arthur Devis was born in Preston and had a moderately successful career in Lancashire and (after 1745) in London. He exhibited at the Society of Artists and became its President in 1768. By that time, however, his small-scale family 'conversation pieces' were going out of fashion. He was not invited to join the Royal Academy, founded a year later.

The decline and recent resurgence of Devis's reputation can be explained only by examining attitudes to British art as a whole. From the time of the foundation of the Royal Academy until World War II, British art was by and large admired as contributing to the mainstream of European painting. After the war a taste grew, especially marked in the collecting of the American, Paul Mellon, for those 18th-century artists, of whom Devis is a perfect example, who seemed deliberately to stand outside this mainstream. Quaint, eccentric, peculiarly English images were especially valued for conveying a sense of period and lifestyle. Owning a Devis is like owning a plot of history. It was during this Devis rediscovery that the Preston museum chose to honour the local artist 'made good'.

This image of a country squire and his family allows us to see

two sides of the Devis phenomenon: is this an absurd marionette theatre, stiff-jointed and ill-composed, or is it a profound insight into the social and gender relations of the 18th century? DST

PROVENANCE With T.B. Wirgman; 1925: bought by Miss L. Thevenard; 1957: purchased by the museum
EXHIBITION *Polite Society of Arthur Devis*, London, National Portrait Gallery, and Preston, Harris Museum, 1983–4, no. 50
REFERENCE E.D. D'Oench, *The Conversation Piece: Arthur Devis and his Contemporaries*, New Haven, 1980, no. 165

40

Thomas Gainsborough RA
(1727–88)

Holywells Park, Ipswich,
c. 1748–50

oil on canvas, 50.8 × 66 cm
Ipswich Borough Council Museums
and Galleries (Christchurch Mansion,
Ipswich), R1992–5

By the time Gainsborough
moved to Bath in 1759 he had
made a conscious policy of
refusing commissions for
topographical landscapes. To one
such offer he returned: 'if His
Lordship wishes to have
anything tollerable [*sic*] of the
name of G[ainsborough]. the
Subject altogether, as well as the
figures &c must be of his own
Brain.' This depiction of a
specific country house is a rarity
even within Gainsborough's

early Suffolk period. It is obvious
that though the ornamental
ponds of the landscape garden
are meticulously recorded there
is much in this landscape that
comes from Gainsborough's 'own
Brain': the framing trees, the
picturesque figure group in the
foreground and the pattern of
clouds, so clearly derived from
Jacob van Ruisdael (cat. 303).
DST

PROVENANCE 1940: bought by
Charles E. Russell from Palser Gallery,
London; 1950, 18 October: Sotheby's,
London, his sale, lot 54, bought by Bode;
bought for a private collection from
Spink's, London; 1980s: acquired by
Christchurch Mansion with the assistance
of the National Heritage Memorial Fund,
the National Art-Collections Fund, the
MGC/V&A Purchase Grant Fund, the
Pilgrim Trust and the Friends of Ipswich
Museum
REFERENCE J. Hayes, *The Landscape
Paintings of Thomas Gainsborough*, London,
1982, no. 26

41

Thomas Gainsborough RA
(1727–88)

Portrait of William
Wollaston, c. 1758–9

oil on canvas, 124.5 × 99 cm
Ipswich Borough Council Museums
and Galleries (Christchurch Mansion,
Ipswich)

William Wollaston (1730–97) of
Finborough Hall, Suffolk, was a
landowner and subsequently MP
for Ipswich in the parliaments of
1768, 1774 and 1780. This
portrait is the only evidence that
he was also an amateur musician,
in which capacity he may have
known Gainsborough, himself
highly musical.

The informality apparent in
this image is a device used
throughout the 18th century to
suggest the creative panache of

poets and musicians. There is
carelessness about Wollaston's
pose, with shoulders slumped
back in the chair, head
swivelling to engage with some
unseen guest, fingers poised over
his flute and music sliding off
his lap. It is not just that this is
a powerful man seen at his
leisure (even missing his wig);
the *ease* of his deportment is also
intended to characterise his
musical performance. Ease was
an important aesthetic concept at
the time and one especially
associated with music, which is
so obviously difficult. Brilliant
passage-work must sound like
spontaneous improvisation, just
as the elegantly fluttering
crumples of Wollaston's clothing
seem to be a sartorial effect
achieved by happy accident.
Gainsborough too displays his
ease – in this Rococo design and
in the flickering patterns of his
brush.

Later in his career, in a letter
of *c.* 1772, he explained the
delights of pictorial handling in
musical terms: portraiture, he
said, required the style of the
virtuoso oboe with 'variety of
lively touches and surprizing
Effects to make the heart dance'.
DST

PROVENANCE By descent to F.
Wollaston; 1888: E.J. Wythes; 1946:
bought at his sale by Gooden & Fox,
London, for Ipswich Borough Council
EXHIBITIONS *Thomas Gainsborough*,
Paris, Grand Palais, 1981, no. 11;
Gainsborough and his Musical Friends,
London, Kenwood House, 1977, no. 2
REFERENCE E. Waterhouse,
Gainsborough, London, 1958, no. 733

42
Sir Joshua Reynolds PRA
(1723–92)
Portrait of the Artist's Father, c. 1746

oil on canvas, 75.7 × 63.1 cm
Plymouth City Museum and Art Gallery, Cottonian Collection

This is one of Reynolds's earliest works and was almost certainly painted soon after his father's death. The Rev. Samuel Reynolds (1681–1745) was a fellow of Balliol College, Oxford, and Master of Plympton Grammar School from 1715 until 1745, and it is as a scholar that his son chooses to present him. The dark gown, simple collar and short hair worn without a wig are employed to give an Antique or at least a timeless air. The profile view is one traditionally adopted for honouring intellectuals (see also cat. 44), as it suggests the minted head on a coin or a medal. The fictive stone window further suggests that this image is as much a monument as a portrait; it can be compared with similar distancing devices in Blake's series of literary worthies (cat. 58, 59). Reynolds later recycled these ideas in his strikingly similar portraits of literary friends, Dr Johnson and Oliver Goldsmith (both exhibited at the Royal Academy in 1770).

The portrait was bequeathed in 1853 to the City of Plymouth. A personal tribute, unknown in Reynolds's lifetime outside his immediate family and of little significance within his artistic development, this is the type of work which is of special interest to the artist's 'local' museum and which has most chance of becoming available. DST

PROVENANCE The artist's nephew, The Very Rev. Joseph Palmer, Dean of Cashel (died 1829); his son, Captain Palmer; William Cotton of Ivybridge; 1853: bequeathed by him to the city of Plymouth.
EXHIBITION London, RA, *Reynolds*, 1986, no. 4

43
Giuseppe Plura the Elder
(died 1756)
Diana and Endymion, 1752

marble, 52 × 54 cm
inscribed: *Jos: Plura Taurinensis Fecit Bathonica 1752*
The Trustees of the Holburne Museum, Bath, 1997/1

This refined masterpiece of charm, sensuousness and virtuosity depicts Diana touching the hand of Endymion, who has been cast into eternal sleep in exchange for everlasting beauty. Plura created the group as a showpiece and his contemporaries were impressed, Ivory Talbot of Lacock Abbey exhorting a correspondent on 13 August 1754: 'When at Bath fail not to see a piece of sculpture of Endymion on Mount Patmos, the Performance of Mr Plura, a Statuary.'

Giuseppe Plura, son of a Turin wood sculptor, settled in Bath in 1749 and married Mary Ford, a local master mason's daughter. He carved a series of busts of worthies and the coat of arms for the pediment of the King Edward VI Grammar School. In 1755 Plura took a studio in Oxford Row, London, but in March of the following year, on the eve of his return to Italy to work at Court in Turin, he died of a 'maligne fever'. His wife returned to Bath with this sculpture. AS

PROVENANCE Bartrams of Bath; mid-1950s: Hugh Honour and John Fleming, Italy; 1996: sold to a dealer in Paris; 1997: acquired by the museum from Daniel Katz Ltd, London, with donations from the Heritage Lottery Fund, the National Art-Collections Fund and numerous benefactors
EXHIBITION *Mostra del barocco piemontese*, Turin, Palazzo Madama and Palazzo Reale, 1963, no. 103
REFERENCES J. Fleming, 'The Pluras of Turin and Bath', *The Connoisseur*, November 1956, pp. 75–81; A. Sumner, 'Museum Acquisitions', in *National Art-Collections Fund: 1996 Review*, London, 1996, p. 65

44

James Barry RA
(1741–1806)

Portrait of Christopher Nugent MD, 1772

oil on canvas, 76.2 × 63.5 cm
inscribed: *Chr. Nugent M. D. Jas. {B}arry R. A. 1772*
Victoria Art Gallery, Bath and North-East Somerset, P.1946.69

James Barry was fired with enthusiasm for the lofty calling of the history painter by his mentor Edmund Burke, and by the writings of Joshua Reynolds. Vehement in his own writing and stiff-necked in his dealings with people, Barry isolated himself from the London art world until finally he became the only artist ever to be expelled from the Royal Academy.

Christopher Nugent (1715–75), a Catholic physician, was Burke's father-in-law and a member of Dr Johnson's literary club. This was the first work Barry exhibited at the Royal Academy and belongs with a group of early portraits in which, true to the ideals of the history painter, he tries to convert the routine formula of the head-and-shoulders image into a celebration of exalted contemplation. The profile view and the way in which the paint is built up into a relief is deliberately suggestive of a coin or medal, a standard symbol in this period of 'sterling' worth. High-minded spirituality is also conveyed by profuse unkempt hair, simple weeds and a halo of misty light. The bowed head and finger on chin derives from St Paul in Raphael's St Cecilia altarpiece (Pinacoteca, Bologna), a figure described by Barry as 'spiritual and beautifully elevated'. For Barry, Nugent is a philosopher and as such should appear to be a species of urban hermit. DST

PROVENANCE By 1867: T. Moreton Wood; 1946: presented to the Victoria Art Gallery by A.E. Burke Nugent
EXHIBITIONS London, RA, 1773; *Second Special Exhibition of National Portraits*, London, South Kensington Museum, 1867, no. 598; *James Barry: The Artist as Hero*, London, Tate Gallery, 1983, no. 18
REFERENCE W. L. Pressly, *The Life and Art of James Barry*, New Haven and London, 1981, no. 43

45

Pompeo Batoni (1708–87)
Portrait of John Smyth, 1773

oil on canvas, 98.5 × 73 cm
inscribed: *P. Batoni pinxit Romae
Anno 1773*
York City Art Gallery

The travelling *Milordi* and the
power of Sterling had a
'standardising' effect on
European painting in the 18th
century. Artists increasingly had
an eye for the English market.
One such was Pompeo Batoni,
who was alternately an Italian
religious painter in the tradition
of Carlo Maratta (1625–1713)
and an English portrait painter.
There are two things about this
image which reveal its Italian
origins. One is the token
backdrop of fragmented Antique
column and Alban Hill to
commemorate the sitter's
experience of 'doing' Rome on
his Grand Tour. The other is a
high-resolution finish – a
precision, like polished silver, in
the surface of the skin and fabric
– which was beyond the scope of
English painters.

John Smyth (1748–1811) was
a landed gentleman and
subsequently MP from Heath
Hall in Yorkshire. His Grand
Tour of the early 1770s is also
celebrated by his inclusion in
Reynolds's group portrait of
members of the Society of
Dilettanti (1777–9; Society of
Dilettanti, London). DST

PROVENANCE By descent in the family
of the sitter to Louisa, daughter of Col.
John George Smyth MP, who married Sir
John Thursby, first Baronet; by descent to
his son, Sir George Thursby, second
Baronet; 1935, 19 June: Sotheby's,
London, his sale, lot 89, bought by R.
Frank; Agnew's, London; E.J. Rousuck,
New York; 1936–41: Newhouse
Galleries, New York; 1941: purchased by
Mrs Roberts Rinchart, New York; thence
by descent; 1984, 19 January: Sotheby's,

New York, anon. sale, lot 24, bought by
Colnaghi's and sold by them to a private
collector, New York; 1996: purchased
from him through Simon Dickinson,
London (lot 1482), by the gallery with
the aid of the National Lottery through
the Heritage Lottery Fund, the

MGC/V&A Purchase Grant Fund, the
National Art-Collections Fund, the
Friends of York Art Gallery, the York
Civic Trust, the York Georgian Society
and an anonymous donor, 1996
EXHIBITIONS *National Exhibition of
Works of Art*, Leeds, 1868, no. 3213; *Art,*

*Commerce, Scholarship: A Window onto the
Art World – Colnaghi 1760 to 1984*,
London, Colnaghi's, 1984, no. 2
REFERENCE A. Clark, *Pompeo Batoni*,
Oxford, 1985, no. 363

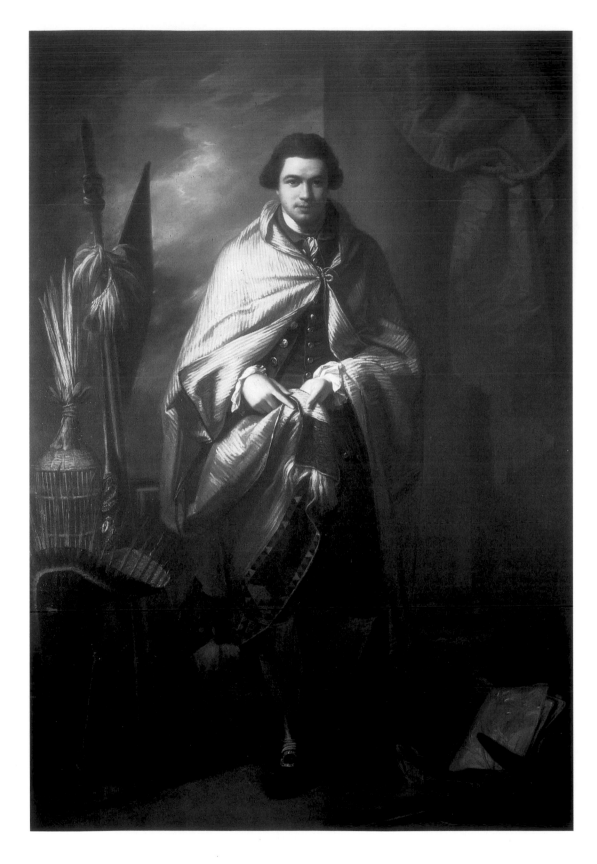

46

Benjamin West PRA
(1738–1820)
Portrait of Sir Joseph Banks,
1771–2

oil on canvas, 234 × 160 cm
Lincolnshire County Council, Usher
Gallery, Lincoln, UG89/9

This portrait commemorates the
'discovery' of Australia and New
Zealand and the triumphant
return of the botanist Joseph
Banks (1743–1820). The
Endeavour had explored the South
Seas from August 1768 to July
1771, captained by James Cook
and carrying a team of natural
historians sponsored by Banks
himself. Banks wraps himself in
a Maori cloak of flax with a dog's
hair fringe and is surrounded by
Polynesian trophies – a Maori
canoe paddle and fighting staff, a
Tahitian headdress. This image
is an early example of a type
which became popular during
the heyday of Empire, showing
the dashing English nobleman
gone semi-native. This mix of
exotic and familiar perfectly
embodies the idea, which runs
throughout Rousseau's *Emile* of
1762, that a desert island is the
nobleman's best finishing school.
The sturdy column and drape
remind the viewer that Banks
was no rootless adventurer, but
wealthy heir to the country seat
of Revesby, near Lincoln.

Banks is famous in Australia,
both from the flora named after
him and for his role in the
foundation of the British colony
there in 1788. This portrait was
bought by the Australian
businessman Alan Bond and its
export licence was deferred,
allowing Lincolnshire County
Council to acquire it for the
Usher Gallery. DST

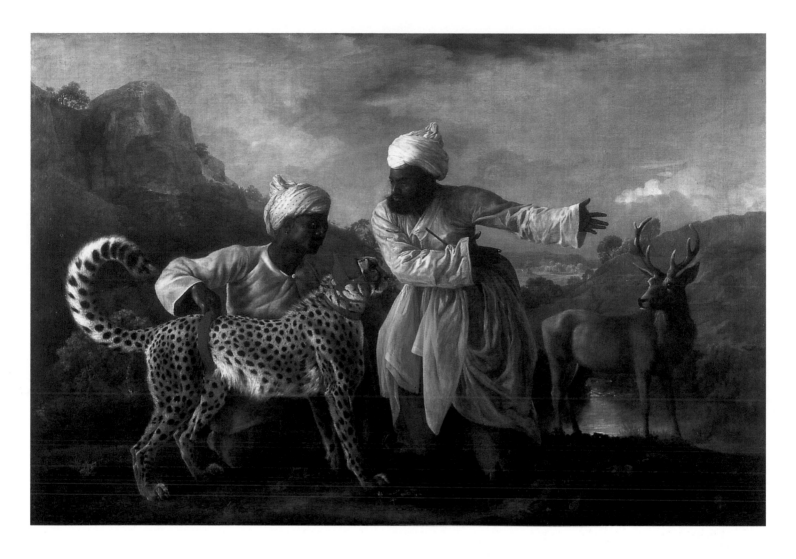

PROVENANCE Probably commissioned
by Robert Banks-Hodgkinson FSA;
Joseph Banks; by descent to his great
nephew W. Milnes; 1886: bought at sale
by Charles Horsley; with James Oakes;
1987: with Alan Bond (export licence
deferred); bought by Lincolnshire County
Council for £1,922,250 with support
from the National Heritage Memorial
Fund, the National Art-Collections Fund,
the Heslam Trust, Pilgrim Trust,
Lincolnshire Museum, Halkes Trust,
Fairburn, Sandars and Lincoln Cathedral
EXHIBITIONS London, RA, 1773;
South Kensington International
Exhibition, 1862, no. 79
REFERENCE H. von Erffa and A. Staley,
The Paintings of Benjamin West, New
Haven and London, 1986, no. 586

47

George Stubbs
(1724–1806)
*Cheetah and Stag with Two
Indians*, c. 1765

oil on canvas, 250 × 305 cm
Manchester City Art Galleries,
1970.34

Stubbs portrays the cheetah and
its two Indian handlers that were
donated in 1764 to George III
by the Governor-General of
Madras, Sir George Pigot. More
specifically he may be suggesting
the rituals of a Mogul hunt with
exotic mountain scenery and
obliging prey (apparently a cross
between an Indian Sambar and

an English red deer). The taut
and nervous cheetah is under
starter's orders, shown his prey
by one attendant and held back
by the other. The red cap is
difficult to read, but it may be a
blindfold removed at the
moment of release. The Duke of
Cumberland, who acquired this
beast for his menagerie at
Windsor Great Park, tried
something similar within an
enclosed arena, only to find that
his pet was ignominiously chased
off by a stag.

The isolation of the animals
and figures, the way that they
seem superimposed rather than
spacially related, creates an
enigmatic mood supported by

the mysterious shadows veiling
the attendants' eyes. Stubbs does
not wish to diminish strangeness
by recording it so faithfully.

DST

PROVENANCE Commissioned by Sir
George Pigot; by descent; 1970: sold by
the Trustees of Sir George Pigot's Will
Trust, bought for the gallery by Agnew's
with grants from HM Treasury, the
Victoria and Albert Museum, the
National Art-Collections Fund and the
Eugene Cremetti Fund
EXHIBITIONS London, Society of
Artists, 1765; *George Stubbs*, London, Tate
Gallery, 1984, no. 79
REFERENCE B. Taylor, *Stubbs*, London,
1971, no. 43

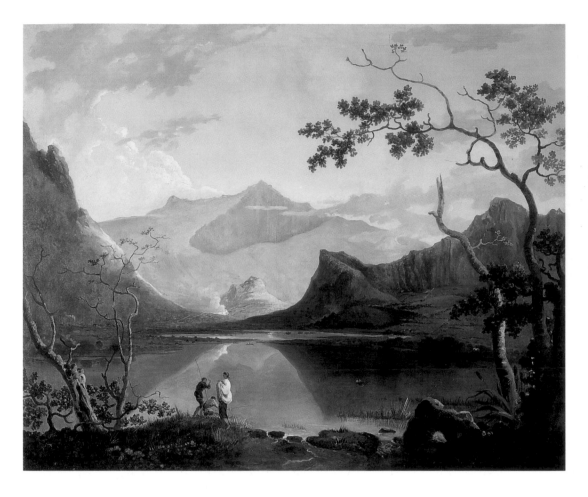

48

Richard Wilson RA
(1714–82)

*Snowdon from Llyn Nantlle,
c.* 1766

oil on canvas, 104 × 127 cm
City of Nottingham Museums,
Castle Museum and Art Gallery,
NCM 1904–85

This late Wilson masterpiece is
difficult to categorise within his
own career and within British
landscape painting generally. An
idealised version of an actual
motif (looking across the lake
called Llyn Nantlle), the image
suggests neither the habitable
idyll of Wilson's Italian and
English views, nor exactly the
hermit's retreat of some of his
imaginary landscapes. In many

ways it seems to be a response to
the cult of the sublime,
following the publication of
Edmund Burke's *A Philosophical
Inquiry into the Origin of our Ideas
of the Sublime and Beautiful* in
1756. The motif is clearly
sublime, being vast and awe-
inspiring; so is the simplicity of
Wilson's treatment. The way in
which the nearer shadowy ridges
make symmetrical sides to a
tunnel of light and the way all
lines (and their reflections) are
approximate arcs of circles
embody Burke's concept of
sublime 'uniformity'. On the
other hand, blue skies are exactly
what Burke advises against for
such mountainous scenery.

If John Martin's Welsh
landscape *The Bard* (cat. 112)
epitomises the mainstream of the

sublime, where does this leave
Richard Wilson's? It is often said
that love of mountain scenery
was invented in this period. In
fact, the ancients liked
mountains well enough if
admired from a distance; Wilson
may be here suggesting the
serene sublimity of Mount
Olympus, home of the Gods.
DST

PROVENANCE 1904: bequeathed to the
museum by R.G. Millus
EXHIBITION London, Society of
Artists, 1766
REFERENCES W.G. Constable, *Richard
Wilson*, London, 1953, p. 186; D. Solkin,
Richard Wilson, London, 1982, no. 117b

49

Joseph Wright of Derby
(1734–97)

Portrait of Fleetwood Hesketh,
1769

oil on canvas, 127 × 102 cm
National Museums and Galleries on
Merseyside (Walker Art Gallery,
Liverpool), WAG 10846

This picture illustrates the
classic pattern of British
painting and collecting. A
gentleman of no special
distinction beyond wealth and
property commissions a portrait
of himself and his wife. After
two hundred years in the family
seat, the pair is acquired by the
local city art gallery.

Fleetwood Hesketh (1738–69)
was from a wealthy ship-owning
family with large estates in
Lancashire who probably
acquired property in Liverpool,
where Wright painted him in
1769 (the artist's sitter book
records a payment of ten guineas
for the portrait). By 1840 the
family had settled at Moels Hall
near Liverpool where the portrait
hung until 1991.

Wright has conveyed the idea
of limitless estates by perching
his sitter on an eminence. The
informality of the country
gentleman is suggested by the
hunting-gun and powder flask
and by a posture of insouciance,
especially daring in an age
obsessed with deportment. DST

PROVENANCE By descent; 1991:
purchased by the gallery with the aid of
grants from the National Heritage
Memorial Fund, the National Art-
Collections Fund, the Friends of the
National Museums and Galleries on
Merseyside and the Hope Fund
EXHIBITION *Wright of Derby*, London,
Tate Gallery, 1990, no. 37
REFERENCE B. Nicolson, *Wright of
Derby*, London and New York, 1968,
no. 81

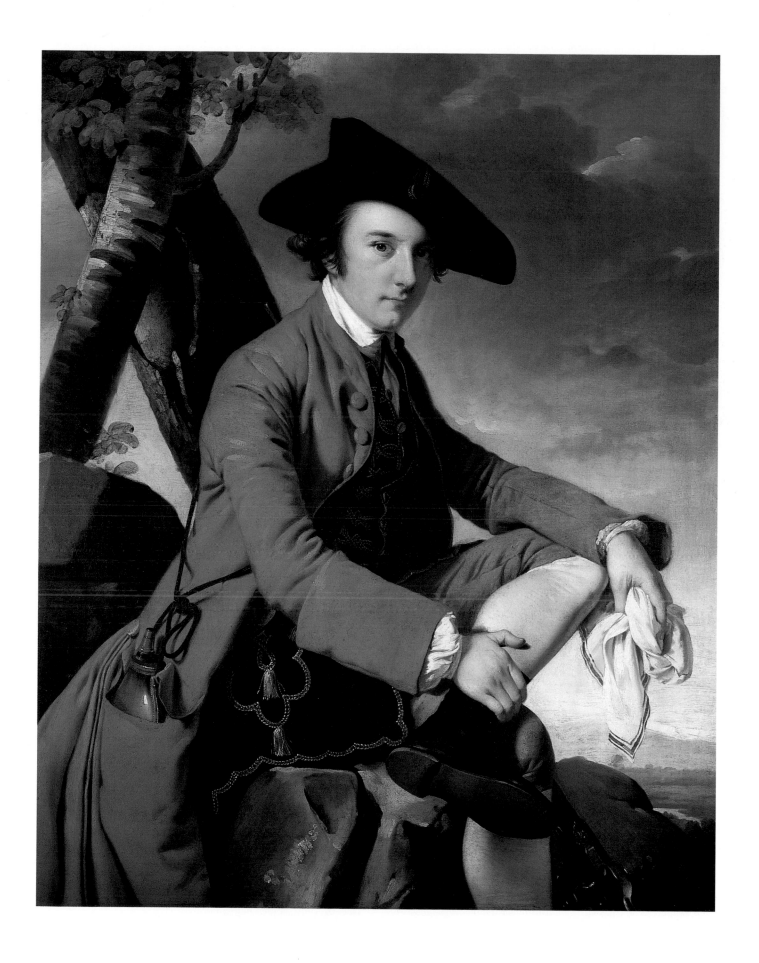

left by an insufficiency of real Antique finds. DST

PROVENANCE Lord Yarborough; by descent; 1932: given by the family to the gallery in lieu of death duties
EXHIBITION London, RA, 1783
REFERENCE J.T. Smith, *Nollekens and his Times*, London, 1986, p. 248

51

Joseph Wright of Derby (1734–97)

The Widow of an Indian Chief watching the Arms of her deceased Husband, 1785

oil on canvas, 101.5 × 127 cm
inscribed: *J. W. 1785*
Derby Museum and Art Gallery, Borough Bequest, 1961–508/6

This unprecedented subject was suggested to Wright by the poet William Hayley (see cat. 57): the widow of an Indian chief apparently kept vigil through every day for a month beneath a war-pole (a sort of pollarded tree, painted red) decked with the arms of her late husband. This, of course, is what Antique matrons did (as recounted in the *Satyricon* of Petronius), just as the war-pole resembles the Antique trophy hung with armour. In the age of Jean-Jacques Rousseau, it was believed that virtue was the monopoly of Republican Romans and 'savages'.

Wright's *Indian Widow* and its companion, *The Lady in Milton's 'Comus'*, were intended to contrast steadfast feminine courage from two different worlds. The Lady suffers a night in a wild wood, the widow a day of fierce sun and an alarming display of meteorological turmoil, with storm clouds, lightning and a smoking volcano. Both women have an Antique form of beauty; the Lady's of simply pleated white drapes, the widow's of modest nakedness, with skin polished and rounded like Neoclassical marbles.

The Derby Art Gallery has by far the finest collection of Wright's work anywhere, an achievement which represents the most successful campaign by a regional English town to honour a local artist. The foundations were laid in the 1880s when two public subscriptions brought *The Alchymist in Search of the Philosopher's Stone* and *The Philosopher Lecturing on the Orrery* to the collection. A sustained purchasing policy helped to encourage a variety of bequests, including that of Col. Burton Borough, who in 1961 donated this painting and *A Philosopher by Lamp Light*. DST

PROVENANCE The artist's studio; 1801: bought by Borrow; by descent (name changed to Borough) to Col. J.G. Burton Borough; 1961: bequeathed to the gallery by him
EXHIBITION *Wright of Derby*, London, Tate Gallery, 1990, no. 67
REFERENCE B. Nicolson, *Wright of Derby*, London and New York, 1968, no. 243

50

Joseph Nollekens (1737–1823)

Mercury, 1778

marble, 105.5 × 68 × 36.5
(without base)
Lincolnshire County Council, Usher Gallery, Lincoln

This marble forms a pair with *Venus chiding Cupid* of 1778; both are now in the Usher Gallery and both were carved by Nollekens for his friend Charles Pelham, MP for Lincolnshire, later Lord Yarborough. Mischief may be the connection between the two.

Mercury here leaves his healing *caduceus* on the floor and holds a purse, one of his other attributes. This reminds us that he is the god of commerce, but also alludes to his thievery – he once stole the herds of Admetus which Apollo had been set to guard. Joshua Reynolds's *Mercury as Cut Purse* (The Faringdon Collection Trust, Buscot) of 1774 may have been the inspiration for this unflattering treatment of the Olympian. In every other respect, however, Nolleken's figure is earnestly classical and would seem to be aimed at the hole in the market

52

Philippe Jacques de
Loutherbourg RA
(1740–1812)

*Belle-Isle, Windermere, in a
Storm*, 1785

oil on canvas, 135.9 × 201.9 cm
inscribed: *P. J. de Loutherbourg/1785*
Abbot Hall Art Gallery, Kendal

De Loutherbourg was
'discovered' in Paris in 1771 by
the actor David Garrick, who
employed him as principal
scenery painter at Drury Lane
Theatre. He revolutionised
theatrical design in England,
creating asymmetrical
'picturesque' scenes made of
many and variously shaped flats,

and lit from behind through
transparent gauzes. These
innovations were also on display
in his *Eidophusikon* (literally,
'forms of nature'), a species of
magic lantern display with
dramatic lighting and shifting
scenes, invented in 1782 and
much admired by Gainsborough.
De Loutherbourg also had a
successful career as a landscape
painter; he and Gainsborough
both visited the Lake District in
1783 (whether in company or
not is uncertain), at a time when
it was coming to epitomise that
wild, rough and dramatic type of
beauty called the 'Picturesque'.

The scene painter's stock in
trade is contrast – the ability to
transform a set, by lighting or

different effects of weather, in
front of the audience's very eyes.
This same idea seems to be the
inspiration behind this painting
and its pendant, *Belle-Isle,
Windermere, in a Calm* of 1786,
also in Abbot Hall Art Gallery.
They were both painted for the
family seat, Workington Hall, of
John Christian Curwen (1756–
1828) in order to celebrate the
family's summer home, Belle-
Isle. The island and its Round
House, designed in 1774 by
John Plaw and visible in the
background of both paintings,
was acquired by Curwen in
1782. The paintings remained in
the family until bought in 1988
by Abbot Hall. DST

PROVENANCE Curwens by descent;
1988: bought by the gallery with support
from the MGC/V&A Purchase Grant
Fund, the National Art-Collections Fund,
the National Heritage Memorial Fund
and the Friends of Abbot Hall
EXHIBITION London, RA, 1785

53

Thomas Gainsborough RA
(1727–88)

*Wooded Landscape with
Cattle by a Pool*, 1782

oil on canvas, 120.4 × 147.6 cm
Lent by the Trustees of
Gainsborough's House, Sudbury

When Gainsborough exhibited
this landscape at the Royal
Academy in 1782 his friend
Henry Bate-Dudley wrote of it:

'Mr. Gainsborough has exhibited but one Landscape – but that his chef d'oeuvre in this line. It is an evening, at Sun-set, representing a wood land scene, a sequestered cottage, cattle, peasants and their children before the cottage ... that would have done honor to the most brilliant Claude Lorain!' Bate-Dudley shows more partiality than discernment: more informed viewers would have seen in this landscape a calculated antithesis to everything Claude stood for. Gainsborough gives English rusticity in place of Claude's classical pastoral grandeur; a cosy close-up glade in the forest in place of sweeping distances; a roughly textured touch in place of Claude's hazy softness. The peculiar beauty of this type of scene (as well as this type of painting) was just beginning to be recognised at this date and given the name 'picturesque'. Systematic definition of the picturesque was provided a decade later by a theorist such as Richard Payne Knight (see cat. 10), who declared that it was a type of beauty to be found in roughness – in the wild, the tumbled-down and the decaying. Contemporaries agreed that in this department Gainsborough excelled all other painters. DST

PROVENANCE Joseph Gillott; 1872: bought at his sale by Agnew's for Kirkman D. Hodgson; bought from him by Sir Edward Guinness (later 1st Earl Iveagh); 1927: inherited by Walter, 1st Lord Moyne; by descent to Hon. Jonathan Guinness; 1987: bought in at his sale; 1987–8: purchased by Suffolk County Council by private treaty sale, transferred to the Trustees of Gainsborough's House, Sudbury, with funds from the National Heritage Memorial Fund, the National Art-Collections Fund and the MGC/V&A Purchase Grant Fund

EXHIBITIONS London, RA, 1782; *Gainsborough*, Paris, Grand Palais, 1981, no. 68; *From Gainsborough to Constable*, Sudbury, Gainsborough's House, 1991

REFERENCE J. Hayes, *The Landscape Paintings of Thomas Gainsborough*, London, 1982, no. 135

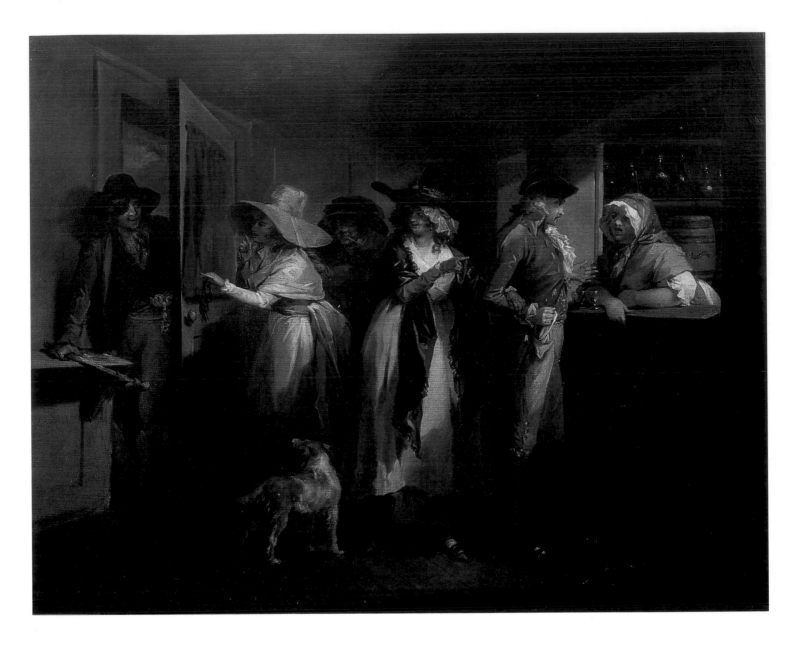

54

George Morland
(1763–1804)

Easy Money, 1788

oil on canvas, 46 × 59 cm
Kirklees Metropolitan Council,
Huddersfield Art Gallery, 2056.1985

English licensing laws as we now
know them were the invention of
the 18th century. Early in the
century cheap gin was on sale in
every chandler's shop and its
devastating effect was frequently
described by reformers,
Hogarth's *Gin Lane* being the
lasting manifestation of their
campaign. Wholesale prohibition
proved unenforceable, but an Act
of 1751 limited the sale of
distilled spirits to licensed
public houses. During the 1780s
there was a further campaign, to
enforce this law more effectively
in order to police the seedier
type of tavern, which was
regarded as a seed-bed of theft,
prostitution and all manner of
abomination.

Morland's scene looks like a
private house turned into an
illegal ginshop. It exhibits all
the villains and vices commonly
railed against – a cudgel-
wielding highwayman, a
probable receiver of stolen goods
and, more generally, the
promiscuous mixing of the
highest and the lowest orders of
society. Morland was a famous
drunk, so he probably knew
what he was painting
about. DST

PROVENANCE Rev. Richard Wells;
1936, 26 June: sold at Christie's, London;
1955. presented to the gallery by Ernest
E. Cook
EXHIBITION *A Gift to the Nation: The
Fine and Decorative Art Collections of Earnest
E. Cook*, Bath, Holburne Museum, 1991

55

Henry Walton
(1746–1813)

*Portrait of Sir Robert Buxton,
1st Bt, with his Wife,
Juliana, and his elder
Daughter, Anne, 1785*

oil on canvas, 73.6 × 92.5 cm
inscribed (on reverse of original
canvas): *Painted by Henry Walton*
Norfolk Museums Service (Norwich
Castle Museum), 9.268.963

Henry Walton was a Norfolk
squire who painted exquisite
conversation pieces in the 1770s
and 1780s. Robert Buxton's
account book records a payment
on 31 October 1785 of £31 10*s*.
0*d*. 'To Mr Walton for painting
a family piece of three figures'.
The young Norfolk squire is
gesturing towards his wife,
Juliana, as they enjoy with
shared pride the intense – but
momentary – concentration of
their daughter, Anne Elizabeth.

The three-year-old has disturbed
her father's reading and her
mother's embroidery to peruse
the book proffered by her
mother. The balance of colour
and composition rewards scrutiny
equal to that with which the girl
examines the (presumably
illustrated) page of the book.

At the time this portrait was
painted, Buxton was on the
threshold of a worthy political
career. From 1790 he represented
Thetford and Great Bedwyn in

the Commons and was raised to
the baronetcy as a reward for
supporting William Pitt the
Younger. HGB

PROVENANCE By descent to Mrs Maud
Buxton; 1963: bequeathed by her
EXHIBITIONS *Henry Walton 1746–
1813*, London, H. Blairman & Sons Ltd,
1950, no. 5; *Henry Walton*, Norwich,
Castle Museum, 1963, no. 21; *Friends &
Family*, Norwich, Castle Museum, 1992,
no. 56
REFERENCE F. Duleep Singh, *Portraits
in Norfolk Houses*, Norwich, n.d. [1927],
II, p. 417, no. 35

George Romney
(1734–1802)
The Four Friends: William Hayley, Thomas Hayley, William Meyer and the Artist, 1796
oil on canvas, 123.2 × 99.7 cm
Abbot Hall Art Gallery, Kendal

William Hayley (1745–1820) was a minor poet dismissed by Byron with the following crushing couplet: 'His style in youth or age is still the same,/ For ever feeble and for ever tame' (*English Bards and Scotch Reviewers*, ll. 313–4).

Being a man of fortune, Hayley had a second career as artistic patron and host. He discovered William Blake, advised Wright of Derby and established an intellectual ascendancy over George Romney. This group portrait was probably Hayley's idea, carried out by his protégé, and celebrates the influence of this modern Maecenas. According to Hayley, it is 'a picture sacred to friendship', bringing together from left to right: William Meyer, son of the miniature painter Jeremiah and here wearing the gown of an academic; Tom Hayley, the poet's son, an apprentice sculptor with Antonio Canova and here holding a figure of Minerva; William Hayley and George Romney. Though painted at Eartham, Hayley's country retreat, the picture is not about the conviviality of friendship but about its solemnity. Each figure is silent, wrapped in thought and dislocated. Hayley has a copy of Cicero's *Essay on Friendship* open in front of him – to swear by,

56

John Opie (1761–1807)
Portrait of Captain Morcom and Thomas Daniell with a Specimen of Copper Ore, 1786
oil on canvas, 99.5 × 112 cm
The Royal Institution of Cornwall,
Royal Cornwall Museum, Truro

Thomas Daniell (1715–93), seated to the right, was a merchant and mine adventurer from Truro. He is shown a specimen of copper ore by a mine captain, Joseph Morcom, who points to the engine house of Polperro mine in the background. Cornwall was famous for its tin mines even in ancient times; copper was also extensively mined throughout the 17th and 18th centuries. It is unlikely that this portrait commemorates any particular discovery.

Opie's father was himself a mine captain (the equivalent of a foreman), from Trevellas, near St Agnes, Cornwall. The date of this portrait marks the apogee of the reputation of the 'Cornish Wonder', as he was called, who was especially admired for the masculine 'Rembrandtesque' qualities seen here. He later recalled that the road to his studio was at this time blocked by carriages; shortly after, when the vogue had passed, it was if his house harboured the plague.
DST

PROVENANCE Ralph Daniell; 1835: purchased at Bath by W.C. Pendarves; from 1950: on loan to the Royal Cornwall Museum; 1994: purchased by the museum with support from the MGC/V&A Purchase Grant Fund, the National Art-Collections Fund, the Cornwall Heritage Trust and private individuals
EXHIBITION London, RA, 1786
REFERENCE A. Earland, *John Opie and his Circle*, London, 1911, p. 272

not to read. Hayley takes his oath with his right hand lain on the sacred text, while his left cradles his head in pensive reverie.

Hayley was obviously aware of the pagan solemnity, which was so fashionable in this, the great age of oath-swearing. He may also have seen the funny side: in a letter of 17 August 1796 to his son describing the portrait he refers to himself as 'the paternal Hermit'. DST

PROVENANCE William Hayley; his solicitor, Captain Godfrey; George Godfrey; 1888: bought at his sale by Shepherd; Leopold Solomons of Norbury Park; J.D. Campbell; 1967: bought at his sale by Johnson; Spink's; 1968: purchased by Abbot Hall with a grant from the National Art-Collections Fund and the Provincial Insurance Co.
REFERENCES H. Ward and W. Roberts, *Romney*, New York, 1904, II, p. 75; A. Chamberlain, *Romney*, London, 1910, pp. 204, 208, 210–11

an Elizabethan portrait of
Spenser known from an
engraving by George Vertue and
Droeshout's engraving of
Shakespeare, famous as the
frontispiece of the First Folio of
1623. The backgrounds are also
curiously chosen. Shakespeare is
represented by two spooky scenes
from *Macbeth*: the hero's first
encounter with the witches and
the ghost of Banquo pointing to
his endless royal progeny (an
irony here, since the last one,
Bonny Prince Charlie, had
recently died in Roman exile).
Spenser is even more improbably
celebrated, as the author not of
the *Faerie Queen* but of the
pastoral *Shepheard's Calender* of
1579. It is the April Eclogue
represented here, a hymn in
praise of Queen Elizabeth. DST

PROVENANCE Series of 18 probably
dispersed after the sale of Hayley's house
c. 1840; re-assembled by William Russell;
1884: his collection sold at Christie's,
London; 1885: 18 heads of poets bought
by the gallery from Agnew's for £125
EXHIBITION London, *Burlington Fine
Arts Exhibition*, 1876
REFERENCE M. Butlin, *The Paintings
and Drawings of William Blake*, New
Haven and London, 1981, no. 343

58, 59
William Blake
(1757–1827)
William Shakespeare
Edmund Spenser
both *c.* 1800

tempera on canvas, 41 × 79.5 and
42 × 84 cm
Manchester City Art Galleries,
1885.3; 1885.5

William Hayley (cat. 57) 'took
up' the young William Blake in
1800. He persuaded him to
move out of London to Felpham
near Chichester, where he wished
to employ him at his own house,
the Turret, on the decoration of
the library (among other
projects). Rather as versions of
Roubiliac's bust of Pope would
have been used throughout the
century, Hayley wanted to turn
his library into a Pantheon of
poets and philosophers. Eighteen
tempera paintings survive from
the scheme, of a peculiar (not
quite standard) long format,
presumably to fit low spaces
available above the shelves. Each
contains a fictive stone medallion
portrait surrounded by semi-
allegorical allusions to the
writer's work.

A Romantic Temple of Fame
differs from an Augustan one.
The bulk of Hayley's selection of
poets comes from the medieval,
Renaissance and 'modern'
periods, rather than from
Antiquity. Chaucer, Shakespeare,
Milton, Dryden and Pope are
obvious choices here, but they
are joined by some more
unexpected and downright
recherché names: Spenser, Tasso,
Otway, Voltaire, Cowper,
Klopstock, Luiz vaz de Camoens
and Alonso de Ercilla y Zuñiga.
The two portraits shown here are
similarly an eccentric collision of
a Classical formula (the stone
medallion) with homespun
detail. Blake has made no effort
to generalise or to depart in any
way from his historical sources:

60

Sir Thomas Lawrence PRA
(1769–1830)

King George III, 1792

oil on canvas, 275.6 × 153.7 cm
Herbert Art Gallery and Museum,
Coventry, CH23

This image of George III
(1738–1820) was commissioned
by two local MPs in 1792 to join
a set of royal portraits
accumulated over three centuries
in St Mary's Guildhall, Coventry.
This was Lawrence's first essay in
the 'extra-large' full-length (some
30 cm higher than the standard
size). Lawrence used 'oversize'
canvases to great effect in the
portraits celebrating the
victorious generals of the
Napoleonic Wars in the Waterloo
Chamber at Windsor Castle.

 This image anticipates this
later project in other ways.
As a response to France's
revolutionary persecution of its
monarch, Lawrence stresses the
sacred mystique of British
Royalty, through the high-
minded upward gaze of a King
standing on a loggia apparently
built in the sky. Jacques-Louis
David, in his recent *Oath of the
Tennis Court*, had shown the
Chapel Royal at Versailles struck
by revolutionary lightning;
Lawrence looks down on St
George's Chapel, Windsor,
which glows with transfiguring
light. The King is a crusading
knight, in the regalia of the
Order of the Garter, its chapel
behind him. DST

PROVENANCE Commissioned for the
City of Coventry by its MPs Sir Sampson
Gideon (later 1st Baron Eardley) and John
Wilmot; transferred to the gallery from St
Mary's Hall
EXHIBITION London, RA, 1792
REFERENCE K. Garlic, *Sir Thomas
Lawrence*, Oxford, 1989, no. 324a

61, 62

John Constable RA
(1776–1837)
Golding Constable's Flower Garden
Golding Constable's Kitchen Garden
both 1815

both oil on canvas, 33 × 50.8 cm
Ipswich Borough Council Museums and Galleries (Christchurch Mansion, Ipswich), 1955–961, 962

It is difficult to pin down what makes these two small paintings so immediate and modern-looking. Unlike most landscapes of the period, they are an accurate record of a particular view (from the upstairs window of the Constables' paternal house at East Bergholt). They could even be stitched together to make one continuous scene. This uncomposed appearance is reinforced by the viewpoint consistently applied to every part of the scene, so that we are acutely aware of our own position at the window. The foreground, brought up to right below the windowsill, takes up a larger than expected area of the painting, is abruptly and 'realistically' cut off by the frame, and (as the titles remind us) is comically mundane. The long shadows in the *Flower Garden*, which can be traced back exactly to the bushes which cast

them in a way unknown in foregrounds of this date, help to give the impression of a precise moment as well as a precise setting.

Such an artless 'snapshot' of experience is unusual even in Constable's work, and completely outside the mainstream of English landscape painting. The pair of paintings was neither exhibited nor sold in the artist's lifetime, and seems to have remained virtually unknown throughout the 19th century. This is the type of private work which can slip through the net of major national and private collections and become available to regional museums, such as that at

Ipswich, which tend to enter the field relatively late in the day.
DST

PROVENANCE Charles Golding Constable; 1887: Christie's, London, his sale, bought by Agnew's for Sir Cuthbert Quilter; 1936: Christie's, his sale, bought by Gooden & Fox, London; Ernest Cook; 1955: bequeathed to the museum by him through the National Art-Collections Fund
EXHIBITIONS *Constable*, London, Tate Gallery, 1976, nos. 134, 135; *Constable*, London, Tate Gallery, 1991, nos. 25, 26
REFERENCE G. Reynolds, *The Early Paintings and Drawings of John Constable*, New Haven, 1996, 15.22, 23

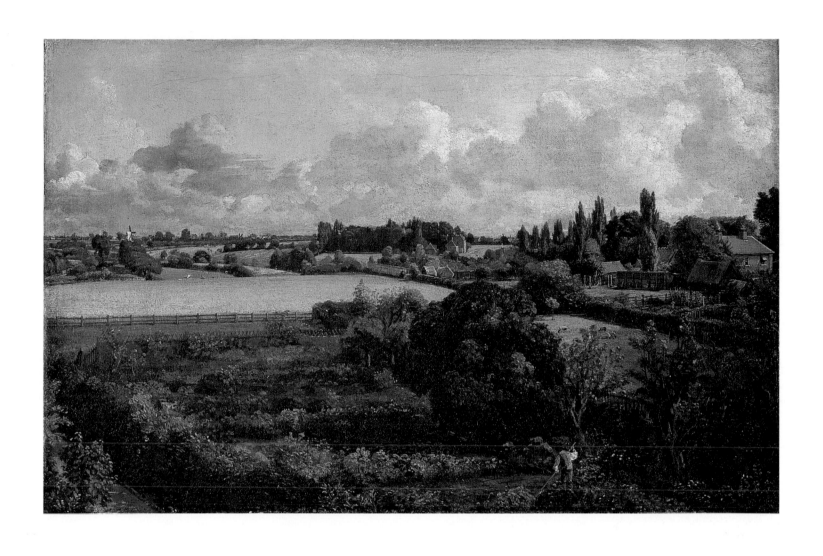

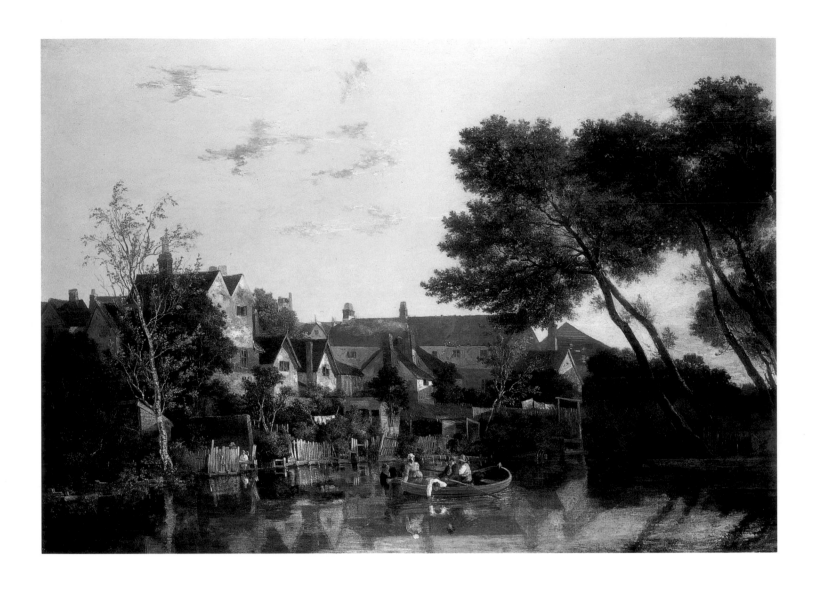

63

John Crome (1768–1821)
Norwich River: Afternoon,
1819

oil on canvas, 71.1 × 100.3 cm
Norfolk Museums Service (Norwich
Castle Museum), 189.994

Norwich in the early 19th
century saw the greatest artistic
activity of any regional city in
England. From 1805 onwards,
the regular exhibitions of the
Norwich Society of Artists
provided a showcase for a
thriving community of artists
who were able to sustain

themselves largely through
landscape painting and the
teaching of drawing and had
little involvement with London.
John Crome was the senior figure
among them; by both age and
reputation. It is an unfortunate
consequence of his great
popularity that there are more
copies and pastiches of his work,
often by pupils and members of
his family, than there are
authentic paintings; and the two
have often been difficult to
distinguish.

There can be no doubt,
however, that *Norwich River:
Afternoon* is among the finest of

all Crome's paintings. The scene
on the River Wensum,
dominated by the long roofline
of the New Mills (so called since
the 15th century), is one Crome
depicted on many occasions, but
never with such poise and
clarity. The debt of Norwich
artists to the Dutch masters then
so much in vogue in the city is
often cited. Crome certainly
displays an admiration for
Hobbema in his woodland scenes
and for Cuyp in his landscapes
and marines; yet in this late
work, with its clear geometry
and strongly lit architecture, his
interest seems to lie in a different

direction altogether, in the work
of Poussin. The gently inclining
trees to the right reinforce the
Italianate atmosphere. T W

PROVENANCE *c.* 1821: Alderman
Hankes, Norwich; Louis Huth; Sir Max
Michaelis; by descent; 1994: acquired by
Norwich Museums Service with support
from the MGC/V&A Purchase Grant
Fund
EXHIBITION (?) Norwich Society of
Artists, 1819, no. 48
REFERENCE N.L. Goldberg, *John Crome
the Elder*, New York, 1978, no. 108 (with
full provenance and bibliography)

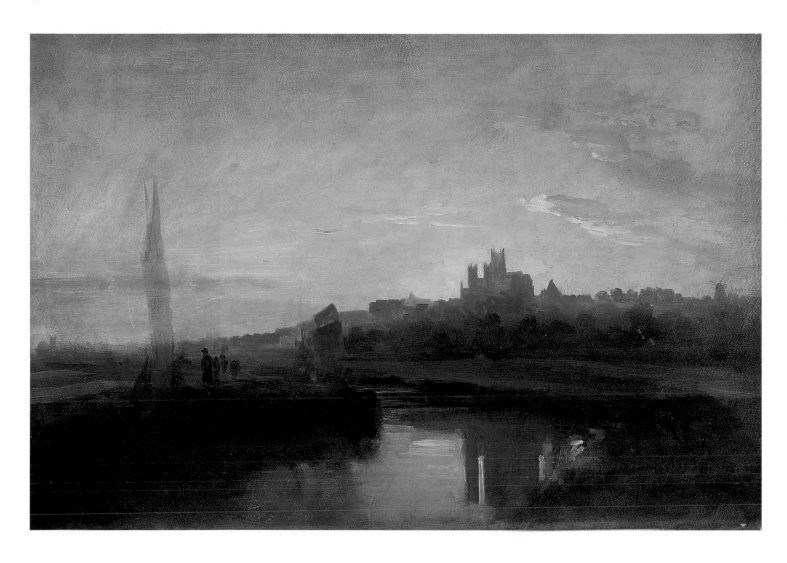

64

Peter De Wint
(1784–1849)

*Lincoln from the River at
Sunset, c.* 1830–45 (?)

oil on paper laid on canvas,
39.5 × 56 cm
Lincolnshire County Council, Usher
Gallery, Lincoln, UG 85/1

Peter De Wint was one of the
most successful watercolourists
of his day. His work in oils
found nothing like the same
favour and most of his exhibited
canvases, along with many
studies, were still in his studio at
his death. In recent years, there
has been a surge of interest in
early 19th-century oil sketching
in Britain and De Wint has been
recognised as an important
exponent.

Many of De Wint's oil
sketches are close-up studies of
plants or foliage, but he was also
particularly fond of broadly
executed, low-toned notations of
light at dawn or dusk, effects
which could be executed quickly
out of doors. *Lincoln from the
River at Sunset* is larger than the
majority of these studies, but
could still have been created on
the spot. With its watery
foreground and principal subject
placed far in the middle-
distance, a favourite approach of
Turner in his 'England and
Wales' watercolours of *c.* 1825–
38, De Wint's oil is more likely
to date from the 1830s or 1840s
than from 1810–20, the decade
when oil sketching was most in
vogue.

De Wint first went to Lincoln
in 1806, the year he met William
Hilton, who was born in the
neighbouring town of Newark.
De Wint married Hilton's sister
in 1810 and the two artists
acquired property in the city,
with which De Wint has ever
since been associated. The Usher
Gallery now owns 235 works by
De Wint. Several recent
acquisitions have been made
with contributions from the
Heslam Trust, endowed by a
local businessman in 1963 to
purchase works of art for the
gallery. TW

PROVENANCE 1985: purchased from
Andrew Wyld with funds from the
Heslam Trust and the Friends of Lincoln
Museums and Art Gallery
REFERENCE *The Heslam Trust
1963–1996*, exh. cat. by R. B. Thomas,
Lincoln, Usher Gallery, 1996

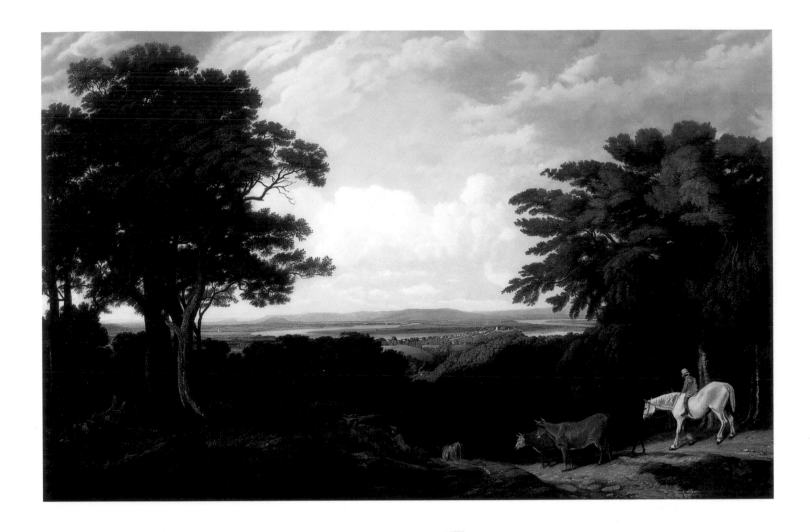

65

William Turner 'of Oxford' OWS

(1789–1862)

Newnham-on-Severn from Dean Hill, c. 1830–40

oil on canvas, 108.3 × 169.5 cm
Gloucester City Museum and Art Gallery

Turner was just eighteen when he was elected to membership of the Royal Society of Painters in Water-Colours in 1808. His dramatic, elemental landscapes earned him a leading position among the younger generation of watercolourists. His early works all depicted views in his home county of Oxfordshire. Turner then ventured into neighbouring Gloucestershire. The extensive views from its hilltops became a recurring feature of his art from 1811 onwards. On these upland commons, usually peopled only by shepherds or drovers, timeless figures existing on the fringes of society, the artist could enjoy a sense of freedom and oneness with nature unencumbered by the social or political changes taking place in the towns below.

Although he made his reputation as a watercolorist, Turner worked in oils throughout his life, often on a large scale. *Newnham-on-Severn from Dean Hill* is difficult to date precisely, but could well have been painted during the 1830s; Turner exhibited a small watercolour entitled *The Severn near Newnham* in 1832. In the oil, he looks in a south-easterly direction across the Severn Valley towards Stroud. The effect is similar to a work exhibited in 1833, when a critic commented in the *Literary Gazette* of 11 May: 'The eye seems to tire in contemplating the almost boundless space between the middle distance and the utmost verge of the horizon.'

This fine landscape has special resonance in its present home, where it can be seen not only in the company of other local views, but among a collection of landscapes that includes works by Wilson and Gainsborough. T W

PROVENANCE 1977: purchased by the museum with support from the MGC/V&A Purchase Grant Fund

66

George Philip Reinagle
(1802–35)

A first rate Man of War driving on a Reef of Rocks and floundering in a Gale, 1826

oil on canvas, 102 × 127 cm
Royal Albert Memorial Museum, Exeter, 28/1938

George Philip was the son of Ramsay Richard Reinagle (1775–1862) and grandson of

Philip Reinagle (1749–1833), both painters. A specialist in marine subjects, he is best known for his prints and paintings depicting the Battle of Navarino of 1827.

There is so much of the atmospheric cataclysm and so little of the naval anecdote about this painting that it is tempting to read it symbolically. Heroic in isolation, engulfed in spray, a man of war flying the union flag braves storm and waves with broken mast and torn sails. Could this be an allusion to the ship of state weathering what was acknowledged at the time to be a peculiarly stormy patch within British history? If so, the painting anticipates Turner's great allegorical sea pieces: *Peace – Burial at Sea* of 1842 and *Slavers Throwing Overboard the Dead and Dying* of 1840.

This painting was donated to the Royal Albert Memorial Museum by a collector and champion of Devonian artists, Robert Worthington. In 1932 Worthington organised an exhibition at the museum (and lent 32 paintings) entitled *Early Devon Painters*, which featured works of local or marine interest by William Traies (the 'Devon Claude', 1789–1872), Thomas Luny (1759–1837), Samuel Prout (1783–1852) and many others. DST

PROVENANCE 1938: presented to the museum by Robert Worthington, Esq., FRCS

EXHIBITIONS London, RA, 1826; *Early Devon Painters*, Exeter, Royal Albert Memorial Museum, 1932

67

John Frederick Herring Sr
(1795–1865)
*The Finish of the Doncaster
Gold Cup*, 1827

oil on canvas, 51.9 × 91.9 cm
inscribed: *J. F. Herring, 1827*
Doncaster Museum Service,
Doncaster Metropolitan Borough
Council, 447.63

In 1822, when Herring was 27,
The Annals of Sporting promised
that he would 'rank with the
most celebrated animal painters
the country has ever patronised'.
His reputation was established
by commissions from *The
Doncaster Gazette* and other print
publishers to sketch winners of
the St Leger, the Derby and the
Oaks. He also painted the most
celebrated race at Doncaster, the
Gold Cup.

According to *The Times*, 'Gold
Cup day is always one of great
interest' and, on Thursday, 20
September 1827, it 'surpassed all
former meetings in the celebrity
of the horses, and the extent of
speculation'. In 'slippery' and
'dirty' conditions, as *The Times*
reported two days later, Lord
Fitzwilliam's brown colt *Mulatto*,
ridden by T. Lye, won the race
over two miles and five furlongs.
The favourite, *Memnon* (owned by

Lord Cleveland), and the winner
in the 1826 Gold Cup, *Fleur-de-
lis* (owned by Sir Matthew White
Ridley), were second and third
but, according to the
Weatherbys' *Racing Calendar*,
were 'so near that the Judge
could not place them'. Herring's
painting shows *Longwaist* and
Tarrare bringing up the rear.
Similar paintings record the
finish of the same race in 1826
and the 1828 race midway round
the course.

Three years after he painted
this canvas Herring, while
maintaining his native contacts
in Yorkshire, moved to
Newmarket. HGB

PROVENANCE 1963: acquired by the
museum
REFERENCE O. Beckett, *J. F. Herring &
Sons*, London and New York, 1981, p. 99,
no. 33

OLD MASTER
DRAWINGS

OLD MASTER DRAWINGS

The history of the collections of Old Master drawings in English regional galleries effectively began in 1765, when General Guise bequeathed more than 2000 drawings to Christ Church, Oxford (cat. 68, 70, 73, 80). Over 80 years later, the Ashmolean Museum received the first in a series of outstanding bequests, destined to make it the greatest repository of Old Master drawings in England outside London. This consisted of works from the collection of Sir Thomas Lawrence, donated to the museum through the efforts of his executor, Samuel Woodburn (cat. 76, 77). Among subsequent bequests were the collections of Francis Douce, bequeathed to the Bodleian Library in 1834 and transferred to the Ashmolean in 1865 (cat. 75), the Chambers Hall collection in 1855 (cat. 97) and that of Grete Ring in 1954, which included one of the most important groups of 19th-century German drawings outside Germany (cat. 109). Outstanding purchases were also made by Dr K.T. Parker, who served as Keeper of Fine Art and Director of the museum from 1934 to 1961 (cat. 81, 87, 107).

Second only to the Ashmolean's collection of Old Master drawings is that of the Fitzwilliam Museum, Cambridge, which received major bequests from A.A. Vansittart in 1862 (cat. 95), Charles Shannon in 1937 (cat. 72, 102, 108, 111) and Louis C.S. Clarke in 1960 (cat. 69, 78, 79, 92). In 1991 the Fitzwilliam was among a group of institutions – including museums in London, Oxford, Birmingham, Liverpool and Edinburgh – that formed a consortium to save for the nation many of the finest drawings from the collection of the Earl of Leicester (cat. 94).

Complementing the riches of Oxford and Cambridge are less well known bequests of Old Master drawings throughout the country. These include the collection of William Cotton, presented to Plymouth in 1853 (cat. 99, 101, 103), and that of John Ingram, acquired in Italy in the late 18th and early 19th centuries and bequeathed by his family to the Royal Museum, Canterbury, in 1899 (cat. 104, 105). Among more recent bequests are those of Thomas Man Bridge (*c.* 1809–83) to the Folkestone museum (cat. 74, 83, 88, 89) and Alfred de Pass to the Royal Cornwall Museum, Truro (cat. 84, 85, 93, 100, 110). Most magnificent of all was the acquisition by the Walker Art Gallery in 1995 of the majority of the extensive collection of drawings, once owned by Charles Blundell, which had passed by descent to the Weld family. Many had belonged to William Roscoe, whose collection of Old Master paintings already comprised one of the greatest artistic treasures of the city of Liverpool (cat. 86, 90). R V

68

Hugo van der Goes
(c. 1437–82)

Jacob and Rachel, c. 1475 (?)

point of the brush in brown wash,
heightened with white body colour,
on slate-grey prepared paper,
33.6 × 57.1 cm
The Governing Body, Christ Church,
Oxford, JBS1309

In the diary of his tour of
Flanders in 1520–2, Albrecht
Dürer records the names of only
three local masters whose fame
survived their deaths: Jan van
Eyck (died 1441), Rogier van der
Weyden (1399/1400–64) and
Hugo van der Goes. The last was
apparently a prolific artist
during his short career, which
lasted from his admission as a
master at Ghent in 1467 until
his death in 1482. His paintings,
notably the altarpiece painted for
Tommaso Portinari *c.* 1473–5
(Uffizi, Florence), introduced a
new monumentality to
Netherlandish art. *Jacob and
Rachel* is the most important of
the artist's surviving drawings
and one of his most beautiful
creations in any medium. It
illustrates the biblical episode in
which Jacob meets Rachel and
falls in love with her (Genesis
29:15–21). Rachel's sister, the
plain Leah, stands on the right,
and their father, Laban, on the
left. So large a drawing may have
been a preparatory study for a
painting, since Van der Goes
worked his compositions out
very carefully before beginning
to paint, but it may equally well
have been a record made for
himself or a patron.

The drawing was probably
sold to General Guise (cat. 3)
by Salomon Gautier, a dealer
from Amsterdam. Several of the
greatest drawings in Guise's
collection at Christ Church came
from this source. CH

PROVENANCE Salomon Gautier (?);
General John Guise; 1765: bequeathed by
him to Christ Church
EXHIBITION *Old Master Drawings*,
London, RA, 1953, no. 240
REFERENCES F. Winkler, *Das Werk des
Hugo van der Goes*, Berlin, 1964, p. 267;
A. Seilern, *Flemish Paintings and Drawings
at 56 Princes Gate London SW7: Addenda*,
London, 1969, p. 40; J. Byam Shaw,
*Drawings by Old Masters at Christ Church,
Oxford*, 2 vols., Oxford, 1976, no. 1309
(with full bibliography)

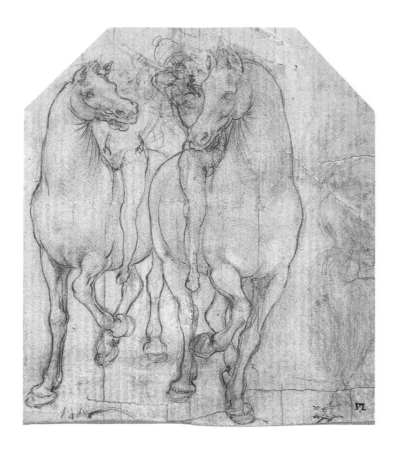

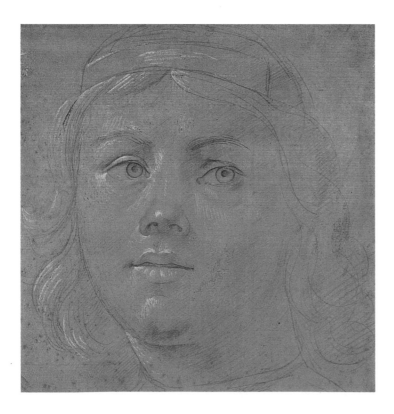

69

Leonardo da Vinci
(1452–1519)
Two Horsemen, 1481

metalpoint with pen and brown ink
on a pinkish prepared ground on
paper, 14.3 × 12.8 cm
Lent by the Syndics of the
Fitzwilliam Museum, Cambridge,
PD 121-1961

Leonardo prepared a treatise,
apparently destroyed in 1499, on
the anatomy, musculature and
movement of the horse. He
introduced the horse into at least
two of his early paintings,
including *The Adoration of the
Kings* commissioned in March
1481 for the convent of
S. Donato a Scopeto outside
Florence, but abandoned when
Leonardo left for Milan that
autumn. Several studies for the
horses in this ambitious painting
(Uffizi, Florence) survive: the
horse on the left of the present
sheet corresponds closely to the
horse nearest the centre of the
painting. The drawing is made
in the demanding medium of
metalpoint on a prepared
ground, much used by
Quattrocento masters –
demanding because it allowed no
hesitation or revision. Leonardo
has accentuated the contours in
pen and ink, fixing them around
the shading in metalpoint to
give the figure more presence.
The drawing comes from the
collection of Louis Clarke (see
cat. 78). CH

PROVENANCE Sir Peter Lely; Jonathan
Richardson Sr; George Hibbert; Hon. A.
Holland-Hibbert; 1926, 29 June:
Sotheby's, London, lot 17, bought by
Agnew's for Charles B.O. Clarke; 1935:
bequeathed by him to Grace Clarke; by
1952: Louis C.G. Clarke; 1960:
bequeathed by him to the museum
EXHIBITIONS *Italian Art and Britain*,
London, RA, 1960, no. 577; *European*

Drawings from the Fitzwilliam Museum,
New York, Pierpont Morgan Library, *et
al.*, 1976–7, no. 20; *Drawings from the
Collection of Louis C.G. Clarke, LL.D.,
1881–1960*, Cambridge, Fitwilliam
Museum, 1981–2, pp. 43–4 (with full
bibliography)
REFERENCE A.E. Popham, *The
Drawings of Leonardo da Vinci*, London,
1946, no. 65

70

Lorenzo di Credi
(1457–1537)
*Head of a Boy in a Cap,
nearly full-face*, c. 1500 (?)

silverpoint, heightened with white,
on buff-coloured ground on paper,
21.8 × 21.2 cm
The Governing Body, Christ Church,
Oxford, JBS31

Lorenzo di Credi studied in the
workshop of Andrea del
Verrocchio (*c.* 1435–88) in
Florence at the same time as
Leonardo, but his work belongs
firmly to the Quattrocento. His
numerous studies in metalpoint
are generally accomplished in
technique, but this example
betrays the pitfalls, as well as the
beauties, of the medium: the left
eye is badly misplaced and could
not be corrected, but the
caressing strokes of the contours
and shading, and the white
highlights, are of great delicacy
and subtlety. It is typical of
drawings made from life of
studio assistants (*garzoni*), not as
portraits but as studies of expres-
sion and facial characteristics.

General Guise (see cat. 3)
apparently intended to build up
a collection of Italian drawings
from the 15th to the 18th
century, in particular the early
Florentine masters, bought at a
time when their fame was all but
eclipsed. CH

PROVENANCE Jonathan Richardson
Sr; General John Guise; 1765:
bequeathed by him to Christ Church
REFERENCES G. Dalli Regoli, *Lorenzo
di Credi*, Pisa, 1966, no. 84; J. Byam
Shaw, *Drawings by Old Masters at Christ
Church, Oxford*, 2 vols., Oxford, 1976, no.
31 (with full bibliography)

71

Francesco di Giorgio Martini (1439–1502)

Adam and Eve: The Fall, late 1460s

pen and brown ink and wash on
vellum, 34.2 × 26.8 cm
The Governing Body, Christ Church,
Oxford, 1976

Francesco di Giorgio was
appointed architect to the city of
Siena in 1485 and is best known
for his designs for municipal
buildings; but he was also a
sculptor and bronze caster and
painted a number of altarpieces.
This remarkable drawing was
probably made early in his career.
The figure of God in a swirling
cloud of angels and cherubs was
clearly an invention that pleased
the artist, for he included it in a
Nativity altarpiece (divided
between The Metropolitan
Museum of Art, New York, and
the National Gallery of Art,
Washington), which would also
seem to date from the late 1460s.
Such a finished drawing, on
expensive vellum rather than
paper, would probably have
served as a contract drawing to
indicate the precise composition
for a commission.

According to his grand-
daughter, Holman Hunt kept
this drawing of two nudes
hidden under a book and showed
it only to 'privileged old
gentlemen'. It was the only
important 'Pre-Raphaelite' work
of art that he owned. CH

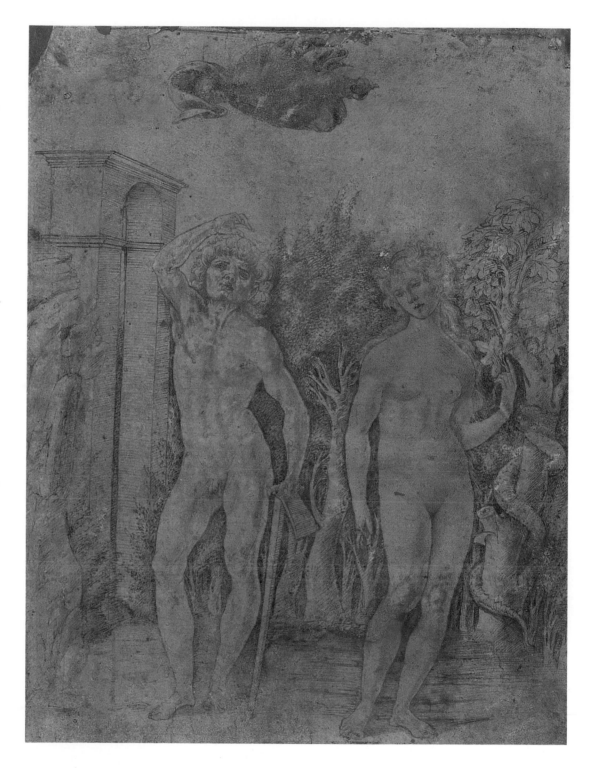

PROVENANCE 1869: bought by
William Holman Hunt (label on verso
inscribed: *This Picture / by Mantegna I
bought / at Assisi 1869 / from a family. /
When relined owing to its worm eaten /
condition, the figure / of the Almighty / became
obscured / W. Holman Hunt*); his daughter,
Mrs Michael Joseph; her adopted
daughter, Mrs Elisabeth Burt; 1964,

4 December: Christie's, London, lot 19;
Paul Hatvany; 1980: accepted by HM
Government in lieu of inheritance tax on
the estate of Baron Hatvany and allocated
to Christ Church
EXHIBITION *Old Master Drawings*,
London, RA, 1953, no. 10
REFERENCES A. McComb, 'The Life
and Art of Francesco di Giorgio', *Art

Studies*, II, 1924, 15, 22, 23, 32; A.S.
Weller, *Francesco di Giorgio 1439–1501*,
Chicago, 1943, pp. 255–6; D. Holman-
Hunt, 'The Holman Hunt Collection: A
Personal Recollection', in *Pre-Raphaelite
Papers*, London, 1984, pp. 206–25

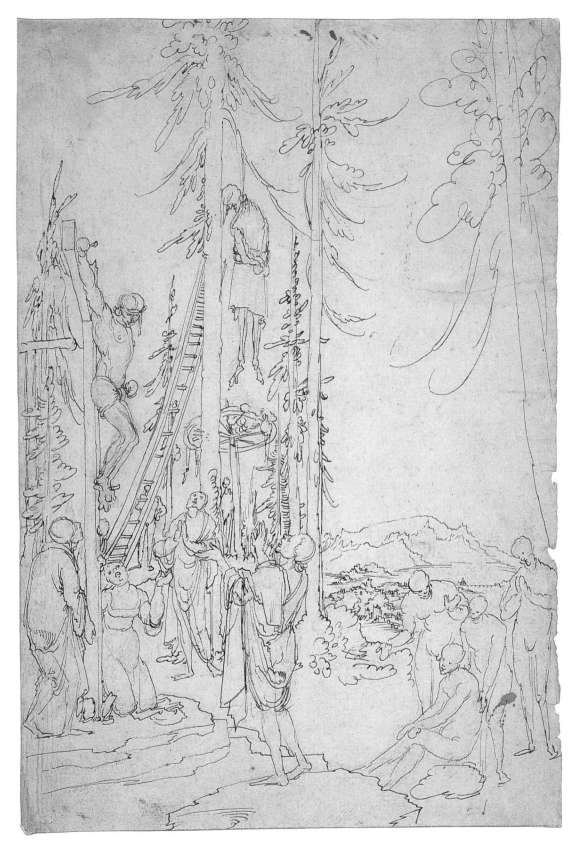

72

Wolf Huber
(*c.* 1480–1553)
The Crucifixion, c. 1525
pen and Indian ink on paper,
32 × 21.5 cm
Lent by the Syndics of the
Fitzwilliam Museum, Cambridge,
2076

The bizarre and fantastic art of
the Danube School at the
beginning of the 16th century
was dominated by Albrecht
Altdorfer (*c.* 1480–1538) and
Wolf Huber. Huber worked
principally at Passau, today on
the Austro-German border.
This drawing is probably a
compositional sketch for the
wing of an altarpiece, although
no related painting survives. Its
rapid, fluid style, including the
cursory drawing of the figures,
some of which are naked and
may have been copied from
wooden dolls, are characteristic
of drawings by Huber dated
1525–6. The scene of execution
includes the traditional three
victims, Christ and two robbers,
but takes place amid the fir-trees
of the Bavarian Alps. Despite
this, the draughtsmanship lends
the drawing an air of unreality
typical of Huber's art. C H

PROVENANCE Charles Ricketts and
Charles Shannon; 1937: bequeathed to the
museum by the latter
EXHIBITIONS *Old Master Drawings*,
London, RA, 1953, no. 228; *Prints and
Drawings of the Danube School*, New
Haven, Yale University Art Gallery, St
Louis, Art Museum, and Philadelphia
Museum of Art, 1969–70, no. 84;
*European Drawings from the Fitzwilliam
Museum*, New York, Pierpont Morgan
Library, *et al.*, 1976–7, no. 55 (with full
bibliography); *All for Art: The Ricketts and
Shannon Collection*, Cambridge,
Fitzwilliam Museum, 1979, no. 137
REFERENCES E. Heinzle, *W. Huber*,
Innsbruck, 1954, no. 47; F. Winzinger,
Wolf Huber: Das Gesamtwerk, 2 vols.,
Munich and Zurich, 1979, no. 72

73

Albrecht Dürer
(1471–1528)

Study for the Tomb of a
Knight and his Lady,
c. 1509–10

pen and brown ink on paper,
25.9 × 17.9 cm
The Governing Body, Christ Church,
Oxford, JBS1422

This drawing served as a
preliminary study both for Dürer
himself and for the Vischer brass
foundry. Dürer incorporated the
figure of the lady into his
woodcut *The Beheading of John the*
Baptist of 1510, in which she
appears as a servant, and it was
adapted by Herrmann Vischer,
with considerable alterations, for
the effigies on two tombs cast in
his workshop: the first, for Count
Hermann VIII von Henneberg
(died 1535) and his wife,
Elisabeth von Brandenburg (died
1507), in the church at Römhild;
the second, for Count Eitel
Friedrich II von Hohenzollern
(died 1512) and his wife,
Magdalena von Brandenburg
(died 1496), in the church at
Hechingen. The collaboration
between artist and founder is not
otherwise documented, but that
Dürer was accustomed to pro-
viding such designs is indicated
by the drawings he produced at
about this time for the tombs in
the Fugger Chapel in the
cathedral at Augsburg, which
were cast by the sculptor Adolf
Daucher (*c.* 1460/5–1523/4).

The existence of at least two
copies of the drawing suggests
that it was widely admired. CH

PROVENANCE General John Guise;
1765: bequeathed by him to Christ
Church, Oxford
EXHIBITIONS *1471 Albrecht Dürer*
1971, Nuremberg, Germanisches
Nationalmuseum, 1971, no. 704; *The Age*
of Dürer and Holbein: German Drawings
1400–1550, London, British Museum,
1988, no. 59

REFERENCES F. Winkler, *Die*
Zeichnungen Albrecht Dürers, 4 vols.,
Berlin, 1936–9, II, no. 489; E. Panofsky,
Albrecht Dürer, 2nd edn, 2 vols.,
Princeton, 1945, no. 1543; J. Byam
Shaw, *Drawings by Old Masters at Christ*
Church, Oxford, 2 vols., Oxford, 1976, no.
1422 (with full bibliography)

74

Jörg Breu the Elder
(*c.* 1475–1537)

Feast of the Passover, c. 1530

pen and brown ink and grey wash on
paper, 9.8 × 27.1 cm
inscribed (on verso): *Christoff
Amberger*
Kent County Council Arts and
Libraries

Breu was a versatile and prolific
artist whose work ranged from
important large-scale decorative
schemes on sacred or secular
themes to designs for stained
glass and book illustrations. This
drawing, illustrating the Feast of
the Passover instituted by Moses
(Exodus 12:3-14), served as the
design for a relief (Szépmüvészeti
Múzeum, Budapest) by Victor
Keyser (died 1552/3), one of the
virtuoso carvers working at
Augsburg in the second quarter
of the 16th century. Although
the relief follows the drawing
fairly closely, Keyser has replaced
Breu's earthy, almost caricatural,
types with idealised figures more
suitable for a church, and the
material itself, the smooth

limestone quarried at Solnhofen,
emphasises this refinement.

The collection of Old Master
drawings now stored in a
warehouse belonging to Kent
County Council was formed by
Thomas Man Bridge (*c.* 1809–
83), who began collecting as a
young man in Italy in the 1830s
and continued to do so for most
of his life. Among a great many
optimistic attributions are several
undisputed masterpieces (cat. 74,
83, 88, 89). CH

PROVENANCE Thomas Man Bridge;
1883: his sister, Frances Hannah, Lady
Bisset; 1890: her husband, General Sir
John Jarvis Bisset; 1894: his daughter,
Amy, Mrs Charles Hoskin Master; 1924:
presented by her to the museum in
memory of the late Lady Bisset
REFERENCE R.A. Morral, 'Jörg Breu
the Elder (*c.* 1475–1537): Renaissance
and Reformation in early Sixteenth
Century Augsburg', unpublished Ph.D.
dissertation, Courtauld Institute of Art,
University of London, 1996, pp. 123–5,
fig. 72

75

**Mathis Nithart, called
Grünewald** (*c.* 1475–1528)

*An Elderly Woman with
clasped Hands, c.* 1510

black chalk on paper, 37.7 × 23.6 cm
inscribed: [M]*athis* / *Matsis* / *Disses
hatt Mathis von Ossenburg des Churfürst
en v*[*on*] *Mentz Moler gemacht und wo
du Mathis geschriben findest das ha*[*tt*]
Er mit Eigener handt gemacht
The Visitors of the Ashmolean
Museum, Oxford, PI 297

One of the most moving
drawings of the German
Renaissance, this was perhaps
made as a study for the Virgin or
Mary Magdalene in one of the
scenes of Christ's Passion. It is
not related to any known
painting, but is usually dated
shortly before Grünewald began
his greatest work, the Isenheim
altarpiece of *c.* 1512–15. The
long inscription attests to the
authenticity of the artist's
signature, otherwise unknown on
Grünewald's drawings.

The bequest of the eccentric
antiquary Francis Douce to the
Bodleian Library was the richest

the University of Oxford has ever
received. It included important
series of drawings and prints,
especially of the early Northern
schools, as well as illuminated
manuscripts, printed books and
invaluable ephemera. CH

PROVENANCE Francis Douce; 1834:
bequeathed to the Bodleian Library,
University of Oxford; 1863: transferred to
the University Galleries
EXHIBITIONS *Dürer to Cézanne:
Northern European Drawings from the
Ashmolean Museum*, New Brunswick, Jane
Voorhees Zimmerli Art Museum, and
Cleveland Museum of Art, 1982–3, no. 7;
The Age of Dürer and Holbein, London,
British Museum, 1988, no. 119
REFERENCES K.T. Parker, *Catalogue of
the Collection of Drawings in the Ashmolean
Museum*, I, *Netherlandish, German, French
and Spanish Schools*, Oxford, 1938, no.
297; E. Ruhmer, *Grünewald Drawings:
Complete Edition*, London, 1970, no. XVI;
F. Baumgart, *Grünewald: Tutti i disegni*,
Florence, 1974, no. XII

Matsis

Disses hat Matsis von
Offenburg des churfürsten
Ments Moler gemacht
und wo die Matsis ge
schriben findest das hat
er mit eigner hand
gemacht

Michelangelo Buonarroti
(1475–1564)
*Various Studies for the Sistine
Ceiling and the Tomb of Pope
Julius II, c.* 1512

red chalk and pen and brown ink on
off-white paper, 28.6 × 19.4 cm
The Visitors of the Ashmolean
Museum, Oxford, PII 297

Two great papal projects
preoccupied Michelangelo
during his earlier years in Rome:
the decoration of the vault of the
Sistine Chapel in the Vatican
(completed in 1514) and the
carving of a tomb for Pope Julius
II (which was never finished).
This sheet includes a red-chalk
study, made from the life, of the
boy accompanying the Libyan
Sibyl on the Sistine ceiling and,
perhaps drawn slightly later, a
series of informal notations for
the slaves to support the papal
tomb and a decorated cornice for
that project. The study of the
boy is closely related to that for
the Libyan Sibyl (The Metro-
politan Museum of Art, New
York), whose right hand can be
seen in the Ashmolean sheet.

The failure of the state to
acquire, at a highly preferential
price, the unique collection of
drawings formed by Sir Thomas
Lawrence is a grave reflection of
the philistinism of government.
After protracted negotiations,
and thanks only to the energies
of private individuals and of
Lawrence's executor, Samuel
Woodburn, the University of
Oxford was given the remains of
the most important group, by
Raphael (cat. 77) and
Michelangelo. They are now one
of the principal treasures of the
Ashmolean Museum. CH

PROVENANCE Pierre-Jean Mariette; Marquis de Lagoy; Sir Thomas Lawrence; Samuel Woodburn; 1846: presented to the University Galleries, Oxford, by a Body of Subscribers
EXHIBITIONS *Italian Art and Britain*, London, RA, 1960, no. 536; *Drawings by Michelangelo in the Collection of Her Majesty the Queen at Windsor Castle, the Ashmolean, the British Museum and other English Collections*, London, British Museum, 1975, no. 19
REFERENCES K.T. Parker, *Catalogue of the Collection of Drawings in the Ashmolean Museum*, II, *Italian Schools*, Oxford, 1956, no. 297; F. Hartt, *The Drawings of Michelangelo*, London, 1971, no. 89

77

Raffaello Sanzio, called Raphael (1483–1520)

Study for an Angel in the Chigi Chapel, c. 1515

red chalk over stylus on paper, 19.7 × 16.8 cm
The Visitors of the Ashmolean Museum, Oxford, PII 567

In his later years in Rome, Raphael found time to undertake major projects for other patrons besides the Pope. For the Sienese Agostino Chigi, the papal banker, he worked on several commissions, including that for the family chapel in Sta Maria del Popolo. Here, Raphael was both architect and decorator, designing the structure itself, the mosaics in the cupola, the tombs on the walls, the marble sculpture in the niches, and the altarpiece. In the centre of the dome, God the Father appears with his arms raised, while beneath him angels set in motion the planets and seven stars. Two of the few surviving drawings for the mosaics are in the Ashmolean: this graceful study for the angel accompanying the planet Jupiter, and another for

the figure of God. From them, Raphael would have made full-scale cartoons, on to which the mosaicist, Antonio del Pace, would have stuck the mosaic pieces (*tesserae*), then transferred the whole design to the ceiling, and removed the cartoon. The drawings are thus in reverse to the mosaics. The decoration was completed in 1516.

The series of drawings by Raphael from Sir Thomas Lawrence's collection, now in the Ashmolean (see cat. 76), is the most representative in the world. CH

PROVENANCE Jean-Baptiste Wicar; Sir Thomas Lawrence; Samuel Woodburn; 1846: presented to the University Galleries by a Body of Subscribers
EXHIBITIONS *Italian Art and Britain*, London, RA, 1960, no. 547; *Drawings by Raphael from the Royal Library, the Ashmolean, the British Museum and other English Collections*, London, British Museum, 1983, no. 153
REFERENCES K.T. Parker, *Catalogue of the Collection of Drawings in the Ashmolean Museum*, II, *Italian Schools*, Oxford, 1956, no. 567; P. Joannides, *The Drawings of Raphael with a Complete Catalogue*, Oxford, 1983, no. 387

Francesco Mazzola, called Parmigianino (1503–40)

The Holy Family, *c.* 1524–7

pen and brown ink and wash, heightened with white, on paper, 15.5 × 14.4 cm
Lent by the Syndics of the Fitzwilliam Museum, Cambridge, PD 123-1961

Parmigianino painted numerous versions of this subject, but this drawing is not directly related to any. It shows an extended Holy Family, including St Anne with the infant John the Baptist. It probably dates from the artist's period in Rome (1524–7), when he made numerous drawings, experimented with etching and painted several altarpieces, notably *The Vision of St Jerome* (National Gallery, London).

Louis Clarke, a distinguished archaeologist and collector, was Director of the Fitzwilliam Museum from 1937 to 1946. His many gifts to the museum included a carefully chosen group of Old Master drawings, several of them from the Pembroke sale of 1917 (see also cat. 79). CH

PROVENANCE Sir Peter Lely; the Earls of Pembroke; 1917, 10 July: Sotheby's, London, Pembroke sale, lot 432, bought by Agnew's for Charles B.O. Clarke; 1935: bequeathed by him to Louis C.G. Clarke; 1960: bequeathed by him to the museum
EXHIBITIONS *European Drawings from the Fitzwilliam Museum*, New York, Pierpont Morgan Library, *et al.*, 1976–7, no. 28; *Drawings from the Collection of Louis C.G. Clarke, LL.D., 1881–1960*, Cambridge, Fitzwilliam Museum, 1981–2, pp. 53–4
REFERENCES S.A. Strong, *Drawings by Old Masters at Wilton House*, London, 1900–2, IV, no. 34; A.E. Popham, *Catalogue of the Drawings of Parmigianino*, 3 vols., London and New Haven, 1971, no. 49

79

Antonio Allegri da
Correggio (1489–1534)
The Nativity, c. 1522

pen and brown ink and wash over
red chalk heightened with white on
paper, 24.3 × 20.9 cm
Lent by the Syndics of the
Fitzwilliam Museum, Cambridge,
PD 119-1961

This drawing has been regarded
at least since the 18th century as
an early study for Correggio's
celebrated altarpiece of the
Adoration of the Shepherds,
known as *La Notte*
(Gemäldegalerie, Dresden). The
contract for the painting was
given at Reggio Emilia on 14
October 1522 and stipulated
that Alberto Pratonero agreed to
pay 200 lire for a Nativity
executed in accordance with the
drawing already supplied by the
artist; the painting was installed
by 1530. This drawing differs
greatly from the painting: the
composition is considerably
simplified, in reverse, the figures
fewer and differently disposed,
and the architecture given much
greater prominence. Moreover,
the transitions between light and
dark, emphasised in the
painting, are not attempted in
the drawing, although the
deterioration of the white body
colour may conceal such
subtleties. Like most of
Correggio's drawings, this
example is functional rather than
formal, a stage in the creative
process rather than an end in
itself.

This is another of the
drawings from the Pembroke
collection bequeathed by Louis
Clarke to the Fitzwilliam
Museum (see also cat. 78). C H

PROVENANCE Sir Peter Lely; William
Gibson; the Earls of Pembroke; 1917, 10
July: Sotheby's, London, lot 490, bought
by Agnew's for Charles B.O. Clarke;
1935: bequeathed to Louis C.G. Clarke;
1960: bequeathed by him to the museum
EXHIBITIONS *Old Master Drawings,*
London, RA, 1953, no. 60; *European
Drawings from the Fitzwilliam Museum,*
New York, Pierpont Morgan Library, *et
al.,* 1976–7, no. 15; *Drawings from the
Collection of Louis C.G. Clarke, LL.D.,
1881–1960,* Cambridge, Fitwilliam
Museum, 1981–2, pp. 39–40

REFERENCES A.E. Popham, *Correggio's
Drawings,* London, 1957, no. 72;
C. Gould, *Correggio's Paintings,* London,
1976, pp. 104, 205, pl. 109B; M. di
Giampaolo and A. Muzzi, *Correggio:
I disegni,* Turin, 1988, no. 82

80

Jacopo Carrucci, called
Pontormo (1494–1557)
The Deposition, c. 1526–7

black chalk, lightly washed,
heightened with body colour,
squared in red chalk on paper; the
outlines reinforced with the stilus,
44.3 × 27.6 cm
The Governing Body, Christ Church,
Oxford, JBS119

In 1525 Lodovico di Gino
Capponi purchased a chapel in
the church of S. Felicita in
Florence, intending that he
should be buried there. He
quickly had the chapel
rededicated, and commissioned
Pontormo to decorate it and
paint the altarpiece. Pontormo's
frescoes and the altarpiece are
some of the most affecting and
original works of Florentine
Mannerism. The altarpiece was
preceded by a large group of
drawings, of which this
compositional study is the most
important.

This drawing, one of the most
significant documents of
Florentine Mannerism, lay
unrecognised at Christ Church
for nearly 200 years after its
bequest by General Guise
(cat. 3). CH

PROVENANCE Jonathan Richardson Sr;
General John Guise; 1765: bequeathed by
him to Christ Church
REFERENCES J. Cox-Rearick, *The
Drawings of Pontormo*, 1964, no. 272;
J. Byam Shaw, *Drawings by Old Masters at
Christ Church, Oxford*, 2 vols., Oxford,
1976, no. 119 (with full bibliography);
P. Costamagna, *Pontormo*, Milan, 1994,
under no. 52

81

Agnolo di Cosimo, called Bronzino (1503–72)

Joseph recounting his Dream of the Sun, Moon and eleven Stars, c. 1548

black chalk on off-white paper, with traces of squaring, 43.5 × 33.1 cm
inscribed (on verso): *del Broncino*
The Visitors of the Ashmolean Museum, Oxford, WA 1961.11

For both political and practical reasons, Duke Cosimo de' Medici established a tapestry manufactory in Florence in 1545. During the first ten years, two main series of hangings were planned for the Palazzo Vecchio, one of them on the story of Joseph for the Sala dei Dugento. For this, three artists from the second generation of Mannerism were commissioned to provide designs: Bronzino made sixteen cartoons, Pontormo three and Salviati one. The second design shows Joseph naively recounting the dream in which he saw the sun and moon and eleven stars making obeisance to him, as his father and mother and eleven brothers would come to do (Genesis 37:9–11). This important drawing, one of only a handful to survive from the project, was made as a study to aid the artist in establishing the composition and also as a finished design to show to Duke Cosimo for approval; the upper part of the sheet is now in the Uffizi. The tapestry was delivered by the weaver between 15 July and 3 August 1549; the drawing was presumably made the previous year. Perhaps Bronzino's masterpiece as a draughtsman, it was unrecorded before being bought for the Ashmolean by K.T. Parker (see cat. 87). C H

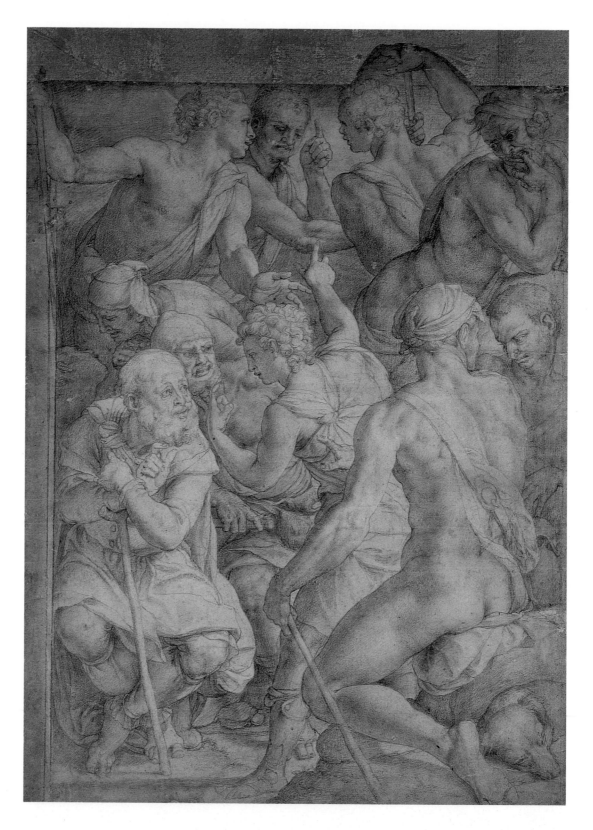

PROVENANCE Filippo Baldinucci (?);
1961: purchased by the museum

REFERENCES C. Monbeig-Goguel, *Il manierismo fiorentino*, Milan, 1971, pl. xiv; C.H. Smith, *Bronzino as Draughtsman: An Introduction*, New York, 1971, pp. 35–9;

H. Macandrew, *Ashmolean Museum Oxford: Catalogue of the Collection of Drawings*, III, *Italian Schools: Supplement*, Oxford, 1980, no. 128-1

Giulio Pippi, called Giulio Romano (*c.* 1499–1546)
Head of an Eagle, c. 1527–8
pen and brown ink and wash on paper, 12.1 × 21.3 cm
inscribed (on backing, by Jonathan Richardson): *J.17.D From the famous Eagle of the Mattei (as 'tis called) an antique in Villa of th[e]*
Pallant House Gallery, Chichester, Hussey Bequest (Chichester District Council), CHCPH0145

This is one of two closely related studies of the head of an eagle (the other is in the British Museum), which have been connected with architectural projects by Giulio at Mantua. Although Richardson associated it with an Antique eagle at a Mattei villa, an eagle was also Duke Federico Gonzaga's emblem.

Lawrence's incomparable collection of Old Master drawings (see also cat. 76, 77, 92) was shown by the dealer Samuel Woodburn in a series of exhibitions between May 1835 and July 1836. The drawings by Giulio Romano and the Carracci family were bought *en bloc* by Lord Francis Egerton, who immediately gave two huge Carracci cartoons to the National Gallery, London, and some 40 of the lesser drawings by the Carracci to the University Galleries at Oxford in 1853. The remainder were exhibited at the family's London residence, Bridgewater House, until World War II. *Head of an Eagle* was later one of the few Old Master drawings owned by Walter Hussey, Dean of Chichester, who preferred works by fashionable modern or 18th-century artists. CH

PROVENANCE Jonathan Richardson Sr; Sir Thomas Lawrence; Samuel Woodburn; 1836: bought by Lord Francis Egerton, created 1st Earl of Ellesmere in 1853; by descent to the 5th Earl, who succeeded as 6th Duke of Sutherland in 1963; 1972, 5 December: Sotheby's, London, lot 25; Brod Gallery; Very Rev. Walter Hussey; 1985: bequeathed by him to the gallery
REFERENCES F. Hartt, *Giulio Romano*, 2 vols., New Haven, 1958, no. 222; D. Coke, *The Fine Art Collections, Pallant House, Chichester*, London, 1990, p. 44

83

Piero Buonaccorsi, called Perino del Vaga (1500–47)
The Reception of Psyche,
c. 1545–6

black chalk, pen and brown ink and wash, partly squared in black chalk, on paper, 28.9 × 22.6 cm
Kent County Council Arts and Libraries

Towards the end of 1537, Perino returned to Rome from Genoa, having fled during the Sack of Rome in 1527. He spent the remainder of his career in the service of Cardinal Alessandro Farnese and his grandfather Pope Paul III, for whom he decorated parts of the state rooms in the Vatican, including the Stanza della Segnatura and the Sala Regia, and the papal suite in the Castel Sant'Angelo. The fresco cycle in the Sala di Amore e Psiche of the latter, painted by Perino and his assistants in 1545–6, tells the story of Psyche, her tribulations with Cupid and final arrival on Mount Olympus. This drawing may be a preliminary study for one of these frescoes, in which case it would show female attendants preparing to bathe and anoint Psyche on her arrival. However, the drawing does not correspond with any of the finished designs in the Castel Sant'Angelo and its subject is by no means certain. The studies on the verso (facing page), which may show participants in the Feast of the Gods on Olympus, are equally characteristic of Perino's style in Rome, the figures drawn in outline and crowded onto the page. CH

PROVENANCE Thomas Hudson; Richard Cosway; Thomas Man Bridge; thence as cat. 74
EXHIBITION *Kent Master Collection*, London, Christie's, *et al.*, 1991–2, no. 2

84

Domenico Campagnola
(*c.* 1500–64)

*Landscape with the Temptation
of Christ, c.* 1540 (?)

pen and brown ink on paper,
26 × 39 cm
The Royal Institution of Cornwall,
Royal Cornwall Museum, Truro,
1928.324

The son of a German bootmaker,
Domenico Campagnola took the
name of his master, Giulio
Campagnola (died 1516), an
associate of Giorgione. From
Giulio he learned not only
painting, but also the techniques
of engraving on copper and wood

and of producing finished
drawings. He moved to Padua in
1523 and became the principal
painter of the city.

Campagnola's early drawings
imitate the style and subject-
matter of Titian's, but he later
produced freer and more
inventive compositions which
were highly prized by collectors.
During his later years, he used
larger sheets, filling them with
panoramic landscapes which
contained biblical or pastoral
subjects. A series with episodes
from the life of Christ probably
dates from this period and in-
cludes this characteristic drawing
from the De Pass collection (see
cat. 85). It betrays Campagnola's

familiarity with engraving
techniques and his concern for a
rhythmical surface and pleasing,
regular texture. The high view-
point over undulating hillsides
reveals his knowledge of
Netherlandish and German
woodcuts and drawings. CH

PROVENANCE Sir Peter Lely; 1907,
5 July: Sotheby's, London, Earls of
Pembroke sale, lot 399, bought by Alfred
de Pass; 1928: presented by him
EXHIBITIONS *Drawings from the De Pass
Collection*, London, Arts Council, 1957, no.
3; London, 1962, no. 317; *Exhibition
Catalogue of Master Drawings from the De
Pass Collection, Royal Cornwall Museum,
Truro*, London, Phillips, and Truro, Royal
Cornwall Museum, 1994, no. 5
REFERENCE G. Penrose, *Catalogue of the
Alfred A. de Pass Collection*, Truro, 1936,
no. 133

85

Jacopo Ligozzi
(*c.* 1547–1627)

*The Virgin Mary blessing two
Monks and accompanied by
Sts Mary Magdalene, Agnes,
Cecilia and Catherine, with
Christ and Angels above,
c.* 1590 (?)

pen and brown ink and wash
heightened with gold, on a brown
ground, on paper, 42.7 × 27 cm
The Royal Institution of Cornwall,
Royal Cornwall Museum, Truro,
1928.336

Ligozzi began his career at
Verona as a miniaturist. After his

move to Florence in 1577, he
was employed by Francesco I de'
Medici in making minutely
detailed drawings of specimens
of plants and animals. He was
appointed court painter to
Ferdinando de' Medici in 1585
and undertook commissions not
only for paintings, but also for
designs for jewellery, glass,
textiles and furniture. This
drawing is one of a group of
exquisitely finished studies
clearly intended as works of art
to be appreciated in the privacy
of the collector's cabinet. The
technique is eccentric and old
fashioned: the coloured ground is
reminiscent of Northern
chiaroscuro woodcuts, while the
minute penwork, in both ink
and gold, is an exaggerated
version of that used by Mantegna
in some of his pen drawings.

The large and eclectic
collection of Old Master and
19th-century drawings in the
Royal Museum at Truro (see also
cat. 93, 100, 110) was formed by
the South African industrialist
Alfred de Pass (1861–1953). He
had a holiday home at Falmouth
and was a consistent donor of
works of art to Cornish
museums, as well as to national
and university museums in
England and South Africa. CH

PROVENANCE Alfred de Pass; 1928:
presented by him to the Royal Institution
of Cornwall
EXHIBITIONS *Drawings from the De
Pass Collection*, London, Arts Council,
1957, no. 12; *Exhibition Catalogue of
Master Drawings from the De Pass Collection,
Royal Cornwall Museum, Truro*, London,
Phillips, and Truro, Royal Cornwall
Museum, 1994, no. 12
REFERENCE G. Penrose, *Catalogue of the
Alfred A. de Pass Collection*, Truro, 1936,
no. 150

Jacopo Robusti, called
Tintoretto (1518–94)
Head of Giuliano de' Medici,
after Michelangelo, 1540s (?)
black and white chalk on blue paper,
39 × 25.5 cm
Board of Trustees of the National
Museums and Galleries on
Merseyside (Walker Art Gallery,
Liverpool), WAG 1995.191

Tintoretto's copies after
sculptures by Michelangelo were
not made from the originals but
from casts and reduced copies
supplied by Michelangelo's pupil
Daniele da Volterra (*c.* 1509–66).
Tintoretto studied them
intensively, as he would the wax
or clay figures he used as models
for his paintings. Michelangelo's
statue of Giuliano de' Medici on
his tomb in the Medici Chapel in
S. Lorenzo, Florence, dates from
1516; Tintoretto made several
copies after both the whole
figure and the head alone.

This was one of 61 drawings
bought from Benjamin West's
sale in 1820 by Charles Blundell.
These joined drawings Blundell
had inherited from his father and
those he had bought at William
Roscoe's sale in 1816 (see cat. 9),
thus uniting the most important
collections in north-west
England. CH

PROVENANCE Benjamin West; 1820,
1–5 July: his sale, Christie's, London,
bought by Charles R. Blundell (died
1827); by descent; 1995: purchased by
the gallery with the aid of contributions
from the National Heritage Memorial
Fund, the National Art-Collections Fund,
Sir Denis Mahon and British Nuclear
Fuels

87

Federico Barocci
(1526–1612)

*St Dominic de Guzman
receiving the Rosary*, *c*. 1592

oil and pen and brown ink over
black chalk, the outlines incised, on
paper, 54.5 × 38.5 cm
The Visitors of the Ashmolean
Museum, Oxford, WA 1944.00

In 1582 the Sisterhood of the
Rosary in Senigallia began to
collect contributions for an
altarpiece. By 1588 they were
able to agree the commission
with Barocci, who did not com-
plete it until autumn 1592 at
the earliest. The subject enjoyed
renewed popularity during the
Counter-Reformation: appearing
to St Dominic one night in the
chapel of the Virgin at Prouille,
c. 1208, the Virgin held a rosary
in her right hand and taught
him to recite its sequence of
prayers. The absence of colour in
such oil sketches as this sets
them apart from later Baroque
oil sketches, which were made to
establish the general composition
rather than effects of light and
shade.

Like the drawings by Bronzino
and Prud'hon (cat. 81, 107), this
oil sketch was purchased for the
Ashmolean by Dr K.T. Parker,
whose career as Keeper of the
Department of Fine Art (1934–
61) and of the whole Ashmolean
Museum (1945–61) was remark-
able for his systematic of the
collection of drawings, which
now ranks second only to the
British Museum among public
collections in England. CH

PROVENANCE Nourri; 1785, 24
February: sale, Paris, lot 119; Lord
Nugent; Sir F. Boileau; 1944: purchased
by the museum
EXHIBITION *Mostra di Federico Barocci*,
Bologna, Museo Civico, 1975, no. 197

REFERENCES K.T. Parker, *Catalogue of
the Collection of Drawings in the Ashmolean
Museum*, II, *Italian Schools*, Oxford, 1956,
no. 94; H. Olsen, *Federico Barocci*,
Copenhagen, 1962, pp. 85–6, 188, under
no. 44; A. Emiliani, *Federico Barocci*
(*Urbino 1535–1612*), 2 vols., n.p., n.d.
[1985], II, pp. 264–71

88

Agostino Carracci
(1557–1602)

Youth straddling a fallen
Monster, a Club raised above
his Head, c. 1593–4

red chalk on buff paper,
27 × 17.6 cm
Kent County Council Arts and
Libraries

Italian artists had studied the
nude throughout the
Renaissance, but the Carracci
family at Bologna made it the
focus of their teaching in the
Accademia degli Incamminati
which they founded in 1582.
Indeed, so numerous are their
drawings from life that only a
fraction was used in finished
paintings. This powerfully drawn
nude is perhaps a preliminary
study for the rather different
group of Hercules and Cacus
painted by Annibale Carracci in
the Palazzo Sampieri at Bologna
c. 1593–4; a larger and more
elaborate study of the same
figure is at Christ Church,
Oxford, drawn in pen and brown
ink with wash, and squared for
enlargement. Although both
drawings are by Agostino
Carracci, the two brothers and
their cousin, Lodovico,
collaborated closely on this and
other projects, and it would not
be surprising to find one of them
making use of another's
preparatory drawings. C H

PROVENANCE Sir Peter Lely; Thomas
Man Bridge; thence, as cat. 74
EXHIBITIONS London, 1962, no. 326;
Kent Master Collection, London, Christie's,
et al., 1991–2, no. 14
REFERENCES J. Byam Shaw, *Drawings*
by Old Masters at Christ Church, Oxford, 2
vols., Oxford, 1976, under no. 924

89

Giovanni Francesco
Barbieri, called Guercino
(1591–1666)

A Boy, half length, his Chin
in his Hand, c. 1620

red chalk on buff paper,
14.6 × 17 cm
Kent County Council Arts and
Libraries

Following the example of the
Carracci family at Bologna,
whose work he may have studied
in his youth, Guercino took to
drawing scenes from daily life.
Among his subjects were local
festivals, domestic interiors and
caricatures, in which he revealed
the sympathy for the humble and
poor remarked on by his
contemporaries. This beautiful
drawing, which shows nothing
more than a boy in a soft hat
daydreaming, is one of the most
intimate of these works. The
thick, greasy red chalk, with
extensive stumping in the
shadows, probably indicates a
date early in Guercino's career,
before he left his native Cento for
Rome in 1621. The image was
later included by the Bolognese
etcher Francesco Curti in a series
of prints after Guercino's
drawings of peasants and
artisans.

Guercino's drawings have been
extensively collected in England
since the 17th century and,
although most of the early
collections have been dispersed,
his work is found in most
regional galleries which boast
Old Master drawings. Thomas
Man Bridge, for example, owned
three drawings by Guercino and
three from his circle, of which
this is by far the most
significant. C H

PROVENANCE Thomas Man Bridge; thence, as cat. 74
EXHIBITION *Kent Master Collection*, London, Christie's, *et al.*, 1991–2, no. 17

90

Sir Peter Paul Rubens (1577–1640)

The Creation of Adam, after Michelangelo, 1601

red chalk and wash with oil paint on paper, 25.3 × 28.2 cm
Board of Trustees of the National Museums and Galleries on Merseyside (Walker Art Gallery, Liverpool), WAG 1995.83

Rubens's visit to Italy in 1600–2 enabled him to see at first hand the riches of ancient and modern art that he had previously known only from engravings and copies. He travelled at the invitation of Vincenzo I Gonzaga, Duke of Mantua, for whom he made copies after paintings and sculptures, but he was allowed a great deal of freedom to undertake private study. While in Rome, he spent long hours in the Sistine Chapel copying Michelangelo's frescoes. Some of these copies were probably intended for presentation, while others enabled Rubens to study Michelangelo's distinctive forms and compositional devices. This copy after a section of the Sistine ceiling is faithful and meticulous, more akin to a presentation drawing by Michelangelo than the spirited free-hand usually found in Rubens's copies. Rubens transformed the pose of God the Father, subtly but appropriately, into the figure of Christ in his *Elevation of the Cross* (Municipal Hospital, Grasse).

The first recorded owner of this drawing, William Roscoe (cat. 9), was forced to sell his collections in 1816 owing to bankruptcy. A group of his paintings was presented by subscribers to the Royal Liverpool Institution before 1819 (see cat. 270, 284); many drawings were bought by Charles Blundell and joined his great collection (see cat. 86) which remained almost intact until its recent purchase by the Walker Art Gallery. CH

PROVENANCE William Roscoe; 1816, 22–8 September: Winstanley, Liverpool, Roscoe sale, bought by Charles R. Blundell (died 1827); by descent; 1995: purchased by the gallery with the aid of contributions from the National Heritage Memorial Fund and the National Art-Collections Fund, Sir Denis Mahon and British Nuclear Fuels
REFERENCES M. Rooses, *L'Œuvre de P.P. Rubens*, V, Antwerp, 1892, no. 1365 (untraced); M. Jaffé, *Rubens and Italy*, Oxford, 1977, pp. 21, 60

91

Isaac Oliver (1560?–1617)
Study of a female Figure,
c. 1610–15

pen and brown ink on paper,
11 × 8.9 cm
Lent by the Syndics of the
Fitzwilliam Museum, Cambridge,
PD 49-1947

Until the advent of Isaac Oliver,
English art was largely
unaffected by the graceful and
affected style known as
Mannerism, prevalent in the
courts of Europe from the 1530s
(see cat. 80, 81, 287). Oliver was
born in France, studied with the
English artist Nicholas Hilliard
(*c.* 1547–1619), travelled widely
in Europe and brought the
sophistication of Mannerist
ideals to English painting in
miniature. In addition to
portraits, he made a speciality of
small and highly worked
historical and genre scenes,

drawn in chalk or pen and
washed with ink and body
colour. He clearly prized his
drawings, bequeathing to his son
Peter 'all my drawings allready
finished and unfinished and
lymning pictures, be they
historyes, storyes or any thing or
limning whatsoever of my owne
hande worke or yet unfinished'.

This small and rather slight
study was probably made late in
Oliver's career. It is reminiscent
of the allegorical females of the
Dutch artist Hendrick Goltzius
(1558–1617), although the long
fingers and graceful pose recall
the figures of Parmigianino (cat.
78, 285), whose work Oliver
copied in Italy. CH

PROVENANCE Col. H.W. Lloyd; 1947,
15 October: Sotheby's, London, lot 30,
bought by the museum
REFERENCE J. Finsten, *Isaac Oliver: Art
at the Courts of Elizabeth I and James I*,
New York and London, 1981, no. 210

92

Sir Anthony van Dyck
(1599–1641)

Portrait of Lucas Vorsterman,
1631

black chalk on paper, 24.4 × 17.9 cm
Lent by the Syndics of the
Fitzwilliam Museum, Cambridge,
PD.30-1961

Van Dyck's *Iconographie* followed
a tradition established in the late
Middle Ages of collecting
portraits of distinguished figures,
accompanied by biographical
information. Begun soon after
the artist's return to Antwerp
from Italy in 1627, it eventually
numbered 98 prints, portraits of
royalty and politicians, military
leaders and philosophers, and,
most numerous, artists and
collectors. The first eighteen
were etched by Van Dyck
himself after his own drawings;
later he relied on professional
printmakers. Lucas Vorsterman
(1595–1675), the most talented
of the engravers trained by Van
Dyck's master, Rubens),
engraved 28 plates for the
Iconographie. Van Dyck took his
portrait several times: this
drawing was probably made in
1631, when Van Dyck stood as
godfather to Vorsterman's
daughter. It was etched for the
Iconographie by the artist himself.
CH

PROVENANCE Henry Tersmitten;
1754, 23 September: De Barry & Yver,
Amsterdam, lot 447; M.D.; Sentelle (?);
Poulain (?); Sir Thomas Lawrence;
E. Desperet; J. de Vos; 1883, 22 May:
Muller, Amsterdam, lot 139, bought by
Thibaudeau for John Postle Heseltine;
Agnew's; 1919: bought by Charles B.O.
Clarke; 1935: bequeathed to Grace
Clarke; by 1939: Louis C.G. Clarke;
1960: bequeathed by him to the museum
EXHIBITIONS *European Drawings from
the Fitzwilliam Museum*, New York,
Pierpont Morgan Library, *et al.*, 1976–7,

no. 68; *Drawings from the Collection of Louis
C.G. Clarke, LL.D., 1881–1960*,
Cambridge, Fitzwilliam Museum,
1981–2, pp. 6–8
REFERENCES M. Mauquoy-Hendrickx,
L'Iconographie d'Antoine van Dyck:

Catalogue raisonné, Brussels, 1956, no. 14;
H. Vey, *Die Zeichnungen Anton van Dycks*,
2 vols., Brussels, 1962, no. 246; D. de
Hoop Schetter, *Antoon van Dyck et son
iconographie*, Paris, 1981, no. 12

93

Giovanni Benedetto
Castiglione (1609–64)
Flocks driven to Water,
late 1640s

brush in brown ink and oil on paper,
27.8 × 39.5 cm
The Royal Institution of Cornwall,
Royal Cornwall Museum, Truro,
1928.327

Castiglione studied with various
minor artists at Genoa, but his
style was most influenced by the
Flemish painter Jan Roos
(1591–1638) and by the popular
biblical paintings of the Bassano

family (cat. 288). Roos had
brought to Genoa a type of
painting dominated by animals
treated in a broad manner on a
large scale, and Castiglione
adapted it and made it
completely his own. Many of his
most characteristic works are
drawings, made in a technique
he seems to have perfected soon
after he arrived in Rome in
1634. They are drawn with a
brush on paper, using coarsely
ground pigment mixed with
linseed oil but without any
binding agent. None of these
drawings is dated, and
Castiglione's development

remains hypothetical. This
example, previously owned by
Alfred de Pass (see cat. 85),
probably dates from the artist's
middle period. Its subject is
typical in being adapted from
biblical themes, such as the
Journeys of the Patriarchs or the
Story of Noah, and in allowing
the painter to display a virtuoso
treatment of form and surface in
a genre scene filled with
domestic animals. C H

PROVENANCE As cat. 85
EXHIBITIONS *Drawings from the de Pass
Collection*, London, Arts Council, 1957,
no. 5; London, 1962, no. 321; *Exhibition
Catalogue of Master Drawings from the de
Pass Collection, Royal Cornwall Museum,
Truro*, London, Phillips, and Truro, Royal
Cornwall Museum, 1994, no. 24
REFERENCE G. Penrose, *Catalogue of the
Alfred A. de Pass Collection*, Truro, 1936,
no. 138

94

**Pietro Berrettini, called
Pietro da Cortona**
(1596–1669)
Wooded River Landscape,
1650s (?)

black chalk, brush and grey ink and
grey wash on paper, 28.3 × 42.5 cm
The Trustees of the Barber Institute
of Fine Arts, University of
Birmingham, and Birmingham
Museums and Art Gallery

Pietro da Cortona was one of the
greatest of 17th-century
landscape artists. His landscape
drawings, of which this is among
the grandest, are usually dated to
the early part of his career,

although it is worth noting that,
as late as 1666, he promised to
send Ferdinando II of Tuscany
some 'watercolour landscapes'.

The drawings at Holkham
Hall, Norfolk, were mostly
bought by the 1st Earl of
Leicester at Rome from 1714 to
1716, during his Grand Tour.
The collection remained intact
until 1991, when the greater
part was consigned to Christie's.
Recognising the unique
importance of the collection as a
whole, a consortium of eight
British museums attempted to
buy it *en bloc*. Unfortunately,
their offer was declined, but they
were later able to acquire
eighteen of the most outstanding

drawings. This landscape was the
most important and beautiful
item and was purchased jointly
by the Birmingham museums in
an arrangement that is becoming
more common as prices on the
art market rise. CH

PROVENANCE Thomas Coke, 1st Earl
of Leicester; by descent to the 6th Earl;
1991, 2 July. Christie's, London, lot 27,
purchased jointly by the museums, after
an export licence had been temporarily
deferred, with the aid of the National
Heritage Memorial Fund and the
National Art-Collections Fund
EXHIBITION *Eighteen Old Master
Drawings from the Collection at Holkham
Hall, Norfolk*, London, British Museum,
et al., 1992–3, no. 9
REFERENCES G. Briganti, *Pietro da
Cortona o della pittura barocca*, Florence,
1962, p. 304, rev. edn, 1982, p. 290;
M. Chiarini, *I disegni italiani di paesaggio
del 1600 al 1750*, Treviso, 1972,
pp. 39–40; A.E. Popham and C. Lloyd,
Old Master Drawings at Holkham Hall,
Chicago, 1986, no. 105

95

Rembrandt Harmensz. van Rijn (1606–69)

The Little Mill, c. 1649–51

pen and brown ink and wash, with white body colour, on coarse buff paper, 8.3 × 22.6 cm

Lent by the Syndics of the Fitzwilliam Museum, Cambridge, 601

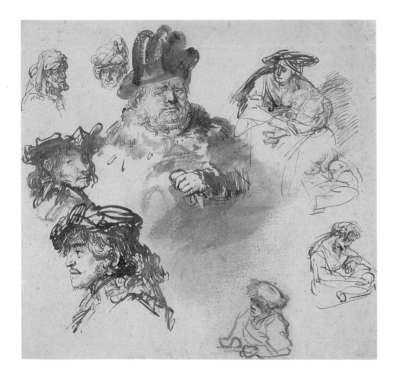

During his wanderings in Amsterdam and the surrounding countryside, Rembrandt drew constantly, as a compulsive recreation and as an aid to studying particular effects of weather and light. He made at least three drawings of Het Molentje (the little windmill) which was a popular watering place on the River Amstel, south-east of Amsterdam. They have all been dated *c.* 1649–51. This example is the most striking and the most economically drawn. It shows the mill and associated buildings clustered on a flat horizon between vast expanses of sky and water. In the distance, the windmills on the Ring Dyke are a reminder of busy activity on the Dutch North Sea coast.

Augustus Arthur Vansittart (1824–82) was a Fellow of Trinity College, Cambridge, and a Syndic of the Fitzwilliam Museum. His gifts of Netherlandish and Italian paintings, drawings and etchings were among the most notable in the museum's early years. CH

PROVENANCE A.A. Vansittart; 1862: presented by him to the museum
EXHIBITION *European Drawings from the Fitzwilliam Museum*, New York, Pierpont Morgan Library, *et al.*, 1976 7, no. 83; *Rembrandt's Landscapes*, Washington, National Gallery of Art, 1990, no. 70
REFERENCE O. Benesch, *The Drawings of Rembrandt*, 6 vols., London, 1954–7, VI, no. 1353

96

Rembrandt Harmensz. van Rijn (1606–69)

Sheet of Studies, c. 1636

pen and brown ink and wash and red chalk on paper, 22 × 23.3 cm

The Trustees of the Barber Institute of Fine Arts, The University of Birmingham

Rembrandt must have made many sheets of disparate studies of heads but, so prized have his drawings been, that most have been cut up into tiny pieces, with one or two heads to each piece. Rembrandt probably began this rare surviving sheet with the imposing fat man in a fur coat and plumed hat, whose left hand forms the centre of a carefully controlled composition, around which are grouped eight widely differing studies, including one in red chalk at the bottom. Some of these figures are related to other works by Rembrandt: the young man in a beret on the left appears in an etching of 1635; the figure above him in another etching of the following year; the mother and child, which may depict Rembrant's wife, Saskia van Ulenborch, and one of their children, is a frequent motif in Rembrandt's art in the mid-1630s. The characterisation of each figure, and the variety of treatment, make this one of the artist's most virtuoso performances as a draughtsman. CH

PROVENANCE By 1878: R.P. Roupell; Christie's, London, 12–14 July 1887, lot 1109, bought by J.P. Heseltine; by 1929: Henry Oppenheimer; 1932: bequeathed to his brother, O.F. Oppenheimer; 1949, 17 June: Christie's, London, lot 27, purchased by the institute
EXHIBITIONS *Old Master Drawings*, London, RA, 1953, no. 302; *Master Drawings in the Barber Institute*, London, Morton Morris & Co., 1986, no. 12
REFERENCE O. Benesch, *The Drawings of Rembrandt*, 6 vols., London, 1954–7, no. 340

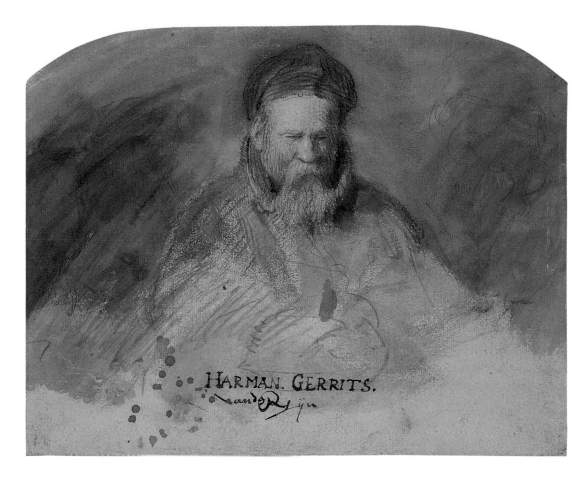

97

Rembrandt Harmensz. van Rijn (1606–69)
Portrait of the Artist's Father, 1630

red chalk with black chalk and brown wash on paper, 18.9 × 24 cm
inscribed: *HARMAN.GERRITS.van de Rhijn*
The Visitors of the Ashmolean Museum, Oxford, PI 182

Rembrandt's father, Harmen Gerritsz. van Rijn (born 1565), and mother, Neeltge van Suydtbroek, lived at Leyden, where the family had been established as millers since 1513. This drawing must have been made shortly before the death of the artist's father in April 1630 and is one of the first of the deeply sympathetic portraits of old people that Rembrandt painted and drew until his own old age. The broad washes conceal earlier attempts at the figure, but also serve to increase the sense of isolation, as the old man sits, perhaps blind, oblivious to his surroundings.

Chambers Hall is a rather shadowy figure, but was clearly a collector of great discernment. His gift to the University Galleries at Oxford in 1855 included important series of etchings and drawings by Rembrandt, Claude and Ostade, as well as oil sketches by Rubens and Van Dyck, paintings by Canaletto and Guardi (cat. 327), drawings by Leonardo, Raphael and Correggio, and one of Dürer's most beautiful watercolour landscapes, *Welsch Pirg* of 1494–5. CH

PROVENANCE Chambers Hall; 1855: presented by him to the University Galleries, Oxford
EXHIBITIONS *Dürer to Cézanne: Northern European Drawings from the Ashmolean Museum*, New Brunswick, Jane Voorhees Zimmerli Art Museum, and Cleveland Museum of Art, 1982–3, no. 45 (with full bibliography)
REFERENCES K.T. Parker, *Catalogue of the Collection of Drawings in the Ashmolean Museum*, I, *Netherlandish, German, French and Spanish Schools*, Oxford, 1938, no. 182; O. Benesch, *The Drawings of Rembrandt*, 6 vols., London, 1954–7, I, no. 56

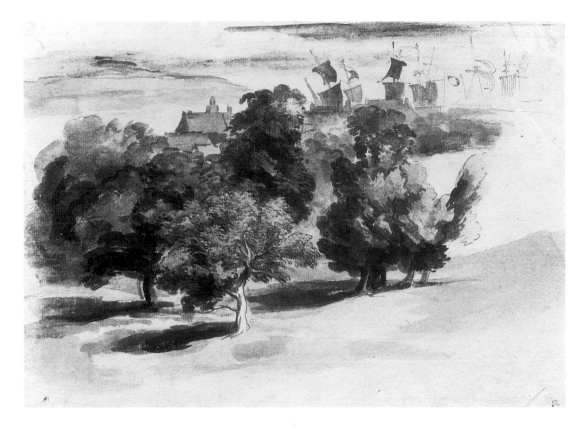

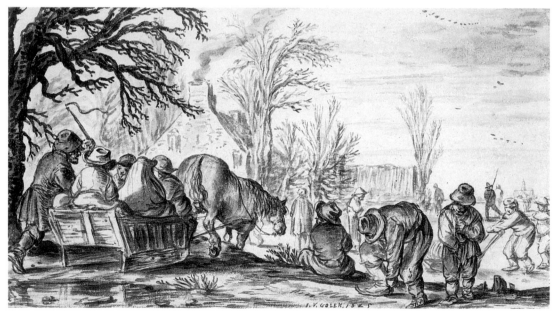

98

Sir Anthony van Dyck
(1599–1641)
*English Landscape,
c.* 1635–41

pen and brown ink, and water and
body colours, on off-white paper,
18.9 × 26.7 cm
The Trustees of the Barber Institute
of Fine Arts, The University of
Birmingham, 39.20

During his time in England
(1632–4, 1635–41) Van Dyck
made a number of studies of
landscapes and plants. Some were
incorporated into portrait
paintings, but others were made
for their own sake, as
topographical studies or simply
as amusement. They were
generally drawn in pen and
brown ink, sometimes with
wash, but a few are coloured in
watercolours. This is the most
brilliant of the group, in
colouring and in handling, with
nervous penwork combined with
a variety of brushstrokes to create
a vivid evocation of a wooded
coast with ships riding at anchor
off a port in the background.

This was one of Thomas
Bodkin's astute purchases for the
Barber Institute during his
directorship. CH

PROVENANCE Jonathan Richardson
senior; Arthur Pond; Sir William
Fitzherbert; 1939: purchased by the
institute
EXHIBITIONS *Old Master Drawings*,
London, RA, 1953, no. 279; *Van Dyck in
England*, London, National Portrait
Gallery, 1983, no. 86; *Master Drawings in
the Barber Institute*, London, Morton
Morris & Co., 1986, no. 11; *The Drawings
of Anthony van Dyck*, New York, The
Pierpont Morgan Library, and Fort
Worth, Kimbell Art Museum, 1991, no.
89 (with full bibliography)
REFERENCE H. Vey, *Die Zeichnungen
Anton van Dycks*, 2 vols., Brussels, 1962,
no. 304

99

Jan van Goyen
(1596–1656)

*Winter Landscape with four
Figures in a horse-drawn
Sledge*, 1625

brush in two shades of greý wash on
paper, 14.1 × 25.9 cm
inscribed: *I.V.GOIEN 1625*
Plymouth City Museum and Art
Gallery, Cottonian Collection

Drawing was so important an
activity for Van Goyen that he
seems occasionally to have given
up painting completely. In
1624–5 he made a series of
drawings depicting scenes from
daily life in Leyden. All are
signed and dated, drawn in
various shades of grey wash and,
unusually for this artist,
concentrate on the human figure
rather than the landscape. All are
of similar size and were clearly
made for sale. Here, a horse-
drawn sledge prepares to cross a
frozen river, while villagers
adjust their skates or cross the
ice on foot. The only other
drawing by Van Goyen of this
type is *Skittle Players and
Bystanders on a Village Green*, also
dated 1625, which was recently
purchased by the British
Museum.

Soon after making these
drawings, Van Goyen all but
abandoned wash to concentrate
on the more rapid sketches in
black chalk which he made for
the remainder of his career. CH

PROVENANCE Charles Rogers; 1784:
William Cotton; 1853: presented by him
to Plymouth Public Library
EXHIBITIONS *Cottonian Collection:
Centenary Exhibition*, Plymouth City Art
Gallery, 1953, cat. p. 22; *An Exhibition of
Old Master and English Drawings and
European Bronzes from the Collection of
Charles Rogers (1711–1784) and the
William Cotton Bequest*, London, Sotheby's,

and Torquay, Sotheby Bearne Rainbow,
1979, no. 7
REFERENCE H.-U. Beck, *Jan van Goyen*,
2 vols., Amsterdam, 1972, no. 50

100

Claude Gellée, called
Claude Lorrain (1600–82)
*Classical Landscape with a
Bay and Shipping, Figures in
the Foreground, c.* 1660

pen and brown ink and wash over
black chalk on paper, 19.5 × 26.3 cm
The Royal Institution of Cornwall,
Royal Cornwall Museum, Truro,
1928.260

Claude's drawings were highly
prized by contemporary
collectors and he must have
made a large number for sale.
He worked up many of his
preliminary sketches for

paintings into drawings for the
collector, often adding or
changing the figures and thus
the subjects. The Truro drawing
exemplifies the complicated
relationship between such
drawings and the paintings. Its
composition repeats in reverse
that of another drawing
(Kupferstichkabinett, Berlin),
save that the figures enact not
the Rape of Europa, but some
other, unspecified story. The
Berlin drawing, in turn, is one of
a sequence of drawings and
paintings of the Rape of Europa
stretching from 1647 to 1670,
all with similar landscapes.

The drawing, one of only a
handful by Claude in English
regional collections outside
Oxford and Cambridge, comes
from the celebrated collection of
the 4th Earl of Warwick, who
inherited many drawings from

his uncle, one of Wellington's
generals in the Peninsular Wars.
The sheet subsequently belonged
to Alfred de Pass (see cat. 85).
CH

PROVENANCE Hon. Sir Charles
Greville; his nephew, 4th Earl of
Warwick; 1896, 20 May: Christie's,
London, lot 75; George Salting; Alfred de
Pass; 1928: presented to the Royal
Institution of Cornwall
EXHIBITIONS *Drawings from the de Pass
Collection*, London, Arts Council, 1957,
no. 29; London, 1962, no. 330; *Exhibition
Catalogue of Master Drawings from the de
Pass Collection, Royal Cornwall Museum,
Truro*, London, Phillips, and Truro, Royal
Cornwall Museum, 1994, no. 41 (with
full bibliography)
REFERENCES G. Penrose, *Catalogue of
the Alfred A. de Pass Collection*, Truro,
1936, no. 44; M. Roethlisberger, *Claude
Lorrain: The Drawings*, 2 vols., Berkeley
and Los Angeles, 1968, no. 791

101

John Michael Rysbrack
(1693–1770)
Design for a Monument to
John Campbell, 2nd Duke of
Argyll and Greenwich, 1743
black lead and red chalk on paper,
40.5 × 26 cm
Plymouth City Museum and Art
Gallery, Cottonian Collection

John Campbell, 2nd Duke of
Argyll (1678–1743), had a
distinguished, if chequered,
political career, falling in and
out of favour with almost every
change of government. On his
death, it was decided to erect a
monument in Westminster
Abbey, and both Rysbrack and
Roubiliac competed for the
commission. Several of
Rysbrack's designs survive; this
example shows Argyll
recumbent, surrounded by Time,
Fortitude and Wisdom in front
of a pyramid. It recalls the
sculptor's monument to the
Duke of Marlborough at
Blenheim, completed *c.* 1732;
but eventually Roubiliac's design
was preferred.

Charles Rogers (1711–84)
greatly admired Rysbrack: he
visited him in old age and
bought several drawings and
small sculptures at the sales of
Rysbrack's possessions after the
artist's retirement in 1766.
He included the sculptor in his
Collection of Prints in Imitation of
Drawings (1778). CH

PROVENANCE Charles Rogers; 1784:
his brother-in-law, William Cotton; his
son, William Cotton; 1816: his son,
William Cotton; 1853: presented by him
to Plymouth Public Library; 1916:
transferred to the gallery
EXHIBITIONS *An Exhibition of Old*
Master and English Drawings and European
Bronzes from the Collection of Charles Rogers
(1711–1784) and the William Cotton

Bequest, London, Sotheby's, and Torquay, Sotheby Bearne Rainbow, 1979, no. 62; *Michael Rysbrack, Sculptor, 1694–1770*, Bristol Museum and Art Gallery, 1982, no. 48
REFERENCE M.I. Webb, *Michael Rysbrack: Sculptor*, London, 1954, p. 87

102

Jean-Antoine Watteau
(1684–1721)

Portrait of Antoine de la Roque, c. 1715

red chalk on beige paper,
22.8 × 16.9 cm
Lent by the Syndics of the
Fitzwilliam Museum, Cambridge,
2266

Antoine de la Roque was born at Marseille and led a restless youth travelling, until a bullet smashed his left leg at the Battle of Malplaquet in 1709. He later followed a literary career, becoming one of the principal contributors to *Mercure de France* in 1721 and its director three years later. One of his first articles for the *Mercure* was an obituary of his friend Watteau, which appeared in August 1721.

Watteau made two portraits of La Roque: a large painting, where he is shown in a forest clearing accompanied by nudes (private collection, New York); and this drawing. C H

PROVENANCE Charles Ricketts and Charles Shannon; 1937: bequeathed to the museum by the latter
EXHIBITIONS *Old Master Drawings*, London, RA, 1953, no. 409; *Cent dessins français du Fitzwilliam Museum Cambridge*, Paris, Galerie Heim, Lille, Musée des Beaux-Arts, and Strasbourg, Musée des Beaux-Arts, 1976, no. 98; *European Drawings from the Fitzwilliam Museum*, New York, The Pierpont Morgan Library, *et al.*, 1976–7, no. 122; *All for Art: The Ricketts and Shannon Collection*, Cambridge, Fitzwilliam Museum, 1979, no. 205;

Watteau, 1684–1721, Washington, National Gallery of Art, Paris, Grand Palais, and Berlin, Schloss Charlottenburg, 1984–5, no. 113
REFERENCES K.T. Parker and J. Mathey, *Antoine Watteau: Catalogue complet de son œuvre dessiné*, 2 vols., Paris, 1957, II, no. 912; P. Rosenberg and L.-A. Prat, *Antoine Watteau, 1684–1721: Catalogue raisonné des dessins*, 3 vols., Milan, 1996, II, no. 317 (with full bibliography)

PROVENANCE As cat. 99
EXHIBITIONS *Cottonian Collection: Centenary Exhibition*, Plymouth City Art Gallery, 1953, cat. p. 42; London, 1962, no. 354; *An Exhibition of Old Master and English Drawings and European Bronzes from the Collection of Charles Rogers (1711–1784) and the William Cotton Bequest*, London, Sotheby's, and Torquay, Sotheby Bearne Rainbow, 1979, no. 33

104

Giandomenico Tiepolo (1727–1804)

Cupid blindfold in the Clouds, after 1770

pen and brown ink and wash on paper, 18.3 × 26 cm
Inscribed: *Dom⁰ Tiepolo f.*
The Royal Museum and Art Gallery, Canterbury, 3012.21

103

Francesco Zuccarelli RA (1702–88)

Landscape with Travellers and Pack Horses, c. 1760 (?)

pen and brown ink and grey wash heightened with white on paper, 27.4 × 42.8 cm
Plymouth City Museum and Art Gallery, Cottonian Collection

Zuccarelli was the most successful of all 18th-century Italian artists who visited England. He came in 1752 and remained for ten years, returning in 1765 for a further six. His reputation rested on his landscapes, both drawn and painted, which he produced for the art market rather than on commission only. George III's

acquisition of Consul Smith's collection in 1762 brought Zuccarelli royal patronage and he was one of the founding members of the Royal Academy in 1768.

This landscape is typical of his many pastoral scenes, composed in the mildest manner of Marco Ricci (1676–1729) in a characteristically Venetian, painterly style which Zuccarelli perpetuated throughout his time in England. Such pictures were preferred by collectors to the more sober, classical style of Zuccarelli's friend and rival Richard Wilson (cat. 48), much to the disgust of Horace Walpole.

The collection of Charles Rogers at Plymouth includes *View on the Road to Foligno*, which bears the inscription 'Drawn by [George] Lambert, and wash'd [i.e. coloured] by Zuccarelli'. CH

After the death in 1770 of his father, Giambattista, Giandomenico Tiepolo's reputation as a painter grew, culminating in his election as *principe* of the Venetian Academy in 1780. Parallel with his numerous commissions for paintings and frescoes, he made extensive series of drawings. Some, such as the large biblical drawings or the *Divertimenti per gli ragazzi*, have a narrative element, while others are elaborate sets of variations on carefully limited themes. This drawing of Cupid blindfold sporting with a band of cherubs and accompanied by two doves which have evidently been released from the harness of Venus' chariot probably follows a ceiling painting (Fondation Ephrussi de Rothschild, Saint-Jean-Cap-Ferrat). It is drawn in the Tiepolos' characteristic mixture of pen and wash, and, like most such drawings, is signed. Many others by

Giandomenico on this theme
exist, including a further two at
Canterbury and one at Truro.

These and other drawings by
the Tiepolos were bought at
Venice by John Ingram
(1767–1841), who was also one
of Francesco Guardi's last
patrons. CH

PROVENANCE John Ingram; his son,
Hughes Ingram; his nephew, Ingram
Fuller Godfrey (1827–1916); 1899:
presented by him to the museum
EXHIBITION Guardi, Tiepolo and
Canaletto from the Royal Museum,
Canterbury and elsewhere, and a Selection of
Venetian 18th Century Decorative Arts,
Canterbury, Royal Museum, 1985, no. 39
REFERENCE J. Byam Shaw, 'Some
Unpublished Drawings by Giandomenico
Tiepolo', Master Drawings, XVII, 1979, pp.
239–44, pl. 1–13, no. 7

105

Giacomo Guardi
(1764–1835)

*Lagoon Capriccio with a
ruined Tower, and fantastic
Rocks and Castles,*
c. 1785–90

pen and brown ink and wash over
black chalk on white paper,
22.5 × 35.8 cm
inscribed: *Guardi F.*
The Royal Museum and Art Gallery,
Canterbury, 3012.11

During his early years, Giacomo
Guardi was assistant to his
father, Francesco (cat. 327), and
closely imitated his drawing
style, even signing his own work
with his father's name. Later,

Giacomo produced innumerable
views of Venice for the less
wealthy tourists, usually in pen
and brown ink or the more
prosaic medium of gouache. The
style of this wonderful early
drawing is deceptively close to
that of Francesco.

The portion of John Ingram's
collection at Canterbury (see cat.
104) includes five very large
drawings by Francesco Guardi
showing Venetian festivals,
another huge drawing of a *Fire at
Palazzo Pisani* in 1828 by
Giacomo and small *capricci* by
both artists. CH

PROVENANCE As cat. 104
EXHIBITION Guardi, Tiepolo and
Canaletto from the Royal Museum,
Canterbury and elsewhere, and a Selection of
Venetian 18th Century Decorative Arts,
Canterbury, Royal Museum, 1985, no. 13
REFERENCE J. Byam Shaw, 'Some
Guardi Drawings Rediscovered', Master
Drawings, XV, 1977, pp. 3–15, no. 1

106

Jean-Auguste-Dominique Ingres (1780–1867)

Mr and Mrs Joseph Woodhead and her brother, Henry Comber, 1816

black chalk on paper, 30.4 × 22.4 cm
inscribed: *Ingres a rome 1816*
Lent by the Syndics of the
Fitzwilliam Museum, Cambridge,
PD 52–1947

The downfall of Napoleon and his family in the capitals of Europe left Ingres with an acute shortage of patrons. He reluctantly took to portrait drawing, which he felt was a distraction from the serious business of history painting. From 1814 to 1816, he made a series of drawings of English visitors to Rome, of which this is one of the most ambitious. It shows the naval agent Joseph Woodhead (1774–1866) with his wife, Harriet Comber (1793–1872), and her brother, Henry George Wandesford Comber (1798–1883). The couple had been married in 1815 and are drawn with their arms intertwined in a slightly awkward pose of romantic devotion. Comber, portrayed as a dandy, went up to Jesus College, Cambridge, in 1817, was both married and ordained in 1822, spent the remainder of his life in family livings in Yorkshire and Somerset, and died bathing at Scarborough. CH

PROVENANCE Mr and Mrs Joseph Woodhead; 1872: their daughter, Mrs Young; her niece, Miss Grace Woodhead; 1933: her nephew, Brigadier-General Henry Alexander Walker; 1947: purchased by the National Art-Collections Fund and presented to the museum

EXHIBITIONS *Cent dessins français du Fitzwilliam Museum Cambridge*, Paris, Galerie Heim, Lille, Musée des Beaux-

Arts, and Strasbourg, Musée des Beaux-
Arts, 1976, no. 50; *European Drawings
from the Fitzwilliam Museum*, New York,
The Pierpont Morgan Library, *et al.*,
1976–7, no. 108
REFERENCE H. Naef, *Die
Bildniszeichnungen von J.-A.-D. Ingres*,
5 vols., Berne, 1977, II, pp. 104–7, IV,
no. 180

107

Pierre-Paul Prud'hon
(1758–1823)

*Innocence preferring Love to
Riches*, c. 1809–10

black and white chalks with
stumping and stippling on blue
paper, 45.4 × 35.4 cm
inscribed: *R. Prud'hon*
The Visitors of the Ashmolean
Museum, Oxford, WA 1952.105

Prud'hon met Constance Meyer,
a pupil of Suvée and Greuze, in
1803, and he became her artistic
mentor, providing her with the
initial sketches for her paintings.
The first and most important of
their collaborations was
exhibited at the Salon of 1804 as
*L'Innocence préfère l'amour à la
richesse* (Hermitage, St
Petersburg). It depicts a girl,
personifying Innocence, resisting
the temptation of an open casket
of jewels offered by an older
woman, Riches, and preferring
instead the embrace of a young
man. The child Cupid dances
playfully nearby. This simple
allegory was developed through a
sequence of drawings and an oil
sketch by Prud'hon (Art
Institute of Chicago), from
which Meyer made her painting.

Probably *c.* 1809 the engraver
Barthélémy Roger engraved the
composition. Although the print
is inscribed 'Peint par Mlle
Meyer', it was clearly made after
this drawing by Prud'hon. It is

one of the few masterpieces of
French Neoclassicism in an
English collection and another
example of the catholicity of
taste shown by K.T. Parker
(see cat. 87). CH

PROVENANCE Thévenin; 1851,
7 January: sale, Paris, lot 90; Laurent
Laperlier; 1867, 11–13 April: sale, Paris,
lot 72; Colnaghi's; 1952: purchased by
the museum
EXHIBITIONS *The Age of Neo-
Classicism*, London, RA, 1972, no. 738;
*Dürer to Cézanne: Northern European
Drawings from the Ashmolean Museum*, New
Brunswick, Jane Voorhees Zimmerli Art
Museum, and Cleveland Museum of Art,
1982–3, no. 95
REFERENCES E. de Goncourt, *Catalogue
raisonné de l'œuvre peint, dessiné et gravé de
P.-P. Prud'hon*, Paris, 1876, p. 311; J.
Guiffrey, *L'Œuvre de P.-P. Prud'hon*, Paris,
1924, no. 68

108

Francisco de Goya
y Lucientes (1746–1828)
Comico descubrimiento,
c. 1826

black chalk on paper, 19.2 × 14.9 cm
inscribed: *Comico descubrimiento / 51*
Lent by the Syndics of the
Fitzwilliam Museum, Cambridge,
2066

Goya compiled eight albums of
drawings during his career, each
planned as a coherent sequence;
they were broken up by the
artist's son, Javier, who lived in
constant penury. The drawings
in the final two albums were
made between 1824 and 1828,
during the aged Goya's exile in
Bordeaux, and are all in black
chalk or lithographic crayon.
Together, they resume many of
the themes that had preoccupied
him throughout his life, among
them madness, childhood and
old age, cruelty and violence,
and the creatures of his fervid
imagination. Several are
connected with the fair at
Bordeaux in 1826, and the
'comical discovery' in this
drawing may be the grotesque
and varied specimens of
humanity found beneath the flap
of a tent at the circus.

Ricketts and Shannon owned
three drawings by Goya, all from
the Bordeaux albums. For
Ricketts, 'it is by his power of
design, an original, varied and
nervous form of design, that
[Goya] excels even more than by
his vivacity of workmanship and
his marvellous if unequal gift of
expression'. C H

PROVENANCE J. Peoli; Charles
Ricketts and Charles Shannon; 1937:
bequeathed to the museum by the latter
EXHIBITIONS *Goya and his Times*,
London, RA, 1963–4, no. 198; *All for
Art: The Ricketts and Shannon Collection*,
Cambridge, Fitzwilliam Museum, 1979,
no. 130
REFERENCES P. Gassier and J. Wilson,
*The Life and Complete Work of Francisco
Goya; with a Catalogue Raisonné of the
Paintings, Drawings and Engravings*, New
York, 1971, no. 1756; P. Gassier, *The
Drawings of Goya: The Complete Albums*,
London, 1973, p. 570, no. 409, Album
G.51

109

Caspar David Friedrich
(1774–1840)

Landscape with an Obelisk,
1803

point of the brush in brown ink and
sepia on paper, 12.9 × 20.2 cm
inscribed: *den 25t May 1803*
The Visitors of the Ashmolean
Museum, Oxford, CJB 33

Together with a similar sheet
also in the Ashmolean, this
melancholy landscape comes
from a sketchbook which
Friedrich began during a
walking tour on the island of
Rügen, in the Baltic Sea, in May
1802 and later used in Bohemia
and Saxony. The precise view has

not been identified, but it may
represent the town of Stolpen in
Saxony. The obelisk is a
milestone of the Saxon postal
service, but its inclusion,
together with the crucifix,
heightens the religious
symbolism of the scene. Such
small drawings were reworked in
sepia on a larger scale and
provided the young artist with
his principal source of income.

Dr Grete Ring (1887–1952)
began her career as a museum
curator, but in 1919 joined the
firm of Paul Cassirer, picture
dealers in Berlin, becoming a
partner five years later. She
emigrated to England in 1938.
Ring's bequest to the
Ashmolean, administered by her

executors, included pencil
studies by French artists such as
Delacroix and Ingres, Degas and
Cézanne, but is most notable for
one of the few significant groups
of 19th-century German
drawings outside Germany,
unique in the UK. CH

PROVENANCE 1954: Ring Bequest to
the museum
EXHIBITION *Dürer to Cézanne: Northern
European Drawings from the Ashmolean
Museum*, New Brunswick, Jane Voorhees
Zimmerli Art Museum, and Cleveland
Museum of Art, 1982–3, no. 17b
REFERENCES M. Bernhard, *Caspar
David Friedrich: Das gesamte graphische
Werk*, Munich, 1974, p. 347; C.J. Bailey,
*Ashmolean Museum, Oxford: Catalogue of the
Collection of Drawings*, V, *German
Nineteenth Century Drawings*, Oxford,
1987, no. 33 (with full bibliography)

the start of the race and trying to recapture them after the finish. Both are represented in drawings at Truro, originally owned by Alfred de Pass (see cat. 85). This sketch, composed in the studio rather than made from life, is drawn in the artist's most rapid style, in outlines made with a fine pen and in rudimentary hatching. Both drawings at Truro were reworked in small oil sketches (that of this composition is lost), but the final monumental canvas was abandoned before it had developed much further. C H

PROVENANCE A.C.H. His de la Salle; Alfred de Pass; 1928: presented by him to the Royal Institution of Cornwall
EXHIBITIONS *Drawings from the De Pass Collection*, London, Arts Council, 1957, no. 30; *Exhibition Catalogue of Master Drawings from the De Pass Collection, Royal Cornwall Museum, Truro*, London, Phillips, and Truro, Royal Cornwall Museum, 1994, no. 51 (with full bibliography)
REFERENCES G. Penrose, *Catalogue of the Alfred A. de Pass Collection*, Truro, 1936, no. 55; G. Bazin, *Théodore Géricault: Etude critique, documents et catalogue raisonné*, IV, *Le Voyage en Italie*, Paris, 1990, no. 1392

Frederick the Great, and partly to his extraordinary virtuosity. His drawings, in particular, demonstrate an enthusiasm and facility for solving the most complex pictorial problems. This sheet is one of innumerable studies of heads from daily life, some of which were incorporated into vast canvases crowded with anonymous characters. Here, detailed studies of a woman's head and two of her right hand, one holding a length of wool, the other a pair of spectacles, have been drawn with rapid and precise strokes in soft carpenter's pencil, favoured by Menzel after 1850.

Ricketts justified the inclusion of this artist among the more distinguished names in his collection by maintaining that Menzel 'expresses profoundly that somewhat middle-class assertion of a busy, personal choice which finds a counterpart in the realistic literature of thirty years ago ... no gallery of art which should aim at a comprehensive record of the nineteenth century could afford to be without some specimen of his work as a painter, and above all as a draughtsman'. C I I

PROVENANCE By 1917: Charles Ricketts and Charles Shannon; 1937: bequeathed to the museum by the latter
EXHIBITIONS *All for Art: The Ricketts and Shannon Collection*, Cambridge, Fitzwilliam Museum, 1979, no. 153; *Treasures from the Fitzwilliam*, Washington, National Gallery of Art, *et al.*, 1989, no. 149

110

Théodore Géricault
(1792–1824)

Men and Horses moving to the Left: La Ripresa, 1817

pen and brown ink on yellowish paper, 17 × 27 cm
The Royal Institution of Cornwall, Royal Cornwall Museum, Truro, 1928.266

Having failed to win the Prix de Rome in 1816, Géricault decided to spend two years in Italy at his own expense. In Rome, he drew a great deal, including copies after the Old Masters, scenes from daily life,

imaginary compositions which he may have intended to develop into oil paintings, and even the odd landscape. He worked on only one major composition, his most ambitious so far, *The Race of the Riderless Horses*. This race was traditionally run on the Corso at the end of the Roman Carnival in February, when horses were goaded not by jockeys but by spiked balls attached to their flanks. Géricault viewed the subject as a reflection of the heroism of man when confronted with the elemental savagery of nature. He worked on two episodes, the grooms restraining the horses at

111

Adolf von Menzel
(1815–1905)

Study of a Lady's Head and Hand, c. 1890

soft pencil on paper, 13.4 × 21 cm
inscribed: *A.M*
Lent by the Syndics of the Fitzwilliam Museum, Cambridge, 2118

Menzel was the most popular artist in 19th-century Germany. He owed his reputation partly to a range of subjects chosen to please the citizens of the new German state, such as the life of

VICTORIANS
AND EDWARDIANS

VICTORIANS AND EDWARDIANS

The wealth of Victorian and Edwardian paintings in English public galleries is most marked in the northern industrial cities, where new galleries were founded in the late 19th and early 20th centuries. Victorian self-confidence was at its height and English collectors, enriched by the profits of trade and industry, bought modern art. This same entrepreneurial class promoted the foundation of municipal galleries and acquired the work of living artists for public display, just as they hung modern paintings in their homes.

In 1832 Etty's *The Storm* (cat. 120) was bought by the privately funded Royal Manchester Institution (RMI), which held annual public exhibitions of contemporary art, formed a small permanent collection and received gifts from local citizens. This set the pattern for the new municipal galleries. In 1882 the RMI was taken over by the city to become Manchester Art Gallery. The city provided £2000 annually for the purchase of works of art for the collection. Early purchases included Herkomer's *Hard Times 1885* (cat. 182) and Ford Madox Brown's *Work* (cat. 130); both subjects were thought appropriate for an industrial city and reflect the educational mission of the municipal galleries.

In 1877 the Walker Art Gallery, Liverpool, opened and began building a collection, funding purchases from the profits of its annual Autumn Exhibition. By far the greater source of acquisitions was gifts and bequests from local collectors. In Preston, even before the completion of the gallery building, a magnificent collection of 62 oils and 45 watercolours was bequeathed by Richard Newsham, whose fortune came from his father's cotton mills (cat. 158). Other collections were bequeathed or given on condition that the muncipalities pay for a gallery to house them, as with the Mappin Art Gallery, Sheffield, and the Bury Art Gallery, housing the pictures of Thomas Wrigley (cat. 117, 148, 149), a paper manufacturer whose collection was formed with the advice of Thomas Agnew, the principal art dealer in Manchester and Liverpool, himself a donor to several galleries. The collection of the patent medicine manufacturer Thomas Holloway and that of the soap magnate Lord Leverhulme became monuments to their founders' tastes.

By the 1920s a new generation of curators was turning away from Victorian and Edwardian painting. Against the odds, two Victorian collections survived: the Holt collection (cat. 147, 197) and the Ashton collection (cat. 136, 137). In the late 1940s and 1950s there were signs of a revival of interest in Victorian art, and paintings by Martin (cat. 50), Tissot (cat. 173) and Egg (cat. 153) were sold to public galleries by adventurous dealers.

Victorian galleries were closely hung. A dense hang has been devised for this section of the exhibition, displayed in the Great Room of the Royal Academy, centrepiece of the annual Summer Exhibition, in which many of these paintings were first shown. JBT

112

John Martin (1789–1854)
The Bard, 1817

oil on canvas, 270 × 170 cm
Laing Art Gallery, Newcastle upon
Tyne (Tyne and Wear Museums),
C6976

The subject comes from Thomas
Gray's poem *The Bard* (1755)
and had been popular
throughout the Romantic period,
with versions by Thomas Jones,
William Blake and Henry Fuseli.
Gray tells how Edward I, after
his conquest of Wales, ordered
all bards to be slaughtered in
order to draw the people's
cultural and nationalistic sting.
The sole surviving bard here
stands 'On a rock, whose
haughty brow/ Frowns o'er old
Conways foaming flood,/ Robed
in the sable garb of woe,/ With
haggard eyes the Poet stood;/
(Loose his beard and hoary hair/
Stream'd, like a meteor, to the
troubled air)' (ll. 15–20). He
curses the departing armies:
'Ruin seize thee, ruthless King!/
Confusion on thy banners wait'
(ll 1–2).

The rediscovery of John
Martin, born at Haydon Bridge
in Northumberland, was
launched by two refugees from
Nazi Germany, Robert and
Charlotte Frank, who set up as
dealers in St James's, London.
The only two important Martins
in the Tate Gallery, the *Last
Judgement* and *The Plains of
Heaven*, were given by Charlotte
in memory of her husband. This
work was acquired from him by
the National Art-Collections
Fund and given to the Laing Art
Gallery on the occasion of its
1951 Martin exhibition, the first
ever to be devoted to this
painter. DST

PROVENANCE With Robert Frank;
1951: acquired for the gallery by the
National Art-Collections Fund
REFERENCES *John Martin*, exh. cat.,
Newcastle, Laing Art Gallery, 1970;

W. Feaver, *The Art of John Martin*,
Oxford, 1975, p. 29

113

Sir Charles Lock Eastlake
PRA (1793–1865)
The Champion, 1824

oil on canvas, 123.2 × 174.8 cm
inscribed: *ROME 1824*
Birmingham Museums and Art
Gallery, P.15'56

Eastlake's career as an artist pales
into insignificance beside his
great administrative
achievements in the Victorian art
world. As Director of the
National Gallery (1855–65) he
transformed the collections and

was also elected President of the
Royal Academy (1850–65).
However, his body of work is by
no means negligible, and *Christ
Lamenting over Jerusalem* (1855;
Glasgow Art Gallery) was one of
the most admired pictures of the
time. *The Champion* was painted
in Rome, when Eastlake's friends
had begun to fear that the easy
success of his views and
picturesque brigands would
tempt him away from more
serious undertakings. The sub-
ject, according to Lady Eastlake,
is 'a Norman-Sicilian Knight in
armour, challenged by a Saracen,

and preparing to follow the
herald, while he receives a scarf
from a lady. This gave [Eastlake]
the opportunity of painting
armour, of which he always felt
the picturesque capacities.' It was
painted under difficult
circumstances, as Eastlake was
suffering from eye troubles and
recovering but slowly from a
recent operation. The painting
was fairly well received at the
British Institution in 1825, and
Eastlake was particularly
gratified by Benjamin Robert
Haydon's opinion that it was
'Titianesque'. CG

PROVENANCE 1956: purchased by the
museum from Messrs Collins,
Birmingham
EXHIBITION London, British
Institution, 1825, no. 193
REFERENCES Lady Eastlake, 'Memoir
of Sir Charles Eastlake', in *Contributions to
the Literature of the Fine Arts*, London,
1870, pp. 104–5, 194; D. Robertson,
*Sir Charles Eastlake and the Victorian Art
World*, Princeton, 1978, pp. 25, 257

114

Francis Danby ARA
(1793–1861)

Sunset at Sea after a Storm,
1824

oil on canvas, 84.5 × 117.4 cm
Bristol Museums and Art Gallery,
K5008

Danby was born in Ireland but
in 1813 settled in Bristol, where
he stayed until moving hastily to
London in 1824 to escape
substantial debts. This was to be
the pattern of his life, with
periods spent in Paris, Bruges,
Zurich and Geneva, until in

1846 he moved to Exmouth in
Devon, where he died in 1861.
His exhibiting reflects this
peripatetic existence, but *Sunset
at Sea after a Storm* comes from a
relatively settled period which
saw an unbroken succession of
important works at the Royal
Academy and the British
Institution, many favourably
noticed by the critics. *Sunset at
Sea* was bought from the Royal
Academy Summer Exhibition of
1824 by the President, Sir
Thomas Lawrence. According to
Richard and Samuel Redgrave's
account in *A Century of British
Painters*, this was the 'work that

made the painter's reputation'.
The figures on a raft, few
survivors from a wreck, recall the
work of Théodore Géricault
(1791–1824) and the American
Washington Allston
(1779–1843), whose
monumental sea-piece *Rising of a
Thunderstorm,* exhibited in Bristol
in 1814, bears a striking
resemblance to this picture. The
intensely romantic image was to
inspire both John Martin and
Turner. CG

PROVENANCE 1824: bought by Sir
Thomas Lawrence PRA; 1861: Ernest
Gambart, 1982. Agnew's, from which
purchased by the museum with support
from the Victoria and Albert Museum
Purchase Grant Fund
EXHIBITIONS London, RA, 1824, no.
350; *Francis Danby 1793–1861*, London,
Tate Gallery, 1988 no. 20
REFERENCE E. Adams, *Francis Danby:
Varieties of Poetic Landscape*, London, 1973,
no. 159

115
Sir Edwin Landseer RA
(1802–73)
Bolton Abbey, c. 1834
oil with pencil on millboard,
25.3 × 35.5 cm
Manchester City Art Galleries,
1920.543

It seems likely that this small
Romantic landscape was painted
while Landseer was at work on
his most famous picture – one of
his few history subjects – *Bolton
Abbey in the Olden Time* (Trustees
of the Chatsworth Settlement),
which was commissioned by the
6th Duke of Devonshire and
completed in 1834. Landseer's
sketches show all the signs of
having been done in the open air
and, since they do not seem to
have been preparatory studies for
finished works, with the sole
function of capturing fleeting
effects of weather and light. The
ruined abbey is seen here in the
distance and a heron flies across
the limpid pool of water in the
foreground, conveying a sense of
solitude. The contrast with the
scene of revelry shown in the hall
of Bolton Abbey in olden times
could not be more complete.

This picture comes from an
important benefactor to the
Manchester art gallery. Lloyd
Roberts was a local doctor who
bequeathed a number of 19th-
century paintings, among them
another of Landseer's landscape
sketches and pictures by Etty,
Frith, George Elgar Hicks
(1824–1914), William Mulready
(1786–1863), David Roberts and
Clarkson Stanfield, as well as a
group of works by Henri Fantin-
Latour and many English
watercolours. C G

PROVENANCE 1874: artist's sale, lot
28; Agnew's; 1901: Dr Lloyd Roberts;
1920: bequeathed by him to the galleries
EXHIBITIONS Glasgow International
Exhibition, 1901, no. 26; *Sir Edwin
Landseer*, London, Tate Gallery, and
Philadelphia Museum of Art, 1981–2,
no. 46

116
William Etty RA
(1787–1849)
Mlle Rachel, 1841 (?)
oil on millboard, 60.9 × 45.7 cm
York City Art Gallery, 988

This strongly characterised
portrait is thought to represent
the great French actress Rachel.
This was the stage name of Elisa
Félix (1821–58), who made her
first appearance on the French
stage in 1837 and her début at
the Théâtre Française in 1838, as
Camille in Corneille's *Horace*. In
the latter year she triumphed as
Roxane in Racine's *Bajazet*. Her
greatest roles were tragic ones
and she excelled in the

impersonation of malignant
passion, which she presented
with a majesty and dignity that
fascinated while it repelled. The
portrait probably dates from
Rachel's first visit to England, in
1841, when her interpretations
of Corneille and Racine were the
sensation of the season. She was
no doubt introduced to Etty by
her friend the English actor
William Macready. J B T

PROVENANCE Sir James Dunn,
London; 1961, 19 April: Sotheby's,
London, sale, lot 97, purchased by the
gallery
EXHIBITION London, RA, 1934, no.
653
REFERENCE City of York Art Gallery,
Catalogue of Paintings, York, 1963, p. 34

117

Joseph Mallord William
Turner RA (1775–1851)
*Calais Sands at Low Water,
Poissards Gathering Bait,*
1830
oil on canvas, 68.6 × 105.5 cm
Bury Art Gallery and Museum,
BUYGM.114.1897

Turner travelled via Calais when
he went to Paris in 1829 and,
although there is no precisely
corresponding preparatory sketch,
there are a number of
watercolours of this date
recording effects of light, weather
and water on the Channel coast.
Butlin and Joll endorse the

suggestion first proposed in the
catalogue *La Peinture Romantique
Anglaise* (Paris, 1972) that the
treatment – a new departure for
Turner, which he also used for
The Evening Star (National
Gallery, London) – recalls the
work of Bonington (cat. 227,
228), whose posthumous sale in
London in 1829 created great
interest. Here Turner is
emulating the scintillating
quality of light and the high key
of Bonington's seascapes.

This is the most important
picture in the Wrigley
Collection. Like Linnell's *Crossing
the Brook* (cat. 124) it was bought
from the pen manufacturer
Joseph Gillott, who had

purchased it from the artist
himself in about 1844 with
eight other paintings for which
he paid £500 each). He disposed
of it two years later and then
bought it back in 1849. Gillott
frequently disposed of items
from his collection and some-
times did not even take delivery
of pictures that he had ordered.
After the rapid initial turnover
he seems to have hung on to this
picture and it was in his sale
after his death in 1872. C G

PROVENANCE *c.* 1844: bought from
the artist by Joseph Gillott; 1872, 20
April: Christie's, London, Gillott sale, lot
161, bought by Agnew's for Thomas
Wrigley; 1880: bequeathed to his
children; 1897: presented by them to the
gallery

EXHIBITIONS London, RA, 1830, no.
304; *Bicentenary Exhibition*, London, RA,
1968–9, no. 158; *La Peinture Romantique
Anglaise et les Préraphaélites*, Paris, Petit
Palais, 1972, no. 264; *Turner*, London,
RA, 1974–5, no. 508; *Presents from the
Past: Gifts to Greater Manchester Galleries
from Local Art Collectors*, Bolton Museum
and Art Gallery, Oldham Art Gallery,
Stalybridge, Astley Cheetham Art
Gallery, and Stockport Art Gallery, 1978,
no. 44; *The Art of Seeing: John Ruskin and
the Victorian Eye*, Phoenix Art Museum
and Indianapolis Museum of Art, 1993–4;
*Making and Meaning: Turner, The Fighting
Temeraire*, London, National Gallery,
1995

REFERENCES W. Wallis and A. B.
Chamberlain, *Illustrated Catalogue of the
Wrigley Collection of Paintings*, Bury, 1901,
pp. 71–4; M. Butlin and E. Joll, *The
Paintings of J.M.W. Turner*, New Haven
and London, 1977, pp. 170–1 (with full
provenance and bibliography)

118

Richard Redgrave RA
(1804–88)

The Poor Teacher, 1845

oil on canvas, 63.8 × 76.4 cm
Shipley Art Gallery, Gateshead
(Tyne and Wear Museums), B3202

The lonely governess sits in the schoolroom. Her black silk dress and the black-edged letter indicate she is in mourning, and her attitude suggests she is musing about her past life.

The status of the governess was a subject of public debate in the mid-1840s. In 1843 the Governess' Benevolent Institution was founded to give assistance to needy and retired governesses. The job was one of the few open to educated women of respectable background. As a paid employee, she was treated as a social inferior by her pupils and their families, yet was more genteel than the other servants. Her ambiguous position was a frequent theme of Victorian novels; it was less often depicted in art, though Redgrave's picture was so popular with patrons that he painted at least four versions of it. This one is a repetition of the earliest, exhibited at the Royal Academy in 1843 (unlocated). The best-known version (1844; Victoria and Albert Museum, London) was commissioned by John Sheepshanks and, presumably at his request, included, as a contrast to the lonely teacher, her happy pupils, seen prominently in the background playing with a skipping rope; in the Gateshead picture the presence of pupils is only hinted at by the shuttlecock glimpsed through the window.

Redgrave had a varied career as an industrial designer, civil servant, writer and curator as well as a painter. As an artist, he defined his aim as 'calling attention to the trials and struggles of the poor and oppressed' and was particularly interested in the social position of women. J B T

PROVENANCE 1909: Shipley Bequest to the gallery
EXHIBITIONS *The Poor Teacher: A Painting and its Public*, Newcastle Polytechnic Art Gallery, 1981, no. 37; *Richard Redgrave*, London, Victoria and Albert Museum, and New Haven, Yale Center for British Art, 1988, no. 29

119

Thomas Jones Barker
(1813–82)

The Bride in Death, 1838–9

oil on canvas, 124.5 × 167.1 cm
inscribed: *T BARKER fecit*
Victoria Art Gallery, Bath and
North-East Somerset, 1923.5

Barker came from a dynasty of
Bath artists, the best known
being his father, Thomas Barker
of Bath (1767–1847), who
married Priscilla Jones of Bath.
Two of their eight children took
up painting. Thomas Jones
Barker did not stay in Bath,
working from 1837 in Paris and
London on dramatic battle and
historical scenes. Barker painted
this, his most celebrated picture,
in the Paris studio of Horace
Vernet (1789–1863) for Princess
Marie d'Orléans, artist daughter
of Louis-Philippe, King of
France. As a reward the artist
received the Légion d'Honneur.
The painting is almost exactly
contemporary with Delaroche's
Execution of Lady Jane Grey
(National Gallery, London), and
it was this type of French
academic painting that
influenced Barker. He took his
subject from a ballad; the action
takes place during the Civil War
and a cavalier is shown
prostrated over the bed of his
young bride, who has died on
the eve of her wedding. One
verse is legible on the scroll of
paper weighted down by a
missal: 'But place the violets in
her hand/ And o'er her brows a
cypress band/ And look your last
on her pretty face/ Ere she goes
to her latest resting place.' The
hourglass on the bedside table is
a reminder of transience. C G

PROVENANCE 1923: presented to the
gallery by Alderman Cedric Chivers
EXHIBITIONS London, British
Institution, 1844, no. 69; exhibited by
Empson, print publisher of Bath, with the
mezzotint, 1845; *The Barkers of Bath*,
Bath, Victoria Art Gallery, 1986, no. 84

120

William Etty RA
(1787–1849)

The Storm, 1829–30

oil on canvas, 91 × 104.5 cm
Manchester City Art Galleries,
1882.4

The Storm was one of Etty's
favourite works, painted, in his
own words, 'in the principle of
attaining harmony of colour by
neutral tints'. The literary and

narrative elements in his figure
groups are often, as here, almost
incidental to the arrangement of
human forms and to the
emulation of the colour and
painterly handling of the
Venetians, which were the
artist's chief preoccupations. Etty
specialised in the nude and was
often castigated for indecency;
but his subject pictures have a
high moral purpose. When
exhibited at the Royal Academy,
The Storm was accompanied by a
quotation from Psalm 22: 'They
cried unto Thee, and were
delivered; they trusted in Thee,
and were not confounded.'

This painting is not a literal
description of a storm; a critic at
the Manchester Art Treasures
Exhibition of 1857 missed the

point when he wrote: 'In such a
sea that cockle-shell boat could
not live an instant, nor could the
group keep their place on board
her.' As another critic at the
same exhibition remarked: 'It is
a poetical licence . . . The artist's
object was evidently to produce a
picture of expression.' J B T

PROVENANCE 1832: purchased from
the artist by the Royal Manchester
Institution; 1882: transferred to the City
Art Gallery
EXHIBITIONS London, RA, 1830, no.
37; Royal Manchester Institution, 1832,
no. 325; Manchester, 1857, no. 273
REFERENCE D. Farr, *William Etty*,
London, 1958, p. 138 (with full
exhibitions and bibliography)

121

David Roberts RA
(1796–1864)

A Street in Grand Cairo,
1846

oil on canvas, 76.2 × 63.5 cm
inscribed: *David Roberts RA 1846*
Royal Holloway, University of
London, Egham, Surrey

Roberts was born in Edinburgh
and started his career as a scene-
painter, before finding his métier
as an architectural and travel
artist with a scrupulous regard
for accuracy. Roberts travelled to
Egypt in 1838–9, spending some
time in Cairo during that winter.
He took a house in order to have
time to draw and remarked that
it was 'a most arduous under-
taking in those narrow Stinking
crowded Streets and mostly in
my European dress'. Roberts
believed that, irrespective of
their artistic merit, his drawings
would be of value for the
information they provided for a
European audience about
architectural styles. This
painting shows a dramatic
perspective, looking towards the
mosque of El Rhamree. The
painting was completed seven
years after Roberts's return. It
was bought for £52 10s. by
Elhanan Bicknell of Herne Hill,
a well-known collector. Dr
Waagen, who visited Bicknell in
1854 on his tour of the private
art collections of England, wrote
admiringly of its 'masterly
execution, in the finest silvery
tone'. Bicknell owned a water-
colour of the same subject, and a
coloured lithograph of the image
by Louis Haghe was published in
1849 in volume three of *The*

Holy Land, Syria, Idumea, Arabia,
Egypt and Nubia. CG

PROVENANCE 1846: Elhanan Bicknell,
Herne Hill; 1863, 25 April: Christie's,
London, Bicknell sale, lot 75; various
owners to Thomas Taylor of Aston
Rowant, Oxfordshire; 1883, 28 April:
Christie's, Taylor sale, lot 64, bought by
Thomas Holloway

EXHIBITIONS London, RA, 1846, no.
91; *David Roberts*, Scottish Arts Council
touring exhibition, no. 22
REFERENCE J. Chapel, *Victorian Taste:*
The Complete Catalogue of Paintings at the
Royal Holloway College, London, 1982,
pp. 131–2 (with full provenance and
bibliography)

122

Edward Lear (1812–88)

The Mountains of Thermopylae, 1852

oil on canvas, 68.5 × 113.8 cm
inscribed: *EL 1852*
Bristol Museums and Art Gallery,
K4351

Lear is celebrated as the author of nonsense rhymes, but he was also an ornithologist and an artist of considerable talent who made his career as a painter of landscape, mostly of romantic and exotic places, reached after gruelling journeys during which he stoically suffered boredom and physical hardship. He took up oil painting in 1838, and the first of his finished works dates from 1840. Initially he attempted painting his subjects out of doors, but gave this up in favour of working in the studio from numerous studies. This view looking south across the plain of the Spercheios towards the mountains of Thermopylae resulted from a trip to Greece in the summer of 1848. Lady Strachey, editor of Lear's letters to her uncle, Chichester Fortescue, believed this to be one of the most beautiful pictures that Lear ever painted. Lear acknowledged the debt he owed to Holman Hunt for advice, particularly on the subject of colour, without which he would have stuck to a grim, monochrome palette. Hunt was Lear's junior by fifteen years, but he became a lifelong mentor and friend. CG

PROVENANCE William F. Beadon;
Chichester Fortescue; by 1907: his niece
Lady Strachey; thence by family descent;
1975: bought by the gallery
EXHIBITION *Edward Lear 1812–1888*,
London, RA, 1985, no. 50
REFERENCE Lady Strachey, ed., *Letters
of Edward Lear,* London, 1907, pp. 10,
316

124

John Linnell (1792–1882)
Crossing the Brook, 1849

oil on canvas, 100.2 × 125.7 cm
Bury Art Gallery and Museum,
BUYGM.081.1897

Linnell spent his early years in London painting landscapes and portraits but, as the Bayswater and Kensington area in which he lived became more built up, he needed a country base. On a painting excursion in May 1849 a chance delay at Redhill Junction left him with the time to explore the nearby Redstone Wood. Instantly captivated, he bought the estate where he was to live for the rest of his life. *Crossing the Brook*, an idyllic landscape in Linnell's most Gainsborough-like style, was painted in the same year and sold for 200 guineas to the Birmingham pen manufacturer Joseph Gillott, to whom he had been introduced in 1847 by David Cox. It was exhibited at the Royal Academy in 1850, when the *Art Journal* descibed it as a 'subject of the simplest kind – gorgeous with colour, brilliant with light as one of the very best of the artist's productions'. By 1857 the painting was owned by Thomas Wrigley, who lent it to the Manchester Art Treasures Exhibition. Linnell made a replica, which he sold to the banker Louis Huth.

This painting retains some of the precision of Linnell's studies of the environs of Kensington and Bayswater. In Surrey, rejecting the imputation of being 'a topographer', and against the minutely naturalistic trend of Pre-Raphaelite painting, he quickly developed an unspecific and Romantic approach with loose brushwork

123

Baron Heinrich Franz
Gaudenz von Rustige
(1810–1900)

The Castle Ferry, c. 1851

oil on canvas, 77.5 × 94 cm
Torbay Council, Torre Abbey
Collection, Torquay

Rustige was born in Westphalia and went to study with Friedrich Wilhelm von Schadow (1788–1862) at Düsseldorf. Schadow had learned a naturalistic approach to landscape from the French artists whom he met in Rome, but his lyrical and idealistic vision kept him out of touch with the new realist trends, and it was this style of painting that he imparted to his pupil. Rustige was made professor of the Städel Institute in Frankfurt am Main and then at the Fine Art Academy in Stuttgart. He spent some time in Paris. Rustige followed the typical artistic career of a 19th-century academic painter, specialising in subjects from his country's history, peasant genre scenes and landscape. This picture combines historical anecdote with romantic landscape, showing a fortified medieval castle by a river ferry with figures in historical costume going about their daily life.

The British landscape school was vigorous enough to satisfy Victorian collectors and examples of Continental, particularly German, 19th-century Romantic landscapes by lesser known artists are rare in public collections. The provenance of this one is not recorded before it was donated to Torre Abbey by a Mr Fletcher, probably a Torquay resident, in the 1930s, along with three other works. CG

PROVENANCE 1930s: donated to the abbey by Mr Fletcher

and rich colour effects. Linnell
was a hugely prolific and
successful artist who amassed a
large fortune, rumoured among
his fellow artists to be £300,000.

Bury Art Gallery was built
from 1899 to 1901 to house the
collection of Thomas Wrigley
(1808–80), a local industrialist
who had made a fortune in the
paper trade. The collection was
donated by his children in 1897
to celebrate Queen Victoria's
Diamond Jubilee. CG

PROVENANCE 1849: Joseph Gillott; by
1857: Thomas Wrigley; 1880:
bequeathed to his children; 1897:
bequeathed to the gallery by them
EXHIBITIONS London, RA, 1850, no.
395; Manchester, 1857 no. 475;
Manchester Art Treasures Exhibition,
1878l *19th Century British Paintings from
the Thomas Wrigley Collection of the Bury
Art Gallery and Museum*, Hong Kong Arts
Centre, 1990, p. 114
REFERENCE W. Wallis and A. B.
Chamberlain, *Illustrated Catalogue of the
Wrigley Collection of Paintings*, Bury, 1901,
pp. 50–1

125

John R. Herbert RA HRI
(1810–90)

Cordelia Disinherited, 1850

oil on canvas, 100.5 × 61 cm
inscribed: *J.R.. Herbert R.A. London
1850*
Harris Museum and Art Gallery,
Preston

Herbert was an admirer of the
architect A.W.N. Pugin and,
like him, converted to
Catholicism in 1840, after which
he concentrated on biblical
themes. He contributed to the
Palace of Westminster frescoes
(see p. 27), his subject being *Lear
Disinheriting Cordelia*, a version of
which was shown in the
Manchester Art Treasures
Exhibition in 1857, lent by the
Manchester collector John
Chapman.

Like Dyce, who was himself
extensively involved with the
Palace of Westminster
decorations, Herbert was
inspired by the German
Nazarene painters, encountered
when he was in Italy soon after
leaving the Royal Academy
Schools, where he had trained
from 1826 to 1829. Herbert's
fresco was commended for the
way in which the emotional
impact of the subject was
conveyed by the facial
expressions of the characters. The
intensity of Cordelia's gaze in the
present picture contrasts with
the bold simplicity of her
intricately embroidered dress,
which is painted in the direct,
rather flat, manner favoured by
the Nazarenes. CG

PROVENANCE 1919: bequeathed to
the museum by William Vaughan

126

William Dyce RA
(1806–64)

The Meeting of Jacob and Rachel, c. 1850–53

oil on canvas, 70.4 × 91.1 cm
Leicester City Museums, F32.1932

The meeting of Jacob and Rachel, who had come to the well to water her father's sheep, is related in Genesis 29:1–12. Dyce depicted the moment of their embrace, contrasting Rachel's modest bearing with Jacob's emphatic forward movement. The choice of subject had a personal significance for the artist, as it was painted in the year of his marriage.

This is one of two versions of a lost painting, *Jacob and Rachel*, exhibited at the Royal Academy in 1850. The other version is now in the Kunsthalle, Hamburg, and, though smaller, shows the figures full length in a Scottish landscape rather than in the Middle Eastern setting indicated here by the palm-tree. The clear, bright colours, strong modelling and precise outlines show how deeply Dyce was influenced by the Nazarenes. He was one of the few British artists who had first-hand contact with them, in Rome in 1827, and on subsequent visits to Italy and Germany he deepened his familiarity with German art. His work formed a link between the Nazarenes and the Pre-Raphaelite Brotherhood, whom he encouraged. J B T

PROVENANCE 1885, 16 May: Christie's, London, Felix Pryor sale, lot 69, bought by Agnew's; H.S. Leon; 1932: bought by the museum from Agnew's
EXHIBITIONS International Exhibition, London, 1862, no. 591; Exposition Universelle, Paris, 1867; *Centenary Exhibition of the Works of William Dyce*, Aberdeen Art Gallery and London, Agnew's, 1964, no. 28
REFERENCES *Leicester Museums and Art Gallery: Collection of Paintings*, Leicester, 1958, pp. 17–18; M. Pointon, *William Dyce*, Oxford, 1979, pp. 119–21, 196, pl. 76

John Faed (1819–1902)

The Cruel Sister, 1851

oil on canvas, 122 × 87.6 cm
Bury Art Gallery and Museum,
BUYGM.059.1897

The subject, from Sir Walter
Scott's *Minstrelsy of the Scottish
Border* (1802–3), a collection of
traditional ballads, is typical of
Faed, most of whose paintings
were inspired by Scottish history,
literature and tradition.

There were two sisters sat in a
 bower,
Binnorie, O Binnorie,
There came a knight to be their
 wooer
By the bonny mill dams of Binnorie.
He courted the eldest with brooch
 and knife,
Binnorie, O Binnorie,
But he loved the younger abune his
 life,
By the bonny mill dams of Binnorie.
The older one was vexed sair,
Binnorie, O Binnorie,
And sair envied her sister fair,
By the bonny mill dams of Binnorie.

127

Thomas Faed RA HRSA (1826–1900)

The Pet Lamb

oil on canvas, 89 × 69.2 cm
Sefton MBC Leisure Services Dept,
Arts and Cultural Services Section,
The Atkinson Art Gallery,
Southport, 1929.369

Thomas Faed was the younger
brother of the painter John Faed
(cat. 128). Their father was a
millwright and engineer in
Kirkcudbrightshire. Thomas was
born there, but his artistic
education took place in
Edinburgh. He settled in London
in 1852. Following his first great
success in 1855 at the Royal
Academy with his painting *The
Mitherless Bairn* (National
Gallery of Victoria, Melbourne),
Faed made a profitable career out
of pathetic Scottish subjects,
many of them with a dimension
of social realism and implied
moral censure. He fulfilled the
criteria of the times for popular
success, appealing to all classes
and degrees of education and
culture. He was promoted by
Agnew's, who gave him a one-
man exhibition in 1860, and he
continued to attract widespread
comment and critical acclaim
with a succession of predictable
subjects such as *The Pet Lamb*, as
well as with stronger images of
rural hardship. *The Pet Lamb* is
an example of Victorian
sensibility and the taste for
children and animals in
sentimental but believable roles
– a great many children in rural
families would have nurtured
orphan lambs – applied to the
18th-century concept of the
rustic shepherdess. Faed's
influence is discernible on such
artists of the Cranbrook Colony
as Hardy (cat. 152) and G.B.
O'Neill (cat. 18); his own debt
was to Sir David Wilkie
(1785–1841), as Ruskin
remarked in his *Academy Notes* for
1855, accusing Faed of 'the most
commonplace Wilkieism'. CG

PROVENANCE 1929: bequeathed to
the gallery by John Henry Bell

The subject of a man choosing
between two women derives
from the Greek fable of the
choice of Hercules, popular with
Renaissance and Baroque
painters who showed Hercules
seated at the crossroads with two
beckoning women personifying
Virtue and Vice. In the Victorian
period the subject shed its moral
overtones to become a man
courting two women, but the
symbolic attributes of earlier
representations lingered on in
such devices as the contrasting
black and white dresses used by
Faed to indicate the characters of
the sisters.
 Faed gained a silver medal at
the Royal Scottish Academy the

year he exhibited *The Cruel Sister*, and the painting was engraved in 1859. JBT

PROVENANCE 1851: Henry Wallis; Thomas Wrigley; 1880: bequeathed by him to his children; 1897: presented by them to the gallery

EXHIBITIONS Edinburgh, RSA, 1851, no. 164; *19th Century British Paintings from the Thomas Wrigley Collection of the Bury Art Gallery and Museum*, Hong Kong Arts Centre, 1990, pp. 70–1

REFERENCE M. McKerrow, *The Faeds: A Biography*, Edinburgh, 1982, pp. 12, 144

129

Ford Madox Brown
(1821–93)

*An English Autumn
Afternoon, Hampstead –
Scenery in 1853,*
1852–3, 1855

oil on canvas, 71.2 × 134.8 cm
inscribed: *F. Madox Brown*
Birmingham Museums and Art
Gallery, 25'16

This view looking across
Hampstead Heath towards
Highgate, painted from the
window of the artist's lodgings in
Hampstead, is more than a literal
transcription of a particular place

at a precise time, done in
accordance with Pre-Raphaelite
ideas of truth to nature. Its
originality lies in the depiction of
an ordinary, everyday landscape,
a scene of back gardens, orchards
and rooftops, with glimpses of
such mundane incidents as a
woman feeding chickens and
workers picking fruit. The canvas
discards the conventions used by
Victorian painters to give their
landscapes sentiment, grandeur
or decorative appeal. The sole
artifice is in the two figures in
contemporary *petit bourgeois* dress.
Their inclusion emphasises both
the raised viewpoint and the
breadth of the view, and may also
allude to Brown and his wife,

Emma, whom the artist married
between starting to paint the
work in October 1852 and
resuming in September 1853.

Brown's painting prompted
Ruskin to ask the artist, 'What
made you take such a very ugly
subject, it was a pity for there
was some *nice* painting in it'; to
which Brown replied, 'Because it
lay out of a back window'. J B T

PROVENANCE 1854: sold at Phillips to
R. Dickinson, who sold it to Charles
Seddon; 1856: bought back by the artist;
1861: sold to George Rae of Birkenhead;
1916: acquired by the museum
EXHIBITIONS London, British
Institution, 1855, no. 79; International
Exhibition, London, 1862, no. 533;
Madox Brown, 191 London, Piccadilly,
1865, no. 13; *Ford Madox Brown,*

Liverpool, Walker Art Gallery,
Manchester City Art Gallery and
Birmingham City Art Gallery, 1964–5,
no. 28; *The Pre Raphaelites*, London, Tate
Gallery, 1984, no. 51
REFERENCES A. Staley, *The Pre-
Raphaelite Landscape,* Oxford, 1973, pp.
35–8; J. Bryant, 'Madox Brown's *English
Autumn Afternoon* Revisited', *Apollo*, July
1997, pp. 41–3

130

Ford Madox Brown
(1821–93)

Work, 1852–63

oil on canvas, 137 × 197.3 cm
inscribed: *F. MADOX BROWN
1852-/65*
Manchester City Art Galleries,
1885.1

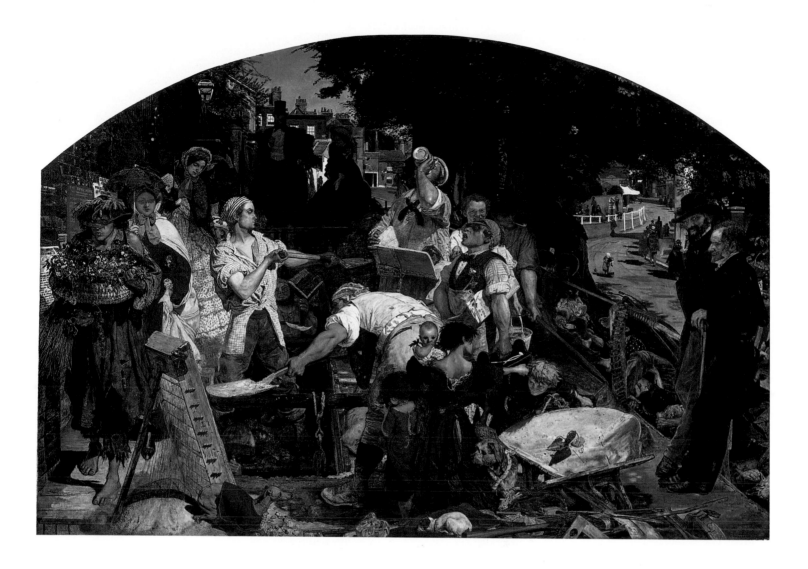

Work is a realistic street scene, painted with Pre-Raphaelite truth to nature. The location is Heath Street, Hampstead; the figures are portraits of real people; and the details of clothing, buildings, plants and animals are all painstakingly observed. But the painting is also an allegory; the figures are grouped to represent different social classes and different aspects of work. In the centre are the manual workers, a group of navvies digging a new water main, with a handsome young labourer embodying the nobility of work. At the rear and to the left are the idle rich who have no need to work, represented by fashionably dressed ladies and an MP on horseback. The ragged children in the foreground and the people under the trees on the right are the poor and unemployed who have never been taught to work. Also depicted are street traders, such as the chickweed seller and the beer seller. The key to the picture's meaning lies in the intellectuals or 'brain-workers' on the right, portraits of Frederick Maurice and Thomas Carlyle, both of whom Brown admired. Maurice was a pioneer of working-class education, while Carlyle's *Past and Present* described a social hierarchy similar to that seen in the painting and argued for the moral value of labour as essential to the spiritual health of society. Thus the painting arose directly from contemporary socio-political ideas. It is the most elaborate example of the Pre-Raphaelite modern moral subject. JBT

PROVENANCE 1852: begun; 1856: commissioned by Thomas Plint; 1862: completed; 1863: repudiated by Plint's executors and bought by Ernest Gambart; 1865: reacquired by Plint's executors, sale, Christie's, London, 17 June, lot 118, bought in; 1868: J.C. Knight; 1884: Benjamin Armitage; 1885; purchased by the gallery

EXHIBITIONS *Madox Brown*, London, 191 Piccadilly, 1865, no. 99; Manchester Royal Jubilee Exhibition 1887, no. 47; *Ford Madox Brown*, Walker Art Gallery, Liverpool, Manchester City Art Gallery and Birmingham City Museum and Art Gallery, 1964–5, no. 25 (with full provenance and bibliography); *The Pre-Raphaelites*, London, Tate Gallery, 1984, no. 88; *Hard Times: Social Realism in Victorian Art*, Manchester City Art Gallery and Amsterdam, Van Gogh Museum, 1987, no. 19 (with further bibliography); *The Victorians*, Washington, National Gallery of Art, 1997, no. 19

REFERENCE G. Curtis, 'Ford Madox Brown's *Work*: An Iconographical Analysis', *The Art Bulletin*, December 1992, pp. 623–36.

131

John William Inchbold
(1830–88)

*At Bolton (The White Doe of
Rylestone)*, 1855

oil on canvas, 68.6 × 50.8 cm
inscribed: *I.W.INCHBOLD/ 1855*
Leeds Museums and Galleries (City
Art Gallery)

This view of Bolton Abbey on
the River Wharfe fifteen miles
north-west of the artist's native
Leeds was loosely inspired, like
Inchbold's earlier *The Chapel,
Bolton* (Northampton Art
Gallery), by Wordsworth's poem
The White Doe of Rylestone, which
was quoted in the catalogue
when the picture was shown at
the Royal Academy in 1855.

The poem describes the
reaction of a crowd of people to
the appearance of the doe at
Rylestone, a few miles west of
Bolton Abbey (see cat. 115).
Inchbold makes no attempt to
illustrate the poem literally, nor
does he seem to employ
Christian symbolism, despite the
uncanny resemblance to Holman
Hunt's *The Scapegoat,* which was
painted in the Holy Land in
1854–5 and shown at the
Academy in 1856. *At Bolton*
seems to be primarily an exercise
in Pre-Raphaelite notions of
truth to nature. There are
pentimenti around the doe,
revealing the artist's difficulties
with the Pre-Raphaelite wet
white ground technique, which
does not easily accommodate
changes.

At Bolton, though accepted by
the Royal Academy, was hung
where it could hardly be seen.
Ruskin described it in *Academy
Notes* as 'ineffective, but yet full
of excellent and right feeling'. It
remained unsold and, after the

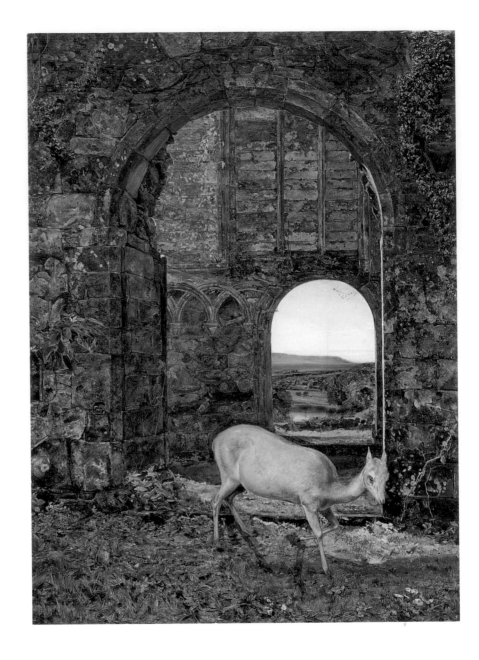

artist's death, was bought by his
brother, whose wish for it to be
given to Leeds City Art Gallery
was later realised. J B T

PROVENANCE 1888, 6 June: Foster's,
studio sale, lot 82, bought by Henry
Inchbold; 1934: given to the gallery by
Ernest Inchbold
EXHIBITIONS London, RA, 1855,
no. 1075; *John William Inchbold, Pre-
Raphaelite Landscape Artist*, cat. by C.
Newall, Leeds City Art Gallery, 1993, no.
5 (with full exhibitions and bibliography)
REFERENCE A. Staley, *The Pre-
Raphaelite Landscape*, Oxford, 1973,
pp. 113–14

132

Sir John Everett Millais
PRA (1829–96)
The Blind Girl, 1854–6

oil on canvas, 81.2 × 62.3 cm
inscribed: *JE Millais 1856*
(initials in monogram)
Birmingham Museums and Art
Gallery, 3'92

A blind girl, forced to beg and
to play the concertina for money,
sits in a landscape, its beauty all

the more poignant because she
cannot see it. Her sightlessness is
emphasised by her companion,
who turns to look at the double
rainbow, and by the butterfly,
which, unnoticed, has settled on
her shawl. The girl's other senses
are suggested by the concertina,
the wild flowers, the rough
textures of the clothing and by
her hands, one feeling a blade of
grass, the other clutching the
hand of her guide. The powerful
impression of the freshness of

grass after rain was noted approvingly by Ruskin.

The Blind Girl is one of a number of Pre-Raphaelite pictures painted after a plea had been published in *The Germ* for artists to forsake historical subjects for contemporary social themes – part of a wider European movement towards modern-life subjects. Millais stresses the pathos rather than the social injustice of the girl's plight, giving the principal figure a Madonna-like calm and including the rainbow as a symbol of divine promise. JBT

PROVENANCE 1856: bought by Ernest Gambart; 1857: John Miller, Liverpool; 1858, 21 May: Christie's, London, lot 171; 1861: David Currie; 1886, 2 April: Christie's, William Graham sale, lot 89, bought by Agnew's; 1891: Albert Wood; 1892: William Kenrick, who presented it to the museum

EXHIBITIONS London, RA, 1856, no. 586; *Millais*, London, RA, 1898, no. 56; *Millais PRA, PRB*, London, RA, and Liverpool, Walker Art Gallery, 1967, no. 51 (with full bibliography); *The Pre-Raphaelites*, London, Tate Gallery, 1984, no. 69; *Visions of Love and Life: Pre-Raphaelite Art from Birmingham Museums and Art* Gallery, Seattle Art Museum, Cleveland Museum of Art *et al.*, 1995, no. 38; *The Victorians*, Washington, National Gallery of Art, 1997, no. 11

REFERENCE A. Staley, *The Pre-Raphaelite Landscape*, Oxford, 1973, pp. 53–4

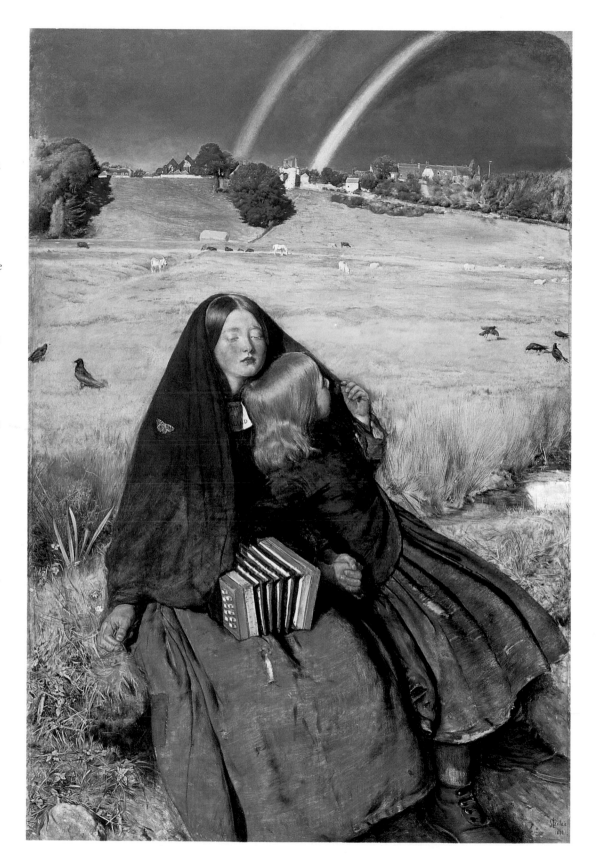

133

David Cox RWS
(1783–1859)

Rhyl Sands, c. 1854

oil on canvas, 45.8 × 63.5 cm
Manchester City Art Galleries,
1917.170

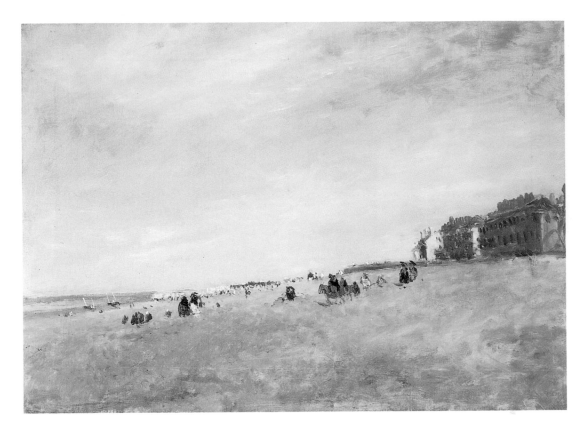

This sparkling view of the beach
at Rhyl exhibits a free handling
unparalleled in English painting
at this date. The simple
composition and the air of breezy
outdoor freshness, conveyed by
rapid dabs of the brush,
anticipate the work of Boudin
(cat. 356) and the French
Impressionists. The originality of
Cox's paintings owes much to his
lack of conventional training in
oils. His main career was as a
painter of watercolour
landscapes, and it was not until
the late 1830s that he turned to
oil painting. In 1841 Cox settled
at Harbourne, near Birmingham.
From there he made annual visits
to North Wales, on one of
which, in August 1854, he
painted this view. The stroke he
suffered in 1853 may have
contributed to the suppression of
detail in the painting, so alien to
the contemporary taste for high
finish. The picture gives every
appearance of having been done
on the spot, but may well have
been executed in the studio from
watercolour sketches, of which
several exist.

The Manchester cotton broker
George Beatson Blair, who
bought the picture in 1913, and
his brother James, who
bequeathed it to the museum in
1917, were both distinguished
collectors and important
benefactors of the City Art
Gallery. James's bequest of 246
items included nine watercolours
and four oils by Cox. In making

the bequest, Blair hoped to set
an example to other collectors,
and to encourage Manchester to
build a larger gallery. JBT

PROVENANCE 1913, 13 March:
Christie's, London, Alexander Young sale,
bought by C.A. Jackson; 1913: sold by
him to George Beatson Blair; 1917:
bequeathed to the gallery by James Blair
EXHIBITIONS *British Art*, London,
RA, 1943, no. 665; *David Cox Centenary
Exhibition*, Birmingham Museums and
Art Gallery, 1959, no. 122; London,
1962, no. 190
REFERENCES T. Cox, *David Cox*,
London, 1947, p. 98, pl. 26a; *The Tate
Gallery 1984–86: Illustrated Catalogue of
Acquisitions*, London, 1988, pp. 63–4

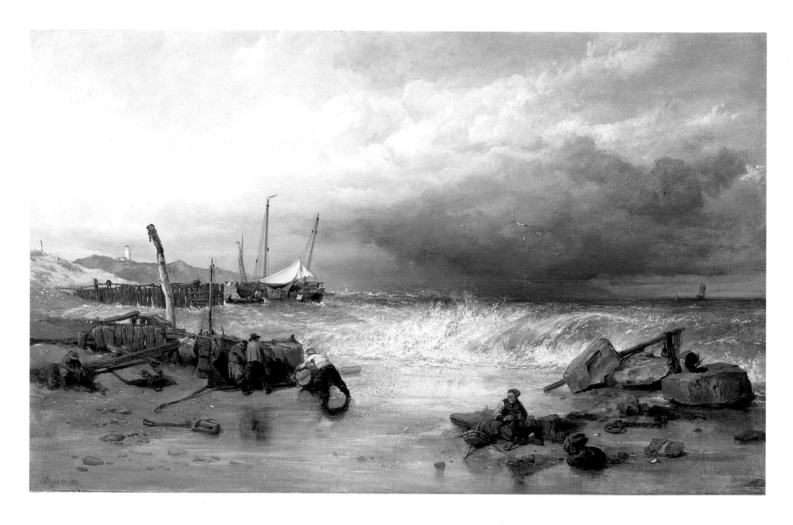

134

William Clarkson Stanfield RA (1793–1867)

On the Coast of Brittany,
1858

oil on canvas, 75.5 × 121 cm
inscribed: *C. Stanfield, R.A. 1858*
Bury Art Gallery and Museum,
BUYGM.107.1897

This fine canvas depicts the most popular kind of marine subject, the drama of a shipwreck. Under dark clouds and a stormy sky, a rough sea, with large waves breaking on the shore, has thrown pieces of wreckage on to the rocks. On the left a fishing boat is hauled up on shore against a wooden landing stage, where three men are hauling at a barrel and another is mending nets; a small boat is proceeding to a lugger against a background of cliffs with a white lighthouse, and to the right is open sea with shipping.

Stanfield was a sailor in early life who showed an aptitude for drawing and sketching marine views. He obtained his discharge from the Navy following a fall and took up scene painting, at the Royalty Theatre and at His Majesty's, Drury Lane, London, combining this with sea pictures, through which he rapidly became known. He exhibited at the Royal Academy from 1829. Though he gave up scene-painting, a tendency to excessively scenic treatment remained with him. He visited Italy in 1839 and added foreign topography to his repertoire, painting Dutch coastal scenery and publishing lithographic views of the Rhine, the Meuse and the Moselle. CG

PROVENANCE David Chapman; Thomas Wrigley; 1880: bequeathed to his children; 1897: bequeathed to the gallery by them
EXHIBITION *19th Century British Paintings from the Thomas Wrigley Collection of the Bury Art Gallery and Museum*, Hong Kong Arts Centre, 1990, p. 163
REFERENCE W. Wallis and A.B. Chamberlain, *Illustrated Catalogue of the Wrigley Collection of Paintings*, Bury, 1901, pp. 67–9

135

Marcus Stone RA
(1840–1921)

Silent Pleading, 1859

oil on canvas, 92.1 × 72.1 cm
Calderdale Museums and Arts
(Smith Art Gallery, Brighouse),
1974.767

The subject of *Silent Pleading*
reflects the artist's connection
with Charles Dickens. In 1853
the novelist, a close friend and
neighbour of Stone's father,
Frank, had congratulated the
twelve-year-old Marcus on a
sketch of Jo the Crossing
Sweeper from *Bleak House*.
Dickens later commissioned him
to illustrate *Our Mutual Friend*
(1864). *Silent Pleading* shows a
tramp sheltering from the snow,
his little child wrapped in his
cloak. A policeman is about to
arrest him but is restrained by a
country gentleman who has
taken pity on the man. The
painting was exhibited in 1859
at the Royal Academy with the
quotation 'Him and his innocent
child' from Shakespeare's *The
Tempest*. This was the artist's
second exhibit at the Academy
and it drew him a favourable
notice from the *Art Journal*
critic. Yet Stone did not fulfil
the promise of this early essay in
contemporary social subjects,
becoming wealthy and successful
with vapid pictures of lovelorn
swains and their ladies in
Regency costume. J B T

EXHIBITIONS London, RA, 1859, no.
456; *Hard Times: Social Realism in Victorian
Art*, Manchester City Art Gallery,
Amsterdam, Van Gogh Museum, and
New Haven, Yale Center for British Art,
1987–8, no. 24

136, 137

Abraham Solomon ARA
(1823–62)

Waiting for the Verdict, 1857
The Acquittal, 1859

oil on millboard, 31.8 × 39.3 cm
oil on panel, 32.4 × 40.6 cm
Tunbridge Wells Museum and Art
Gallery, TUNWM1952/86(13);
TUNWM1952/86(14)

These are reduced replicas of
Solomon's most famous subjects,
the full-sized versions of which
are in the Tate Gallery, London.
Waiting for the Verdict attracted
almost unanimous praise at the
Royal Academy in 1857. Ruskin
found it 'very full of power', but
he added, 'rather a subject for
engraving than painting. It is
too painful to be invested with
the charm of colour'. Particular
commendation from the critics
was elicited for the speaking
depiction of grief and despair on
the faces. The story can be read
in the careful details of the
clothing. The heavy boots of the
old countryman on the left
indicate the rustic origins of the
accused, and it can be seen that
the terrible consequences of a
'guilty' verdict will fall on the
unhappy wife and her two
children. The only criticism was
of the nature of the subject, the
accused being on trial for his life.
Such suspense before the verdict
could be known made the
picture unsuitable to be hung in
the home, according to *The
Times*.

In 1859 Solomon allayed the
public's fears by showing the
happy outcome of the trial in the
painting entitled *Not Guilty*, also
known as *The Acquittal*. There
was bound to be an element of
anti-climax, and when the
picture was exhibited at the
Royal Academy the August issue
of *Blackwood's Magazine* was
quick to point out the trap lying
in wait for the series painter:
'The picture, sufficiently
vigorous and telling, shares,
however, the proverbial fate
attendant on the continuation of
a once-told story. The mind
wrought into the threatening
fear of tragic doom, the plot once
marshalled for effect, each
repeated echo palls upon the ear,
and what ought to end in climax
necessarily falls into an expiring
decadence.' Both pictures were
enormously popular and
Solomon had to make a number
of reduced replicas; this pair
must have been acquired soon
after they were painted, since
Alfred Ashton's collection was
completed by 1863. The small
pair has been in the gallery at

Tunbridge Wells since 1952,
but it was not until 1982 that
the original full-sized pair
entered a public collection, when
they were bought for the Tate
Gallery. CG

PROVENANCE By 1863: Alfred
Ashton; bequeathed to his children; 1952:
presented by them to the gallery
REFERENCES J. Ruskin, 'Academy
Notes', in *The Works of John Ruskin*, ed.
E.T. Cook and A. Wedderburn, London,
1904, XIV, p. 14; R. Treble, *Great
Victorian Paintings*, London, 1978, nos.
51, 52 (with full provenance and
bibliography); *Solomon, a Family of
Painters*, exh. cat., London, Geffrye
Museum, 1985, p. 55

138
Adriaen Eversen (1818–97)
Dutch Street Scene, 1858
oil on canvas, 80 × 100.5 cm
Cheltenham Art Gallery and
Museum

Eversen belonged to a talented
group of artists, including the
Koekkoek family and Cornelius
Springer (1817–91), his master.
He spent most of his long career
in Amsterdam. Eversen's
townscapes are convincing
architecturally but few are
topographically precise. In this
example an impromptu awning
has been contrived by
suspending a large canvas sheet
from a window on the upper

floor of the main building,
beneath which some spectacle is
taking place. On the pavement a
vendor of old furniture and
household goods has set up his
stall, and among the local
peasantry is a well dressed
couple. Although once identified
as a street in Dordrecht, the
buildings appear to be entirely
imaginary.

Eversen worked in the manner
of the 17th-century Dutch 'Little

Masters', producing the type of
picture that made up the greater
part of the collection formed in
the mid-19th century by the 2nd
Baron de Ferrieres. The taste for
combining Dutch 17th-century
artists and their 19th-century
pasticheurs was typical of
Continental collecting of the
period, but rare in England, and
few of these highly accomplished
19th-century works have found
their way into public galleries.

After his father's death in
Cheltenham in 1864, the 3rd
Baron Ferrieres set about
publicising the collecton and
this work was lent to the
National Exhibition in Leeds in
1868, an event which was set up
to rival the Manchester Art
Treasures Exhibition of a decade
earlier. The collection was
presented to Cheltenham in
1898. CG

PROVENANCE 2nd Baron de Ferrieres;
1864: bequeathed to his son, 3rd Baron
de Ferrieres; 1898: presented by him to
the gallery
EXHIBITION National Exhibition,
Leeds, 1868
REFERENCE C. Wright, *Baron de
Ferrieres Collection*, Cheltenham, 1988,
p. 60

139

Rosa Bonheur (1822–99)
*Landscape with Cattle,
c. 1856*

oil on canvas, 96 × 125 cm
Wakefield Museums and Arts
(Wakefield Art Gallery and
Museum)

Born into a family of artists in
Bordeaux, Rosa Bonheur received
her earliest lessons from her
father, Raymond. She loved
animals, excelled at painting
them and, following the example
of Théodore Géricault, whom she
greatly admired, made studies in
the Paris slaughter-houses. Her
first success was with *Ploughing
in the Nivernais* (Musée National
du Château de Fontainebleau),
which won a medal at the Paris
Salon in 1849. She was not afraid

of large and ambitious subjects,
for instance the famous *Horse
Fair* (Metropolitan Museum of
Art, New York). There is a
replica of this in the National
Gallery, London, presented by
Jacob Bell, the pharmaceutical
chemist, in 1859. *The Horse Fair*
had become known in Britain
when it was exhibited round the
country by the dealer Ernest
Gambart in 1855. The artist
herself accompanied the picture
for a triumphal tour during
which she met Sir Edwin
Landseer with Sir Charles and
Lady Eastlake: 'It was the dream
of her life to see Landseer, and I
sent them down to dinner
together', Lady Eastlake wrote in
her diary. 'Landseer was full of
impudence. ... He told me to
tell her that he would be happy

to become Sir Edwin Bonheur.'
Gambart took her to Scotland,
where the scenery and the
weather delighted her, providing
her with subjects for twenty
years. Gambart continued to
foster her career, exhibiting her
work frequently in London and
winning commissions from
English and American collectors,
with whom she was enormously
popular. This romantic view
with a ruined castle shows how
accomplished she was as a
landscape painter. A picture with
this title was shown as no. 662
at the Manchester Art Treasures
Exhibition in 1857, lent by A.H.
Novelli. CG

PROVENANCE 1923: presented to the
gallery by Harold H. Holdsworth, JP

140

Frederick Goodall R A HRI
(1822–1904)

Relief of Lucknow (Jessie's Dream), 1858

oil on canvas, 81 × 122 cm
Sheffield Art Galleries and Museums
(Mappin Art Gallery), 101

Goodall's painting derives its subject from an incident that occurred during the Indian Mutiny. A friend of Brigadier-General Havelock, who with Lieutenant-General Outram relieved the besieged garrison at Lucknow after 109 days in September 1857, the artist recounts Havelock's campaign in his *Reminiscences* (1902). The second relief, on November 14 1857, accomplished with the assistance of Sir Colin Campbell, resulted in Havelock's death.

Jessie Brown, the wife of a corporal in the 70th Highlanders, dreamed that she heard the sound of the bagpipes of the second relieving force approaching under Campbell's command. The painting, exhibited at the British Institution in 1858 with the title *The Campbells are Coming: Lucknow, September 1857*, shows her discovering that her dream was correct. Goodall cannot have had first-hand knowledge of the mutiny scene, but by 1858 eye-witness accounts of experiences endured during the massacre at Cawnpore and the seige of Lucknow had been published, many of them by women. Like Sir Joseph Noël Paton, whose *In Memoriam* (also 1858; private collection) shows anguished survivors of mutiny atrocities being rescued by Highlanders, Goodall has tried to capture the horrors of the siege for the women. The mutiny inspired many painters, among them Thomas Jones Barker, who exhibited *The Dawn of Victory – Lord Clyde Reconnoitring the Position of the Enemy in Advance of the Relief of Lucknow* at the Royal Academy in 1862. CG

PROVENANCE 1873, June 6: Christie's, London, lot 261 (as *A Scene in the Trenches at Lucknow*), bought by Permain; J.N. Mappin, by whom bequeathed to the gallery
EXHIBITION London, British Institution, 1858, no. 70
REFERENCE N.G. Slarke, *Fred Goodall, RA*, 1981, p. 49 (ill.)

141

Eugene Isabey (1803–86)
Hurricane before Saint-Malo,
1860

oil on canvas, 108 × 155 cm
Cooper Gallery, Barnsley, Permission
of the Cooper Trustees, Barnsley
Metropolitan Borough Council

After early success at the Paris Salon, winning a 1st class medal for his first exhibited landscapes when he was only 21, Isabey travelled to England in 1825. There he came into contact with Delacroix and Bonington, and was profoundly impressed by the English school of watercolour painting. Isabey's speciality was coastal scenes in Normandy, but he was able to make convincing and lively pictures from all kinds of sea subjects and he was nominated official marine painter to the French Navy, in which capacity he was sent to Algiers in 1830. He was a prolific artist with a large circle

of friends and pupils, and his work was collected in Britain and the United States by enthusiasts for French landscape painting of the Barbizon type. As official painter to King Louis-Philippe, he recorded the visit of Queen Victoria to France in 1843 and the arrival of the King himself at Portsmouth in 1844. Through this connection Queen Victoria came to admire his work. She owned watercolour versions of the pictures record-ing her visit to France, of which the King had oil versions made for his gallery at Versailles illustrating the history of France.

Among Isabey's English patrons was Samuel Joseph Cooper (1830–1913), donor of the founding collection and the building for the Cooper Gallery. Cooper's taste was typical of his time, combining contemporary French painters with minor Dutch 17th-century masters and Italian 18th-century artists. C G

PROVENANCE 1912: donated to the gallery by Samuel Cooper

211

142

Frederick Sandys
(1829–1904)

Autumn, *c.* 1860–2

oil on canvas, 79.6 × 108.7 cm
Norfolk Museum Services (Norwich
Castle Museum), 1209.235.951

An old soldier reclines on the banks of a river with a young woman, either his wife or daughter, and a child. Sandys probably intended the soldier to represent the autumn of life; perhaps he is recounting past glories to the younger generation. The artist planned a companion picture, *Spring*, but this was never executed. A drawing of *Spring*, the same size as a drawing of *Autumn* (both in Norwich), shows a group of young children seated beneath trees.

The man in the painting has been identified as Charles Faux. He served in the Sikh wars in India (1845–9), as his medal ribbons and uniform show, and after his discharge from the regular army became a member of the West Norfolk Militia. Sandys was born in Norwich and frequently returned there: the view shows the River Wensum, Bishop's Bridge and the ruins of Norwich Castle on the hilltop. The treatment of the landscape is heavily dependent on Millais' *Sir Isumbras at the Ford* (1857; Lady Lever Art Gallery, Port Sunlight), which Sandys parodied in the print *The Nightmare*. Sandys may also have been influenced by Millais' two symbolic paintings on the themes of Autumn and Spring, *Autumn Leaves* (1856; Manchester City Art Galleries) and *Apple Blossoms* (1859; Lady Lever Art Gallery). JBT

PROVENANCE 1867: William Dixon, Norwich; 1882, 17 May: Spelman's, Norwich, his sale, lot 230, bought by Clowes; sold to J.J. Colman and thence by descent; 1946: bequeathed to the museum by R.J. Colman
EXHIBITIONS *Norwich and Eastern Counties Working Classes Industrial Exhibition*, Norwich, 1867, no. 754; *Frederick Sandys*, Brighton Museums and Art Gallery, and Sheffield, Mappin Art Gallery, 1974, no. 52; *The Pre-Raphaelites*, London, Tate Gallery, 1984, no. 116
REFERENCE *Visions of Love and Life: Pre-Raphaelite Art from Birmingham Museums and Art Gallery*, exh. cat. by S. Wildman, Art Services International, Alexandria, Virginia, 1995, p. 226

143

Sir John Everett Millais PRA (1829–96)

The Black Brunswickers, 1860

oil on canvas, 104 × 68.5 cm
inscribed: *18M60* (intertwined)
Board of Trustees of the National
Museums and Galleries on
Merseyside (Lady Lever Art Gallery,
Port Sunlight), LL3643

An English girl tries to prevent
her Prussian sweetheart from
leaving for battle on the eve of
Waterloo. She is dressed for a
ball, and he wears the black
uniform of the Brunswick Cavalry
(known as the Brunswickers).
The regiment fought heroically
but unsuccessfully to resist
Napoleon's initial advance at
Quatre Bras, a few days before the
emperor's final defeat at Water-
loo. The engraving on the wall is
after J.-L. David's equestrian
portrait of Napoleon of 1800.

The canvas was intended as a
pendant to one of his early
successes, *A Huguenot*, which
shows a couple united in love
but divided by allegiance. J B T

PROVENANCE 1860: bought by Ernest
Gambart; 1862, 7 May: Christie's,
London, T.E. Plint sale, bought by
Graves; 1868, 20 June: Christie's, Albert
Grant sale, bought by Moore; 1868:
Agnew's, sold to James Price; 1887: resold
to Agnew's, who sold it to J. Hall Renton;
1898, 30 April: Christie's, his sale, lot 90,
bought by Agnew's and sold to W.H.
Lever; 1922: Lady Lever Art Gallery
EXHIBITIONS London, RA, 1860, no.
29; *Millais*, London, Grosvenor Gallery,
1886, no 123; *Millais*, London, RA,
1898, no. 21; *Millais PRA PRB*, London,
RA, and Liverpool, Walker Art Gallery,
1967, no. 59; *The Pre-Raphaelites*, London,
Tate Gallery, 1984, no. 108
REFERENCE M. Bennett, *Artists of the
Pre-Raphaelite Circle: The First Generation –
Catalogue of Works in the Walker Art
Gallery, Lady Lever Art Gallery and Sudley
Art Gallery*, London, 1988, pp. 144–9
(with full provenance, exhibitions and
bibliography)

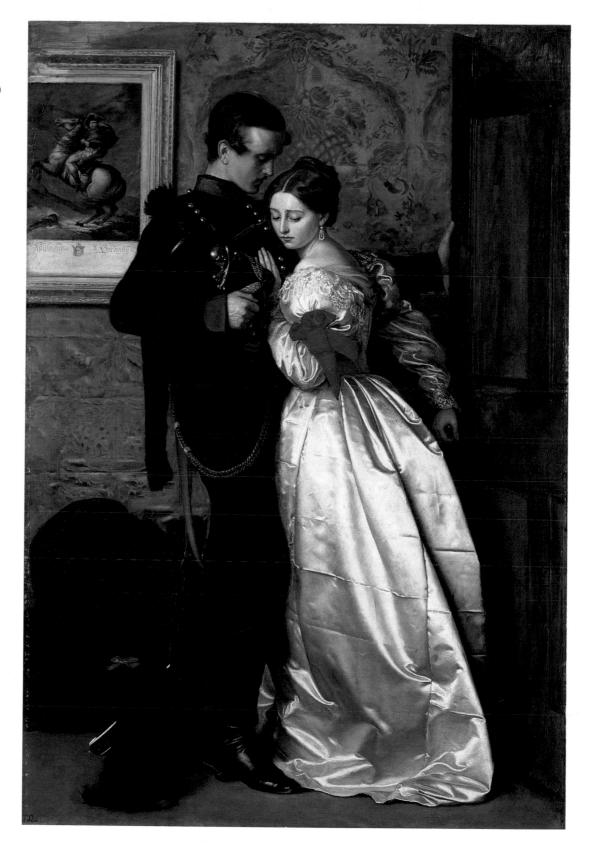

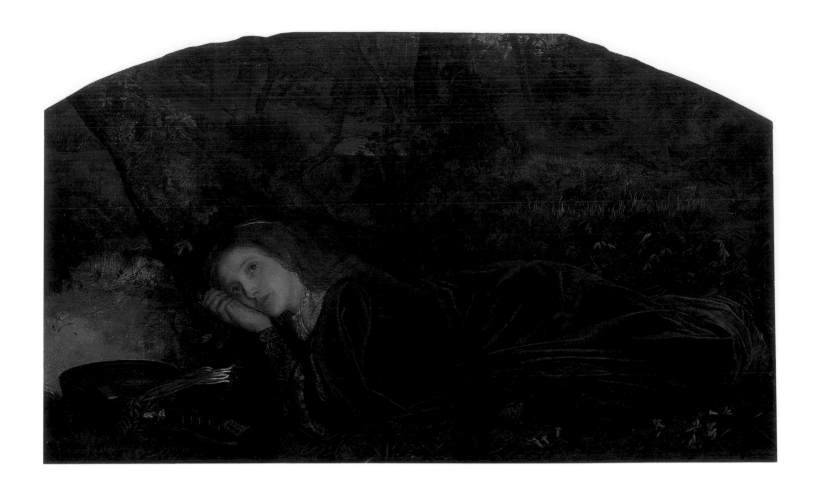

144

Arthur Hughes
(1832–1915)

The Rift in the Lute, 1862

oil on canvas, arched top,
55 × 92.7 cm
inscribed: *Arthur Hughes*
Tullie House, City Museum and Art
Gallery, Carlisle

The painting is loosely inspired
by Vivien's song in Tennyson's
'Merlin and Vivien' from his
Idylls of the King (1859): 'It is the
little rift within the lute,/ That
by and by will make the music
mute,/ And ever widening slowly
silence all./ The little rift within
the lover's lute/ Or little pitted
speck in garnered fruit,/ That
rotting inward slowly moulders
all.'

A smaller version of the
composition is entitled *Enid and
Geraint* (private collection),
demonstrating that such works
are not precise illustrations, but
evocations of poetical mood.
Many of the ingredients of
Hughes's work of this type –
romantic medieval fantasy,
figures making music and
melancholy female beauties –

can be traced to the influence of
Rossetti's watercolours of the late
1850s. Several of Hughes's
paintings of the 1860s express
romantic love in musical terms,
heightening the emotional
intensity by glowing colours,
especially purple and emerald.

The painting, originally
purchased at the Royal Academy
by James Leathart, a lead
manufacturer from Newcastle
upon Tyne who formed an
important collection of Pre-
Raphaelite paintings, was
bequeathed to the gallery by the
poet Gordon Bottomley. His
bequest of over 600 works was
especially rich in works by the
Pre-Raphaelites, Charles
Shannon (1863–1937), Charles
Ricketts (1866–1931) and Paul
Nash (1889–1946). J B T

PROVENANCE 1862: purchased by
James Leathart; 1897, 19 June: Christie's,
London, Leathart sale, lot 33; 1949:
bequeathed to the gallery by Gordon
Bottomley
EXHIBITIONS London, RA, 1862, no.
192; *Arthur Hughes*, Cardiff, National
Museum of Wales, and London, Leighton
House, 1971, no. 6; *Pre-Raphaelites,
Painters and Patrons in the North East*,
Newcastle upon Tyne, Laing Art Gallery,
1989, no. 50 (with full bibliography)

145

Daniel Maclise RA
(1806–70)

A Student, 1862

oil on canvas, 91.1 × 70.4 cm
inscribed: *D MACLISE 1862*
Bury Art Gallery and Museum,
BUYGM.083.1897

Maclise made his reputation
providing near-caricature
portraits for *Fraser's Magazine*; he
painted literary and Classical
subjects, as well as historical
genre scenes, very much in the
popular taste of the early
Victorian period. This is one of
several works from the 1850s
and 1860s showing pairs of
lovers; this couple may be
Goethe's Faust and Gretchen.

The painting may have been
inspired by Gounod's opera
Faust, based on Goethe's drama
and first produced in Paris in
1859. The artist depicts the
scene in which Mephistopheles
brings the rejuvenated Faust to
the house of Marguerite (as
Gretchen becomes in the
Frenchman's opera) to woo and
win her. The idealised female
figure is typical of Maclise's
literary pictures. In this one she
is holding a daisy or
'marguerite', which means
'beautiful' or 'pearl' and perhaps
symbolises the jewels with which
Mephistopheles provides Faust as
a means to tempt Marguerite.
The darkly shadowed male figure
has a suggestion of evil,
appropriate to Faust, who had
become a creature of the Devil.
Ivy (fidelity) and roses (love) are
entwined round the columns of
the cloister. There is Pre-
Raphaelite influence in the
richly detailed medieval setting
and costume, but Maclise's
painterly technique owes more to
the Italian Renaissance. C G

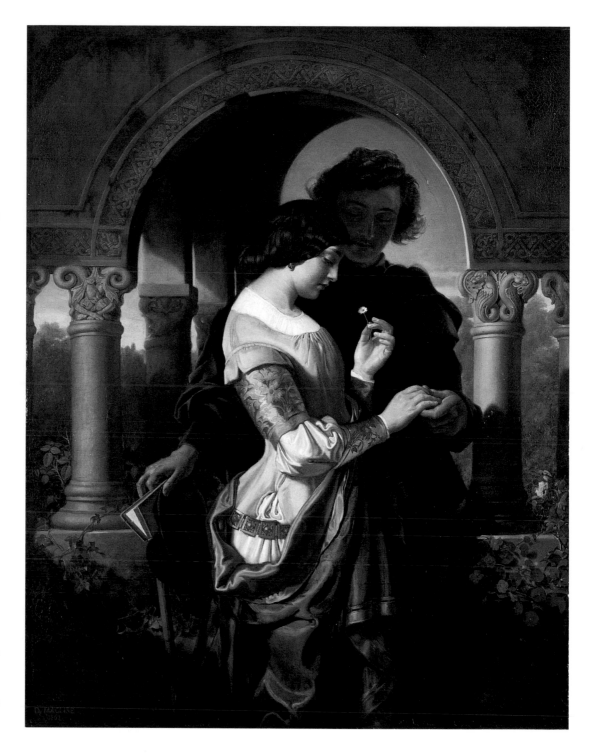

PROVENANCE 1862: probably
purchased from the artist by Thomas
Wrigley; 1880: bequeathed to his
children; 1897: bequeathed to the gallery
by them
EXHIBITIONS *Daniel Maclise
1806–1870*, London, National Portrait
Gallery, and Dublin, National Gallery of
Ireland, 1972, no. 109; *Presents from the

Past: Gifts to Greater Manchester Galleries
from local Art Collectors*, Bolton Museum
and Art Gallery, Oldham Art Gallery,
Staleybridge, Astley Cheetham Art
Gallery, and Stockport Art Gallery, 1978,
no. 43; *19th Century British Paintings, from
the Thomas Wrigley Collection of the Bury
Art Gallery and Museum*, Hong Kong Arts
Centre, 1990, p. 116–17

REFERENCE W. Wallis and A.B.
Chamberlain, *Illustrated Catalogue of the
Wrigley Collection of Paintings*, Bury, 1901,
pp. 52–3

146

Frederick Thrupp
(1812–1895)
The Good Shepherd, 1861

marble, 76.2 × 43 × 46 cm
inscribed: *The Good Shepherd/Fred.k
Thrupp 1861*
Torbay Council, Torre Abbey
Collection, Torquay, SCM5

The Good Shepherd is part of a
remarkable collection of works
by Thrupp at Torre Abbey. The
sculptor, who was noted in his
day for public memorials and for
'ideal' works on religious themes,
retired to Torquay, where his
studio collection of marble and
plaster statues, reliefs, clay
models and drawings was to find
a home.

Thrupp trained at the Royal
Academy Schools and from 1837
to 1842 worked in Rome. He
later obtained a number of
prestigious commissions, includ-
ing the Wordsworth Memorial
in Westminster Abbey (1848).

The Good Shepherd combines
the pastoral theme with a pose
recalling Classical prototypes,
and traditional rustic imagery in
the detailing of the costume;
perhaps most remarkable is the
sensitive naturalism displayed in
the depiction of the lamb and
ewe. Drawings of shepherds and
their flocks are in the abbey's
collection, as well as clay studies
for the present subject. M G

PROVENANCE 1911: presented by the
Thrupp family to Torquay Corporation as
part of the sculptor's studio collection;
presumably transferred to Torre Abbey
when Torquay Borough Council
purchased the abbey in 1929
EXHIBITION London, RA, 1870, no.
1097
REFERENCES B.E. Reade, 'Anecdotes of
Torbay in Transition', in *The Brian
Edmund Reade Collection on Display at Torre
Abbey*, Torquay, n.d., [*c.* 1977], pp. 48–9;
B. Read, *Victorian Sculpture*, New Haven,
1982

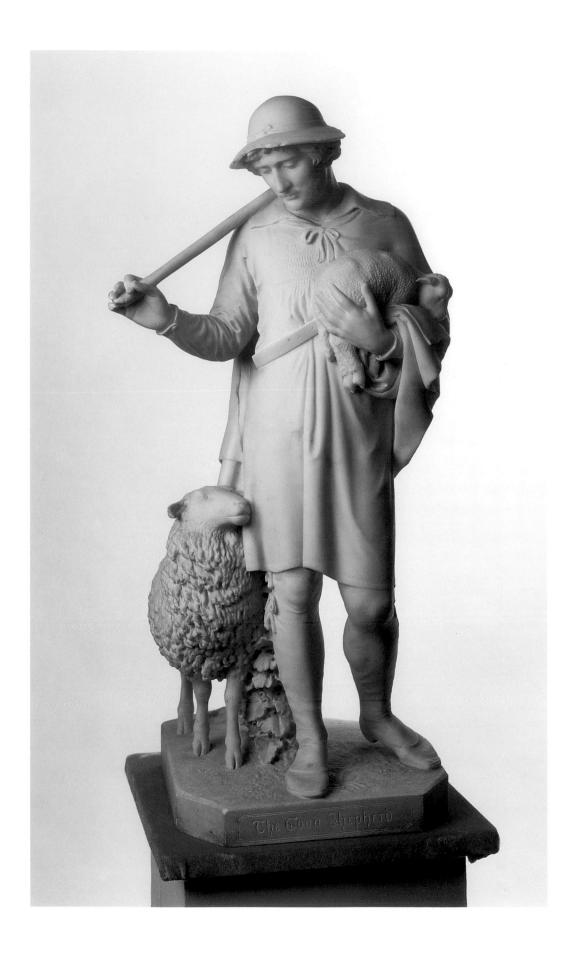

147

William Dyce RA
(1806–64)

The Garden of Gethsemane,
c. 1857–60

oil on millboard, 41.8 × 31.2 cm
Board of Trustees of the National
Museums and Galleries on
Merseyside (Emma Holt Bequest,
Sudley House), WAG 221

Jesus praying alone in
Gethsemane is seen in a wild and
stony Scottish glen at twilight.
A deeply religious man, Dyce
believed in a contemporary
Christ, presenting him as a real
person with whom the modern
viewer could identify, and
placing him in a real setting.
The landscape not only creates an
intense mood appropriate to
Christ's spiritual struggle; it also
embodies the subject in its
symbolism of an oppressive
valley and a winding stony path
leading through an open gate to
a dense forest under a waxing
moon. This is one of a number of
small-scale pictures by Dyce
which set religious events in
Scottish landscapes, treated with
minute Pre-Raphaelite precision.

The first owner of the
painting, John Farnworth, was a
Liverpool timber merchant and
active Wesleyan; the last private
owner, George Holt, a Liverpool
ship-owner, formed a notable
collection of mainly contem-
porary art, which his daughter
bequeathed to the city. Uniquely
among Victorian merchant
collections, Holt's survives in
the house for which it was
made. J B T

PROVENANCE John Farnworth of
Walton, Liverpool; 1874, 18 May:
Christie's, London, Farnworth's executors'
sale, lot 100, bought by Agnew's; 1874:
Albert Grant; 1877, 27 April: Christie's,

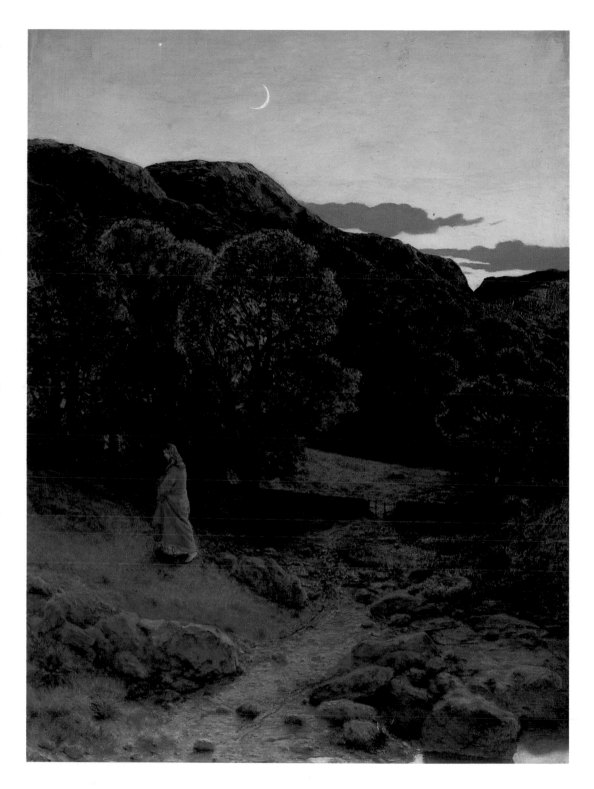

Grant sale, lot 910E; 1878: bought by
George Holt; 1947: bequeathed by Emma
Holt to Liverpool
EXHIBITIONS Manchester Royal
Jubilee Exhibition, 1887, no. 760;
London, 1962, no. 196; *Centenary
Exhibition of the Works of William Dyce,*

Aberdeen Art Gallery and London,
Agnew's, 1964, no. 32
REFERENCES M. Pointon, *William
Dyce*, Oxford, 1979, pp. 161–4, 192,
pl. 92; M. Bennett, *Artists of the Pre-
Raphaelite Circle: The First Generation –
Catalogue of the Works in the Walker Art*

*Gallery, Lady Lever Art Gallery and Sudley
Art Gallery*, London, 1988, pp. 56–7
(with full provenance, exhibitions and
bibliography)

217

148, 149
James Sant RA
(1820–1916)
The Infant Samuel
The Infant Timothy unfolding
the Scriptures both *c.* 1853

both oil on canvas, 74.4 × 62 cm
both inscribed: *JS* (monogram)
Bury Art Gallery and Museum,
BUYGM.104.1897;
BUYGM.105.1897

The future prophet Samuel sits
up in bed, answering the call of
the Lord with the words 'Speak,
thy servant heareth' (I Samuel
3:10), under which title the
painting was first exhibited. In
the companion picture, the
young Timothy, later one of
Jesus's disciples, unfolds a
Hebrew scroll; though his father

was a Gentile, his mother
brought him up to be well
versed in the Holy Scriptures
(Acts 16:1).

Sant, a successful and prolific
portraitist, specialised in
portraits of children. In 1871 he
became portrait painter to Queen
Victoria; several of the royal
children sat for him, though his
portrait of the Queen with her
three grandchildren earned her
displeasure, and she forbade him
to paint her again. Sant achieved
far wider fame through the
engravings of his fancy pictures
of children. *Samuel* and *Timothy*
were engraved by Samuel
Cousins in 1855 and hung in
many homes.

Sant's pretty, wide-eyed
English children in the guise of
biblical characters are the kind of

vague and sentimental religious
images which the Pre-Raphaelites
hated; at the very time when
Samuel and *Timothy* were being
engraved, Holman Hunt was on
his first visit to the Holy Land
searching out authentic Middle
Eastern models and settings for
his biblical subjects. J B T

PROVENANCE 1857: William Bashall
of Preston; 1871: purchased by Agnew's
and sold to Thomas Wrigley of Bury;
1880: bequeathed by him to his children;
1897: presented by them to the gallery
EXHIBITIONS London, RA, 1835, no.
507 (*Samuel*); Manchester, 1857, no. 445
(*Samuel*); *19th Century British Paintings*
from the Thomas Wrigley Collection of the
Bury Art Gallery and Museum, Hong Kong
Arts Centre, 1990, pp. 154–7 (*Samuel* and
Timothy)
REFERENCES M. Clive, *The Day of*
Reckoning, London, 1964, pp. 75–6;
H. Guise, *Great Victorian Engravings: A*
Collector's Guide, London, 1980, p. 156

150

George Frederick Watts
OM RA (1817–1904)
Time, Death and Judgement,
c. 1870

oil on canvas, 90 × 70 cm
Kirklees Metropolitan Council,
Huddersfield Art Gallery,
2120.1985

Watts was obliged to make his
career as a portrait painter, but
throughout his life he cherished
ambitions to paint large fresco
cycles embracing great universal
themes. This is a version of his
famous allegorical design *Time,*
Death and Judgement. It consists
of three figures. The crowned
and commanding male 'Time',
holding a scythe, stands hand in
hand with the veiled female

'Death'. Behind them is 'Judgement' or Nemesis, with the scales that weigh human destiny. In 1868 Watts wrote to C.H. Rickards, the Manchester collector and purchaser of an early version (probably that now in the Art Institute of Chicago): 'Allegory is much out of favour now and by most people condemned, forgetting that spiritual and even most intellectual ideas can only be expressed by similes, and that words themselves are but symbols. The design "Time and Death" is one of several suggestive compositions that I hope to leave behind me in support of my claim to be considered a real artist, and it is only by these that I wish to be known. I am very glad that you find the ring of poetry in it.'

The first sketch was made probably in the early 1860s, and the artist made variants until the end of his life. The present one, and that in the Mappin Art Gallery, Sheffield, have the distinction of having been purchased, rather than given by Watts himself. CG

PROVENANCE 1905: purchased by Huddersfield Corporation
REFERENCES H. Macmillan, *The Life and Work of G.F. Watts*, London, 1903, p. 236; *Victorian High Renaissance*, exh. cat., Manchester City Art Gallery, Minneapolis Institute of Art and New York, The Brooklyn Museum, 1978–9, pp. 87–8

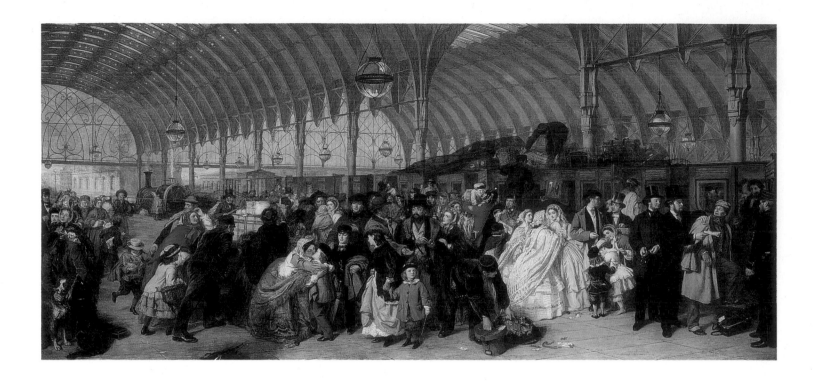

151

William Powell Frith
(1819–1909)
The Railway Station,
1860–2

oil on canvas, 116.7 × 256.4 cm
inscribed: *W.P.Frith fect 1862*
Royal Holloway, University of
London, Egham, Surrey

Frith shows the platform of
Paddington Station bustling
with people hurrying to catch
the train as luggage is loaded.
Portraits of the artist, his wife
and children are included in the
group of a mother kissing a boy
who is being sent away to school
with his brother. Also depicted
are a foreign visitor disagreeing
with a cab driver about the fare,
a wedding party seeing off a
bride and groom, and, on the far
right, two well-known London
detectives, Michael Haydon and
James Brett, about to make an
arrest. The man talking to the
engine driver in the left
background is a portrait of the
art dealer Louis Victor Flatow,
who commissioned the picture
from Frith, exhibited it at his
London gallery, toured it round
the regions, sold subscriptions
for the engraving after it and
then, in 1863, sold it to the
publisher of the engraving,
Henry Graves. Graves issued
over 3000 copies of the
engraving and kept the oil until
1883, when he sold it to the
patent medicine manufacturer
Thomas Holloway, founder of
Holloway College.

Frith claimed that he painted
every detail from nature, but he
also used photographs
commissioned from Samuel Fry.
The background of the station
was executed for Frith by the
architectural painter William
Scott.

Because Frith gave his modern
subjects the scale and status
previously reserved for history
painting, they were at first
criticised for vulgarity. By the
1860s they had become
acceptable both to critical
opinion and to the general
public, with whom they had
always been popular. J B T

PROVENANCE 1860: commissioned by
L.V. Flatow; 1863: sold by him to Henry
Graves; 1883: bought from him by
Thomas Holloway
EXHIBITIONS London, Flatow's
Gallery, 1862; Paris, Exposition
Universelle, 1878, no. 78; London, RA,
Winter 1911, no. 37; *Great Victorian
Pictures*, Arts Council, 1978, no. 15
REFERENCE J. Chapel, *Victorian Taste:
The Complete Catalogue of Paintings at the
Royal Holloway College,* London, 1982,
pp. 87–92 (with full provenance,
exhibitions and bibliography)

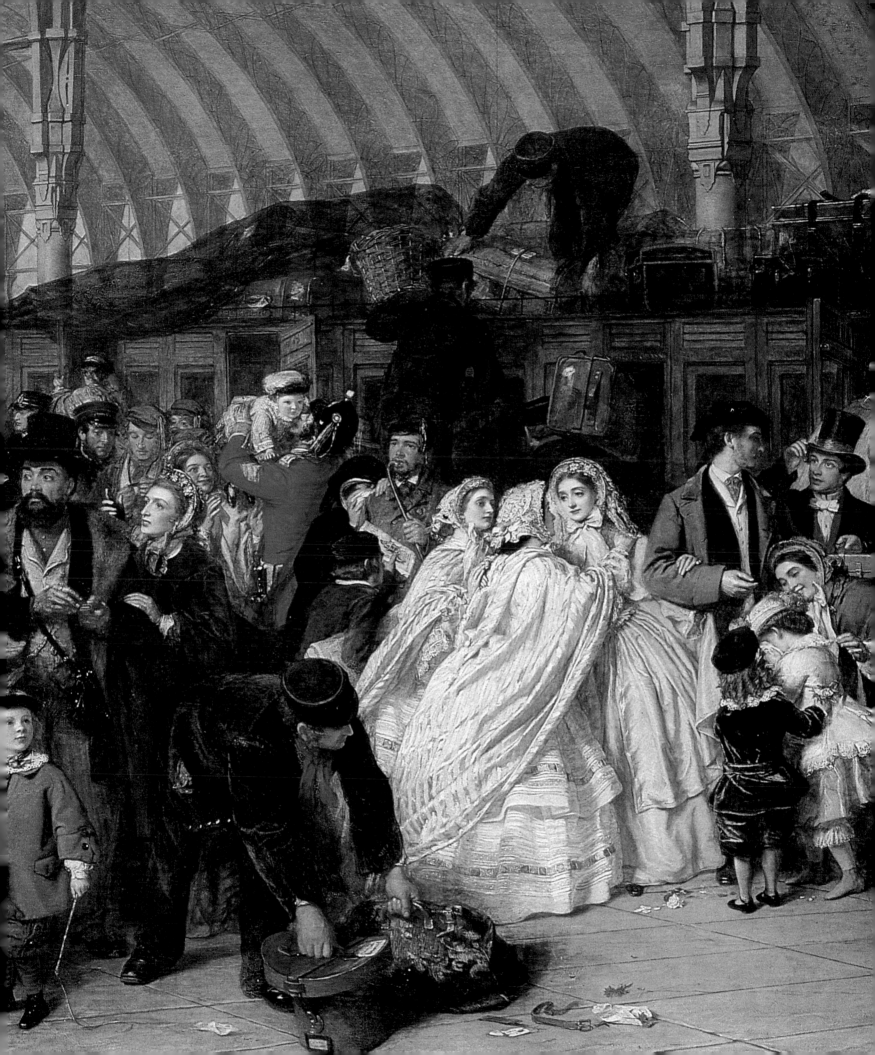

152

Frederick Daniel Hardy
(1826–1911)

The Young Photographers,
1862

oil on mahogany panel,
30.1 × 45.6 cm
inscribed: *F. D. Hardy 1862*
Tunbridge Wells Museum and Art
Gallery, 52/86, no. 23

Like his older brother, George,
and their friend Thomas
Webster (1800–86; a relation by
marriage), Frederick Daniel
Hardy became a member of the
Cranbrook Colony of artists in
Kent. There, with his fellow
colonists J.C. Horsley (1817–
1903), Mulready (1843–1904)
and O'Neill (cat. 18), as well as
Webster, Hardy painted rustic
subjects in the manner of Sir
David Wilkie (1785–1841). His
quiet colouring, the textures of
brick, wood and stone for which
he was commended in the *Art*

Journal in 1854, and the
carefully posed groups of figures
reflect the influence of 17th-
century Dutch interiors. *The
Young Photographers* introduces a
note of contemporary technology
into the traditional rustic idyll.
The camera is a pretence, and the
real photographer's studio can be
seen through the open door.
Outside in the street he solicits
passers-by for their custom, and
the precariousness of the
provincial photographer's
profession is suggested by the
poverty of the room.

This is a reduced-size version
of the picture exhibited as no. 78
at the Royal Academy in 1862.
The collector Alfred Ashton had
a predilection for such smaller
versions of popular subject
paintings (see also cat. 136,
137). CG

PROVENANCE By 1863: Alfred
Ashton; 1952: bequeathed to the museum
by his son and daughter

153

Augustus Egg RA
(1816–63)

The Travelling Companions,
1862

oil on canvas, 64.5 × 76.5 cm
inscribed: *Augustus Egg R.A.*
Birmingham Museums and Art
Gallery, P.7'56

The Travelling Companions shows
two identically dressed girls,
presumably sisters, in a railway
carriage. One dozes, the other
reads, a modern version of the
traditional contrast between the
active and contemplative life, or
industry and idleness. The
jolting movement of the train is
neatly suggested by the tassel of
the blind in the centre, while the
claustrophobia and heat of the
journey are conveyed by the
contrast between the bright
landscape and the dark
upholstered interior, and by the
girls' voluminous travelling

clothes. The view through the
window shows the coast near
Menton, in southern France: Egg
was a frequent visitor to the
Riviera because of his weak
health.

The simple device of echoing
the symmetry of the carriage
interior in the near mirror
images of the girls makes this
one of the most successful of the
several railway and omnibus
paintings of the mid-century (see
also cat. 151). Egg painted other
subjects of contemporary leisure,
but his most famous modern-
dress work, the triptych *Past and
Present* (Tate Gallery, London),
is a moralising social drama
about an adulterous wife. It owes
much to the young Pre-
Raphaelites, whom Egg
befriended and supported early
in their careers. Egg's exhibited
paintings were mainly historical
costume pieces; most of his
modern-dress works remained
unsold at his death from asthma
in 1863.

The Leicester Galleries, the
London dealers from whom this
painting was acquired in 1956,
were pioneers in the revival of
interest in Victorian taste. JBT

PROVENANCE 1863, 16 May:
Christie's, London, Egg studio sale, lot
123; 1876: Albert Levy; 1956: Leicester
Galleries, London; 1956: presented to
the museum by the Trustees of the Feeney
Charitable Trust
EXHIBITION *The Victorian Scene,*
London, Leicester Galleries, 1956, no.
121
REFERENCE Birmingham City
Museums and Art Gallery, *Catalogue of
Paintings,* 1960, p. 50 (with full
provenance)

154

Pierre-Edouard Frère
(1819–86)

Snowballing, 1861

oil on canvas, 62.4 × 80 cm
inscribed: *Edouard Frere 1861*
Bury Art Gallery and Museum,
BUYGM.067.1897

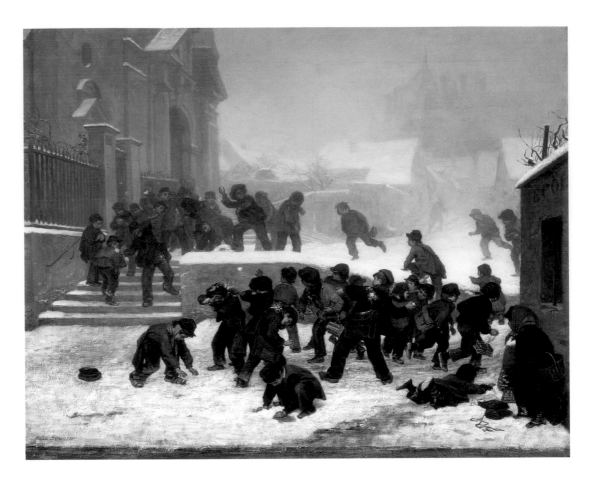

Frère trained in the Paris studio of Paul Delaroche (1797–1856) and first exhibited at the Salon in 1842. His career established, Frère soon retreated to the French countryside at Ecouen, where he remained for the rest of his life. This winter scene is probably set there. Frère's paintings of simple daily life, often featuring children, were popular, and he won medals at successive Salons in the 1850s. From 1854 Ernest Gambart showed his pictures in London at the French Gallery, 121 Pall Mall, where they attracted extravagant praise from John Ruskin – 'pictures of children of quite immortal beauty'. His popularity outside France was remarked upon by a French critic: 'Collectors in Holland and England purchase his little interiors . . . painted with a profound sentiment for reality and a charm that characterises the masters of Flanders.' From 1868 to 1885 Frère exhibited annually at the Royal Academy, and in 1873 at Agnew's.

Superficially his subjects resemble those favoured by the Cranbrook Colony painters Hardy (cat. 152) and Thomas Webster (1800–86). Like Frère, these artists were working under the influence of Dutch 17th-century painting, but painted narrative pictures – one such, Webster's *Boy with many Friends* (1841) was bequeathed by Thomas Wrigley's descendants to Bury Art Gallery whereas Frère was a realist. Ruskin strongly believed in the significance of this truthfulness, writing of Frère's French Gallery exhibits in 1856: 'It is quite impossible to say what importance may, in some future day, attach to such records of the French peasant life of the 19th century.'

Thomas Wrigley, a paper manufacturer from Bury, was advised by Agnew's. He had conservative taste and, in this instance, his interest in Frère may have been stimulated by Ruskin's admiration for the artist as much as by Agnew's support of him. C G

PROVENANCE Sam Mendel, Manchester; Thomas Wrigley; 1880: bequeathed by him to his children; 1897: presented to the gallery by them
EXHIBITIONS Manchester Art Treasures Exhibition, 1878; *19th Century British Paintings from the Thomas Wrigley Collection of the Bury Art Gallery and Museum*, Hong Kong Arts Centre, 1990, pp. 87–8
REFERENCE W. Wallis and A. B. Chamberlain, *Illustrated Catalogue of the Wrigley Collection of Paintings*, Bury, 1901, pp. 41–2

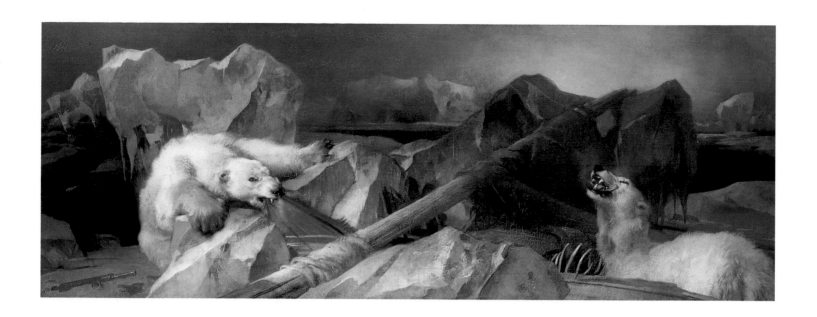

155

Sir Edwin Landseer RA
(1802–73)

Man proposes, God disposes,
1864

oil on canvas, 91.4 × 243.7 cm
Royal Holloway, University of
London, Egham, Surrey

This powerful and deeply
pessimistic work took as its
starting point the enormous
public disquiet at the fate of Sir
John Franklin's expedition in
search of the elusive North West
Passage, the arctic sea route
connecting the Atlantic to the
Pacific oceans. Franklin set out in
1845 with two ships and 138
men and they were never seen
again. A series of relief
expeditions followed. That of Dr
John Rae discovered a telescope
in 1854, and Sir Leopold
McClintock's voyage of 1858–9
found human skeletons, some of
which had been destroyed by
animals; polar bear tracks were
identified nearby. Landseer shows
the bears rapaciously destroying
the remains of the expedition; the

telescope and a naval jacket lie
poignantly at the left. Landseer
had never experienced an arctic
landscape but gave it a powerful
and haunting form: the unusual
proportions of the canvas, the
jagged shapes of the ice-floes and
the translucency of the colours
and reflections suggest a world of
infinite destructiveness and
inhumanity. The title, from
Thomas à Kempis's *Imitation of
Christ*, gives the theme of the
vanity of human endeavour in the
face of Divine Providence; but
the image goes further,
imagining a godless world ruled
by brute force. The painting
dates from towards the end of
Landseer's life, when he was beset
by depression and nervous illness
which later developed into
insanity; yet his artistic power
remained undimmed. JBT

PROVENANCE 1864: painted for
E.J. Coleman of Stoke Poges Park; 1881,
28 May: Christie's, London, his sale,
bought by Thomas Holloway
EXHIBITIONS London, RA, 1864,
no. 163; *Sir Edwin Landseer*, Philadelphia
Museum of Art and London, Tate Gallery,
1982, no. 151; *The Victorians*,
Washington, National Gallery of Art,
1997, no. 5
REFERENCE J. Chapel, *Victorian Taste:
The Complete Catalogue of Paintings at Royal
Holloway College*, London, 1982, pp. 101–4
(with full exhibitions and bibliography)

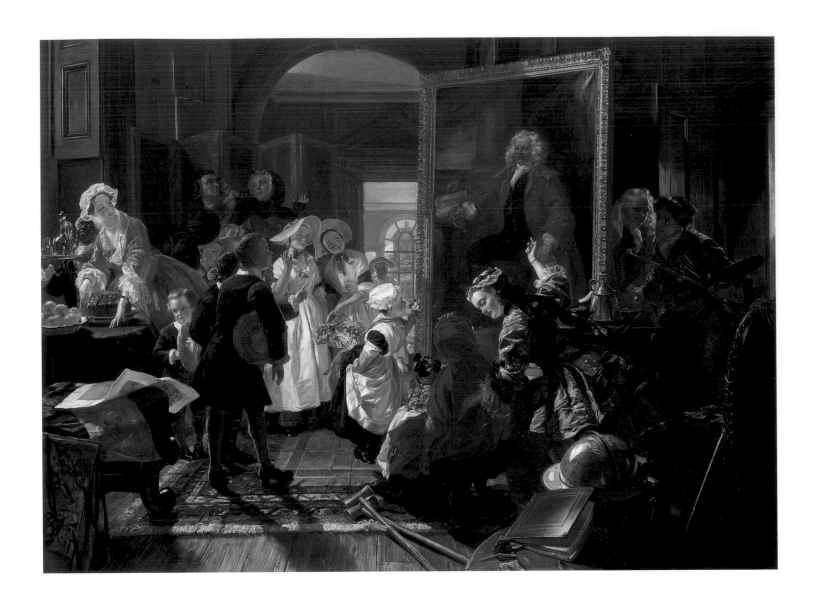

156

Edward Matthew Ward
RA (1816–79)

*Hogarth's Studio in 1739 –
Holiday Visit of the
Foundlings to view the
Portrait of Captain Coram,*
1863

oil on canvas, 120.6 × 165.1 cm
inscribed: *E M Ward RA 1863*
York City Art Gallery, 349

The title explains Ward's
painting. Captain Coram himself
is present in the studio, listening
with the artist from behind the

easel to comments from the
foundling children. Ward was an
admirer of William Hogarth
(1697–1764), his main
inspiration after the more
immediate model provided by
C.R. Leslie (1794–1859).
Hogarthian details abound: the
subject celebrates one of
Hogarth's finest and most
controversial portraits; the pug is
Hogarth's own dog, Trump; and
the pose of the couple by the
screen comes from one of the
scenes in *Marriage à la Mode.*
Hogarth's portrait of Captain
Coram was lent by the
Foundling Hospital to the

Manchester Art Treasures
exhibition in 1857, where Ward
would certainly have seen it,
since two of his own paintings
were in the exhibition. Interest
in Hogarth was stimulated by
George Augustus Sala's nine
essays on the artist and his
subjects published in *The
Cornhill Magazine* in 1860.
When first exhibited, this
painting was accompanied by a
quotation from the fifth of these.

Artists using their subject-
matter to warn against the evils
of drinking, gambling, infidelity
and dissipation admired
Hogarth's moralising; and they

were generally successful with
the Victorian public (cat. 157).
Ward's reputation declined in
the 1870s, however, and he
eventually committed suicide.
He was long outlived by his
wife, Henrietta (1832–1924),
who painted literary scenes of a
similar character to his. C G

PROVENANCE 1862: commissioned by
Duncan Dunbar; 1866: John Burton,
Poppleton Villa, York; 1882: bequeathed
by him to the gallery
EXHIBITIONS London, RA, 1863, no.
199; *Great Victorian Pictures*, London, RA,
1978, no. 60 (with full provenance and
bibliography)

157

Alfred Elmore RA
(1815–81)

On the Brink, 1865

oil on canvas, 114.3 × 83.2
inscribed: *A.Elmore.1865* and (verso):
Homburg
Lent by the Syndics of the Fitzwilliam
Museum, Cambridge, PD 108–1975

The nature of this dramatic
incident at the gaming tables of
Homburg, a fashionable German
resort, has to be deduced from
clues provided by details in the
painting. The lady's empty purse
and the torn gaming card at her
feet indicate she has gambled
away all her money, while the
lily being strangled by a rampant
passion flower suggests she is
being tempted by the man into
adultery or prostitution. The
drama is heightened by the
contrast between what the *Art
Journal* described as the 'hectic
glow' of the interior and the
moonlit pallor of the lady's face.
Elmore's work consists mainly of
historical scenes, but here he
takes up the modern moral
subjects of the Pre-Raphaelites.
The association of gambling
with loose morals is seen in
historical scenes by E.M. Ward
and Augustus Egg, but Elmore
was the first to put it into
contemporary dress, anticipating
Frith's Hogarthian series, *The
Road to Ruin* (1878). The theme
also occurs in novels, such as
Trollope's *Can You Forgive Her?*
(1864) and George Eliot's *Daniel
Deronda* (1880).

The painting, an unusual
acquisition for the Fitzwilliam,
was purchased from the estate of
the Cambridge bibliophile and
librarian A.N.L. Munby. When
he bought it in 1947 Victorian
art was still generally
unfashionable. J B T

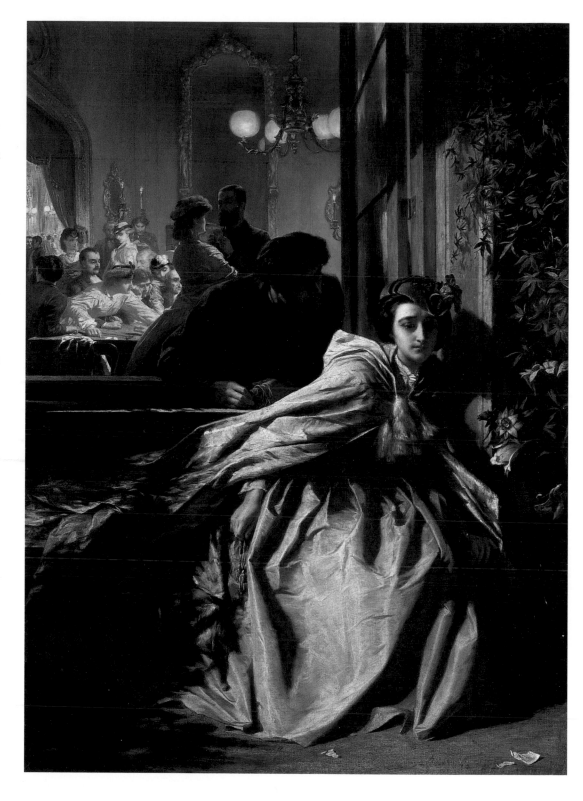

PROVENANCE E.J. Coleman; 1947,
10–11 February: Sotheby's, Randall
Davies sale, lot 168, bought by A.N.L.
Munby; 1975: bought from Munby's
executors with assistance from the
Victoria and Albert Museum Purchase
Grant Fund and given to the museum by

the Friends of the Fitzwilliam in his
memory
EXHIBITIONS London, RA, 1865, no.
138; Paris, Exposition Universelle, 1967,
British section, group 1, no. 30B; *Treasures
from the Fitzwilliam*, Washington, National
Gallery of Art, *et al.*, 1989, no. 156

REFERENCE J.W. Goodison,
*Fitzwilliam Museum, Cambridge: Catalogue
of Paintings*, III, *British School*, Cambridge,
1976, pp. 70–1, pl. 43

158

John Frederick Lewis
RA OWS (1805–76)

In the Bey's Garden, Asia Minor, 1865

oil on panel, 106.5 × 68.5 cm
inscribed: *J. F. Lewis, R.A. Elect, 1865*
Harris Museum and Art Gallery, Preston

Lewis spent the years 1841 to 1851 in Cairo, where he made nearly 600 watercolours and drawings. These served as a repertoire of images for the pictures he produced after his return to London, first in watercolour and then, from the late 1850s, in oil. They depict figures in Oriental dress against detailed backgrounds of street architecture, bazaars, mosques, harem interiors or desert landscapes. *In the Bey's Garden, Asia Minor* is one of a small group of garden scenes of which Michael Lewis, the artist's descendant, has written, 'apart from their costumes, they might all be taken for the vicar's wife in a country garden in England'. The painting probably depicts Lewis's wife, Marian, who often modelled for him; the green jacket she wears is also preserved in the Harris Museum and Art Gallery.

The first owner of the painting, the barrister Richard Newsham (1798–1883), was the son of Richard Newsham, partner in Horrocks, Miller & Co, cotton manufacturer of Preston; the son inherited his father's estate in 1843, enabling him to retire. An active philanthropist, he made donations to schools, churches and charities, as well as bequeathing his art collection to

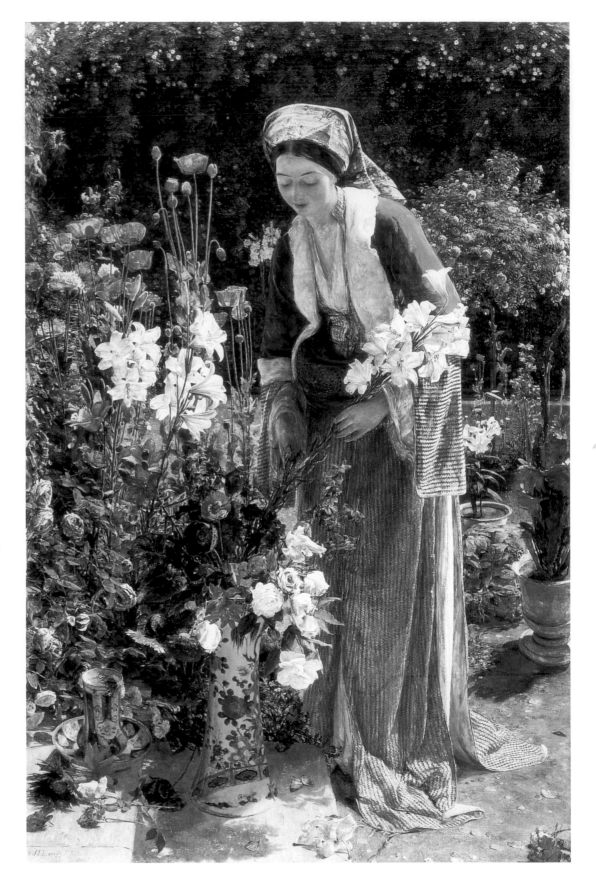

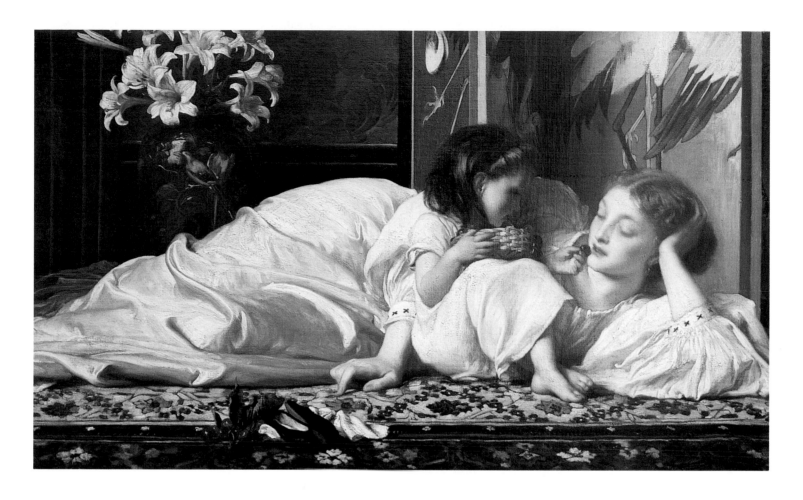

the Harris in 1884. *In the Bey's Garden* was his last purchase; he stopped collecting because his walls were covered with over 100 paintings. J B T

PROVENANCE 1865: purchased by Richard Newsham; 1883: bequeathed to the museum by him
EXHIBITION London, RA, 1865, no. 234
REFERENCES M. Lewis, *John Frederick Lewis RA 1805–76*, Leigh-on-Sea, 1978, pp. 41, 96 (with full exhibitions and bibliography); D.S. Macleod, *Art and the Victorian Middle Class*, Cambridge, 1996, p. 458

159
Frederic, Lord Leighton, Baron Leighton of Stretton PRA (1830–96)
Mother and Child (Cherries), *c.* 1864–5

oil on canvas, 48.2 × 82 cm
Blackburn Museum and Art Gallery

The pictures of young women and children and couples enjoying tranquil domestic intimacy that Leighton painted in the early 1860s were a great contrast to the large historical subjects with which he had first made his name at the Royal Academy. He was only 24 when *Cimabue's Madonna* (Royal Collection, on loan to the National Gallery, London) was exhibited at the Academy; shortly before exhibiting this delicate picture of a mother and child twenty years later he had shown *Jezebel and Ahab* (Scarborough Art Gallery) and *Dante in Exile* (Lloyd Webber Collection), both strong, serious works that advanced his reputation with the Academicians. *Mother and Child* demonstrates his sensitivity to artistic trends, combining figures of classical derivation with an 'aesthetic' setting dominated by a handsome Japanese screen. Japanese decorative art was a recent discovery, introduced to the English public when the collection of the British Consul-General to Japan, Sir Rutherford Alcock, was displayed at the London International Exhibition in 1862. Whistler and Rossetti were enthusiasts and keen collectors. Leighton himself acquired Japanese pieces to furnish his studio. The ravishing creamy tones of the dresses of mother and child recall the beautiful *Sisters* (Pre-Raphaelite Inc.), a subject very similar in mood that was exhibited at the Academy in 1862. C G

PROVENANCE 1911: bought from Arthur Tooth & Son by the museum
EXHIBITIONS London, RA, 1865, no. 120; *Japan and Britain: An Aesthetic Dialogue 1850–1930*, London, Barbican Art Gallery, 1991, no. 91; *Frederic Leighton, 1830–1896*, London, RA, 1996, no. 32
REFERENCES L. and R. Ormond, *Lord Leighton*, London, 1975, p. 155, no. 105; C. Newall, *The Art of Lord Leighton*, Oxford, 1990, pp. 48, 51, pl. 30

160

Daniel Alexander
Williamson (1823–1903)

*The Startled Rabbit, Warton
Crag, c. 1861–4*

oil on panel, 26.4 × 38.9 cm
inscribed: *DAW* (monogram)
Williamson Art Gallery and
Museum, Birkenhead

Two children stand stock still,
having surprised a rabbit, which
is shown in mid-air as it bounds
forward. The painting has a
peculiar stillness, as if of a
moment frozen in time. The
brilliant colour and the precise
detail, the interest in rock
formations and the flattened
space are hallmarks of the Pre-
Raphaelite landscape.

One of a Liverpool family of
artists, Williamson adopted the
Pre-Raphaelite style in the early
1860s when living at Warton-
in-Carnforth in North
Lancashire. There he painted a
series of small, intensely coloured
and detailed landscapes. A
virtual recluse, he ceased
exhibiting at the Royal Academy
after 1858, showing only in
Liverpool, and his works, though
collected by a small circle of
patrons, were unknown to the
wider world. His later work
abandoned Pre-Raphaelite
precision for a broader, more
impressionistic style.

The painting belonged to two
important Liverpool collectors,
first the tobacco merchant John
Miller and second James Smith
of Blundellsands, a wine and
spirit merchant who was
Williamson's chief patron. Smith
bequeathed the major part of his
collection to the Walker Art
Gallery in 1923. It included
many important paintings by
Liverpool artists. JBT

PROVENANCE John Miller, Liverpool; 1912: James Smith, Blundellsands; 1928, 28 April: Christie's, London, Smith sale, lot 55, purchased by the gallery
EXHIBITIONS *Paintings and Drawings by James Charles, George Sheffield, William Scott and D.A. Williamson*, Manchester City Art Gallery, 1912, no. 253; *Landscape in Britain 1850–1950*, London, Hayward Gallery, 1983, no. 19; *Viktorianische Malerei von Turner bis Hogarth*, Munich, Alte Pinakothek, and Madrid, Prado, 1993, no. 59
REFERENCE A. Staley, *The Pre-Raphaelite Landscape*, Oxford, 1973, pp. 148–9

161

Frederic, Lord Leighton, Baron Leighton of Stretton PRA (1830–96)

Temple of Philae, 1868

oil on canvas, 18.7 × 29.3 cm
Manchester City Art Galleries,
1934.416

Throughout his career Leighton followed the Continental practice of making small-scale open-air landscape sketches. Sometimes they provided material for the backgrounds of his subject pictures and portraits, but frequently they were simply an end in themselves. Leighton regularly spent August to October abroad, and in 1868 he journeyed up the Nile as far as the island of Philae. He was enchanted with the scenery of the island, producing, by his own account, two or three sketches, of which two are known to survive, this and another of the portico of the Large Temple at Philae (sold Sotheby's, 4 March 1992, lot 140). This painting shows the colonnaded outer court of the Temple of Isis looking south to the Nile. Leighton wanted to render the difficult effect of the searing heat beating down from

a sky that resembled 'burnished steel over a land of burning granite'. His landscape sketches were unnoticed on the rare occasions when they were exhibited during his lifetime, and most of them remained in his studio at his death. They reveal an individuality and spontaneity which even today is unsuspected in the eminent Academician.

John Yates bequeathed pictures by Alma-Tadema, Holman Hunt, Albert Moore and G.F. Watts, as well as a number of landscapes (four by B.W. Leader) and animal paintings, to the Manchester gallery. C G

PROVENANCE 1896, 11–14 July: Christie's, London, artist's sale, lot 235, bought by Agnew's; 1914: John E. Yates; 1934: bequeathed by him to the gallery
EXHIBITIONS *Victorian High Renaissance*, Manchester City Art Gallery, Minneapolis Institute of Arts and New York, The Brooklyn Museum, 1978–9, no. 47; *Frederic Leighton, 1830–1896*, London, RA, 1996 no. 47
REFERENCE L. and R. Ormond, *Lord Leighton*, London, 1975, pp. 35, 98, 158, pl. IV

162

Thomas Sidney Cooper RA (1803–1902)

Catching Wild Goats at Moel Siabod, North Wales, 1862

oil on canvas, 157 × 131.5 cm
inscribed: *T. Sidney Cooper 1862*
The Royal Museum and Art Gallery,
Canterbury

This is one of Cooper's finest paintings from the 1860s, the setting of a broad romantic landscape suggesting light and atmosphere in the manner derived from 17th-century Dutch animal painters such as Paulus Potter (1625–54). The

goats were studied from tame animals bred from a pair given to Cooper many years earlier by his friend and fellow animal painter Richard Ansdell. Cooper became so adept at painting animals from memory that he eventually did not require models.

Cooper was born in Canterbury and started his career at the age of eleven, working first for a coachbuilder and then painting scenery. He studied at the Royal Academy Schools before going to Brussels in 1827. A formative experience was working in the studio of the successful Belgian landscape and animal painter Eugène Verboekhoven (1799–1881). When Cooper returned to London in 1831 he began to exhibit at the Royal Academy,

eventually setting its record for continuous exhibiting — by the time he died, a total of 266 works, all animal paintings. He showed no interest in any other subject-matter and varied his activities only by adding the animals to landscapes by Frederick Richard Lee (1798–1879) and Thomas Creswick (1811–69). C G

PROVENANCE 1863: bought from the British Institution by George Furley, a banker, of Canterbury; presented by him to the museum
EXHIBITION London, British Institution, 1863, no. 60
REFERENCES T. S. Cooper, *My Life*, London, 1890, pp. 267–8; S. Sartin, *Thomas Sidney Cooper, 1803–1902*, Leigh-on-Sea, 1976, pp. 39, 65

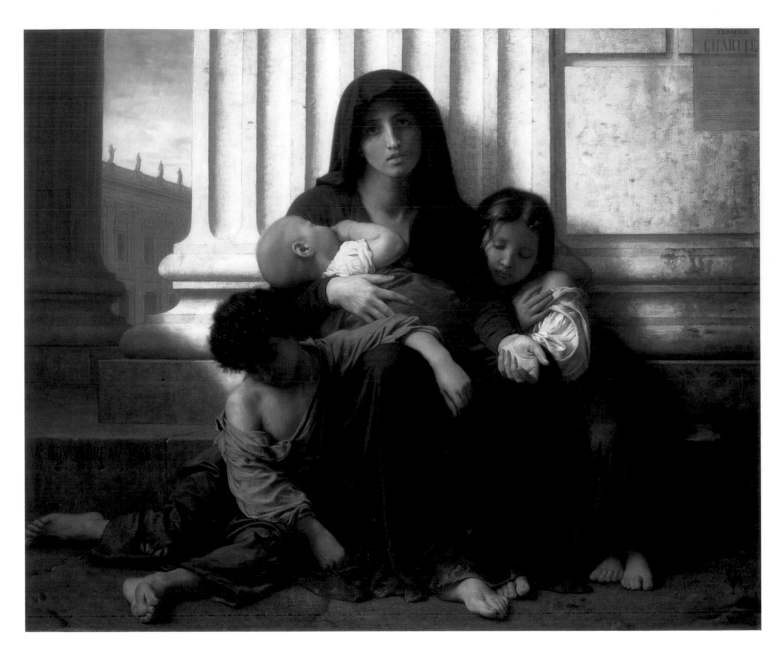

163

William-Adolphe
Bouguereau (1825–1905)
Charity, 1865

oil on canvas, 121.9 × 152.4 cm
inscribed: *W. Bouguereau 1865*
Birmingham Museums and Art
Gallery, 11'97

Bouguereau was an
outstandingly successful
academic painter, commanding
very high prices throughout his
career. In the late 19th century
his popularity in the United
States was probably greater than
in his native France. After his
death his reputation suffered a
total eclipse, and 19th-century
French academic art, with its
polished finish and pearly tones,
is still overshadowed by
Impressionism in popular

estimation. *Charity* was
presented to Birmingham Art
Gallery during Bouguereau's
lifetime and, although it is
comparatively early and has a
classical austerity that contrasts
with the looser, feathery finish
and more sentimental character
of the most admired late works,
it will have been a significant
acquisition. The following year,
1898, Bouguereau visited
London, where his paintings
were exhibited at the Guildhall.

Charity was shown at the Paris
Salon in 1865 with the title *La
Famille indigente*. A sorrowing
mother with a child or children
was a typical subject for
Bouguereau in the 1860s; here
'Charity' is placed in a genre
setting, as a destitute peasant
begging alms for her baby and
two older children. They are
seated on the steps of the Church
of the Madeleine in Paris. A
poster on the wall to the upper
right advertises a lecture on the

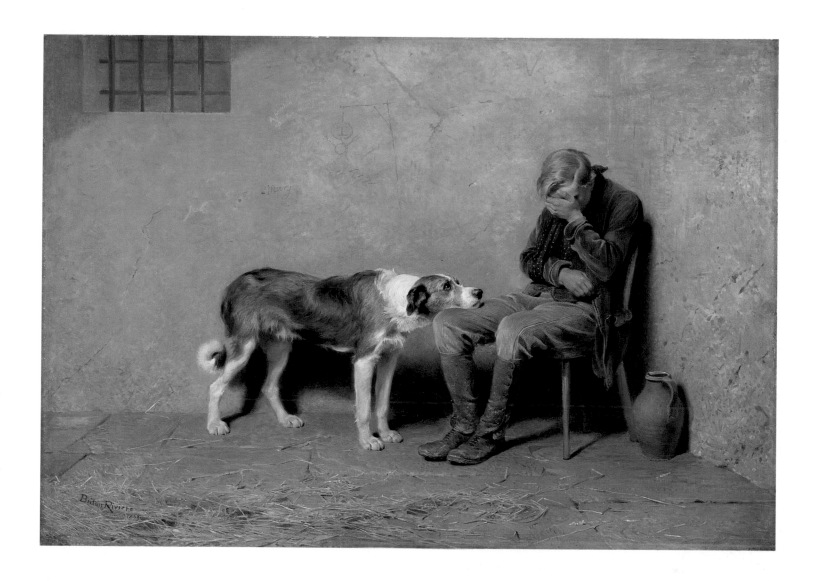

theme of charity by the radical priest and writer on spiritual matters Père Lacordaire, which explains the title by which the picture is now known. CG

PROVENANCE Stephen Plummer; 1882, 11 March: Christie's, London, lot 147; Charles Harding; 1897: presented to the gallery by him
EXHIBITION Paris Salon, 1865

164

Briton Rivière RA
(1840-1920)
Fidelity, 1869

oil on canvas, 80 × 115.5 cm
inscribed: *Briton Rivière 1869*
Board of Trustees of the National Museums and Galleries on Merseyside (Lady Lever Art Gallery, Port Sunlight), LL3123

The painting, originally called *Prisoners*, shows a poacher and his dog locked up awaiting trial. The title was changed by Lord Leverhulme when he bought the painting in 1903 in order to promote Sunlight Soap by offering colour reproductions of the painting in exchange for a number of soap wrappers or coupons. Leverhulme had started to collect paintings for use in advertising campaigns in 1899, purchasing Frith's *The New Frock* and adding to it the words 'Sunlight Soap. So Clean'. This was one year after Millais' *Bubbles* had been used to advertise Pears's soap. *Fidelity* recalls Landseer's classic depiction of the faithful dog in *The Old Shepherd's Chief Mourner* (1837; Victoria and Albert Museum, London). Rivière inherited Landseer's mantle as the most popular animal painter of the day. Several of his sentimental animal subjects feature the theme of a dog as the faithful friend in adversity. JBT

PROVENANCE Ernest Schuster; 1903: bought by Lord Leverhulme; 1922: Lady Lever Art Gallery
EXHIBITION London, RA, 1869, no. 343
REFERENCE E. Morris, *Victorian and Edwardian Paintings in the Lady Lever Art Gallery*, London, 1994, pp. 105–6

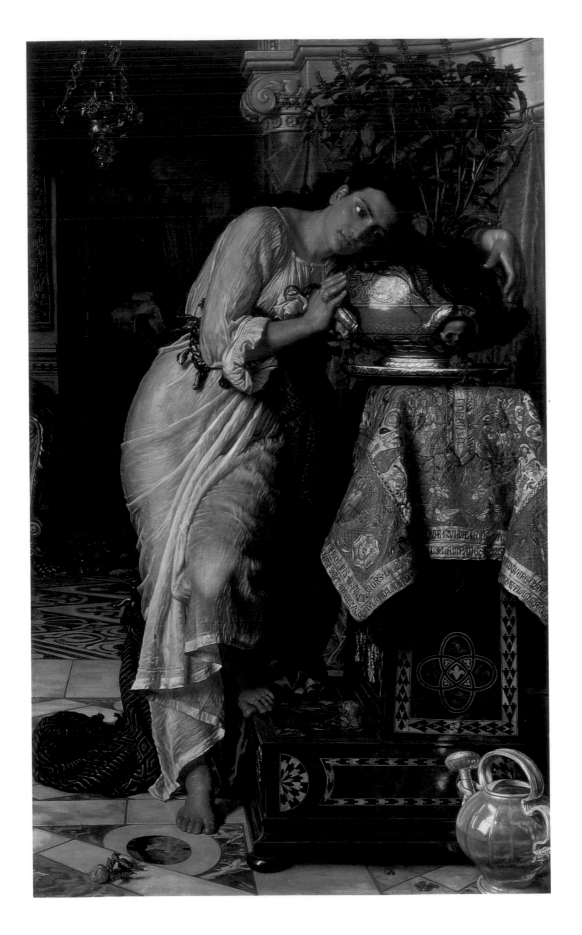

165

William Holman Hunt
(1827–1910)

Isabella and the Pot of Basil,
1866–8, retouched 1886

oil on canvas, 187 × 116.5 cm
inscribed: *Whh* (monogram)
FLORENCE.1867
Laing Art Gallery, Newcastle upon
Tyne (Tyne and Wear Museums)

The subject comes from Keats's
poem *Isabella, or the Pot of Basil*
(1820), itself based on a tale by
Boccaccio. Hunt chose to
represent the latter part of the
story: after Isabella's brothers
had murdered her lover Lorenzo,
his ghost appeared to her and she
exhumed his body, cutting off
the head and placing it in a pot
which she planted with basil.
Hunt shows Isabella in a kind of
shrine dedicated to her dead
lover. He began the painting in
Florence, where he was held up
en route to the East, and was able
to find appropriate Italian
furnishings, which he depicted
in characteristically thorough
detail. He had the majolica pot
made to his own design.

Isabella embraces the pot,
recalling Keats's description of
how she 'in peace Hung over her
sweet Basil evermore,/ And
moistened it with tears unto the
core'. In contrast to Keats, who
relates how Isabella pined away
and died, Hunt painted her in
rude health. The type of female
beauty, with long flowing hair
and the lines of her body
showing through a diaphanous
gown, is unusually sensual for
Hunt and may be a response to
the contemporary 'fleshly'
women depicted by Rossetti (cat.
166). The first owner of the
work, James Hall, by whose
descendants it was presented to

the Laing, was a Tynemouth ship-owner, one of a group of Pre-Raphaelite collectors on Tyneside. JBT

PROVENANCE 1867: purchased from the artist by Ernest Gambart; by 1870: James Hall; 1953: presented to the gallery by the executors of Dr Wilfred Hall EXHIBITIONS London, Gambart's, 1868; *William Holman Hunt*, Liverpool, Walker Art Gallery, and London, Victoria and Albert Museum, 1969, no. 41 (with full provenance, exhibitions and bibliography); *The Pre-Raphaelites*, London, Tate Gallery, 1984, no. 138; *Pre-Raphaelites, Painters and Patrons in the North East*, Newcastle upon Tyne, Laing Art Gallery, 1989–90, no. 60

166

Dante Gabriel Rossetti (1828–82)

The Blue Bower, 1865

oil on canvas, 84 × 70.9 cm
inscribed: *DGR* (monogram)/ *1865*
The Trustees of the Barber Institute of Fine Arts, The University of Birmingham

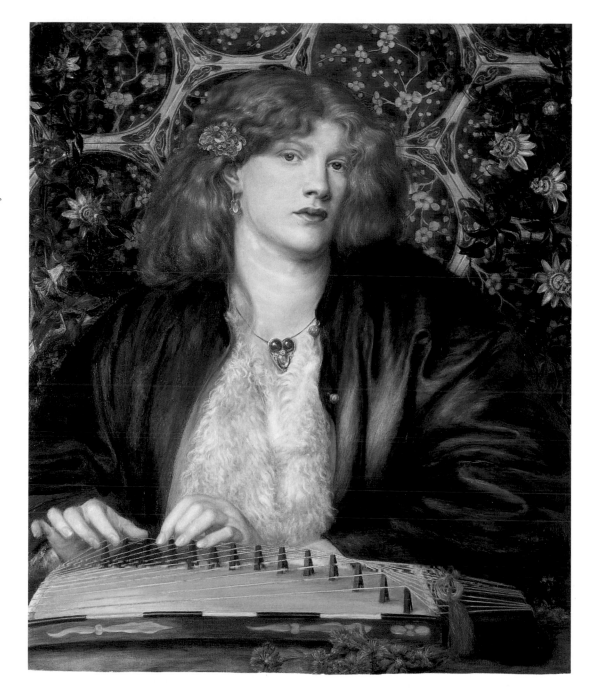

From the late 1850s Rossetti painted a series of opulent bust-length female portraits, celebrating woman's beauty. All are set in confined spaces and display carefully chosen colour harmonies, luxurious costumes and decorative accessories. *The Blue Bower* takes its name from the patterned background of hexagonal tiles decorated with prunus blossom, a hybrid invented by Rossetti combining Arabic form with a Chinese motif. The model was Rossetti's sometime housekeeper and mistress, the Junoesque cockney beauty Fanny Cornforth; the cornflower in the foreground is a reference to her name, just as the passion flower and clinging convolvulus refer to her nature. This type of picture, designed as a beautiful object in itself, without subject or story, set the pattern for the paintings of female models by other artists of the Aesthetic movement (see cat. 174, 185). Those by Rossetti are distinguished by their powerful air of sensuality, inspired perhaps by the half-length images of 'courtesans' painted by Titian and Veronese. JBT

PROVENANCE 1865: bought from the artist by Ernest Gambart, sold to Agnew's, bought by Sam Mendel of Manchester; 1887: J. Dyson Perrins; 1959, 22 April: Sotheby's, London, Dyson Perrins sale, bought by the institute EXHIBITIONS London, RA, 1883, no. 303; Manchester Royal Jubilee Exhibition, 1887, no. 707; *The Pre-Raphaelites*, London, Tate Gallery, 1984, no. 132; *Viktorianische Malerei von Turner bis Whistler,* Munich, Neue Pinkothek, and Madrid, Prado, 1993, no. 65 REFERENCE V. Surtees, *The Paintings and Drawings of Dante Gabriel Rossetti (1828–1882),* Oxford, 1971, I, p. 102, no. 178

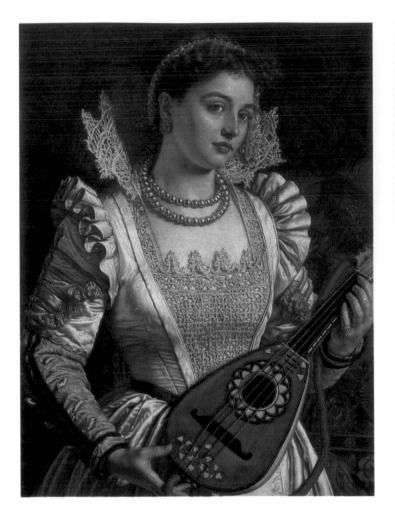

167
William Holman Hunt
(1827–1910)
Bianca ('The Patroness of Heavenly Harmony'), 1869

oil on canvas, 85 × 65 cm
inscribed: *18 Whh 69*
Worthing Museum and Art Gallery,
1957.151

Hunt has used a Shakespearean subject, Bianca from *The Taming of the Shrew*, as a pretext for a portrait, painted in Florence in 1868–9, the year after the death of his first wife. Although Hunt denied that it was an actual portrait (in a letter to F.G. Stephens), Judith Bronkhurst has discovered from MS letters the true identity of the 'American' whom Hunt met in Florence and who initially sat for Bianca. Margaret Noyes-Bradhurst was half English and half German (on her mother's side); her stepfather, Mr Bradhurst, was American, and, as Hunt wrote to Stephens, she had 'lived almost exclusively on the continent' since she was five years old. Hunt was searching for a wife who would accompany him on the difficult and dangerous trip he proposed to make to paint in the Holy Land and wondered briefly whether Noyes-Bradhurst would be suitable. He eventually had to make the trip alone.

Bianca is an image in the Renaissance manner, with sumptuous costume and background. Years later Hunt's granddaughter Diana found the pearl necklace. Her grandmother urged her to wear it: 'Try this necklace and the pearl tiara – these are Bianca's pearls – you should really have her mandoline as well.' C G

PROVENANCE 1957: purchased by the gallery
REFERENCE D. Holman Hunt, *My Grandmothers and I*, London, 1960, p. 94

168
Attributed to Andrea Landini (1847–*c.* 1911)
Indecision: Conversation Piece, c. 1880

oil on canvas, 50.9 × 62.3 cm
Plymouth City Museum and Art Gallery, Plymg.1966.77

A label on the reverse of the picture gives its title and the name of the artist as 'A. Landini'. The attribution to the Florentine Andrea Landini is based on the likely date of the work and on comparison with similar subjects by this artist. He was trained in his native city and worked there and in Paris as a painter of genre pictures, portraits and flowers. His polished and meticulously detailed finish lent itself to his chosen subjects – in portraiture mothers and children, and in genre narrative episodes set in elaborately furnished and decorated 18th-century interiors. In the present painting, the cardinal and his companion in cherry-coloured satin evening dress are playing chess in a luxurious room; they have evidently dined and drunk well. The indecision of the title is that of the cardinal's opponent over his next move in the game.

'Cardinal pictures' were popular on the Continent in the 19th century. Their brand of humour was rather lost on an English audience with little experience of the supposed venalities of the princes of the Church, and such paintings are rarely found in public galleries in this country. They were admired for the consummate

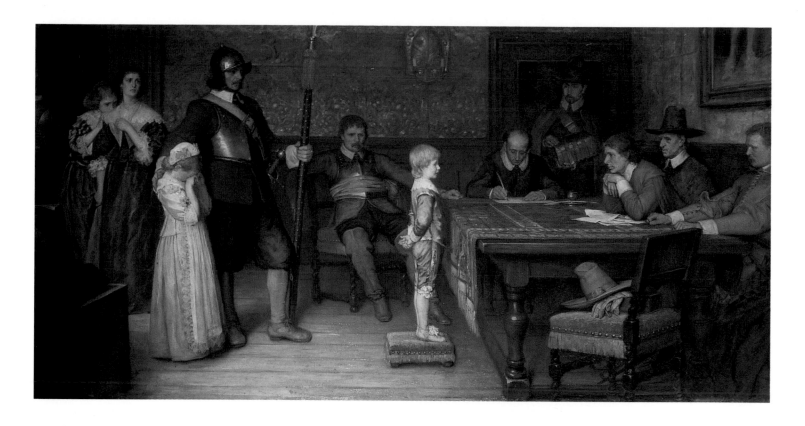

skill with which lace, satin, silk, porcelain and gilding were painted. Landini was a respected practitioner in this field, which was dominated by the prolific output of Jean-François Vibert (1840–1907). Their English equivalent is Walter Dendy Sadler (1854–1923), who substituted jolly monks for the cardinals, and also specialised in sentimental 18th-century genre subjects.

Prosperous industrial magnates, a new brand of collector and a serious force in the art market in the second half of the 19th century, showed a preference for this story-book genre. The early provenance of this painting, however, is not recorded. CG

PROVENANCE 1966: bequeathed to the gallery by Mrs Dingle of Plymouth Hoe

169

William Frederick Yeames (1835–1918)

And When Did You Last See Your Father?, 1878

oil on canvas, 131 × 251.5 cm
inscribed: *W. F. Yeames 1878*
Board of Trustees of the National Museums and Galleries on Merseyside (Walker Art Gallery, Liverpool), WAG 2679

The subject was inspired by Yeames's nephew, described by his uncle as 'of an innocent and truthful disposition': 'It occurred to me to represent him in a situation where the child's outspokenness and unconsciousness would lead to disastrous consequences, and a scene in a country house, occupied by the Puritans during the Rebellion in England, suited my purpose'. Captain Marryat's *Children of the New Forest* (1847), featuring the adventures of four orphaned Royalist children, may have suggested the historical setting.

And When Did You Last See Your Father? was bought from the artist one year after the inauguration of the Walker Art Gallery in 1877. Early purchases were made from the profits from the annual Autumn Exhibition. Some adventurous works were acquired (cat. 204), but an effort was made to buy 'subjects of a popular character . . . which, by appealing to common feelings and sentiments of our daily life, have afforded a fine moral lesson, and given great pleasure to the numerous visitors to the Gallery who are uninitiated in the higher forms of art'. JBT

PROVENANCE 1878: purchased by the gallery from the artist
EXHIBITIONS London, RA, 1878, no. 329; Autumn Exhibition, Liverpool, Walker Art Gallery, 1878, no. 2970; *And When Did You Last See Your Father?*, Liverpool, Walker Art Gallery, 1992, no. 44
REFERENCES R. Strong, *And When Did You Last See Your Father?*, London, 1978, pp. 136–44; E. Morris, *Victorian and Edwardian Paintings in the Walker Art Gallery and at Sudley House*, London, 1996, pp. 524–7 (with full provenance, exhibitions and bibliography)

170

John Atkinson Grimshaw
(1836–93)

*'Burning Off' a Fishing Boat
at Scarborough*, 1877

oil on canvas, 82.4 × 122.1 cm
inscribed: *Atkinson Grimshaw, 1877*
Scarborough Borough Council,
Department of Tourism and Leisure
Services, Scarborough Art Gallery

During the 1870s Grimshaw
took a house in Mulgrave Place,
Scarborough, overlooking the
North Bay. Named by him
'Castle-by-the-Sea', it was to be a
place to entertain friends, and, as
with Knostrop Old Hall, the
artist's romantic 17th-century

manor house outside Leeds, he
decorated it with old woodwork,
tiling and quaint furniture.
Scarborough was a fishing port
and spa town which was just
entering a phase of prosperity as
a holiday resort, largely through
the building of Cuthbert
Brodrick's Grand Hotel, then
one of the biggest in England,
completed in 1867.

In contrast with Grimshaw's
earlier, tranquil lakeland
landscapes, harbour scenes and
domestic subjects, two of his
Scarborough paintings, *'Burning
Off'* and *The Burning of the Spa
Saloon* (also Scarborough Art
Gallery), show dramatic scenes of
fires by night. In the present

picture the effect of the
moonlight is intensified by the
complementary light of a
burning tar barrel, set on the
outer pier to warn off shipping
attempting to enter the harbour
in a storm.

Grimshaw, a Leeds artist of
modest origins, was self-taught
and left remarkably few traces of
his life and friendships. The
obvious influences on his work
are Whistler, Tissot and Alma-
Tadema. This painting
previously belonged to Tom
Laughton, brother of the actor
Charles Laughton and owner at
various times of three hotels at
Scarborough. His gift to
Scarborough Art Gallery was of

works by British artists and by
foreign artists working in
Britain. They range from the
17th to the 20th century and
include paintings by William
Etty and John Martin. CG

PROVENANCE Tom Laughton, Grand
Hotel, Scarborough; 1968: Laughton Gift
presented to the gallery
REFERENCE A. Robertson, *Atkinson
Grimshaw*, Oxford, 1988, p. 67

171

Sir Luke Fildes RA
(1844–1927)

*Applicants for Admission to a
Casual Ward*, 1874

oil on canvas, 137.1 × 243.7 cm
inscribed: *Luke Fildes 1874*
Royal Holloway, University of
London, Egham, Surrey

Fildes's sombre painting shows a
queue of homeless people huddled
outside a London police station
on a wintry night waiting for
tickets to the overnight lodgings
(or 'casual ward') of a workhouse.
The picture was exhibited at the
Royal Academy in 1874 with a
quotation from a letter by
Dickens describing a similar
scene: 'Dumb, wet, silent horrors!
Sphinxes set up against the dead
wall, and none likely to be at the
pains of solving them until the
general overthrow.' It caused a great
stir. Reactions varied from
disgust (*Manchester Courier*) to
praise (*Athenaeum*), while the *Art
Journal* debated the larger
question of the subject's fitness
for art, concluding, 'there is little
in a theme of such grovelling
misery to recommend it to a
painter whose purpose is beauty'.

The painting is a version of
the artist's illustration 'Houseless
and Hungry', published in 1869
in *The Graphic*, and demonstrates
how popular illustration
enlarged the range of subject-
matter open to artists. *The
Graphic* was one of the first
magazines to use trained artists
rather than jobbing engravers. In
enlarging his illustration, Fildes
rearranged the composition,
heightening the emotionalism of
the scene to give it the epic
grandeur of high art. It doubtless
appealed to Thomas Holloway,
the founder of Holloway College,
as a moral example for the
education of young ladies. J B T

PROVENANCE 1874: bought by
Thomas Taylor of Wigan and Aston
Rowant, Oxfordshire; 1883, 28 April:
Christie's, London, Taylor sale, lot 71,
bought for Holloway
EXHIBITIONS London, RA, 1874, no.
504; Exposition Universelle, Paris, 1878,
no. 73; *Hard Times: Social Realism in
Victorian Art*, Manchester City Art
Gallery, Amsterdam, Van Gogh Museum,
and New Haven, Yale Center for British
Art, 1987–8, no. 74; *The Victorians*,
Washington, National Gallery of Art,
1997, no. 45
REFERENCE J. Chapel, *Victorian Taste:
The Complete Collection of Paintings at the
Royal Holloway College*, London, 1982, pp.
83–7 (with full provenance, exhibitions
and bibliography)

172

Sir Hubert von Herkomer
RA (1849–1914)

Anna Herkomer (née Weise),
1876

oil on canvas, 48.7 × 58.2 cm
inscribed: *H.H. Painted/ for our dear/
children/ Aug. 1876*
Watford Museum

Herkomer was Bavarian by birth
and he married Anna Weise, a
German woman some years older
than himself, in 1873. Very soon
after the marriage she developed
consumption, which proved fatal
in 1882. J. Saxon Mills,
Herkomer's biographer, believed
that the marriage had been
precipitate and that Anna's
illness made Herkomer's early

years very difficult. There were
two children of the marriage,
Siegfried and Elsa, and it is to
them that the painting is
dedicated. This intimate study
shows an unusual depth of
insight into the character and
painful disability of the sitter,
and it was never exhibited, the
artist himself remarking that it
was painted for his own private
pleasure. A year before this
portrait, Herkomer had achieved
his first great success at the
Royal Academy, with *The Last
Muster* (Lady Lever Art Gallery,
Port Sunlight), but his career as
a professional portrait painter
was still in the future.

Herkomer applied some of the
rewards of an immensely
successful career to building a

dream house, 'Lululaund' at
Bushey in Hertfordshire, to the
designs of the American
architect H.H. Richardson. The
Watford Museum is only
minutes away from the site of
the house and this portrait comes
from an interesting group of
Herkomer portraits and other
family material which has been
assembled there. C G

PROVENANCE 1983: bought from
David Messum by the museum with
assistance from the Victoria and Albert
Museum Purchase Grant Fund
REFERENCE J. Saxon Mills, *Life and
Letters of Sir Hubert Herkomer*, London,
1923, p. 97

173

James Jacques Joseph
Tissot (1836–1902)

The Convalescent, c. 1876

oil on canvas, 76 × 98 cm
inscribed: *J.J. Tissot*
Sheffield Art Galleries and Museums
(Mappin Art Gallery)

In the shade a young woman
recovering from illness reclines
in a basket chair, accompanied
by her elderly chaperone. On a
third chair is a black hat and a
cane, suggesting a man
temporarily absent from the tea
party. Boredom threatens, and
dissatisfaction pervades the
scene. The setting is Tissot's
garden in Grove End Road,
London. The circular colonnade
and pool, inspired by the Parc
Monceau in Paris, were to feature
again in his work. The picture is
poignantly prescient; all too soon
the suggestiveness and humour
would seem inappropriate. In the
year Tissot showed this picture
at the Royal Academy, he met
and fell in love with a divorcée,
Kathleen Newton, who became
his mistress and stayed with him
for the few remaining years of
her life. She was suffering from
consumption, and died in 1882.
With her arrival the mood of
Tissot's painting changed, and
the studies of her lying weak and
ill in the same basket chair
painfully recall this work.

Tissot lived in England for
eleven years, bringing French
sophistication and technical
accomplishment to an audience
often critical of the absense of
the strong narrative and moral
precept. He painted Thameside
subjects, picnics and boating
parties, elegant tourists and
social events, capturing them
with informality and
impartiality, like a cameraman.

When he returned to Paris in 1882 and embarked on a series entitled *La Femme à Paris*, French critics remarked on their English bias. Tissot's late pictures are, however, artificial in comparison to his earlier work. CG

PROVENANCE 1949, 21 January: bought at Christie's, London, by the Fine Art Society

EXHIBITIONS London, RA, 1876, no. 530; *James Tissot: An Exhibition of Paintings, Drawings and Etchings*, Sheffield, Graves Art Gallery, 1955, no. 27; *James Tissot*, London, Barbican Art Gallery, and Paris, Petit Palais, 1984–5, no. 95; *London's Pride: Glorious History of the Capital's Gardens*, Museum of London, 1990, p. 210 (ill.)

REFERENCE M. Wentworth, *James Tissot*, Oxford, 1984, pl. 113, pp. 112, 120

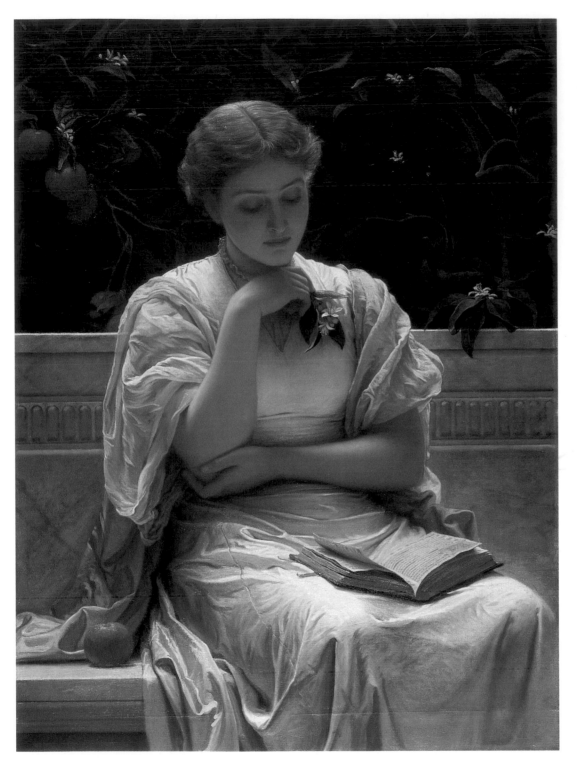

174

Charles Edward Perugini
(1839–1918)

Girl Reading, 1878

oil on canvas, 97. 9 × 73 cm
inscribed: *CP* (monogram) *1878*
Manchester City Art Galleries,
1917.237

Carefully arranged paintings of
female models posed with
decorative accessories, such as
flowers and patterned
backgrounds, were a vehicle for
artists of the Aesthetic
movement of the 1870s and
1880s to convey beauty for its
own sake. Perugini painted many
works of this kind. Typically, his
model wears the loose, flowing
draperies of Aesthetic dress
rather than fashionable clothing;
this adds to the mood of timeless
serenity. This is not an entirely
abstract evocation of harmony
and beauty, however; orange
blossom, traditionally signifying
purity, was associated with
brides, and the critic of *The
Magazine of Art* demonstrates
how such an image could be
interpreted by contemporaries:
'A girl, with a book upon her
knees, is reading with indolent
grace, no doubt a love poem, for
she is of the age when "maidens'
thoughts do run on love".' The
background of flowers, foliage
and fruit shows the influence of
contemporary wallpaper designs
by William Morris, Edward
William Godwin and Bruce
Talbert. Perugini's high finish,
which distinguishes his work
from the similar subject-matter
of Albert Moore (cat. 185), has
more in common with the
academic figure style of Lord
Leighton (cat. 159). Perugini,
born in Naples, met Leighton in
Rome and became his protégé.
Later, Perugini settled in London

and married Kate, daughter of Charles Dickens.

Sir William Eden, who bought the painting from the artist at the Royal Academy, was a distinguished collector, a patron of Degas and Whistler and a friend of the Irish artist and critic George Moore. The picture subsequently passed to James Blair (see cat. 133). JBT

PROVENANCE 1878: purchased from the artist by Sir William Eden, Bt; 1889, 15 June: Christie's, London, his sale, bought in; 1896: sold by Shepherd Brothers to James Blair; 1917: bequeathed by him to the gallery
EXHIBITIONS London, RA, 1878, no. 96; Manchester Royal Jubilee Exhibition, 1887, no. 819
REFERENCE *The Magazine of Art*, 1878, p. 25

175

William Powell Frith
(1819–1909)

The Fair Toxophilites, 1872

oil on canvas, 98.2 × 81.7 cm
inscribed: *W.P. Frith 1872*
Royal Albert Memorial Museum, Exeter, 305/1976

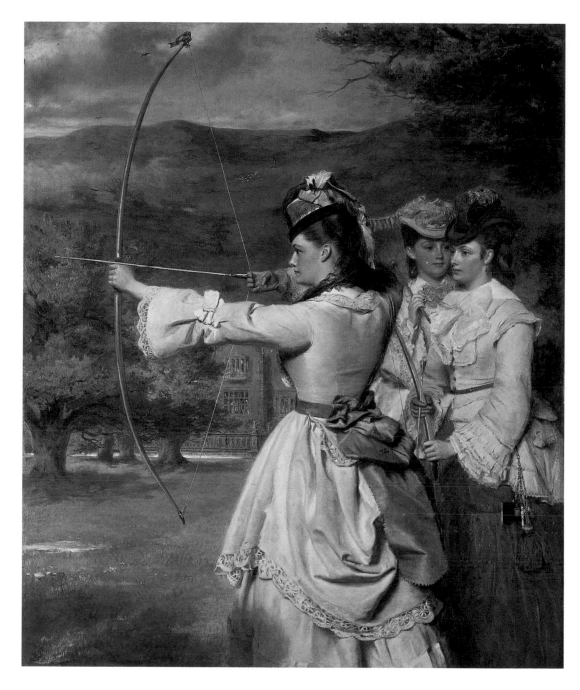

Frith's daughters, Alice, Fanny and Louisa (left to right), modelled for the picture, originally exhibited as *English Archers, 19th Century*. Always on the lookout for new ideas for modern-dress subjects, the artist wrote in his memoirs that this work 'was suggested by some lady-archers, whose feats had amused me at the seaside'. He disingenuously continued, 'the subject was trifling, and totally devoid of character interest; but the girls are true to nature and the dresses will be a record of the female habiliments of the time'. From Louisa's waist hangs a large tassel for cleaning arrows, a grease box, two ornamental acorns and an ivory pencil for scoring.

Queen Victoria, who was an enthusiastic toxophilite, had given the sport her seal of approval in 1839, when she presented a prize of an enamelled gold bracelet in an archery competition at St Leonard's-on-Sea. Archery was, like croquet, which Frith also depicted, one of the few sports open to middle-class young ladies and provided occasions for them to mix with the opposite sex. 'Who can deny that bows and arrows are amongst the prettiest weapons in the world for feminine forms to play with?' (George Eliot, *Daniel Deronda*, 1880). JBT

PROVENANCE By descent from the artist to Edgar Shephard; 1976: purchased by the museum with the aid of a grant from the Department of Education and Science
EXHIBITION London, RA, 1873, no. 99
REFERENCE *Catalogue of Oil Paintings, Watercolours, Drawings and Sculpture in the Permanent Collection*, Royal Albert Memorial Museum, Exeter, 1978, p. 60

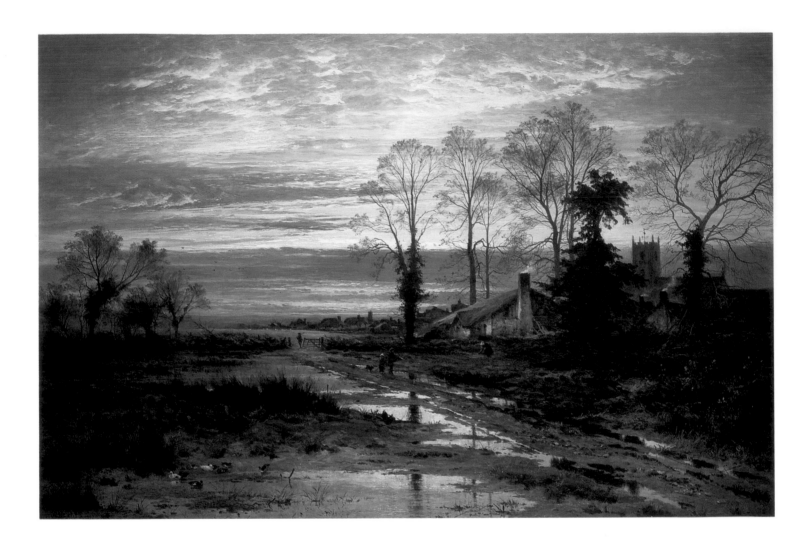

176

Benjamin William Leader
RA (1831–1923)
February Fill Dyke, 1881
oil on canvas, 121.9 × 183 cm
inscribed: *B W Leader, 1881*
Birmingham Museums and Art
Gallery, 308'14

Leader's view of an evening after
rain is based on his native
Worcestershire. The title comes
from an old country rhyme about
farmers' hopes for snow or rain:
'February fill the dyke,/ Be it
black or be it white,/ But if it be
white/ It's the better to like.'
The painting is typical of the
kind of landscape which became
popular in Britain in the last
quarter of the 19th century, in
reaction to the bright colour,
sharp detail and factual
recording of the Pre-Raphaelite
landscape. Leader's career
embraced this change in style;
his work of the 1860s is a
mechanical version of Pre-
Raphaelitism, which gave way in
his later paintings to looser
handling and a darker palette.
Leader's landscapes were widely
admired for their apparent truth
to nature, but he exploited the
liking of the late Victorians for a
combination of realism with
nostalgia and sentiment, a trend
stemming from the bleak, wintry
Highland views of the 1860s and
1870s by Millais and Peter
Graham. *February Fill Dyke*
became one of the best-loved of
all Victorian landscapes, its fame
spread by Theodore Chauvel's
etching, published in 1884 in
London, Paris and America. The
picture became so well known
that it was attacked by Roger
Fry, Clive Bell and, later,
Kenneth Clark as exemplifying
in its 'false naturalism' the worst
of Victorian taste. J B T

PROVENANCE 1914: bequeathed to the
gallery by Mrs Wilson in memory of her
husband, J.E. Wilson
EXHIBITIONS London, RA, 1881, no.
42; Manchester Royal Jubilee Exhibition,
1887, no. 23; *Great Victorian Pictures*,
Leeds City Art Gallery *et al.*, 1978, no. 27
(with full bibliography); *The Victorians*,
Washington, National Gallery of Art,
1997, no. 53
REFERENCE *Catalogue of Paintings,
Birmingham City Museum and Art Gallery*,
1960, p. 88

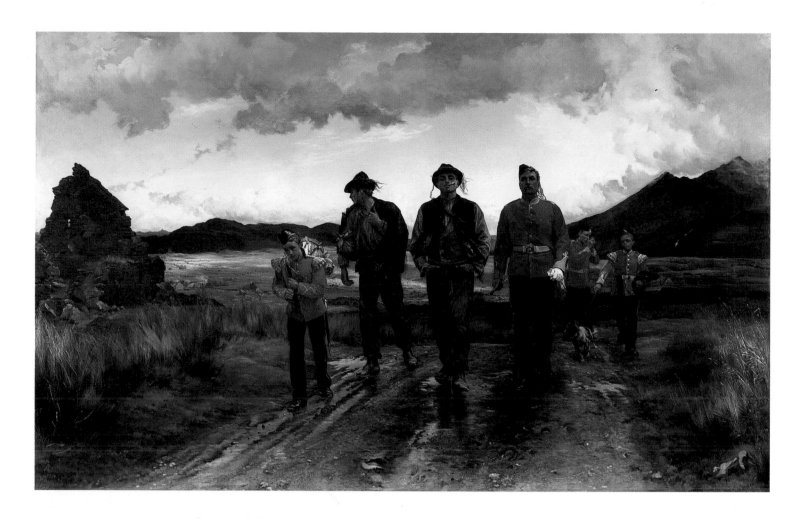

177

Elizabeth Thompson, later
Lady Butler (1846–1933)
*'Listed for the Connaught
Rangers': Recruiting in
Ireland*, 1878

oil on canvas, 106.5 × 169.5 cm
inscribed: *ET* (monogram)/ *18EB78*
Bury Art Gallery and Museum,
BUYGM.434.1937

This scene in County Kerry in
the west of Ireland shows two
Irish peasants enlisted by a
recruiting party for the 88th
(Connaught Rangers). In 1877
the artist married Major (later
Lieutenant-General Sir) William
Butler, an Irish Catholic. While
honeymooning in the west of
Ireland, she wrote in her diary of
the beauty of the scenery and the
picturesque Irish costume which,
in her picture, she contrasted
with the bright red uniforms.
Two cousins called Foley
modelled for the recruits. 'The
elder of the two had the finer
physique, and it was explained to
me that this was owing to his
having been reared on herrings as
well as potatoes, whereas the
other, who lived in the
mountains, away from the sea,
had not known the luxury of the
herring. I wish we could get
more of these men into our
army.' These words reflect Major
Butler's campaign to improve
the British treatment of the Irish
in order to benefit recruitment
into the army and stop
emigration to America. The
painting indirectly refers to this
issue in the ruined cottage, a
reminder of the depopulation
caused by famine and poverty.

While the painting was on
show at the Royal Academy,
Lady Butler was nominated for
election to Associate. Though
she received more votes than her
rivals in the first ballot, she lost
the subsequent ballots and it was
not until 1922 that a woman
artist became an Associate. The
painting was commissioned by
John Whitehead, a wealthy
calico bleacher of Bury and
Manchester who had also
purchased the artist's earlier
success, *Balaclava* (1876;
Manchester City Art Gallery).
JBT

PROVENANCE 1878: commissioned by
John Whitehead; 1937: donated to the
museum by his son Robert
EXHIBITIONS London, RA, 1879, no.
20; Manchester Royal Jubilee Exhibition,
1887, no. 16; *Lady Butler, Battle Artist*,
London, National Army Museum,
Durham Light Infantry Museum and
Leeds City Art Gallery, 1987–88, no. 30
(with full exhibitions and bibliography)

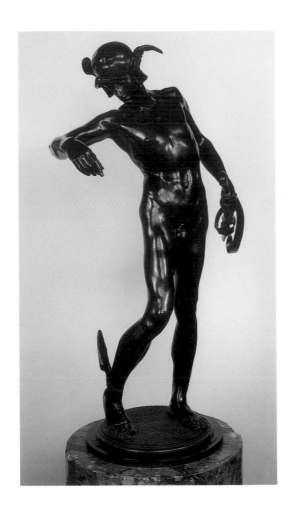

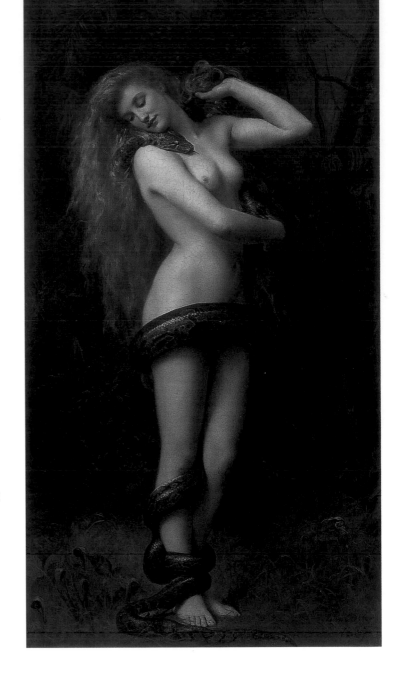

178

Sir Alfred Gilbert RA
(1854–1934)

Perseus Arming, first cast in
1881

bronze, 65 × 41 × 20 cm
Bradford Art Galleries and
Museums, Cartwright Hall, 1913-2

Perseus Arming, Alfred Gilbert's
first statue to be cast in bronze,
was a formative work of the
'New Sculpture' (see cat. 207) in
which the artist's admiration for
the Florentine Renaissance and
his individualistic approach to
Classical mythology were first
given expression.

Gilbert studied at the Ecole
des Beaux-Arts in Paris and,
from 1878 to 1884, worked in
Rome, where his early bronzes
were produced. He later achieved
universal fame with the Shaftes-
bury Memorial in Piccadilly
Circus, London (1886–93), and
the tomb of the Duke of
Clarence at Windsor Castle
(1892–1928).

Perseus Arming was designed
following a trip Gilbert made to
Florence in 1879. Cellini's *Perseus*
and Donatello's *David* are
reinterpreted by Gilbert as a
slender, vulnerable figure,
balancing himself awkwardly as
he glances down to check the fit
of his winged sandal – an image
which Gilbert also related to his
own status as a young, 'untried'
sculptor. The model was cast in
1881 using the *cire perdue* ('lost
wax') method. This technique,
which permitted the delicate
contours of the original wax
figure to be retained, was
unknown in England at the time
and contributed to the work's
impact when it first appeared. It
was exhibited at the Grosvenor
Gallery, London, in 1882 as a cast
29 inches (74 cm) high; a number
of later and variant editions,
including the present cast, were
issued in three different sizes. MG

PROVENANCE 1913: presented to the
galleries by Asa Lingard
REFERENCES S. Beattie, *The New
Sculpture*, New Haven, 1983; R. Dorment,
Alfred Gilbert, New Haven, 1985; *Alfred
Gilbert, Sculptor and Goldsmith*, exh. cat. by
R. Dorment, London, RA, 1986

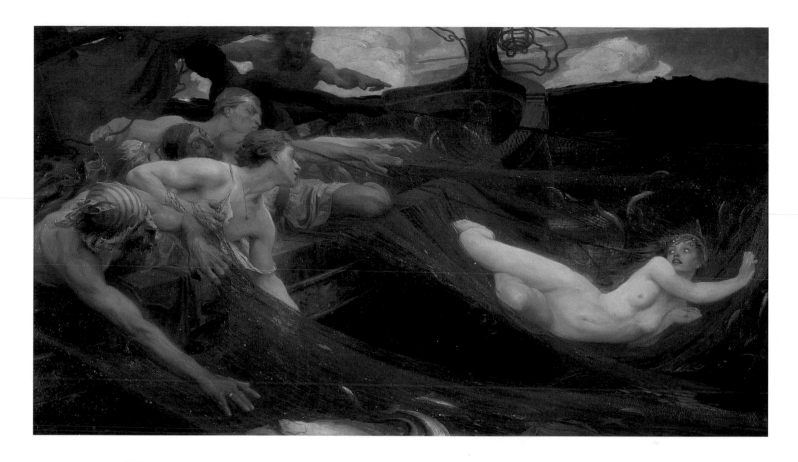

179

The Hon. John Collier
(1850–1934)

Lilith, 1887

oil on canvas, 237 × 141 cm
Sefton MBC Leisure Services Dept,
Arts and Cultural Services Section,
The Atkinson Art Gallery,
Southport, B. 1938.188

Lilith was said to be the wife
that Adam had before Eve; she is
a figure of terror, feared as a
demon or vampire, and a night
monster. Rossetti wrote about
her in *House of Life* and painted
her in 1868 (Bancroft Collection
Wilmington, Delaware, USA).
She is also known as Lamia;
Keats describes her as a serpent
which assumed the shape of a
beautiful woman 'palpitating
snake … of dazzling hue,
vermillion spotted, golden, green
and blue', and it is this image
which seems to have captured
Collier's imagination. The
subject also attracted the
Symbolists.

Collier was a successful society
portrait painter, but he was also
celebrated for the narrative
pictures which he exhibited at
the Royal Academy, such as *The
Last Voyage of Henry Hudson*
(1881; Tate Gallery, London).
He studied under Poynter (cat.
188) at the Slade School of Art,
in Paris with J.-P. Laurens
(1838–1921) and in Munich.
C G

PROVENANCE 1938: presented to the
gallery by F.C. Johnson

180

Herbert James Draper
(1864–1920)

The Sea Maiden, 1894

oil on canvas, 122 × 220 cm
The Royal Institution of Cornwall,
Royal Cornwall Museum, Truro,
1919.21

Draper produced large and
imposing mythological subjects
for exhibition at the Royal
Academy, notably *The Lament for
Icarus* (RA, 1898). *The Sea
Maiden*, inspired by lines from
the poem *Chastelard* by Algernon
Swinburne – 'A song of drag-
nets hauled across thwart seas/
And plucked up with rent sides
and caught therein/ A strange
haired woman with sad singing
lips' – shows bewildered
fishermen who have caught a
siren in their net. R.A.M.
Stevenson, *Art Journal* critic, did
not like it: 'Mr Draper's "Sea
Maiden" caught in a fisher's net,
grows daily more patently false
to the visitor, and as its unreality
becomes apparent, its febrile
violence of colour becomes
revolting.'

The picture was owned by Mr
C.H.T. Hawkins of Truro, who
presented it to the museum with
a large collection of fine and
decorative art. C G

PROVENANCE C.H.T. Hawkins; 1905:
presented to the Central Technical
Schools, Truro, for Truro Art Gallery;
1919: transferred from the Truro Art
Gallery as a bequest from Mrs Hawkins
EXHIBITIONS London, RA, 1894, no.
370; Dublin International Exhibition,
1907

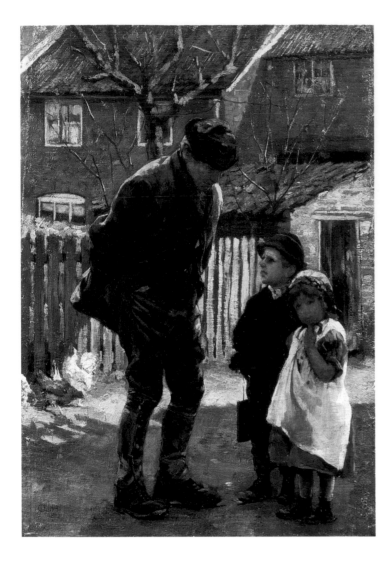

181

James Charles (1851–1906)

Grandad, she doesn't want to go to school, 1883

oil on canvas, 36.5 × 25 cm
inscribed: *J Charles 1883*
Warrington Museum and Art
Gallery, 1960.17.1

This is typical of the charming, small-scale genre paintings of village children, often with a humorous slant, which Charles painted in the 1880s, while living in South Harting, Sussex; other examples are *Will it rain?* (Tate Gallery, London), *The Knifegrinder* (Manchester City Art Galleries) and *The Village Shop*

(Johannesburg Art Gallery). Charles also painted larger, more highly worked genre subjects, such as *Christening Sunday* (Manchester City Art Gallery) and *Signing the Marriage Register* (Bradford Art Gallery), but his most significant achievement is in the field of landscape. Charles was one of the earliest painters in Britain to adopt the free handling and broken, painterly brushwork of the French Impressionists. After his initial training in London, he had studied in Paris at the Académie Julian, where he was deeply influenced by the *plein air* movement. His work was

collected by a few English patrons, especially the Bradford collector John Maddocks, but Charles never received the recognition he deserved in Britain, despite winning medals in Paris in 1889 and Chicago in 1893. This is one of a group of seventeen works by the Warrington-born painter in the art gallery of his native town. The collection is still occasionally added to. J B T

PROVENANCE Walter Butterworth of Manchester; 1960: presented to the gallery by his son, L.M. Angus-Butterworth

182

Sir Hubert von Herkomer (1849–1914)

Hard Times 1885, 1885

oil on canvas, 86.5 × 112 cm
inscribed: *HH 85*
Manchester City Art Galleries,
1885.24

This picture of an unemployed agricultural worker with his wife and two children in a bleak, winter landscape was painted after the particularly hard winter of 1884–5 had caused thousands of farm labourers to be thrown out of work. Workers wandering through the countryside in search of jobs, carrying belongings and tools in a bundle, were a common sight that winter.

Though Herkomer depicted a real landscape, near his home at Bushey in Hertfordshire, the image was deliberately contrived. His models, the Quarry family, were posed in the studio. The man gazes into the distance, expressing both hope and despair, while his wife's attitude embodies the suffering of womankind. The winding road draws the spectator into the

picture, but also serves as a symbolic device, suggesting the future.

Hard Times 1885, its title a reference to Dickens's novel of 1845, comes in a line of Victorian representations of exhausted rural wanderers resting by the wayside. Like those by G.F. Watts and Frederick Walker, Herkomer's works have a heroic quality: he posed the figures to recall both the Rest on the Flight into Egypt and the emblem of Charity as a woman with two babies. In thus combining traditional iconography with a contemporary subject and a specific historical moment with a timeless, universal message, Herkomer was making a modern equivalent to the classically and mythologically based history paintings of the late 18th and early 19th centuries. J B T

PROVENANCE 1885: purchased from the artist at the Manchester Autumn Exhibition
EXHIBITIONS London, RA, 1885 no. 1142; Autumn Exhibition, Manchester City Art Galleries, 1885, no. 252; Manchester Royal Jubilee Exhibition, 1887, no. 74; *Hard Times: Social Realism in Victorian Art*, Manchester City Art Gallery, Amsterdam, Van Gogh Museum, and New Haven, Yale Center for British Art, 1987–8, no. 82; *The Victorians*, Washington, National Gallery of Art, 1997, no. 51

183

Philip Homan Miller (active 1877–died 1928)

Workmen and Workwomen: The Interior of a Salt Works, 1884

oil on canvas, 96 × 125 cm
(sight size)
inscribed: *PHM* (monogram) *1884*
City of Salford Art Gallery, 1885.3

In British social realism, factory interiors were unusual, and paintings of women at work even rarer. Here, both men and women are shown in an open-pan salt works, with steam rising from the salt pans above the furnace used to dry the salt. An Irishman, Miller spent much of his life in London, and exhibited a variety of subjects in both London and Dublin. He may have been aware of the 1876 commission of enquiry into the salt industry. This described the long hours, heavy work and hazardous conditions prevalent in salt works, where the hot and steamy atmosphere and the wet and slippery walkways caused frequent accidents. It was common for a pan to be rented by a man who worked it using the labour of his wife and children. In addition to the men stoking the furnace and shovelling coal, Miller shows a young woman, top right, probably turning out lumps of salt. A man is sleeping in the heat, another seems to be lighting his pipe and, on the left, an older woman talks to a woman nursing a baby.

The donor was the wife of a wealthy Manchester coal merchant and manufacturer of colliery brattice cloth. He was the initiator of the Manchester Royal Jubilee Exhibition of 1887. JBT

PROVENANCE 1885: presented to the museum by Mrs Ellis Lever
EXHIBITION London, RA, 1885, no. 750
REFERENCE *Working Conditions in the Cheshire Salt Industry*, Cheshire Libraries and Museums, Salt Museum, undated leaflet

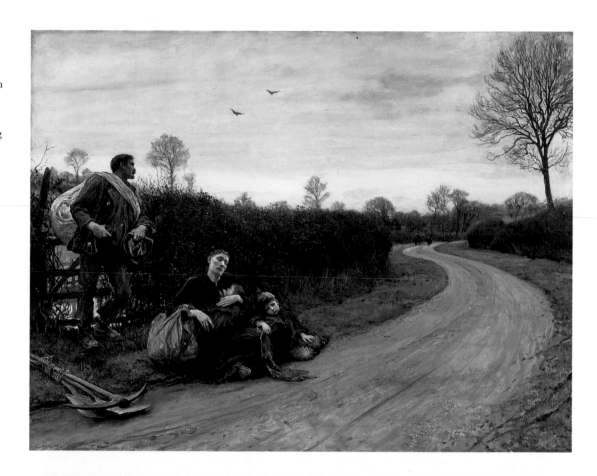

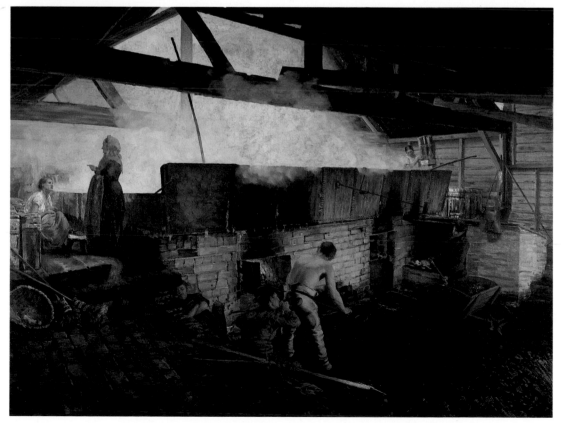

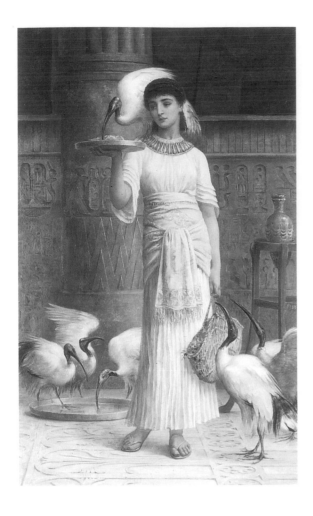

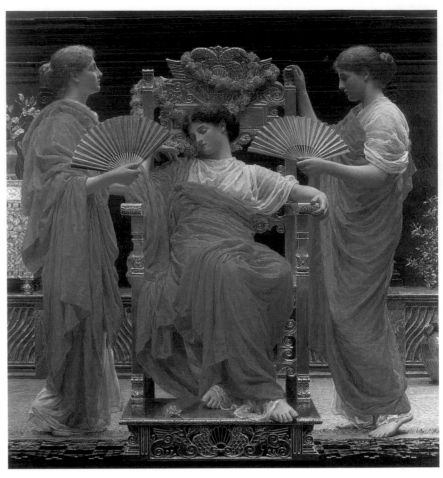

184

Edwin Longsden Long RA
(1829–81)

*Alethe, Attendant of the
Sacred Ibis; in the Temple of
Isis, Memphis, circa 255 AD,*
1888

oil on canvas, 108 × 68.5 cm
Russell-Cotes Art Gallery and
Museum, Bournemouth, 01350

Long was the son of a hairdresser
in Bath. He began his career as a
portrait painter, and first
exhibited at the Royal Academy
in 1855. He moved to London in
1858. He was a competent
portraitist, but his reputation
was made by his subject pictures,
particularly his large-scale scenes
from ancient history. His
subject-matter divides neatly
into two phases, defined by his
travels. For more than fifteen
years from 1857 he had an
enthusiasm for Spain, where he
travelled each year in search of
subjects. In 1874 he visited the
East and his extensive series of
Egyptian and biblical subjects
followed, beginning with the
large and crowded scene *The
Babylonian Marriage Market*
(1875; Royal Holloway,
University of London, Egham).

Alethe is a character from
Thomas Moore's poem *Alciphron*
(1839), written in an attempt to
repeat the success of *Lallah Rookh*
(1817). She stands with the
sacred ibis birds amid a wealth of
Eastern decorative art. Long's
source for the furniture and
artefacts in his Egyptian subjects
may have been the Henry Salt
collection of antiquities from
Thebes which had been in the
British Museum since the 1820s.

Long was the favourite artist
of Sir Merton Russell-Cotes,
whose taste still dominates the
Bournemouth gallery, largely on
account of works such as Long's
five-metre-wide *Flight into Egypt*.
That taste was perpetuated in
purchases like the brilliantly
coloured painting by Albert
Moore (cat. 185). CG

PROVENANCE Sir Merton and Lady
Russell-Cotes
REFERENCE R. Quick, *The Life and
Works of Edwin Long RA*, Bournemouth,
1970, p. 9

185

Albert Joseph Moore
(1841–93)

Midsummer, c. 1886–7

oil on canvas, 159.8 × 153 cm
inscribed twice with anthemion
device (used by Moore instead of a
signature)
Russell-Cotes Art Gallery and
Museums, Bournemouth, 01536

Albert Moore's work consists of
ever more subtle variations on
one type of subject-matter:
female figures, shown singly or
in groups, nude or, more usually,
wearing exquisitely coloured
classical draperies, and combined
with such decorative accessories
as flowers, birds, vases and
patterned surfaces. Moore
exemplifies the Aesthetic

movement at its purest. He rejected narrative and emphasised form, colour and pattern, arranging the poses of his figures, the fall of draperies and the patterns of textiles and furniture with fastidious care to create a world of ideal beauty and harmony.

Midsummer has no story. The enthroned figure and her two handmaidens suggest the worship of beauty; the brilliant orange draperies (stronger in colour than the pale tints usually employed by Moore) evoke the heat of midsummer; the slumber of the central figure creates a hypnotic mood of languor.

The first owner of the painting, the Glasgow commodity broker William Connal, was one of Moore's most important patrons, and also owned works by other Aesthetic and Symbolist artists, including Burne-Jones, Poynter, Rossetti, Whistler and the Belgian Fernand Khnopff (1858–1921). JBT

PROVENANCE 1888. William Connal; 1908, 14 March: Christie's, London, his sale, 1936: purchased by the gallery
EXHIBITIONE London, RA, 1887, no 394; *Victorian High Renaissance*, Manchester City Art Gallery, Minneapolis Institute of Arts and New York, The Brooklyn Museum, 1978–9, no. 83 (with full exhibitions and bibliography); *The Victorians*, Washington, National Gallery of Art, 1997, no. 58

186

Sir Edward Burne-Jones
(1833–98)

The Annunciation, 1887

tempera and watercolour heightened with gold on three pieces of joined paper, 245 × 96.2 cm
Norfolk Museums Service (Norwich Castle Museum), 1932.89

This is the preparatory cartoon for Burne-Jones's *Annunciation*, completed in 1879, in the Lady Lever Art Gallery at Port Sunlight. John Christian has explained the striking, elongated format as being related to the artist's stained glass-designs. The architectural background was taken from sketches made on a visit to Italy in 1871, a crucial experience in Burne-Jones's artistic development.

Ruskin's description of Burne-Jones as chiaroscuristic rather than colourist is apt. The primary version, an almost monochrome oil painting in tones of blue and grey, was exhibited at the Grosvenor Gallery in London in 1879 and went to a fellow artist, George Howard, 9th Earl of Carlisle. Julia Stephen (née Jackson), mother of Vanessa Bell, niece of Julia Margaret Cameron and Sara Prinsep and cousin to Val Prinsep (cat. 199), modelled for the Virgin. Although the version shown here was used as the cartoon for the oil painting, being worked up in watercolour and tempera with gold in 1887, the model for the Virgin seems to have been changed. A small version in watercolour with gold is in the British Museum. All three versions of *The Annunciation* were owned by members of the aristocratic circle known as the Souls. This one belonged to Cyril Flower, Lord Battersea, whose sister-in-law, Blanche Lindsay, was owner with her husband, Sir Coutts, of the Grosvenor Gallery. CG

PROVENANCE 1892: Cyril Flower, Lord Battersea; 1932: bequeathed to the museum by Lady Battersea
EXHIBITION *Burne-Jones and his Followers*, British Council travelling exhibition, Japan, 1987, no. 19
REFERENCE *Burne-Jones*, Arts Council exhibition, 1975–6, under no. 136

187
Henry Stacy Marks
(1829–98)
A Select Committee, 1891

oil on canvas, 111.7 × 86.7 cm
inscribed: *H. S. M.*
Board of Trustees of the National
Museums and Galleries on
Merseyside (Walker Art Gallery,
Liverpool), WAG 2827

When this picture was exhibited
at the Royal Academy in 1891,
it was described by one reviewer
as 'a council, board and congress
. . . of blue, white and black
parrots and cockatoos perched in
an aviary and gravely discussing
the affairs of birdland'. Presiding
over this meeting is a
Hyacinthine Macaw, raising its
claw to address the group. The

other members of the committee
consist of a blue and yellow
Macaw and various species of
cockatoo, all of them described
with painstaking accuracy,
thanks to the artist's numerous
visits to the parrot house at
London Zoo, which Marks
described as a 'good winter
studio' despite the
'Pandemonium of discordant
shrieks, squeals, squalls, and
screeches!'

Though he began his career as
a painter of medieval, Shake-
spearean and other literary sub-
jects, Marks enjoyed enormous
popularity for his humorous
paintings of birds gathered in
conclave. Though he insisted
that he never caricatured or
humanised his subjects, his titles

frequently belie this – at least in
part. Anyone familiar with the
colourful and cantankerous world
of parrots will know that all the
poses and expressions depicted in
this picture may be found there.
Only the context has been
artfully contrived. R V

PROVENANCE 1891: purchased by the
gallery from the artist
EXHIBITIONS London, RA, 1891,
no. 259; Autumn Exhibition, Liverpool,
Walker Art Gallery, 1891, no. 53;
Bicentenary Exhibition 1768–1968,
London, RA, 1968–9, no. 500
REFERENCES A. Kavanagh, 'Parrots
with a Smile: The Bird Studies of Henry
Stacy Marks (1829–98)', *Country Life*, 13
February 1986, pp. 412–14; E. Morris,
*Victorian and Edwardian Paintings in the
Walker Art Gallery and at Sudley House:
British Artists born after 1810 but before
1861*, London, 1996, pp. 300–1

188
Sir Edward Poynter PRA
(1836–1919)
Diadumené, 1884

oil on canvas, 51 × 50.9 cm
inscribed: *E.J.P.* (monogram) *1883*
Royal Albert Memorial Museum,
Exeter, 77/1969

Described by *The Magazine of Art*
(1884, p. 351) as 'very small,
very careful and fine, and very
attractive', this is one of the
small decorative Classical genre
scenes to which Poynter
increasingly turned in the 1880s.
The title refers to a celebrated
statue by the Greek sculptor
Polyclitus, known only from
later copies, showing a man
tying a fillet around his head.
Poynter's painting of a woman
engaged in the same action was
based on a recently discovered
statue, the 'Esquiline' *Venus*,
excavated in 1874; other artists
of the Victorian Classical revival,
including Leighton, Moore,
Watts and Alma-Tadema, also

painted pictures of models in
poses taken from ancient statues
(see cat. 150, 185, 195). The
elaborate mosaic decoration
reflects Poynter's interest in the
decorative arts; in 1868 he
studied mosaics in Italy in
connection with a commission to
decorate the Lecture Theatre at
the South Kensington Museum,
a scheme which was never
realised.

The year after exhibiting
Diadumené Poynter showed, also
at the Royal Academy, a much
larger painting of the same title,
showing a nude model in the
same pose. While the first
version attracted little criticism,
the large one became embroiled
in a controversy about the use of
the nude model in art that
involved several other artists.
Some years later, Poynter painted
drapery on the large version but,
as he continued to paint the
female nude, this was
presumably because it had not
sold. J B T

PROVENANCE 1969: purchased by the
museum from the Veitch Bequest Fund
with the aid of a grant from the
Department of Education and Science
EXHIBITIONS London, RA, 1884, no.
368; *Imagining Rome: British Artists and
Rome in the Nineteenth Century*, Bristol City
Museums and Art Gallery, 1996, no. 56

189

John Singer Sargent RA
(1856–1925)

Portrait of Dorothy Barnard,
1889

oil on canvas, 70.5 × 39.4 cm
Lent by the Syndics of the
Fitzwilliam Museum, Cambridge,
PD34–1949

The subject of this unfinished
portrait was Miss Dorothy
Barnard (1878–1949), daughter
of the painter and illustrator of
Dickens Frederick Barnard
(1848–96), one of Sargent's
friends from the artistic colony
in the Cotswold village of
Broadway, whom he met for the
first time in 1885. Dorothy and
her sister Polly were the models
for the two girls in Sargent's
most famous painting, *Carnation,
Lily, Lily, Rose* (1885–6; Tate
Gallery, London). The present
study of Dorothy was painted
three years later, at Fladbury
Rectory, Pershore, in
Worcestershire, where Sargent
had established himself in order
to continue his experiments with
open-air subjects. It was here
that some of his most
Impressionist works were
painted. Portraits occupied the
times when the weather was bad.
Sargent's reputation as a portrait
painter has overshadowed his

accomplishments in landscape
and open-air studies. C G

PROVENANCE 1889: Mrs Frederick
Barnard; bequeathed to the Misses
Barnard; 1949: bequeathed by Miss
Dorothy Barnard to the museum
EXHIBITIONS *Works by the late John S.
Sargent, RA*, London, RA, 1926, no. 595;
Works by John Singer Sargent, RA,
Birmingham City Museum and Art
Gallery, 1964, no. 19; *John Singer Sargent
and the Edwardian Age*, Leeds Art
Galleries, London, National Portrait
Gallery, and Detroit Institute of Arts,
1979, no. 29
REFERENCES E. Charteris, *John Sargent*,
1927, p. 261; J.W. Goodison, *Catalogue of
Paintings*, III, *British School*, Fitzwilliam
Museum, Cambridge, 1977, p. 216;
Stanley Olsen *et al.*, *Sargent at Broadway*,
New York and London, 1986, pl. XLI,
pp. 63–75

190

William Michael Harnett
(1848–92)

The Old Cupboard Door,
1889

oil on canvas, 154.9 × 102.8 cm
inscribed: *W.M. Harnett 1889*
Sheffield Art Galleries and Museums
(Graves Art Gallery), 2738

Distinguished works by
American 19th-century artists
are a great rarity in English
collections. Although Irish-born,
Harnett was brought up in
Philadelphia from a very early
age. He moved to New York in
1871, studying drawing in the
evenings while he worked as a
silver engraver during the day.
Harnett had trained as a silver
engraver and this undoubtedly
contributed to the precision of
his execution when he started
painting in 1875. His early still-
lifes were in the meticulous
manner of 17th-century Dutch
painters, probably as mediated
by the American Raphaelle Peale
(1774–1825). Harnett spent the

years 1880 to 1886 in Munich and Paris, producing traditional tabletop still-lifes featuring ornate tankards, pipes, books or writing materials.

The Old Cupboard Door, painted after his return to New York, is Harnett's last major *trompe l'œil* work. It shows cracked and splintered planks hung with a violin and bow, a worn tambourine and faded musical scores, and a manuscript poem on a scrap of paper; the ledges support a little Antique bronze of an athlete and a dying rose in a vase. The cool, almost eerie precision of Harnett's work endeared him to the Surrealists and he has proved the most influential of American still-life painters. CG

PROVENANCE H.H. Andrews; 1903: bequeathed by him to the gallery

REFERENCES A. Frankenstein, *After the Hunt: William Harnett and other American Still-life Painters, 1870–1900*, Berkeley and Los Angeles, 1953, rev. edn 1969; C.J. Oja, 'The Still-life Paintings of William Michael Harnett', *The Musical Quarterly*, LXIII, October 1977, pp. 516–17

doorway. The saucerless teacup subtly underlines the poverty of the modest household. With the marine painter Charles Napier-Hemy (1841–1917) Tuke was by far the most considerable figure among the Falmouth group.

Sailing was Tuke's favourite sport and he famously specialised in pictures of naked youths in a marine setting which caused unease in the artistic establishment, but which were accepted at face value as open-air Cornish boating subjects, one being acquired for the Chantrey Bequest. CG

PROVENANCE 1923: presented by M.A.A. de Pass to the Falmouth Free Library
EXHIBITION *Painting in Newlyn 1880–1930*, London, Barbican Art Gallery, 1985, no. 32
REFERENCE C. Fox, *Stanhope Forbes and the Newlyn School*, Newton Abbot, 1993, p. 36 (ill.)

192

Sir George Clausen RA (1852–1944)

The Stone Pickers, 1887

oil on canvas, 107.6 × 79.2 cm
inscribed: *G.Clausen, 1887*
Laing Art Gallery, Newcastle upon Tyne (Tyne and Wear Museums)

One of a series of paintings of agricultural workers made by Clausen in the 1880s in a style deeply influenced by the French artist Jules Bastien-Lepage (1848–84), *The Stone Pickers* is very similar to the latter's *Pauvre Fauvette* (Glasgow Art Gallery). Clausen could have seen this exhibited in London in 1882. Bastien-Lepage was idolised in the 1880s by many young painters, who took up his square-brush technique, his careful rendering of tonal values and his rustic subjects. Clausen also

191

Henry Scott Tuke (1858–1929)

The Message, 1890

oil on canvas, 100 × 90 cm
inscribed: *H S TUKE 1890*
Kindly loaned by Falmouth Town Council, Falmouth Art Gallery, A/20

Tuke's family were devout Quakers from York who moved to Falmouth in his childhood on account of his father's health. He studied in London at the Slade School of Art and from 1881 to 1883 in the Paris studio of J.P. Laurens (1838–1921), where he came across Jules Bastien-Lepage (1848–84) and became one of his followers. Tuke made his way to Newlyn in 1883 but eventually settled in Falmouth. Although

he claimed a distinct identity for the Falmouth group of artists, *The Message* has a strongly Newlyn character, combining social realism with an intimate domestic setting. The painting shows Tuke's long-suffering housekeeper, Mrs Fouracre, and her sons, Georgy Fouracre is seated at the table and Richard Fouracre looks up at the Post Office messenger, William Martin, who is leaning in the

admired Bastien-Lepage's studied impartiality, depicting country people as they lived, without comment. Here he shows peasants preparing a field for ploughing. The pose and facial expression of the standing girl suggest the hardship of labour, but Clausen denied he was a social realist and used not a real peasant but his children's nursemaid, Polly Baldwin, as a model.

The worship of Bastien-Lepage and the espousal of rustic subjects was part of a movement that rejected academic teaching and exhibitions, leading to the formation of the New English Art Club, where *The Stone Pickers* was first shown, in the Club's second exhibition. The painting went on to win a second class medal in Paris in 1889. Its first owner, James Staats Forbes, uncle of the painter Stanhope Forbes (cat. 194), was a railway director who formed a notable collection of modern British and Continental paintings. JBT

PROVENANCE James Staats Forbes; 1907: purchased by the gallery
EXHIBITIONS London, New English Art Club, 1887, no. 32; Paris, Exposition Universelle, 1889, no. 27; *Post-Impressionism*, London, RA, 1979, no. 281 (with bibliography); *Sir George Clausen RA 1852–1944*, Bradford, Cartwright Hall, *et al.*, 1980, no. 46 (with bibliography)

193

Elizabeth Adela Armstrong
Forbes (1859–1912)

School is Out, 1889

oil on canvas, 106.4 × 145 cm
inscribed: *EA* (monogram)
Penlee House Gallery and Museum,
Penzance

Elizabeth Armstrong was born in
Canada but trained in New York
with William Merritt Chase
(1849–1916). In London she
developed close links with
Sickert and Whistler and
experimented with etching.
In 1883, she worked in the
cosmopolitan artistic colony at
Pont-Aven in Brittany. She met
her future husband, Stanhope
Forbes (cat. 194), when she
arrived in Newlyn in 1885 to
join the group established there.
In 1889, soon after Forbes sold
The Health of the Bride (Tate
Gallery, London) to Sir Henry
Tate, they were married.
Armstrong had admired Jean-
François Millet (1814–75) and
Jules Bastien-Lepage (1848–84)
since her early art school days in
New York and the Newlyners'
strict adherence to painting from
nature and rural realist subjects
appealed to her. *School is Out*, her
most ambitious and popular
work, was completed shortly
before her marriage. Armstrong
had a particular aptitude for
painting children, displayed here
in individual studies of great
insight. For all its naturalism,
the painting is dramatically lit
and strongly structured, with the
figure of the crying boy on the
left forming a diagonal with the
teacher seated in the window and
with the open door taking the
eye of the viewer to the world
beyond the schoolroom. C G

PROVENANCE Given to the gallery by
Monica Anthony
EXHIBITIONS London, RA, 1889, no.
568; *Painting in Cornwall*, Royal
Institution of Cornwall, 1978, no. 11;
Artists of the Newlyn School, 1880–1900,
Newlyn Art Gallery, 1979, no. 74; *Women
Artists in Cornwall, 1880–1940*, Falmouth
Art Gallery, 1986, p. 14
REFERENCES M. Jacobs, *The Good and
Simple Life: Artist Colonies in Europe and
America*, Oxford, 1985, pl. 136; J. Laity,
The Penzance Art Collection at Penlee House,
1986, p. 9; C. Fox, *Stanhope Forbes and the
Newlyn School*, Newton Abbot, 1993,
pp. 46, 48 (ill.)

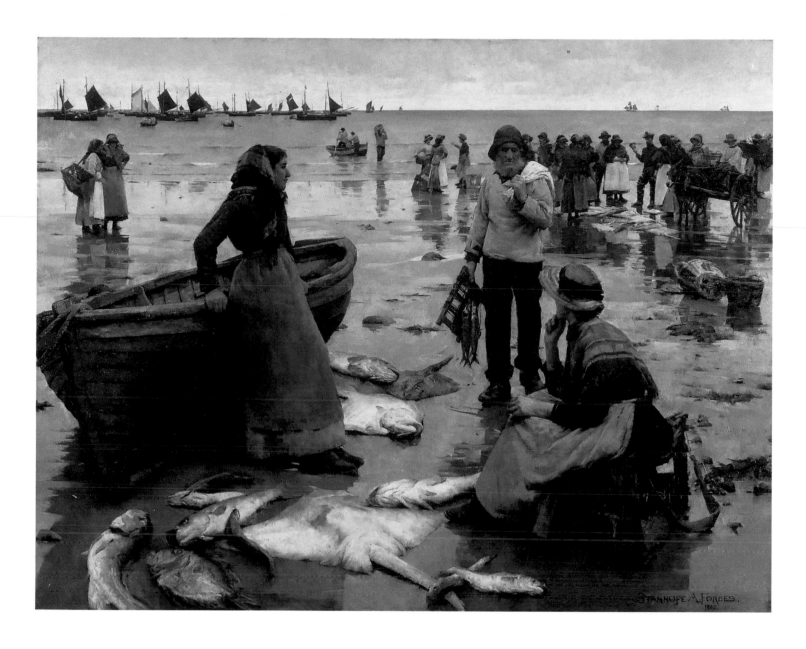

194

Stanhope Alexander Forbes
RA NEAC (1857–1947)

*A Fish Sale on a Cornish
Beach*, 1885

oil on canvas, 121.3 × 154.9 cm
inscribed: *Stanhope A. Forbes 1885*
Plymouth City Museum and Art
Gallery, Plymg.1962.108

Forbes was born in Dublin. His
father and his uncle were railway
managers; the latter, James Staats
Forbes, was a noted collector (see

cat. 192). The time he spent in
France – first in Paris in the
studio of Léon Bonnat
(1834–1922), then in Brittany –
and his membership of the New
English Art Club, known at that
date for its anti-establishment
stance, were formative influences.
From his time in Brittany he
took his subject-matter, the
square-brush technique and a
commitment to working in the
open air whatever the conditions.
Back in England he set out to
find a country place suitable to

following this ideal, and settled
on Newlyn in Cornwall. When
he arrived in 1884 he found
artists from Brittany established
there, and others soon arrived,
among them Clausen, La
Thangue and Tuke (cat. 191,
192, 206). Elizabeth Armstrong
(cat. 193), his future wife, came
in 1885. Forbes became the
leader of the Newlyn School
largely through his success at the
Royal Academy in the first years
of the group's existence. *A Fish
Sale on the Cornish Beach*

established the Newlyners as
artists producing innovative and
distinctive work. CG

PROVENANCE 1892: J.J. Brown,
Reigate; 1962: bought by the gallery
EXHIBITIONS London, RA, 1885, no.
1093; *Stanhope Forbes RA*, Plymouth Art
Gallery, 1984, no. 2; *Painting in Newlyn,
1880–1930*, London, Barbican Art Gallery,
1985, no. 3; *The Victorians*, Washington,
National Gallery of Art, 1997 no. 60
REFERENCES M. Jacobs, *The Good and
Simple Life: Artist Colonies in Europe and
America*, Oxford, 1985, pl. 6, pp. 149–50;
C. Fox, *Stanhope Forbes and the Newlyn
School*, Newton Abbot, 1993, pp. 22 (ill.),
24–5

195

Sir Lawrence Alma-Tadema RA OM (1836–1912)

Unconscious Rivals, 1893

oil on panel, 45.1 × 62.9 cm
inscribed: *L. Alma-Tadema op. CCCXXI*
Bristol Museums and Art Gallery, K1248

Two richly dressed women are idling by an azalea on a marble balcony overlooking the sea. The air of luxury, the shimmering view beyond the painted vault, and the tiny fragment of red-tiled roof glimpsed in the centre suggest the opulent summer villas of wealthy Romans on the Bay of Naples. The subject and the technical brilliance in the rendering of marble and rich fabrics are typical of the artist's reconstructions of the ancient world. Though the languorously posed females resemble the decorative compositions of the Aesthetic movement (see cat. 174, 185), the title hints at a narrative: flirtation and desire are conveyed by the enigmatic facial expressions and by the woman gazing over the parapet, perhaps at a lover. This reading is confirmed by the marble Cupid trying on a mask of Silenus (original in the Capitoline Museum, Rome) and by the feet of the statue, which was based on the *Seated Gladiator* in the Lateran Museum, Rome: gladiators were frequently involved in passionate liaisons with Roman women of good family. Photographs of both statues, and of the marble relief on the parapet, survive in the artist's reference collection.

Unconscious Rivals was originally bought by Baron J.H. von Schroeder, the Anglo-German financier who was one of

Alma-Tadema's principal patrons. JBT

PROVENANCE 1893: purchased by Baron J.H. von Schroeder; 1910: bequeathed by him to the Kunsthalle, Hamburg; 1927: sold by the Kunsthalle; 1935: bequeathed to the museum by Jessie and Robert Bromhead
EXHIBITIONS London, New Gallery, 1893, no. 12; *Alma Tadema*, London, RA, 1913, no. 195; *Sir Lawrence Alma-Tadema*, Amsterdam, Van Gogh Museum, and Liverpool, Walker Art Gallery, 1996–7, no. 78
REFERENCE V. Swanson, *The Biography and Catalogue Raisonné of the Paintings of Sir Lawrence Alma-Tadema*, London, 1990, p. 248, no. 358 (with full provenance and exhibitions)

196

John William Waterhouse (1849–1917)

Circe Offering the Cup to Ulysses, 1891

oil on canvas, 148 × 92 cm
inscribed: *JW Waterhouse 1891*
Oldham Art Gallery, 3.55/9

Circe was the daughter of Helios, the sun god, and Perse, Ocean's daughter. The striking composition of this painting, illustrating the meeting of Ulysses with Circe as told by Homer (*Odyssey* X), underlines Circe's evil reputation. She poisoned her husband and was expelled by his people. She went to live on the Isle of Aeaea and, by magic spells and potions, turned all who landed there into animals. The companions of Ulysses on his voyage were turned to swine, and one of the

stupified beasts is shown lying at her feet in the picture. Ulysses himself escaped by using the leaf of a herb given to him by Hermes. He forced Circe to restore his companions to their human form, but she enchanted him and he spent a year with her, forgetting his wife Penelope. This was Waterhouse's first Homeric subject, marking a new, literary, departure in his art.

Waterhouse, the son of an artist, was born in Rome and, although his family settled in London in 1855, he returned to Italy throughout his early career in search of inspiration. He became assistant to his father in his London studio in 1868. In the 1880s his subjects from ancient Roman daily life recall Alma-Tadema, but they are larger in scale and looser in handling. His mature style was

to be broad and bold, displaying a glib facility with paint that makes his work easily recognisable. His characterisation tended to stereotypes, innocent girls being counterbalanced by *femmes fatale* such as Circe, and this may explain his relative lack of skill at portraiture. CG

PROVENANCE 1902: purchased from the artist by Charles Lees; bequeathed to Marjory Lees; 1952: presented by her to the gallery

EXHIBITIONS London, New Gallery, 1891, no. 153; *J.W. Waterhouse RA 1849–1917*, Sheffield, Graves Art Gallery, and Wolverhampton Art Gallery, 1978–9, no. 5; *Burne-Jones and his Followers*, Tokyo Shimbun, 1987, no. 44; *The Charles Lees Collection*, Aylesbury, Buckinghamshire County Museum and Art Gallery, 1997

REFERENCES *The Magazine of Art*, 1892, p. 273 (ill.); *The Art Journal*, Christmas 1909, p. 6 (etched by J. Dobie); A. Hobson, *J.W. Waterhouse*, London, 1989, pl. 31, p. 49

197

John Melhuish Strudwick
(1849–1935)

Oh Swallow, Swallow, 1894

oil on canvas, 93 × 59 cm
inscribed: *JMS 1894*
Board of Trustees of the National
Museums and Galleries on
Merseyside (Emma Holt Bequest,
Sudley House), WAG 305

The girl is holding a golden
chain, given to her by her lover,
and the song of the swallow
flying past is a message from
him. The original title was a
stanza from Tennyson's *The
Princess*: 'Oh Swallow, flying
from the golden woods/ Fly to
her, and pipe and woo her, and
make her mine,/ And tell her,
tell her, that I follow thee.' The
artist was a former studio
assistant to Burne-Jones. The
mannered treatment of the figure
and the intricate detail of the
interior are typical of Strudwick's
style, prettier and sweeter than
that of his master (cat. 186,
248).

The Liverpool ship-owner
George Holt (see cat. 147) was
one of the artist's most
important patrons. He bought
his first Strudwick in 1890 and
commissioned three more, of
which *Oh Swallow, Swallow* is
one. They are all still exhibited,
with the rest of the Holt
collection, at the family home in
a suburb of Liverpool. JBT

PROVENANCE 1893: commissioned by
George Holt; 1894: completed; 1944:
bequeathed by Emma Holt
EXHIBITION London, New Gallery,
1895, no. 64
REFERENCE E. Morris, *Victorian and
Edwardian Paintings in the Walker Art
Gallery and at Sudley House*, London,
1996, pp. 443–5 (with full exhibitions
and bibliography)

198

Arthur Hacker RA
(1858–1919)

The Cloister or the World?
1896

oil on canvas, 218 × 170.5 cm
Bradford Art Galleries and Museums
(Cartwright Hall), 1920–21

Like Stanhope Forbes (cat. 194),
who had been his fellow student
in London, Hacker chose the
studio of Léon Bonnat (1834–
1922) to complete his artistic
education. Attracted by French
realism and by open-air land-
scape subjects, he exhibited a
scene of peasant life at the Royal
Academy in 1881, but by 1887
had embarked on a series of full-
blown academic subjects with
portentous themes. *The
Annunciation* was bought for the
Chantrey Bequest in 1892; it
was followed in 1894 by *The
Temptation of Sir Percival* (Leeds
City Art Galleries) and two years
later by this painting. *The
Cloister or the World* presents the
dilemma of choice between
worldly delights and spiritual
fulfilment, a theme popular with
Victorian painters and their
public, in melodramatic
counterpoint: a nun kneels in
ecstasy before a vision of the
angel of the Annunciation while
a figure dances sensuously in the
background. It was 'the Picture
of the Year' at the Academy.

Hacker turned his hand to genre scenes when the taste for literary paintings diminished. In *The Progress of Art in the Century* (1906) William Sharp wrote that Hacker's work 'always suggests the amazingly clever effort of a literary man to express in paint his romance, poem, religious reverie, or seasonable meditation'. C G

PROVENANCE 1920: presented to Bradford by Alderman Thomas Sowden and Mrs Sowden
EXHIBITION London, RA, 1896, no 478

199
Valentine Cameron Prinsep
RA (1838–1904)
Lady Layland-Barratt,
c. 1900

oil on canvas, 132 × 106 cm
Torbay Council, Torre Abbey
Collection, Torquay, A99

Prinsep was a young man of
means whose mother, Sarah
Monckton, presided over a
famous artistic salon at Little
Holland House in Kensington.
He started his career by assisting
Rossetti in his ill-fated venture
to paint murals in the Oxford
Union, and his first paintings
were Pre-Raphaelite in character,
with Rossetti's influence in
evidence. Prinsep studied
alongside Edward Poynter and
Whistler in the flourishing Paris
studio of the Swiss-born Charles
Gleyre (1806–74). In India in
1876–7 he was commanded by
Queen Victoria to paint a large
group portrait of the Imperial
Durbar at Delhi, and in his later
career he was in demand as a
society portrait painter. His
upbringing in the Little Holland
House circle imparted the
'aesthetic' slant to his portraits.

Prinsep shows his sitter at her
writing-table, quill-pen in hand,
in a sumptuous green and gold
silk dress with lace embroidered
cuffs and neckline and a pink
rose at her breast. A potted palm
and green screen in the back-
ground hint at artistic tastes.
The portrait makes a pair with
that of Sir Francis Layland-
Barratt 1st Bt (also in the Torre
Abbey Collection) of the Manor
House, Torquay, MP for Torquay
from 1900 to 1910. CG

PROVENANCE 1968: transferred from
Torbay Borough Library to Torre Abbey

200

Thomas Cooper Gotch
(1854–1931)

*The Exile, 'Heavy is the Price
I Paid for Love'*

oil on canvas, 91 × 61 cm
Alfred East Art Gallery, Kettering,
100

Gotch was born in Kettering
into a prominent Midlands
Baptist banking and
manufacturing family. After an
unhappy period in the family
boot and shoe business he
departed to study art at
Heatherley's school and at the
Slade School of Art in London
before going to Paris to the
studio of J.-P. Laurens
(1838–1921), where Tuke also
trained during his Paris years.
On returning to England, Gotch
became a member of the New
English Art Club and went to
Newlyn to join the colony
established there by Stanhope
Forbes (see cat. 194). His mature
style was to have little in
common with the social realist
slant of the Newlyners. After
spending the winter of 1891–2
in Florence, Gotch decided to
abandon both history painting
with a specifically storytelling
purpose and the open-air
landscape discipline which he
had followed when first in
Newlyn. Instead he developed a
distinctive and personal form of
Symbolism, painting very
precisely delineated serene and
silent figures wearing Early
Renaissance-inspired robes and
often playing musical
instruments, their purpose
seemingly purely allegorical.
Death the Bride of 1895, his most
mainstream painting in terms of
the Continental Symbolist
movement, is in the
representative collection of his
work at the Kettering gallery.

For all his individuality Gotch
was attuned to developments in
representation. Here he has left
Late Romanticism behind, in
favour of the brightly lit
modernism of the younger
generation. In *The Exile* the
element of straightforward
portraiture has been transmuted
into a Symbolist subject by the
enigmatic and suggestive title
and the timeless costume, a
loosely fitting robe of patterned
and striped silk. C G

PROVENANCE 1932: acquired by the
gallery, provenance unknown
REFERENCE P. B. Hepburn, *Thomas
Cooper Gotch, 1854–1931*, Kettering,
1994, pp. 28, 31 (ill.)

201

William Stott of Oldham
ARA (1857–1900)

A Freshet, c. 1885

pastel and watercolour on paper,
48 × 76 cm
Oldham Art Gallery, 3.03

A freshet is a rush of water resulting from heavy rain or melting snow. Stott used pastel for the challenging subject of tumbling, fast-moving water in a virtuoso display of painting from nature. The medium is opaque watercolour mixed with pastel, particularly intractable since it dries very fast – mistakes cannot be rectified. The whiteness of the tone suggests that Stott intended to imply the icy quality of melted snow. He made a number of associated studies of torrents similar in size and format to this and in a variety of media, including pure pastel. Technique played an important part in the open-air work by the Newlyn School of artists, of which Stott was a member. Like many of his French-trained contemporaries, he had developed a fresh and delicate oil technique that has much in common with watercolour in its use of thin, translucent paint. Pastel also has the advantage of freshness and speed, invaluable for capturing open-air effects.

Stott was born at Oldham in Lancashire, and was in Paris by 1879, earlier than the other Newlyners. Arriving before Stanhope Forbes and La Thangue, he studied at the Ecole de Beaux-Arts under Léon Bonnat (1834–1922) and J.-L. Gérôme (1824–1904), and is mentioned by fellow student Shirley Fox in *An Art Student's Reminiscences of Paris in the Eighties*: '[Stott] was, at the time I entered the Beaux-Arts, quite a well-known painter. His two pictures "Le Passeur" and "La Baignarde" had made for him a considerable reputation at the Salon, and gained for him a well-earned medal.' Stott spent the summers at Grez-sur-Loing with a cosmopolitan group of young artists who had moved on from Barbizon when it became too well known, among them the Irishman Frank O'Meara (1853–88), who was to be a great influence on him. Stott was one of the first to attempt an open-air painting in the manner of Jules Bastien-Lepage (1848–84), with *Girl in a Meadow* (1880; Tate Gallery, London). C G

PROVENANCE 1903: purchased by the gallery from the artist's executors
EXHIBITION: *William and Edward Stott*, London, Fine Art Society, 1976, no. 31

202

John Byam Liston Shaw
(1872–1919)

The Boer War, 1900, 1901

oil on canvas, 101.8 × 76 cm
inscribed: *Byam Shaw 1901*
Birmingham Museums and Art
Gallery, 204'28

The picture was exhibited in
1901 with a quotation from
Christina Rossetti's poem *A Bird
Song* (*c.* 1871–3): 'Last Summer
green things were greener,/
Brambles fewer, the blue sky
bluer.' A young woman in black
is musing on the death of a loved
one killed in the war in South
Africa (1899–1902); she is
oblivious to the beauty of nature
all around her. The landscape is
at Dorchester-on-Thames and
the sitter was the artist's sister
Margaret. Shaw was one of a
number of painters who in the
1890s revived the early Pre-
Raphaelite style, with its
brilliant colours and minute
naturalistic detail. The revival
was stimulated by the
retrospective exhibitions of
Millais and Holman Hunt held
in London in 1886, at which the
work of the early 1850s was
much praised. Shaw favoured
medieval subjects in the manner
of Rossetti but, uniquely in
Shaw's work, this is a
contemporary and highly topical
theme. It is treated with an
intensity of feeling which also
derives from early Pre-
Raphaelitism. JBT

PROVENANCE 1928: anonymous gift to
Birmingham
EXHIBITIONS London, RA, 1901, no.
241; *Byam Shaw,* Oxford, Ashmolean
Museum, 1986, no. 13
REFERENCES R.V. Cole, *The Art and
Life of Byam Shaw,* London, 1932, p. 119;
*Catalogue of Paintings, City Museum and
Art Gallery, Birmingham,* 1960, p. 132;
P. Skipwith, 'Byam Shaw 1872–1919:
A Pictorial Storyteller', *Apollo,* March
1976, p. 192

203

Sir Frank Brangwyn RA
(1867–1956)

A Venetian Funeral, 1906

oil on canvas, 228.6 × 289.7 cm
inscribed: *FB* (monogram)
Leeds Museums and Art Galleries
(City Art Gallery)

From the turn of the century
through to the mid-1920s
Brangwyn was the most
celebrated British artist on the
international stage. In the 1890s

he helped decorate the Hôtel de
l'Art Nouveau in Paris and
designed stained glass for
Tiffany's; he went on to paint
major murals in America and
was honoured by the British,
French, Belgian, Dutch and
Italian governments.

Brangwyn's reputation was
based principally on full-scale
decorative paintings, which gave
full range to his extraordinary
facility and gift for covering
large surfaces with lush, vibrant,

decorative detail. The present
example was painted while
Brangwyn was working on
panels for the British Pavilion at
the Venice Biennale, and it is
probably no accident that Leeds
City Art Gallery should have
purchased it, for one of the
gallery's greatest benefactors,
Sam Wilson, acquired and
donated the panels from the
British Pavilion.

Brangwyn's reputation
survived many attacks, but by

the late 1920s his rather
bombastic style of painting
seemed hopelessly old-fashioned,
and he received a final indignity
when the House of Lords rejected
his *British Empire* panels, now in
Swansea. P S

PROVENANCE 1906: purchased by the
gallery
EXHIBITION London, RA, 1906,
no. 532
REFERENCE V. Galloway, *The Oils and
Murals of Sir Frank Brangwyn*, Leigh-on-
Sea, 1962

204

Edward Atkinson Hornel
(1864–1933)

Summer, 1891

oil on canvas, 128.3 × 103 cm
inscribed: *E A Hornel 1891*
Board of Trustees of the National
Museums and Galleries on
Merseyside (Walker Art Gallery,
Liverpool), WAG 2934

In 1891 Hornel painted two
exuberant celebrations of the
seasons, *Springtime* and *Summer*.
Both show girls joyously singing
and dancing, the figures half
merging with a landscape
fragmented into a patchwork of
rich colour, pattern and
movement. Hornel was one of
the group of painters known as
the Glasgow Boys, who came to
prominence in the 1880s and
1890s. He absorbed a number of
influences, including the stylised
design of Japanese prints: in
Summer the girl chasing a
butterfly with her handkerchief
on the right wears a tunic with a
Japanese pattern.

The painting was well received
in Glasgow but became the
object of fierce criticism when it
was included in the Liverpool
Autumn Exhibition of 1892.
The Glasgow Boys had been
invited to show in Liverpool as a
group by Philip Rathbone,
chairman of the committee
responsible for the Walker Art
Gallery (see pp. 71–2). When
Rathbone recommended that
Summer be purchased for the
Walker's collection, the
controversy grew bitter. Abuse
was heaped on Hornel and
Rathbone, and the painting was
reviled. The City Council
rejected the purchase, the local
artists signed a petition in
support of the acquisition, and

nationally respected critics, such
as D.S. MacColl and George
Moore, weighed in against
municipal philistinism.
Meanwhile, attendance at the
Walker soared. The question of
purchase was referred back to the
committee and was approved
only after Rathbone had

threatened to resign. Though
paintings by the Glasgow Boys
had been acquired by
Continental galleries, *Summer* was
the first of their works (other
than commissioned portraits) to
enter a British public gallery.
JBT

PROVENANCE 1892: purchased from
the artist by the gallery
EXHIBITIONS Spring Exhibition,
Glasgow Institute, 1892, no. 167;
Autumn Exhibition, Liverpool, Walker
Art Gallery, 1892, no. 1123; London,
Grafton Galleries, 1893, no. 60
REFERENCES R. Billcliffe, *The Glasgow
Boys*, London, 1985, pp. 252–3; B. Smith,
*The Life and Work of Edward Atkinson
Hornel*, Edinburgh, 1997, pp. 71–82

pictures be left to the nation by establishing a trust fund to secure their display in Castle House, Dedham, home of the artist from 1920 until his death.

W B

PROVENANCE After 1959: acquired by the museum through the Violet Munnings Trust Fund
EXHIBITIONS *Sir Alfred Munnings KCVO PPRA*, London, RA, 1956, no. 62; *Alfred Munnings 1878–1959*, Manchester City Art Gallery, 1986, no. 23
REFERENCES A. Munnings, *An Artist's Life*, London, 1950, pp. 239, 246; S. Booth, *Sir Alfred Munnings, 1898–1959*, London, 1978, p. 88

206

Henry Herbert La Thangue
RA NEAC (1859–1929)
The Waterplash, 1900

oil on canvas, 116.8 × 94 cm
inscribed: *H.H.La THANGUE*
Victoria Art Gallery, Bath and
North-East Somerset, 1954.27

After attending the Royal Academy Schools, where Stanhope Forbes (cat. 194) was a fellow student, La Thangue went to Paris where, recommended by Lord Leighton, he was able to enter the studio of Jean-Léon Gérôme (1824–1904). Like so many of his contemporaries he fell under the spell of Jules Bastien-Lepage (1848–84). Anxious to pursue Lepage's principles, and in search of suitable subjects, he went to Quimperlé in Brittany where he was shortly joined by Forbes. Another formative influence in France was Jean-Charles Cazin (1841–1901); La Thangue's *Boatbuilders*, now in the National Maritime Museum, Greenwich, employs both a palette and a technique that come very close to Cazin's work. Back in England he was a founding member of the

205

Sir Alfred Munnings RWS
PRA (1878–1959)
The Ford, 1910

oil on canvas, 127.5 × 162.5 cm
The Sir Alfred Munnings Art
Museum, Dedham, CH 132

The horse was the central, quintessentially English, theme of the paintings by which Munnings is remembered. This subject-matter enabled him to build up a ready market for his work and facilitated the rapid expansion of his social circle. Before World War I, as the son of an East Anglian miller, he found his subjects in the Norfolk countryside and used as models the local farm-boys, the itinerant gypsy population, the working horses and ponies. *The Ford* (on the River Waveney), painted in three versions (one shown at the Royal Academy in 1911), represents what the artist termed 'a grey weather subject'.

Popular recognition and commercial success burgeoned after the war, when Munnings was in constant demand as the painter of racehorses, hunts and society equestrian portraits. He was President of the Royal Academy from 1944 to 1949.

The real achievements of Munnings as a painter have been overshadowed by the intemperate vehemence with which he expressed his hatred of all but the most traditional representational sculpture and painting. The reputation of the Royal Academy in turn suffered through the elevation to the presidential pulpit of a painter who dismissed out of hand the greatest art and artists of this century.

Lady Munnings implemented her husband's wish that his

New English Art Club. He soon substituted a bolder impasto and stronger colours for the delicate mosiac of flat touches done with a square brush that he had learned from Bastien-Lepage and the pale, creamy tones derived from Cazin.

This scene of a girl driving geese employs the brilliantly suggestive effect of dappled sunlight that La Thangue was to make almost a hallmark of his later style. His fellow painter Clausen remarked that 'it was the beauty of things in sunlight that excited him'. Mr Fox, of the dealers Gooden & Fox who bought the painting for £483 from Christie's in 1913, believed *The Waterplash* to be La Thangue's masterpiece. C G

PROVENANCE 1913: bought at Christie's by Gooden & Fox for Miss Alice Radcliffe; bequeathed to Miss Henderson of Bathwick; 1954: presented to the gallery
EXHIBITION London, RA, 1900, no. 351 (as *The Waterplash*)
REFERENCE Victoria Art Gallery, *Concise Catalogue of Paintings and Drawings*, Bath, 1991, p. 69 (as *The Watersplash*)

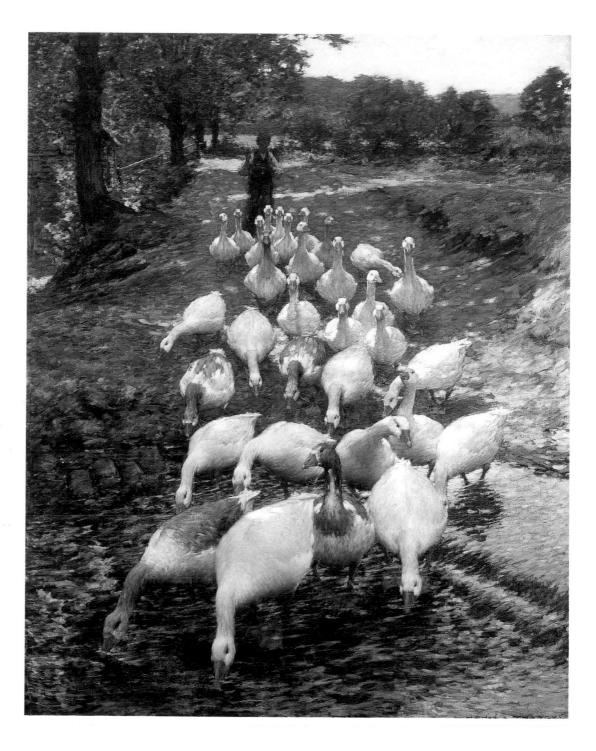

207

Sir Hamo Thornycroft RA
(1850–1925)

The Mower, 1894

bronze, 200 × 130 × 85 cm
inscribed: *HAMO THORNYCROFT.*
A.R.A./LONDON./Sc.1884
Board of Trustees of the National
Museums and Galleries on
Merseyside (Walker Art Gallery,
Liverpool), WAG 4136

Hamo Thornycroft's *Mower* was a
pioneering work of the 'New
Sculpture', a movement
originating in the 1870s whose
chief practitioners – including
Frederic Leighton, Alfred Gilbert
(cat. 178), George Frampton
(1860–1928) and Thornycroft –
introduced an expressive
naturalism into sculpture and a
preoccupation with modern and
personal themes.

Hamo Thornycroft was the son
of the sculptors Thomas and
Mary Thornycroft, in whose
studio he initially worked. He
entered the Royal Academy
Schools in 1869 and, in 1871,
visited Italy, where he admired
Quattrocento art. Thornycroft's
early Classical subjects (*Artemis*,
1880; *Teucer*, 1881), following
the example set by Leighton in
his *Athlete wrestling with a Python*
(1877), revealed a dynamic and
life-like approach to form which
marked a departure from the
generalised 'ideal' figures of the
mid-19th century.

The Mower, of which a first
full-scale version, in plaster, was
made in 1884, was probably the
first 19th-century life-size
exhibition statue to represent a
modern labourer. Recalling
Donatello's *David* in its pose and
Leighton's *Athlete* in its strongly
modelled physique, the figure
was derived from a drawing that
Thornycroft had made of an
agricultural worker at rest on a
riverbank. The life-size plaster
statue was exhibited at the Royal
Academy in 1884, accompanied
by the following lines from
Matthew Arnold's *Thyrsis*: 'A
Mower, who, as the tiny swell/Of
our boat passing, heaved the
river-grass,/Stood with
suspended scythe to see us pass'.
The poetry points to
Thornycroft's essentially lyrical
and 'romantic' conception of the
subject: a harsher image of the
modern labourer was projected
by later sculptors such as
Constantin Meunier (1831–
1905) and A.-J. Dalou
(1838–1902). Thornycroft
himself pursued the theme in
The Sower (1886) and *The Navvy*
(1902). M G

PROVENANCE 1894: bought from the
artist
EXHIBITION London, RA, 1894,
no.1744
RERERENCES E. Manning, *Marble &
Bronze: The Art and Life of Hamo
Thornycroft*, London, 1982; S. Beattie, *The
New Sculpture*, New Haven, 1983

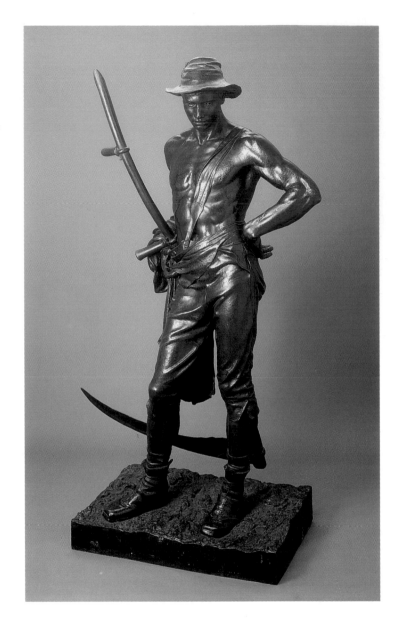

WATERCOLOURS
AND WORKS ON PAPER

WATERCOLOURS AND MODERN
WORKS ON PAPER

By the late 19th century the mythology of watercolour as the great national art was well established. The publication of J.L. Roget's *History of the Old Watercolour Society* in 1891 epitomised a new enthusiasm for defining the origins and development of watercolour painting, an enthusiasm that coincided with the foundation of a number of municipal museums and galleries. One of the specific intentions of the institute established in Manchester by the legatees of the engineer Sir Joseph Whitworth (1803–87) – who seems to have had little personal interest in art – was collecting English watercolours. From the outset the Whitworth (since 1958 part of the university) attracted a series of notable bequests of watercolours, as well as making astute purchases with limited funds. The City Art Gallery, Manchester, Birmingham Museum and Art Gallery, and Leeds City Art Gallery all collected watercolours from the beginning, and subsequently developed local loyalties and benefactions; thus in Birmingham, birthplace of David Cox (cat. 240) and Edward Burne-Jones, fine examples of their work have been acquired, while in Leeds, the remarkable collection of Cotman material (cat. 222) is due to the enthusiasm, scholarship and generosity of Sydney Kitson, a member of a local locomotive engineering dynasty. As well as museums in the great manufacturing cities, smaller collections equally reflected local patriotism: the Sandbys and Boningtons at the Castle Museum, Nottingham (cat. 215, 228), De Wint in Lincoln, Albert Goodwin in Maidstone (cat. 243), among others.

The university collections at Oxford and Cambridge had collected British drawings and watercolours fairly haphazardly until the mid-19th century. Bequests and gifts – especially Ruskin's donations of Turner watercolours – were to provide the basis for a more serous, comprehensive approach in the late 19th century and the early decades of this century. This was the age of the connoisseur; scholar–collectors include A.P. Oppé (whose remarkable collection was acquired from his heirs for the Tate Gallery in 1996) and Tom Girtin, while, among curators, K.T. Parker (later Sir Karl) at the Ashmolean made outstanding acquisitions. It was also a period when Friends organisations were established, whose financial support was to become increasingly essential, often in conjunction with the National Art-Collections Fund, founded in 1903. Cecil Higgins (1856–1941) collected in his lifetime with the intention of forming a museum, and bequeathed both his collection and a handsome endowment to Bedford, which has one of the finest holdings of watercolours outside London (cat. 212, 217, 223, 229). In Sudbury, Gainsborough's House Society is developing a representative collection of Gainsborough's graphic work (cat. 208), as well as of his oil paintings. The age of collecting watercolours *en masse* has passed, for reasons of scarcity and cost, but funds from the Heritage Lottery Fund and other sources have enabled museums to acquire outstanding watercolours. L S

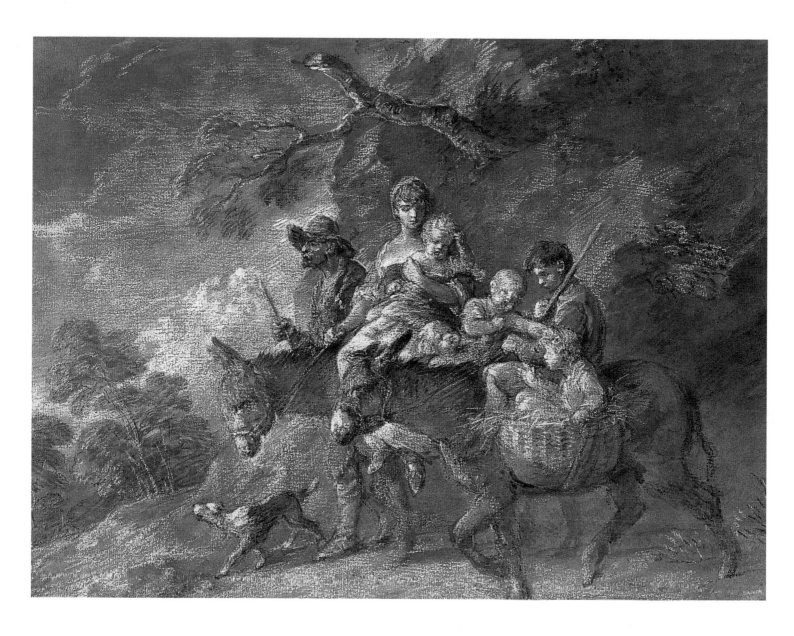

208

Thomas Gainsborough RA
(1727–88)

Peasants going to Market,
1770–4

black and white chalk, stump, grey
and brown wash heightened with
white on brown prepared paper,
41 × 53.8 cm
Lent by the Trustees of
Gainsborough's House, Sudbury,
1993.001

'If I were to rest his reputation
upon one point, it should be

on his Drawings', wrote
Gainsborough's friend William
Jackson. This drawing reveals
Gainsborough's knowledge of a
wide range of visual sources – in
this case all 17th-century – and
his ability to assimilate these into
his own highly distinctive style.
The chief source is Rembrandt's
1651 etching *The Flight into
Egypt*, but Gainsborough also used
an etching by Salvator Rosa and
sculpted putti (or perhaps casts)
by or after François Duquesnoy.
Not surprisingly, Gainsborough
himself never parted with the

drawing, which is among his
largest and most sophisticated. It
is appropriate that it should be
kept in his birthplace. LS

PROVENANCE The artist's family;
given to Henry Briggs; 1831, 25 February:
Christie's, London, Briggs sale, lot 107,
bought by Johnson; before 1853: Mr
Eldridge; 1945, 12 December: Sotheby's,
London, Walter, 4th Baron Northbourne
sale, lot 45, bought by Cooper; 1946: J.
Leger & Son, London; 1947: Sir Kenneth
Clark; 1982, 15 June: Christie's, Lord
Clark sale, lot 84, withdrawn; Trustees of
Lord Clark's Settlement Trust; 1992, 14
July: Christie's, lot 83, bought by
Timothy Clode; 1993: acquired by The
Gainsborough's House Society, with the

assistance of the National Heritage
Memorial Fund, an anonymous donation
through the National Art-Collections
Fund, the Gainsborough's House Society
Development Trust, the MGC/V&A
Purchase Grant Fund and the NACF
EXHIBITIONS London, J. Leger & Son,
1946; *Thomas Gainsborough*, London, Arts
Council, 1949, no. 23; *Three Centuries of
British Watercolours and Drawings*, London,
Arts Council, 1951, no. 73; *European
Masters of the Eighteenth Century*, London,
RA, 1954–5, no. 545
REFERENCES J. Hayes, *The Drawings of
Thomas Gainsborough*, 2 vols., London,
1970, I, pp. 50, 300, no. 826, II, pl. 119;
H. Belsey, 'Two Works by
Gainsborough', *National Art-Collections
Fund Review*, 1992, pp. 8–12

209
Thomas Hearne
(1744–1817)
Sir George Beaumont and Joseph Farington Sketching a Waterfall, 1777

pen and black ink with brown and grey wash on paper, 46 × 60.4 cm
The Wordsworth Trust, Dove Cottage and Wordsworth Museum, Grasmere

Sir George Beaumont (1753–1827), amateur artist, patron both of artists and of poets, notably Wordsworth and Coleridge, collector and future guiding spirit in the foundation of the National Gallery, was a particular admirer of Thomas Hearne. In the summer of 1777, probably inspired by reading Thomas Gray's *Journal of the Lakes* (1775), Beaumont invited Hearne and his fellow artist Joseph Farington to make a sketching tour of the Lake District. This watercolour was almost certainly painted when the three were staying near the Falls of Lodore, Derwentwater, and shows Beaumont and Farington sketching in oils from nature, still an unusual practice at this date. Their inspiration may have lain in the example of Richard Wilson (Farington's master and Beaumont's mentor in landscape; cat. 48), who had experimented with this technique in Italy during the 1750s. Hearne here endows the Falls of Lodore with something of the significance of the Falls of Tivoli, the favourite sketching ground of landscapists working in Rome from Claude and Gaspard Dughet onwards.

Farington first exhibited at the Royal Academy in 1777 – *A Waterfall*, sent in from Keswick. His *Views of the Lakes* were published between 1783 and 1787, although he is better known to posterity as a diarist and commentator on his contemporaries in the art world. L S

PROVENANCE 1984: purchased by the Trust from the Beaumont family
EXHIBITIONS *The Discovery of the Lake District 1750–1810*, Grasmere, The Wordsworth Museum, 1982, no. 115; *The Discovery of the Lake District*, London, Victoria and Albert Museum, 1984, no. 22; *Thomas Hearne 1744–1817*, Bolton Museum and Art Gallery, 1985, no. 15; *William Wordsworth and the Age of English Romanticism*, New York Public Library, Chicago Historical Society and Bloomington, University of Indiana, 1987–8, no. 178
REFERENCE M. Hardie, *Water-Colour Painting in Britain*, I, London, 1966, pl. 181

210
Thomas Jones
(1742–1803)
Lake Nemi looking towards Genzano, 1777

watercolour over pencil on paper, 24.7 × 41.3 cm
inscribed: *Looking over Gensano toward the promontory of Monte Felice from the Capuchini Convent 8 May 1777 Prince Cesarini's Palace T.J./m Felice. Cesarini Palace. Capachini*
The Whitworth Art Gallery, University of Manchester, D.1961.15

Thomas Jones was rediscovered in the 1950s. In 1951 an invaluable and often entertaining journal, chiefly kept during his years in Italy, 1776–83, was published. Then, in 1954, a group of oil sketches and watercolours, mostly painted in Italy, were sold at auction and revealed him to be one of the most original artists of the 18th century; a second, smaller group, which included this watercolour, was sold in 1961. Jones had previously been known only from his exhibited landscapes, as a minor follower of Richard Wilson.

In May 1777, Jones recorded that he stayed in Genzano for three weeks, exploring and sketching the surrounding countryside. Jones and J.R. Cozens often sketched together and it is intriguing to compare their very different vision and technique. Jones recorded exactly what he saw, including the scrubby foreground terrain, seen under a uniformly bright, clear sky, each landmark identified. Cozens, on the other hand (cat. 214), concentrated on unifying his composition with Claudean light, subduing the topographical content and evoking atmosphere. L S

PROVENANCE The artist's son-in-law
Capt. John Dale; thence by descent
through his daughter Rose to the Adams
family; Mrs Bethea Adams; 1961, 26
July: Sotheby's, London, lot 59, bought
by Agnew's; 1961: presented to the
gallery by Lady Chorley through the
Friends of the Whitworth
EXHIBITIONS *Travels in Italy
1776–1783: Based on the 'Memoirs' of
Thomas Jones*, Manchester, Whitworth Art
Gallery, 1988, no. 66 (with previous
bibliography); *From View to Vision: British
Watercolours from Sandby to Turner*,
Manchester, Whitworth Art Gallery,
1993, no. 45

211

William Marlow
(1740–1813)
The Thames at Richmond,
c. 1780

watercolour, body colour and ink
over pencil on paper, 32.1 × 63.5 cm
Birmingham Museums and Art
Gallery, 1985P60

A pupil of Samuel Scott
(1701/2–72), the painter of
marine views and of London
topographical subjects, Marlow
visited France and Italy in
1765–6, an experience which
provided him with subjects for
paintings and drawings
throughout his life. In the 1770s
he succeeded Scott as the leading
painter of the Thames and
moved to Twickenham, where he
lived in Scott's old house. As
well as painting in oils, Marlow
made a number of watercolours,
of which this is among the most
beautiful. It shows the bend of
the Thames between
Twickenham and Richmond,
where a regular ferry service
operated: a laden boat can be
seen in the foreground and on
the left is a large timberyard.
The panoramic format reflects

the influence of Canaletto (cat.
320) and Scott, though the
informality of the subject and
Marlow's sensitive understanding
of light and atmosphere give it a
distinct individuality. LS

PROVENANCE 1985: purchased by the
gallery from the Public Picture Fund
EXHIBITION *British Watercolours from
Birmingham 1750–1900*, Tokyo Station
Gallery *et al.*, 1991–2, no. 4

212

Francis Towne
(1740–1816)

The Colosseum from the
Caelian Hills, 1799

watercolour with pen and black ink
over pencil on paper, 31 × 46.5 cm
The Trustees of the Cecil Higgins
Art Gallery, Bedford, P96

Towne's distinctive style began
to emerge in the 1770s, but it
was not until his visit to Italy in
1780–1 – when he was already
40 – that it found its full
expression. His work was
scarcely noticed in his own
lifetime, yet his bold pen and
ink drawings with their broad

sweeps of watercolour wash now
seem the poetic high point of the
18th-century tradition of tinted
drawing. His definition of form
through outline is the opposite
of J.R. Cozens's subtle
modulation of surface texture by
means of tiny strokes of related
colour (cat. 214).

Towne arrived in Rome in
October 1780. Although he did
not keep a written journal, as did
his old friend Thomas Jones (cat.
210), his carefully dated and
annotated watercolours form a
visual account of his travels.
From October to December
1780, and in January and
February 1781, Towne made a
series of studies of the

Colosseum, devoted to its
combination of splendour and
decay, sometimes concentrating
on details of the vaulted arcades,
sometimes on its dominating
presence, seen from a distance.

On his return to England,
Towne (like Cozens) used the
drawings he had made in Italy as
the basis for watercolours and a
number of oil paintings,
although he received few
commissions. An unsuccessful
candidate for election to the
Royal Academy on four
occasions, Towne was dogged by
lack of recognition. His
disappointment with the art
establishment caused him to
organise his own one-man

exhibition in London in 1805, an
event which passed almost
unnoticed. Towne's
concentration on pattern and
bold effects led to a reawakening
of interest in his work only
comparatively recently. L S

PROVENANCE 1953: purchased by the
gallery from Agnew's
EXHIBITION London, 1962, no. 362

213

Francis Towne
(1740–1816)
The Bay of Naples, 1785
pencil, pen and grey ink, and
watercolour on paper,
40.4 × 88.5 cm
inscribed: *F.Towne delt 1785*
The Whitworth Art Gallery,
University of Manchester,
D.1927.15

According to the *Memoirs* of
Thomas Jones (cat. 210), Towne
arrived in Naples on 8 March
1781 and stayed until 3 April;
his first Neapolitan drawing,

which was to serve as the basis
for this watercolour, is dated 17
March. Jones acted as *cicerone* and
he recorded their adventures.
Two weeks after Towne's arrival,
he was threatened at knife-point
by 'two gigantic Troopers', and
some days later, on an excursion
to the wild Salvator Rosa-like
countryside on the road to Santa
Maria de' Monti, east of Naples,
they were set upon by *banditti*:
'Towne started back as if struck
by an electric Shock, [and] with
a most solemn face, adding with
a forced smile, that however he
might admire such scenes in a

picture, he did not relish them
in Nature.'

This panoramic view of the
Bay of Naples was taken from a
point near Capodimonte much
favoured by artists; Towne's
study for the right-hand side of
the composition is in the
Fitzwilliam Museum,
Cambridge. The watercolour was
worked up by Towne after his
return to England. LS

PROVENANCE 1927: purchased by the
gallery from E.S. Abbott
EXHIBITIONS *Englishmen in Italy*,
London, Victoria and Albert Museum,
1968, no. 97; *British Artists in Europe*,
Manchester, Whitworth Art Gallery,
1973, no. 9; *Travels in Italy 1776–1783:
Based on the 'Memoirs' of Thomas Jones*,
Manchester, Whitworth Art Gallery,
1988, no. 97; *From View to Vision: British
Watercolours from Sandby to Turner*,
Manchester, Whitworth Art Gallery,
1993, no. 41
REFERENCE A. Bury, *Francis Towne:
Lone Star of Water-Colour Painting*,
London, 1962, p. 136

214

John Robert Cozens
(1752–97)

*Lake Nemi looking towards
Genzano*, after 1777

watercolour over pencil on paper,
36 × 52.8 cm
The Whitworth Art Gallery,
University of Manchester,
D.1892.24

J.R. Cozens was among the greatest and most influential of British landscape watercolourists. He made two extended visits to Italy, from 1776 to 1779 when he accompanied the connoisseur Richard Payne Knight (cat. 10) as draughtsman, and again from 1782 to 1783 when he made a similar journey with William Beckford; other major patrons included Sir George Beaumont (cat. 209) and Dr Thomas Monro. Thus Cozens was closely associated with the leading collectors, dilettanti and art theorists of his generation. His views of the Swiss mountains embodied the awesome, immeasurable Sublime of Edmund Burke, while those of the landscape and Classical ruins of Italy expressed the mood of melancholic grandeur associated with reflections on lost glory. The Alban Hills, south-east of Rome, were a favourite area for artists and tourists: Cozens was sketching there in April 1777. Like Thomas Jones (cat. 210) he chose to paint the panoramic view from the grounds of the Capuchin monastery looking towards the Palazzo Cesarini and the distant sea. This subject became one of Cozens's most popular, for he repeated it in at least six watercolour versions, some dating from his first visit to Italy, others from well after his return to England; each is subtly different. The influence of Claude's paintings is apparent, both in composition and in mood. Cozens's achievement lay in the transformation of such prototypes into Romantic works, and in subduing the topographical elements to emphasise the pictorial and emotional qualities of his watercolours. Past and present, art and nature, are united to haunting effect: 'all poetry', as Constable described Cozens. LS

PROVENANCE C.S. Bale; Dr John Percy; 1892: presented to the gallery by J.E. Taylor
EXHIBITIONS *Travels to Italy 1776–1783: Based on the 'Memoirs' of Thomas Jones*, Manchester, Whitworth Art Gallery, 1988, no. 70 (with previous bibliography); *From View to Vision: British Watercolours from Sandby to Turner*, Manchester, Whitworth Art Gallery, 1993, no. 43

215

Paul Sandby RA
(1731–1809)

A Rocky Coast by Moonlight,
c. 1790

body colour on paper, 31.8 × 47 cm
City of Nottingham Museums,
Castle Museum and Art Gallery,
1971-86

Like his brother Thomas, Paul
Sandby was born in Nottingham.
Both were first employed as
military draughtsmen, working
for the Board of Ordnance's
survey of Scotland after the
battle of Culloden in 1746, a
background from which Paul
Sandby developed as a
topographical artist, drawing
master, engraver and occasional
painter in oils. The Sandbys were
active in supporting newly
established exhibiting societies
and in helping to raise the status
of artists; both were founder-
members of the Society of Artists
in 1761 and of the Royal
Academy in 1768, Thomas
becoming the Academy's first
Professor of Architecture. Paul
Sandby's achievement was to
have developed painting in
watercolour as an exhibition
medium in its own right,
bringing a new sophistication
and assurance to a hitherto
utilitarian activity.

Although working chiefly as a
topographer – his pre-eminence
in this area was acknowledged by
Gainsborough – Sandby also
painted imaginary landscapes.
This one shows his awareness of
the work of Claude-Joseph
Vernet (1714–89), whose
marines and harbour scenes,
often set under a moonlit sky,
Sandby almost certainly knew
either in the original or from
engravings. LS

PROVENANCE 1971, 24 June:
Sotheby's, London, lot 130a, bought by
D. Phillips; 1971: bought by the museum
EXHIBITIONS *Great British*
Watercolours, Nottingham, Castle
Museum, 1981, no. 64; *Richard Parkes*
Bonington und Paul Sandby: Wegbereiter der
Aquarellmalerei, Karlsruhe, Städtische
Galerie, 1990, no. 71; *The Great Age of*
British Watercolours 1750–1880, London,
RA, 1993, no. 255

216

Thomas Rowlandson
(1756–1827)

Mr Henry Angelo's Fencing Academy, 1787

pen and grey and grey-black ink and watercolour over pencil on paper, 34.6 × 51.3 cm
inscribed: *T.Rowlandson 1787*
Trustees of the Cecil Higgins Art Gallery, Bedford, P115

Rowlandson's very real talents as a draughtsman are sometimes obscured by his vivid sense of comic characterisation. By the early 1780s he had developed a style combining caricature and a gift for comic invention with elegant figure drawing, a style which remained essentially unchanged for the rest of his life. He used his pen to mock the follies of human life, but – unlike James Gillray (1757–1815) – only rarely to satirise.

Among Rowlandson's closest friends was Henry Angelo (1760–1839?), who ran the fashionable fencing academy shown here. In 1787 he was visited by the greatest swordsman of the period, the Chevalier de St George, who presented Angelo with his portrait by Mather Brown, which Rowlandson shows over the chimneypiece. Many, if not all, the figures must be portraits.

Could the fencer in a red jacket be the Chevalier himself, and the standing figure holding two foils Angelo? The lunging fencer in the foreground bears some resemblance to Rowlandson's other great friend and former fellow student at the Royal Academy, Jack Bannister, by 1787 a promising comic actor. And surely (though apparently unnoticed previously) the figure in profile on the extreme right must – to judge from a drawing made by Bannister in 1795 – be Rowlandson himself. LS

PROVENANCE 1957: purchased by the gallery from Agnew's
EXHIBITIONS London, 1962, no. 367; *Watercolours and Drawings from the Cecil Higgins Art Gallery*, London, Agnew's, 1962, no. 11; *Thomas Rowlandson 1756–1827*, New York, The Frick Collection, Pittsburgh, The Frick Art Museum, and Baltimore Museum of Art, 1990, no. 38
REFERENCES M. Salaman, 'A Group of Rowlandson Drawings', *Apollo*, X, 1929, p. 24, ill. p. 21; *Watercolours and Drawings in the Cecil Higgins Collection*, Bedford, 1959, p. 25, pl. 10; A. Bury, 'The Cecil Higgins Museum, Bedford', *The Old Water Colour Society's Club*, XXXVI, 1961, p. 35, pl. xiib

217

John Downman ARA
(1750–1824)

Mrs Croad, the determined Widow, 1806

black chalk and stump, tinted with watercolour, on paper, 31 × 23.4 cm
Trustees of the Cecil Higgins Art Gallery, Bedford, P269

Downman's portrait drawings of 'persons of rank and fashion' enjoyed a considerable vogue from the early 1780s. An inventive and occasionally inspired technician, he evolved a method of drawing which was both rapid and – in general – pleasing to his sitters. He began by making a study of his subject's head from life, usually requiring only one sitting; coloured chalk or watercolour or both was then applied to the verso, which gave a soft, diffused tonality when seen from the recto; finally, he would add scumbled black chalk for broader effect. While his finished portraits on occasion seem lacking in individuality, his *ad vivum* drawings are far more revealing glimpses into his sitters' personalities. Sometimes direct to the point of being unflattering, they appeal to the modern taste for psychological as well as physical truth in portraiture.

From the mid-1790s, Downman began to make portrait drawings which were larger in scale, bolder in execution and more penetrating in their analysis of personality. He often annotated his studies with details of his sitters' pedigrees and characteristics, in succinct yet telling phrases. One particularly unlovely sitter, for example, was described with

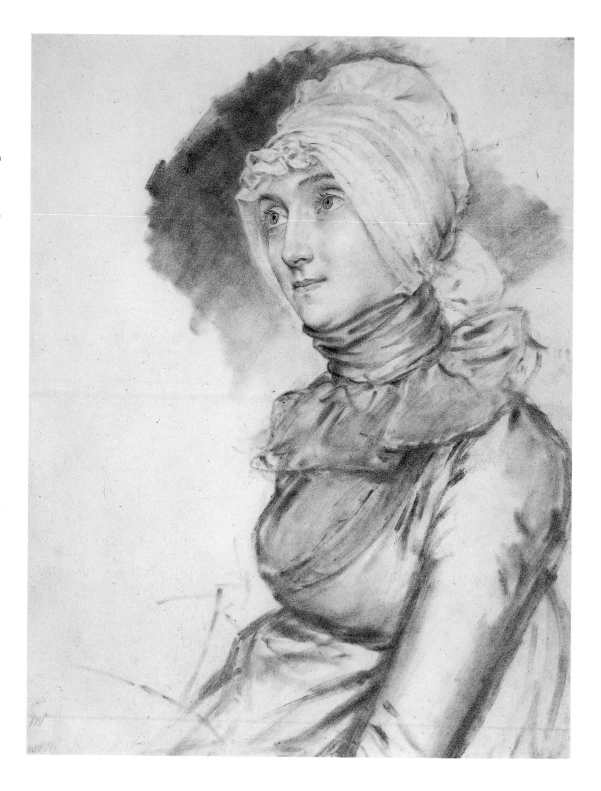

heavy irony: 'Oh you beauty!!!' The formidable-looking Mrs Croad certainly appears to have suited Downman's epithet 'determined'. LS

PROVENANCE 1958: purchased by the gallery from Agnew's
EXHIBITION London, 1962, no. 386

218

James Cranke Jr
(1746–1826)
Glassmaking, Warrington,
c. 1780

watercolour on paper, 87.5 × 71.5 cm
Warrington Museum and Art
Gallery, 1920.16

Glassmaking in Warrington is
first recorded in the 1640s, but
became a large-scale industry in
1757 with the establishment of
Peter Seaman's factory, to be
followed by Perrin & Co. in
1767. The ready availability of
coal to fire kilns, and easy access
to a network of canals to
distribute the finished products,
help to account for the long
history of glassmaking in the
area, which finally came to an
end in 1935.

Cranke lived and worked in
Warrington from about 1773
and was patronised chiefly by the
local gentry, for whom he
painted portraits and made
copies after the Old Masters.
Here, in a drawing perhaps made
for the owner of the factory, he
shows a glassblower and his
apprentice at work. The
Industrial Revolution inspired
remarkable and original works of
art, but humbler records such as
this have their own fascination
and significance. LS

PROVENANCE 1920: presented to the
museum by Alderman Joseph Davies

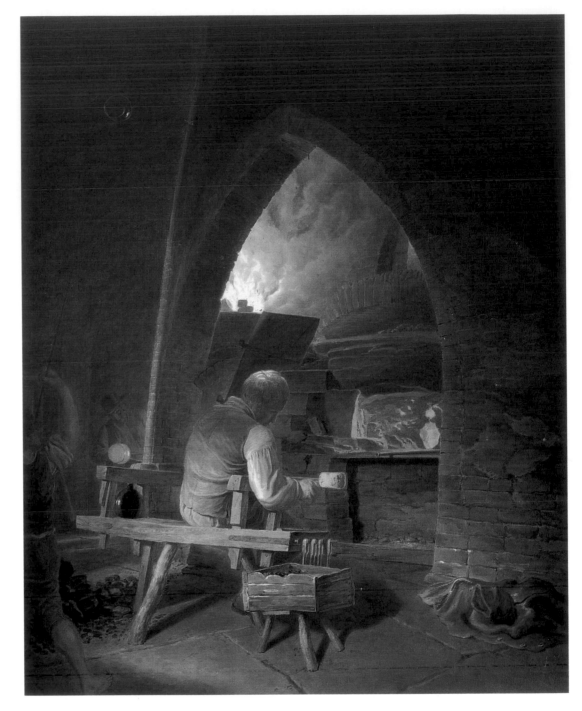

219

William Blake (1757–1827)

The Ancient of Days, 1824 (?)

watercolour, body colour, black ink
and gold paint over a relief-etched
outline printed in yellow on paper,
23.2 × 17 cm
inscribed: *Blake 1824* (smudged
inv?)
The Whitworth Art Gallery,
University of Manchester, D.1892.32

This justly celebrated design,
known as *The Ancient of Days*
(Daniel 7:22), was used by Blake
as the frontispiece to his *Europe:
A Prophecy*. The motif of the
compasses is a symbol of the
creation described in Proverbs
(8:27): 'When he prepared the
heavens, I was there: when he set
a compass upon the face of the
depth.' Blake also had in mind
Milton's description in *Paradise
Lost* (VIII.124–7): '. . . and in his
hand / He took the golden
Compasses, prepar'd / In God's
Eternal store, to circumscribe /
This Universe, and all created
things'. In Blake's mythology,
Urizen, the creator of the
universe, is identifiable with the
Jehovah of the Old Testament,
an unyielding oppressor who
decreed law and reason at the
expense of imagination. *Europe* is
Blake's imaginative prophecy of
the overthrow of unenlightened
reason.

Blake used novel techniques of
reproduction which dissolved the
barriers between printmaking
and painting. He completed
several *Ancient of Days* prints in
watercolour, but none has such
rich, deep colouring as this
version. It has been identified
with the impression coloured by
Blake 'when bolstered-up in his
bed only a few days before he
died'. L S

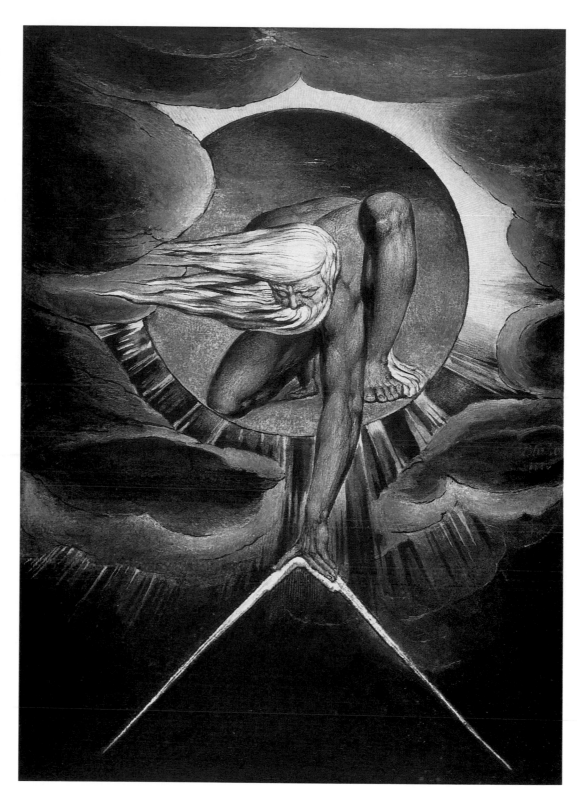

PROVENANCE Frederick Tatham;
George Blamire (?); 1863, 7 and 9
November: Christie's, London, perhaps
part of lot 120, bought by Halsted; 1892:
presented to the gallery by J.E. Taylor

EXHIBITIONS *William Blake*, London,
Tate Gallery, 1978, no. 68; '*The most
beautiful art of England*': *Fifty Watercolours
1750–1850*, Manchester, Whitworth Art
Gallery, 1983, no. 17

REFERENCE M. Butlin, *The Paintings
and Drawings of William Blake*, 2 vols.,
New Haven and London, 1981, I, p. 149,
no. 271 (with full bibliography)

220

Thomas Girtin
(1775–1802)
*Morpeth Bridge,
Northumberland, c.* 1802

watercolour, with pen and brown ink
and touches of pencil, on paper,
32.1 × 52.9 cm
Laing Art Gallery, Newcastle upon
Tyne (Tyne and Wear Museums)

Together with Turner, his exact
contemporary, Girtin
transformed the art of
watercolour. Both artists were
trained in the topographical
tradition and both were
encouraged by the collector Dr
Thomas Monro to study and
copy the work of J.R. Cozens
(cat. 214). For Girtin in
particular, Cozens's freedom of

handling within a deliberately
limited colour range, and the
uniquely melancholy beauty of
his watercolours, were critical.

Each year, Girtin made
sketching tours, at first in search
of antiquarian and architectural
subjects; but in 1796, when he
visited Yorkshire and
Northumberland for the first
time, he experienced a different
type of landscape – broad
stretches of moorland, barren
hills, low horizons and rolling
skies – that was to evoke a new
and deeply felt response.
Subsequent visits to the north of
England inspired Girtin's most
remarkable watercolours, and in
1799 he was being spoken of as
'a genius'. *Morpeth Bridge*,
among his last works, is a
superficially picturesque subject,

but Girtin's treatment is wholly
unpicturesque in its directness
and breadth, a boldness
emphasised by the distribution
of light and shade, in which the
heavy clouds enhance the mood
of sombre grandeur. LS

PROVENANCE William Wells of
Redleaf; 1857, 21 January: Christie's,
London, lot 281, bought by Bond;
C.S. Bale, 1881, 13 May: Christie's,
lot 88, bought by Palser; E. Cohen;
E. Poulter; F.W. Keen; 1933,
10 November: Christie's, lot 199, bought
by Walker's Galleries; N.K. Newall;
1979, 13 December: Christie's, Newall
Collection sale, lot 40, bought by Tyne
and Wear County Council
EXHIBITIONS *The Works of Thomas
Girtin*, London, Burlington Fine Arts
Club, 1875, no. 109; *Loan Exhibition of
Watercolour Drawings by Thomas Girtin*,
London, Agnew's, 1953, no. 69; *The
Picturesque Tour in Northumberland and
Durham c. 1720–1830*, Newcastle upon
Tyne, Laing Art Gallery, 1982, no. 89

REFERENCES T. Girtin and D. Loshak,
The Art of Thomas Girtin, London, 1954,
pp. 85–9, 91–2, 97, 108, 202, no. 489
(iii), pl. 99; M. Hardie, *Water-Colour
Painting in Britain*, II, London, 1967,
p. 18; S. Morris, *Thomas Girtin 1775–
1802*, New Haven, 1986, p. 22

221

Joseph Mallord William
Turner RA (1775–1851)
*The Passage of Mount
St Gotthard,* 1804

watercolour with scraping out on
paper, 98.5 × 68.5 cm
inscribed: *IMW Turner RA 1804*
Abbot Hall Art Gallery, Kendal,
1010/72

In February 1802, Turner was
elected an Academician and in
July he left London for his first

foreign tour. The recently ratified Treaty of Amiens enabled British travellers to cross the Channel after years of war. Previously, Turner had explored the most remote and dramatic regions of Britain, but his search for ever more Sublime subjects and his knowledge of J.R. Cozens's Swiss watercolours, painted some twenty years earlier, combined to make a tour of the Alps his chief objective.

The Passage of Mount St Gotthard, completed two years after his return to England, is one of the grandest of his early Swiss subjects. Conceived as paintings in watercolour, the visual impact of such works astonished contemporaries. Here, Turner exploits the dramatic compositional possibilities of the vertiginous chasm, deliberately omitting the summits of the cliffs and the bottom of the ravine to create a dizzying sense of disorientation.

Turner was to return to Switzerland in the 1830s and 1840s, visits which resulted in some of his most perfect late watercolours, but he was never to paint the Alps again in the massive, rugged style of the early 1800s. LS

PROVENANCE Walter Fawkes; thence by descent; 1937, 2 July: Christie's, London, Fawkes sale, lot 36; Esmond Morse; 1972: Esmond Morse Bequest to the gallery

EXHIBITIONS (?) London, Turner's Gallery, 1804; London, RA, 1815, no. 281; *Collection of Watercolour Drawings in the Possession of Walter Fawkes, Esq.*, London, 45 Grosvenor Place, 1819, no. 4; *Public Exhibition in Aid of the Mechanics Institute*, Leeds, Music Hall, 1839, no. 68; *Turner 1775–1851*, London, RA, 1974–5, no. 67

REFERENCE A. Wilton, *The Life and Work of J.M.W. Turner*, Fribourg, 1979, pp. 95–6, 341, no. 366, pl. 93

222

John Sell Cotman
(1782–1842)

On the Greta 'Hell Cauldron', 1806

pencil and watercolour on paper,
44 × 33.7 cm
Leeds Museums and Galleries (City Art Gallery), 16.2/55

In July 1805 Cotman was invited to Rokeby in North Yorkshire by John Morritt, Classical scholar, traveller and collector of pictures, among them the Rokeby *Venus* by Velázquez (National Gallery, London). Cotman was to spend nearly five weeks in the area, attracted in particular by the park at Rokeby; its wooded slopes, their winding paths and hidden dells threaded by the River Greta, inspired some of his finest watercolours.

While Cotman's correspondence that summer suggests that some at least of his Greta subjects were coloured on the spot, this one was almost certainly painted in London at the very beginning of 1806. Such ambiguity is interesting in itself, for Cotman, like Constable at this time, was narrowing the gap between sketch and finished picture, imbuing the latter with much of the freshness of a *plein air* study and imposing on the former some of the contrivances of picture-making.

These watercolours failed to find favour with the public. It was not until earlier in the present century that Cotman's Greta subjects were reassessed, largely through the scholarship of Sydney Kitson, a generous benefactor to Leeds City Art Galleries. LS

PROVENANCE Sir Henry Englefield (?); Mrs Rice; 1936, 12 June: Christie's,

London, lot 114, bought by Gooden &
Fox, London; Ernest E. Cook; 1955:
presented to the gallery by the National
Art-Collections Fund from Ernest E.
Cook's Bequest
EXHIBITIONS *John Sell Cotman
1782–1842*, London, Victoria and Albert
Museum, Manchester, Whitworth Art
Gallery, and Bristol City Museum and
Art Gallery, 1982–3, no. 45; *Cotmania
and Mr Kitson*, Leeds, City Art Galleries,
1992, no. 16; *The Great Age of British
Watercolours, 1750–1880*, London, RA,
1993, no. 42
REFERENCES S. Kitson, *The Life of John
Sell Cotman*, London, 1937, p. 84; A. Bury,
'The Leeds Art Gallery: Some Important
English Water-Colours and Drawings',
Old Water-Colour Society's Club, XXXV,
1960, p. 91, pl. VII; M. Rajnai and
M. Allthorpe-Guyton, *John Sell Cotman:
Early Drawings in Norwich Castle Museum*,
1979, p. 61

223

John Constable RA
(1776–1837)

*Coal Brigs on Brighton
Beach*, 1824

pencil, pen and black ink with pale
red wash, 17.8 × 25.8 cm
Trustees of the Cecil Higgins Art
Gallery, Bedford, P.119

In the spring of 1824, Constable
took his ailing wife, Maria, to
Brighton, in the hope that the
sea air would restore her health;
she was to make several
prolonged visits before her death
from tuberculosis in 1828.
Constable expressed his

reservations about the rapidly
developing resort in a letter of
August 1824: 'Brighton is the
receptacle of the fashion and
offscouring of London. The
magnificence of the sea, and its
... everlasting voice is drowned
in the din and lost in the tumult
of stage coaches – gigs- 'flys'
& c. – and the beach is ...
Piccadilly ... by the sea-side'.
Nevertheless, the oil sketches
and drawings made between
July and October 1824 show
Constable's fascination with the
bustling life of the beach: this is
one of a sequence of wash
drawings of colliers. It is clear
from Constable's correspondence

that these were initially drawn
on the spot, and developed later
with carefully applied pen and
wash, perhaps in connection with
a projected – though unrealised
– series of engravings which his
Paris dealer, John Arrowsmith,
had intended to publish. LS

PROVENANCE Spink's; 1957:
purchased by the gallery
REFERENCES G. Reynolds, *The Later
Paintings and Drawings of John Constable*,
2 vols., New Haven and London, 1984, I,
p. 144, no. 24.47 (with full bibliography),
II, pl. 518; I. Fleming-Williams,
Constable and his Drawings, London, 1990,
p. 212, n. 5

Ugolino, like that of Paolo and Francesca, appealed to artists of the Romantic era because it suggested the idea of guilt redeemed (or rendered irrelevant) by suffering. Blake especially repudiated Dante's vengeful vision of Hell, explaining that 'whatever Book is Against Forgiveness of Sin is not of the Father but of Satan the Accuser & Father of Hell'.

Ugolino's frozen and frontal stare in Blake's version derives from Dante's reference (xxxiii.49–50) to the father 'petrified' by grief while his children weep. Even his hair stands up in flaming fossils of horror. Around this physiognomic study of despair, Blake arranges symmetrical attendants: two guardian angels, two starving sons and two grandsons, cleaving to their grandfather – literally his own flesh and blood. The composition is like that of an altarpiece depicting God the Father mourning his dead son; the technique is that of an illuminated manuscript. Ugolino's rehabilitation is complete: the traitor has become a saint and martyr.

Blake's art, and to a lesser extent his writings, are a 20th-century rediscovery: this panel entered the Fitzwilliam as recently as 1978, donated by the Sir Geoffrey Keynes, a pioneer of Blake scholarship. DST

PROVENANCE By 1876: J.W. White; 1885: bought from W. Bell by J. Pearson; by 1906: Mrs Graham Smith; 1942: offered by Hon. Anthony Asquith for sale at Hodgson's, London, bought before sale by Geoffrey Keynes; 1978: donated by him to the museum
EXHIBITION William Blake, London, Tate Gallery, 1978, no. 311
REFERENCE M. Butlin, The Paintings and Drawings of William Blake, London and New Haven, 1981, no. 805

224

William Blake
(1757–1827)
Count Ugolino and his Sons in Prison, 1826–7

pen, tempera and gold on panel,
32.7 × 43 cm
Lent by the Syndics of the Fitzwilliam Museum, Cambridge, PD 5-1978

Count Ugolino, a member of the Ghibelline faction in 13th-century Pisa, made a secret pact with the Guelf leader, Archbishop Ruggieri, only to be betrayed by him, sealed up within a tower with his sons and grandsons, and left to starve. In Dante's Inferno (xxxii–xxxiii) Ugolino is condemned to feed on his rival Ruggieri's head in the deepest circle of Hell reserved for traitors (according to Dante he should have stuck by the Ghibellines). The story of

225

James Ward RA
(1769–1859)
A Lion attacking a Boar, 1828

watercolour on paper,
18.5 × 26.7 cm (sight size)
inscribed: JWARD (monogram) RA 1828
Hereford City Museums, 3781

Ward is a key figure in the transition between Stubbs's Neoclassical, rational and Enlightenment approach to his art (cat. 47) and Landseer's anthropomorphism (cat. 155). Originally a mezzotint engraver of some distinction, Ward began to paint under the influence of his brother-in-law George Morland (cat. 54) and became known as an animalier; he later painted landscapes, the most famous of which is Gordale Scar (1811–15; Tate Gallery, London), and history subjects.

Keenly aware of Flemish prototypes, in particular Rubens and Frans Snyders (1579–1657), Ward infused his animal subjects with a new emotionally charged naturalism, which was to astound French artists such as Delacroix and Géricault. This watercolour, modest in concept though it is, shows something of Ward's skill in depicting the savagery of wild creatures. A preparatory drawing for it is in the same collection. LS

PROVENANCE 1939: given to the museum by Herbert A. Powell through the National Art-Collections Fund

226

Samuel Palmer OWS
(1805–81)

Self-portrait, c. 1824–5

black chalk heightened with white
on buff paper, 29.1 × 22.9 cm
inscribed (on back of the old mount,
by the artist's son A.H. Palmer):
*Samuel Palmer by himself. His mouth
was difficult to draw, sensitive and full
of expression and feeling, not hard, and
defiant as in H. Walter's caricature in
'The Followers of William Blake'. I gave
this drawing to Mr Richmond for his
life-time*
The Visitors of the Ashmolean
Museum, Oxford, 1932.211

This must rank among the most
haunting of artists' self-portraits.
It was probably drawn *c.* 1824–5,
a turning-point in Palmer's life.
In October 1824 he met William
Blake for the first time, a
meeting that was to influence the
course of his life. It was also in
1824 that his own highly
distinctive, almost hermetic, style
began to emerge in a sketchbook,
now in the British Museum,
which reveals the intensity of his
artistic and literary imagination;
Palmer had also just made his
first visits to Shoreham, where he
was to spend the most creative
years of his early maturity. He
was struggling to reconcile his
inner life with his newly
heightened perception of nature
and with artistic tradition, a
struggle which seems to be
reflected in this self-portrait,
expressive as it is of his intro-
spection, sensitivity and self-
doubt, yet which also conveys
something of his uncompromis-
ing conviction that 'the visions of
the soul being perfect, are the
only true standard by which
nature must be judged'. LS

PROVENANCE The artist's son
A.H. Palmer; 1929, 4 March: Christie's,

London, lot 41; 1932: purchased by the
museum (Hope Collection)
EXHIBITION *Samuel Palmer and the
Ancients*, Cambridge, Fitzwilliam
Museum, 1984, no. 9 (with full
exhibition history)
REFERENCE R. Lister, *Catalogue
Raisonné of the Works of Samuel Palmer*,
Cambridge, 1988, pp. 55–6, no. 63
(with full bibliography)

also of considerable significance as one of the chief links between English and French Romanticism, not least for transmitting his English taste for watercolour to a number of French contemporaries, including Delacroix.

Through Delacroix, Bonington met Baron Charles Rivet, with whom he spent over two months in northern Italy in the spring of 1826. The most significant part of the visit was a stay of three weeks in Venice, scenes of which formed a large part of Bonington's output during the last two years of his life. This fresh, free study, taken from a rooftop or window, has all the characteristics of Bonington's much admired handling of watercolour (as does cat. 228) and anticipates some of Turner's studies made in Venice in 1833. LS

PROVENANCE 1944: George S. Elgood Bequest to the museum
REFERENCE *English Watercolours at Maidstone Museum and Art Gallery*, Maidstone, 1996, p. 7, no. 5

227

Richard Parkes Bonington (1802–28)

Venetian Campanili, c. 1826

watercolour with scraping out on paper, 16 × 13.3 cm
Maidstone Museum and Art Gallery, 10.1944 (38)

Born near Nottingham in 1802, Bonington died of consumption in London in 1828; his creative life was concentrated into the years between 1817 and his death. When he was fifteen his family left England and settled first in Calais, where his father (who had been a drawing master) set up a lace-manufacturing business, and then in Paris. Apart from three visits to his native country and one journey to Italy, he lived in France, and it may be argued that he belongs essentially to that group of young French artists of the 1820s who rebelled against the Neoclassical formulas of the previous generation. Yet he is

228

Richard Parkes Bonington
(1802 28)

The Undercliff, 1828

watercolour with scraping out over pencil on paper, 13 × 21.6 cm
inscribed: *RPB 1828* and, on the verso in the hand of the artist's mother: *August 6th and 7th 1828. The last drawing made by our dear son about prior to his fatal dissolution. Never to be parted with. E. Bonington*
City of Nottingham Museums, Castle Museum and Art Gallery, 1928–171

The suddenness and severity of Bonington's fatal illness appalled his friends: in late June 1828 he seems to have developed pulmonary consumption, by late July he was in a desperate condition, and in September his parents decided to take him back to London to consult a fashionable specialist in lung disorders. He died a month before his 26th birthday.

This watercolour, almost certainly his last work, as his mother's note states, is in part a reprise of one painted earlier in 1828, *Near Dieppe* (Wallace Collection, London). Unusually for Bonington, it has a narrative element: this area had been notorious for pirates and smugglers, and he shows sailors waiting with pack mules and waggons to receive contraband. Patrick Noon has suggested that the solitary seated figure on the left is a self-portrait. The brilliance and luminosity of watercolours like this inspired his fellow artists with admiration if not envy. Delacroix wrote: 'I could never weary of admiring his marvellous understanding of effects, and the facility of his execution.' LS

PROVENANCE 1836, 6 May: Foster's, London, Bonington sale, lot 49, bought in; 1838, 10 February: Sotheby's, London, Bonington sale, lot 54, bought by Austen, Sara Austen (?); Charles Frederick Huth; 1895, 6 July: Christie's, London, lot 128, bought by Vokins; Stephen Holland; 1908, 25 June: Christie's, lot 140, bought by Agnew's; William Lowe; 1928: presented to the museum by Victor Reinacker
EXHIBITIONS London, Cosmorama Rooms, Regent Street, 1834, no. 109; *R.P. Bonington 1802–1828*, Nottingham, Castle Museum and Art Gallery, 1965, no. 232; *Richard Parkes Bonington: 'On the Pleasure of Painting'*, New Haven, Yale Center for British Art, and Paris, Petit Palais, 1991–2, no. 165 (with full bibliography)

229

**William Henry Hunt
OWS (1790–1864)**
The Maid and the Magpie,
1838

watercolour on paper,
44.1 × 56.9 cm
inscribed (verso): *Shillington, Beds.
Cottage David Coopers daughter paring
apples. Drawn by Wm.Hunt for my
father in 1838*
Trustees of the Cecil Higgins Art
Gallery, Bedford, P 609

After a short period in which he
specialised mainly in landscape,
in the mid-1820s Hunt began to
draw portraits of country people
and studies of interiors, under
the influence of his master, John
Varley (cat. 231). These interests
he combined in the watercolours
he painted in the 1830s and
1840s, recording rural life with
sympathy and sometimes gentle
humour. Hunt was also a highly
accomplished still-life painter,
and his interest in representing
the domestic detail of a simple

cottage in Shillington (not far
from Bedford) is apparent here,
while the play of light on the
girl's face as she turns to look at
the spectator is most beautifully
and tenderly depicted. Inspired
by keen observation and his
obvious pleasure in recording
humble events, Hunt evoked the
mood of restrained sentiment
that so delighted the early
Victorians.

Despite the later inscription
by Horace Musgrave on the
verso, this is the watercolour

exhibited by Hunt at the Old
Water-Colour Society in 1834.
LS

PROVENANCE George Musgrave;
Horace Musgrave; C. Fairfax Murray;
1970: purchased by the gallery
EXHIBITIONS London, Old Water-
Colour Society, 1834, no. 20; London,
RA, 1908, no. 214
REFERENCE J. Witt, *William Henry
Hunt 1790–1864: Life and Work with a
Catalogue*, London, 1982, p. 168, no. 267,
pl. 75

230

Joseph Mallord William
Turner RA (1775–1851)

Nottingham, c. 1832

watercolour on paper, 30.5 × 46.3 cm
City of Nottingham Museums,
Castle Museum and Art Gallery,
1940-18

During the 1820s and 1830s
Turner undertook a number of
projects to illustrate
topographical books, the most
ambitious of which was
*Picturesque Views in England and
Wales*. He attached enormous
importance both to the
watercolours and to the
engravings made after them,

which he regarded as the
culmination of his creative
process. Commercially the
enterprise was a failure, yet the
watercolours and the prints were
much admired by many critics
and collectors. Unsurpassed in
their variety, lyricism and
technical mastery, the
watercolours constitute Turner's
most sustained and inventive
sequence.

Nottingham was closely based
on a drawing made by Turner
over 35 years earlier. As Eric
Shanes has pointed out, the
drawing is a symbolic
representation of the passing of
the Reform Bill in 1832.
Nottingham Castle, seen on the
extreme left, was owned by the

Duke of Newcastle, an active
opponent of reform, when the
Bill was defeated in the Lords in
1831, the Castle, as the
letterpress issued with the
engraving in 1833 noted, 'was
attacked and devastated by a
lawless mob'. The stubble-
burning shown below the Castle
probably alludes to this, while
the open lock represents the
successful passage of the Bill.
Turner extends the allegory to
include the forces of nature: a
storm passes away to reveal
rainbows and sunshine.

Nottingham Castle was not
restored until 1875–8, when it
became one of the first
municipal museums of art in
England. LS

PROVENANCE 1833: Charles Heath;
John Knowles; 1880, 5 June: Christie's,
London, lot 488, bought by Agnew's; Sir
E.H. Scott, Bt; 1940, 19 June: Sotheby's,
London, lot 31, bought by N. Mitchell;
1940: bought by the museum
EXHIBITION London, Moon, Boys &
Graves Gallery, 6 Pall Mall, 1833, no. 60
REFERENCES E. Shanes, *Turner's
Picturesque Views in England and Wales
1825–1838*, London, 1979, pp. 41–2,
no. 59; A. Wilton, *Life and Work of
J.M.W. Turner*, Fribourg, 1979, no. 850

Anthony Vandyke Copley Fielding OWS
(1787–1855)
Robin Hood's Bay, Yorkshire,
c. 1840–50

watercolour on paper, 49.1 × 75 cm
Calderdale Museums and Arts
(Bankfield Museum, Halifax), 1940.7

Anthony Vandyke Copley Fielding (born, to judge from his name, with high parental expectations) was one of four brothers, all watercolourists, whose family came from Yorkshire. He spent the early part of his career teaching and exhibiting in the North of England; in 1809 he moved to London, where he became one of the circle around Varley. He first exhibited at the Society of Painters in Water-Colours in 1810, was elected a full member in 1812 and was President from 1831 until 1854. In all he exhibited 1748 works at the Society, a figure described by a contemporary critic as 'appalling'. His facility and technical virtuosity made him a favourite with the public, who admired his atmospheric effects and sense of breadth and distance. His spirited painting of seas and skies owed something to Turner, but as Ruskin (who in his youth had been Copley Fielding's pupil) noted, his repetitiveness diminished his achievement: 'had he painted five instead of five hundred such, and gone on to other sources of beauty, he might, there be little doubt, have been one of our greatest artists'. LS

PROVENANCE 1940: presented to the museum by the National Art-Collections Fund

231
John Varley OWS
(1778–1842)
Landscape, 1841
watercolour heightened with gum arabic on cream paper,
19.9 × 51.5 cm
inscribed: *Varley 1841*
Oldham Art Gallery, 9.88/31

Varley was an influential figure for the generation of watercolourists born in the 1780s and 1790s. A founder-member of the Society of Painters in Water-Colours, to whose annual exhibitions he became a profuse contributor, he was an important teacher, whose pupils included Cox, De Wint and Linnell. While he encouraged them to adopt a naturalistic approach, with an emphasis on sketching from nature, his own exhibition watercolours often relied on the somewhat schematised idealised compositions which he popularised in the teaching manuals that he published. This late work by him, unusual in its elongated format, shows the influence of ideal landscape painting of the 17th century – Claude in particular – filtered through the taste of the Romantic era. LS

REFERENCE *Oldham Museum and Art Gallery: Catalogue of Watercolours*, Oldham, 1990, p. 28

233

John Martin (1789–1854)

Manfred and the Witch of the Alps, 1837

watercolour and body colour on
paper, 38.8 × 55.8 cm
inscribed: *J.Martin 1837*
The Whitworth Art Gallery,
University of Manchester, D.1974.6

The eponymous hero of Byron's
verse drama *Manfred* (1817) is a
Faustian figure who, tormented
by guilt for 'some half-
maddening sin' and cursed by
the spirits of the universe, is
denied the oblivion he seeks.
After an attempt at suicide –
illustrated by Martin in a

companion watercolour
(Birmingham City Art Gallery)
– Manfred invokes the Witch of
the Alps and reveals his sin, his
incestuous love for his sister
Astarte. The Witch, who 'rises
beneath the arch of the rainbow
of the torrent', commands him to
surrender his soul to her as the
price for her assistance: the
shadowy apparition to the right
in this watercolour is his soul,
with which he considers parting,
but refuses to do so.

Painted at a time of emotional
and financial crisis in Martin's
life when he told a friend that he
felt a 'ruined, crushed man …
there are no more bright days for

me', this watercolour shows both
his astonishing technique and his
identification with Byron's
doomed, romantic hero. LS

PROVENANCE 1974: purchased by the
gallery from Hazlitt, Gooden & Fox,
London, with the aid of the Victoria and
Albert Museum Purchase Grant Fund and
the Friends of the Whitworth
EXHIBITIONS London, Society of
British Artists, 1838, no. 214; *John
Martin*, London, Hazlitt, Gooden & Fox,
1975, no. 35; *Zwei Jahrhunderte englische
Malerei: Britische Kunst und Europa 1680
bis 1880*, Munich, Haus der Kunst,
1979–80, no. 224; *From View to Vision:
British Watercolours from Sandby to Turner*,
Manchester, Whitworth Art Gallery,
1993, no. 138
REFERENCES T. Balston, *John Martin
1789–1854: His Life and Works*, London,
1947, p. 280; W. Feaver, *The Art of John
Martin*, Oxford, 1975, pp. 153–4, 230,
n. 85, pl. 115

234

John Ruskin (1819–1900)

Study of Rocks and Ferns in a Wood at Crossmount, Perthshire, 1847

watercolour with pen and black ink on paper, 32 × 46 cm
Abbot Hall Art Gallery, Kendal, 1134/73

Ruskin's earliest enthusiasms included geology and botany, interests reflected in many of his drawings. In 1842 he experienced a near-mystical revelation, when he realised that he had never been taught to draw 'what was really there' and that nature composed itself 'by finer laws than any known of men'. His new attitude of absolute reverence to nature animates the first volume of *Modern Painters* (1843) and almost all his subsequent drawings are characterised by a fanatical concern with precise, factual observation. Details of nature in particular fascinated him, as in this remarkable study.

In August 1847, Ruskin went to stay with a young friend, William Macdonald, who owned a shooting lodge at Crossmount, Perthshire, above Loch Rannoch and Loch Tunnel. Here Ruskin pondered his feelings for his cousin Effie Gray, walking in the hills and making a series of drawings, of which this is one. In October he proposed to her; the ill-fated marriage took place the following year and was to be annulled in 1854.

This watercolour illustrates exactly the kind of naturalism which Ruskin yearned for in British art – the kind which he championed from 1851 in his support of the Pre-Raphaelites. Ruskin demanded a similar treatment of rocks and lichens when he posed for his portrait by Millais at Glenfinlas in 1853.
LS

PROVENANCE Mr and Mrs Arthur Severn; Robert Ellis Cunliffe; Mrs Cunliffe and thence by descent; 1973: Cunliffe Bequest to the gallery
EXHIBITIONS *John Ruskin*, Manchester, Whitworth Art Gallery, 1982, no. 48; *Treasures from Abbot Hall*, London, Leger Galleries, 1989, p. 64

235

George Price Boyce RWS
(1826–97)

Babbacombe Bay, Devon,
1853

watercolour on paper,
33 × 54.6 cm
inscribed: *GPBoyce 1853*
Astley Cheetham Art Gallery,
Stalybridge, Tameside MBC Leisure
Services, 1952.3

As a young man Boyce trained as
an architect, but in 1849 he met
David Cox and decided to
become an artist. At first he
painted in the broad,
atmospheric manner of Cox (cat.
240), but soon developed an
interest in the emerging Pre-
Raphaelite landscape style,
which was to a great extent
inspired by the early volumes of
John Ruskin's *Modern Painters*
Under this influence, he
concentrated on the painstaking
observation of nature, sketching
with Thomas Seddon (cat. 236)
and attracting the
encouragement of Ruskin
himself. This watercolour of
Babbacombe Bay on a sunlit day,
with its minutely described
rocks and pebbles, and the
broken forms of the distant
headland, is a thoroughly Pre-
Raphaelite landscape. In June
1858, Boyce noted in his journal
that Rossetti had borrowed two
sketches made at Babbacombe to
help with the background of a
'little drawing of a loving couple
on a sea beach on a windy day'.

Significantly, perhaps, since
Rossetti had minimal interest in
landscape, the finished
watercolour, *Writing on the Sand*
(British Museum, London),
shows no direct borrowing from
Cox's *Babbacombe Bay*.

Boyce had independent means
and was an avid collector both of
the work of his Pre-Raphaelite
friends and of French artists. His
journal is an important source of
information about the Pre-
Raphaelite circle. LS

PROVENANCE 1897, July 26:
Christie's, London, Boyce sale, lot 110 (?):
1952: bequeathed to the gallery by Percy
Charles Mordan through the National
Art-Collections Fund
EXHIBITIONS *American Exhibition of
British Painting*, New York, National
Academy of Design, Philadelphia
Academy of Fine Arts and Boston
Museum of Fine Arts, 1857–8 (no
catalogue); *George Price Boyce*, London,
Tate Gallery, 1987, no. 12
REFERENCE V. Surtees, ed., *The Diaries
of George Price Boyce*, Norwich, 1980, pp.
11, 18, 24, 85, n. 25

236

Thomas Seddon (1821–56)
The Well of En-rogel,
1854–5

watercolour and body colour on
card, 25 × 35 cm
Harris Museum and Art Gallery,
Preston, P533

Motivated partly by strong
religious feelings and partly by
artistic curiosity, Seddon
travelled to the Holy Land in the
winter of 1853, staying there for
around a year, some of the time
in the company of Holman

Hunt. Seddon was part of the
Pre-Raphaelite circle, a friend of
Ford Madox Brown and the
Rossetti brothers, and his
combination of truth to nature
with belief in the spiritual
associations of the places he
painted was to impress Ruskin.
The particular significance of the
present view lay in the Old
Testament references to the well
of En-rogel. In the Book of
Joshua, it was the frontier of the
land held by the tribe of the
children of Judah, while in
I Kings, Adonijah, King David's
son, 'slew sheep and oxen and fat

cattle by the stone of Zoheleth,
which is by En-rogel'. Seddon
gives visual expression to the
mid-19th century idea that the
Bible's veracity could be
established through rational,
archaeological enquiry.

On his return to London,
Seddon held an exhibition in
1855 of his paintings and
watercolours, and again in 1856,
probably to raise money for a
second visit to the Middle East.
He died in Cairo in November
1856. LS

PROVENANCE 1927: purchased by the
museum
EXHIBITION *Victorian Landscape
Watercolours*, New Haven, Yale Center for
British Art, Cleveland Museum of Art
and Birmingham Museum and Art
Gallery, 1992–3, no. 23
REFERENCE *Watercolours, Drawings and
Prints from the Collection of the Harris
Museum and Art Gallery*, Preston, 1989,
p. 41

237

John Frederick Lewis OWS RA (1805–76)

Courtyard of the Painter's House, Cairo, c. 1851

watercolour and body colour on five conjoined sheets of paper, 97.5 × 126 cm
inscribed: *JFL* (monogram)
Birmingham Museums and Art Gallery, 44'48

After visiting Lewis in Cairo in 1844, the artist's friend Thackeray noted that he appeared to exist 'like a languid Lotus-eater – a dreamy, hazy, lazy, tobaccofied life'. His house, 'far away from the haunts of European civilisation, in the Arab quarter', was described in detail by the novelist, who even mentioned the presence of a gazelle and a camel in the courtyard. In 1850 Lewis exhibited the first of a series of watercolours of Oriental subjects, *Hareem Life, Constantinople*, which were to create a sensation with their glimpses of an exotic and gorgeous world, depicted in brilliant colours and in a mesmerically detailed style,

which combined to look more like an oil painting than a watercolour (and he did also paint such views in oils; see cat. 158). It is not so surprising that in 1858 he resigned from the Old Water-Colour Society in order to concentrate on oil painting: 'I felt that work was destroying me. And for what? To get by water-colour art £500 a year, when I know that as an oil painter I could with less labour get my thousand'.

Curiously, Lewis seems to have abandoned this richly atmospheric and grand watercolour just short of completion – the figures to the right and in the foreground on the left are unfinished. LS

PROVENANCE 1948: purchased by the museum
EXHIBITION *British Watercolours from Birmingham 1750–1900*, Tokyo, Station Gallery, *et al.*, 1991–2, no. 95
REFERENCE C. Newall, *Victorian Watercolours*, Oxford, 1987, p. 36, pl. 17

238

Thomas Miles Richardson Jr OWS (1813–90)
The Valley of St Nicholas, Monte Rosa Range, 1884
watercolour with body colour on paper, 85.5 × 117 cm
inscribed: *T.M.Richardson Jnr. 1884*
Torbay Council, Torre Abbey Colection, Torquay

The work of the younger Richardson, whose father was a noted Northern landscape painter, marks the apogee of a certain kind of Victorian taste in watercolours: large, grandly picturesque views of Scottish and Continental scenery, mostly ignored by the critics or dismissed as formulaic, but consistently popular with collectors. Neither his style nor his subject-matter changed appreciably for the greater part of his life. A member of the Society of Painters in Water-Colours from 1851, he was to exhibit over 650 works in the course of his career. In 1884 the Society's exhibition was considered by the *Art Journal* to be the best for many years, marred only by an infatuation with large works: this characteristic view will have contributed to that impression. LS

PROVENANCE 1939: presented to Torre Abbey by Mrs D. Field

239

John Brett (1831–1902)

Near Sorrento, 1863

watercolour and body colour on
paper, 24.9 × 33.5 cm
inscribed: *J.B.Oct.1863*
Birmingham Museums and Art
Gallery, 34'17

Brett's youthful interests were
divided equally between
painting and astronomy. He
entered the Royal Academy
Schools in 1853, but seems to
have learned more from the work
of the Pre-Raphaelites and the
writings of Ruskin, whose

evocation of the beauties of
mountain scenery in volume IV
of *Modern Painters* was the motive
force behind Brett's oil of 1856,
The Glacier of Rosenlaui (Tate
Gallery, London). Under the
influence of the Pre-Raphaelites,
he went on to paint
contemporary figurative subjects,
such as *The Stonebreaker* (Walker
Art Gallery, Liverpool). Yet
Brett's reputation was really
made with his *tour de force* of
naturalism, *The Val d'Aosta*
(private collection), exhibited at
the Academy in 1859. Painted at
Ruskin's urging, and praised

highly by him, it nevertheless
failed to sell until Ruskin
eventually – and reluctantly –
bought it.

In the 1860s, Brett tended to
work on a smaller scale – again,
on Ruskin's advice – and for a
while regarded watercolour as his
principal medium. In August
1863 he sailed to the
Mediterranean and spent the
winter in Capri. This
watercolour, dated October
1863, is in the spirit of his *Val
d'Aosta*, with its minute
delineation of the cliffs, the
distant houses and the

mountains rising up behind. The
deliberate exclusion of any
foreground, save water far below,
gives the spectator the
disconcerting but curiously
effective sensation of being
suspended in the air. LS

PROVENANCE 1917: presented to the
museum by Sir Richard Cooper, Bt
EXHIBITION *Victorian Landscape
Watercolours*, New Haven, Yale Center for
British Art, Cleveland Museum of Art
and Birmingham Museum and Art
Gallery, 1992–3, no. 54
REFERENCE A. Staley, 'Some
Watercolours by John Brett', *Burlington
Magazine*, CXV, 1973, pp. 86–93, fig. 24

240
David Cox OWS
(1783–1859)
Penmaen Bach, 1852

watercolour with scraping out and
body colour over pencil on paper,
57.2 × 82.6 cm
inscribed: *David Cox 1852* and, on a
label on the back of the frame, also
in the artist's hand: *N1 Penmaen
Bach, on the Coast between Conway and
Bangor David Cox*
Birmingham Museums and Art
Gallery, 2519'85

The boldness and brooding
grandeur of Cox's late works were
unmatched by any of his
contemporaries. When *Penmaen
Bach* was first exhibited in 1852,
The Spectator thought it 'wonder-
ful. All dim and solemn through
a lowering atmosphere . . . In his
works there are power and
insight enough to swamp all the
others put together'. The
dramatic scenery of North Wales,

Cox's favourite sketching area,
had inspired Thomas Roscoe's
book *Wanderings and Excursions in
North Wales* (1836), for which
Cox had made an illustration of
this stretch of coastline; by 1852,
however, his style and technique
had intensified. His extreme
freedom of handling, using
loosely applied, low-toned
watercolour washes on coarse
Scotch paper to suggest the
rugged, massive character of the
landscape surprised fellow
members of the Society of
Painters in Water-Colours. As he
wrote to his son in 1853, 'it
strikes me the committee think
them too rough; they forget they
are the work of the mind, which
I consider very far before portraits
of places'.

Birmingham, where Cox was
born and where he lived from
1841, has the finest collection of
his work in both oil and
watercolour. LS

PROVENANCE Sir Josiah Mason; 1882:
presented to the museum by Martyn
Smith
EXHIBITIONS London, Old Water-
Colour Society, 1852, no. 198; Royal
Birmingham Society of Artists, 1873, no.
107; *Loan Collection of the Works of the Late
David Cox*, Liverpool Art Club, 1875, no.
151; *David Cox et son Temps*, Bourges,
Maison de la Culture, 1970, no. 38;
David Cox 1783–1859, Birmingham
Museum and Art Gallery, 1983; *David
Cox, 1783–1859*, London, Victoria and
Albert Museum, 1984, no. 99; *Victorian
Landscape Watercolours*, New Haven, Yale
Center for British Art, Cleveland Museum
of Art and Birmingham Museum and Art
Gallery, 1992–3, no. 18

241
Myles Birket Foster OWS
(1825–99)
*Holywell, near Newcastle,
c. 1870*

watercolour on paper,
35 × 25 cm (sight size)
Blackburn Museum and Art Gallery

Birket Foster was born in North
Shields, Northumberland, and,
although his family moved to
London when he was a child, he
retained an attachment to the
area. He was originally trained as
a wood-engraver and illustrator,
but by the late 1850s had turned
chiefly to painting watercolours.
The *Art Journal* noted in 1860
that his drawings 'must be
classed with the Pre-Raphaelite
School'. Birket Foster rapidly
achieved enormous popularity,
but financial pressures later
compelled him to turn out
dreary repetitions of standard
compositions. LS

242
Samuel Palmer OWS
(1805–81)
*Tityrus restored to his
Patrimony, c. 1874–7*

watercolour and body colour with
touches of gum arabic on card laid
down on paper, 50.5 × 70.3 cm
inscribed: *SAMUEL PALMER*
Birmingham Museums and Art
Gallery, 279'05

Virgil's pastoral poetry was an
important inspiration for
Palmer's art. In his last decade
the artist began a series of
etchings to accompany his own
translation of the *Eclogues* and
may also have planned a series of
watercolours like those he

painted from 1864 onwards to illustrate Milton. These two projects show Palmer coming to terms with his youthful 'visions of the soul', fusing intensity of mood with a more subtly reflective style.

This is the only exhibited watercolour that Palmer painted in connection with his Virgil project. Exceptionally rich and elaborate, glowing with heightened colour and densely worked with opaque pigment and gum arabic, it is also a lyrical homage to Claude. It illustrates a passage from the first Eclogue, a dialogue between the exiled Meliboeus and Tityrus, a shepherd whose lands have been restored to him. The watercolour is in its original frame and bears an autograph label with an extract from Palmer's translation: 'O fortunate who now at last among / Known streams and sacred fountain heads, have found / A shelter and a shade on your own ground.'
I.S

PROVENANCE 1891: George Gurney; 1905: presented to the museum by J. Palmer Phillips
EXHIBITIONS London, Old Water-Colour Society, 1877, no. 100; *A Collection of Drawings, Paintings and Etchings by the Late Samuel Palmer*, London, Fine Art Society, 1881, no. 23; Winter Exhibition, London, RA, 1891, no. 145; London, Guildhall, 1896, no. 37; *Samuel Palmer and John Linnell*, Reigate, Town Hall, 1963, no. 23; *Samuel Palmer: A Vision Recaptured*, London, Victoria and Albert Museum, 1978, no. II; *British Watercolours from Birmingham 1750–1900*, Tokyo, Station Gallery, *et al.*, 1991–2, no. 84
REFERENCE R. Lister, *Catalogue Raisonné of the Works of Samuel Palmer*, Cambridge, 1988, pp. 229–30, no. V2 (with full bibliography)

watercolours of his near contemporary Frederick Walker (cat. 245). The watercolour was commissioned by G.B. Longstaff, who was the owner of the house and conservatory in Wandsworth, London, and the father of the little girl in white it depicts. The title is presumably a reference to Charles Kingsley's much-loved story (published in 1863) of Tom, the boy sweep, who tumbles down a chimney into the bedroom of a little girl, Ellie, and for the first time becomes aware of his blackened, grimy body; he runs away, falls into a river, is transformed into a water-baby and after many adventures is reunited with Ellie.

Albert Goodwin was born in Maidstone; the Museum and Art Gallery has assembled an important collection of over 200 works by him. L S

PROVENANCE 1874: G.B. Longstaff; 1954: presented to the museum by Claude Bendall
EXHIBITION *Albert Goodwin RWS 1845–1932: A Maidstone Artist*, Maidstone Museum and Art Gallery, 1994, no. 3

243
Albert Goodwin RWS
(1845–1932)
Water-Babies (*The Conservatory*), 1874
watercolour and body colour on paper, 37.8 × 55.5 cm
inscribed: *Albert Goodwin 74*
Maidsrone Museum and Art Gallery, 50.1957

A pupil of Arthur Hughes and Ford Madox Brown, Goodwin absorbed the principles of Pre-Raphaelitism. Taken up by Ruskin in the 1870s, he gradually developed a freer style which was deeply influenced by Turner's late watercolours (cat. 230). An enormously prolific and popular artist, Goodwin is known chiefly for his Turnerian landscapes. *Water-Babies* reflects something of his Pre-Raphaelite background, and is close in subject and mood to the

244
Helen Allingham RWS
(1848–1926)
Valewood Farm, 1891
watercolour on paper,
48.8 × 38.8 cm
inscribed: *H.Allingham*
Birmingham Museums and Art Gallery, 35'91

Trained at the Birmingham School of Art and at the Royal Academy Schools, Helen Patterson married the Irish poet William Allingham in 1874, and thus came into the circle of the Pre-Raphaelites. In 1890 she became the first full female

member of the Royal Society of
Painters in Watercolours;
together with her friend Kate
Greenaway she was much
admired by Ruskin.

Allingham's watercolours
mark the close of the Picturesque
movement, with its nostalgia for
a supposedly happier rural past.
Like her friend M.B. Foster (cat.
241), she saw country life as an
idyllic refuge from an
increasingly urbanised society,
while feeling concern for the
condition of the rural poor in a
period of agricultural depression.
From 1881 she lived for some
years in Surrey, then on the
point of losing most of its rural
character. Allingham felt that
her watercolours provided a
record of a fast-disappearing way
of life. L S

PROVENANCE 1891: purchased from
the artist by the museum
EXHIBITION *British Watercolours from
Birmingham 1750–1900*, Tokyo, Station
Gallery, *et al.*, 1991–2, no. 59

245
Frederick Walker OWS ARA (1840–75)
My Front Garden, 1864

watercolour and body colour on
paper, 22.8 × 31.7 cm
inscribed: *F.W.1864*
Harris Museum and Art Gallery,
Preston, P1397

Walker began his career as an
illustrator, in particular of
Thackeray's novels which were
issued in parts by *The Cornhill
Magazine* in the early 1860s. He
soon turned to painting, and
evolved a highly wrought and
elaborate watercolour technique.
Though influenced by the Pre-
Raphaelites, he strove to set
himself apart from the pursuit of
absolute truth to nature: 'Com-
position is the art of preserving
the accidental look', he wrote.

My Front Garden, painted in
the year Walker was elected an

Associate of the Old Water-
Colour Society, shows the arrival
of a postman at the artist's house
in Bayswater, London. While in
Pre-Raphaelite compositions the
figures tend to be seen in some
intensely charged moment of
spiritual or moral crisis, Walker
chooses an everyday incident
which he observes with an
illustrator's eye. 'I think for an
absolute representation of what a
scene in a story would be like
F. Walker's drawings are
perfection', noted Burne-Jones.

By the beginning of the 1870s
Walker was widely regarded as
one of the most talented and
original artists of his generation,
but his early death prevented his
full development. An account of
a posthumous exhibition, in
1885, attracted the attention of
Van Gogh, who admired both
Walker and his contemporary
George Pinwell: '[they] restored
nature over convention;
sentiment and impression over
academic platitudes and
dullness'. L S

PROVENANCE 1952: purchased by the
museum
EXHIBITION London, Old Water-
Colour Society, 1864, no. 410 (?)
REFERENCES J.G. Marks, *Life and
Letters of Frederick Walker ARA*, London,
1896, p. 50; *Watercolours, Drawings and
Prints from the Collections of the Harris
Museum and Art Gallery*, Preston, 1989,
p. 46

246

Simeon Solomon
(1840–1905)

Carrying the Scrolls of the Law, 1867

watercolour and body colour on paper, 35.7 × 25.5 cm
inscribed: *SS* (monogram) *Rome 1867*
The Whitworth Art Gallery, University of Manchester, D.1919.8

Simeon Solomon's best work dates from the 1860s and marks the beginning of the transition from Pre-Raphaelitism to Aestheticism. He was much admired by Rossetti, Burne-Jones, Walter Pater and the poet Swinburne, whose supposedly corrupting influence was thought to be responsible for Solomon's moral and artistic decline in the 1870s. Arrested in 1873 for homosexual offences, he became a complete social outcast.

Solomon's drawings included many studies of Jewish life and ritual. This watercolour, painted during a visit to Rome in 1867, was based on drawings he had made in the synagogue in Genoa. It is the first and most successful version of a composition which Solomon was to depict several times.

Carrying the Scrolls of the Law is in its original frame, which bears a scroll inscribed in Hebrew: 'The people who hold the tree of life support it from happiness'; the scroll in the watercolour is inscribed 'God is Holy'. L S

PROVENANCE 1919: purchased by the gallery
EXHIBITION *Solomon: A Family of Painters*, London, Geffrye Museum, 1985, no. 57
REFERENCE S. Reynolds, *The Vision of Simeon Solomon*, Stroud, 1985, p. 23, pl. 46

247

Dante Gabriel Rossetti
(1828–82)

Horatio Discovering Ophelia's Madness, 1864

watercolour on paper, 39.4 × 29.2 cm
inscribed: *DGR April 1864*
Oldham Art Gallery, 3.55/7

During the 1850s and early 1860s Rossetti's imaginative and creative powers were at their height. While other members of the Pre-Raphaelite Brotherhood – Holman Hunt and Millais – developed themes taken from contemporary life (cat. 132,

143), Rossetti abandoned such modern moral subjects. Instead, he developed a vague, poetic medievalism in both his painting and his writing. He concentrated chiefly on working in watercolours, evolving an entirely individual style; minutely hatched and stippled layers of intense colour, sometimes strengthened by the addition of body colour or gum, were applied with an almost dry brush, giving the appearance of small-scale, jewel-like paintings. His central theme was romantic love, with concentration on some highly charged moment of near-claustrophobic, emotional tension between a man and woman characterising his most effective compositions.

Here Rossetti (compressing Act 4, scene 5 of Shakespeare's play) shows Ophelia mad with grief from Hamlet's rejection of her and from her father's death.

Watched by the King and Queen, she is led away by Horatio. 'O this is the poison of deep grief ... poor Ophelia, divided from herself and her fair judgement.' L S

PROVENANCE Walter Dunlop; William Graham; 1886, 3 April: Christie's, London, Graham sale, lot 108; Humphrey Roberts; Charles E. Lees; 1952: presented to the gallery by his daughter, Miss M. Lees
EXHIBITIONS London, RA, 1883, no. 356; *Dante Gabriel Rossetti: Painter and Poet*, London, RA, 1973, no. 310
REFERENCE V. Surtees, *The Paintings and Drawings of Dante Gabriel Rossetti: A Catalogue Raisonné*, 2 vols., Oxford, 1981, I, p. 97, no. 169 (with full bibliography)

248

Sir Edward Burne-Jones (1833–98)

The Choristers, c. 1869–70

both body colour on paper,
diam. 44.5 cm
The Mercer Art Gallery, Harrogate, HARAG 25

Throughout his life Burne-Jones maintained a busy schedule of designing, mainly for stained glass, alongside his career as a painter. These two roundels form part of a complex scheme for the apse windows in Holy Trinity, Meole Brace, near Shrewsbury, Shropshire (1868–71). The importance of the Gothic Revival church (1867–8, by E. Haycock Jr) lies entirely in the stained glass, nearly all by Morris & Company to designs by Burne-Jones. Other designs for the apse windows survive in private collections, dated 1868–9.

These finished watercolours may be versions of the Meole Brace designs rather than preparatory cartoons. Burne-Jones frequently used to recycle compositions for other purposes, and his stained-glass designs were also repeated in other churches. Of the designs for this particular commission, he noted in his account book: 'I have seldom if ever produced works of such marked inferiority – I felt indifferent to the reputation of the Firm at the time. Let us think no more about it.' Posterity has judged differently, estimating the windows in the apse at Meole Brace as among the best of Burne-Jones's designs. C G

PROVENANCE donated to the gallery by Miss E.M. Coleman through the National Art-Collections Fund
REFERENCE A.C. Sewter, *The Stained Glass of William Morris and his Circle*, New Haven, 1974–5, II, p. 131

249

John Ruskin (1819–1900)

S. Maria della Spina, Pisa,
1845

pencil, pen and ink with watercolour
on paper, 50.3 × 37.5 cm
Collection of the Guild of St George,
Ruskin Gallery, Sheffield, R51

For Ruskin, this drawing had
particular significance, not so
much for its aesthetic qualities,
but because of the importance
that S. Maria della Spina held in
his imagination from childhood
onwards. The chapel had been
depicted by Turner (a water-
colour subsequently owned by
Ruskin) for a plate in Finden's
Life of Byron (1832–4): this gave
it both literary and picturesque
importance for a boy educated to
admire the artist and the poet.
Ruskin first visited Pisa in 1840,
but it was not until his second
visit, in 1845, that he fully
responded to all he saw there.
He daguerrotyped the chapel
– a practice he later noted
employing without scruple, and
which he regretted that artists in
general did not make more use of
– making the present drawing
from the daguerrotype. S. Maria
della Spina was effectively
destroyed in 1872, during the
reconstruction of the banks of
the Arno, to Ruskin's great
distress, and when he reproduced
this drawing as the frontispiece
to Letter 20 of *Fors Clavigera* in
1872 (a periodical pamphlet
addressed to the 'Workmen and
Labourers of Great Britain'), he
described it as 'Part of the
Chapel of St. Mary the Thorn,
Pisa, as it was 27 years ago. Now
in Ruins'. Ruskin was later to
locate the chapel in the
'dominion of Daedalus', the
potentially dangerous realm of

'delight of the eyes'.

This drawing was given pride
of place in St George's Museum,
founded by Ruskin in 1875 for
the workers of Sheffield. LS

PROVENANCE 1888: presented by the
artist to the Guild of St George
EXHIBITION *John Ruskin*, Sheffield,
Mappin Art Gallery, *et al.*, 1983, no. 226

REFERENCES J. Ruskin, *Fors Clavigera*,
London, 1872 (frontispiece to Letter 20);
E.T. Cook and A. Wedderburn, *The
Works of John Ruskin*, London, 1903–12,
XXVII, p. 349, XXVIII, p. 508,
XXXVIII, p. 274

250

Edouard Manet (1832–83)
Déjeuner sur l'herbe,
after 1863

black chalk, pen and ink and water-
colours on paper, 37.2 × 46.2 cm
inscribed: *Ed. Manet*
The Visitors of the Ashmolean
Museum, Oxford, WA 1980.83

Manet's ambition to present a
nude – traditionally regarded as
the peak of academic achieve-
ment – at the Salon resulted in
two scandalous pictures,

Le Déjeuner sur l'herbe, shown at
the Salon des Refusés in 1863,
and *Olympia*, exhibited at the
Salon of 1865 (both now Musée
d'Orsay, Paris). This drawing for
the former, and a freely brushed
oil sketch (Courtauld Institute,
London) of the composition,
were made later than the
painting itself. Manet is known
to have made watercolour copies
of his paintings at the request of
friends, and as preparatory
studies for etchings; the drawing
may have been one of the former.

It belonged to the celebrated
collection of Eugène Blot, before
its purchase by the Berlin art
dealer Bruno Cassirer. Cassirer
and his family emigrated to
Oxford in 1933 and both
daughters married dons in the
University. This was among the
works inherited by Sophie
Cassirer. CH

PROVENANCE Portier; 1900: Eugène
Blot; 1906, 10 May: sale, Paris, lot 105;
Bernard; Bruno Cassirer; his daughter,
Sophie Walzer; 1980: accepted by HM
Government in lieu of capital transfer tax
on the estate of Dr and Mrs Richard

Walzer, and allocated to the museum in
accordance with their wishes
EXHIBITION *Dürer to Cézanne: Northern
European Drawings from the Ashmolean
Museum,* New Brunswick, Jane Voorhees
Zimmerli Art Museum, and Cleveland
Museum of Art, 1982–3, no. 107
REFERENCES A. Tabarant, *Manet et ses
œuvres,* Paris, 1947, no. 568; D. Rouart
and D. Wildenstein, *Edouard Manet:
Catalogue raisonné,* 2 vols., Lausanne and
Paris, 1975, no. 306

251

James McNeill Whistler
(1834–1903)
Beach Scene with two Figures,
c. 1893–7

watercolour on off-white paper laid
down on card, 12.5 × 21.4 cm
inscribed with the artist's butterfly
mark
Birmingham Museums and Arr
Gallery, P117'55

Watercolour became important
for Whistler from the 1880s
onwards. After tentative
beginnings, his use of this
medium became bold and
experimental, and he often
painted *en plein air*: a number of
studies are splashed with rain or
sea spray. Coastal landscapes and
sea subjects offered the type of
simple composition that most
interested him – here, a broad
band of sky above the dark sea
and a strip of sand in the
foreground, each tone carefully
calculated, a structure not
dissimilar to the schemes of wall
decoration he had devised. The
large rocks and the two figures,
rapidly painted in calligraphic
fashion, act as counterpoints to
the strongly horizontal design.
Just as carefully calculated are

the grey ship silhouetted against
the sky, and the little pink and
grey lighthouse. In 1884
Whistler wrote from St Ives of
the difficulty he experienced in
translating what he observed
into art: 'Well for dullness, this
place is simply amazing! –
nothing but nature about – and
Nature is but a poor creature
after all . . . poor company
certainly – and, artistically, often
offensive'. His solution was to
distill his observations into semi-
abstracted compositions like this
watercolour. LS

PROVENANCE Bequeathed by the
artist to his sister-in-law, Miss R. Birnie
Philip; 1955: sold to Colnaghi's, from
whom purchased by the gallery
EXHIBITION *Victorian Landscape
Watercolours*, New Haven, Yale Center for
British Art, Cleveland Museum of Art
and Birmingham Museum and Art
Gallery, 1992–3, no. 104
REFERENCE M.F. MacDonald, *James
McNeill Whistler: Drawings, Pastels and
Watercolours – A Catalogue Raisonné*, New
Haven and London, 1995, p. 492, no.
1368 (with full bibliography)

other members of the family, and was transferred to the Ashmolean through the generosity of Lucien's widow, Esther. C H

PROVENANCE Lucien Pissarro; 1952: presented to the museum by the Pissarro family
REFERENCES L. Pissarro and L. Venturi, *Camille Pissarro: son art – son œuvre*, 2 vols., Paris, 1939, no. 1652; R. Brettell and C. Lloyd, *A Catalogue of the Drawings by Camille Pissarro in the Ashmolean Museum, Oxford*, Oxford, 1980, no. 219

252
Camille Pissarro
(1830–1903)
Peasant Women planting Pea Sticks into the Ground, 1890

tempera and black chalk on grey-brown paper, 39 × 60.2 cm (fan), 40.7 × 64.1 cm (sheet)
inscribed: *C. Pissarro 1890*
The Visitors of the Ashmolean Museum, Oxford, B&L219

Pissarro may have been encouraged to make fans by Degas, and doubtless saw in the contemporary vogue for Japanese fans a means of relieving his perpetual indigence. He made his first fan in 1878 and showed twelve at the fourth Impressionist exhibition in 1879. He exhibited another large group in 1890, which he hoped to sell at 200 francs each. This fan, the last of the 1890 set, was ready by 19 December and sent to his son, Lucien, as a New Year gift. It depicts peasant women planting the sticks on which the pea plants will climb. The apple trees are in blossom and the scene is one of idyllic happiness, the women engaged not in a laborious task but in a rhythmic dance in Arcadia. Unlike most of the fans, which are painted in gouache, Pissarro has here used tempera, a much drier medium consisting of powdered colours which sometimes give the appearance of pastel.

The Pissarro collection at the Ashmolean Museum is the largest archive devoted to any major Impressionist painter. It includes letters, documents and other items relating to Camille Pissarro, his son Lucien, Lucien's daughter, Orovida, and many

253
John Singer Sargent RWS
(1856–1925)
Soldiers at Rest, 1918

watercolour over traces of pencil on paper, 34.3 × 53.5 cm
Lent by the Syndics of the Fitzwilliam Museum, Cambridge, 1151

Sargent spent much of World War I in America, working on large-scale mural decorations in Boston and travelling to the Canadian Rockies and Florida. In 1918 he returned to England and was commissioned by the War Artists Committee to paint a war picture. In July he was with the army in France. His naivety was extraordinary ('I suppose there is no fighting on Sundays?') and reflects his lifelong detachment from political, let alone military, matters. He produced a series of watercolours, for the most part low-key and undramatic, showing the daily existence of soldiers, whether at rest, foraging for food or as casualties in a hospital unit. Eventually, the horror and bitterness of the war did affect him and his epic painting *Gassed* (1918–19; Imperial War Museum, London) is a powerful and monumental achievement. L S

254

Vincent van Gogh
(1853–90)

Sorrow, 1882

pencil and black chalk on brown
paper, 44.5 × 27 cm
inscribed: *Vincent del. Sorrow/*
Comment se fait-il qu'il y ait sur la terre
une femme seule-delaissé / Michelet
The Garman-Ryan Collection,
Walsall Museum and Art Gallery,
GR128

This drawing of a naked woman,
seemingly blind to such signs of
hope as the spring flowers at her
feet, was made in The Hague,
where Van Gogh lived from
1881 to 1883. The model was
Sien Hoornik, an occasional
prostitute and an alcoholic. The
theme of the abandoned woman
is indicated by the quotation at
the bottom of the sheet, which
comes from *La Femme* by the
French writer Jules Michelet.
Sien's own circumstances were
sadly appropriate: pregnant and
already with a small daughter,
she had been abandoned by her
husband when Van Gogh started
to live with her. A child born in

July 1882 may have been his.
Van Gogh stated the drawing
was made in the style of British
graphic artists and expressed 'the
struggle of life'. He may have
hoped to have it published in a
journal: he produced a litho-
graph after the design, though
only a few prints were made.

The Garman-Ryan Collection
was assembled by Kathleen
Garman (Lady Epstein) and the
American sculptor Sally Ryan
between 1959 and 1973. M C

PROVENANCE: J. van Gogh-Bonger,
Amsterdam; Montross Gallery, New
York; T. Pitcairn, Bryn Althyn, USA;
1966, 24 June: Christie's, London, lot 48;
Lady Epstein, London; Garman-Ryan;
1973: presented to the museum
EXHIBITIONS *Vincent van Gogh*
Drawings, Otterlo, Rijksmuseum Kröller-
Müller, 1990, no. 35; *The Age of Van*
Gogh: Dutch Painting 1880–1895,
Glasgow, Burrell Collection, 1990–1, and
Amsterdam, Van Gogh Museum, 1991,
no. 37; *French Impressionism: Treasures from*
the Midlands, Birmingham, Museum and
Art Gallery, 1991, p. 44
REFERENCES *The Garman-Ryan*
Collection: Illustrated Catalogue, Walsall,
1976, pp. 67–8; J.-B. de la Faille, *Vincent*
van Gogh: The Complete Works on Paper,
Catalogue Raisonné, San Francisco, 1992
edn, no. 929a

255

Vincent van Gogh
(1853–90)

The Fortifications of Paris,
1878

watercolour, body colour, chalk and
pencil on grey paper, 38.7 × 53.4 cm
The Whitworth Art Gallery,
University of Manchester, D.1927.4

This depicts the ring of fortifi-
cations that surrounded the inner
city of Paris, specifically Bastion
no. 43 (the large five-storeyed
building beyond the rampart)
situated to the east of the Porte

de Clichy on the Boulevard
Bessières. Such areas provided
open spaces to which the
inhabitants of the crowded
industrial zones of Paris could
escape for recreation.

Van Gogh would have been
able to reach this area easily by
walking down the Boulevard
National from the apartment in
the Rue Lepic he was renting
with his brother, Theo. He had
arrived in Paris from Antwerp in
March 1886 and stayed there
two years before departing for
Arles on his ill-fated mission to
form a community of artists

there. The Whitworth drawing
(Van Gogh referred to his
watercolours as drawings rather
than paintings) can be compared
to other watercolours of the
Clichy area, now in the
Rijksmuseum Vincent van
Gogh, Amsterdam.

Sir Thomas Barlow made his
career in the family's Manchester
textile business and was a
considerable collector, primarily
of Old Master paintings and of
Dürer prints. He was Chairman
of the Whitworth Institute from
1930 to 1958, when he
suggested that the gallery and its

collections should be offered to
the University of Manchester.
The gallery's lecture theatre is
named after him. M C

PROVENANCE Mrs J. van Gogh-
Bonger, Amsterdam; V.W. van Gogh,
Laren; Leicester Galleries, London; Sir
Thomas Barlow; 1927: presented to the
museum by him
EXHIBITIONS London, 1962, no. 243;
*French 19th Century Drawings in the
Whitworth Art Gallery*, Manchester, 1981,
no. 34; *Van Gogh à Paris*, Paris, Musée
d'Orsay, 1988, no. 49; *Vincent van Gogh
Drawings*, Otterlo, Rijksmuseum Kröller-
Müller, 1990, no. 160
REFERENCE J.-B. de la Faille, *The
Works of Vincent van Gogh: His Paintings
and Drawings*, London, 1970, no. 1404

256

Edgar Degas (1834–1917)
Half-length Nude Girl,
c. 1898

charcoal, heightened with white, on
tracing paper, 53.3 × 38.7 cm
Atelier stamp: *Degas*
Lent by the Syndics of the
Fitzwilliam Museum, Cambridge,
PD 35–1978

This and two other drawings of
clothed dancers in a similar pose
(Degas sales II, no. 334, and IV,
no. 193) are probably studies for
the left-hand dancer in a richly
coloured pastel of square format,
Behind the Scenes (Pushkin Fine
Art Museum, Moscow). This
dates from about 1898 and is
closely related to two other
pastels (Lemoisne 1344, 1352)
which, in turn, can be linked to
the large painting *Four Dancers*
(National Gallery of Art,
Washington). The complex
inter-relationships of Degas's art
are further demonstrated by the
possible origin of the pose of the
dancer with a raised arm in a
glass collodion-plate photograph
of *c.* 1895 or earlier, possibly
made by Degas and certainly
belonging to him (Bibliothèque
Nationale, Paris). Moreover, the
same pose already occurs in a
drawing of *c.* 1865 (Louvre,
Paris) for the painting *Medieval
War Scene* (Musée d'Orsay, Paris).

 Andrew Gow was by training
a Classical scholar. A Fellow of
Trinity College and Syndic of the
Fitzwilliam, he always intended
that his collection should be left
to the museum. He began
collecting shortly before World
War II and continued to do so
until the late 1960s. He had a
fondness for French art of the
late 19th century, and Degas in
particular. M C

PROVENANCE 1918, 6–7 November: Paris, Degas sale III, lot 247; 1949: purchased from Redfern Gallery, London, by Andrew Gow; 1978: bequeathed by him to the museum
EXHIBITIONS *Selected Works from the Andrew Gow Bequest*, London, Hazlitt, Gooden & Fox, 1978, no. 30; *The Private Degas*, Manchester, Whitworth Art Gallery, and Cambridge, Fitzwilliam Museum, 1987, no. 94

257

Pablo Picasso (1881–1973)

Poverty, 1903

pen and ink and wash on paper, 37.5 × 26.7 cm
The Whitworth Art Gallery, University of Manchester, D.1928.4

Picasso painted this study while living in Barcelona, still a poor and unrecognised artist. A palette of blues and a pre-occupation with the down-and-outs in society are both characteristic of this phase in his oeuvre, later termed the Blue period.

In *Poverty* there are religious associations: the frail and destitute family bear a resemblance to images of the Holy Family on the Flight into Egypt. The sense of despair in much of his work at this time has been associated with the grief that Picasso suffered after the suicide of his friend Casegames, in 1901. Such works reflect, too, the influence of the Symbolist painters, such as Puvis de Chavannes (1824–98), whose images of lonely individuals also exhibit a restricted range of colours. Mortality is communicated by the skull-like appearance of the heads of both mother and baby. R B

PROVENANCE 1928: presented to the gallery by A.E. Anderson
REFERENCE *The Whitworth Art Gallery: The First Hundred Years*, Manchester, 1988, p. 98 (ill.)

258

Henri Gaudier-Brzeska (1891–1915)

Two Warriors, 1913

pen and ink on paper, 38 × 51 cm
Middlesborough Art Gallery
(Middlesborough Art Gallery)

Born Henri Gaudier in Neuville St Vaast in France, the sculptor changed his name after meeting the Polish artist Sophie Brzeska. Gaudier-Brzeska's brilliant career was cut short when he was killed in 1915, fighting in the French Army in World War I.

Two Warriors was a sketch he made while working in London in 1913, the year in which he met the artist-critic Roger Fry and the poet Ezra Pound and in which he started exhibiting his first sculptures. Gaudier-Brzeska was also a friend of Percy Wyndham Lewis (cat. 384) and contributed statements on Vorticist sculpture to Lewis's short-lived, but important magazine *Blast*.

Two Warriors displays a freedom of line and an energetic primitivism which was also emerging in his sculptures of the period, in which the influence of Brancusi and Epstein became more apparent. R B

PROVENANCE 1978: purchased by the gallery from Mercury Gallery, London, with assistance from the Victoria and Albert Museum Purchase Grant Fund

259

Amedeo Modigliani
(1884–1920)

Caryatid, c. 1912

pencil and blue crayon paper,
56 × 42.3 cm
The Garman-Ryan Collection,
Walsall Museum and Art Gallery,
GR170

Modigliani became attracted to
the subject of caryatids –
sculpted female figures used as
columns – around 1911, while
living in Paris. The great
expressive freedom of the figures
in his first caryatid drawings
gave way to a more austere
sculptural style in 1912 and
early 1913.

 In drawings such as this he
makes no use of shading to
suggest depth, which is rendered
quite simply by the precision of
the artist's line. Any spatial
references are purely decorative.
The influence of African masks,
tattoos, earrings and necklaces
had begun to appear in
Modigliani's work from *c.* 1910.

 The artist's drawings were
clearly intended to reach fruition
in sculptural form and
Modigliani did indeed attempt
to carve a caryatid in stone, but
was forced to abandon it as
physically too demanding. R B

PROVENANCE before 1920: given to
Jacob Epstein by the artist in Paris; Lady
Epstein; donated by her to the gallery
REFERENCES F. Russoli, *Modigliani
Drawings*, London, 1969; N. Alexandre,
The Unknown Modigliani, 1993,
pp. 189–92

260

Constantin Brancusi
(1876–1957)
Nude, before 1927

pen and ink on paper, 30 × 22.8 cm
inscribed: *C. Brancusi*
Kettle's Yard, University of
Cambridge, CBI

The Romanian sculptor
Constantin Brancusi, who spent
most of his life in Paris, had an
enormous influence on modern
concepts of form, both in the
fine arts and in the design of
manufactured objects. The
strong sensuality that marks his
sculpture also finds expression in
his drawings. Brancusi believed
passionately in the importance of
constantly drawing the human
form, both for its own sake and

as preparation for three-
dimensional work. The present
undated nude bears no obvious
relationship to any known
sculpture by the artist.

In his autobiography, *A Way
of Life*, H.S. ('Jim') Ede, to whom
Brancusi gave the drawing in
1927, wrote: 'When I first went
to see Brancusi, I felt that all the
elements were there collected in
his studio, almost as though it
were nature's workshop. There I
found air and light, and the
poise and rhythm of his carvings.
It was only the first of many
visits and I never lost the sense
of living energy.' R B

PROVENANCE 1927: given by the
artist to H.S. ('Jim') Ede; 1966: donated
by him to the University of Cambridge
EXHIBITION *Drawing the Line*, London,

Hayward Gallery, *et al.*, 1995, no. 84
REFERENCE S. Geist, *Brancusi: The
Sculpture and Drawings*, New York, 1975

261

Emile Nolde (1867–1956)
Head with Red-Black Hair,
c. 1910

watercolour on paper, 40.3 × 32 cm
Leicestershire City Museums,
F8.1944

Significant influences on Nolde's
work were the landscape of his
native North Germany and
religion. In 1906 he joined the
Brücke, an Expressionist artists'
collective whose members were
inspired by 'primitive' non-
European art and the European
avant-garde.

By 1908 Nolde's work had
become populated with
grotesque figures, rendered
schematically. He began
producing works on religious
themes and scenes of urban night
life. This head, artificially lit
from below, is an image in
which a 'primitive essence' of
character is defined through
colour and light. D B

PROVENANCE 1944: purchased by the
museum from Mrs T. Hess, Leicester
EXHIBITION *Watercolours and Drawings*,
London, Roland, Browse & Delbanco,
1952, no. 38
REFERENCES *Leicester Museum and Art
Gallery: Watercolours and Drawings*,
Leicester, 1963, no. 235 (as *The Mask*);
B. Herbert, 'German Expressionists at
Leicester', *Arts Review*, XXIII/12, 19 June
1971, p. 377

262

Henry Moore (1898–1986)

Pit Boys at Pit Head, 1942

pencil, pen and ink, charcoal, wax
crayon and wash on paper,
33.5 × 54.6 cm (sight size)
Wakefield Museums and Arts
(Wakefield Art Gallery and
Museum)

Henry Moore attended Leeds
College of Art and the Royal
College of Art, London, in the
1920s. 'Primitive' art and
Classical sculpture were the main
influences on his work, inspired
by visits to the British Museum
and the writings of Roger Fry
(1866–1934). Moore, along with
Barbara Hepworth (cat. 393),
believed in 'truth to materials', a
credo which entailed working
with the organic properties of
the materials themselves through
'direct carving'. The human
figure – and, by extension, the
human condition – was Moore's
sole concern as he sought to
invent a physical language that
was universal, independent of
socio-cultural and other
historical frameworks.

During World War II, Moore
worked as an Official War Artist,
making drawings of Londoners
sheltering in Underground
stations and of coal-miners near
his native Castleford. *Pit Boys at
Pit Head* is a portrait of four
disconsolate miners, the lines
etched in their faces as if in
stone. In this series of drawings,
Moore was interested in
portraying the alienation of the
miners' lives as well as the sheer
brutality of their daily working
conditions. DB

PROVENANCE 1947: presented to the
gallery by the War Artists Advisory
Committee
EXHIBITIONS *Henry Moore: War
Drawings*, London, Imperial War
Museum, 1976; *Henry Moore Drawings*,
London, Tate Gallery, and Ottawa,
National Gallery of Ontario, 1977–8

263

Dame Barbara Hepworth
(1903–75)

Figures, 1949

oil and pencil on board,
40.6 × 57.2 cm
inscribed: *Barbara Hepworth*
27/11/49
Collection of Rugby Borough
Council (University of Warwick)

From 1947 to 1951 the
Yorkshire-born sculptress
Barbara Hepworth executed two
series of figurative drawings.
That devoted to life drawing
demonstrates her rekindled
interest in the male and female

nude, which had been the
subject of numerous drawings
during the 1920s. The linear
style of this work suggests some
influence from her husband, Ben
Nicholson.

Instead of professional models,
Hepworth used trained dancers,
who were asked to move
naturally, rather than to adopt
traditional art school poses. Alan
Bowness has written about the
technique of these drawings,
again citing Nicholson's richly
textural paintings of the early
1930s as an influence: 'The
rhythm of the figure is expressed
in the pencil line which

describes the form. Some of the
drawings are done on paper . . .
but these tend to be the more
summary ones. The more
considered early ones are drawn
on boards prepared with
scumbled oil paints muted in
colour [as here]; this is often
scraped and rubbed off in places
As the drawing proceeds, the
pencil lines are strong and
delicate, sometimes heightened
with a coloured line – a red
crayon – and supported by softly
shaded areas to bring out the
forms. There is, however, no
question of a three dimensional
realisation of the figure as there

was in the very early drawings:
the search is much more for the
rhythm of a figure in movement.
Profiles for example are
important in giving a rhythmical
pulse to the whole drawing.' RB

PROVENANCE 1951: presented to
Rugby by the Contemporary Art Society
REFERENCES *The Rugby Collection:
Artists of Promise and Renown*, Rugby,
1986, p. 24, no. 30; *Barbara Hepworth:
A Retrospective*, exh. cat., Liverpool, Tate
Gallery, 1994, pp. 88–92

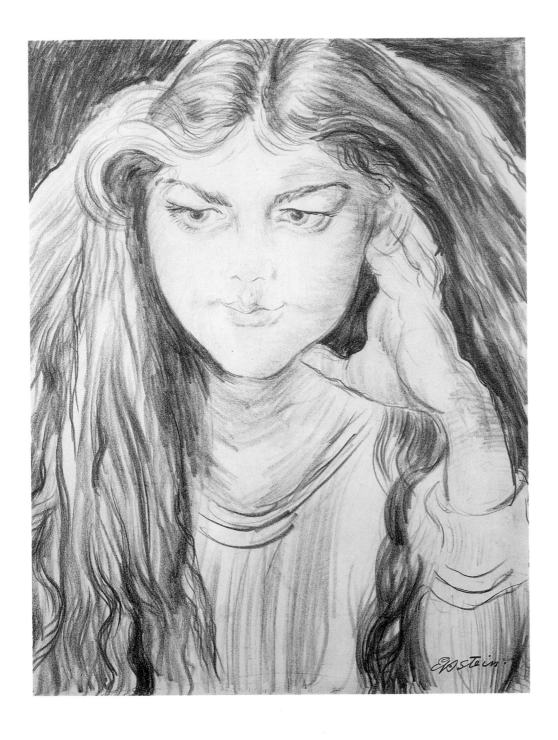

264
Sir Jacob Epstein
(1880–1959)
Portrait of Kitty, 1937
pencil on paper, 56 × 43.5 cm
inscribed: *Epstein*
The Garman-Ryan Collection,
Walsall Museum and Art Gallery,
GR70

Kathleen (born 1927), known as
Kitty, was the second-born child
of Epstein and Kathleen Garman
(see cat. 398). She was ten years
old when Epstein made this
drawing. His earliest sculpted
portrait of her was done in 1944
(*Kitty with Curls*). Thereafter, in
1948 and 1957, he made two
further sculptures of her. Kitty
married the painter Lucian Freud
in 1948 (the marriage was
dissolved in 1952).

Kitty's intense, brooding
expression, the rhythmic
character of the drawn lines, the
close-up, cropped focus, all
contribute to the disturbing and
powerful effect of this portrayal.
It has something of the mystical
quality of a drawing by William
Blake; something of the morbid
introspection of a Pre-Raphaelite
illustration. One cannot but
wonder whether it helped to
fashion Freud's own approach to
portraiture, which made use of
similar stylistic and compo-
sitional devices. W B

PROVENANCE Garman-Ryan
Collection; 1972: given to the museum
REFERENCES R. Buckle and Lady
Epstein, *Epstein Drawings*, London, 1962,
p. 22, pl. 60; *Jacob Epstein: Sculpture and
Drawings*, exh. cat. ed. E. Silber and T.
Friedman, Leeds, City Art Galleries, and
London, Whitechapel Art Gallery, 1987,
repr. 1989, pp. 254 (ill.), 258, no. 162

265

Sir Stanley Spencer RA
(1891–1959)

Self-portrait, c. 1912

red chalk on two pieces of paper,
40 × 22 cm
Williamson Art Gallery and
Museum, Birkenhead, BIKMG 3224

Stanley Spencer was born on 30
June 1891 at Cookham-on-
Thames, the village in Berkshire
which became so central to his
life and art. He studied at the
Slade School of Art in London
from 1908 to 1912, commuting
daily from his beloved Cookham
to the bewilderment of the other,
more metropolitan students,
such as C.R.W. Nevinson, David
Bomberg and Mark Gertler, who
collectively made up one of the
greatest student classes in the
history of English art. This self-
portrait drawing, which was
made towards the end of
Spencer's time at the Slade,
belonged to Sir Edward Marsh,
one of his most important early
supporters. Marsh was a generous
patron and benefactor and a
devoted champion of the
Contemporary Art Society (CAS),
serving as its chairman from
1936 to 1952. This drawing was
among the 200 works of art that
made up the Sir Edward Marsh
Bequest in 1953, a gift to the
CAS which enriched the
collections of almost every public
gallery in Britain. R W I

PROVENANCE Sir Edward Marsh;
1953: bequeathed by him to the CAS;
1954: presented to the gallery by the CAS
EXHIBITIONS *Drawings by Stanley
Spencer*, London, Art Council Gallery, *et
al.*, 1954; *Stanley Spencer: Heaven on Earth*,
New York, CDS Gallery, 1983; *Stanley
Spencer: A Sort of Heaven*, Liverpool, Tate
Gallery, 1992

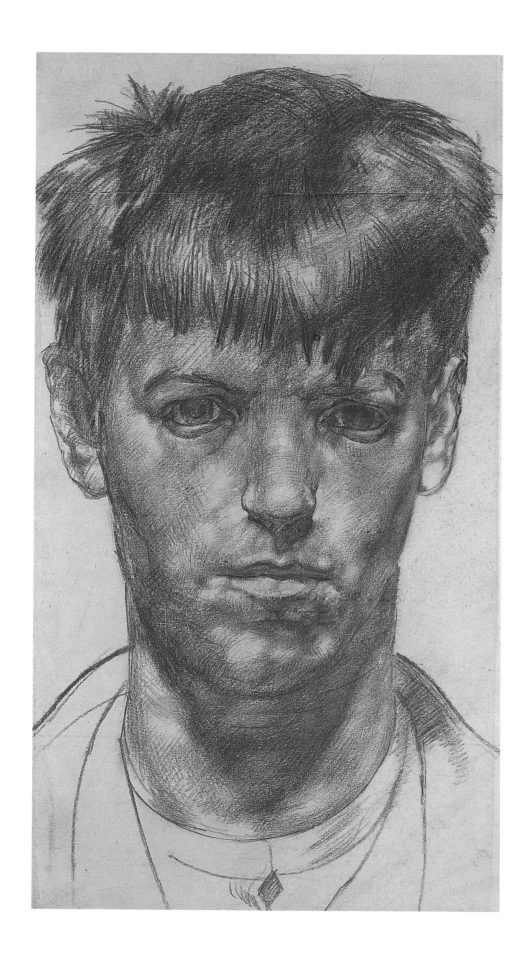

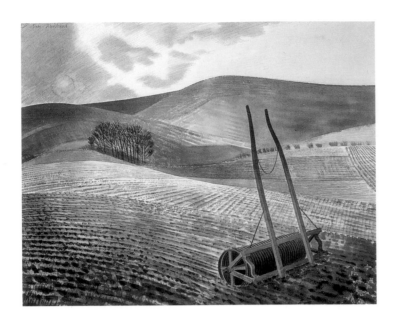

266

Eric Ravilious (1903–42)

Downs in Winter, c. 1934

watercolour on paper, 45 × 55 cm
Towner Art Gallery, Eastbourne, 656

Ravilious, after attending
Eastbourne College of Art, went
in 1921 to the Design School at
the Royal College of Art in
London, where he met Edward
Bawden. The two were among
the ablest pupils of Paul Nash
(cat. 381, 385) at the Royal
College, emerging with a
quirkily English vision and a
diversity of skills.

Although he had moved away
from Sussex, Ravilious continued
to paint the gentle but stark
beauty of the South Downs, with
their wide vistas and rolling
contours. Old and abandoned
machinery also held a lasting
fascination for him: in an almost
archaeological sense, it gave clear
proof of man's activity, though
the human figure itself seldom
appears in Ravilious's
watercolours, giving them a
haunted and slightly surreal
aspect. It was probably these
qualities which appealed most
directly to Kenneth Clark in
1939, when Ravilious was
commissioned as an Official War
Artist. For the next few years,
before his tragic disappearance
on a mission over Iceland,
airfields, submarines, shipping in
the North Sea and the waters
around Iceland and Scandinavia
were to provide a rich vein of
subject-matter for his brush and
lithographic chalk. *The Downs in
Winter*, an early example of
Ravilious's fully mature style,
with its dry and linear use of
watercolour, was acquired by the
Towner Art Gallery at
Eastbourne in 1936, soon after it
was painted. The Towner has

always had a strong bias towards
artists from Sussex. Since 1936
the gallery has consistently
collected work by Ravilious in
all media and now has a room
devoted to his work. PS

PROVENANCE 1936: acquired by the
gallery
EXHIBITION *Eric Ravilious 1903–42:
A Re-Assessment of his Life and Work*,
Eastbourne, Towner Art Gallery, 1986,
no. 8
REFERENCE F. Constable, *The England
of Eric Ravilious*, London, 1982

267

David Jones (1895–1974)

Vexilla Regis, 1947–8

pencil, watercolour and body colour
on paper, 75 × 55 cm
inscribed: *David Jones 1948*
Kettle's Yard, University of
Cambridge, DJ4

In 1946–8, David Jones made a
series of large drawings of trees
at Bowden House in Harrow, the
nursing home where he went to
recuperate after a bout of mental
illness. *Vexilla Regis* is, in some
senses, the culmination of these
works. Jones's observation of the
natural world is here transformed
by layers of complex symbolism
in which the present and the
past, the material and the
spiritual, history and myth
coexist and even coalesce.

The title, meaning 'the
standards of the king', is taken
from a Latin hymn which formed
part of the Roman liturgy for
Good Friday – words which
Jones had already used in a small
inscription a few years earlier. In
a letter to the painting's first
owner, Jones attempted to
unravel some of its meaning,
beginning with the hymn, 'in
which are many allusions to the
tree and the Cross, and to the

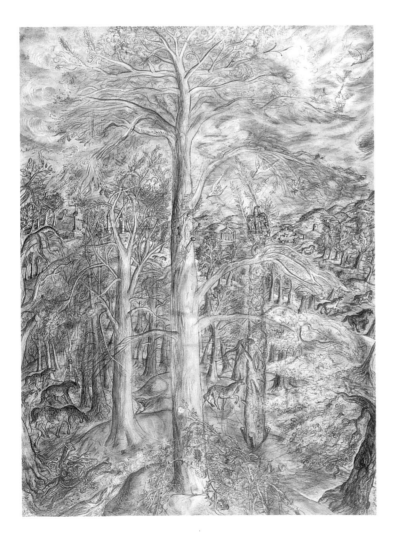

Cross as a tree etc'. The Crucifixion imagery extends to the two trees flanking the central one, that on the left evoking the good thief of the gospel narrative, while the right-hand trunk, not rooted, but supported by wedges, is crowned by a Roman standard as an emblem of worldly power and ambition.

Though not acquired directly by Jim Ede, the founder of Kettle's Yard, the painting accords well with his aim to create, as he put it in his introduction to the collection *Handlist* of 1970, 'a continuing way of life ... in which stray objects, stones, glass, pictures, sculpture, in light and space, have been used to make manifest the underlying stability which more and more we need to recognise if we are not to be swamped by all that is so rapidly opening up before us'. The house was accepted by the University of Cambridge in 1966, in order that future generations of students should continue to benefit from its unique atmosphere. T W

PROVENANCE 1949: bought from the artist by Mrs Ede; 1953: bequeathed by her to her son, H.S. ('Jim') Ede; 1966: donated by him to the University of Cambridge
EXHIBITIONS London, Redfern Gallery, 1948; *David Jones*, London, Tate Gallery, 1981, no. 122
REFERENCE N. Gray, *The Painted Inscriptions of David Jones*, London, 1981, no. 6; *idem*, *The Paintings of David Jones*, London, 1989, p. 48

268

John Northcote Nash (1893–1977)

Summer: Stoke by Nayland, 1947

watercolour and crayon on paper, 45.5 × 57 cm
Rochdale Art Gallery, 704

Like his better known elder brother, Paul, John Nash excelled as a landscapist, both as an Official War Artist in 1918 and later, when he taught at the Royal College of Art in London (1934–57).

This delicately observed study of Stoke by Nayland, where Nash lived for many years, is executed in watercolour and crayon, a combination which the artist, who frequently experimented with medium and technique, often favoured. The landscape reveals his mastery of watercolour, a medium perfectly suited to the subtle restraint of his vision. The visionary and poetic force of the work shows Nash capable of imbuing his landscape with an evanescent mystery comparable to that evinced by his brother's work. The delicate range of summery pinks, greens and mauves are characteristic of John Nash's landscape studies in the post-war years. R B

PROVENANCE 1948: purchased by the museum for £42 from the Royal Academy's Summer Exhibition using funds from the W.C. Bright Bequest
EXHIBITIONS *Frameworks*, Rochdale Art Gallery, 1992; *Who's Collecting Who*, Rochdale Art Gallery, 1993
REFERENCES J. Rothenstein, *John Nash*, London, 1983, p. 82; A. Freer, *John Nash: The Delighted Eye*, London, 1993

269

Edward Burra ARA
(1905–76)

Silver Dollar Bar, 1955
watercolour heightened with body
colour on paper, 104.8 × 73.3 cm
York City Art Gallery, R1437

Weakened from childhood by
arthritis and chronic anaemia,
Burra lived all his life in his
parents' house in Rye, Sussex.
There he developed his unique
and idiosyncratic vision,
expressed in full, densely
coloured watercolour, tempera
and gouache drawings. When
his health permitted, he travelled
abroad, often with friends,
including Paul Nash, who lived
for a time in Rye, and the
American poet Conrad Aiken.
Like Toulouse-Lautrec, also set
apart by physical infirmity,
Burra frequented nightclubs,
bars and brothels. Silver Dollar
Bar was a nightclub in Boston,
first visited by Burra in 1937.
He wrote to Paul Nash at the
time: 'The Silver Dollar Bar
must be seen to be believed such
a clientele of human debris
interspersed with dwarfs,
gangsters, marines and hostesses
fresh from the morgue.'

Silver Dollar Bar probably
dates from 1955, when Burra
visited America for the last
time. W B

PROVENANCE 1955: Swetzoff Gallery,
Boston; Lefevre Gallery, London; 1980:
purchased by the gallery
EXHIBITIONS Boston, Swetzoff
Gallery, 1955; *Edward Burra: Paintings
from America*, catalogue foreword by
B. Robertson, London, Lefevre Gallery,
p. 3, no. 6; *Edward Burra*, London,
Hayward Gallery, *et al.*, 1985–6, no. 110
REFERENCE: A. Causey, *Edward Burra:
Complete Catalogue*, Oxford, 1985, no. 235

OLD MASTER PAINTING
AND SCULPTURE

OLD MASTER PAINTING
AND SCULPTURE

The wealth and diversity of Old Master paintings in England's regional museums is largely due to a succession of remarkable benefactors, collectors, curators and directors. Inevitably, these individuals did not attempt to create comprehensive collections of Western art, but were led instead by their personal taste.

One of the earliest was Viscount Fitzwilliam of Merrion, Dublin, who in the mid-18th century collected paintings by Italian, Dutch and Flemish masters which he bequeathed to the museum in Cambridge that bears his name. Even more enterprising was the Liverpool banker and historian William Roscoe. In the early 19th century, he amassed a collection of Italian and Netherlandish primitives to illustrate the development of art up to the Renaissance, many of which are now in the Walker Art Gallery (cat. 270, 276). At the end of the century, both Thomas Kay – manufacturer of patent medicines – and the Cheetham family, who made their fortune in cotton, created notable collections of Italian primitives which now adorn the museums of Rochdale and Stalybridge (cat. 271, 272, 274). But the greatest of all such bequests was that of John and Josephine Bowes, who lived in Paris in the mid-19th century, where they bought French, Italian and Spanish paintings – including El Greco and Goya (cat. 289, 329), at that time unappreciated in Britain – which are now in the Bowes Museum, Barnard Castle.

Other bequests have created – or transformed – regional museums. Among these are the Dutch and Flemish pictures bequeathed to Cheltenham by Baron de Ferrieres, to Barnsley by William Harvey (cat. 301, 309, 315), and to Manchester City Art Gallery by Mr and Mrs E. Assheton Bennett (cat. 307). More diverse was F.D. Lycett Green's bequest of Old Masters to York in 1955 (cat. 285, 290) and Ernest Cook's great collection, which was distributed to over 100 museums throughout Britain. In 1932 Lady Barber created an institute bearing her name by donating a lump sum (but no pictures) to provide a gallery for Birmingham worthy of the National Gallery or the Wallace Collection.

Certain museums have collected artists who were unfashionable at the time. Among these are the remarkable group of Italian Baroque paintings acquired by Birmingham Museum and Art Gallery in the years after World War II (cat. 296), the fine collection of Dutch art at the Ferens Art Gallery, Hull (cat. 305, 311), and the impressive holdings of French Neoclassical painting formed at Bristol and Cambridge (cat. 331, 336). Most spectacular of all, however, has been the continuing success of the Walker Art Gallery – the only nationally funded Old Master collection in the English regions – in acquiring major masterpieces by Poussin, Elsheimer, Van Cleve and Van Vliet in the last twenty years (cat. 283, 291, 298, 310). R V

270

Simone Martini
(*c.* 1284–1344)

The Christ Child discovered by his Parents in the Temple, 1342

tempera and gold on panel,
49.6 × 35.1 cm
inscribed: *SYMON. DE.SENIS.ME PINXIT. SVB. A.D. M. C{CC}XL.II* (on frame) and *Fili qui{d} fecesti n{obis}* ...(on the Virgin's book)
Board of Trustees of the National Museums and Galleries on Merseyside (Walker Art Gallery, Liverpool), WAG 2787

The subject is taken from Luke 2:48: while staying in Jerusalem for the feast of the Passover, the Virgin and St Joseph were separated from the boy Jesus; after searching for three days they found him in the temple disputing with wise men. The words of the Virgin – 'Son, why hast thou thus dealt with us?' – are inscribed in her book.

Simone Martini, the greatest Sienese painter of his generation, worked from 1339 until his death at the Papal court, then in exile in Avignon, where this panel, his last known work, was painted. His exquisite style and keen sensibility to the expression of character through gesture is particularly evident in this panel, which was made as an independent work of art, its original frame elaborately decorated with punchwork, its back painted to simulate polychrome marble.

When William Roscoe catalogued his collection in 1816 it contained 43 paintings that could be described as 'primitive', 32 of them Italian. His intention was to illustrate the progress of art from primitive beginnings to

the High Renaissance both through his collection and in a projected book, *The Historical Sketch of the State of the Arts during the Middle Ages.* On 12 May 1804 he informed his wife that he had bought some paintings once in the collection of the Earl of Bristol, a pioneer collector of Italian 'primitives'. Unlike the Earl-Bishop, who travelled extensively on the Continent, Roscoe amassed his remarkable collection entirely in England. A note in Roscoe's sale catalogue found by Burton Fredericksen in the Rijksbureau voor Kunsthistorische Documentatie, The Hague, states: 'The Marquis Riccardi when in Liverpool went to the Royal Institution – on seeing this painting Lot 8 by Simone Memmi he said "This was stolen from my father's library".' JTM

PROVENANCE (?) Florence, Vincenzo Riccardi (died 22 September 1752); 4th Earl of Bristol; 1802, 9–10 April: Christie's, London, lot 13, bought by Colonel Matthew Smith, Governor of the Tower of London; 1804, 12 May: his sale, Christie's, London, lot 40, bought by William Roscoe for £5. 5*s.*; 1816, 17 September: Winstanley, Liverpool, Roscoe sale, no. 8, bought in; by 1819: presented to the Liverpool Royal Institution; 1848: presented to the gallery
EXHIBITIONS Manchester, 1857, no. 37; London, RA, 1881, no. 225; London, New Gallery, 1894, no. 79; *Exhibition of Italian Art, 1200–1900*, London, RA, 1930, no. 55; *Italian Art and Britain*, London, RA, 1960, no. 306; London, 1962, no. 2
REFERENCES M. Compton, 'William Roscoe and early Collectors of Italian Primitives', *Liverpool Bulletin*, IX, 1960–1, pp. 27–50; *Walker Art Gallery, Liverpool: Foreign Catalogue*, 2 vols., Liverpool, 1977, no. 2787; A. Martindale, *Simone Martini*, Oxford, 1988, pp. 190–1; J. Gardner, 'The Back of the Panel of Christ discovered in the Temple by Simone Martini', *Arte Cristiana*, NS, 741, 1990, pp. 389–98

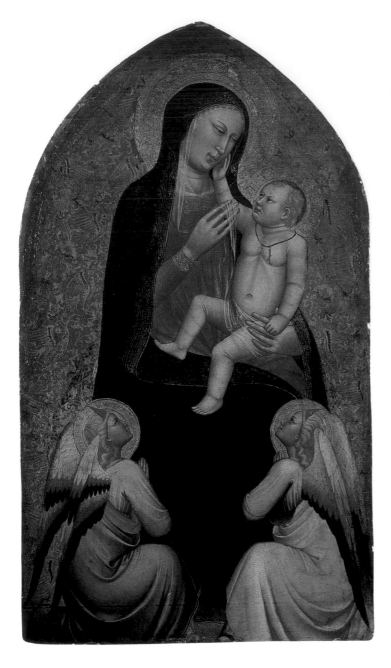

271

Jacopo di Cione
(*fl.* 1365–98) and
workshop
*Virgin and Child with two
Adoring Angels, c.* 1380
tempera and gold leaf on panel,
106.2 × 60.6 cm
Astley Cheetham Art Gallery,
Stalybridge, Tameside MBC Leisure
Services, 1923.3

This once formed the central
panel of an altarpiece; it has been
cut at the base and mounted in a
19th-century 'Gothic' frame.
Before 1931 it was ascribed to
Cimabue; many early Italian
panels passed through the sales
rooms with highly optimistic
attributions. In *Presents from the
Past* Jonathan Alexander
attributed the painting to Jacopo
di Cione, comparing it to a

Virgin of Humility (Accademia,
Florence) with virtually identical
punched patterns in the haloes.

Jacopo di Cione came from a
Florentine dynasty of painters,
the greatest of whom was his
brother, known as Andrea
Orcagna. This intimate
devotional painting is typical of
the Orcagna workshop. Jacopo
often worked in collaboration
with other artists, for example on
a *Crucifixion* now in the National
Gallery, London (no. 1468), in
which the figures generally
attributed to Jacopo have
similarly hooded eyes and
improbably long and elegant
jointless fingers as the Virgin.
The Christ Child wears coral
around his neck to protect him
from evil.

The Cheetham family owned
Bankwood cotton mills in
Stalybridge. This panel could
have been acquired by John
Cheetham of Eastwood House,
Cheshire, or by his son John
Frederick Cheetham
(1835–1916), MP for North
Derbyshire (1880–85) and for
Stalybridge (1905–9), created
Privy Councillor in 1911. The
latter bought paintings from
William Graham's sale in 1886;
they included works attributed
to Masaccio, Baldovinetti and
Bellini, which suggests he had a
taste for 'primitive' art. He
presented Stalybridge with a
Jubilee Memorial Free Public
Library and in 1901 donated the
Art Gallery to the town. JTM

PROVENANCE Rt. Hon. J.F.
Cheetham; Miss Agnes Cheetham; 1931:
bequeathed by her to the gallery
EXHIBITIONS London, 1962, no. 29;
*Medieval and Early Renaissance Treasures
from the North West*, Manchester,
Whitworth Art Gallery, 1976, no. 82;
Presents from the Past, Bolton Museum and
Art Gallery, Oldham Art Gallery, Staly-
bridge, Astley Cheetham Art Gallery, and
Stockport Art Gallery, 1978, no. 2

272

The Master of the Straus
Madonna
(*fl. c.* 1385–1415)
*Virgin and Child Enthroned
with Angels and Saints,
c.* 1410
tempera and gold on panel,
69.9 × 46.3 cm
on the reverse: Milan customs seal
and two paper labels inscribed: 8 (5?);
N7 (?) *Giotto 1276 M.G.*
Astley Cheetham Art Gallery,
Stalybridge, Tameside MBC Leisure
Services, 1923.43

This panel from a small
devotional altarpiece originally
would have had wings on either
side. It shows the Virgin and
Child enthroned, flanked by
angels and, on the left, St James
the Great and St John the
Baptist; on the right, St Julian
the Hospitaller and St Dorothy.
At the Virgin's feet lies Eve,
draped in a transparent shawl
and holding a miniature Tree of
Knowledge. Medieval typology
cast the Virgin Mary as the 'new
Eve', who redeemed the original
sin of Adam and Eve.

Richard Offner named the
Master of the Straus Madonna
after a Virgin and Child, now in
the Museum of Fine Arts,
Houston, that once belonged to
Percy S. Straus. This prolific
Florentine painter had a marked
taste for rich patterning and
decoration and shares stylistic
traits with his contemporary
Masolino. His masterpiece is an
Annunciation in the Accademia,
Florence. For the collector, see
cat. 271. JTM

PROVENANCE (?) John Cheetham; his
son, Rt. Hon. J.F. Cheetham; 1916: Miss
Agnes Cheetham; 1931: bequeathed by
her to the gallery

EXHIBITIONS London, 1962, no. 29;
*The Art of Painting in Florence and Siena
from 1250 to 1500*, London, Wildenstein,
1965, no. 3; *Medieval and Early
Renaissance Treasures in the North West*,
Manchester, Whitworth Art Gallery,
1976, no. 81; *Presents from the Past*, Bolton
Museum and Art Gallery, Oldham Art
Gallery, Stalybridge, Astley Cheetham
Art Gallery, and Stockport Art Gallery,
1978, no. 6; *Early Italian Paintings and
Works of Art, 1300–1480*, London,
Matthiesen Fine Art Ltd, 1983, no. 27

REFERENCES M. Quinton Smith, 'The
Winter Exhibition at the Royal Academy,
I: Paintings of St Fina and of Eve
Recumbent', *The Burlington Magazine*, CIV,
1962, pp. 62–6; M. Boskovits, *Pittura
fiorentina alla vigilia del Rinascimento,
1370–1400*, Florence, 1975, p. 365;
C. Wilson, *Italian Paintings XIV–XVI
Centuries in the Museum of Fine Art,
Houston*, London and Houston, 1996,
pp. 101–3, 115

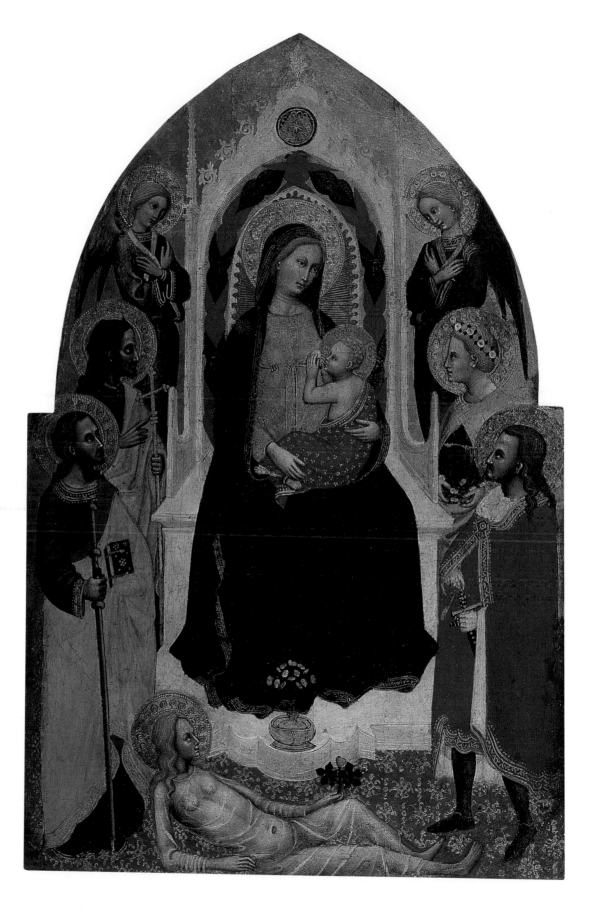

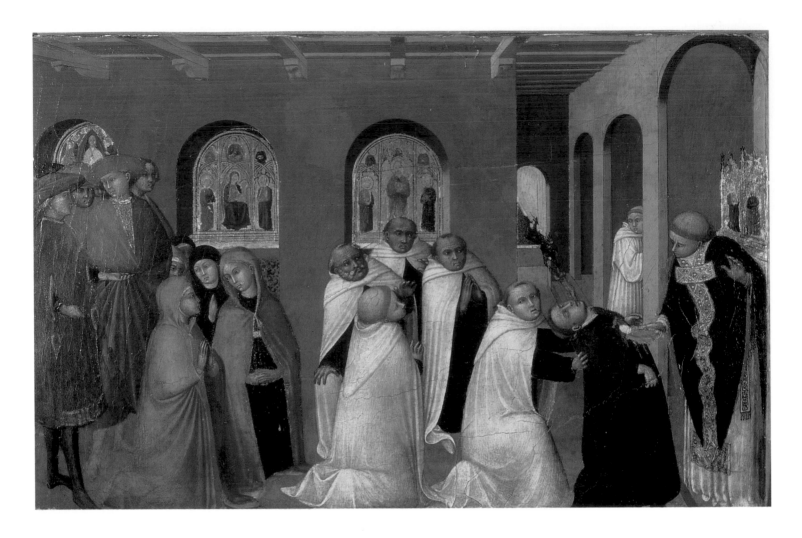

273

Stefano di Giovanni, called
Sassetta (1392–1450)

A Miracle of the Eucharist,
c. 1423–6

tempera and gold on panel,
24.1 × 38.2 cm
The Bowes Museum, Barnard Castle,
Co. Durham, 52

A Carmelite priest, standing
before the high altar of a church,
proffers the sacrament to a
novice, who expires; the latter's
soul – in the form of a miniature
nude – is claimed by a devil and
the host transubstantiates,
bleeding into the paten. Such is
the consequence of offering the
consecrated host to a heretic.

This is one of seven predella
panels from an altarpiece painted
by Sassetta for the Sienese wool
merchants' guild and probably
intended for the Carmelite church
in Siena. The guild sponsored the
Carmelites' celebration of the
feast of Corpus Domini. The
altarpiece, now dispersed and in
part lost, glorified the doctrine of
transubstantiation. Two of its
predella panels show the deaths of
heretics; it has been suggested
that they are John Wycliffe (died
1384) and Jan Hus (burned at the
stake in 1415), both of whom
denied transubstantiation and
whose teachings were condemned
at the Church councils of
Constance (1415) and Siena
(1423–4).

Sassetta's depiction of the
interior of a church complete
with wooden roof and gold-
backed triptychs, of the horrified
Carmelite monks and bewildered
bystanders in contemporary
dress, evinces a clarity and a
sophistication that hark back to
the narrative style of Pietro
Lorenzetti (active 1320–48) and
has parallels with Sassetta's
contemporary Gentile da
Fabriano, who worked in Siena
in 1425.

John and Josephine Bowes
bought this panel for their house
in Teesdale from the dealer
Edward Solly as a Fra Angelico;
Sassetta, a Sienese contemporary
of Angelico's, was virtually
forgotten at the time. Langton

Douglas convincingly attributed
the painting to Sassetta in 1904.
JTM, EC

PROVENANCE 1840, 25 July: Christie's,
London, Duke of Lucca sale, no. 2 (as Fra
Angelico), bought by Edward Solly for
£6. 15s.; bought from him by John and
Josephine Bowes
EXHIBITIONS London, Burlington
Fine Arts Club, 1904, no. 25; *Italian Art
and Britain*, London, RA, 1960, no. 349;
London, 1962, no. 6; *Early Italian
Paintings and Works of Art*, London,
Matthiesen Fine Art Ltd, 1983, no. 32;
Painting in Renaissance Siena, 1420–1500,
New York, The Metropolitan Museum of
Art, 1988–9, no. 1c (with previous
bibliography); *European Paintings from the
Bowes Museum*, London, National Gallery,
1993, pp. 4–5

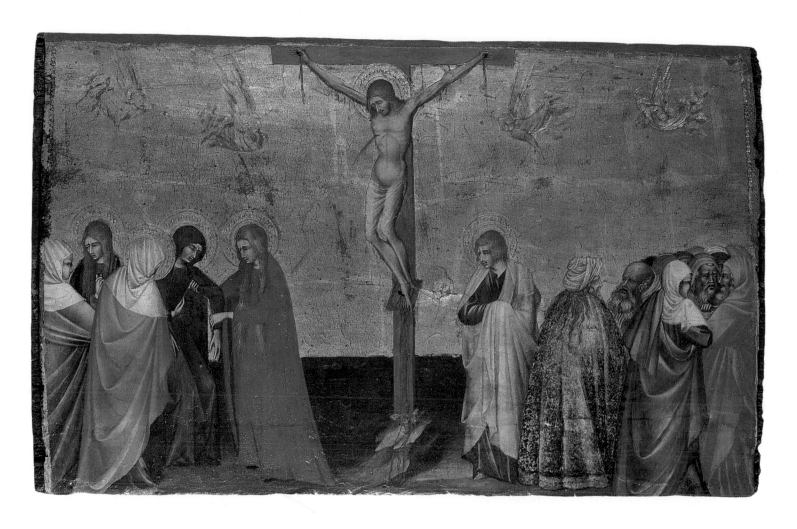

274

Giovanni di Paolo
(active by 1417; died 1482)
The Crucifixion, c. 1423–6
tempera and gold leaf on panel,
30.5 × 49.5 cm
Rochdale Art Gallery, 1240

St John is isolated in his grief at
the foot of the Cross, turning his
back on the animated rabble; the
Holy Women comfort the
Virgin; above, four angels, barely
indicated by lines incised in the
gold ground, beat their breasts
in anguish. Giovanni di Paolo, a
Sienese painter and illuminator,
did much of his work for the
religious communities in his
native town; in the 19th century
many of his altarpieces were

dismembered, their predellas
being cut up into individual
scenes, such as this Crucifixion.
It appears to be an early work,
similar to another Crucifixion in
the Lindenau-Museum,
Altenburg, Thüringen.

Thomas Kay (1841–1914)
made his fortune manufacturing
patent medicines, in particular
throat lozenges. He was a friend
of the painter William Stott of
Oldham (cat. 201), a member of
Manchester Literary and
Philosophical Society, and
travelled widely, collecting
Italian and Dutch works. Kay
was an amateur artist – his
monogram appears as a vignette
at the end of his *Descriptive
Catalogue*. He founded technical
schools at Heywood and

Stockport and in 1911 opened an
art gallery in the Heywood
school, stipulating that if his
collection were not required
there it should be offered to
Stockport. In his catalogue he
wrote that he had selected
paintings to show the 'progress
of Painting and the Decorative
Arts from an early period',
describing this panel as 'a good
example of Byzantine Art,
probably executed in Italy'. JTM

PROVENANCE Acquired by Thomas
Kay from the collection of Mr W.
Grimshaw (of Stoneleigh?), but not from
his sale (Christie's, London, 3 December
1898); 1912: bequeathed to Heywood
Technical School's Art Gallery; 1978:
Kay collection transferred to Rochdale
EXHIBITION *Medieval and Early
Renaissance Treasures in the North West*,
Manchester, Whitworth Art Gallery,
1978, no. 87
REFERENCES T. Kay, *Descriptive
Catalogue of Pictures in the Municipal Art
Gallery of the Technical School at Heywood...*,
Heywood, 1911, pp. 7, 23, 26, no. 1;
M. Alexander, 'An unknown early panel
by Giovanni di Paolo', *Pantheon*, XXX,
iv/4, 1976, pp. 271–4

275

Petrus Christus
(1444–75/6)
Christ as the Man of Sorrows,
c. 1450

oil on panel, 11.4 × 8.6 cm
Birmingham Museums and Art
Gallery, 306'35

This tiny painting combines two
themes: Christ as Man of Sorrows
and Christ as Judge. Crowned
with thorns, Christ displays his
wounds – a reference to the
sacrifice he made for the
redemption of mankind's sins.
To either side mourning angels
hold the sword of judgement and
the lilies of mercy. In meditating
upon Christ's suffering, the

viewer is encouraged to
experience his redemptive
powers, a common devotional
practice in the celebration of
Mass. A further reference to this
is the gushing wound in Christ's
side and the flowing water
below, which link the Sacrament
of Holy Communion with the
promise of salvation.

Active in Bruges, Petrus
Christus was the most important
follower of Jan van Eyck,
though the heavy-featured and
somewhat schematic heads are
typical of Christus and find no
antecedents in Van Eyck's more
expressive art.

Previously ascribed to an
anonymous Flemish master, this
painting was attributed to

Christus in 1962 and is one of
only three works by this artist in
Britain. R V

PROVENANCE Empress Maria Theresa
(?; her seal is embossed in paper and
affixed to the reverse); Rev. Henry Parry
Liddon; his niece, Mary Ambrose; by
descent to M.R. Liddon; Trustees of the
Feeny Charitable Trust; 1935: given by
them to the museum
EXHIBITIONS Loan Exhibition of
Pictures from the City Art Gallery,
Birmingham, London, Agnew's, 1957,
no. 22; Old Masters from the City of
Birmingham, London, Wildenstein, 1970,
no. 3; Petrus Christus, Renaissance Master of
Bruges, New York, The Metropolitan
Museum of Art, 1994, no. 9
REFERENCES City Museum and Art
Gallery, Birmingham, Catalogue of
Paintings, Birmingham, 1960, p. 51;
J. Rowlands, 'A Man of Sorrows by Petrus
Christus', Burlington Magazine, CIV, 715,
1962, pp. 419–23; M. Friedländer, Early
Netherlandish Painting, I, Leiden, 1967,
p. 107; P.H. Schabacker, Petrus Christus,
Utrecht, 1974, pp. 105–6; J.M. Upton,
Petrus Christus: His Place in Fifteenth-
Century Flemish Painting, University Park
and London, 1990, pp. 44–7, 55–7

276

Master of the Virgo inter
Virgines (active 1480–95)
The Entombment, c. 1486

oil on panel, 55.2 × 56.3 cm
Board of Trustees of the National
Museums and Galleries on
Merseyside (Walker Art Gallery,
Liverpool), WAG 1014

This harrowing picture depicts a
moment between the Deposition
and Lamentation of Christ. The
body of Christ has been removed
from the Cross and is borne by
Joseph of Arimathea, Nicodemus
and the Magdalene. At the left,
the Virgin, supported by St
John, is accompanied by two
holy women. As John edges
forward, the distraught Virgin
stares fixedly at Christ, his right
arm dangling aimlessly in space.

In a split second, she will
embrace him and the two groups
will merge.

With large heads, unnaturally
high foreheads and pallid flesh
tones, the figures enacting this
drama express their grief in
gaping expressions of an almost
deranged intensity. Adding to
the impact of the scene is the
desolate landscape and the
cadaverous body of Christ, which
resembles an ordinary corpse.

The anonymous master who
painted this picture was active in
Delft in the late 15th century.
His name derives from a picture
in the Rijksmuseum,
Amsterdam, that depicts the
Virgin seated among four female
saints. About twenty works have
been ascribed to him, including
a large Crucifixion altarpiece in
the Bowes Museum. Of these,
the present painting is certainly
among the greatest. All the
hallmarks of the artist's
uncompromising style appear
here: a contempt for
conventional standards of beauty,
a preoccupation with death and
human frailty, and a willingness
to sacrifice everything for the
most extreme expressions of
emotion. R V

PROVENANCE 1806, 24–26 April:
Skinner, Dyke and Co., London, Count
Truchsess sale, lot 43; 1816: Winstanley,
Liverpool, Roscoe sale, lot 78, bought by
Mason, 1819. presented to the Liverpool
Royal Institution; 1893: deposited at the
Walker Art Gallery; 1948: presented to
the gallery
EXHIBITIONS Manchester, 1857, no.
443; Dutch Art, London, RA, 1929, no.
11; Nord-Niederlandische Primitieven,
Rotterdam, Boymans Museum, 1936, no.
17; Dutch Art 1450–1750, London, RA,
1952–3, no. 13; London, 1962, no. 25
REFERENCES M. Friedländer, Early
Netherlandish Painting, V, Leiden, 1969,
pp. 39–40 and 80, no. 58; Walker Art
Gallery, Foreign Schools Catalogue,
Liverpool, 1963, pp. 112–3; idem, Foreign
Catalogue, Liverpool, 1977, p. 120

277

Bernardino Fungai
(1460–1516)
*The Martyrdom of St
Clement*, 1498–1501

tempera and oil with gold on poplar,
42 × 63.5 cm
York City Art Gallery, 1355

This is one of five predella panels
that once formed part of a large
altarpiece, probably that painted
by Fungai for the church of S.
Maria dei Servi, Siena, of which
the main panel, *The Coronation of
the Virgin,* is still *in situ*. The
central predella panel, depicting
the Man of Sorrows, is untraced;
the others, of which two are in
York City Art Gallery, illustrate
the life of St Clement, to whom
the Servite church was originally
dedicated.

Clement (pope *c.* 91–*c.* 101)
was fourth in succession to St
Peter, but accounts of his
miracles and martyrdom are
apocryphal, derived from the
Golden Legend of Jacobus de
Voragine (died 1298). According
to that source, Clement was
exiled from Rome by the
Emperor Trajan, sent to
Chersonesus in the Crimea and
suffered martyrdom by being
thrown overboard lashed to an
anchor. His disciples prayed that
his body might be restored to
them: the sea receded to reveal a
marble temple on which the
saint's body lay. This miracle is
shown on the right of the panel.

Fungai, a Sienese, was an
engaging, if naive, painter with a
talent for narrative scenes and
delicate landscapes reminiscent
of the Umbrian school. J T M

PROVENANCE 1929, 17 July:
Sotheby's, London, sale, lot 21a, bought
by Zink; Langton Douglas; (?) Paul
Bottenweiser; Sir Thomas Merton,
Maidenhead; his widow, Lady Merton;
1979: purchased by the gallery through
Agnew's with the aid of the Victoria and
Albert Museum, the Pilgrim Trust, the
York Civic Trust, the National Art-
Collections Fund, an anonymous donation
and a public appeal
EXHIBITIONS *Italian Art and Britain*,
London, RA, 1960, no. 349; *Painting in
Renaissance Siena: 1420–1500*, New York,
Metropolitan Museum of Art, 1989,
no. 76d
REFERENCES F.F. Mason Perkins, 'Two
Panel Pictures by Bernardino Fungai',
Apollo, XV, 1932, p. 143; A. Sharf, *A
Catalogue of Pictures and Drawings from the
Collection of Sir Thomas Merton, FRS, at
Stubbings House, Maidenhead*, 1950,
no. vii (with previous bibliography);
B. Berenson, *Italian Pictures of the
Renaissance: Central Italian and North
Italian Schools*, I, London, 1968, p. 150;
C. Wilson, *Italian Painting XIV–XVI
Centuries in the Museum of Fine Arts,
Houston*, London and Houston, 1996,
pp. 256, 261

278

Giovanni Bellini
(*c.* 1430–1516) and studio
*The Madonna and Child
Enthroned with Saints Peter
and Mark and a Donor,*
1505

oil on poplar, 91.4 × 81.3 cm
inscribed: *JOHANNES BELLINUS/
MCCCCCV*
Birmingham Museums and Art
Gallery, P.227'77

Although signed by Giovanni
Bellini and dated 1505, the year
that his great *Sacra Conversazione*
was installed in San Zaccaria and
that Dürer, visiting Venice,
declared the elderly artist to be
'still the greatest painter', this
altarpiece is not accepted as a
fully autograph work. Yet it is
an interesting product of
Bellini's studio at the time that
Titian was working in it.

This small-scale altarpiece will
have been commissioned by the

unidentified donor kneeling
before the Virgin and Child. It
has been suggested that it was
sent from Bellini's studio to the
Venetian mainland and that the
donor's head was added by a
local artist, possibly in Verona,
where the painting is first
recorded. The identity of the
right-hand saint is in doubt,
although in the absence of any
attribute St Mark, patron saint of
Venice, is now more generally
accepted than St Paul; the other
saint is Peter. The saints' heads
are of great quality and closest to
Bellini's own style at this date;
that of the Madonna is more
likely to have been executed by a
studio assistant. J T M

PROVENANCE By 1648: Muselli
collection, Verona; 1718: Sereghi
collection; 1801, 16 February: White's,
London, John Purling sale; 1807: Edward
Cox sale; 1812: Christie's, London, John
Humble sale, bought by Samuel
Woodburn; 1814: Great Yarmouth,
William Carey's sale, bought by Dawson
Turner; 1852: Christie's, Dawson

Turner's sale, bought by Niewenhuis; by 1878: at Ashburnham House; 1899: sale of 5th Earl Ashburnham, bought by Vernon Watney of Cornbury Park; Mr Oliver Vernon Watney; 1977: bought by public subscription with assistance of special government grants and contributions from charitable trusts, industry, commerce, The City of Birmingham, West Midlands County Council, the National Art-Collections Fund, the Victoria and Albert Museum Purchase Grant Fund and the Friends of the Museum and Art Gallery

EXHIBITIONS London, RA, 1895, no. 116; *A Bellini from Birmingham*, NACF masterpiece loan, London, National Gallery, 1993 (no catalogue)

REFERENCES P. Cannon-Brookes, *The Cornbury Park Bellini: A Contribution towards the Study of the Late Paintings of Giovanni Bellini*, Birmingham, 1977; D.A. Brown, 'Bellini and Titian', in *Titian*, exh. cat., Venice, Palazzo Ducale, and Washington, National Gallery of Art, 1990, pp. 59–60; A. Tempestini, *Giovanni Bellini: Catalogo completo*, Florence, 1992, no. 92, pp. 258–9 (with previous bibliography)

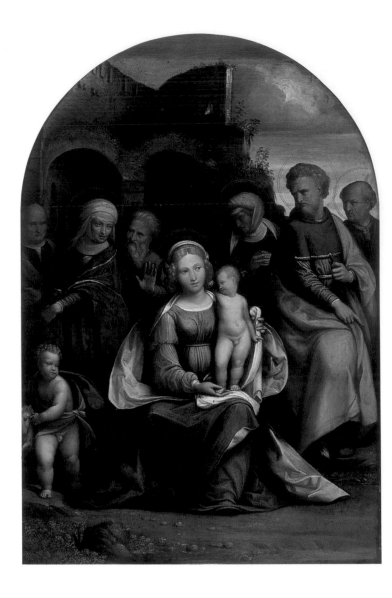

279

Benvenuto Tisi, called
Garofalo (*c.* 1476–1559)

*Virgin and Child with
Saints*, *c.* 1512

oil on panel, 63.5 × 43.1 cm
Northampton Museums and Art
Gallery, D.3.1946–7

A native of Ferrara, Garofalo was
a prolific painter of altarpieces
and small devotional pictures,
many of them modelled on
works by Raphael which he saw
on several early visits to Rome.

 This picture depicts the
Virgin and Child seated with
Joseph at the right and the
infant Baptist holding a lamb on
the opposite side. Behind this
group are five standing saints
whose identity remains
uncertain. The aged couple
immediately behind the Baptist
are probably intended to
represent his parents, Elizabeth
and Zacharias, while the
comparable figures behind
Joseph may be Joachim and
Anna, parents of the Virgin. If
these identifications are correct,
the picture may be read as an
extended Holy Family. The
standing man at the extreme left
of the composition bears no
attributes and would appear to
be unidentifiable.

 The picture is typical of
Garofalo in its graceful and
mobile poses, delicate modelling
and rich colouring. Also
characteristic is the atmospheric
landscape background with
Classical ruins and the somewhat
uncoordinated actions of the
figures, whose poses appear only
loosely interrelated.

 The large collection of Italian
Renaissance and Baroque
paintings is one of the great
strengths of Northampton
Museums and Art Gallery. R V

PROVENANCE Randall Collection; by
1831: Caleb Whiteford Collection; by
1854: Joseph Neeld, Grittleton House,
Wiltshire; 1944, 9 June: Christie's,
London, Neeld sale, lot 9, bought by Lord
Hesketh; 1946: presented to the museum
in his memory by Lady Hesketh
REFERENCE G.F. Waagen, *Treasures of
Art in Great Britain*, London, 1854, II,
p. 224

280

Sebastiano del Piombo
(1485–1547)

Virgin and Child, *c.* 1513

oil on panel, average diam. 68.5 cm
Lent by the Syndics of the
Fitzwilliam Museum, Cambridge,
PD 55-1997

A Venetian by birth, Sebastiano
moved to Rome in 1511. He
soon became a friend of
Michelangelo's, collaborating
with him until the early 1530s.

 This picture was painted soon
after the artist's arrival in Rome
and combines Venetian and
Roman elements. The Virgin
cradles the Christ Child, who
turns towards his mother
holding a goldfinch, symbol of
the Passion. The monumental
proportions of these figures owe
an obvious debt to the Sistine
Ceiling, as do their poses: the
twisting *contrapposto* pose of
Christ is borrowed from one of
the putti supporting God the
Father in the *Creation of Adam*,
and that of the Madonna is
inspired by the Cumaean Sibyl.
The tondo format derives from
Florentine and Roman art, rather
than that of Venice.

 Distinctly Venetian, on the
other hand, are the landscape
background and cloth of honour
behind the figures and the rich
colour harmony of whites, greys
and crimson. Together with the
atmospheric landscape, these
contrast with the severe
expression of the Virgin and
almost forbidding austerity of
the figures. The result is an
intriguing compromise between
the sudden and overwhelming
impact of Rome and Sebastiano's
Venetian heritage. R V

PROVENANCE 1947, 2 May: Christie's,
London, Charles Ranshaw sale, lot 117,
bought by Philip Pouncey on behalf of his
uncle, Duncan Roberts; 1949: bequeathed
by him to Philip Pouncey; his widow;
1997: acquired by the museum with the
aid of grants from the Heritage Lottery
Fund, the National Art-Collections Fund,
the Perrins Bequest, Cunliffe Fund,
Friends of the Syndics of the Fitzwilliam
Museum and University Purchase Fund
EXHIBITION *Art Historians and Critics
as Collectors*, London, Agnew's,
Edinburgh, National Galleries of
Scotland, and Cambridge, Fitzwilliam
Museum, 1995–6, no. 14
REFERENCE M. Hirst, *Sebastiano del
Piombo*, Oxford, 1981, pp. 38–9

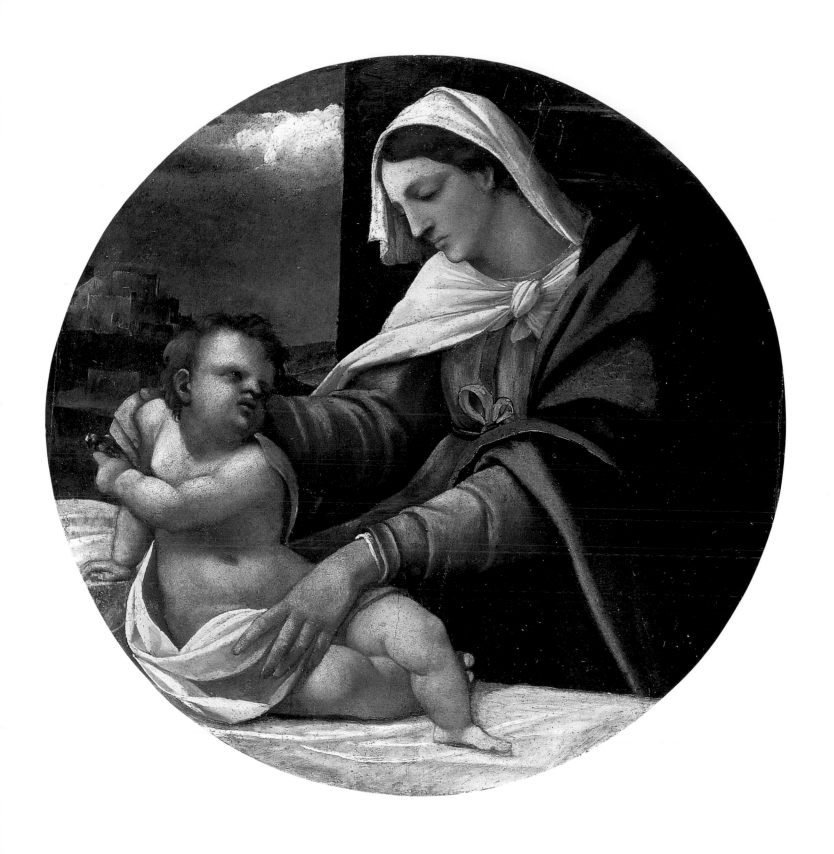

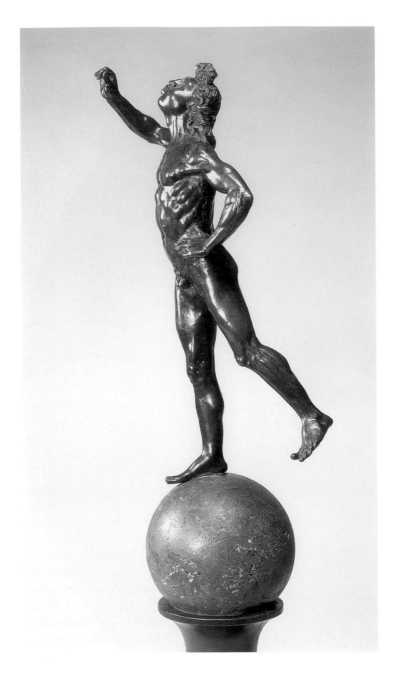

281

Giovanni Francesco Rustici
(1474–1554)

Mercury, *c.* 1515

bronze, mounted on later *breccia*
ball and wooden socle, height of
figure 47.9 cm
Lent by the Syndics of the
Fitzwilliam Museum, Cambridge,
M.2-1997

Commissioned in 1515 by
Cardinal Giulio de' Medici for
the garden court of the Palazzo
Medici, Florence, this fountain
sculpture is minutely described
by Vasari in his life of Rustici.
Now missing are a caduceus
with windmill-like blades
which the figure held in his
right hand and which spun in
the jet of water that issued from
the mouth, and four wings
which were attached to the
ankles.

In his 1904 catalogue of the
W.F. Cook collection, A.B.
Skinner suggested that these
pieces were added later to con-
vert the figure into a Mercury.
It would appear that a later
owner, Henry Harris, discarded
them, only subsequently to
discover, or perhaps rediscover,
the Vasari description.
Unfortunately, no photograph is
known to survive showing
Mercury with the attributes.

The right foot is a replacement
(possibly French, 19th century)
and this may indicate that the
sculpture was ripped from its
fountain. RAC

PROVENANCE *c.* 1515: Palazzo Medici,
Florence; Sir Francis Cook, Bt (died
1901); 1901: Wyndham Francis Cook;
1905: Humphrey Wyndham Cook; 1925,
8 July: his sale, Christie's, London, lot
242, bought by Henry Harris; 1950, 24
October: his sale, Sotheby's, London, lot
106, bought by Sylvia Adams for Lt Col.
The Hon. M.T. Boscawen; 1958: his heir,

by whom bequeathed to the museum in
1995 (received 1997)
EXHIBITIONS *Exhibition of Italian Art
1200–1900*, London, RA, 1930, no. 934;
Mostra Medicea, Florence, 1939, no. 11;
Italian Bronze Statuettes, London, Victoria
and Albert Museum, 1961, no. 21; *The
Boscawen Collection*, Cambridge,
Fitzwilliam Museum, 1997, no. 2
REFERENCES J. Pope-Hennessy, *Italian
High Renaissance and Baroque Sculpture*,
London, 1st edn, 1963, pl. 40, p. 43, 2nd
edn, 1979, pl. 40, p. 342; A.F. Radcliffe,
(forthcoming, with full bibliography)

282

Jan Gossaert, called
Mabuse
(active 1503–died 1532)

Hercules and Deianeira, 1517

oil on panel, 36.8 × 26.6 cm
inscribed: *HERCULES
DYANIRA/ 1517*
The Trustees of the Barber Institute
of Fine Arts, The University of
Birmingham, 46.10

Seated and embracing in a
Classical niche inscribed with
their names, Hercules holds a
club, and Deianeira, his wife, sits
upon the cloak she had been
given by the centaur Nessus,
who had deceitfully claimed that
it would secure for her Hercules'
love and fidelity. Instead, when
Hercules put it on, it enveloped
his body in flames and killed
him. Carved in relief on the base
of the niche are three of
Hercules' Labours: his wrestling
match with Antaeus, the killing
of the Nemaean lion and the
bearing of the globe of Atlas.

A native of Maubeuge, then in
Hainault, Gossaert visited Rome
in 1508–9 and (according to
Vasari) became the first
Northern master to import the
subject of nudes and mythologies
from Italy to the Netherlands.

This picture is one of the two earliest of these works to survive.

The subject of Hercules and Deianeira may be intended here as a mythological parallel to the theme of Adam and Eve, which likewise concerns a woman deceived by a beast into bringing death to her husband. Gossaert painted the latter theme on several occasions, most notably in a picture of *c.* 1520 on loan to the National Gallery, London, from the Royal Collection. R V

PROVENANCE 1800, 3 May: Christie's, London, Vandyke sale, lot 93 (as Dürer), bought by Hammond; 1879, 23–24 May: Christie's, London, W. Benoni White sale, lot 51, bought by Lesser; 1879: sold by Sir J.C. Robinson to Sir Francis Cook; 1946: acquired by the institute from the Cook Collection

EXHIBITIONS *Exhibition of Flemish and Belgian Art 1300–1900,* London, RA, 1927, no. 187; *L'Europe Humaniste,* Brussels, Palais des Beaux-Arts, 1954–5, no. 37; *Le Siècle de Bruegel,* Brussels, Musée royaux des beaux arts, 1963, no. 108; *Kunst voor de Beeldenstorm,* Amsterdam, Rijksmuseum, 1986, no. 1

REFERENCES M. Friedländer, *Early Netherlandish Painting.* Leiden, 1972, VIII, pp. 33 and 97, no. 50; *Handbook of the Barber Institute of Fine Arts,* 2nd edn, Birmingham, 1983, p. 15; L. Silver, '*Figure nude, historie e poesie*: Jan Gossaert and the Renaissance Nude in the Netherlands', *Nederlands Kunsthistorisch Jaarboek,* XXXVII, 1986, pp. 12–13

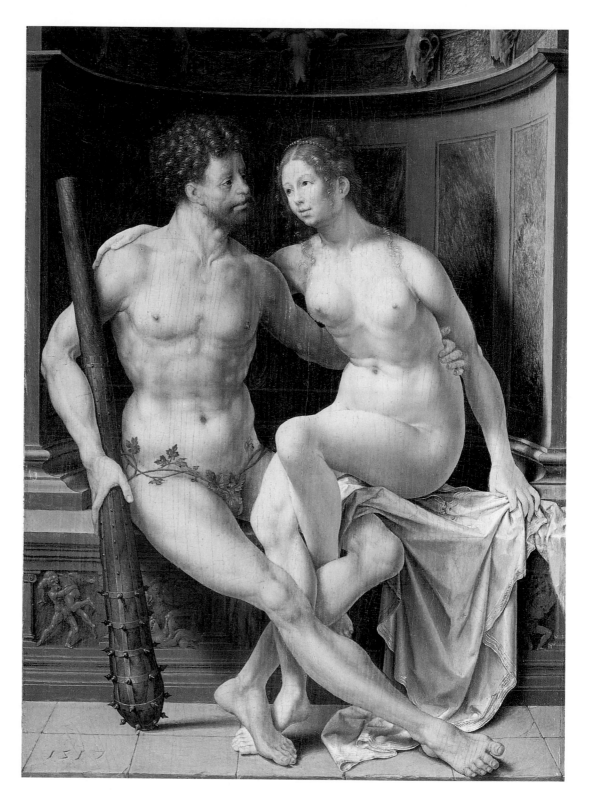

283

Joos van Cleve
(active 1511–40/1)
*Virgin and Child with
Angels*, *c.* 1520–5

oil on oak panel, 85.5 × 65.5 cm
inscribed: *PULCRA ES ET SVAVIS*
Board of Trustees of the National
Museums and Galleries on
Merseyside (Walker Art Gallery,
Liverpool), WAG 9864

Once owned by Charles Blundell
of Ince Hall near Liverpool, this
Virgin and Child is now among
the undisputed gems of the
Walker Art Gallery. At the
right, three angels serenade the
infant, who holds an apple, fruit
of salvation; on the left, another
offers the Virgin a bowl of
cherries, symbol of the delights
awaiting the blessed. On the
table is a carafe of wine and
bunch of grapes – both
eucharistic symbols – together
with some cherries, a knife and
half a lemon. The inscription on
the canopy derives from the Song
of Solomon (4:7; 6:3) and is a
reference to Christ's love for the
Church.

The picture originally had an
arched top and probably formed
part of a small triptych. The
landscape is borrowed from a *Rest
on the Flight into Egypt* (Thyssen
Collection, Madrid) by Joachim
Patinier, a contemporary of Van
Cleve, also active in Antwerp. A
more surprising influence is that
of Leonardo, evident in the
ecstatic expression and wavy hair
of the angel at the left and in the
caressing shadows employed
throughout the picture. Unique
to Van Cleve, however, is the
earthly pride of the Virgin as she
contemplates her sweetly
sleeping son. R V

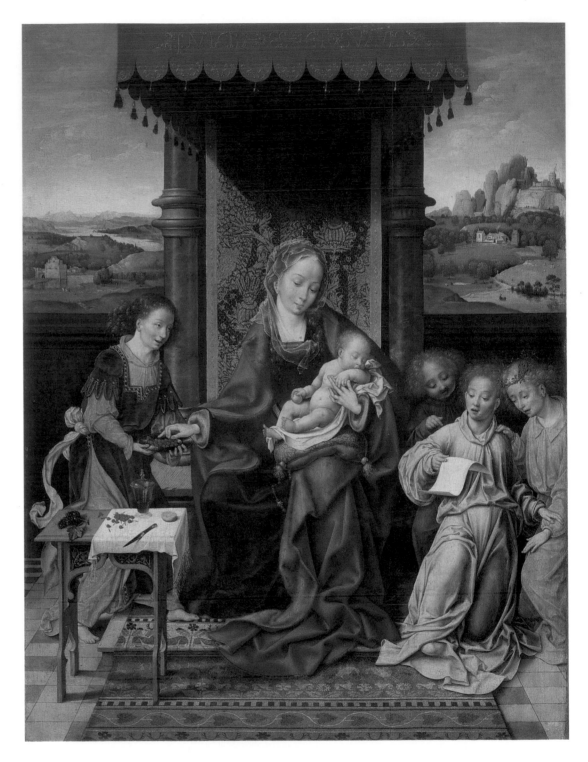

PROVENANCE 1835–7: acquired by
Charles Blundell; by descent to Col. Sir
Joseph Weld; 1981: purchased by the
gallery with the aid of funds from the
Victoria and Albert Museum Purchase
Grant Fund, the National Heritage
Memorial Fund, the National Art-
Collections Fund, the Special Appeal
Fund, the Friends of Merseyside County
Museums and Art Galleries, and a
donation from Unilever
EXHIBITION *Flemish Art 1300–1700*,
London, RA, 1953–4, no. 86

REFERENCES M. Friedländer, *Early
Netherlandish Painting*, IXa, Leiden, 1972,
p. 65, no. 67; M. Evans, 'An Early
Altarpiece by Joos van Cleve', *Burlington
Magazine*, CXXIV, 955, 1982, pp. 623–4

284

Jan Mostaert
(active *c.* 1475–1555/6)
Portrait of a Young Man,
c. 1520–5

oil on panel, 96.6 × 73.7 cm
Board of Trustees of the National
Museums and Galleries on
Merseyside (Walker Art Gallery,
Liverpool), WAG 1018

This enigmatic portrait depicts
an elegantly dressed young man
praying. Behind him is a
mountainous landscape with
fortified buildings and an
animated group of figures. One
of these is St Eustace – or St
Hubert – kneeling before a stag
bearing an image of the crucified
Christ, an episode associated
with both saints from the 15th
century onwards. To the right of
him, a party of hunters witnesses
this miracle; and, above, four
figures picnic under a tree.

Mostaert worked in Haarlem,
painting religious pictures and
portraits, mainly for the
aristocracy. His style is
characterised by fastidious
attention to detail, especially in
the depiction of costume –
evident in this picture in the
sheened surface of the sitter's
sleeves and gloves. Rarely
engaged with the personality of
his sitters, Mostaert preferred
instead to view them objectively.
As the handsome young man
depicted here demonstrates, such
detachment permitted the artist
to imbue his portraits with a
timeless serenity. R V

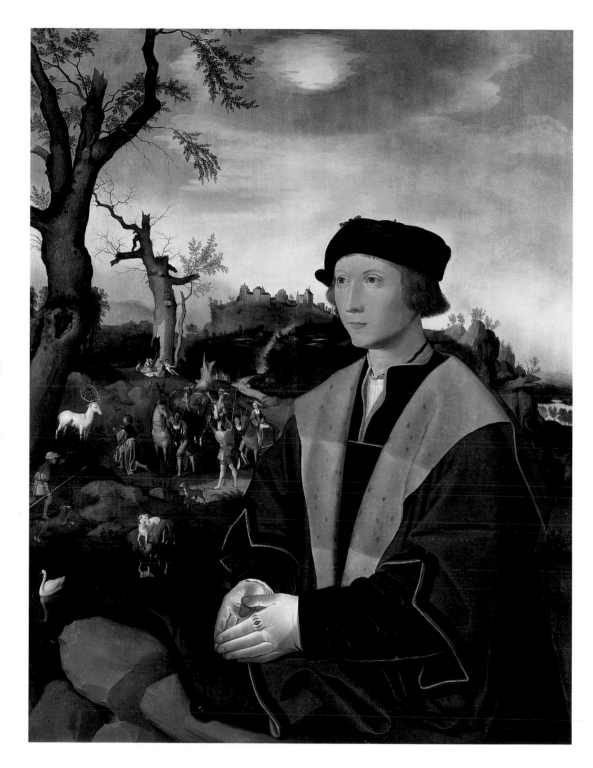

PROVENANCE Griffier Fagel, The
Hague; 1813, 15 March: Phillips, Henry
Fagel sale, lot 41 (as Lucas van Leyden),
bought by Emerson; 1816: Winstanley,
Liverpool, William Roscoe sale, lot 149,
bought by Compton; 1819: presented to
the Liverpool Royal Institution; 1893:
deposited at the Walker Art Gallery;

1948: presented to the gallery
EXHIBITIONS Manchester, 1857, no.
452; *Flemish Art*, London, RA, 1927, no.
119; *Dutch Pictures 1450–1750*, London,
RA, 1952, no. 7; London, 1962, no. 38
REFERENCES M. Friedländer, *Early
Netherlandish Painting*, Leiden, 1973, X,
p. 123, no. 38; Walker Art Gallery,

Liverpool, *Foreign Schools Catalogue*.
Liverpool, 1963, pp. 123–4; *idem. Foreign
Catalogue*. 1977, p. 136

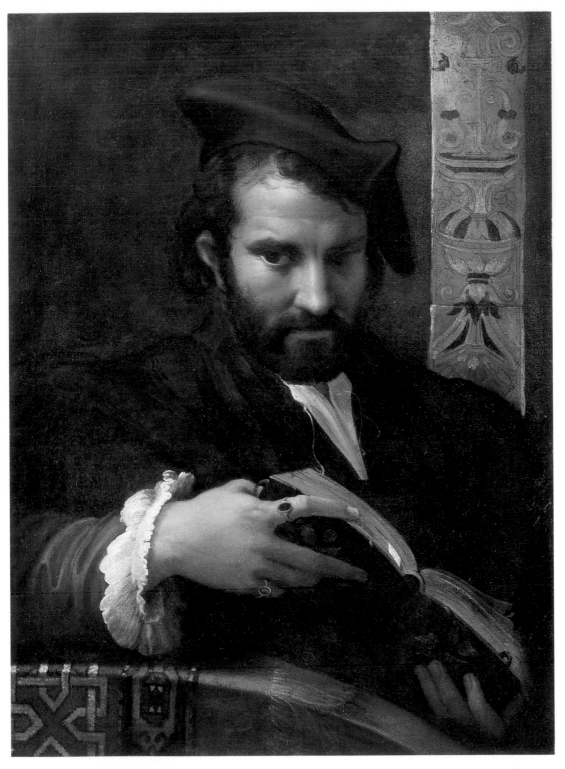

285

Francesco Mazzola, called
Parmigianino (1503–40)
A Man with a Book,
c. 1523–4

oil on canvas, 70 × 52 cm
York City Art Gallery, 739

Formerly attributed to
Correggio, this brooding portrait
is now widely accepted as by
Parmigianino and dated to his
early years in Parma. The
unknown sitter holds a book,
which suggests that he was a
scholar. Traces of an inscription
on the volume ('*l Aet Vltra*') were
read in 1962 as '*In Aeternum et
Ultra*' ('In eternity and beyond').
A quest for the unfathomable is
indeed reflected in the unkempt
appearance and introspective
gaze of the sitter and is enhanced
by the abrupt play of light over
his features, which casts one half
of his face in impenetrable
shadow.

The picture is one of a small
group of profoundly personal
early portraits by the artist
which may depict close friends or
acquaintances. Deeply neurotic
in his later years, and possessed
of a lifelong interest in alchemy,
Parmigianino here appears to
anticipate Vasari's description of
him at the end of his life as 'a
bearded, long-haired, neglected,
and almost savage or wild man'.

The picture is one of more
than 100 Old Master paintings
bequeathed to the York City Art
Gallery by F.D. Lycett Green in
1955, a gift that made the
gallery's holdings in this field
among the most interesting and
representative in the country. R V

PROVENANCE 1931, 29 May:
Christie's, London, anon. sale, lot 76 (as
Correggio), bought by Wilson; 1955:
presented to the gallery by F.D. Lycett

Green through the National Art-Collections Fund

EXHIBITIONS *Between Renaissance and Baroque: European Art 1520–1600,* City of Manchester Art Gallery, 1965, no. 179; *The Age of Correggio and of Carracci: Emilian Painting in the Sixteenth and Seventeenth Centuries,* Bologna, Pinacoteca Nazionale, Washington, National Gallery of Art, and New York, Metropolitan Museum of Art, 1986–7, no. 56
REFERENCES City of York Art Gallery, *Catalogue of Paintings,* I, *Foreign Schools 1350–1800,* York, 1961, pp. 32–3; C. Gould, *Parmigianino,* New York, 1995, pp. 46–53, 193

286

Domenico Beccafumi
(*c.* 1486–1551)
The Holy Family with St John the Baptist, c. 1530
oil on panel, diam. 87.6 cm
Leicester City Museums, F42.1965

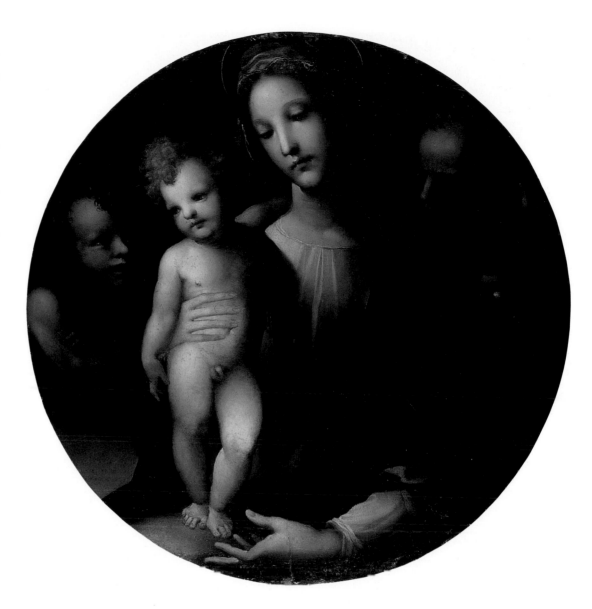

The leading Sienese painter of the first half of the 16th century, Beccafumi is chiefly remembered for the monumental frescoes and altarpieces he executed for his native city, many of which inhabit a world of extravagant fantasy that verges on the bizarre. He also painted numerous Holy Families inspired by his experience of comparable works by Raphael on visits to Florence and Rome early in his career. In many of these, the figures are set in a landscape, as in the classic Holy Families of Raphael's Florentine years. In others, they are depicted against a neutral background, like Raphael's celebrated *Madonna della Sedia* of 1514–15 (Pitti, Florence).

This picture belongs to the latter group and portrays the Virgin and Child with Joseph and the infant Baptist. The group is pressed close to the picture plane and engulfed in shadow, which nearly obscures Joseph and lends a mysterious and disquieting mood to the painting. Adding further to the atmosphere of strangeness are the Madonna's impassive expression, the waxen flesh tones of her and the Christ Child and the unexpected colour harmonies of bluish green and cyclamen pink. Oddest of all are the fiery and unkempt locks of Christ, which echo the brooding forehead of Joseph on the right of the picture. RV

PROVENANCE 1965: purchased from Colnaghi's by the museum with the assistance of grants from the Victoria and Albert Museum Purchase Grant Fund and the Friends of the Museum Fund
EXHIBITION *Paintings by Old Masters,* London, Colnaghi's, 1965, no. 1
REFERENCE G. Briganti and E. Bascheschi, *L'opera completa del Beccafumi,* Milan, 1977, no. 195

287

Circle of Francesco
Primaticcio (1504–70)
The Rape of Helen, c. 1570
oil on canvas, 155.6 × 188.6 cm
The Bowes Museum, Barnard Castle,
Co. Durham, 76

A native of Bologna, Primaticcio
spent his maturity in France,
where he worked extensively on
the interior decoration of the
château at Fontainebleau,
creating a figure style that was to
influence French art for the rest

of the 16th century. Charac-
teristic of this are the long
tapering limbs and highly
stylised poses in this picture,
which is one of the rare examples
in Britain of the School of
Fontainebleau. Adding to the air
of unreality that pervades the
painting are the pale, devitalised
colours and abrupt spatial
transitions. All of these features
endow the work with an
elegance and artifice typical of
the Mannerist style favoured by
the French court from Francis I
to Henry IV.

Though nothing certain is
known of the original function of
this picture, a painting of a
similar subject formed part of
the decoration of the Chambre
du Roi at Fontainebleau, which
was dismantled in the 18th
century. It is possible that this
virtuosic canvas is a replica of
that work, executed by a
member of Primaticcio's studio.
A drawing of the composition,
attributed to Primaticcio
himself, is in the Louvre. R V

PROVENANCE 1797: Duke of
Buckingham, Stowe; Edward Solly; 1841:

purchased from him by John and
Josephine Bowes
EXHIBITIONS London, 1962, no. 67;
*Between Renaissance and Baroque, European
Art 1520–1600.* City of Manchester Art
Gallery, 1965, no. 193; *L'Ecole de
Fontainebleau,* Paris, Grand Palais,
1972–3, no. 142; *De Nicolo dell'Abate à
Nicolas Poussin: Aux Sources du Classicisme
1550–1650.* Meaux, Musée Bossuet,
1988–9, no. 1; *European Paintings from the
Bowes Museum,* London, National Gallery,
1993, pp. 8–9
REFERENCES S. Béguin, 'Note sur
l'Enlèvement d'Hélène du Bowes
Museum', *La Revue des Arts,* IV, 1954, pp.
27–30; E. Young, *Catalogue of the Spanish
and Italian Paintings in the Bowes Museum,*
Durham, 1970, pp. 111–12

288

Jacopo de Ponte, called
Jacopo Bassano
(c. 1510–92)
The Adoration of the Magi,
c. 1560

oil on canvas, 94.3 × 130 cm
The Trustees of the Barber Institute
of Fine Arts, The University of
Birmingham, 78.1

A native of Bassano in northern
Italy, Jacopo was the most
illustrious of a dynasty of
painters working there and in
nearby Venice until the early
17th century. Though he painted
some portraits, he specialised in
religious and genre subjects set
in a landscape and including a
multitude of animals. This
excellently preserved canvas is a
characteristic example. The
Classical ruins at the left, behind
Joseph, symbolise the decay of
paganism.

With its sensuous colour and
dextrous handling, the painting
shows Bassano's art at its best.
Particularly striking is the
shimmering play of light over
the Magi and their page, which
introduces fugitive accents of
gold, white and pink into the
colours of their garments.

Several other versions of the
design are known, among them a
canvas in the Kunsthistorisches
Museum, Vienna, which would
appear to be an autograph
replica. R V

PROVENANCE Sir William Abdy Bt;
1911, 5 May: Christie's, London, his sale,
lot 85; F.A. Konig, Tyringham; 1939:
Agnew's; Major Peter Harris; 1978:
acquired by the institute
EXHIBITIONS *Loan exhibition of Thirty-*
Nine Masterpieces of Venetian Painting,
London, Agnew's, 1953, no. 1; *Master*
Paintings: Recent Acquisitions, London,
Agnew's, 1977, no. 23
REFERENCES L. Fröhlich-Bume, 'Some
Adorations by Jacopo Bassano', *Apollo,* LXV,
June 1957, p. 212; W. Arslan, *J. Bassano,*
Milan, 1960, pp. 105–7, 170; *Handbook of*
the Barber Institute of Fine Arts, 2nd edn,
Birmingham, 1983, p. 2

now hurries away to tell Peter of Christ's Resurrection. At the right, a clump of ivy, symbol of immortality, is presumably included to indicate that St Peter's faith will be restored.

Intensifying the picture's spiritual fervour are the expressive extremes of El Greco's highly personal style. With its disembodied forms and glacial palette, the picture vividly evokes a world in which flesh has become spirit and the soul yearns ecstatically for union with the divine. It is unanimously agreed to be the earliest of the artist's several versions of the theme and surpasses all later ones in its subtle modelling and colouring. R V

PROVENANCE Conde de Quinto; 1869, 16 April: Paris, his widow's sale, lot 62, bought by Gogué; purchased from him by John and Josephine Bowes
EXHIBITIONS London, 1962, no. 76; *Between Renaissance and Baroque: European Art 1520–1600,* Manchester City Art Gallery, 1965, no. 130; *Four Centuries of Spanish Painting,* Barnard Castle, Bowes Museum, 1967, no. 24; *El Greco to Goya,* London, National Gallery, 1981, no. 5; *El Greco of Toledo,* Toledo, Museum of Art, *et al.,* 1982–3, no. 15; *European Paintings from the Bowes Museum,* London, National Gallery, 1993, p.12
REFERENCES H. E. Wethcy, *El Greco and his School,* Princeton, 1962, I, p. 45, II, no. 269; Bowes Museum, Barnard Castle, *Catalogue of Spanish and Italian Paintings,* by E. Young, 1970, pp. 38–40

289
Domenikos Theotokopoulos, called El Greco
(1541–1614)
The Tears of St Peter, 1580–5

oil on canvas, 108 × 89 cm
inscribed (in Greek letters): *domenikos theotokopolis epoiei*
The Bowes Museum, Barnard Castle, Co. Durham, 642

El Greco was the first artist to portray the repentant St Peter, a subject central to Counter-Reformation faith and ideally suited to the visionary intensity

of the artist's own style. The moment depicted here is just after the second crowing of the cock, when Peter realises that he has fulfilled Christ's prophecy and denied him (Mark 14:72). In the background an angel guards Christ's tomb, which has just been visited by Mary Magdalene, carrying an ointment jar, who

290

Attributed to Annibale
Carracci (1560–1609)
*Portrait of Monsignor
Giovanni Battista Agucchi,
c. 1603*

oil on canvas, 60.3 × 46.3 cm
York City Art Gallery, 787

Formerly ascribed to the
Bolognese painter Domenichino
(1581–1641), this arresting
portrait has recently been
convincingly attributed to his
master, Annibale Carracci. The
sitter was a notable scholar and
art theorist who was active in
papal circles from 1600 onwards
and, in 1621, became secretary
to Pope Gregory XV. X-rays
reveal that he was originally
depicted holding a pen in his
right hand and a smaller piece of
paper in the other. Whatever the
reasons for this change, the
existing hands and letter are
among the most sensitively
delineated passages in the
picture.

The freshness and immediacy
of the handling find numerous
precedents in Annibale Carracci's
naturalistic early works, but
none in the more laboured and
polished style of Domenichino.
More surprising is the picture's
date, which – judging from
Agucchi's age – must be around
1603, when the sitter was in his
early 30s. Though Annibale
apparently painted no other
portraits during the later years of
his career, it is fitting that he
should have made an exception
to paint Agucchi, who would
later acclaim the artist as 'the
greatest man in the world in his
profession'. R V

PROVENANCE 1652: Francesco
Fioravanti (postmortem inventory); by
descent to Alessandro Agucchi Legnani,

listed in 1841; Edgar Sebright; 1937, 2
July: Christie's, London, his sale, lot 91;
Kenneth Clark; 1944: Arcade Gallery;
F.D. Lycett Green; 1955: presented by
him to the gallery through the National
Art-Collections Fund
EXHIBITIONS London, 1962, no. 112;
L'Ideale classico del seicento in Italia e la

pittura di paessagio, Bologna, Palazzo dell'
Archiginnasio, 1962, no. 29; *Domenichino
1581–1641,* Rome, Palazzo Venezia,
1997, no. 24
REFERENCES City of York Art
Gallery, *Catalogue of Paintings,* I, 1961,
pp. 16–17; R. Spear, *Domenichino,* New
Haven and London, 1982, I, pp. 228–9;

S. Ginzburg, 'The Portrait of Agucchi at
York reconsidered', *Burlington Magazine,*
CXXXVI, 1090, January 1994, pp. 4–14

Giovanni Battista Crespi, called Il Cerano
(*c.* 1575–1632)
The Flight into Egypt,
c. 1600–10

oil on canvas, 146.5 × 113.3 cm
Bristol Museums and Art Gallery,
K2155

The greatest Milanese artist of the early 17th century, Cerano was an architect, sculptor, writer and engraver in addition to practising as a painter. Here, the Holy Family is led by a putto, who offers Christ an apple, symbol of his role as redeemer of mankind. Pressed close to the foreground of the picture, the colossal figures fill the frame.

Complementing the grandeur of the composition are the humanity and tenderness of the actions and emotions. The scene is at once both intimate and imposing – intensely private in mood, yet unmistakably public in scale.

Nothing is known of the early history of this picture, which was attributed to an anonymous Italian artist until the late 1950s, when it was recognised as by Cerano. An oil sketch for the painting is in a private collection in Milan. RV

PROVENANCE Said to have been originally at Longleat; 1958, 30 May: Christie's, London, anon. sale, lot 3, bought by Agnew's; 1958: acquired by the museum with assistance from the National Art-Collections Fund
EXHIBITIONS *Italian Art and Britain*, London, RA, 1959–60, no. 385; London, 1962, no. 53; *Mostra del Cerano*, Novara, Museo Civico, 1964, no. 56; *Pictures from Bristol*, London, Wildenstein, 1969, no. 9; *Lombard Paintings c. 1595 – c. 1630: The Age of Federico Borromeo*, Birmingham, City Museums and Art Gallery, 1974, p. 115
REFERENCE City Art Gallery, Bristol, *Catalogue of Oil Paintings*, Bristol, 1970, p. 146

291
Adam Elsheimer
(1578–1610)
Apollo and Coronis,
c. 1607–8

oil on copper, 17.4 × 23 cm
Board of Trustees of the National Museums and Galleries on Merseyside (Walker Art Gallery, Liverpool), WAG 10329

The subject is from Ovid (*Metamorphoses* II. 542–632). Apollo is informed by a crow of the infidelity of his lover Coronis and kills her with an arrow. Regretting his deed, the god seeks healing herbs in a vain attempt to revive her. As the body of Coronis is consigned to the funeral pyre, Apollo wrenches the unborn child, Aesculapius, from her womb.

Elsheimer portrays the scene of remorse. Coronis lies dead in the foreground left; behind her, Apollo searches for medicinal herbs. In the background, satyrs prepare the funeral pyre.

Elsheimer, a German, spent his maturity in Italy, settling in Rome in 1600, where he specialised in small paintings on copper, which often contain an important landscape component and combine the classicism and monumentality of the Italian tradition with a detailed observation of nature that is quintessentially Northern. Though Elsheimer was short-lived and notoriously indolent, his paintings were admired and imitated by such later masters as Rubens, Rembrandt and Claude for their dramatic inventiveness and their poetical light effects.

At least seven versions of *Apollo and Coronis* are known, the finest of which is the present picture.
RV

PROVENANCE Sir Paul Methuen; by descent to the 4th Baron Methuen; 1979: accepted by HM Government in lieu of estate duty; 1982: allocated to the gallery
EXHIBITIONS *Exhibition of 17th Century Art*, London, RA, 1938, no. 257; *Artists in 17th Century Rome*, London, Wildenstein, 1955, no. 42; *Adam Elsheimer*, Frankfurt am Main, Städelsches Kunstinstitut, 1966–7, no. 35; *Fiamminghi a Roma 1508/1608: Artistes des Pays-Bas et La Principate de Liège à Rome à la Renaissance*, Brussels, Palais des Beaux-Arts, and Rome, Palazzo delle Esposizioni, 1995, no. 83
REFERENCES K. Andrews, *Adam Elsheimer*, Oxford, 1977, pp. 31, 33, 36 and 151, no. 21; Walker Art Gallery, Liverpool, *Supplementary Foreign Catalogue*, 1984, pp. 3–6

293

Matthias Stomer (Stom)
(*c.* 1600–after 1651)
Isaac blessing Jacob, c. 1635

oil on canvas, 136.5 × 182 cm
The Trustees of the Barber Institute
of Fine Arts, The University of
Birmingham, 94.2

The subject is from Genesis
27:1–29. The aged Isaac, nearly
blind, has summoned his eldest
son, Esau, to prepare him a meal
and receive the patriarchal
blessing. Isaac's wife Rebecca
substitutes her own favourite
son, Jacob, putting goat-skin
gloves on his hands so that he
might resemble the hairy Esau.
As Isaac reaches out to bless
Jacob, the latter approaches
warily and offers his father a
plate of meat. In the centre, the
wily Rebecca enjoins the viewer
not to divulge the ruse.

The picture contains references
to the five senses: touch (Isaac's
blessing), taste (the meat),
hearing (Rebecca's gesture),
smell (the leaping dog) and sight
(the blind Isaac). Poignantly, the
light flooding in from the right
is of no avail to the old man.

Born in Amersfoort, Stomer
settled in Italy around 1630,
working in Rome, Naples and
Sicily, where he presumably died
sometime after 1651. His style is
modelled on that of Caravaggio
and his Dutch followers in its
realistic figure types, dramatic
immediacy and strong contrasts
of light and shade.

This picture probably dates
from the mid-1630s and was
originally one of three depicting
sacred confrontations between
youth and old age. A companion
painting by Stom of *Christ
disputing with the Doctors* and an
anonymous *Tobias healing the blind
Tobit* (both in private collections)
completed the set. R V

PROVENANCE Prince Carraciolo; by
descent to Prince Carafa, Naples; private
collection, New York; Trafalgar Galleries,
London; 1994: acquired by the institute
with the aid of grants from the National
Art-Collections Fund and the Victoria
and Albert Museum Purchase Grant Fund
REFERENCE *Trafalgar Galleries at the
Royal Academy IV*, London, 1985, no. 4

294

Abraham van Janssens
(c. 1575–1632)

Peace and Plenty binding the Arrows of War, 1614

oil on panel, 157.5 × 264 cm
inscribed: *Abraham Janssens Vannissen fecit A. 1614.*
Wolverhampton Art Gallery and Museums, 580

This picture was commissioned for the Town Hall, Antwerp, in 1614, with *Allegory of the River Scheldt* by Janssens, now in the Koninklijk Museum voor Schone Kunsten, Antwerp. Both works celebrate the blessings and benefits of peace following the signing in 1609 of the Twelve Year Truce between the United Provinces and Spain.

At the left sits a figure holding a cornucopia, symbol of Plenty; seated below are two other females, binding the arrows of war together and thereby rendering them useless. One woman, with a dove, represents Peace; the other, cradling an infant in her lap, is presumably intended to symbolise Plenty. Above is a putto bearing a wreath of Victory. Cowering in the background is the haggard figure of Discord, her Medusa like expression registering horror and alarm at the triumph of Peace.

With Rubens, Janssens was the most important history painter working in Antwerp in the early 17th century. The only certain work by him in a British public collection, this magnificent picture is one of the greatest revelations to be found in an English regional collection. Purchased for £80 in 1885, it has been especially cleaned for this exhibition with the aid of a generous grant from the Heritage Lottery Fund. R V

PROVENANCE 1885: purchased by the gallery from Mrs Thornley of Birmingham
EXHIBITIONS London, 1962, no. 56; *Le Siècle de Rubens,* Brussels, Musée des Beaux-Arts, 1965, no. 113
REFERENCES N. Pevsner, 'Some Notes on Abraham Janssens', *Burlington Magazine,* LXIX, 1936, pp. 120–9; D. Bodart, 'The Allegory of Peace by Abraham Janssens', *Burlington Magazine,* CXVIII, 1976, pp. 308–11

for the gallery after a national appeal
EXHIBITION *Some Masterpieces from Manchester Art Gallery,* London, David Carritt Ltd., 1983, no. 1
REFERENCES M. Heimburger-Ravalli, *Alessandro Algardi Scultore,* Rome, 1973, pp. 112–13, no. 34; *A Century of Collecting 1882–1982,* Manchester City Art Gallery, 1983, no. 40; J. Montagu, *Alessandro Algardi,* New Haven and London, 1985, II, pp. 423–4, no. 144

296

Orazio Gentileschi
(1563–1639)

The Rest on the Flight into Egypt, c. 1615–20

oil on canvas, 175.3 × 218.4 cm
Birmingham Museums and Art Gallery, P.5'47

Born in Pisa, Gentileschi worked largely in Rome from 1576 to 1621, where he was influenced by the dramatically realistic style of Caravaggio. The humanity of the present scene is intensified by the plebeian poses of the Virgin and Joseph and by the crumbling masonry that frames them. Coupled with these are the elegant artifice of Gentileschi's draughtsmanship and the exquisite colour harmonies.

Two other autograph versions of the composition exist (Louvre, Paris, and Kunsthistorisches Museum, Vienna). This picture is arguably the most poetical in mood and brilliant in handling of the three. The only autograph work by Gentileschi in a public museum in Britain, this magnificent canvas was purchased at auction in 1947 and now forms one of the great glories of a collection of 17th-century Italian paintings second only to that of London's National Gallery among English museums. RV

295

Alessandro Algardi
(1598–1664)

Monsignor Antonio Cerri, c. 1638–42

marble, 66 × 60 × 23 cm
Manchester City Art Galleries

This magnificent bust was originally intended to adorn Antonio Cerri's tomb in the church of Il Gesù, Rome, where its place is taken by a replica attributed to Algardi's assistant Domenico Guidi. It is conceivable that the bust, which was almost certainly carved from life, was immediately deemed too fine for such an inaccessible location and retained by the sitter's descendants, who will then have commissioned the copy.

Antonio Cerri (1569–1642) was a lawyer who held various offices under Pope Urban VIII. He is here shown in his late 60s, his alert and penetrating gaze seemingly belying his thinning hair and beard and the delicate wrinkles around his eyes. Particularly fine are the sensitive modelling of the sitter's features and costume. The forward tilt of the head and downward gaze may be explained by the intended position of the bust, looking down from a tomb high above the ground.

Second only to Bernini among Italian Baroque sculptors, Algardi was an outstanding portraitist. Though his sculpted busts lack the dynamism of his great rival's, they possess a power and intensity that arguably linger longer in the memory; for, whereas Bernini is pre-eminently disposed to exploring a sitter's worldly achievements, Algardi is uniquely concerned with revealing an individual's personality. RV

PROVENANCE 1917, 18–19 July: Christie's, London, Deepdene Surrey (Hope heirlooms) sale, lot 267, bought by Mrs W. Burns; 1925, 8 May: Sotheby's, Walter S.M. Burns sale, lot 30, bought in (?); 1979, 24–25 September: Christie's, North Mymms Park, Hatfield, Sir George Burns sale, lot 14, bought by Agnew's; purchased by The Metropolitan Museum of Art, New York, but eventually secured

PROVENANCE Cavaliere Massei, Lucca; Marchese Boccella, Lucca; Duke of Lucca; 1841, 5 June: Phillips, London, lot 38 (as Simone Cantarini da Pesaro), bought by Talbot; by descent to Miss Emily Talbot; 1941, 29 October: Christie's, Margam Castle, her sale, lot 376 (as Artemisia Gentileschi); HRH the Duke of Kent; 1947, 14 March: Christie's, HRH the Duchess of Kent's sale, lot 35, purchased by the gallery

EXHIBITIONS *Mostra del Caravaggio e dei Caravaggeschi,* Milan, Palazzo Reale, 1951, no. 113; *Italian Art,* Birmingham City Museum and Art Gallery, 1955, no. 51; *Italian Art and Britain,* London, RA, 1960, no. 376; *Old Masters from the City of Birmingham.* London, Wildenstein, no. 11

REFERENCES Birmingham City Museum and Art Gallery, *Catalogue of Paintings,* Birmingham, 1960, pp. 59–60; R. Ward Bissell, *Orazio Gentileschi and the Poetic Tradition in Caravaggesque Painting,* University Park and London, 1981, pp. 39–40, 48 and 167–8, no. 38

297

Philippe de Champaigne
(1602–74)

The Annunciation, *c.* 1644

oil on canvas, 74.3 × 54.6 cm
Ferens Art Gallery, Kingston upon
Hull City Museums, Art Galleries
and Archives, 533

This painting is widely regarded
as the *modello* for Champaigne's
altarpiece of the Annunciation in
the Wallace Collection, London,
which was executed for an
unidentified patron in the mid-
1640s. The two pictures are
unusual in showing both figures
standing and the archangel
Gabriel without a lily, symbol of
the Virgin's purity.

 Though Flemish by birth,
Champaigne spent virtually his
entire career in Paris, where he
settled in 1621. His style reflects
his mixed artistic ancestry,
uniting a fullness of form and
brilliance of colour reminiscent of
Rubens with a compositional
discipline that calls to mind the
classical art of Poussin. In this
painting, the ethereal light and
delicate colour harmonies of rose,
blue and turquoise create an
appropriately otherworldly
impression. Combined with these
are the hieratic arrangement of
the figures, the restrained and
dignified poses, and the stark
simplicity of the setting – all of
which endow the work with an
air of ritualistic gravity. R V

PROVENANCE Charles Gaspard
Guillaume de Vintimille, Archbishop of
Paris; 1787, 26 November: Paris, Comte
de Vaudreuil sale, lot 40; 1820, 21
March: Paris, Duc d'Alberg sale, lot 58;
Lord Belper; 1963: bought from Agnew's
by an anonymous benefactor and
presented to the gallery
EXHIBITION *Masterpieces of Reality:
French 17th Century Painting*, Leicester,
Museum and Art Gallery, 1985–6, no. 56

REFERENCES 'The Annunciation by Philippe de Champaigne', *Bulletin,* Ferens Art Gallery, Kingston upon Hull, January–March 1964, n.p.; B. Dorival, *Philippe de Champaigne 1602–1674,* Paris 1976, II, p. 20

298

Nicolas Poussin
(1594–1665)
Landscape with the Ashes of Phocion collected by his Widow, 1648

oil on canvas, 116.5 × 178.5 cm
Board of Trustees of the National Museums and Galleries on Merseyside (Walker Art Gallery, Liverpool), WAG 10350

One of the greatest Old Master paintings in an English regional collection, this picture takes its theme from Plutarch's *Life of Phocion* (XXXVII). Phocion, a noble Athenian general, was condemned to death by his enemies and forced to drink hemlock. His body was refused burial within the city walls and was carried to the outskirts of Megara, where it was cremated. His widow gathered his ashes (the scene depicted here) and transported them back to Athens, where they were accorded an honourable burial once the tide of political opinion had changed.

The painting's pendant is *Landscape with the Body of Phocion carried out of Athens* (1648; The Earl of Plymouth, on loan to the National Museum of Wales, Cardiff). Both pictures rank among the supreme achievements of Poussin's maturity and are regarded as cornerstones of the 17th-century classical landscape tradition, which influenced such later artists as Wilson (cat. 48), Valenciennes (cat. 335), Corot (cat. 337) and Cézanne (cat. 351, 360). R V

PROVENANCE 1648: painted for Cérisier; 1665: still in his possession; 1776/82: acquired by the 12th Earl of Derby; thence by descent; 1983: acquired by the Walker Art Gallery with contributions from the National Heritage Memorial Fund, the Victoria and Albert Museum Purchase Grant Fund, the National Art-Collections Fund and other benefactors
EXHIBITIONS Manchester, 1857, no. 607; *Nicolas Poussin,* Paris, Louvre, 1960, no. 81; *Nicolas Poussin 1594–1665,* Paris, Galeries nationales du Grand Palais, 1994–5, no. 169; *Nicolas Poussin 1594–1665,* London, RA, 1995, no. 68
REFERENCES A. Blunt, *The Paintings of Nicolas Poussin: A Critical Catalogue,* London, 1966, no. 174; *idem, Nicolas Poussin,* The A. W. Mellon Lectures in the Fine Arts, London and New York, 1967; Walker Art Gallery, Liverpool, *Supplementary Foreign Catalogue,* 1984, pp. 15–18

299

Georges de La Tour
(1593–1652)

The Dice Players, c. 1650

oil on canvas, 92.5 × 130.5 cm
inscribed: *George De La Tour Invet et Pinx*
Stockton-on-Tees Museum Services
(Preston Hall Museum),
SBC200.1976

Rediscovered in 1972, and never before exhibited in London, this is one of only three works by La Tour in Britain. It depicts a gaming scene, a subject made popular by Caravaggio and his followers, especially in northern Europe. Three young soldiers play a game of dice at a table lit by a candle. Three dice have been thrown, all of them revealing a one. At the left, an older man smoking a pipe

appears about to pick the pocket of one of the soldiers. On the right another figure – who may be either male or female – observes the game attentively. Though the scene is not overtly moralising, the themes of gaming and card-playing were often associated with idleness, cheating and deceit, and found a biblical precedent in the subject of the Prodigal Son wasting his fortune in a tavern or brothel.

The picture possesses the hard surface and stylised poses characteristic of the increasingly abstract concerns of La Tour's last years. Together with the lack of psychological interplay among the figures, these features have led some scholars to regard the picture as a collaboration between Georges de La Tour and his son, Etienne, by whom no

certain works are known. Other passages in the picture – such as the luminous and inquisitive profile at the right – are of outstanding beauty and justify retaining the attribution to Georges who, with Vermeer, remains one of the most elusive and mysterious of 17th-century masters. R V

PROVENANCE Edward Clephan JP; Annie Elisabeth Clephan; 1930: bequeathed to the city of Stockton-on-Tees
EXHIBITIONS *Georges de La Tour,* Paris, Orangerie des Tuileries, 1972, no. 31; *Georges de La Tour and his World,* Washington, National Gallery of Art, and Fort Worth, Kimbell Art Museum, 1996–7, no. 32; *Georges de La Tour*, Paris, Grand Palais, 1997–8, no. 63
REFERENCES B. Nicolson and C. Wright, *Georges de La Tour,* London, 1974, pp. 191–2; P. Rosenberg and M. Mojana, *Georges de La Tour: Catalogo completo dei dipinti,* Florence, 1992, pp. 126–9, no. 44

300

Salvator Rosa (1615–73)

L'umana fragilità, c. 1656

oil on canvas, 197.4 × 131.5 cm
inscribed: *SR*
Lent by the Syndics of the Fitzwilliam Museum, Cambridge, PD.53–1958

This disturbing canvas is an allegory of transience. A baby seated on a woman's lap is instructed by Death to write '*Conceptio Culpa, Nasci Pena, Labor Vita, Necesse Mori*' ('Conception is Sinful, Birth a Punishment, Life Hard Labour, Death Inevitable'). These words, which derive from a poem by the 12th-century writer Adam of St Victor, are elaborated by Rosa through a host of recondite symbols.

The woman is seated on a glass sphere, symbolising

fragility, and wears roses in her hair, a reference to the fleeting nature of love. Behind her is a bust of Terminus (God of Death) and an owl, ill-omen of Death. At the left are a knife (death and separation), spent rocket (transience) and thistle (fragility). Above, a putto blows bubbles, while another sets fire to some tow, which will soon die down. Nearby are two butterflies (the brevity of life) and a funerary monument bearing five reliefs: the heads of a baby and old man (the ages of man); a fish (hatred and death); a falcon (human vitality); and a hippopotamus (the violence and discord that mark the approach of death).

A profoundly pessimistic artist, Rosa possessed an interest in alchemy and witchcraft, which are reflected in this picture's lugubrious symbolism and in its morbid colouring and cavernous lighting, which vividly evoke the presence of death. R V

PROVENANCE Cardinal Flavio Chigi; by descent to John, 2nd Lord Northwick; 1859, 26 July: Phillips, Thirlestane House, Cheltenham, Northwick's sale, lot 1120, bought by Agnew's; 1859: sold to R. C. Fergusson; by descent to Lt Col Wallace Cunninghame; 1958, 7 March: Christie's, London, Cunninghame's sale, lot 28, bought by Knoedler; 1958: acquired by the museum
EXHIBITIONS *Italian Art and Britain*, London, RA, 1960, no. 404; *Salvator Rosa*, London, Hayward Gallery, 1973, no. 27; *Treasures from the Fitzwilliam*, Washington, National Gallery of Art, *et al.*, 1989, no. 99
REFERENCES L. Salerno, *Salvator Rosa*, Milan, 1963, pp. 110-11; Fitzwilliam Museum, Cambridge, *Catalogue of Paintings*, II, *Italian Schools*, 1967, pp. 139–43; R. Wallace, 'Salvator Rosa's *Democritus* and *L'Umana Fragilità*', *Art Bulletin*, L, 1968, pp. 27–31

301

Jan Asselijn (c. 1615–52)

Landscape with a Stone Bridge, c. 1647

oil on canvas, 43.2 × 49.5 cm
inscribed: *JA*
Cannon Hall Museum, Barnsley
MBC

The ruined bridge in this outstanding painting, which has been dated to the late 1640s from the style of the figures, is based on the Ponte Rotto in Rome. The picture is characteristic of Asselijn in its sharply focused forms and glowing effects of light and atmosphere. Particularly noteworthy are the rosy hues of the sky and the audacious composition, which balances two converging diagonals on the left of the picture against an open vista on the opposite side.

Asselijn was among the most versatile of the Italianate Dutch landscape painters of the mid-17th century. He was in Italy between 1635 and 1644, and then journeyed to France, before settling in Amsterdam in 1647. In addition to executing landscapes of Italian scenes, he painted panoramic mountain landscapes and native Dutch views.

One of only a handful of works by Asselijn in Britain, the picture is part of the remarkable collection of Dutch 17th-century art bequeathed to the nation by William Harvey of Barnsley and permanently on display at Cannon Hall since 1972. R V

PROVENANCE M. Reynders, Brussels; 1833, 10 May: C. J. Nieuwenhuys sale, London; 1834: Colonel Biré; William Harvey of Barnsley; by descent to William Harvey of Leeds; 1917: presented by him to the National Loan Collection Trust, which exhibited the collection throughout Britain and the Commonwealth before depositing it at Cannon Hall in 1972
EXHIBITION *Art in Seventeenth Century Holland*, London, National Gallery, 1976, no. 2
REFERENCES A. C. Steland-Stief, *Jan Asselijn nach 1610 bis 1652*, Amsterdam, 1971, p. 71, n. 2, and pp. 153–4, no. 182; Cannon Hall Museum, *The William Harvey Collection of Dutch and Flemish Paintings*, n.d., no. 1

302

Salomon van Ruysdael (1600/3–70)

Farm Buildings in a Landscape, 1626(?8)

oil on panel, 30.2 × 47 cm
inscribed: *S v RuyESDAEL*
Lent by the Syndics of the Fitzwilliam Museum, Cambridge, no. 1049

The uncle of the more famous Jacob van Ruisdael (cat. 303), Salomon van Ruysdael was one of the leading Dutch landscapists of the second quarter of the 17th century. He settled in Haarlem in 1623, specialising in dune landscapes, seascapes and river views. His earliest dated painting is from 1626, possibly also the year in which he created this well preserved panel (whose date may be read as either 1626 or 1628).

The unpretentious motif is typical of Ruysdael's earliest works, which often portray isolated groups of buildings or

trees seen at close range and executed on a small scale. Also characteristic of such early 'tonal' landscapes is the monochromatic palette, here confined to a range of glistening browns and ochres. Boldly applied, these grow paler as they recede, creating the illusion of space largely through gradations of tone. Another recessional device employed in the picture is the use of two diagonals which progress from the top and bottom of the composition to converge upon the horizon.

These devices persist in Van Goyen's *Winter Scene* of 1653 (cat. 307), but comparison of the two paintings reveals the differences between Ruysdael's optimistic spirit and Van Goyen's more sombre temperament. R V

PROVENANCE Rev. W. H. Stokes, Denver, Norfolk; Mrs Laurence Humphrey; 1921: bequeathed by her to the museum
REFERENCES W. Stechow, *Salomon van Ruisdael*, Berlin, 1938, pp. 18 and 97, no. 251; Fitzwilliam Museum, Cambridge, *Catalogue of Paintings*, 1960, I, p. 114, no. 1049

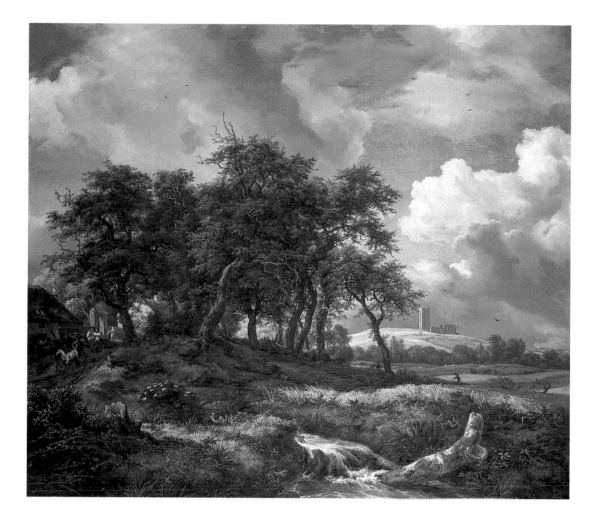

303

Jacob van Ruisdael (1628/9–82)

Landscape near Muiderberg, c. 1653

oil on canvas, 66 × 75 cm
The Visitors of the Ashmolean Museum, Oxford, A875

The greatest of all Dutch landscapists, Ruisdael painted dune and forest landscapes, waterfalls, winter scenes, panoramas, seascapes and even some city views. This picture combines elements of several of these.

Rarely content to paint identifiable sites, Ruisdael preferred to create imaginary landscapes assembled from existing motifs which are often invested with a deeper, symbolic significance and, on occasion, overtly allegorical. Though the present picture is hardly portentous in mood, it is not purely topographical and, as E. John Walford has observed, 'as a Dutch landscape [it] is incongruous'. With its images of growth and decay, its ruined church and its rushing stream, the picture conjures up thoughts of the elemental struggle between life and death in nature, a recurring theme in the artist's career.

Ruisdael is the foremost exponent of the so-called 'classic' phase of Dutch landscape painting, which flourished during the third quarter of the 17th century. Characteristic of this phase are the heroic forms, highly structured composition, and dramatic tonal and colouristic contrasts of this picture. R V

PROVENANCE 1828, 22 December: Brussels, Heris sale (as owned by Danoot); 1830: H. Buchanon (inscribed on stretcher); the Loyd family; 1937, 30 April: Christie's, London, lot 128 (as owned by Captain E.N.F. Loyd); 1955: presented to the museum by the National Art-Collections Fund from the collection of Mr E.E. Cook
EXHIBITIONS Manchester, 1857, no. 954; *Art Treasures Centenary*, Manchester City Art Gallery, 1957, no. 116
REFERENCE E. John Walford, *Jacob van Ruisdael and the Perception of Landscape*, London and New Haven, 1991, pp. 91–2

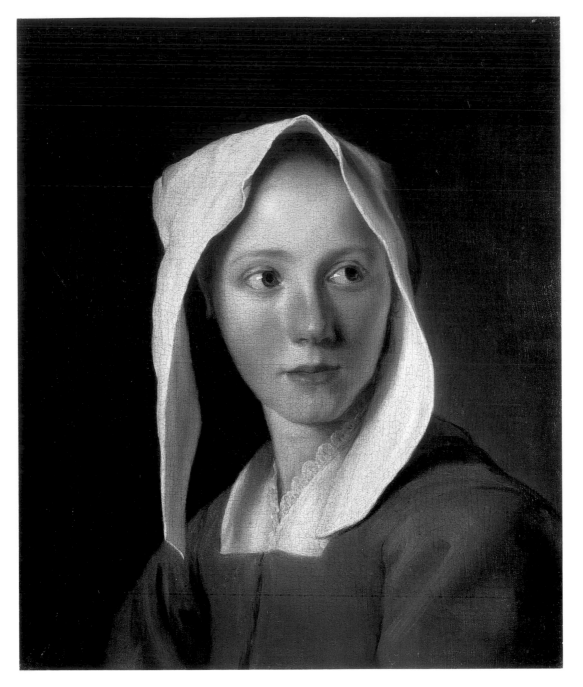

304

Michael Sweerts (1624–64)
Portrait of a Girl, 1655–60

oil on canvas, 43.5 × 36.5 cm
Leicester City Museums, F201.1975

Until it was exhibited in Birmingham in 1934, this haunting image was attributed to Vermeer; and few would deny that it possesses a mystery, poetry and pellucid clarity also encountered in Vermeer's so-called 'mother of pearl' pictures of the mid-1660s.

Michael Sweerts was a Flemish artist who worked in Rome between *c.* 1646 and 1654. By 1656 he had returned to his native Brussels, where he founded a drawing academy but, in 1661, he departed for the Orient with a group of missionaries, dying in India three years later.

This picture is one of a group of character heads by Sweerts probably intended to represent types, rather than specific individuals. With her body facing one way and her head another, Sweerts's youthful sitter appears momentarily distracted, her smooth, porcelain features gently animated by an inquisitive gaze and sparkling eyes. Framing her oval head is a crisp, white headdress which adds to the felicity of the characterisation. Most wondrous of all are the picture's subtle gradations of light and shade and exquisite colour harmonies. Confining himself to a limited palette of whites, greys and pinks, Sweerts explores a range of nuances within these basic tints that invites comparison with Vermeer's miraculous *Head of a Girl* in the Mauritshuis, The Hague. R V

PROVENANCE (?) R. P. Knight; by
descent to Major Kincaid-Lennox,
Downton Castle; 1970: accepted by the
Inland Revenue in lieu of duty on his
estate; 1975: allocated to the gallery by
HM Treasury
EXHIBITIONS *Commemorative Exhibition
of the Art Treasures of the Midlands*, City of
Birmingham Museum and Art Gallery,
1934, no. 150; *Michael Sweerts en
Tijdenoten*, Rotterdam, Boymans Museum,
1958, no. 49; *The Arrogant Connoisseur:
Richard Payne Knight 1751–1824*,
Manchester, Whitworth Art Gallery,
1982, no. 196
REFERENCE N. Pevsner, 'The
Birmingham Exhibition of Midland Art
Treasures', *Burlington Magazine*, LXVI,
1935, pp. 30–5

305

Frans Hals (1581/5–1666)

Portrait of a Young Woman,
c. 1655–60

oil on canvas, 60 × 55.6 cm
Ferens Art Gallery, Kingston upon
Hull City Museums, Art Galleries
and Archives, 526

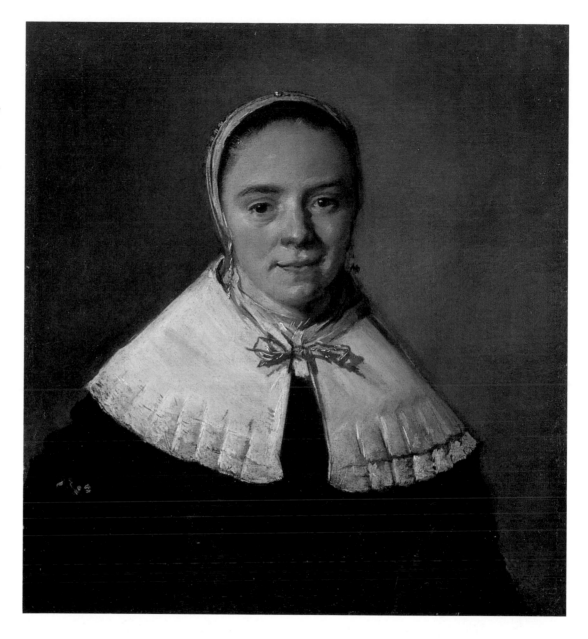

This tender portrait belies the
popular notion of Frans Hals as
an 'inspired Cyrano de Bergerac
of the brush' (to use Seymour
Slive's memorable phrase).
Though that description fits the
painter of *The Laughing Cavalier*,
at the end of his life Hals
explored a range of moods second
to those of Rembrandt alone
among Dutch 17th-century
painters in their profound
insight into the human
condition.

The unknown woman
portrayed here is depicted with a
candour and sympathy
characteristic of Hals's mature
portraits. Posed frontally, with
her lips just parting to reveal a
smile, she is further enlivened by
the gentle tilt of her head and by
the asymmetrical arrangement of
her large, pleated collar.

Enhancing the intimacy of the
characterisation are the subtle
play of light over her features
and the restrained brushwork.
These features demonstrate that,
unlike many of his greatest
contemporaries, Hals was as
humane and empathetic a
portraitist of female as of male
sitters.

The picture is among the prize
possessions of the Ferens Art
Gallery in Hull, which, given
the city's trading links with the
Netherlands, has actively
pursued a policy of acquiring
major works of Dutch art. R V

PROVENANCE 1836: possibly acquired
by the 4th Earl of Egremont; by descent;
1961, 24 November: Christie's, London,
George Wyndham sale, lot 70; 1963:
purchased by the gallery
EXHIBITIONS *Dutch Pictures
1450–1750*, London, RA, 1952, no. 137;
*Dutch 17th Century Pictures in Yorkshire
Collections*, Leeds City Art Gallery,
1982–3, no. 4; *Images of a Golden Age:
Dutch Seventeenth Century Paintings*,
Birmingham City Museums and Art
Gallery, 1989–90, no. 55; *Frans Hals*,
Washington, National Gallery of Art,
London, RA, and Haarlem, Frans
Halsmuseum, 1989–90, no. 74
REFERENCES W. Martin, 'An
Unknown Portrait by Frans Hals',
Burlington Magazine, XCIV, 1952,
pp. 359–60; S. Slive, *Frans Hals*,
London, 1970–4, I, p. 194, III, p. 102,
no. 196

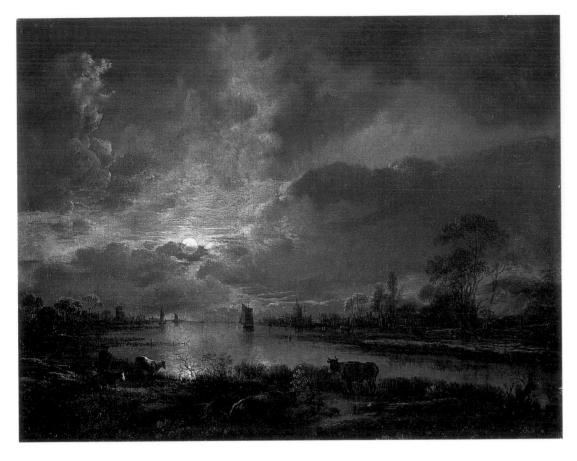

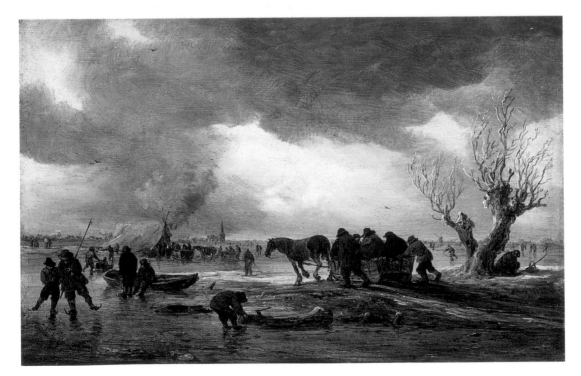

306

Aert van der Neer
(1603/4–77)

A River Moonlight Scene with Cattle, c. 1650–60

oil on canvas, 27.1 × 34.9 cm
inscribed: *A V D N*
The Royal Museum and Art Gallery,
Canterbury, CANCM: 4039

A prolific master of moonlight
and winter scenes, Van der Neer
spent all his life in Amsterdam,
where he is recorded as keeping
an inn in 1659. Three years later
he went bankrupt, living in
destitute conditions to the end of
his career.

This evocative landscape is the
type most closely associated with
the artist. It depicts a river lined
by feathery trees and lit by the
moon. In the foreground, cattle
graze and, in the distance,
sailing boats are silhouetted
against the night sky. Peace and
contentment pervade the scene,
which is animated only by fleecy
clouds – and by the remarkable
nuances of light and colour that
Van der Neer introduces into
this essentially monochromatic
painting. Using thinly applied
layers of paint, which often show
through, the artist creates a
translucent effect of multi-
coloured light that evokes the
magic and mystery of nature in
repose.

The poetical effects of
moonlight were first explored by
Adam Elsheimer and later
portrayed incomparably by both
Rubens and Rembrandt.
Although numerous other Dutch
artists also depicted nocturnal
landscapes, Van der Neer alone
specialised in them. Evidently
such scenes went out of fashion
after the 1650s. Though Van der
Neer had two sons who became

painters, neither followed their father in portraying this theme. R V

PROVENANCE S. Herman de Zoete, London; 1905: given to the museum by G.F. de Zoete of Bournemouth
EXHIBITION *Winter Exhibition of Old Masters*, London, RA, 1884, no. 133

307

Jan van Goyen
(1596–1656)

Winter Landscape with a Sledge in the Foreground and Figures gathering round a Tent on the Ice, 1653

oil on panel, 27.9 × 43.1 cm
inscribed: *VG 1653*
Manchester City Art Galleries, 1979.459

With Salomon van Ruysdael (cat. 302), Jan van Goyen was the chief exponent of the 'tonal' phase of Dutch landscape painting, which flourished during the second quarter of the 17th century. Typical of the works of both masters are their vibrant brushwork, monochromatic palette and low horizon line.

This brilliant winter scene is a late work and reveals a boldness of touch and dynamic tonal range typical of this phase of the artist's career. Characteristic of Van Goyen are the painterly effects, especially in the foreground and sky, where the brown underpainting shows through.

The picture was one of 96 paintings presented to Manchester City Art Gallery by Mr and Mrs Edgar Assheton Bennett in 1979, the majority of them of the Dutch 17th-century school. This bequest makes the gallery one of the greatest repositories of Dutch art in the English regions. R V

PROVENANCE 1943, 21 May: Christie's, London, lot 101, bought by Duits; by 1952: E. Assheton Bennett, London; 1965: on permanent loan to Manchester City Art Gallery; 1979: bequeathed to the museum
EXHIBITIONS *Dutch Pictures 1450–1750*, London, RA, 1952, no. 232; *Jan van Goyen*, Leiden, Stedelijk Museum, 1960, no. 48; *The Assheton Bennett Collection*, London, RA, 1965, no. 51; *Jan van Goyen 1596–1656: Poet of the Dutch Landscape*, London, Alan Jacobs Gallery, 1977, no. 30; *A Century of Collecting 1882–1982*, Manchester City Art Galleries, 1983, no. 54
REFERENCES City of Manchester Art Gallery, *Catalogue of Paintings and Drawings from the Assheton Bennett Collection*, 1965, no. 21; H. U. Beck, *Jan van Goyen, 1596–1656*, Amsterdam, 1972–87, II, p. 44, no. 84, III, p. 148, no. 84

308

Adam Isaacksz. Colonia
(1634–85)

Noah and his Family leaving the Ark, 1663

oil on canvas, 90 × 94 cm
inscribed: *A Colonia. fixit. 1663*
Bolton Museum and Art Gallery, 3.1891

Colonia was born in Rotterdam but moved to London in 1670, where he spent the later part of his career. He specialised in landscapes filled with figures and animals, some of which owe an obvious debt to similar works by Cornelius Saftleven (1607–81) and Nicolaes Berchem (1620–83), while others are unashamedly modelled on compositions by Rembrandt.

This picture, which is one of Colonia's finest works, depicts the rare subject of Noah and his family leaving the Ark (Genesis 8: 15–19). To the left of Noah is

his wife; and mounted in the right centre are his three sons and one of their wives. In the distance is the Ark, a throng of beasts still issuing from its side. Most prominent – and amusing – of all are the pairs of animals and birds that fill the foreground of the picture, cackling, preening and giving vent to sighs and smiles of relief after their long ordeal in the Ark.

It has been suggested that this picture cannot represent the departure from the Ark because of the sorrowful expression of Noah's wife, the tower still standing intact behind the group and the fact that the animals appear not to have reared any young during their confinement (!). But this is to credit Colonia with a degree of intellectual sophistication that was probably alien to his nature. R V

PROVENANCE 1891: acquired by the museum
EXHIBITIONS *Images of a Golden Age: Dutch Seventeenth Century Paintings*, Birmingham City Museums and Art Gallery, 1989–90, no. 93; *Rotterdamse Meesters wit de Gouden Eeuw*, Rotterdam, Historisch Museum, 1994–5, no. 12

Van Everdingen is best known as a painter of allegories and mythologies, though he also painted portraits and a few still-lifes. Though his history paintings are very classicising in style, his portraits are often disarmingly realistic – and none more so than the present picture. With her beribboned hat and cheeky grin, this little girl immediately captivates us as she strides into view, her warmth and vitality pricking the bubble of pretence represented by the billowing drapery and pillar. R V

PROVENANCE William Harvey of Barnsley; by descent to his nephew, William Harvey of Leeds; 1917: presented by him to the nation, to be administered by the National Loan Collection Trust, which exhibited the collection throughout Britain and the Commonwealth before depositing it at Cannon Hall in 1972
EXHIBITION *Images of a Golden Age: Dutch Seventeenth-Century Paintings*, Birmingham City Museums and Art Gallery, 1989–90, no. 52
REFERENCE Cannon Hall Museum, *The William Harvey Collection of Dutch and Flemish Paintings*, n.d., pp. 7–9

310
Hendrik Cornelisz. van Vliet (1611/12–75)
The New Church at Delft with the Tomb of William of Orange, 1667

oil on canvas, 127 × 85.5 cm
inscribed: a signature and date were read in 1962, but are now no longer visible
Board of Trustees of the National Museums and Galleries on Merseyside (Walker Art Gallery, Liverpool), WAG 1994.1

One of the leading Dutch architectural painters of the mid-17th century, Van Vliet

309
Cesar van Everdingen
(*c.* 1617–78)
A Child holding an Apple, 1664

oil on canvas, 98 × 79 cm
inscribed: *CVE Tatis z An. N 1664*
Cannon Hall Museum, Barnsley MBC

The subject of this sparkling portrait has been identified as

Maria Baert (1661–89), daughter of the Burgomaster of Alkmaar, van Everdingen's native town. In the background stands a large house lined by trees, which may be the family residence. Van Everdingen was evidently well acquainted with the sitter's parents; in 1671 he painted portraits of both of them, which are now in the Rijksmuseum, Amsterdam.

Though the apple and goldfinch have religious connotations – the latter is a symbol of the Passion – these are unlikely to apply here. Certainly, portraits of children holding birds are common in Dutch and Flemish art and may be related to a proverb originally found on ancient tombstones: 'Life is like playing with birds, sometimes it flies away quickly.'

specialised in views of the Oude Kerk and Nieuwe Kerk in his native city, Delft. This picture depicts the interior of the latter with the tomb of William of Orange, Father of the United Netherlands, who was assassinated at Delft in 1584. The tomb (1614–23) came to be regarded as a monument to the Dutch Republic, becoming a site of veneration and pilgrimage that was frequently depicted by Dutch artists.

The picture is typical of Van Vliet in its unusual perspectival effects, which here combine a view of the tomb and choir with one of the transept. Also characteristic is the hidden symbolism. In the foreground of the picture is an open grave; beside it lie a pile of skulls and bones and grave-digger's tools. At the left sits a woman with two children, who may be intended to represent Charity. The picture may thus be seen as a *memento mori* with allusions to the spiritual virtues of Faith, Hope and Charity. R V

PROVENANCE 1833: presented to the Liverpool Mechanics Institution; Liverpool Institute Schools; 1962: on loan to the Walker Art Gallery; 1994: acquired by the museum with the aid of a grant from the National Art-Collections Fund

EXHIBITIONS *Dutch Church Painters*, Edinburgh, National Gallery of Scotland, 1984, no. 38; *Images of a Golden Age: Dutch Seventeenth Century Paintings*, Birmingham City Museums and Art Gallery, 1989–90, no. 84; *Delft Masters: Vermeer's Contemporaries*, Delft, Stedelijk Museum het Prinsenhof, 1996, pp. 76–8

REFERENCES Walker Art Gallery, Liverpool, *Foreign Catalogue*, 1977, p. 225; W. A. Liedke, *Architectural Painting in Delft*, Doornspijk, 1982, pp. 67 and 109, no. 113

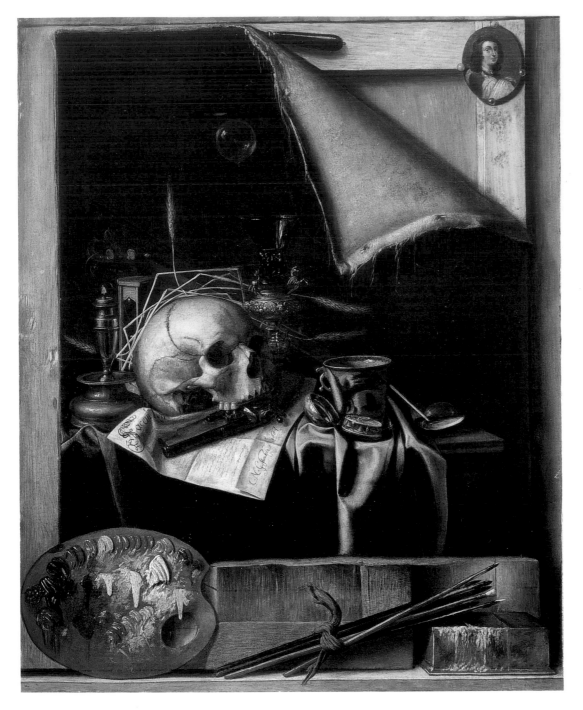

311

Cornelius Norbertus
Gysbrechts
(active *c.* 1659–*c.* 1678)
Vanitas (Still-life), 1664
oil on canvas, 87 × 70 cm
inscribed: *C. N. Gysbrechts 1664*
Ferens Art Gallery, Kingston upon
Hull City Museums, Art Galleries
and Archives, 577

An elusive artist, who worked in
Antwerp, Germany and
Denmark, Gysbrechts specialised
in *vanitas* still-lifes. This
painting depicts a picture within
a picture and shows a *vanitas*
still-life (see cat. 312) resting on
a ledge, below which are the
artist's palette and brushes.
Included in the still-life are
familiar objects symbolic of
transience: the skull, hour-glass,
watch, candle and bubble. The
vanity of earthly pleasure and
power are represented by the
drinking-vessel and pistol; the
shafts of corn wrapped around
the skull allude to the promise of
eternal life. Beneath the skull is
a sheet of paper resembling a
legal document (a will?) and
bearing the artist's signature and
date. At upper right, a portion of
canvas torn from its stretcher
reveals a portrait miniature of a
young man. Though it is
tempting to imagine that this
depicts Gysbrechts himself,
portrait miniatures of other
individuals figure in comparable
works by the artist.

Vanitas still-lifes containing
attributes of the painter's craft
were often intended to illustrate
the motto '*Vita brevis ars longa*' –
'life is short, but art lives on'. In
portraying the fragility of art
itself in this picture, Gysbrechts
gives this theme a disturbing
new twist. R V

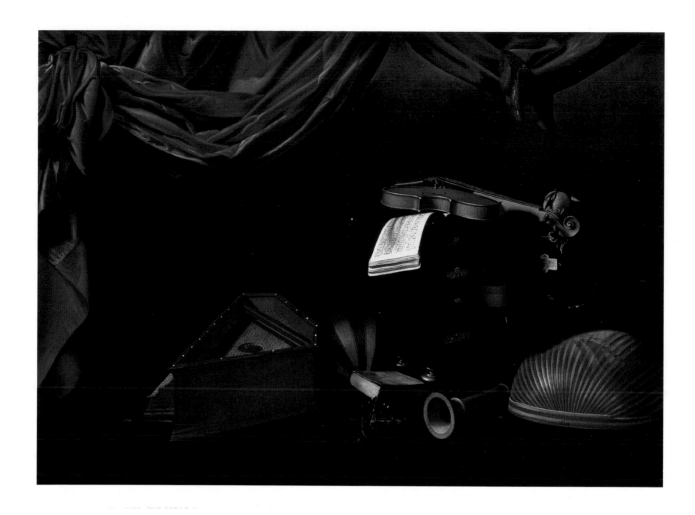

PROVENANCE Captain E.G. Spencer Churchill, Northwick Park; 1965, 29 October: Christie's, London, his sale, lot 99, bought by Brod Gallery; 1967: acquired by the gallery
EXHIBITION *The Irresistible Object: Still Life 1600–1985*, Leeds City Art Gallery, 1985, no. 22

312

Evaristo Baschenis

(1617–77)

Still-life with Musical Instruments, c. 1660

oil on canvas, 95.5 × 129 cm
inscribed: *EVARISTUS BASCHENIS F. BERGOMI*
The Trustees of the Barber Institute of Fine Arts, The University of Birmingham, 97.5

A Jesuit priest and native of Bergamo, Baschenis specialised in kitchen still-lifes and those featuring musical instruments. He is now widely regarded as the greatest Italian still-life painter of the 17th century.

This picture is a *vanitas*, intended as a reminder of the futility of earthly knowledge, pleasure and possessions, and the inevitability of death. At the upper right is an orange, which (like the apple) symbolises the fruit of temptation. Nearby is an unidentified musical score and a violin bearing a broken string, an allusion to the futility of pleasure. These objects rest on a coffer, symbolising human greed. At the left are a book, Spanish guitar and spinettino. Another

volume, entitled *La Rosalinda*, lies beneath the coffer. This is a romance of 1650 by Bernardo Morando, which tells the tale of a nun named Rosalinda, who was distinguished by her talents as a singer and musician. At the right is a shawm and a lute covered in dust – a virtuosic touch that is a trademark of Baschenis and an obvious allusion to the themes of futility and death. The lute bears the monogram of Michael Hartung, a German lute-maker active in Padua in the early 17th century.

The only painting by Baschenis in Britain, the picture provides a contrast to the unnerving *vanitas* by Gysbrechts (cat. 311), possessing a formal harmony and colouristic

splendour that imbue it with a solemn and meditative quality that is profoundly uplifting. R V

PROVENANCE 1875–1928: stored in London from a private collection, New York; 1928, 7 December: Christie's, London, lot 130 (as H. Maltese, i.e. Francesco Fieravino), bought by Wells; A.G. Dickson Ltd.; 1962, 6 February: Phillips, London, lot 238 (as Fieravino), bought by B. Cohen; Benjamin Trust; 1997: acquired by the institute
EXHIBITION *Anniversary Exhibition*, London, Trafalgar Galleries, 1996, pp. 4–6

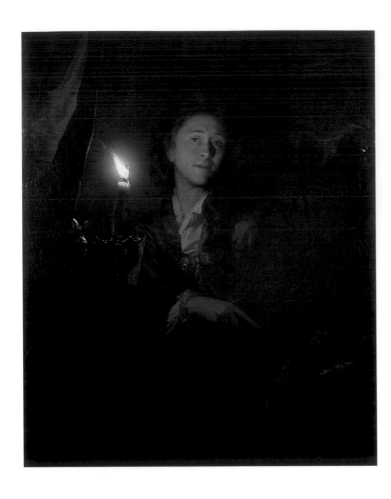

allegory of painting rather than as a genuine self-portrait. Though this would account for the motif of the hand pointing to the palette, it would not necessarily explain the artist's flagrant vanity. R V

PROVENANCE Sir Frederick Cook, Richmond; by descent to Francis Cook; 1953: acquired by the museum
EXHIBITIONS *Dutch Pictures 1450–1750*, London, RA, 1952, no. 599; *Images of a Golden Age: Dutch Seventeenth Century Paintings*, Birmingham City Museums and Art Gallery, 1989–90, no. 37
REFERENCE T. Beherman, *Godfried Schalcken*, Paris, 1988, p. 155, no. 57

314

Bartolomé Esteban Murillo (1617–82)

The Infant Christ asleep on the Cross, c. 1670

oil on canvas, 141 × 108 cm
Sheffield Art Galleries and Museums (Mappin Art Gallery), 73

his art, whether in his rare genre paintings of street urchins or in works like the present painting. With its fluid brushwork, delicate colouring and caressing light, the picture betrays Murillo's tender affection for the theme. But its tragic overtones do not escape him. These are apparent both in the dark and portentous clouds that fill the sky and in the insouciant pose of Christ, who slumbers like any ordinary infant, innocent and vulnerable. R V

PROVENANCE 1766: Charles Jennings, London; inherited by Earl Howe through his father, a cousin of Charles Jennings; 1933, 8 December: Christie's, London, Howe sale, lot 45, bought by J. G. Graves, who bequeathed it to the gallery
EXHIBITIONS London, 1962, no. 108; *Four Centuries of Spanish Painting*, Barnard Castle, Bowes Museum, 1967, no. 71; *Bartolomé Esteban Murillo 1617–1682*, Madrid, Museo del Prado, and London, RA, 1982–3, no. 60
REFERENCE D.A. Iniguez, *Murillo*, Madrid, 1981, I, p. 422, II, no. 215

313

Godfried Schalcken (1643–1706)

Self-portrait by Candlelight, c. 1695

oil on canvas, 109.7 × 88.7 cm
inscribed: *Schalcken*
Leamington Spa Art Gallery and Museum, A452.1953

One of the most celebrated Dutch artists of his generation, Schalcken worked in Düsseldorf and The Hague in addition to his native region of Dordrecht. This striking self-portrait is stylistically comparable to two other self-portraits dated to the mid-1690s, when Schalcken visited London.

Schalcken was a pupil of Gerrit Dou (1613–75), who had studied with Rembrandt in Leiden, where the latter painted a number of candlelight scenes. Working on a much larger scale than Dou, Schalcken perfected this subject, attracting numerous imitators, even as late as the 19th century. Typical of his style are the refined draughtsmanship and sheened surface of this picture, together with the rosy glow that illuminates the artist's features. Candlelight and moonlight combine to create a romantic image of the informally clad Schalcken as an elegant and fashionable gentleman-painter. Schalcken was over 50 when the painting was executed; yet he appears to be in his 30s. This anomaly has led one critic to suggest that this idealised image may have been intended as an

The subject of the Infant Christ asleep on the Cross originated in the mid-16th century and became very popular with Italian and Spanish artists of the 17th century. A premonition of the Passion, it was often also intended to represent Christ's triumph over Death, symbolised by the infant's hand resting upon a skull. Murillo painted four works on this theme, the finest of which is this picture.

The greatest Spanish painter of his generation, Murillo spent virtually the whole of his life in his native Seville, working for the churches, convents and monasteries of the city and surroundings. One of fourteen children, he fathered nine of his own and had an obvious affinity for portraying such subjects in

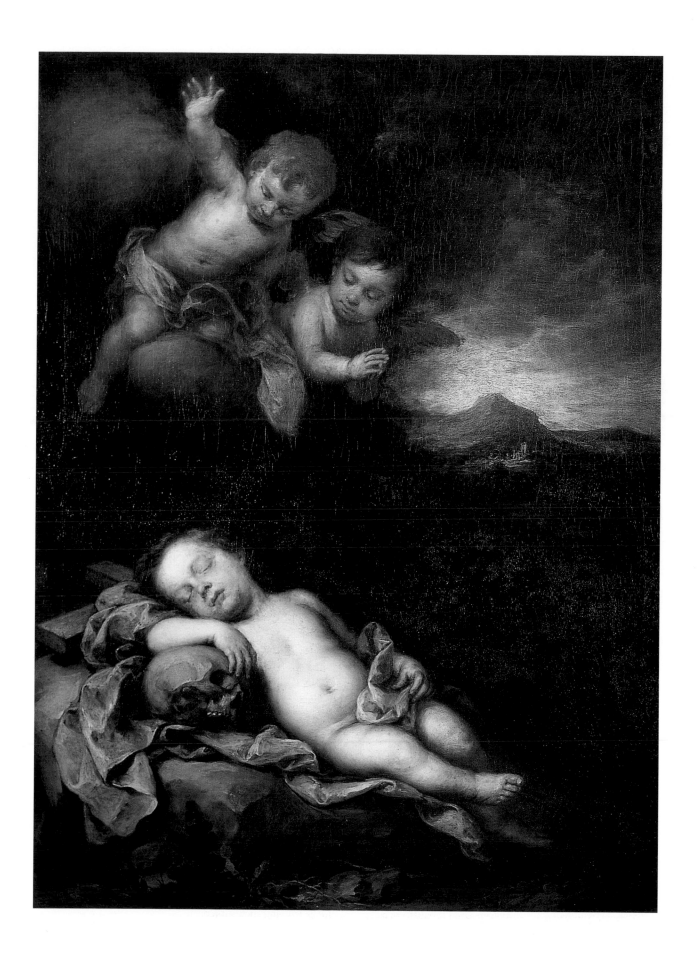

371

315

Jan van der Heyden

(1637–1712)

A View in Amsterdam,

c. 1670

oil on panel, 34 × 50 cm
inscribed: *V Heide*
Cannon Hall Museum, Barnsley MBC

The greatest Dutch cityscape painter of his generation, Jan van der Heyden painted numerous views of Amsterdam, where he settled in 1650. Though once described as a view along the Singel Canal, this picture is more likely to be an imaginary scene made up of buildings in different parts of the city, painted with the meticulous attention to detail characteristic of the artist. The figures have been attributed to Adriaen van de Velde (1636–72), who often collaborated with Van der Heyden.

In addition to his luminous landscapes and architectural scenes, which number more than 200, Van der Heyden also painted some still-lifes and interiors and enjoyed a prominent career as an inventor, entrepreneur and city official. In 1668, he devised a plan to provide Amsterdam with street lamps, which was successfully adopted the following year; and, in 1672, he and his brother invented an improved fire machine to replace the bucket brigades then in use throughout the city. He died a wealthy man, leaving his widow with an estate valued at more than 80,000 guilders. R V

PROVENANCE William Harvey of Barnsley; by descent to his nephew, William Harvey of Leeds; 1917: presented by him to the nation, to be administered by the National Loan Collection Trust, which exhibited the collection throughout Britain and the Commonwealth before depositing it at Cannon Hall in 1972

EXHIBITION *Images of a Golden Age: Dutch Seventeenth Century Paintings,* Birmingham City Museums and Art Gallery, 1989–90, no. 139

REFERENCES H. Wagner, *Jan van der Heyden 1637–1712,* Amsterdam and Haarlem, 1971, p. 88, no. 92; Barnsley, Cannon Hall Museum, *The William Harvey Collection of Dutch and Flemish Paintings,* n.d., no. 18

316

Philips Koninck (1619–88)
An Extensive Landscape,
c. 1655

oil on canvas, 87 × 122.4 cm
Southampton City Art Gallery,
211963

Though he painted portraits,
history pictures and genre scenes,
Philips Koninck is chiefly
remembered as a master of
panoramic landscapes. This
picture exemplifies his mature
art at its finest. The scene is
imaginary and depicted from a
high vantage point which

divides the composition into
equal areas of earth and sky. In
the foreground a brightly lit
hillock flanks a roadside leading
into a landscape dotted with
houses and figures, which recedes
towards a seemingly limitless
distance unbroken by any
vertical elements. Towards the
horizon, the description of the
land is reduced to broad bands of
thick paint, laid on in parallel
strokes, creating a hazy effect,
which dissolves into an
atmospheric sky patterned with
what one critic has aptly
described as 'some of the finest
clouds ever painted'.

The result is an impression of
grandeur and monumentality
created with the minimum of
means. Peace and serenity
pervade the picture, with only
the bold handling and dramatic
tonal contrasts betraying the
influence of Rembrandt, with
whom Koninck is reputed to
have studied in the early 1640s.

Like many other Dutch artists,
Koninck pursued more than one
career. Late in life he became the
owner of an inland shipping line
between Rotterdam and
Amsterdam and apparently
abandoned painting altogether.
R V

PROVENANCE Cook Collection,
Richmond; Wildenstein; 1963: purchased
by the gallery with the aid of a grant
from the Victoria and Albert Museum
EXHIBITIONS *Pictures from Southampton*,
London, Wildenstein, 1970, no. 10;
*Images of a Golden Age: Dutch Seventeenth
Century Paintings*, Birmingham City
Museums and Art Gallery, 1989–90,
no. 114
REFERENCE H. Gerson, *Philips Koninck*,
Berlin, 1936, p. 109, no. 50

317, 318

Jan van Huysum
(1682–1749)
Classical Landscape with the
Rest on the Flight into Egypt
Classical Landscape with a
Woman refusing a Wreath
both *c.* 1737

both oil on copper, 21.6 × 27.9 cm
both inscribed: *Jan van Huysum fecit*
Peterborough City Council,
Peterborough Museum and Art
Gallery, 193791108.1/2

The greatest Dutch flower
painter of the early 18th century,
Van Huysum also executed a
number of Arcadian landscapes
on copper or panel. Many of
these are very small and
obviously appealed because of
their evocation of themes
associated with Claude and his
Dutch followers.

The identical dimensions of
these two works indicate that
they were conceived as a pair,
though their themes are
unrelated. The depiction of the
Rest on the Flight into Egypt is
based on another version of the
same subject (private collection),
which is signed and dated 1737.

Given their Dutch origin and
Antique setting, it is appropriate
that both paintings are first
recorded in the collection of
Thomas Hope (1769–1831), who
was born in Amsterdam, fled to
London in 1795 and was one of
the leading antiquarians,
connoisseurs and designers of his
day, noted for his interest in
both Classical and Egyptian art
(see cat. 333). RV

PROVENANCE Thomas Hope; 1917,
20 July: Christie's, London, Hope
Heirlooms sale, lot 37, bought by Cooper;
1937: bequeathed to the museum by
G.S. and E.S. Martin

319

Jan van Os (1744–1808)

Flowers and Fruit, c. 1780

oil on panel, 65 × 47 cm
inscribed: *J Van Os. fecit*
Warrington Museum and Art
Gallery, WAGMG 1955.10

Jan van Os was the greatest
Dutch still-life painter of the late
18th century and specialised in
sumptuous displays of flowers
and fruit. Often they include
flowers that do not bloom at the
same time of year – evidence that
Van Os relied upon studies of
flowers painted at different
seasons. Here tulips, roses,
peonies, larkspur and other
flowers are arranged with fruit to
brilliant colouristic effect.
Characteristic of Van Os is the
bright tonality and highly
polished surface texture.

Also visible in the painting are
a butterfly and several flies.
Though flies – like flowers –
were often used as symbols of
transience by 17th-century
painters, it is hard to imagine
such concerns bedevilling the
thoughts of artists of Van Os's
generation.

This picture originally formed
part of the collection of Ernest
Cook, grandson of the founder of
the travel agency. The collection
was bequeathed to the National
Art-Collections Fund in 1955
and subsequently distributed to
nearly 100 museums and
galleries throughout Britain –
the most munificent single
bequest to the nation's museums
made this century. R V

PROVENANCE 1939, 31 March:
Christie's, London, Lincoln sale, lot 39;
Cook Collection, Richmond; 1955: Cook
Bequest to the NACF – allocated to the
museum
EXHIBITION Manchester, 1857,
no. 1014

320

Antonio Canale, called Canaletto (1697–1768)

View on the Grand Canal,
c. 1728

oil on canvas, 65 × 96 cm
Ferens Art Gallery, Kingston upon
Hull City Museums, Art Galleries
and Archives, 551

This view depicts the longest
straight section of the Grand
Canal in Venice, seen on turning
its only sharp corner on the way
from the Piazza San Marco
towards the Rialto Bridge, which
is just visible round the next
corner. To the left is the Palazzo

Balbi, built in 1582 by
Alessandro Vittoria, seen here
with five arched openings at its
centre rather than the three of
fact. The dome of the church of
SS. Giovanni e Paolo appears in
the distance.

In this early work Canaletto
appears as much interested in
atmosphere and mood as in the
precise recording of the scene.
He conveys the mottled and
crumbling walls of the city with
a flickering, insubstantial touch
of a kind more associated with
Francesco Guardi (cat. 327).
DST

PROVENANCE Max Hevesi, London;
1948: Hazlitt Gallery, London, then
Agnew's (as Guardi); Mrs Richard Warde;
1964: bequeathed by her to the gallery
REFERENCE W.G. Constable, *Canaletto*,
Oxford, 1976, no. 214

321

**Giambattista Tiepolo
(1696–1770)**

*The Harnessing of the Horses
of the Sun, c. 1733–6*

oil on canvas, 91 × 73.6 cm
The Bowes Museum, Barnard Castle,
Co. Durham, 51

With a gesture of poignant
tenderness, the sun god Apollo
presses his hand against the
cheek of his half-mortal son,
Phaeton, who is being urged
towards the chariot of the sun,
and his subsequent death, by the
bearded figure of Time. Below, a
putto and the Hours yoke the
barely restrained horses. Tiepolo
had explored this subject from
Ovid in 1718 at the Villa
Baglioni near Padua and he
turned to it again in 1730–1 for
his first major commission
outside the Venetian republic,
frescoes for the Palazzo Archinto
in Milan (destroyed in World
War II). Both this oil sketch and
one at the Vienna Academy,
which shows a less immediate
interpretation of the same scene,

have been associated with a ceiling at the Palazzo Archinto, but the exact relationship either between the sketches themselves or between these and the commissioned work remains unclear.

Although the Bowes' purchase of this work cannot be considered groundbreaking in the manner of their espousal of the Spanish school (see cat. 329), it is worth noting that the National Gallery did not acquire its first Tiepolo until 1885. Similarly, while appreciation of Tiepolo's sketches and *modelli*, highly acclaimed during the artist's lifetime, persisted in the realm of private connoisseurship, the inclusion of such a boldly executed painting (the Vienna picture is far more 'finished') in a public collection of this period is remarkable. N K

PROVENANCE Before 1874: bought by John and Josephine Bowes
EXHIBITIONS London, National Gallery, 1920–7 (long-term loan); *Italian Art*, London, RA, 1930, no. 806; *18th Century Venice*, London, Whitechapel Art Gallery, 1951, no. 119; *Pictures from the Bowes Museum*, London, Agnew's, 1952, no. 12; *European Masters of the 18th Century*, London, RA, 1954, no. 488; London, 1962, no. 35.; *Giambattista Tiepolo*, Venice, Ca' Rezzonico, and New York, Metropolitan Museum of Art, 1996, pp. 292–5, no. 47b (with full bibliography)

322

Pierre Subleyras
(1699–1749)

St John of Avila, 1746

oil on canvas, 135.9 × 97.7 cm
inscribed: *VENER . . . MAS
JOANNES DE AVILA/ VANDA . . .
LICIAE APOST OBIIT MON-
/TILIAE . . . DIE X MAII AN
MDLXIX*
Birmingham Museums and Art
Gallery, P.43'59

After initial success in his native
Toulouse, Subleyras moved to
Paris, where he won the Prix de
Rome in 1727. He arrived at the
French Academy in Rome the
following year and remained in
the city for the rest of his life.
His early reputation was founded
on portraits, while during the
last decade of his intensely active
career he was occupied chiefly
with prestigious commissions for
altarpieces in Italy and France.

The image of the Spanish
priest John of Avila (*c.* 1499–
1569), the confessor of St Teresa
of Avila, was commissioned by
Cardinal Annibale Albani,
probably in 1746. The cardinal
was leading the campaign for his
canonisation and, according to
the demands of the Church, the
establishment of a recognisable
iconography for a prospective
saint was an essential element in
the process. Subleyras painted
four such images.

The white surplice plays an
important role in establishing
the subject's unimpeachable
probity, but an even greater part
is played by the refined features,
the intensity of the deep-brown
eyes and, above all, the
wonderfully expressive left hand.
Pointing simultaneously out
towards the crucifix and in
towards his own heart, the
gesture sums up all that was

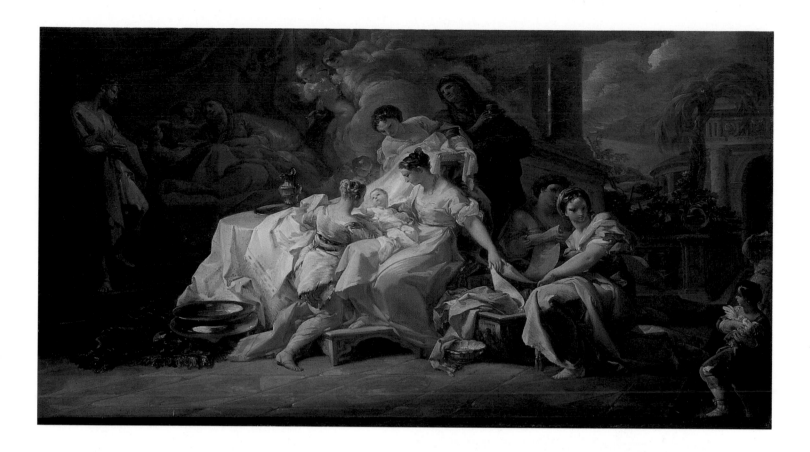

claimed for the subject's exceptional spirituality. Despite such compelling advocacy by Subleyras, John of Avila did not achieve sainthood until 1971. TW

PROVENANCE 1746 (?): commissioned by Cardinal Annibale Albani; by descent to the Chigi family; 1959: purchased from Colnaghi's by the gallery

EXHIBITION *Subleyras (1699–1749)*, Paris, Musée du Luxembourg, 1987, no. 112

323

Corrado Giaquinto
(1699–1765)

The Birth of the Virgin,
c. 1751–52

oil on canvas, 54 × 98.5 cm
The Governing Body, Christ Church, Oxford, JBS 229

Not attributed to Giaquinto until 1917, this painting is one of several sketches known for his *Birth of the Virgin* in the Cathedral of Pisa. The Oxford picture differs from the final painting in several details and in its unusual horizontal format, factors which led Byam Shaw to suggest that it could be a private commission, post-dating the Pisan composition of 1751–2.

Giaquinto enjoyed a highly successful career as an exponent of the Rococo style in Rome, culminating in his summons, in 1753, from Ferdinand VI of Spain to paint ceiling frescoes in the new palace in Madrid.

This image, with its emphatic pyramidal grouping, demonstrates Giaquinto's combination of strong design with a brilliant sense of colour and lush handling. The central figures are contrasted against the sombre tones of the background; their chromatic particularity and intensity convey the heightened and superior reality of the depicted event.

Horace Walpole described General Guise (cat. 3) as 'a great connoisseur in pictures' and his distinct preference for Italian masters was noted by George Vertue. The purchase of this sketch (which is not documented) must date from the latter part of Guise's life, when he was still actively collecting, primarily, it is thought, from contacts abroad rather than in the London sale-rooms. NK

PROVENANCE 1765: probably Guise Bequest to Christ Church

EXHIBITIONS *The Eighteenth Century*, London, RA, 1954–5, no. 293; *Italian Art and Britain*, London, RA, 1960, no. 249; *Neapolitan Baroque and Rococo Paintings*, Barnard Castle, Bowes Museum, 1962; *Masterpieces from Christ Church*, Liverpool, Walker Art Gallery, 1964, no. 23

REFERENCE J. Byam Shaw, *Paintings by Old Masters at Christ Church Oxford*, Oxford, 1967, pp. 118–19 (with full bibliography)

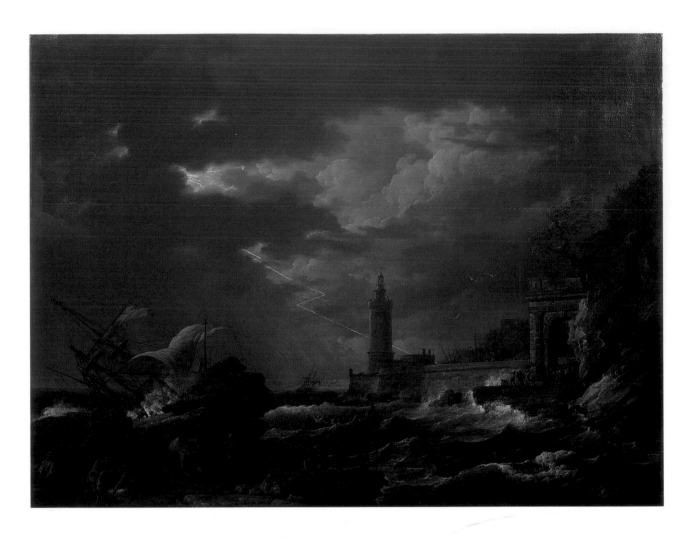

324

Claude-Joseph Vernet
(1714–89)

Storm on the Coast, 1754

oil on canvas, 96.5 × 129 cm
Haworth Art Gallery, Accrington
(Hyndburn Borough Council)

The first nineteen years of
Vernet's painting career, from
1734 onwards, were spent in
Italy. In 1737, he paid the first
of several visits to Naples, then
enjoying a cultural renaissance
under the Bourbon King Charles
III. Vernet's paintings often

evoke the rocky coastline beyond
the Bay of Naples, into which he
inserts specific landmarks – here
the famous lighthouse on the
waterfront. Using motifs familiar
from the landscapes of Claude,
Vernet took the study of light
and atmosphere to far greater
extremes, producing contrasting
pairs of daylight and moonlit
views or storm and calm as a
development of the established
coupling of morning and
evening.

Vernet returned to France in
1753 to commence his series *The
Ports of France* for Louis XV. He

worked on the monumental
canvases until 1762, eventually
completing fifteen – the largest
single commission carried out
during the King's reign. Vernet
began the series in Marseille and
while there he received a number
of requests from local *amateurs*
seeking examples of his work.
Monsieur Poulhariez, a
merchant, was one of them and
Vernet painted a small and a
large pair of landscapes for him.
Storm on the Coast belongs to the
latter. Its pendant is probably a
work last seen in 1961, on the
London art market. T W

PROVENANCE 1754: commissioned by
M. Poulhariez of Marseille; Alderman
T.E. Higham, Mayor of Accrington, who
presented it to the museum
EXHIBITION *Claude-Joseph Vernet,
1714–1789,* London, Kenwood, 1976,
no. 33 (with full provenance and
bibliography)

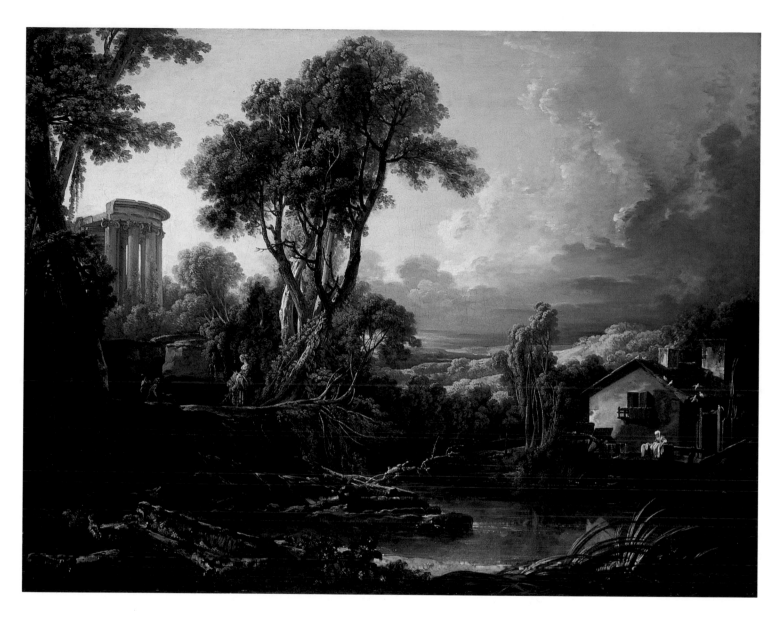

325

François Boucher
(1703–70)

Landscape with Water Mill,
1743

oil on canvas, 90.8 × 118.1 cm
inscribed: *f. Boucher/1743*
The Bowes Museum, Barnard Castle,
Co. Durham, 486

Boucher's erotic mythologies and
pastorals were already keenly
sought after – and fetching high
prices – by the mid-19th
century, as evinced by the many

purchases of the 4th Marquis of
Hertford (now in the Wallace
Collection, London). This
landscape reflects the Bowes'
tendency to find single examples
by artists relatively cheaply
(1600 francs, compared to
20,200 francs paid by Hertford
for Boucher's pair *The Rising of
the Sun* and *The Setting of the Sun*).
The subject-matter, picturesque
rather than sensuous, may also
have been considered more
suitable for what was always
intended to be a public and
educative collection.

Boucher's landscapes are
influenced by both his experience
of tapestry design and his work
for the theatre. One of a group of
artists discovering the appeal of
sketching in the countryside
around Beauvais and the gardens
at Arcueil, Boucher refined and
repeated observed motifs, and
combined them with Italianate
temples and staffage. Here, the
typical 'confusion of rustic
objects' described by the brothers
Goncourt is contained by the
strong composition and distinc-
tive green-blue tonality. NK

PROVENANCE 1863: bought by John
and Josephine Bowes from the dealer
Benjamin Gogué, Paris

EXHIBITIONS *Pictures from the Bowes
Museum*, London, Agnew's, 1952, no. 49;
European Masters of the 18th Century,
London, RA, 1954, no. 476; *France in the
18th Century*, London, RA, 1968, no. 42;
A Month in the Country, London, National
Gallery, 1981; *François Boucher*, New
York, Metropolitan Museum of Art,
1986, no. 46; *European Paintings from the
Bowes Museum*, London, National Gallery,
1993, no. 18

REFERENCE A. Ananoff and
D. Wildenstein, *François Boucher*,
Lausanne and Paris, 1976, no. 254

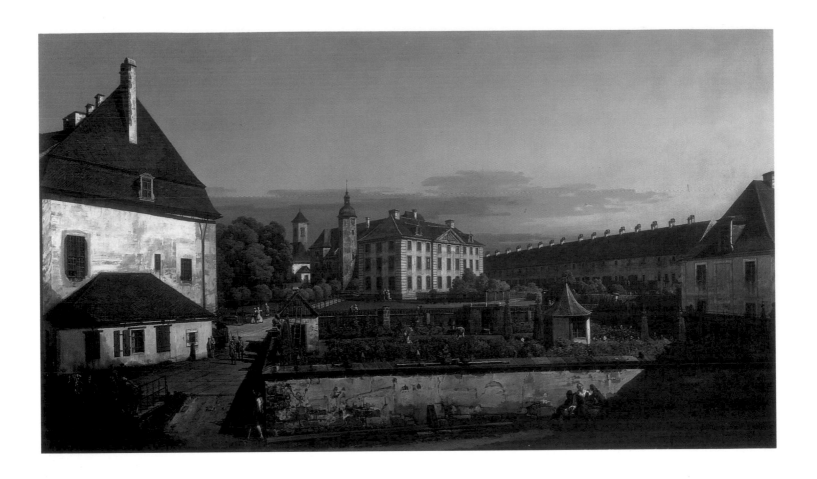

326

Bernardo Bellotto
(1721–80)

*The Castle at Königstein from
the West, c.* 1756–8

oil on canvas, 133.9 × 238 cm
Manchester City Art Galleries,
1982–712

The nephew of Canaletto, in
whose studio he trained, Bellotto
produced view paintings distinct
from those of his more famous
uncle. This is partly a matter of
geography, since Bellotto's
chosen scenes ranged far beyond
Venice, but more profoundly the
result of his characteristic
creation of uncannily vivid views
by balancing sharply observed
detail within grand, wide-angled
compositions. The present
painting is one of five of the
castle at Königstein
commissioned by Augustus III,
King of Poland and Elector of
Saxony, who had summoned
Bellotto from Venice in 1747.
Planned to complement the
great series of Dresden and Pirna
painted by Bellotto as
celebrations of Saxony under the
rule of Augustus and his father,

the Königstein pictures never
reached their intended
destination. The Prussians
invaded Saxony in 1756 and by
the winter of 1758–9 Bellotto
had moved to Vienna. All five
pictures of Königstein are
recorded in England by the end
of the 18th century. Two remain
in an English private collection,
one is now in the National
Gallery of Art, Washington, and
*The Castle at Königstein from the
South* was purchased by
Manchester City Art Galleries in
1983. N K

PROVENANCE 1778, 7 March: sold by
'Ly. Bun' (Lady Brown?), Christie's,
London, lot 79 or 80 (as 'Canaletti'),
bought by Tempest for 76 gns.; by
descent in the Vane-Tempest family at
Wynyard Park, Co. Durham; 1982:
bought by Manchester City Art Galleries
with the aid of the National Art-
Collections Fund, including a
contribution from the Wolfson
Foundation
EXHIBITION *A Bellotto to
Birmingham*, Birmingham Museum and
Art Gallery, 1995–6
REFERENCES S. Kozakiewicz,
Bernardo Bellotto, London and New
York, 1972, I, pp. 100–1, II, p. 189,
no. 241; E. Camesasca, *Bellotto*, Milan,
1974, p. 103, no. 137; J. Byam Shaw,
'Two Views of Königstein Castle',
National Art-Collections Fund Review,
1984, pp. 139–40; E. Bowron, *The
Fortress of Königstein*, Washington, 1993

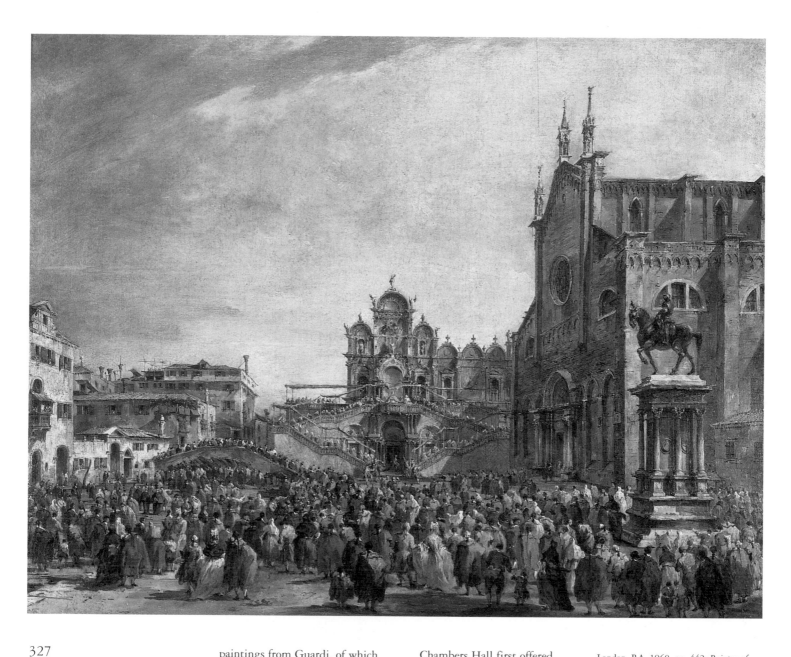

327

Francesco Guardi
(1712–93)

*Pope Pius VI blessing the
Multitude on the Campo
SS. Giovanni e Paolo*, 1782

oil on canvas, 64 × 81 cm
The Visitors of the Ashmolean
Museum, Oxford, A149

To commemorate the visit of
Pius VI to Venice from 15 to 19
May 1782, the Venetian state
commissioned a set of four

paintings from Guardi, of which
this is the fourth. The contract
stipulated the events to be
depicted and required Guardi to
make studies of the actual sites
and follow instructions for the
placement of figures. Here the
Pope, who lodged at the convent
of SS. Giovanni e Paolo, is shown
standing on the elaborate
temporary tribune erected in
front of the Scuola Grande di San
Marco, from where he blessed
the assembled crowds on Whit
Sunday, 19 May 1782.

Chambers Hall first offered
this picture, in 1839, to the
National Gallery, London,
describing it as 'altogether a
capital specimen of that Master,
& of which you appear to stand
in need'. The National Gallery,
which acquired its first Guardi
in 1846, declined the gift. N K

PROVENANCE 1855: presented to the
museum by Chambers Hall
EXHIBITIONS *Italian Art*, London, RA,
1930, no. 797; London, Matthiesen
Gallery, 1939, no. 74; *European Masters of
the Eighteenth Century*, London, RA,
1954–5, no. 92; *Italian Art and Britain*,
London, RA, 1960, no. 442; *Painters of
Venice*, Amsterdam, Rijksmuseum, 1990,
no. 50; *Francesco Guardi: Vedute capricci
feste*, Venice, Fondazione Cini, 1993,
no. 70
REFERENCES F. Haskell, 'Francesco
Guardi as a *vedutista* and some of his
Patrons', *Journal of the Warburg and
Courtauld Institutes*, XXIII, 1960, pp.
256–76; R. Watson, 'Guardi and the
Visit of Pius VI to Venice in 1782', *Report
and Studies in the History of Art*, II, 1967,
pp. 115–32; A. Morassi, *Guardi*, 1975, I,
pp. 185–6, 360, II, pl. 300; *The Glory of
Venice*, exh. cat., London, RA, 1994, p.
305; *Italian Paintings of the Seventeenth and
Eighteenth Centuries*, exh. cat., Washington,
National Gallery of Art, 1996, p. 126

President of the French Chamber of Commerce, whose companion portrait is now in the Musée de Marseille, on deposit from the Louvre. The clarity and simple pyramidal structure make the portrait of Mme Bruyère a model of classical restraint, with the sitter's wealth and status hinted at only by the solid rings and one long earring. Gros concentrates all the impact of the portrait in the eyes, which, though modestly averted, are rendered with the sharpness and precision of a sculptor.

The portrait was acquired by Bristol in 1967 as an addition to a group of 19th-century French paintings which had been built up since 1953 and already included works by artists as diverse as Delacroix, Courbet and Seurat. The price of £28,000 was the highest ever paid by the gallery and became the subject of considerable local controversy. T W

PROVENANCE Mme Jacob Alby, daughter of the sitter; by descent; Galerie Daber, Paris; 1967: purchased from it by the gallery
EXHIBITIONS *France in the Eighteenth Century*, London, RA, 1968, no. 334; *Neoclassicism*, London, Fourteenth Council of Europe exhibition, 1972, no. 123

328
Antoine-Jean Gros
(1771–1835)
Portrait of Mme Bruyère,
1796
oil on canvas, 79.1 × 65.4 cm
inscribed: *à Gènes, Gros 1796*
Bristol Museums and Art Gallery

Gros is now remembered first and foremost for his epic canvases chronicling events in the campaigns of Napoleon, yet throughout his career he also painted portraits. He entered David's studio in 1785, aged fourteen, and travelled to Italy as his protégé in 1793. Gros settled in Genoa and, through exposure there to work by Rubens, adapted David's classicism to a more fluid style, in which colour also played a significant part.

Among many commissions that Gros executed in Genoa was this portrait of Mme Bruyère, the wife of a ship-owner and

329

Francisco José de Goya
y Lucientes (1746–1828)

*Don Juan Antonio Meléndez
Valdés*, 1797

oil on canvas, 73.3 × 57.1 cm
inscribed: *A Melendez Valdes su amigo
Goya / 1797*
The Bowes Museum, Barnard Castle,
Co. Durham, 26

The Bowes Museum has the
largest collection of Spanish
paintings in Britain outside the
National Gallery, London, a
selection, moreover, not
dominated by names made
familiar by the preferences of
18th and early 19th-century
connoisseurs. Even Goya was
little known in this country
when these purchases were made.
However, John and Josephine
Bowes were spurred not by a
wish to revolutionise taste but by
their desire to form a large and
representative collection quickly
and cheaply. Based in Paris, they
would in any case have been
more aware than most English
collectors of Spanish painting,
which enjoyed something of a
vogue in mid-century France
(the first monograph on Goya
was published in Paris in 1858).
Through the dealer and picture
restorer Benjamin Gogué, John
Bowes had access to the
collection of Francisco Xavier,
Conde de Quinto, which his
widow was preparing to sell in
Paris. Quinto had been Director
of the National Museum of
Paintings, created to house
works confiscated after the
suppression of religious
communities in Spain in 1835.

Meléndez Valdés (1754–1817),
poet and judge, was a member of
the enlightened circle around the
liberal minister Jovellanos. The

direct humanity of this portrayal
suggests sympathy between
painter and sitter, the product of
shared ideals and interests. NK

PROVENANCE Francisco Azebal y
Arratia, Madrid (according to X.
Desparmet-Fitzgerald); 1864: Hôtel
Drouot, Paris, Conde de Quinto sale, lot
24, bought by John and Josephine Bowes
EXHIBITIONS *Goya and the Spirit of the
Enlightenment*, Madrid, Museo del Prado,
Boston, Museum of Fine Arts, and New
York, The Metropolitan Museum of Art,
1989, no. 24; *European Paintings from the
Bowes Museum*, London, National Gallery,
1993, no. 23
REFERENCES Bowes Museum, *Catalogue
of Spanish Paintings*, Barnard Castle, 1988
(with full exhibitions and bibliography);
S. Dubosc, 'La Peinture espagnole dans la
collection Quinto', Ph.D thesis, Université
de Paris, Sorbonne, 1997

330

French School

Portrait of a Woman,
c. 1804–10

oil on canvas, 60.5 × 74 cm
Ferens Art Gallery, Kingston upon
Hull City Museums, Art Galleries
and Archives, 582

This arresting and enigmatic
portrait first appeared on the
Parisian art market as a portrait
of Mme de Staël by Ingres.
Neither of these identifications
can now be sustained, but no
convincing alternatives have
been proposed. Research has not
been assisted by the fact that the
painting has been reduced in
size.

The portrait can be dated with
reasonable accuracy *c.* 1804–10
by the costume, especially the
frilled, layered collar and the
long sleeves with their successive
gatherings. Portraiture at this
period was dominated by the
pupils of David and several have
been put forward as the author of
the Hull painting, from Baron
Gérard (1770–1837), then at the
pinnacle of his career, to the
much less well known Henry-
François Mulard (1769–1850).

The sumptuous handling of
fabrics is typical of the period;
less common, perhaps, is the
immediacy of the pose, with the
sitter compressed into a shallow
space very close to the picture
plane, an effect enhanced by, but
not wholly dependent on, the
subsequent reduction of the
canvas. The resulting spatial and
psychological claustrophobia
calls to mind the portraits of
another leading pupil of David,
Anne-Louis de Girodet-Trioson
(1767–1824).

It is to be hoped that the
inclusion of the portrait here will
stimulate further research.

Despite the interest of British
galleries in Neoclassical portraits
during the 1960s, when three of
the examples shown
here (see cat. 328, 340) were
acquired, there has been no
systematic study of this
important field, either in this
country or abroad. T W

PROVENANCE 1901, 21 November:
Drouot, Paris, anon. sale; by 1963: Emil
Hahnloser, Zurich; 1967, 24 November:
Sotheby's, London, lot 53, bought by
Arcade Gallery; 1968: purchased from it
by the gallery
REFERENCE H. Lapauze, *Jean Auguste
Dominique Ingres*, Paris, 1911, p. 54

331

François-Xavier Fabre
(1766–1837)

Allen Smith seated above the
Arno, contemplating Florence,
1797

oil on canvas, 69.3 × 89.2
inscribed: *F. X. Fabri/ Florentiae*
1797
Lent by the Syndics of the
Fitzwillian Museum, Cambridge,
PD16-1984

Fabre was a pupil of Jacques-
Louis David (1748–1825) who
sat out the Revolution and its
aftermath in Italy after winning
the Prix de Rome in 1787. He
bequeathed his collection of
paintings and that of his lover,
the Countess of Albany, to his
native Montpellier, where it

became the core of the
distinguished museum which
bears his name.

This image of a traveller
meditating is closely modelled
on Tischbein's famous portrait of
Goethe in the Roman Campagna
(1786; Städelsches Kunstinstitut,
Frankfurt am Main). Fabre has
employed the same scattering of
Antique fragments; the
traveller's cloak passing for a
toga; the impersonal and
honorific profile of a medal; the
shadows around the face which
suggest that the distant
landscape occurs within the
mind's eye of the sitter.

Florence became an
independent centre of artistic
pilgrimage during the 19th
century; at this stage it is still
presented as a province of Rome,

its mixture of medieval and Renaissance architecture polished and regimented to resemble Nicolas Poussin's visions of Antiquity.

Continental Neoclassicism is woefully represented in English public collections, a situation which has been improved in recent years by some important acquisitions, including this gem of a portrait. It was donated to the Fitzwilliam in 1984 by the Friends of the museum to mark their 75th anniversary, with support from Hazlitt, Gooden & Fox, the National Art-Collections Fund and Cambridge University. DST

PROVENANCE Henry Sinclair of Dublin; 1916: bought at his sale by Agnew's for Charles Clarke; by descent to Mr and Mrs J.P.S. Clarke; 1984: acquired from their executors by the Friends of the Fitzwilliam Museum
EXHIBITION *Treasures from the Fitzwilliam*, Washington, National Gallery of Art, *et al.*, 1989, no. 129, p. 128

332

Elisabeth Vigée-Le Brun
(1755–1842)
Portrait of Countess Golovin,
1800–1 (?)

oil on canvas, 83.5 × 66.7 cm
The Trustees of the Barber Institute
of Fine Arts, The University of
Birmingham, 80.1

'Countess Golovin was a
charming woman; she rarely
received visitors but her wit and
talent were sufficient to keep us
entertained. She drew very well,
and composed some charming
romantic verse which she sang
for us, accompanying herself on
the piano. She was also aware of
all the literary developments in
Europe and these were discussed
in her house at the same time as
they were in Paris.' Thus Vigée-
Le Brun recalled the woman who
became one of her closest friends
during the six years she spent in
Russia as an exile from
Revolutionary France.

Varvana Nikolaevna Galitzin,
born in 1766, married Count
Golovin against her mother's
wishes; husband and wife were
prominent figures in the
imperial court of St Petersburg.
On the accession of Paul I in
1796, compromising rumours
forced the Countess to depart for
Moscow, and it may have been
there, towards the end of Vigée-
Le Brun's time in Russia, that
the portrait was painted.

The artist, who was always
acutely conscious of her own
position and of the need to
reinforce the status of her clients,
achieves in this portrait a rare
intimacy. Her mastery of drapery
as both formal and expressive
device is evident in the red shawl
that the Countess pulls tightly
around her body. The gesture

evokes the sitter's sensuality, her
self-sufficiency and also, perhaps,
the bitter cold of the Moscow
winter, of which Vigée-Le Brun
complained in a letter to her
estranged husband in Paris.
Vigée-Le Brun left Russia in the
spring of 1801, arriving in Paris
the following year. It was there

that the Countess, too, finally
took up residence and where, in
1821, she died. T W

PROVENANCE By descent; 1981:
purchased by the institute
EXHIBITION *Elisabeth Louise Vigée-Le
Brun 1755–1842*, Fort Worth, Kimbell
Art Museum, 1982, no. 46 (with full
bibliography)

333

Antonio Canova
(1757–1822)

Venus, *c.* 1817–20

white marble, height 178 cm
Leeds Museums and Galleries (City
Art Gallery), 21.3/59

The Hope *Venus* is the last in a
series of figures of Venus by
Canova, all inspired by the
Greco-Roman Medici *Venus* in
Florence. The sculptor's interest
in this subject arose from a com-
mission from Felix Bacciochi,
King of Etruria, in 1803 to
make a replica of the celebrated
ancient statue, which had been
removed by Napoleon to Paris.

Canova was famed for his
ability to render marble as flesh
and his suavely erotic female
figures were eagerly sought by
wealthy foreigners who visited
his studio in Rome. One such
was Thomas Hope (1769–1831),
architect, interior designer and
passionate collector (see cat. 317,
318). Hope gave his *Venus* pride
of place in a gallery of his
mansion and private museum in
Duchess Street, London.
Removed by his heirs to his
country residence, Deepdene in
Surrey, it was eventually sold in
London by his great grandson
Lord Francis Pelham Clinton
Hope. The purchaser was an
eminent chemical manufacturer,
Edward Allen Brotherton (later
Lord Brotherton), who paid 1100
guineas for it and displayed it in
the entrance hall of his residence,
Roundhay Hall in Leeds. On his
death it was inherited by his
niece-in-law Dorothy Una
Ratcliffe, a glamorous lady
renowned for her volumes of
Yorkshire lyrics who, in the late
1950s and early 1960s, dispersed
much of her art collection around
local galleries and museums. A W

PROVENANCE 1816/7: commissioned
by Thomas Hope; 1917, 19 July: sold by
Lord Francis Pelham Clinton Hope,
Christie's, London, lot 268, purchased by
Edward A. Brotherton; 1930: bequeathed
by him to Dorothy Una Ratcliffe; 1959:
given by her to the City of Leeds
EXHIBITION *The Age of Neo-classicism*,
London, RA and Victoria and Albert
Museum, 1972, no. 327
REFERENCES H. Honour, 'Canova's
Statues of Venus', *Burlington Magazine*,
CXIV, 1972, pp. 658–70; D. Lewis, 'The
Clark Copy of Antonio Canova's Hope
Venus', in *The William A. Clark Collection*,
exh. cat., Washington, Corcoran Gallery
of Art, 1978, pp. 105–15

334
Achille-Etna Michallon
(1796–1822)
The Oak and the Reed, 1816

oil on canvas, 43.5 × 53.5 cm
inscribed: *Michallon 1816*
Lent by the Syndics of the
Fitzwilliam Museum, Cambridge,
PD 180–1991

Michallon was born in the
Louvre, where lodgings were
provided for large numbers of
artists. His father, a sculptor,
died when the child was only
two and Michallon grew up in
the studio of another sculptor,
his widowed mother's stepfather.
He began to draw at an early age
and his interest was apparently
always in landscape. Michallon
was thirteen when he first
attended classes at the Ecole des
Beaux-Arts, under Valenciennes
(cat. 335), and within a year or
two he entered the studio of

Valenciennes's leading pupil,
Jean-Victor Bertin (1767–1842).
In 1812, aged sixteen, Michallon
exhibited three landscapes at the
Salon.

The Oak and the Reed was
painted at a time when
Michallon had been extending
his technique by copying 17th-
century Dutch paintings in the
Musée Napoléon, bringing
greater realism and vigour to the
reassuring confections typical of
Bertin. The subject is taken from
the *Fables* of La Fontaine (I, xxii).
The mighty oak mocks the
feeble reed until the advent of a
storm, which bends the reed, but
rends the tree in two. It is this
climactic moment that
Michallon has depicted. He
astutely introduces a new type of
iconography to landscape,
classical but not grandiose,
moralising but without the
pretension which seemed
inescapable in the genre. Some
have seen a reference to the fall
of Napoleon, but Michallon may
just as well have had his eye on
the first competition for
landscape in the Prix de Rome,
which was to take place early in
1817: a study of a tree integrated
into a finished landscape was one
of the major qualifying exercises.

Michallon won the contest and
was the first Prix de Rome artist
to go to the city as a landscape
specialist. His finest works
continued to be dominated by
storms and tragic events, as he
shifted towards a more Romantic
conception of landscape. Back in
Paris in 1821, he had hardly
begun to profit from his
reputation as the leading talent
of his generation when he died
of pneumonia in 1822,
aged 25. TW

PROVENANCE 1991: purchased by
the museum
EXHIBITION *Achille-Etna Michallon
(1796–1822)*, Paris, Louvre, 1994, no. 12

335
Pierre-Henri de
Valenciennes (1750–1819)
*Landscape with a Ruined
Bridge*, 1817

oil on canvas, 33.7 × 41.9 cm
inscribed: *Val.1817*
The Bowes Museum, Barnard Castle,
Co. Durham, 448

Valenciennes can with justice be
regarded as the father of 19th-
century French landscape, from
Corot to the Impressionists. His
importance is twofold. First, his
treatise *Eléments de perspective
pratique à l'usage des artistes, suivis
de Réflexions et conseils à un Elève
sur la peinture, et particulièrement
sur le genre du Paysage*, published
in 1800, laid great emphasis on
prolonged study of nature in all
its guises. Second, Valenciennes
campaigned for a new status for
landscape painting, previously
regarded as of little significance
within the hierarchy of genres,
and succeeded in establishing the
Prix de Rome for landscape (first
awarded in 1817, to his brilliant
pupil Michallon!; cat. 334). His
oil sketches from nature, now
prized for their spontaneity and
attention to fluctuating con-
ditions of light and atmosphere,
must have been familiar to his
many pupils, in whom he
inculcated the value of painting
in oils out of doors. The sketches
were unknown to later genera-
tions, however, and re-emerged
only with the donation of a large
group to the Louvre in 1930.

The works Valenciennes
painted for the Salons were

paysages composés, landscapes literally 'assembled' from the experience of his studies in the open air, but relying on memory rather than direct transcription. Towards the end of his career, Valenciennes's Arcadian visions were more often disrupted by storm and disaster. Thus, *Landscape with a Ruined Bridge* bears the strong imprint of an alternative tradition to the classicism which had dominated the artist's early work, and appears indebted to Jacob van Ruisdael (cat. 303), who was also an important influence on Michallon at exactly this time.

The Bowes Museum owns five landscapes by Valenciennes, the largest concentration of his work outside the Louvre. They were all bought on a single day in Paris in August 1865. T W

PROVENANCE 1865, 26 August: purchased by John and Josephine Bowes from Lamer, Paris
EXHIBITION *Romanticism*, London, Tate Gallery, 1959, no. 362

336

Alexandre Millin Du Perreux (1764–1843)
A View of Cauterets in the Pyrenees, 1810

oil on canvas, 35.2 × 44.5 cm
inscribed: *A P* (monogram) *1810*
Bristol Museums and Art Gallery, K4093

Millin Du Perreux was a pupil of Valenciennes (cat. 335) and began his career in 1793, when he exhibited classical landscapes at the Salon. From 1798 he also showed paintings based on direct study of nature. The first of these to depict a subject in the Pyrenees was exhibited in 1801 and the region subsequently featured regularly among his Salon submissions.

In the second part of his influential treatise on landscape painting, published in 1800, but based on his long experience as a teacher, Valenciennes declared that the high mountains of the Pyrenees were second to none in grandeur and in the vistas they afforded the painter. Millin Du Perreux's appreciation of these very characteristics is evident in this view of the little spa town of Cauterets, above Lourdes. At the Salon of 1808, Millin Du Perreux had exhibited a painting of Cauterets owned by Hortense, Queen of Holland, whose patronage had contributed greatly to the town's prestige. His favour in court circles extended to the Empress Josephine, who eventually owned four works by him, fashionable costume pieces in landscape settings.

The precision of Millin Du Perreux's handling caused this work to be ascribed first to the German, then to the Austrian school on its appearance on the London art market. This misattribution is in itself evidence of the diversity within the tradition that Valenciennes sought so energetically to promote, a diversity that is particularly impressive when the painting is viewed alongside other 19th-century landscapes in the Bristol gallery. T W

PROVENANCE 1971: purchased by the gallery from W. Katz

337

Jean-Baptiste Camille Corot (1796–1875)

Lake Piediluco, Umbria, 1826

oil on canvas, 24 × 41 cm
The Visitors of the Ashmolean
Museum, Oxford, A403

Corot was 26 before he received
any formal instruction as a
painter, first under Michallon
(cat. 334), then from Jean-Victor
Bertin (1767–1842). Some of
Corot's earliest landscape
sketches were made in the forest
of Fontainebleau and near his
parents' country house at Ville
d'Avray. However, it was not
until his departure for Italy in
1825 that his great sensitivity as
a painter of landscape began to
emerge clearly.

Corot remained in Italy until
1828. He was based in Rome,
but instead of concentrating on
the over-familiar Campagna and
the Alban Hills, he preferred the
more varied, more dramatic
scenery to the north of the city.
He worked at Cività Castellana

in May and June 1826, then
moved slightly further north to
the village of Papigno, near the
falls of Terni. Lake Piediluco was
close by.

In contrast to his earlier
studies, often made under the
harsh light of the midday sun,
from July to September at
Papigno Corot worked in the
gentler conditions of morning
and evening. Instead of strong
contrast, these works are typified
by subtlety of tone and colour
and by special attention to
atmospheric perspective. This is
nowhere more in evidence than
in the Ashmolean's sketch of
Lake Piediluco, where sky, water
and the receding planes of the
hills are all rendered in tones of
essentially the same hue. T W

PROVENANCE 1875, 25 May: Corot
studio sale, lot 178, bought by
Dubuisson; Sir Michael Sadler; 1931:
bequeathed by him to the museum
through the National Art-Collections
Fund, in memory of Lady Sadler
EXHIBITION *Corot*, Manchester City
Art Gallery *et al.*, 1991, no. 10
REFERENCE P. Galassi, *Corot in Italy*,
New Haven and London, 1991,
pp. 199–200, fig. 255

338

Théodore Caruelle d'Aligny (1798–1871)

Young Man Reclining on the Downs, c. 1833–5

oil on paper laid on canvas,
21.6 × 45.2 cm
Lent by the Syndics of the
Fitzwilliam Museum, Cambridge,
PD 119-1985

After initial study in Paris,
d'Aligny set off in 1822 to
complete his training as a
landscape painter in Rome. Like
Corot, he was no attached to the
French Academy there, and the
two artists struck up a
friendship; in his drawings,
particularly, Corot owed much to
d'Aligny's analytical, linear
approach. On his return to
France, d'Aligny travelled widely
and worked in the Rhone Valley,
in Normandy and also, during
1832, in the Swiss Alps. Like
many of the landscape artists of
his generation he was often at
Fontainebleau. *View of the Quarry
at Mont St-Père in the Forest of
Fontainebleau* (Musée Bargoin,

Clermont Ferrand), which he
showed at the Salon in 1833, was
compared favourably to Corot by
one critic, who declared, 'the
reign of d'Aligny is about to
begin'. In the event, d'Aligny
never achieved the eminence that
was predicted for him and much
of his later work perpetuated the
rather stiff, formal landscapes of
the classical tradition.

*Young Man Reclining on the
Downs* has been dated to the
period of d'Aligny's Salon
success, but the location of the
view depicted has yet to be
established. The landscape has
very little in common with the
type of motif d'Aligny favoured
around Fontainebleau, although
there are similarities with the
terrain in the distance of the
Salon painting.

This study was acquired by
the Fitzwilliam as part of a
collection of 19th-century
landscape sketches through the
bequest of John Tillotson. It is
apparently the only work in an
English public collection by this
central figure of mid-19th-
century French landscape
painting. T W

PROVENANCE 1984: bequeathed to
the museum by John Tillotson
EXHIBITION *The Tillotson Collection*,
Cambridge, Arts Council Gallery, 1966,
no. 1
REFERENCE M.-M. Aubrun, *Théodore
Caruelle d'Aligny 1798–1871: Catalogue
raisonné de l'œuvre peint, dessiné, gravé*, Paris,
1988, no. 30

339

Hippolyte-Benjamin Adam
(1808–53)

*L'Hôpital St Louis et les
Buttes-Chaumont, Paris,
c.* 1830–40 (?)

oil on canvas, 21.8 × 36.7 cm
Bristol Museums and Art Gallery,
K5434

This painting, acquired by the
Bristol gallery as an unidentified
scene by an unknown French
artist, was identified thanks to
another version, in slightly
different format, in the Musée
Carnavalet, Paris. The principal
features visible in the
composition are the Canal St
Martin in the foreground, which
runs to the east of the Gare de
l'Est in Paris, and the Hôpital
St Louis, founded by Henri IV
in 1607 and still functioning.
In the distance are the heights
of the Buttes-Chaumont, long
quarried for their gypsum
deposits (the source of 'plaster of
Paris'), which were transformed
in 1866–7 into a public park.

During his short career, Adam
was known principally as a
portrait and figure painter. The
quality of this urban view reveals
him to have been a gifted and
dispassionate observer of the city
in which he spent his entire life.
Its recent acquisition for the
Bristol collection adds a valuable
and relatively uncommon strand
to the gallery's representation of
19th-century French painting.
TW

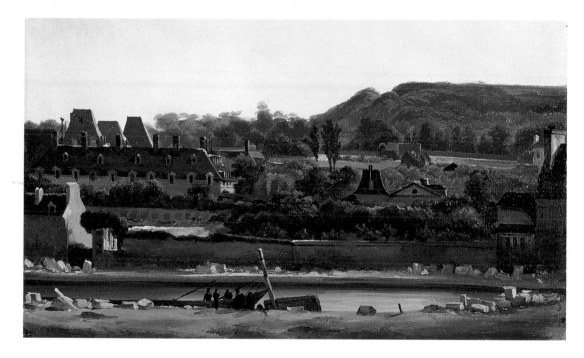

PROVENANCE 1989: purchased by the
gallery

340

Louis-Léopold Boilly
(1761–1845)

Portrait of a Boy, 1823

oil on canvas, 46 × 37.5 cm
inscribed: *B/1823*
Hatton Gallery, University of
Newcastle upon Tyne, OP:0043
88B01:001

It has been estimated that Boilly may have painted as many as 5000 portraits. The majority were executed on uniform canvases measuring just 21 × 15 cm. They were often completed in a single sitting of about two hours and were supplied to the client complete with a standard frame. Boilly began his production of these portraits in about 1805 to provide himself with a steady income and they remained in huge demand until the artist's retirement in 1829. His clients came mainly from the middle ranks of society, the newly influential bourgeoisie – doctors, lawyers, with the occasional actor or man of letters from the Institut de France. Boilly sometimes painted two or even three generations of the same family; this has been seen as a consequence of the French Revolution, the family unit coming to be prized as an example of social cohesion among the ruins of Church and State.

The Hatton Gallery's *Portrait of a Boy* is uncharacteristically large in format. This, and the size of the boy's sparkling white collar, may suggest that the patron was wealthier than most of Boilly's other clients, but regrettably the sitter is unlikely to be identified. The boy's expression of apprehensiveness, a certain unease coupled with resolute concentration, is astonishingly vivid, though it

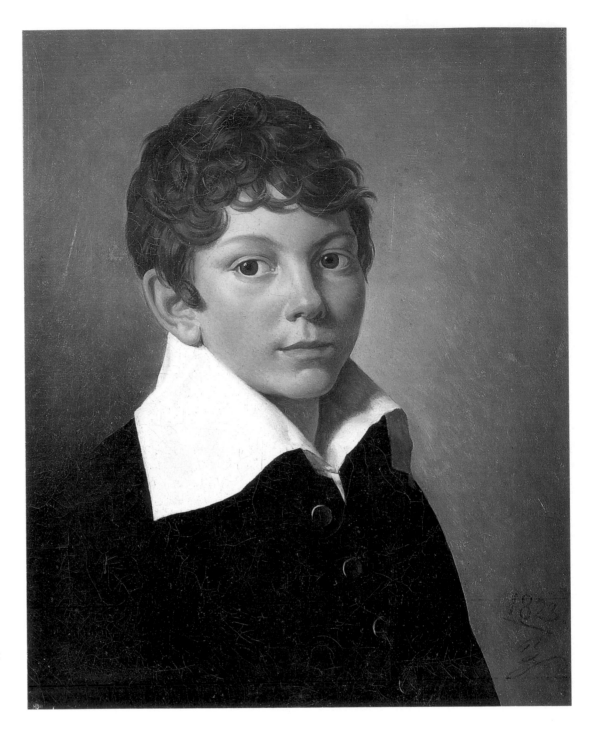

conveys, perhaps, less of the personality of the subject than of the experience of being painted by France's most formidable exponent of the almost instant likeness.

Newcastle University's Hatton Gallery contains a varied collection of French and Italian Old Masters, mostly acquired through a vigorous and enlightened purchasing policy. In 1996 the gallery was threatened with closure, but gained a temporary reprieve owing to the generosity of an honorary graduate of the university, Catherine Cookson. T W

PROVENANCE 1968, 10 January: Sotheby's, lot 207, purchased by the gallery

IMPRESSIONISTS
AND AFTER

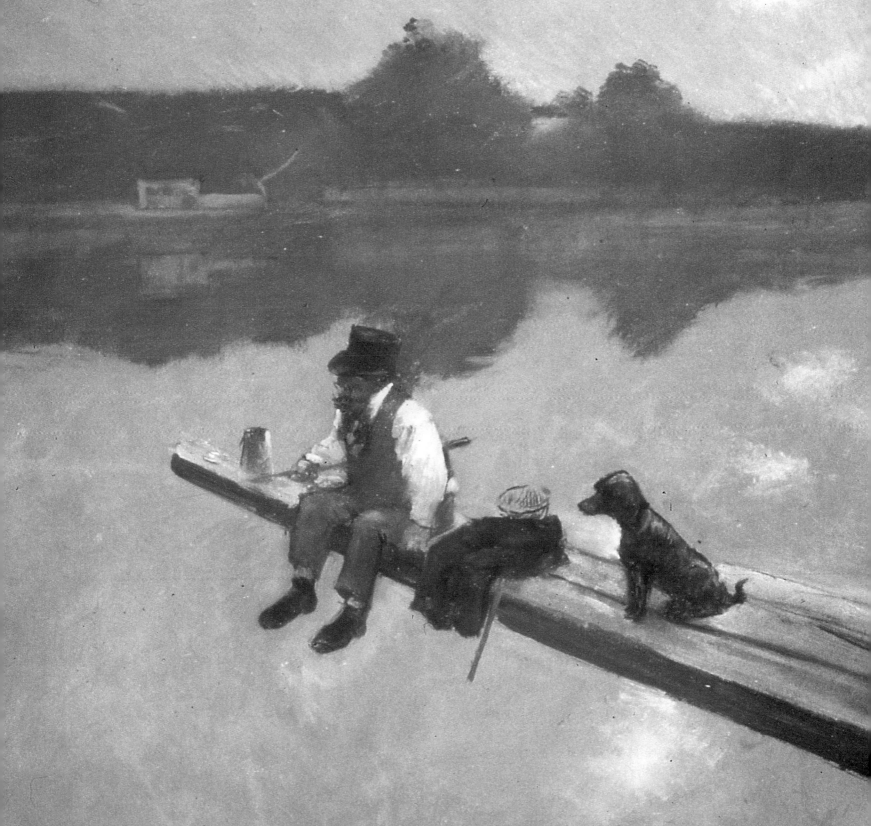

IMPRESSIONISTS AND AFTER

When Samuel Courtauld began collecting works by the major Impressionist and Post-Impressionist painters in the 1920s, Great Britain lagged far behind France, Germany and the United States in such holdings. Although this gap has narrowed significantly in the case of the major national museums, England's regional collections still reflect it – albeit in differing degrees. The museums at Oxford, Cambridge, Birmingham and Liverpool contain representative collections of early modern pictures to complement their outstanding holdings of Old Master paintings. Yet several smaller museums are unexpectedly rich in works of late 19th and 20th-century art. Chief among them are Southampton, Leeds and Leicester.

By the mid-1930s the City Art Gallery in Southampton was purchasing major works by the French Impressionists and their followers, including outstanding canvases by Sisley and Forain (cat. 345, 355). More recent purchases, of Monet, Vuillard, Delvaux and others, have consolidated the museum's position as one of the finest in England in this field (cat. 353, 359, 368). Also in the mid-1930s, the newly founded Barber Institute in Birmingham began acquiring works by Monet and his contemporaries, which were destined to form the nucleus of one of the most representative small collections of late 19th-century French art in the country (cat. 352, 354). In 1939 the Fitzwilliam Museum, Cambridge, received the bequest of Frank Hindley Smith, which included important paintings by Renoir, Cézanne, Degas and Matisse (cat. 348, 360). Most far-sighted of all, however, was the decision of Trevor Thomas and Hans Hess, respectively Director and Curator of Leicester Art Gallery, to acquire works by German Expressionists in the early 1940s, an initiative that resulted in the greatest collection of such works in England (cat. 363, 364). In the years immediately after World War II, two important bequests transformed other regional museums. The first was the small gift of more than 40 19th-century French and Dutch pictures to the Art Gallery in Berwick-upon-Tweed by the Glasgow ship-owner Sir William Burrell (cat. 356). Even more notable was the Pissarro bequest to the Ashmolean Museum, Oxford, in 1950–1, which constitutes by far the largest collection of his art in the world (cat. 350).

More recent landmarks are the fine group of Impressionist and early modern paintings acquired by Birmingham Museum and Art Gallery in the 1950s and 1960s (cat. 341) and the superb collection of such works purchased and bequeathed to Leeds City Art Gallery from the 1930s to the 1970s (cat. 349), initially under the directorship of Sir John Rothenstein, who subsequently became Director of the Tate Gallery. R V

341

Edgar Degas (1834–1917)

A Roman Beggar Woman,
1857

oil on canvas, 100.3 × 75.2 cm
inscribed: *Degas/1857*
Birmingham Museums and Art
Gallery, P.44'60

Degas had strong family
connections with Italy. His
1856–9 stay there was for artistic
reasons, however. Young French
artists of promise traditionally
studied in Italy, often as winners
of the Prix de Rome. By the
1850s this practice no longer
held quite the attraction it had
for previous generations, and
Degas never entered himself for
the competition. Yet his
admiration for the art of the
Italian Renaissance had been
stimulated by his study of the
collection housed in the Louvre.
Contemporary art in Italy held
little interest for Degas, which
makes this moving image of a
beggar woman all the more
remarkable. Together with *Old
Italian Woman*, also of 1857
(Metropolitan Museum of Art,
New York), it should be
considered in the context of the
realist revival then being pro-
moted at the French Academy in
Rome by its director, Victor
Schnetz. A penetrating study,
the painting possesses a still
objectivity which puts one in
mind of earlier masters such as
Velázquez. The acquisition of
such a rare and untypical early
work by Degas represents
museum purchasing at its most
inspired and enlightened. M C

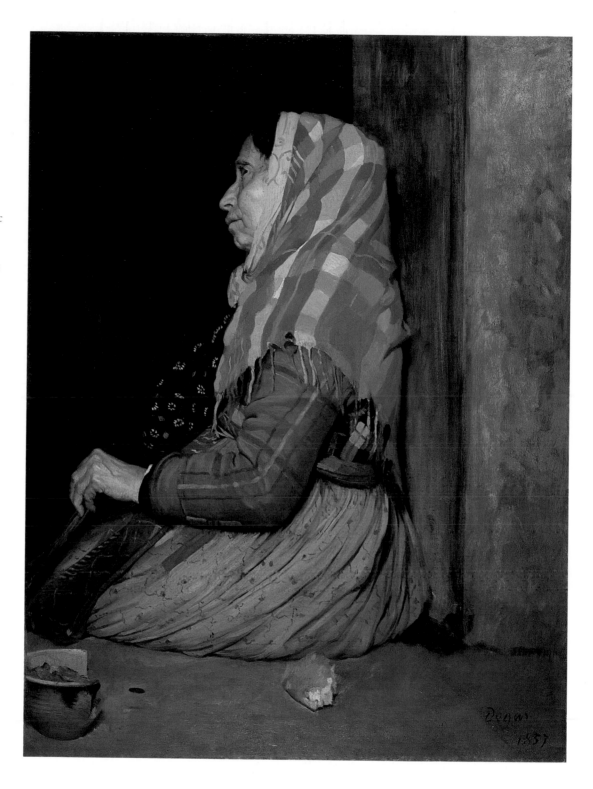

PROVENANCE 1895: deposited by
Degas with Durand-Ruel, Paris; after
1934: bought by Mrs Alfred Chester,
London; after 1952: her husband, Sir
Alfred Chester Beatty; 1955–60:
deposited with the Tate Gallery, London;
1960: purchased by the museum

EXHIBITIONS London, 1962, no. 212;
Degas, Paris, Grand Palais, 1988, no. 11;
*French Impressionism: Treasures from the
Midlands*, Birmingham Museum and Art
Gallery, 1991, p. 6
REFERENCES *Catalogue of Foreign
Paintings in the Birmingham Museum and*

Art Gallery: A Summary Catalogue,
Birmingham, 1983, no. 41; P.-A.
Lemoisne, *Degas et son œuvre*, New York
and London, 1984 edn, II, no. 28

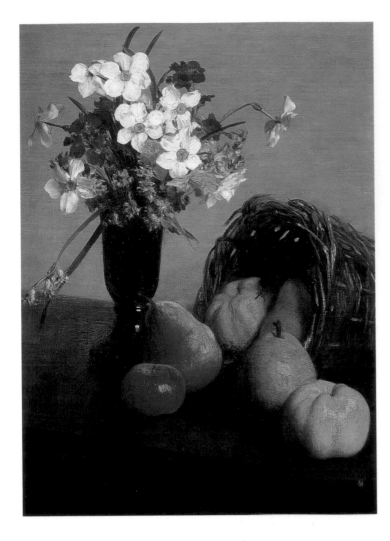

342

Henri Fantin-Latour
(1836–1904)

Fruit and Flowers, 1866

oil on canvas, 60 × 44.1 cm
inscribed: *Fantin 1866*
The Bowes Museum, Barnard Castle,
Co. Durham, 514

During his second visit to
England in the summer of 1861,
Fantin was encouraged to paint
still-lifes by his host, Whistler's
brother-in-law Seymour Haden.
They were well received and, on
his return to Paris, Fantin began
to devote himself almost
exclusively to this subject. His
earlier association with Courbet
and the realists provided him
with a basis for the revival of a
genre based primarily on
observation of the real world.

In 1864 Fantin sold two
paintings of bouquets of flowers
to Constantine Ionides (now part
of the latter's bequest to the
Victoria and Albert Museum)
and many further commissions
followed from other members of
the Greek community in
London. Fantin was, as ever,
plagued by self-doubt, at one
moment satisfied that these
truthful compositions were
doing justice to his aspirations as
an artist, as well as bringing in
much-needed income, at the next
regretting that his energy was
expended on work which
counted for so little. Having
shown his still-lifes at the Royal
Academy from 1862, he decided
in 1866 that they were worthy of
exhibition at the Salon. The
canvas he submitted was well
placed and attracted some
favourable comment. John and
Josephine Bowes presumably saw
it there, for the purchase of their
still-life by Fantin, also a work of
1866, took place in Paris in May

of that year. The dark (glass?)
vase and the fruit basket with
apples and pears on a narrow
polished wooden table were
present in the Salon painting
(now in the National Gallery of
Art, Washington), as in several
other works painted during the
early part of 1866. The spring
bouquet with its white narcissi
and red wallflowers, when
compared to the lilacs or
camellias in the other paintings,
makes it one of the most vivid
and appealing of the whole
series. T W

PROVENANCE 1866, 24 May: bought
by John and Josephine Bowes from Mme
Lepautre, Paris
EXHIBITION *The Realist Tradition:
French Painting and Drawing 1830–1900*,
Cleveland Museum of Art, 1980–1,
no. 125

343

Honoré Daumier
(1808–79)

The Third-Class Railway
Carriage, c. 1865

oil on panel, 25.9 × 33.5 cm
inscribed: *h.D.*
Manchester City Art Galleries,
1955.36

Daumier's work as a painter is
often overshadowed by his
reputation as a caricaturist. In
the course of his career he
produced over 4000 lithographs,
political satires and social
commentaries for publications
such as *Le Charivari*. On a
number of occasions he tried to
establish himself as a painter,
but his inability to complete
many of his paintings (he was in
all probability self-taught in the
medium), coupled with the
critics' perception of a lack of
finish in the pictures he did

manage to produce, were reasons for his failure.

Daumier first depicted public transport in his lithographs, but then he made it the subject of a number of paintings from about 1856 to 1865. He painted all three classes of railway traveller with their various foibles. The Manchester picture differs from his other paintings of third-class passengers in featuring a solitary traveller as opposed to a group. It is closely related to an outline drawing reversing the composition (Myrtil Frank Collection, New York).

Lord Bernstein, who bequeathed the painting to the gallery, founded Granada Television in 1954. He was a keen collector, promoted the display of contemporary art on Granada's premises and, through the Granada Foundation, assisted several major purchases by galleries in the North-West. M C

PROVENANCE Sir George A. Drummond; Velten; Goupil Gallery, London; Barbizon House, London; Margaret S. Davies; 1960, 4 May, Sotheby's, anon. sale, lot 107; Redfern Gallery, London; 1995: bequeathed to the gallery by Lord Bernstein
EXHIBITION Daumier, London, Barbizon House, 1923, no. 2
REFERENCE K.E. Maison, Honoré Daumier: Catalogue Raisonné of the Paintings, Watercolours and Drawings, San Francisco, 1996 edn., I-178

344

Gustave Courbet (1819–77)
Young Ladies of the Village, 1851

oil on canvas, 54 × 65.4 cm
Leeds Museums and Galleries (City Art Gallery), 37.4/37

Young Ladies of the Village was painted as a preparatory study for the work Courbet submitted to the 1852 Salon entitled *Young Ladies of the Village giving Alms to a Cow Girl in a Valley at Ornans, 1851* (Metropolitan Museum of Art, New York). In the study, the figures are dominated by the landscape, whereas in the Salon painting, nearly four times as large in each dimension, the women have much greater prominence. The balancing of these two distinct elements was a new departure for Courbet and he

could not disguise his difficulties. Despite his declared intention to do 'something gracious', the work was reviled, although the critics seized largely on the painting's technical deficiencies, hardly referring to its theme of rural charity.

Set against the distinctive landscape near his home-town of Ornans in Franche-Comté, Courbet depicts three well-dressed young women (modelled by his sisters) giving money to a peasant girl. The work addresses the tensions between city and country, and between the bourgeoisie and the labouring classes which had contributed to the Coup d'Etat of 1851. Courbet's mention of the year in the painting's title suggests a link with those events; yet his own position within this drama was ambiguous, for, however

much he liked to pose as a peasant to the art circles in Paris, his background was among the rural landowners. Politically, the painting is a gesture towards blurring simplistic Parisian conceptions about country life, just as artistically, it attempts to unite genre and landscape.

Courbet regarded the smaller version as complete in itself, since he exhibited it in his one-man show, the 'Pavillon du Réalisme', in 1855 while the large canvas was on display at the Exposition Universelle. T W

PROVENANCE Charles Roberts; 1937: given by him to the gallery
EXHIBITIONS: Gustave Courbet 1819–1877, London, RA, 1978, no. 27; Courbet Reconsidered, New York, The Brooklyn Museum, 1988, no. 13
REFERENCE R. Fernier, La Vie et l'œuvre de Gustave Courbet, 2 vols., Paris, 1977–8, I, no. 126 (with full provenance and bibliography)

345

Alfred Sisley (1839–99)

*Avenue of Chestnut Trees at
La Celle-Saint-Cloud*, 1867

oil on canvas, 95.5 × 122.2 cm
inscribed: *A.Sisley 1867*
Southampton City Art Gallery, 524

The 1860s were a decade of
discovery and experiment for the
young Impressionists and many
of their works contain references
to the art of the past and of the
generation that immediately
preceded them. The centralised
recession of this composition
harks back to the 17th-century
Dutch painter Meindert
Hobbema's *Avenue at
Middleharnis* (National Gallery,
London) and also to Théodore
Rousseau's 1839 *Avenue of
Chestnut Trees* (Louvre, Paris).
Sisley's view of a ride through
the forest close to the village of
La Celle was accepted at the
Salon of 1868 and was
undoubtedly painted in large
format with that aim. It is
obviously indebted to Corot
(cat. 337), Charles Daubigny
(1817–78) and, perhaps most
specifically, to Courbet (cat.
344), especially in the range of
greens and the motif of the deer
emerging from the forest. La
Celle was a popular resort for
Parisians, lying some twenty
kilometres west of the city
beyond Saint-Cloud. The Avenue
of Chestnut Trees was considered
the most interesting of the three
woods which surrounded the
village. Forest scenery, most
famously that of Fontainebleau
as depicted by the Barbizon
School artists, played a crucial
liberating role in French 19th-
century landscape painting:
nature, freed from classical
associations, could be

experienced and appreciated
by the urban tourist and
picture lover. MC

PROVENANCE 1911, 12–13
December: Drouot, Paris, Henri
Haro sale, lot 25, bought by
Durand-Ruel; Mme de la Chapelle,
Paris; A.D. Mourandian; 1936:
purchased from him by the gallery
with the Chipperfield Fund
EXHIBITIONS Salon, Paris, 1868,
no. 2312; London, 1962, no. 229;
Alfred Sisley, London, RA, 1992,
no. 6
REFERENCES F. Daulte, *Alfred
Sisley: Catalogue raisonné de l'œuvre*,
Lausanne, 1959, no. 9; *Landscapes:
An Anthology from Southampton Art
Gallery*, 1979, no. 35; *Southampton
Art Gallery Collection: Illustrated
Inventory*, 1980, p. 424

346

Paul Gauguin

(1848–1903)

Harbour Scene, Dieppe, 1885

oil on canvas, 60.2 × 72.3 cm
inscribed: *P.Gauguin*
Manchester City Art Galleries,
1944.46

Gauguin stayed in Dieppe from
July to October 1885. The
surviving paintings of Dieppe are
limited to two views each of the
port and the beach. This one was
painted from the end of the Quai
Henri IV, looking across to Le
Pollet, the fishermen's quarter. In
the years after the Franco-
Prussian war Dieppe became
extremely fashionable, attracting
a number of prominent musicians
and artists. Gauguin may have
heard Whistler's 'Ten O'Clock
Lecture' delivered there. In *A
Free House!* the English painter
Walter Sickert later
mischievously recalled meeting
in Dieppe at that time 'a sturdy
man with a black moustache and
a bowler . . . who was thinking of
throwing up a good berth in
some administration in order to
give himself up entirely to the
practice of painting'. In view of a
sketch shown to him by the
bowler-hatted artist, Sickert
strongly advised against this. The
artist was Gauguin. M C

PROVENANCE 1893: M. Pasteur,
secretary of the Legation de France, Copen-
hagen; Gustave Cahen; Marcel Bernheim,
Paris; 1926: P. Duxbury, Bury; 1944:
presented to the gallery by his widow
EXHIBITIONS *Paul Gauguin
(1848–1903)*, Tokyo, National Museum
of Modern Art, and Aichi, Prefectural Art
Gallery, 1987, no. 12; *The Dieppe
Connection: The Town and its Artists from
Turner to Braque*, Brighton Museum and
Art Gallery, 1992, no. 23
REFERENCES G. Wildenstein, *Paul
Gauguin*, Paris, 1964, no. 169; *Manchester
City Art Gallery: Concise Catalogue of
Foreign Paintings*, Manchester, 1980, p. 38

351

Camille Pissarro

(1830–1903)

*A Village Street,
Louveciennes,* 1871

oil on canvas, 46 × 55.5 cm
inscribed: *C Pissarro 1871*
Manchester City Art Galleries,
1969.67

Pissarro was the only one of the
Impressionists to exhibit at all
eight of their shows between
1874 and 1886 and is usually
considered the most consistent
and conciliatory member of the
group. He settled at
Louveciennes in 1869, but left
the following year and spent
most of the Franco-Prussian War
(1870–1) in England, before
returning to Louveciennes. This
picture, dated 1871, must have
been painted in the late autumn
to judge from the sparse foliage,
brown leaves and wintry light. It
depicts the view down the Rue
des Voisins, a street also painted
by Renoir and several times by
Sisley.

One of the earliest
Impressionist works to enter a
British collection, this was
acquired by Samuel Barlow
(1825–93) of Stakehill,
Lancashire, probably from
Durand-Ruel's 1872 Summer
Exhibition in London (no. 27).
Barlow was Mayor of Middleton
and President of the Manchester
Arts Club. He owned four
Pissarros and it has been
suggested that his interest in the
artist was stimulated by his
friend the German painter
William Rathjens (1842–82),
who knew Pissarro. M C

PROVENANCE Durand-Ruel, Paris;
1872 (?): Samuel Barlow; by descent to
his great-niece, Mrs Enid M. Holden;
1969: purchased from her by the gallery
EXHIBITIONS *Retrospective Camille
Pissarro*, Tokyo, Isetan Museum of Art,
Fukuoka, Art Museum, and Kyoto,
Municipal Museum of Art, 1984, no. 16;
*Camille Pissarro: Impressionism, Landscape
and Rural Labour*, Birmingham Museum
and Art Gallery, and Glasgow, Burrell
Collection, 1990, no. 8
REFERENCES C. Gould, 'An early
Buyer of French Impressionists in
England', *Burlington Magazine*, 1966,
pp. 141–2; *Manchester City Art
Gallery: Concise Catalogue of Foreign
Paintings*, Manchester, 1980, p. 83

348

Pierre-Auguste Renoir
(1841–1919)

The Gust of Wind, c. 1872

oil on canvas, 52 × 82 cm
inscribed: *A.Renoir*
Lent by the Syndics of the
Fitzwilliam Museum, Cambridge,
2403

This thinly brushed painting of
an Ile de France landscape
embraces a theme also tackled by
J.-F. Millet in his *Gust of Wind*
(National Museum of Wales,
Cardiff) of about the same date.
However, whereas Millet's
Norman scenery is blasted by a
violent storm that uproots trees
and buffets the human figure,
Renoir's more gentle artistic

temperament has led him to
depict undulating woods and
fields which shiver and shimmer
under a sky of brightly lit clouds
and patches of blue. The blurred
forms act as a metaphor for the
swift movement of air and, in
the broadest possible sense,
convey an 'impression' of nature.
Renoir had originally trained as a
porcelain painter, which may
explain the decorative character
of much of his work. A contrib-
utor to the Impressionist exhibi-
tions from 1874 on, he spent his
later years on his estate at Cagnes
in the south of France and
concentrated increasingly on the
theme of the female nude.
French paintings of the later
19th century were hardly

represented in the Fitzwilliam
until Hindley Smith's 1939
bequest which, in addition to
this Renoir, included works by
Bonnard, Cézanne (cat. 360),
Courbet, Degas, Matisse, Sisley
and Vuillard. MC

PROVENANCE 1875, 24 March:
Drouot, Paris, Impressionist sale
organised instead of a second
Impressionist exhibition; 1923: bought
by Frank Hindley Smith from Lefevre &
Son, London; 1939: bequeathed by him to
the museum
EXHIBITION *Renoir*, Boston, Museum
of Fine Arts, and Paris, Grand Palais,
1985–86, no. 25
REFERENCE J.W. Goodison,
H. Gerson and D. Sutton, *Catalogue of
Paintings in the Fitzwilliam Museum
Cambridge*, I, Cambridge, 1960, p. 192

349

Alfred Sisley (1839–99)

The Fields, 1874

oil on canvas, 46 × 64 cm
inscribed: *Sisley. 74.*
Leeds Museums and Art Galleries
(City Art Gallery), 16/73

Sisley probably painted this
picture at or near Louveciennes
in the summer of 1874 before his
departure for England in July.
Market gardens in the Paris
hinterland, of which Sisley
produced a number of paintings
in the early 1870s, had
traditionally supplied the capital
with fresh fruit and vegetables
but, after the completion of the
Paris–Nice railway link in 1870,
were increasingly in competition

with the South of France. Pissarro was similarly interested in agricultural scenery around this date. Just as Sisley's chosen subject-matter is taken from the contemporary landscape, so his natural, uncontrived composition demonstrates how fundamentally the Impressionists broke with traditional formulas: instead of a recession formed by framing trees, as in a classical landscape, or the strong diagonals first used in Dutch art, here the eye is gently led to the horizon by the lines of crops. The two human figures under the branches of the tree give a sense of scale to the composition. In common with a number of Sisley's other agricultural landscapes of this time, *The Fields* displays a use of black chalk underdrawing, particularly in the trees on the left, the crops in the foreground and the vine stakes on the horizon. MC

PROVENANCE Initially belonged to Picq-Véron of Ermont-Eaubonne, a creditor of the dealer Paul Durand-Ruel, who reclaimed it in 1892; Tooth & Co., London; 1973: purchased from them by Leeds

EXHIBITION *Alfred Sisley*, London, RA, 1992, Paris, Musée d'Orsay, and Baltimore, Walters Art Gallery, 1992–3, no. 21

REFERENCE *Leeds City Art Gallery Concise Catalogue*, Leeds, 1974, p. 132

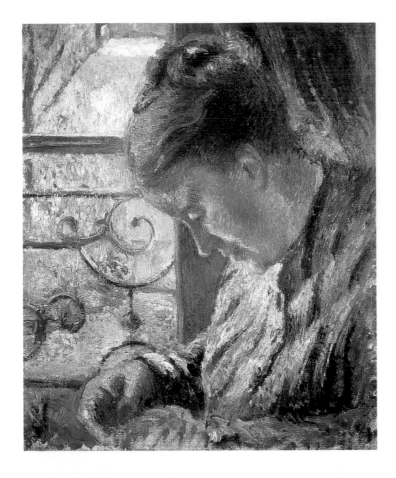

350

Camille Pissarro
(1830–1903)

*Mme Pissarro sewing near a
Window*, *c.* 1878–9

oil on canvas, 54 × 45 cm
inscribed: *CP*
The Visitors of the Ashmolean
Museum, Oxford, A823

One of several portraits that
Pissarro painted of his wife, this
canvas was possibly executed in
his Parisian studio in the Rue
des Trois-Frères. A precedent for
such domestic scenes can be
found in the work of Fantin-
Latour.

Pissarro met Julie Vellay
c. 1860 when she entered his
family's service. A liaison was
soon formed and their first child,
Lucien, was born in 1863. They
finally married at Croydon in
1871 while away from France
during the Franco-Prussian War.
Julie died in 1926. Lucien, who
lived most of his life in England
and married an Englishwoman,
Esther Bensunan, died in 1944.
His widow decided to present
the bulk of the family collection
to the Ashmolean and the first
part was transferred in 1950. She
died in 1951, but by the
following year the transfer by
instalments had been completed
and the Ashmolean was able to
boast one of the greatest
collections of any single
Impressionist's oeuvre. MC

PROVENANCE Lucien Pissarro, London;
Esther Pissarro; 1950: presented by her to
the museum
EXHIBITION *Camille Pissarro*, Boston,
Museum of Fine Arts, 1981, no. 49
REFERENCES: L.-R. Pissarro and
L. Venturi, *Camille Pissarro: Son art et son
œuvre*, Paris, 1939, no. 423; *Ashmolean
Museum, Oxford: Catalogue of Paintings*,
Oxford, 1961, p. 118; A. Callen,
Techniques of the Impressionists, London,
1982, pp. 88–9

351

Paul Cézanne (1839–1906)

Bassin du Jas de Bouffan,
c. 1876

oil on canvas, 45 × 54 cm
Sheffield Art Galleries and Museums
(Graves Art Gallery), 2580

Cézanne's father, Louis-Auguste,
was a wealthy dealer and
exporter of hats. He purchased
the 18th-century manor and
estate Jas de Bouffan in 1859 for
90,000 francs. Situated some two
kilometres west of Aix-en-
Provence, the house still stands.
Cézanne worked more at Jas de
Bouffan than anywhere else in
the course of his career.

Between 1874 and 1878
Cézanne, who had participated in
the First Impressionist
Exhibition in 1874, divided his
time between Paris and the
Midi. This view, painted very
freely – unusually so for Cézanne
– is of one side of the oblong,
ornamental pool just in front of
the house at Jas de Bouffan. The
composition derives its structure
from the vertical of the tree
trunk in the centre balanced by
the horizontal of the edge of the
pond. The pink flowers of the
clump of shrubs, just to the
right of centre, provide the focal
point. MC

PROVENANCE Ambroise Vollard,
Paris; Georges Bernheim, Paris; R.A.
Peto, London; 1964: purchased by the
gallery
EXHIBITION *Cézanne and Poussin: The
Classical Vision of Landscape*, Edinburgh,
National Gallery of Scotland, 1990, no.
13
REFERENCE L. Venturi, *Cézanne: Son
Art, son oeuvre*, I, Paris, 1936, no.160

352

Edgar Degas (1834–1917)

Jockeys before the Race,
c. 1878–9

oil, essence, gouache and pastel on
paper, 107.3 × 73.7 cm
inscribed: *Degas*
The Trustees of the Barber Institute
of Fine Arts, The University of
Birmingham, 50.2

During his Italian visit of 1856–9
Degas sketched horses running
free in the race on the Corso in
Rome. On his return to France,
from *c.* 1860–2, he began
regularly to produce racing
scenes. This is one of his largest
essays in the genre and was based
on an earlier composition of
1868 (private collection, USA).

Degas called the technique he
used here *'peinture à l'essence'*,
achieved by blotting the oil from
the oil paint and thinning it
with turpentine. The resulting
effect has the dryness and surface
delicacy of an eggshell.

Included in the Fourth
Impressionist Exhibition in
1879, the painting was also
shown in London in 1883, where
it attracted the attention of the
Punch critic among others.　M C

PROVENANCE Durand-Ruel, Paris;
1922, 7 December: Paris, Charles
Haviland sale, lot 42; D.W.T. Cargill,
Lanark; 1950: bought from the Cargill
Trustees
EXHIBITION: Fourth Impressionist
Exhibition, Paris, 1879, no. 63; Société
des Impressionnistes, London,
Dowdeswell, May 1883, no. 58; *Degas
1879*, Edinburgh, National Gallery of
Scotland, 1979, no. 11; *French
Impressionism: Treasures from the Midlands*,
Birmingham Museum and Art Gallery,
1991, p. 22
REFERENCES *Catalogue of the Paintings,
Drawings and Miniatures in the Barber
Institute of Fine Arts, University of
Birmingham*, Cambridge, 1952, p. 30;
P.-A. Lemoisne, *Degas et son œuvre*, New
York and London, 1984 edn, II, no. 649;
The Barber Institute of Fine Arts Handbook,
Birmingham, 1993, p. 38

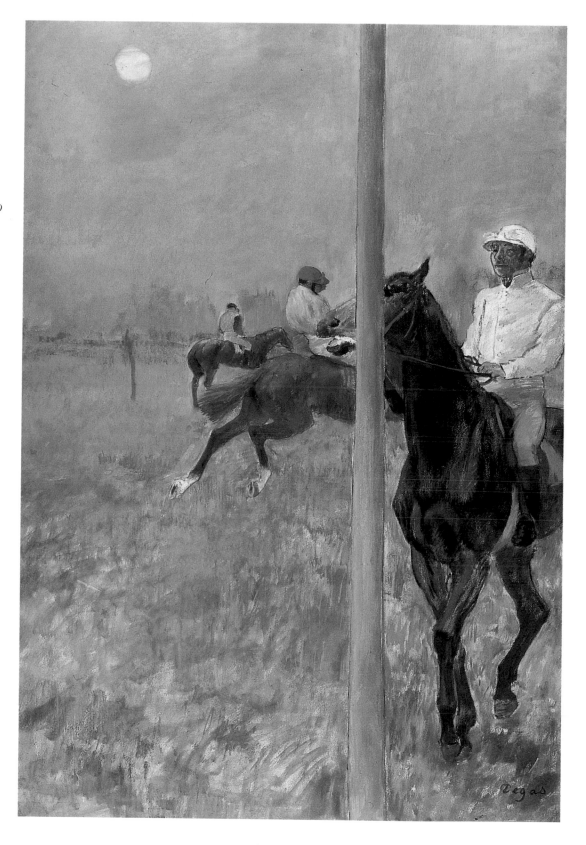

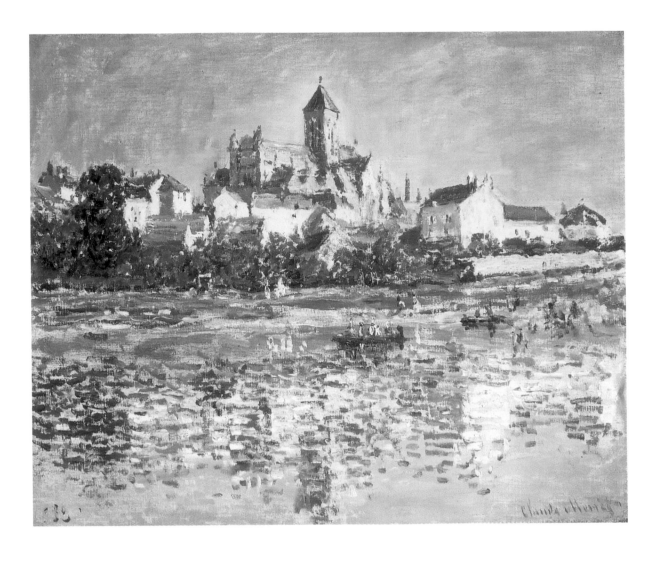

353

Claude Monet
(1840–1926)
The Church at Vétheuil,
1879

oil on canvas, 50.5 × 61 cm
inscribed: *Claude Monet* and, by the
artist at a later date: *1880*
Southampton City Art Gallery,
183/1975

Vétheuil lies some 60 kilometres
north of Paris on the River Seine
opposite Lavacourt. Monet first
visited it in August 1878 on a
summer painting trip and settled
there on account of its cheap cost
of living. Vétheuil at that time
was an unspoilt village with 622
inhabitants, a doctor and a post
office. The Monet family
remained there until they moved
to Poissy in 1881. The period at
Vétheuil was one of the most
prolific in Monet's career,
resulting in well over 200
pictures, many of them painted
within a couple of kilometres of
the house which he rented at the
southern end of the village. The
Southampton painting shows the
view from the south-west across
the river to the 13th-century
church of Vétheuil. Set on raised
ground, the church dominates
the village and recurs,
understandably, as the main
motif in many of Monet's
Vétheuil paintings. MC

PROVENANCE Bernheim-Jeune, Paris;
Boussod, Valadon et Cie, Paris; 1885:
Desfossés, Paris; 1899, 26 April: his sale,
lot 44, bought by Bernheim-Jeune; 1900,
6 March: Paris, Tavernier sale, bought by
Hessel; *c.* 1910: Oscar Schmitz, Dresden;
Wildenstein; Commander C.J. Balfour;
1975: purchased by the gallery with the
Chipperfield Fund
EXHIBITION *Monet*, Edinburgh, Royal
Scottish Academy, and London, Tate
Gallery, 1957, no. 58
REFERENCES D. Wildenstein, *Claude
Monet: Biographie et catalogue raisonné*,
Lausanne and Paris, 1974, I, no. 531;
*Southampton City Art Gallery: Illustrated
Inventory*, 1980, p. 60

354

Claude Monet
(1840–1926)
The Church at Varengeville,
1882

oil on canvas, 65 × 81.3 cm
inscribed: *Claude Monet 82*
The Trustees of the Barber Institute
of Fine Arts, The University of
Birmingham, 38.7

In the 1880s Monet's favourite
area for painting was
undoubtedly the Normandy
coast, easily accessible from his

homes at Vétheuil and, later,
Giverny. The scenery of Dieppe,
Pourville, Varengeville and
Etretat provided him with
dramatic terrain which he de-
picted with the poetic intensity
characteristic of so much of his
middle and later work.

In this view of the 13th-
century church at Varengeville,
seen *contre-jour* from the opposite
slope of the desolate valley Gorge
des Moutiers, the heightened
colouring and the long,
expressive brushstrokes produce
a scintillating *effet*. Monet

painted seven pictures of the
church at Varengeville in 1882.

Although he was an agnostic,
Monet was repeatedly drawn to
depicting ecclesiastical
architecture, from the churches
of Argenteuil to those at
Vétheuil (cat. 353) and
Varengeville and, of course, the
great series of paintings of the
cathedral façade at Rouen. It is
difficult to escape the conclusion
that, all formal considerations
aside, he was not immune to the
spiritual symbolism of these
ancient structures. M C

PROVENANCE c. 1889: Prince Edmond
de Polignac; 1897: acquired from him by
Durand-Ruel, Paris; 1938: bought from
them by the Barber Trust
EXHIBITION *Monet*, Edinburgh, Royal
Scottish Academy, and London, Tate
Gallery, 1957, no. 69; *Claude Monet*,
Vienna, Österreichische Galerie, 1996,
no. 32
REFERENCES *Catalogue of the Paintings,
Drawings and Miniatures in the Barber
Institute of Fine Arts, University of
Birmingham*, Cambridge, 1952, p. 76;
D. Wildenstein, *Claude Monet: Biographie
et catalogue raisonné*, Lausanne and Paris,
1979, II, no. 727; *The Barber Institute of
Fine Arts Handbook*, Birmingham, 1993,
p. 55

PROVENANCE Dr Barnes; 1912, 7–8
March: American Art Galleries, New
York, W. Merritt Chase sale, lot 78;
Durand-Ruel; Mme Katia Granoff, Paris;
1936: aquired from her by the gallery
with the Chipperfield Fund

REFERENCES L. Browse, *Forain the
Painter 1852–1931*, London, 1978, pp.
26–7, 103, no. 19; *Southampton Art
Gallery Collection: Illustrated Inventory*,
1980, p. 31; R. Thomson, *Art History*,
1982, p. 325

355

Jean-Louis Forain
(1852–1931)
The Fisherman, 1884
oil on canvas, 94.7 × 100.1 cm
inscribed. *Forain/1884*
Southampton City Art Gallery, 204

Forain's work, with its mixture
of social commentary and
whimsical individuality, is often
unjustly overlooked in
comparison to that of some of his
more illustrious contemporaries.
This is one of his best known
images. The isolated figure of
the bourgeois fisherman, seated
at the end of the plank and
accompanied by his faithful dog,
is set against an atmospheric,
thinly painted background, the
treatment of which is
reminiscent of Whistler. The
bold composition of the jutting
plank reflects a general interest
in Japanese prints. Forain had
originally received an academic
training, but in his 20s he mixed
with Degas' circle and was much
admired by critics such as
Huysmans for his affinities with
Degas, with whom he shared a
love of ballet and opera. Forain,
who was also friendly with
Manet and joined in the
gatherings at the Café Guerbois,
was a staunch supporter of the
Impressionists – on one occasion
he challenged a young critic who
had criticised their work to a
duel – and participated in their
group shows between 1879 and
1886. For the most part,
however, he was unable to sell
his paintings and earned his
living as a graphic artist. Forain
was elected a member of the
Royal Academy in 1930, a rare
honour for a foreign artist. MC

356

Eugène Boudin
(1824–1898)

Landscape, River Touques,
1891

oil on canvas, 49.5 × 73 cm
inscribed: *La Touques/E.Boudin. 91*
Berwick-upon-Tweed Borough
Museum and Art Gallery,
BERMG 1425

In his oil sketches and his
exploration of the light and
atmosphere of the Normandy
coast Boudin was highly
influential on the young
Impressionists. He met Monet in
1858 and advised him to paint
out of doors. Boudin settled in
Honfleur in 1860 and was a
contributor to the First
Impressionist Exhibition in
1874. His mature style showed
little development thereafter.
This view of the River Touques
is a typical example. The
Touques divides the rival towns
of Deauville and Trouville on the
Normandy coast and featured in
Boudin's paintings from the
1870s onwards. This painting is
particularly close to another
(French private collection) of the
same date that shows a virtually
identical landscape, with an
overcast sky, but is painted with
more broken brushwork.

Sir William Burrell
(1861–1958) was a wealthy
Glasgow ship-owner who, his
fortune made, devoted the rest of
his life to collecting. The bulk of
his collection was donated to the
City of Glasgow in 1944 and
eventually housed in the
magnificent building bearing his
name in Pollok Park, opened to
the public in 1983. His gift to
Berwick-upon-Tweed is less well
known. In 1916 he had acquired
Hutton Castle from Lord
Tweedmouth and lived there for
the rest of his life. The 1949 gift
to nearby Berwick consisted of
42 paintings, mainly 19th-
century French and Dutch, and
was a source of disagreement
with the then Director of
Glasgow Museums and Art
Galleries, Tom Honeyman. MC

PROVENANCE 1902, 12 April: Hôtel
Drouot, Paris, Adrien Lacroix sale, lot 13;
Sir William Burrell; 1949: given by him
to the museum
EXHIBITION *Boudin at Trouville*,
Glasgow, Burrell Collection, and London,
Courtauld Institute, 1992–3, no. 90
REFERENCE R. Schmit, *Eugène Boudin
1824–1898*, III, Paris, 1973, no. 2858

to Brittany from 1886 onwards. He was attracted by the landscape and the inhabitants with their traditional costumes, ancient customs and strong religious faith.

This painting dates from Gauguin's first visit. Its technique is still recognisably Impressionist, with broken brushwork and bright colours. When he returned to Brittany in 1888 Gauguin developed the use of large areas of one colour, resembling the panes of medieval stained glass – a technique known as 'Cloisonnism' and exemplified most famously by *The Vision after the Sermon* in the National Gallery of Scotland, Edinburgh. A number of the motifs in the Newcastle picture recur in Gauguin's ceramics of the period. M C

PROVENANCE 1888: sold by Gauguin probably to Léon Fauché; Gustave Fayet; 1908, 16 May: Paris, anon. sale, lot. 23; 1950: Paul Rosenberg; Mrs Fulford; 1945: bequeathed by her to the National Art Collections Fund and presented to Newcastle
EXHIBITIONS Paris, Salon d'Automne, 1906, no. 11; London, 1962, no. 252; *The Art of Paul Gauguin*, Washington, National Gallery of Art, The Art Institute of Chicago and Paris, Grand Palais, 1988–9, no. 17
REFERENCES G. Wildenstein, *Gauguin*, Paris, 1964, no. 203; *Tyne and Wear County Council Museums and Art Galleries: Collection Handlist. Fine and Applied Art*, n.d., p. 28

357

Auguste Rodin
(1840–1917)

Young Woman kissed by a Phantom, 1880s (?)

bronze, 23 × 44 × 24 cm
inscribed: *A. Rodin*
Reading Museum Service, Reading Museum and Art Gallery, 1963.120.1

There is a Symbolist ambiguity about this group. In the context of funerary art the combination of angel and female figure might connote death and transcendence, but here the sprung posture of the nude woman prompts thoughts of erotic initiation. An early critical response actually referred to the winged figure as a succubus. Although no other examples of this composition have been located, the photographic collection of the Musée Rodin in Paris has early pictures of a version in plaster or marble. These photographs bear

Rodin's drawn additions; in one case he has given the figures herm-like plinths from which they emerge vertically as caryatids. Individual features of the composition are replicated in a plaster of the female figure alone and in another group – *The Dream* – in which this figure floats above another lying face down.

The group is one of two Rodin works included in a donation to the Reading museum made by the daughter of the British sculptor John Tweed. Tweed had studied under Rodin and later acted as host and guide during the Frenchman's visits to England. The rest of the Tweed donation consists of Tweed's own works, several of them echoing Rodin compositions, and of manuscript material, including a substantial number of letters from Rodin to Tweed and his wife, Edith. P W J

PROVENANCE 1963: given to the museum by Miss J. Tweed
REFERENCES A. Elsen, *In Rodin's Studio*, Oxford, 1980, pp. 176–7, pl. 81–2; *Rodin: Sculpture and Drawings*, exh. cat. by C. Lampert, London, Hayward Gallery, 1986–7, p. 213, no. 111; *Le Corps en morceaux*, exh. cat., Paris, Musée d'Orsay, 1990; J. Newton, '"Rodin is a British Institution"', *Burlington Magazine*, CXXXVI, 1994, pp. 822–8

358

Paul Gauguin
(1848–1903)

The Breton Shepherdess, 1886

oil on canvas, 60.4 × 73.3 cm
inscribed: *P. Gauguin 86*
The Laing Art Gallery, Newcastle upon Tyne (Tyne and Wear Museums Service), C643

'I like Brittany, it is savage and primitive.' The search for the remote, for an environment that was the opposite of the perceived sophistication of Paris, explains Gauguin's motives for his visits

411

as a result of his association with the Nabis (Hebrew for 'prophet'), a group formed in 1888 by students from the Académie Julian in Paris. They rejected traditional academic theory in favour of the Synthetist ideas formed by Gauguin and his circle and promulgated by Paul Sérusier (1863–1927) in particular.

The identities of the people depicted here are unknown. Perhaps they were members of the social circle of Thadée Natanson, art critic and co-director of the *Revue blanche*, and his wife, the Polish pianist Misia Godebska. They may even be the Natansons themselves, whom Vuillard, unmarried, frequently visited at their Paris apartment and their country residences. M C

PROVENANCE V. Golubew, Paris; Paul Odo Cross and Angus Wilson, Tidcombe Manor, Wiltshire; 1965, 31 March: Sotheby's, Odo Cross sale, lot 80; Tooth & Sons, London; 1968: purchased from them by the gallery with the aid of the Chipperfield Fund

EXHIBITION *Vuillard*, Glasgow, Museum and Art Gallery, Sheffield, Graves Art Gallery, and Amsterdam, Rijksmuseum Van Gogh, 1991–2, no. 27

REFERENCE *Southampton Art Gallery Collection: Illustrated Inventory*, 1980, p. 85

359

Edouard Vuillard
(1868–1940)

The Manicure, c. 1896–7

oil on card on wood, 33.5 × 30 cm
inscribed: *Vuillard*
Southampton City Art Gallery,
2/1968

Vuillard, whose career stretched from the Symbolist era of the late 19th century to the outbreak of World War II, is best known for his intimate interior scenes, in which he was concerned not so much with recording the exact appearance of domestic life as with capturing the essential emotion or sentiment. As in this

example, patterned wallpaper and upholstery often predominate, and the individual features of the participants are not portrayed. Well versed in the art of the Old Masters (and the Southampton canvas invites comparison with earlier genre scenes), Vuillard had established the fundamental tenets of his art

360

Paul Cézanne (1839–1906)

Landscape, c. 1900

oil on canvas, 62.2 × 51.5 cm
Lent by the Syndics of the
Fitzwilliam Museum, Cambridge,
2381

Although dated 1882–5 by
Venturi, this painting was
redated *c.* 1900 in the 1961
Cambridge catalogue, on the
basis of observations by Douglas
Cooper, who grouped it with a
number of works in which
Cézanne 'adopted a technique of
overlapping square brush strokes
of thin paint, developed from his
increasing experience of handling
water-colour'. The connection
with Cézanne's watercolours is
highly relevant, for the late oils
and watercolours often share a
greater transparency: the white
of the paper or the primed canvas
is allowed to shine through,
increasing the overall brilliance.
Cézanne discussed these bare
patches on his canvases in a letter
to Émile Bernard of 1905: 'Now,
being old, nearly seventy years,
the sensations of colour, which
give light, are the reason for the
abstractions that prevent me
from either covering my canvas
or continuing the delimitation of
objects when their points of
contact are fine and delicate;
from which it results that my
image or picture is incomplete.'
The precise site of the
Fitzwilliam canvas has not been
identified. In his last years, apart
from a trip to the shores of Lake
Annecy, Cézanne remained in
Aix-en-Provence and its
immediate environs, concentrat-
ing on just a few motifs. M C

PROVENANCE Ambroise Vollard,
Paris; Alex Reid & Lefèvre, London;
1939: bequeathed to the museum by
Frank Hindley Smith

EXHIBITION *French Landscapes from The
Fitzwilliam Museum, Cambridge*, Tokyo,
Isetan Museum of Art, *et al.*, 1988, no. 56
REFERENCES L. Venturi, *Cézanne: Son
art, son oeuvre*, I, Paris, 1936, no. 421;
J.W. Goodison, H. Gerson and D. Sutton,
*Catalogue of Paintings in the Fitzwilliam
Museum Cambridge*, I, Cambridge, 1960,
p. 53

361

André Derain (1880–1954)

Portrait of Bartolomeo Savona, 1906

oil on canvas, 45.7 × 35.4 cm
inscribed: *a. derain*
The Trustees of the Barber Institute
of Fine Arts, The University of
Birmingham, 97.1

This engaging portrait – which
has never before been exhibited –
is an important addition to
Derain's early years, when, along
with Matisse and Vlaminck, he
was one of the leading members
of the Fauve group of artists. The
sitter was a Sicilian who visited
London in 1906 to improve his
English and later enjoyed a
career as a teacher of this
language in his native Palermo.
On his visit, Savona stayed at a
guest house in Holland Park,
where he met Derain, who was
paying his second visit to
London. Savona family tradition
has it that Derain executed the
portrait in gratitude for the
Italian's services as an interpreter
when the artist had toothache
and needed to consult a dentist.
Painted on an inexpensive
Winsor and Newton canvas,
the picture is the only portrait
known by Derain from his two
early visits to England.

Wearing a bright blue jacket
and waistcoat and a pink shirt,
Savona is silhouetted against a
citron yellow background, his
soulful and somewhat dreamy
expression indicating apparent
obliviousness to the outburst of
colour around him. Further
enlivening the characterisation
are the jaunty rhythms of his
jacket and hair, painted in
sweeping strokes of blue and red
set against the complementary
hue of bluish-green. No less

remarkable are the myriad
touches of unfused colour that
animate the sitter's face and
features. In its intimacy and
spontaneity, the picture suggests
a genuine rapport between artist
and sitter and was apparently
completed in only three twenty-
minute sittings. R V

PROVENANCE 1997: purchased by the
institute from the family of the sitter
with assistance from the Heritage Lottery
Fund and the National Art-Collections
Fund
REFERENCE F. Grasso, 'A Palermo un
Derain del periodo fauve', *Sicilia*, 1958,
pp. 44–7

362

Pablo Picasso (1881–1973)
Head of a Woman, 1909–10

oil on canvas, 66 × 53 cm
inscribed: *Picasso*
Lent by he Syndics of the
Fitzwilliam Museum, Cambridge,
PD 13–1974

This bust-length portrait
probably depicts Fernande
Olivier, Picasso's mistress from
1904 to 1911. In the back-
ground at the left is an easel
with a canvas on it.

The picture is a characteristic
example of Picasso's 'analytical'
Cubism of 1909–11. Reducing
the head to a series of angular
and interpenetrating planes, the
artist retains a sense of solid form
while reasserting the autonomy
of the work as a two-dimensional
design on a flat surface. Though
the background is treated
similarly, it is more summarily
defined, allowing the head
greater prominence. The
monochromatic palette is typical
of Picasso's art of these years and
reaffirms the non-illusionistic
nature of the image. Rather than
presenting us with a
representation of Fernande,
Picasso encourages us to
reconstruct this in the
imagination from a series of
visual clues. The result
emphasises the tactile nature of
the forms and their relationship
to the surrounding space, while
conveying a mood of intimacy
and tenderness between artist
and sitter.

Aware that the essential reality
of objects can be known only
when the mind interprets the
visible world, Picasso and
Braque evolved an increasingly
abstract and hermetic artistic
language in 1909–11. As Braque
asserted in 1908–9: 'I couldn't

portray a woman in all her
natural loveliness ... I haven't
the skill ... I must therefore
create a new sort of beauty ...
of volume, of line, of mass, of
weight, and through that beauty
interpret my subjective
impression ... I want to expose
the Absolute, and not merely the
factitious woman'. R V

PROVENANCE Sir Michael Sadler;
Alistair Hunter; 1974: given to the
museum by an anonymous benefactor
EXHIBITIONS *Selected Paintings.
Drawings and Sculpture from the Collection of
Sir Michael Sadler*, London, Leicester
Galleries, 1944, no. 127 (as *Head of the
Artist*); *Picasso*, London, Tate Gallery,
1960, no. 50

REFERENCES C. Zervos, *Pablo Picasso*,
Paris, 1932–78, II, no. 219; D. Scrase,
'Pablo Picasso, *Bust of a Woman*, 1909–10',
The Cambridge Review, 29 January 1982,
pp. 129–30

Although he is best known as a painter of animals, Marc executed a number of works featuring nude figures in a landscape which express his mystical belief in the fundamental harmony of all existence. This consoling image is among the finest of such works and the only picture by Marc in the United Kingdom.

The painting owes an obvious debt to Gauguin's Tahitian canvases. With her back to the viewer and her hand upraised, the figure appears to surrender herself to the primal forces of creation, as though seeking to regain a state of lost innocence. Vividly evoking this union are the eurhythmic lines and cornucopian forms that dominate the composition together with the exotic hues, especially the tropical red of the nude and the landscape which elevate the image to a higher and more purely symbolic plane.

With Kandinsky, Marc was the founder of the *Blaue Reiter* (Blue Rider) group of artists in Munich in 1911. In its paradisiacal union of man and nature, *Red Woman* exemplifies the group's desire to create what Marc described as 'symbols for their own time . . . that belong on the altars of a future spiritual religion'. R V

PROVENANCE 1944: purchased by the gallery from S. Pauson, Glasgow
EXHIBITIONS *Forty Years of Modern Art*, London, Institute of Contemporary Arts, 1948, no. 51; *Fauve Paintings*, London, Roland, Browse and Delbanco, 1951, no. 38; London, 1962, no. 281; *German Impressionism and Expressionism from Leicester*, London, Agnew's, 1985, no. 32
REFERENCES K. Lankheit, *Franz Marc: Katalog der Werke*, Cologne, 1970, no. 174; B. Herbert and A. Hinshelwood, *The Expressionist Revolution in German Art 1871–1933*, Leicestershire Museums, 1978, p. 85, no. 44

363
Lyonel Feininger
(1871–1956)
Behind the Church, 1916
oil on canvas, 73.6 × 90 cm
inscribed: *Feininger 1916*
Leicester City Museums, F9.1944

Born in New York City, Feininger moved to Germany at the age of sixteen, remaining there until his permanent repatriation in 1937. After studying at the Berlin Art Academy, Feininger worked as a successful political cartoonist for magazines and newspapers in Berlin until 1909. He then spent time in Paris learning to paint and was greatly influenced by the Fauves' use of colour as well as by the work of Van Gogh.

However, in 1911 he discovered Expressionism and Cubism, which were to affect his work profoundly for the rest of his life. In 1917 he became one of the original instructors at the Bauhaus in Weimar.

Feininger's paintings are densely composed prismatic constructions in which light and shadow are not estranged from one another. *Behind the Church*, also known as *The Square*, is a mysterious composition in luminescent rays of browns and blues, rhythmically enclosing a silent world of silhouetted figures in the static monumentality of an urban landscape. People and architecture merge as if one, in an existential economy of alienation in which a sense of

ground/figure dichotomy is diminished and artifice is augmented. D B

PROVENANCE Georg Kaiser, Weimar; Alfred Hess, Erfurt; 1944: purchased by the museum from Mrs T. Hess, Leicester
EXHIBITIONS Berlin, Galerie Der Sturm, 1917, no. 32; London, 1962, no. 282; *Lyonel Feininger 1871–1956*, Munich, Haus der Kunst, 1973, no. 89
REFERENCES H. Hess, *Lyonel Feininger*, London, 1961, no. 155; B. Herbert and A. Hinshelwood, *The Expressionist Revolution in German Art 1871–1933*, Leicestershire Museums, 1978, p. 60, no. 13

364
Franz Marc (1880–1916)
The Red Woman, 1912
oil on canvas, 100.4 × 69.8 cm
inscribed (on reverse): *Fz Marc 12*
Leicester City Museums, F10.1944

365

Gino Severini (1883–1966)

Danseuse No. 5, c. 1913–16

oil on canvas, 93.3 × 74 cm
Pallanr House Gallery, Chichester,
Kearley Bequest, CHCPH 0594

Gino Severini was among the
Italian artists who signed F.T.
Marinetti's *Manifesto of Futurist
Painters* in 1910. Although he
was a committed Futurist for ten
years, Severini was strongly
influenced by the Neo-
Impressionism of Georges Seurat
(1859–91) and by the 'synthetic'
Cubism of Picasso and Juan Gris
(1887–1929). *Danseuse No. 5* is
one of a series of paintings of
chorus girls that Severini
executed in Paris, where he spent
most of his adult life. The image
of the dancer describes
movement through a dissection
of form and through contrasting
colour planes. Such strictly
ordered compositions gave the
static medium of painting a new
energy and dynamism. The
painting rehearses a theme
central to the Futurist project, in
which perception of a generic
subject (here, a dancer) is altered
through the optical
disassociations engendered by
superimposition and
simultaneity within a
fragmented pictorial space. D B

PROVENANCE John Quinn, California;
1971, 7 July: Sotheby's, London, bought
by Charles Kearley; 1989: Kearley
Bequest to the gallery
EXHIBITIONS London, Marlborough
Galleries, 1913: *Monet to Freud*, London,
Sotheby's and National Art-Collections
Fund, 1989, no. 130
REFERENCE Palant House, Chichester,
The Fine Art Collections, Chichester, 1990,
pp. 12, 58, no. 594

366

Kurt Schwitters
(1887–1948)
Flight, 1945

mixed media construction, partly
painted in oil, 43.2 × 35.6 cm
inscribed: *KS*
Abbot Hall Art Gallery, Kendal,
584/67

Kurt Schwitters is known
primarily for the invention of
'Merz'. Influenced by the early
years of Expressionist landscape
painting and by German Dada,
Merz was a *bricolage* art form,
created from refuse, which relied
on the fortuitous nature of
collecting and the art of
combining disparate materials.
Although Schwitters's concerns
were ostensibly formal, the
pictures and constructions betray
a sense of tempered cultural
critique or, at the very least,
possess a trans-aesthetic
referentiality.

Schwitters left Nazi Germany
in 1937. He eventually settled in
Ambleside in the Lake District
where, apart from working on
his '*Merz* barn' (unfinished at his
death and now in the Hatton
Gallery, University of Newcastle
upon Tyne), he produced
Expressionistic landscape
paintings and constructions, such
as this one, that incorporated
painterly brushwork. D B

PROVENANCE Edith Thomas; 1967:
purchased by the gallery with assistance
from the Friends of Abbot Hall, the
National Art-Collections Fund and the
MGC/V&A Purchase Grant Fund
EXHIBITIONS *Schwitters in the Lake
District*, Kendal, Abbot Hall Art Gallery,
1965, no. 9; *Paintings from the Collection of
Abbot Hall*, Accrington, Hayworth Art
Gallery, 1970; London, Marlborough Fine
Art, 1981
REFERENCESE M. E. Burkett, *Kurt
Schwitters, Creator of Merz*, Kendal, 1979;
V. Slowe, *Treasures of Abbot Hall*, Kendal,
1989

367

László Moholy-Nagy
(1895–1946)
Emery Paper Collage, 1930

gouache and paper collage on paper,
20.3 × 28.3 cm
Whitworth Art Gallery, University
of Manchester, D.1936.17

After fighting in World War I,
Moholy-Nagy, who had qualified
as a lawyer in his native
Hungary, moved to Berlin to
study art. In the early part of his
career, he painted highly
individual landscapes. In Berlin
he became acquainted with El
Lissitsky (1890–1941), Naum
Gabo (1890–1977) and Kasimir
Malevich (1878–1935) and, in
1923, he started teaching at the
Bauhaus.

This abstract collage of 1930
shows the influence of Lissitsky
and Malevich, most especially in
its use of squares and diagonals,
dynamically moving as if
through space. Moholy-Nagy
became fascinated with the
potential of abstract form during
this period and, together with
Lissitsky, established a
revolutionary non-figurative
style. He also began
experimenting with
'photograms' (painting with
light), photography, stage
design, documentary films and
designs for advertising. R B

PROVENANCE 1936: given by the artist
to A. C. Sewter; 1953: presented to the
gallery by him
EXHIBITIONS *Moholy-Nagy*, Arts
Council of Great Britain touring
exhibition, 1980; *The Non-Objective World*,
London, Hayward Gallery, *et al.*, 1992,
no. 45

368
Paul Delvaux (1897–1994)
A Siren in Full Moonlight,
1940

oil on wood, 111.9 × 180 cm
Southampton City Art Gallery,
87/1963

The son of a lawyer and an
overprotective mother,
determined to defend her son
against feminine wiles, the
Surrealist Paul Delvaux painted
subtly erotic nudes, inspired by
classical art, which were deeply
controversial at the time. In his
native Belgium, in particular,
they were seen to transgress
sexual taboos.

By 1934, after his visit to the
Surrealist exhibition *Minotaure*,
Delvaux's artistic path had
become clear. The influence of
Giorgio de Chirico (1888–1978)
was particularly strong; the
latter's painting *Mystery and
Melancholy* came as a revelation
to him and the mysterious
classical background in *A Siren in
Full Moonlight* contains strong
elements of de Chirico. The
provocative sexuality of
Delvaux's siren recalls André
Breton's remarks in *Le Surréalisme
et la peinture* about an artist who
has 'made the universe the
empire of a woman who always
stays the same, and who rules
over the great thoroughfares of

the heart'. Delvaux's sublimation
of women in his art finds a
counterpart in the work of the
Surrealist poets, such as Paul
Eluard.

The classical architectural
background, the avenues of trees
and the full moon in this
painting are all characteristic of
Delvaux's work of the 1940s. At
the centre lies a voluptuous
mermaid, one breast exposed and
her head turned around as if
narcissistically admiring her own
beauty. Delvaux often favoured
the poetic mystery of the night;
here the moon draws out the
shadow of the trees, which seem
to be moving towards the
distance. R B

PROVENANCE Jean-Louis Merclex,
Brussels; Arthur Jeffress; 1963:
bequeathed by him to the gallery
REFERENCE M. Butor, J. Clair and
S. Houbart-Wilkin, *Paul Delvaux:
Catalogue de l'œuvre paint*, Brussels, 1975

BRITISH ART
OF THE 20TH CENTURY

BRITISH ART OF THE 20TH CENTURY

During the first half of the century, when there was no public funding for purchases and little popular appreciation of the work of living artists, the strongest impetus behind the acquisition of contemporary British art by galleries outside London was the Contemporary Art Society (CAS). Founded in 1910 by a group of enlightened enthusiasts, patrons, art critics and curators, this subscription society bought an eclectic selection of work by living artists for gift to national and municipal galleries in Britain and the Commonwealth. It also organised touring exhibitions, incorporating recent acquisitions, to encourage the appreciation nationwide of paintings and sculpture in a contemporary idiom (cat. 372, 377). Additionally, the most discerning patrons of their time, including Kenneth Clark, Edward Marsh (cat. 265) and Michael Sadler (cat. 392), chose to donate works of art from their personal collections to public galleries through the CAS. Although during the later 20th century there were alternative sources of funding, notably government grants administered by the Victoria and Albert Museum (cat. 408), the CAS continued to play a critical role in enriching collections throughout the country (cat. 401, 410).

Manchester City Art Gallery, where, over a period of six weeks in 1911–12, 45,000 people visited the first exhibition mounted by the CAS, was an early buyer of contemporary British art (cat. 381). Its collecting policy helped to persuade Charles Rutherston (a brother of William Rothenstein) to give his collection of some 800 British works to Manchester for use as a source of circulating loans to educational institutions in the North of England. In Leeds the energies of Frank Rutter, Director of the City Art Gallery from 1912 to 1917 (see cat. 370), and Michael Sadler, Vice-Chancellor of the University of Leeds from 1911 to 1923, combined to support the acquisition of the best contemporary British art for that city (cat. 378, 392).

Many galleries established purchase funds and increasingly directed their acquisitions to work by living British artists. Some were created by a single benefactor, such as T.R. Ferens in Hull and Cecil Higgins in Bedford. Purchasing for Southampton relied heavily on bequests from two local residents, R. Chipperfield and F.W. Smith. Spending such funds was often the prerogative of a local committee, usually guided by the gallery's staff. An outside buyer might be appointed as in Carlisle, where William Rothenstein bought art ranging from G.F. Watts to Stanley Spencer.

Galleries outside London continued to rely on bequests from individuals. Some benefactions – the Garman-Ryan Collection given to Walsall Art Gallery in 1972 (cat. 264, 398), the Munnings collection in Dedham (cat. 205) – were sufficient to create a new collection. H.S. Ede gave his entire collection to the University of Cambridge to establish Kettle's Yard (cat. 260, 267, 389). W B

369

Philip Wilson Steer
(1860–1942)

Knucklebones, Walberswick,
c. 1888

oil on canvas, 61 × 76.2 cm
inscribed: *P. W. Steer*
Ipswich Borough Council Museums
and Galleries (Christchurch
Mansion), R1947-31.23

Knucklebones, an ancient
English game involving tossing
and catching the bones of
animals, is here being played
with pebbles by children
sprawled on the sloping shingle
beach at Walberswick in Suffolk,
where Steer spent many summers
during the 1880s.

Knucklebones was one of eight
works by Steer shown at the
1889 exhibition of work by ten
painters who represented the
adventurous 'Impressionist'
clique of the New English Art
Club. That it was shown in two
Royal Academy exhibitions of
the 1970s, one dealing with
Impressionism (1974), the other
with Post-Impressionism (1979),
points to a controversy that has
long shadowed this painting. For
Steer, it was a transitional work
produced at a time when, with
the help of examples from
France, he was beginning to
discard the streaky application of
liquid paint – influenced by
Whistler – and to experiment
with broken brushwork and
broken colour. Is this handling
derived from Monet and
Impressionism or from Seurat
and Post-Impressionism? Where
does Degas fit in? These
questions and others are
discussed by Laughton (1971),
by Jane Munro (Fitzwilliam exh.
cat., where Blackwell is
incorrectly credited with lending

the painting to the 1889
exhibition) and by McConkey
(Barbican exh. cat.).

C.J. Holmes's enthusiastic
review of Steer's exhibition at the
Goupil Gallery in 1909 inspired
Geoffrey Blackwell to buy two
pictures by Steer and thus begin
collecting work by living artists.
It is not known when he bought
Knucklebones, but he probably
sold it to Herbert West through
Barbizon House (a prewar
commercial gallery which dealt
in work by members of the New
English Art Club) in 1935. The
gallery at Ipswich is a fitting
repository for one of Steer's most
important paintings of the
Suffolk coast. W B

PROVENANCE Geoffrey Blackwell; by
1935. Herbert E. West; 1947: presented
by him to the gallery
EXHIBITIONS *London Impressionists*,
London, Goupil Gallery, 1889, no. 34
(not 35); *P. Wilson Steer 1860–1942*,
London, Tate Gallery, *et al.*, 1960–1, no.
8; *Philip Wilson Steer, 1860–1942*,
Cambridge, Fitzwilliam Museum, 1986,
no. 8 (with full exhibition list and
bibliography); *Impressionism in Britain*,
London, Barbican Art Gallery, and
Dublin, Hugh Lane Municipal Gallery of
Modern Art, 1995, no. 210
REFERENCES W. Sickert, *Whirlwind*,
12 July 1890, p. 40 (lithograph after the
painting); D.S. MacColl, *Life, Work, and
Setting of Philip Wilson Steer*, London,
1945, p. 37; B. Laughton, *Philip Wilson
Steer*, Oxford, 1971, pp. 17–19, 20, 38

Leeds Art Gallery has a noted holding of Camden Town paintings, mostly acquired during the 1930s and 1940s. This interest was first nurtured during the directorship (1912–17) of Frank Rutter, influential art critic of *The Sunday Times*, joint editor (with Herbert Read) of *Art and Letters*, founder of the Allied Artists Association in 1908 and organiser of the exhibition of avant-garde British art at the Doré Galleries, London, in 1913. Rutter established the Leeds Art Collections Fund. W B

PROVENANCE 1949: bought by the gallery from the Redfern Gallery, London
EXHIBITIONS *Paintings by Spencer F. Gore and Harold Gilman*, London, Carfax Gallery, 1913, no. 37; *Spencer Gore 1878–1914*, Colchester, The Minories, Oxford, Ashmolean Museum, and Sheffield, Graves Art Gallery, 1970, no. 40; *Spencer Frederick Gore*, London, Anthony d'Offay, 1983, no. 13

371

Malcolm Drummond
(1880–1945)
St James's Park (In the Park),
1912

inscribed: *DRUMMOND*
oil on canvas, 72.5 × 90 cm
Southampton City Art Gallery, 1427

Drummond's membership of the Fitzroy Street and Camden Town groups came about through his attendance at Walter Sickert's painting and etching classes from 1908 to 1910. However, the inspiration for this, his most ambitious painting, is found not in the work of Sickert, but of Seurat, principally in *Une dimanche après-midi à l'Ile de la Grande-Jatte*. In painting his own scene of urban leisure,

370

Spencer Gore (1878–1914)
The Balustrade, Mornington Crescent, 1911

oil on canvas, 60.9 × 50.8 cm
inscribed: *S F Gore*
Leeds Museums and Galleries
(City Art Gallery), 10/49

Gore's brief life was crowded with achievement. He was a founder-member of the Fitzroy Street Group (1907), the Camden Town Group (1911) and the London Group (1913). In the ten years before pneumonia killed him (March 1914), his intuitive artistic intelligence, supported by his growing understanding of French Post-Impressionism, led him from sensitive essays in a modified Impressionist idiom to bold experimental compositions, radical in form and colour.

The depth and richness of colour in this painting hint at future developments. The figure is Mollie Kerr (to become the artist's wife in January 1912), painted during the summer of 1911, the year they met. Identification of the setting is more problematical. It is traditionally known as Mornington Crescent, an address common to many masterpieces of Camden Town painting between 1906 and 1911. Sickert painted figure subjects in his rooms at number 6. From his room at number 31, where he lived from 1909 to 1911, Gore painted the Crescent, the Underground station and the communal gardens. However, in no other representation of the Crescent does a stone balustrade appear. Moreover, the painting was exhibited in Gore's lifetime simply as *The Balustrade*.

Drummond recaptured Seurat's sense of time suspended at a moment of pure poetry, using the same means: frozen movement; simplified silhouettes; heightened colours; a strong sense of pattern; and an austere compositional structure based on the diagonal division of the picture plane.

In his lifetime, public and private collectors neglected Drummond's work. The first exhibition dedicated to it was a small memorial display organised by the London Group in 1945. Southampton Art Gallery was the first public collection in Britain to acquire paintings by Drummond dating from the Camden Town period and the first to host a major showing of the whole group (the 'Festival of Britain' exhibition in 1951). In 1952 Southampton bought Drummond's *Backs of Houses, Chelsea*, which, on loan from Victor Pasmore, had been included in the 1951 exhibition. *St James's Park* was bought the following year from Denys Sutton, the art critic and future editor of *Apollo* magazine. W B

PROVENANCE Denys Sutton; 1953: purchased from him by the gallery
EXHIBITIONS *The Camden Town Group*, London, Carfax Gallery, 1912, no. 29; Salon des Indépendants, Paris, 1913, no. 905; *English Post-Impressionists, Cubists and Others*, Brighton Art Gallery, 1913–14, no. 133; *Malcolm Drummond 1880–1945*, Arts Council of Great Britain travelling exhibition, 1963–4, no. 6; *British Art in the 20th Century*, London, RA, 1987, no. 21
REFERENCES: W. Baron, *The Camden Town Group*, London, 1979, pp. 28, 45–6, 303, 304–5, 365; *The Camden Town Group*, exh. cat. by W. Baron and M. Cormack, New Haven, Yale Center for British Art, 1980, p. 15, no. 22 (with full exhibition list)

PROVENANCE 1916: bought from the artist by the Contemporary Art Society; 1924: presented to the gallery by the CAS
EXHIBITIONS London, Allied Artists' Association, 1913, no. 544; *Post-Impressionists and Futurists*, London, Doré Galleries, no. 49; *Harold Gilman and Charles Ginner*, London, Goupil Gallery, 1914, no. 34 (as *Victoria*); *The Camden Town Group*, Southampton Art Gallery, 1951, no. 44; *British Art in the 20th Century*, London, RA, 1987, no. 19; *The Painters of Camden Town 1905–1920*, London, Christie's, 1988, no. 121
REFERENCES C. Ginner, 'Notebooks', unpubl. MS, I, p. lxvi; W. Baron, *The Camden Town Group*, London, 1979, pp. 28, 342, 370, pl. 138

373

Robert Polhill Bevan
(1865–1925)
Cab Yard, Night, c. 1910

oil on canvas, 63.5 × 69.9 cm
inscribed: *Robert Bevan*
Royal Pavilion, Libraries and
Museums, Brighton and Hove
(Brighton Museum and Art Gallery),
000121

Many of Bevan's paintings, of Exmoor, Sussex, Brittany and Poland, feature horses. In London, his most successful and characteristic subjects included horse cabs, horse sales and scenes featuring dray horses at work in Camden Town's Cumberland Market (where he had a studio).

Bevan joined Walter Sickert's circle in Fitzroy Street in 1909 and was a founder-member of the Camden Town Group. His inclusion of several cab-yard subjects in the group's first two exhibitions (June and December 1911) reflected the belief fundamental to Sickert and his circle that the painter can find beauty in every aspect of his or her immediate environment. Bevan's cab-horse subjects were all painted in the yard at

372

Isaac Charles Ginner ARA
RWS (1878–1952)
Victoria Station. The Sunlit Square, 1913

oil on canvas, 76.2 × 88.3 cm
inscribed: *C. GINNER*
Sefton MBC Leisure Services Dept,
Arts & Cultural Services Section,
The Atkinson Art Gallery, Southport

Ginner, born in France of Anglo-Scottish parents, studied painting in Paris before settling in London in the winter of 1909. He soon joined the painters who, led by Sickert, congregated to show their work in a studio in Fitzroy Street and in 1911 created the Camden Town Group.

On his arrival in England, Ginner was already using the thickly encrusted oily paint which remained his hallmark. Over the next three years he developed a more controlled application of loaded paint, characterised by the small, tight touches and strong feeling for pattern which disciplined his meticulous transcriptions from nature. His handling has been described as like knitting or embroidery.

London as a subject permeated the vocabulary of Camden Town painting. Shabby rooms in North London are the setting for the informal figure subjects, depicting models nude or clothed, alone or in conversation, painted by Sickert, Gore and Gilman (cat. 375). London streets, squares and gardens were repeatedly painted by others, including Bevan, Gilman, Gore, Drummond (cat. 371) and Ginner. Unlike Bevan (cat. 373), Gilman and Gore (cat. 370), who each painted their own immediate locality, Ginner recorded the bustling centres of the metropolis. W B

Ormonde Place, St John's Wood, a short walk from his house near Swiss Cottage. In this example of *c.* 1910, Bevan's subtle division of tones and colours models the broad beam of light cast by the oil lamp to throw into relief a silhouette pattern of strong and simplified shapes. R.A. Bevan relates that his father told him he gave up painting hansom cabs around 1912 because he was 'anxious not to be accused of sentimentalising an almost vanished feature of London life'.

In *The Sunday Times* of 3 December 1911, Frank Rutter, reviewing the second exhibition of the Camden Town Group, urged that one of Bevan's masterly cab scenes be acquired for the nation before more appreciative foreign buyers snapped them up. Two years later Brighton bought the picture from the show mounted in its own gallery. It remained the only work by Bevan acquired by a public art gallery during the artist's lifetime. W B

PROVENANCE 1913: bought by the gallery from an exhibition in Brighton
EXHIBITIONS *The Camden Town Group*, London, Carfax Gallery, December 1911, no. 31; *Paintings and Drawings by Robert Bevan*, London, Carfax Gallery, 1913, no. 12; *English Post-Impressionists, Cubists and Others*, Brighton Art Gallery, 1913–14, no. 36; *The Painters of Camden Town 1905–1920*, London, Christie's, 1988, no. 61
REFERENCES R.A. Bevan, *Robert Bevan 1865–1925: A Memoir by his Son*, London, 1965; W. Baron, *The Camden Town Group*, London, 1979, pp. 219 (exhibitions 1913–76 listed), 362; S. Watney, *English Post-Impressionism*, London, 1980, pp. 63–5

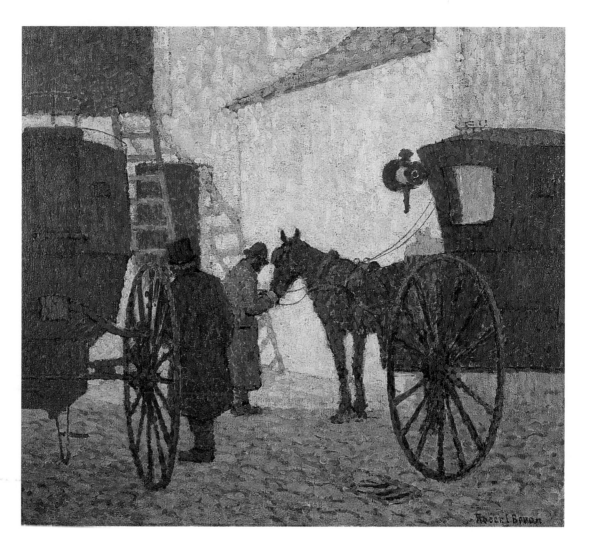

374

Samuel John Peploe
(1871–1935)
*Interior with a Japanese
Print, c.* 1915

oil on canvas, 80 × 62 cm
inscribed: *Peploe*
University of Hull Art Collection,
104

Peploe's father, an Edinburgh
banker, encouraged his
apprenticeship with a legal firm,
but Peploe's convictions led him
first to evening classes at
Edinburgh College of Art, then
to the Julian and Colorossi
academies in Paris. From 1910
to 1912 he lived in Paris and
experimented with his own
brand of Post-Impressionism,
inspired by Van Gogh, Cézanne
and the Fauves rather than
contemporary Cubism. These
pictures, made up of planes of
strong, clear colour, heavily
outlined (a little like stained
glass), were poorly received when
Peploe showed them in
Edinburgh in 1913, but they
established him as one of the
most forward-thinking painters
of his generation. He is known as
one of the '4 Colourists', with
reference to a term coined by a
critic in 1915 to describe the
painting of Peploe's friend
F.C.B. Cadell and used since to
bracket their work with that of
fellow Scots George Leslie
Hunter and John Duncan
Fergusson. The careful
arrangement of furniture and
objects in *Interior with a Japanese
Print* recalls the work of Cadell,
but Peploe was the greater
master of still-life. 'There is so
much', he said, 'in mere objects,
flowers, leaves, jugs, what not . . .
I can never see the mystery of it
coming to an end.' RWI

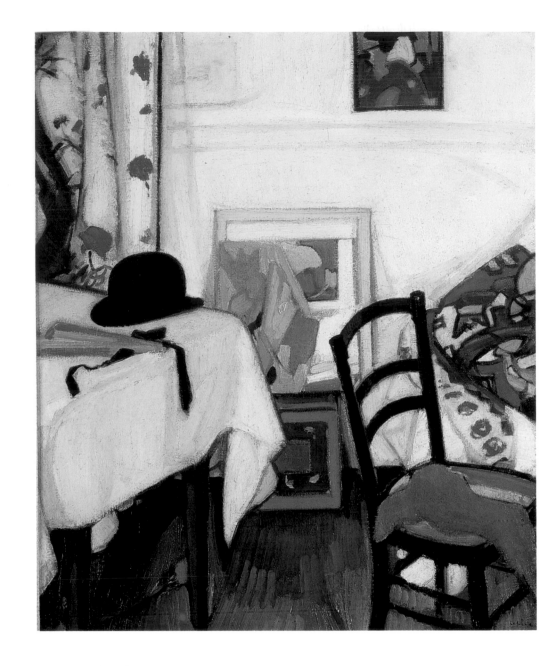

PROVENANCE With Reid & Lefevre
and Anthony D'Offay, London; 1950s:
purchased from The Fine Art Society by
George Black; 1970: purchased from The
Fine Art Society by the University of
Hull
EXHIBITION *S.J. Peploe*, Edinburgh,
Scottish National Gallery of Modern Art,
1985, no. 69

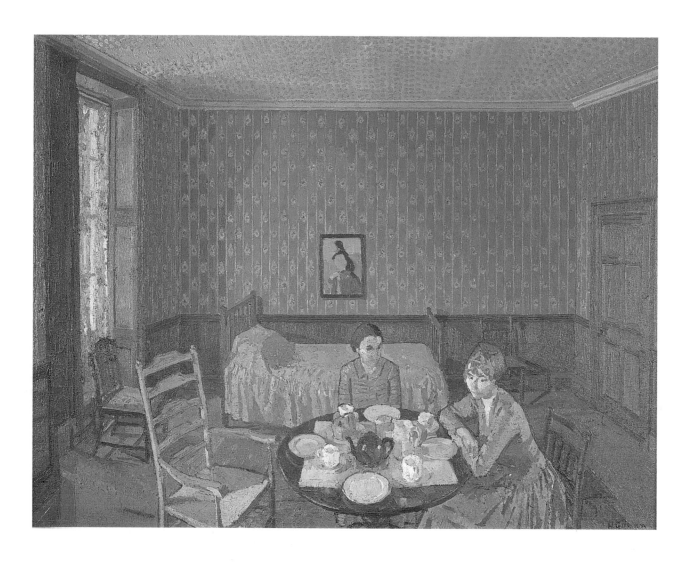

375

Harold Gilman

(1876–1919)

Tea in the Bedsitter, c. 1916

oil on canvas, 71 × 92 cm

inscribed: *H. Gilman*

Kirklees Metropolitan Council,
Huddersfield Art Gallery, 2048.1985

This interior at 47 Maple Street
(off London's Tottenham Court
Road), where Gilman lived and
worked from 1914 until 1917, is
a key work of his short maturity.
It demonstrates how, having
absorbed the teaching of his
Camden Town colleagues
(notably Sickert and Ginner) and
assimilated his passion for Van
Gogh, he had evolved a unique,

intensely personal, means of
expression. The focus of
Gilman's composition is the
circular table with its meticulous
teatime still-life. The model for
the woman on the right was
Sylvia Hardy, to become
Gilman's second wife in 1917.
Louis Fergusson commented on
the painting's 'Vermeeresque-
banality'. Gilman's loving
depiction of the interior
furnishings, the painting on the
far wall and the enigmatic
relationship of the figures to each
other may indeed be deliberate
references to Vermeer.

Gilman was a founder-member
(1913) and the first president of
the London Group. The

importance he attached to this
painting, for him unusually large
and unusually highly priced,
may be reflected in his decision
to include it in London Group
exhibitions in two successive
years. Lady Alice Shaw-Stewart,
a daughter of the Marquess of
Bath, probably bought the
painting on its second showing
in 1917. It thereafter
disappeared from public view
and was not included in the
memorial exhibition held after
Gilman's death from influenza in
1919. W B

PROVENANCE Probably 1917: bought
by Lady Alice Shaw-Stewart; Lady
Howick of Glendale; 1965: bought from
Leicester Galleries by the gallery
EXHIBITIONS London Group, summer
1916, no. 72 (as *Interior*); London Group,
autumn 1917, no. 53 (as *Interior*); *Harold
Gilman 1876–1919: An English Post-
Impressionist*, Colchester, The Minories,
Oxford, Ashmolean Museum, and
Sheffield, Graves Art Gallery, 1969, no.
42; *Harold Gilman 1876–1919*, Arts
Council of Great Britain travelling
exhibition, 1981–2, no. 74 (with full
exhibition list); *British Art in the 20th
Century*, London, RA, 1987, no. 17; *The
Painters of Camden Town 1905–1920*,
London, Christie's, 1988, no. 142
REFERENCE P. Wyndham Lewis and
L. Fergusson, *Harold Gilman: An
Appreciation*, London, 1919, p. 61 (as
Interior)

376

David Bomberg
(1890–1957)
Composition with Figures,
1912–13
oil on panel, 41 × 32.8 cm
The Whitworth Art Gallery,
University of Manchester, O.1981.1

In 1912–13, while still a student
at the Slade School of Art,
Bomberg produced a body of
work as precocious and radical as
anything yet seen in Britain. In a
series of figure groups, some epic
in reference (such as *The Vision of*
Ezekiel), some confined – as here
– to two or three figures
sketched on a small scale, he
reduced what his eye saw to a
vigorous arrangement of
interlocking coloured blocks.
The figures have no identifiable
settings. Anthony d'Offay's
interpretation of this picture as
an East End boxing scene
recognises the physical and
dramatic tensions conveyed
through Bomberg's brusque
handling and energetic
expression of interactive gesture.

Bomberg was one of the most
influential teachers of the post-
World War II generation of
British artists, notably at the
Borough Polytechnic from 1945
to 1953. Leon Kossoff (born
1926) and Frank Auerbach (born
1931) are among those who
freely and generously
acknowledge the impact of his
teaching and his example on the
formation of their art. However,
during his lifetime he had little
success in selling his work to
private or public collectors and
almost no recognition from the
art establishment. His lifelong
achievements, and especially the
authority of his radical early
work, were consistently ignored;

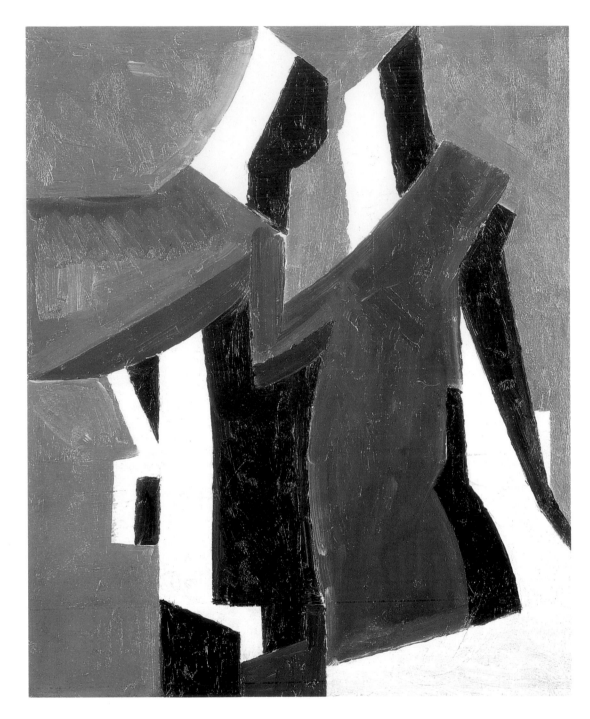

the first major Bomberg
retrospective was mounted by
the Arts Council in 1958, a year
after his death. W B

PROVENANCE Lilian Bomberg, wife of
the artist; 1981: bought by the gallery
from Anthony d'Offay
EXHIBITIONS *David Bomberg*
1890–1957: Works from the Collection of
Lilian Bomberg, London, Anthony d'Offay,
1981, no. 4; *David Bomberg*, London, Tate
Gallery, 1988, no. 18
REFERENCE R. Cork, *David Bomberg*,
New Haven and London, 1987, pp. 58–9

Mark Gertler (1891–1939)
The Fruit Sorters, 1914

oil on canvas, 76.2 × 63.5 cm
inscribed: *Mark Gertler / 1914*
Leicester City Museums, F3.1924

In 1914 Gertler was trying hard
to find subjects for painting
beyond the claustrophobic
environment of his family and
synagogue in the East End of
London. While retaining his
distinctive means of attacking
motifs head-on through monu-
mental design and simplification
of form, *The Fruit Sorters* displays
a new sophistication in its
adaptation of 'primitive' as well
as contemporary influences. The
frieze of linked figures recalls
Egyptian mural painting (in
1912 Gertler had visited the
Egyptian collection of the
British Museum in the company
of Epstein) but also looks to
Augustus John's series of
monumental family and peasant
groups. Like John, Gertler has
set his figures in a landscape, a
new departure which enchanted
him by the opportunity, as he
put it in a letter of April 1914 to
Dora Carrington, to introduce
into the background of his
picture 'some buds of the
springtime, little twigs, leaves
and flowers!'.

Lady Ottoline Morrell, a friend
and patron of Gertler, had been
one of the ten founders of the
Contemporary Art Society (CAS),
set up in 1910 to promote
contemporary art by acquiring
the work of living artists for
eventual gift to national and
municipal collections. She
selected *The Fruit Sorters* (the first
of 30 paintings by Gertler to be
acquired for the nation by the
CAS) on her first stint as
purchaser. WB

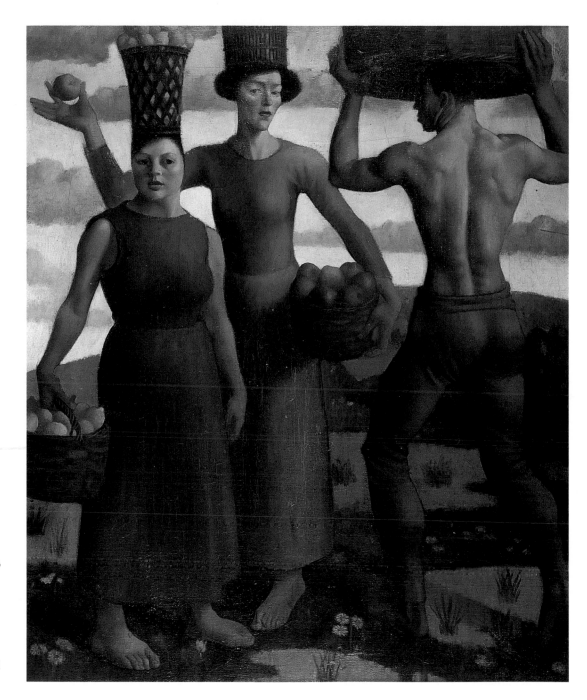

PROVENANCE 1914: bought before a
New English Art Club exhibition for the
Contemporary Art Society by Lady
Ottoline Morrell; 1924: presented to the
museum by the CAS
EXHIBITIONS New English Art Club,
summer 1914, no. 271; *Mark Gertler:
Paintings and Drawings*, London, Camden
Arts Centre, Nottingham, Castle
Museum, and Leeds City Art Gallery,
1992, no. 20

REFERENCES *Mark Gertler: Selected
Letters*, ed. N. Carrington, London, 1965,
p. 65; J. Woodeson, *Mark Gertler*,
London, 1972, pp. 141–3, 363

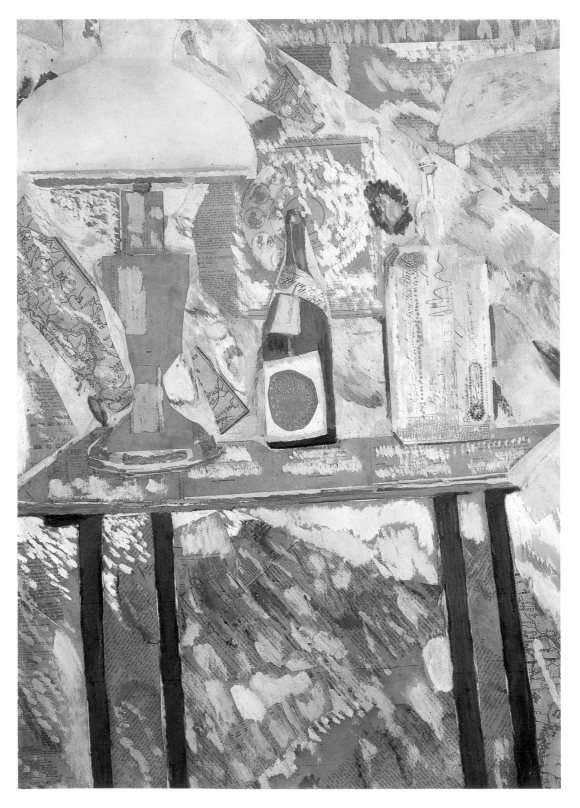

378

Vanessa Bell (1879–1961)

Triple Alliance (*Still-life*),
c. 1914

oil, pastel and paper collage on
canvas, 81.9 × 60.3 cm
The University of Leeds Art
Collection, 1923.1

Sister of Virginia Woolf, wife of
Clive Bell, close friend of Roger
Fry and partner of Duncan Grant,
Vanessa Bell was a key figure in
the Bloomsbury Group. The
years 1914–15 were perhaps the
most experimental of her career, a
time when she simplified the
shapes and colours in her
paintings, even to the point of
pure abstraction. She also created
a few works in collage. In this
example, scraps of newspaper, a
map of central Europe and a
cheque are used to construct a
decorative table still-life
incorporating a lamp and two
bottles. The work has a deeper
meaning, to which the current
title refers. The torn pieces of
map denote the then recent
rupture of the alliance between
Germany, Austria-Hungary and
Italy, which since 1882 had
shaped European diplomacy. Italy
had broken this alliance by
declaring its neutrality at the
outbreak of World War I.

 Vanessa Bell contributed this
work to an exhibition organised
by Roger Fry in 1917 to
represent the new movement in
painting. It was one of eight
paintings bought from the
exhibition by Sir Michael Sadler,
a discerning collector of
contemporary art. Sadler
presented the work to the
University of Leeds in 1923
when he gave up his post there
as Vice-Chancellor to become
Master of University College,
Oxford. W B

PROVENANCE 1917: bought by Sir Michael Sadler; 1923: presented by him to the University of Leeds
EXHIBITIONS *An Exhibition of Works Representative of The New Movement in Art*, Royal Birmingham Society of Artists and London, Heal's Mansard Gallery, 1917, no. 9 (as *Bottles on a Table*); *Modern Art in Britain 1910–1914*, London, Barbican Art Gallery, 1997, no. 8
REFERENCE R. Shone, *Bloomsbury Portraits*, London, 1976, pp. 173–4

379

Sir Matthew Smith
(1879–1959)
Dulcie, c. 1913–15

oil on canvas, 82.5 × 77 cm
inscribed: *MS* (monogram)
Southampton City Art Gallery, 1394

Smith's art was formed in France. Having left the Slade School of Art, he visited Pont-Aven in Brittany (1908) and then went to live and work in Paris. He attended Matisse's *atelier* for a few weeks in 1911. In 1912 he settled with his wife in Gréz-sur-Loing. By chance he was on a visit to England when war broke out and thus spent the years 1914–19 away from France.

 Dulcie used to be dated 1915, chronologically close to a series of nudes seated on upright chairs painted by Smith in Fitzroy Street at that time. In the 1983 Barbican exhibition catalogue it was suggested that *Dulcie* compared in certain respects (the appearance of the model and the execution) to other works done in Gréz, indicating that its date should be revised to 1913. However, Smith's heady integration of Matisse and Duncan Grant (1885–1978), combining a hot colour scheme with extensive passages of

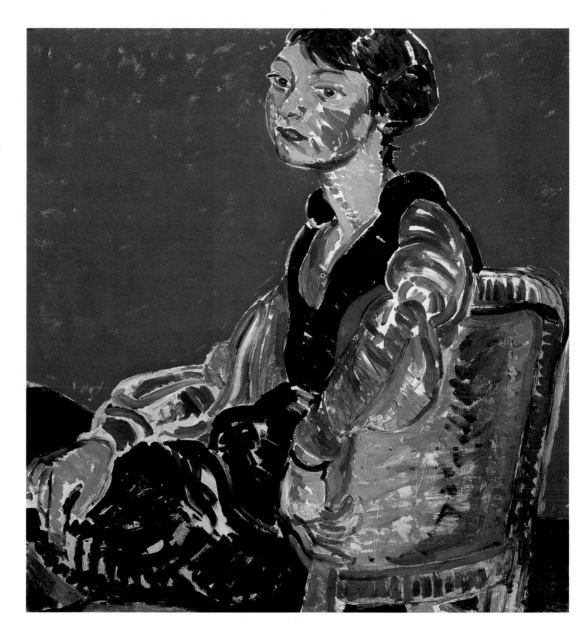

broadly hatched brushstrokes, as well as the circumstantial similarity of the chair on which the model is seated, support the traditional dating. W B

PROVENANCE 1951: purchased by the gallery from Arthur Tooth & Sons, London
EXHIBITIONS *Paintings by Matthew Smith*, London, Reid & Lefevre, 1942, no. 14; *Matthew Smith*, London, Tate Gallery, 1953, no. 6; *A Memorial Exhibition of Works by Sir Matthew Smith CBE 1879–1959*, London, RA, 1960, no. 35;

Matthew Smith 1879–1959: A Loan Exhibition, London, Arthur Tooth and Roland, Browse and Delbanco, 1976, no. 11; *Matthew Smith*, London, Barbican Art Gallery, 1983, no. 10; *British Art in the 20th Century*, London, RA, 1987, no. 82
REFERENCE M. Yorke, *Matthew Smith: His Life and Reputation*, London, 1997, pp. 95, 106

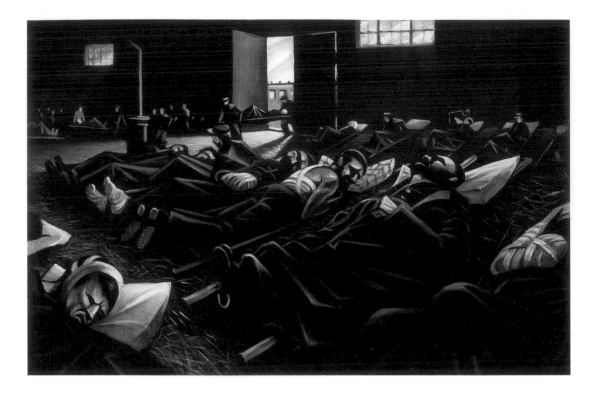

O. Sitwell, *C.R.W. Nevinson*, London and New York, 1925, pp. 27–8, pl. 6; C.R.W. Nevinson, *Paint and Prejudice*, London, 1937, pp. 79, 85; R. Cork, *A Bitter Truth: Avant-Garde Art and the Great War*, New Haven and London, 1994, pp. 131–2

381

Paul Nash (1889–1946)

Wounded, Passchendaele, 1918

oil on canvas, 45.9 × 50.7 cm
inscribed: *Paul Nash*
Manchester City Art Galleries, 1920.79

Nash, like Nevinson (cat. 380), recorded both world wars. His youthful work before the 1914–18 war, mostly in watercolour, was romantic, visionary and decorative. His experience at the Front, first as a combatant, but above all as an Official War Artist from November 1917 on, transformed him. He wrote to his wife from Passchendaele: 'It is unspeakable, godless, hopeless. I am no longer an artist interested and curious. I am a messenger who will bring back

380

Christopher Nevinson RBA ARA (1889–1946)

La Patrie, 1916

oil on canvas, 60.8 × 92.5 cm
inscribed: *C.R.W. NEVINSON*
Birmingham Museums and Art Gallery, 1988 P104

Nevinson's military paintings are among the most haunting images of war produced anywhere in Europe. In *La Patrie* their customary dynamism is banished to unfold a scene terrible for its very lack of animation. Drawing upon his experiences working with a Red Cross unit in northern France, Nevinson recalls a railway shed outside Dunkirk which served as a makeshift hospital. In his memoirs he described the dark room, the straw-strewn floor, the rows of stretchers on which, 'foul with old bandages and filth', lay 'those gaunt, bearded men, some white and still with only a faint

movement of their chests to distinguish them from the dead by their side', those few with the strength crying for their mothers.

Most writers have recognised irony in Nevinson's title for this painting. However, Konody, a contemporary and usually perceptive critic, wrote that in *La Patrie* 'a noble idea – sacrifice of life and limb and all for home and country – tones down the crudeness of the theme'. The second owner of the painting, Laurence Cadbury, had served with Nevinson in the Quaker Friends Ambulance Unit in 1914. W B

PROVENANCE 1916: bought by Arnold Bennett (died 1931) from Leicester Galleries, London; by 1937: Laurence J. Cadbury; 1988: presented to the museum by Sir Adrian Cadbury in memory of his parents, Laurence and Joyce Cadbury
EXHIBITIONS London Group, June 1916, no. 88; *Paintings and Drawings of War by C.R.W. Nevinson*, London, Leicester Galleries, September 1916, no. 7; *C.R.W. Nevinson: War Paintings, 1914–18*, Sheffield, Graves Art Gallery, 1972, no. 7; *Die letzten Tage der Menschheit: Bilder des Ersten Weltkrieges*, Berlin, Deutsches Historisches Museum, 1994, no. II/107
REFERENCES P.G. Konody, *Modern War: Paintings by C.R.W. Nevinson*, London, 1917, pp. 26, 51 (ill.);

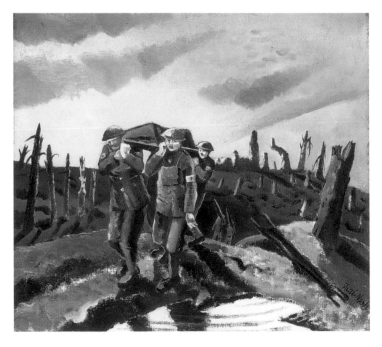

word from the men who are fighting to those who want the war to go on for ever. Feeble, inarticulate, will be my message, but it will have a bitter truth, and may it burn their lousy souls.' Working in London from drawings made at the Western Front, he produced his first paintings in oil and found, in the expressive potential of colour, an added means of conveying the poetic intensity of the horror he had witnessed. In May 1918 his war pictures, five paintings in oil and 51 graphic works, were exhibited at the Leicester Galleries. As Arnold Bennett wrote in his preface to the catalogue, the supreme achievement of these works was that 'in their sombre and dreadful savagery they are beautiful'.

Passchendaele, as this painting was originally titled, is the least well known of Nash's war pictures. The inclusion of figures, generally absent or reduced to ciphers in Nash's paintings, sets *Wounded* apart and suggests that the artist may have deliberately undertaken a unique exercise in the manner of William Orpen (1878–1931).

The City Art Gallery in Manchester was an early and adventurous purchaser of contemporary British art. W B

PROVENANCE 1920: bought from the artist by the gallery
EXHIBITION *Void of War: An Exhibition of Pictures by Lieut. Paul Nash*, London, Leicester Galleries, 1918, no. 7 (as *Passchendaele*)
REFERENCES M. Eates, *Paul Nash 1889-1946: The Master of the Image*, London, 1973, p.113; A. Causey, *Paul Nash*, Oxford, 1980, p. 366, no. 223

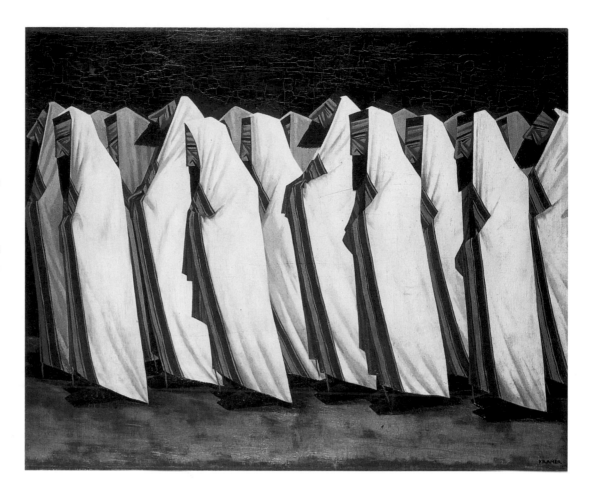

382

Jacob Kramer (1892–1962)
The Day of Atonement, 1919

oil on canvas, 99 × 121.9 cm
inscribed: *KRAMER / 1919*
Leeds Museums and Galleries
(City Art Gallery), 276/20

Kramer's family escaped the pogroms in their native Ukraine to join the flourishing Jewish community in Leeds in 1900. With the encouragement of Michael Sadler, appointed Vice-Chancellor of Leeds University in 1911, Kramer persevered with his art studies and in 1912 won a grant to attend the Slade School of Art. His friends in London included several Jewish artists, among them Gertler, Epstein and Bomberg (cat. 264, 376, 377, 398). While Kramer drew what he needed from each of these artists (simplification of form and structure from Gertler, the formalised expression of spiritual and physical energy from Epstein and Bomberg), his art remained more resistant than theirs to classification. His social life also remained more detached and, when the war ended, he returned to live in Leeds.

Many of Kramer's most important works are rooted in his racial and religious background. The Day of Atonement is the most solemn time in the Jewish calendar. For 25 hours Jews forget their physical needs (hence the prohibition on eating, drinking, bathing and sexual relations) and together seek to atone for their sins (individual and collective) of the past year. Kramer's dense frieze of male worshippers, each wrapped in his prayer shawl, is a powerful metaphor for the theme of self-denial within a communal striving for spiritual release and forgiveness. The year over which Kramer would have reflected was that in which the war had ended. In the style and format of Kramer's painting, it is possible to see an echo of the columns of anonymous troops marching to slaughter on the Western Front painted by his friend Nevinson. W B

PROVENANCE 1919: commissioned by the Leeds Jewish Representative Council; 1920: presented by it to the gallery
REFERENCE *Jacob Kramer Reassessed*, exh. cat. ed. A. Katz, London, Ben Uri Art Gallery, *et al.*, 1984, pp. 4, 5, 21, no. 34

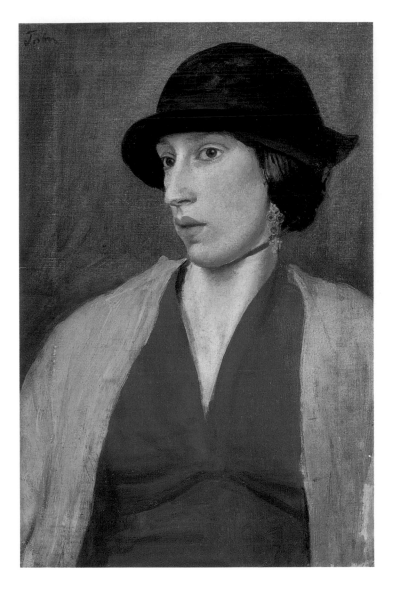

were later to secure his fame and fortune.

In 1963 the University of Hull decided that some of the accumulated balance of the Ferens Fine Art Fund might be spent on buying works of art produced in Britain between 1890 and 1940. Other organisations – in this case the Gulbenkian Foundation – were persuaded to contribute to particular purchases selected by Dr Malcolm Easton, the discerning and scholarly curator of the collection. In his 1967 catalogue, Easton acknowledges that the choice of period was influenced by the impact of the exhibition of Edward le Bas' collection of modern British art at the Royal Academy in 1963. WB

PROVENANCE Lord Alington; Rex Nan Kivell; Redfern Gallery, London; 1964: bought by the university from the summer exhibition at the Redfern Gallery with a grant from the Gulbenkian Foundation
EXHIBITION *Art in Britain 1890–1940, from the Collection of the University of Hull*, University of Hull, 1967, no. 16
REFERENCE M. Easton, 'Augustus John, "Portrait of Mrs Randolph Schwabe"', *Burlington Magazine*, CVII, 1965, pp. 597–8

and critic, as well as a formidable painter. Influenced by Futurism, Cubism and the art of ancient Greece, Lewis founded the Vorticist movement in 1914 with a manifesto he published in his magazine *Blast*. The poet Ezra Pound was one of his greatest champions, in addition to fellow painters Edward Wadsworth (cat. 392) and William Roberts (cat. 394). Vorticism was a reaction to machine-age modernity in an urban setting. It is characterised by terse, rigidly angular abstraction that combines geometric lines with vivid colour in vertiginous spaces. Lewis's anti-humanist cityscapes and human figures expressed a sense of bounded energy, rather like the machines that his art embraced.

The experience of World War I and the demise of Vorticism caused Lewis to reassess his work, which became more tempered and less abstract. He became interested in portraiture. *Mr Wyndham Lewis as a Tyro* is a sinister self-portrait in lurid earth tones which gives expression to the grotesquely savage element in the human unconscious. DB

PROVENANCE 1977, 16 November: Sotheby's, London, bought by Mayor Gallery, from whom purchased by the gallery
EXHIBITION *Tyros and Portraits*, London, Leicester Galleries, 1921, no. 28; *Wyndham Lewis as Vorticist*, London, Tate Gallery, 1956, no. 117; *British Art in the 20th Century*, London, RA, 1987, no. 115; *Eye to Eye: The Ferens Portraits*, Stoke-on-Trent, City Museum and Art Gallery, 1989–90, no. 45
REFERENCES W. Michel, *Wyndham Lewis*, 1971, p. 337, no. 27, pl. 74; T. Normand, *Wyndham Lewis the Artist*, 1992, p. 126

383
Augustus John RA
(1878–1961)
Portrait of Mrs Randolph Schwabe, c. 1914–17
oil on canvas, 61 × 40.6 cm
inscribed: *John*
University of Hull Art Collection, 31

This portrait, one of three John painted of the wife of the artist Randolph Schwabe, was bought by the University of Hull in 1964 as *Birdie: The Black Hat*. Easton explains that the sitter acquired this nickname when she was a student at London's Slade School of Art because of her habit of perching on top of the lockers. The Hull painting is a study for a larger, full-length portrait (whereabouts unknown) bought by the American collector John Quinn. Mrs Schwabe remembered sitting for John in his Chelsea studio between 1914 and 1917, a time when John was honing his powers on studies of his friends, family and colleagues, and not yet receiving the commissions for portraits of dignitaries which

384
Percy Wyndham Lewis
(1882–1957)
Mr Wyndham Lewis as a Tyro, 1920–1
oil on canvas, 76 × 45.8
Ferens Art Gallery, Hull City Museums, Art Galleries and Archives, 659

Percy Wyndham Lewis attended the Slade School of Art, London, and was an accomplished writer

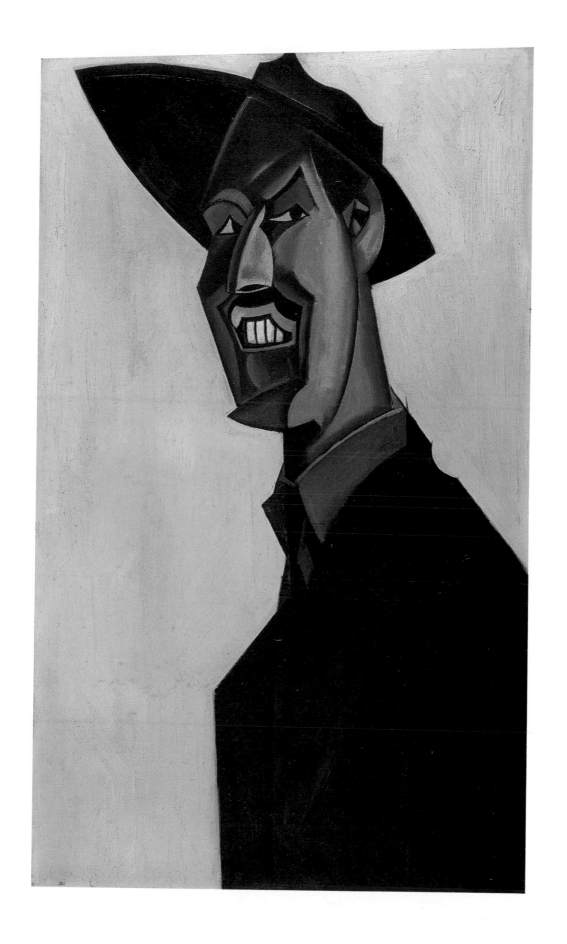

385
Paul Nash (1889–1946)
The Shore, 1923

oil on canvas, 62.2 × 94 cm
inscribed: *Paul Nash/1923*
Leeds Museums and Galleries
(City Art Gallery), 23.1/46

Nash's work before the 1914–18 war, romantic, visionary and decorative, was mostly in watercolour. He began to use oils when preparing work to show at the Leicester Galleries in London in May 1918. That exhibition included five oil paintings of savage intensity based on his countless drawings of the ravaged wartime landscape of northern France.

The Shore belongs to the earliest significant series of work in oil and watercolour created by Nash after the war. It shows the sea wall at Dymchurch in Kent which, troubled in mind and body, Nash first visited in 1919 and where he lived from 1921 to 1924. Dymchurch, with its man-made bastion separating the temperamental and uncertain sea from the bleak vastness of Romney Marsh, offered a rich source of metaphor for Nash's emotions. By 1923 a new and more accepting calmness had become apparent in the Dymchurch pictures. This is conveyed in the open and balanced structure and the near abstract simplicity of the component forms of *The Shore*. The spare handling is characteristic of Nash's use of oil paint: he employed the medium primarily to achieve exquisite juxtapositions of colour fields. W B

PROVENANCE 1923 or 1924: purchased by Mrs D. Bluett Duncan from the Leicester Galleries, London; 1946: bought by the gallery from the dealer Arthur Tooth, London
EXHIBITIONS *Paintings and Watercolours by Paul Nash*, London, Leicester Galleries, 1924, no. 22; *Paintings and Drawings by Paul Nash*, Leeds, Temple Newsam House, 1943, no. 3; *Paul Nash: A Memorial Exhibition*, London, Tate Gallery, 1948, no. 7; *Paul Nash: Paintings and Watercolours*, London, Tate Gallery, et al., 1975–6, no. 75; *British Art in the 20th Century*, London, RA, 1987, no. 128; *Aerial Creatures: Paul Nash*, London, Imperial War Museum, 1996, no. 5
REFERENCES M. Eates, ed., *Paul Nash: Paintings Drawings and Illustrations*, London, 1948, pl. 27; M. Eates, *Paul Nash 1889–1946: The Master of the Image*, London, 1973, p. 32, pl. 38; A. Causey, *Paul Nash*, Oxford, 1980, pp. 125, 382, no. 386, pl. 147 (with more extensive bibliography and exhibition list to 1980)

386

Frank Dobson
(1886–1963)
Cornucopia, 1925–7

Ham Hill stone, 107.5 × 35 × 35 cm
University of Hull Art Collection

In the 1920s and 1930s Dobson was an important member of the British avant-garde. With Henri Gaudier-Brzeska (cat. 258) and Jacob Epstein (cat. 398) he represented what was best and most advanced in sculpture in Britain. In 1925 the artist-critic Roger Fry described his work as 'true sculpture and pure sculpture . . . almost the first time that such a thing has been attempted in England'. The previous year Dobson had been elected President of the London Group. In 1925, the year in which he started work in *Cornucopia*, his largest sculpture to date, he showed four sculptures and seven drawings in the Tri-National Art Exhibition, which was seen in Paris, London and New York. He was beginning to gain an international reputation.

The strong sense of movement in *Cornucopia* is frequently connected with Dobson's travels in Ceylon with the novelist L.H. Myers in 1921 and his subsequent exposure to Indian art and culture. Even before the work was completed, the critic Clive Bell had hailed it as 'the finest piece of sculpture that has been produced by an Englishman since I don't know when'. The sculpture was cleaned and conserved in 1994. R B

PROVENANCE 1967: purchased by the university with the aid of grants from the National Art-Collections Fund and the Friends of the University
EXHIBITION *British Art in the 20th Century*, London, RA, 1987, pp 41, 46, no. 94

387

Gwen John (1876–1939)
*Portrait of Mère Poussepin,
c.* 1915–20

oil on canvas, 68.7 × 51.2 cm
Southampton City Art Gallery, 1456

Gwen John was born two years
after her brother Augustus (cat.
383), whose path she followed in
1895 to the Slade School of Art
in London. By 1904 she had
settled more or less permanently
in Paris, where she soon became
model and mistress to Rodin. In
1911, in order to be nearer his
country house, she moved to the
suburb of Meudon, where she
came to know Les Sœurs du
Charité de la Sainte Vierge de
Tours, an order of nuns who ran
a school in the town. John
became a Catholic in 1913 and
at around the same time accepted
a commission from the nuns to
paint several portraits of their
founder, Mère Marie Poussepin
(1653–1744), based on an
unattributed 18th-century
portrait. She worked very slowly,
never confident of her own
abilities, and only one of the six
versions was ever given to the
nuns. This version, in which
Mère Poussepin seems rather
younger and softer than in some
of the others, remained in the
possession of the artist's family
until it was bought by the
Southampton gallery in 1954.
R W I

PROVENANCE Until 1954: the artist's
family; 1954: purchased from the
Mathiesen Gallery, London, by
Southampton Art Gallery through the
Chipperfield Bequest
EXHIBITIONS *Gwen John Memorial
Exhibition*, London, Mathiesen Gallery,
1946; *Gwen John*, London, Barbican Art
Gallery, 1985, no. 20
REFERENCE C. Langdale, *Gwen John*,
London, 1987, no. 55, p. 151, pl. 70

388

Walter Sickert RBA RA
(1860–1942)

Portrait of Victor Lecourt,
1921–4

oil on canvas, 81.3 × 60.5 cm
inscribed: *Sickert – 1924*
Manchester City Art Galleries,
1947.165

Although dated 1924, when
Sickert lived in London, this
portrait was begun in 1921,
during his last sojourn in
Dieppe, with sittings in his
seafront studio. Victor Lecourt
was the former proprietor of Le
Clos Normand, a restaurant just
outside Dieppe in the village of
Martin-Eglise. Sickert's relish for
his subject, whom he described
as 'a superb great creature like a
bear', is evident in the rich
texture of the paint, the
succulent variety of brushstroke,
the lush colours and the
astonishing shorthand definition
whereby the barely modelled
figure, seen *contre-jour*, emerges
as a solid presence through the
roughly scrubbed ochres used to
describe reflected light bouncing
off sleeve, beard and bald pate.

The critics welcomed the
refreshing informal style and
handling of this painting,
Sickert's first major submission
to a Summer Exhibition at the
Royal Academy following his
recent election as ARA. Over the
next ten years, until his election
as a full Academician in 1934,
Sickert sent several of his more
startling portraits to the summer
exhibitions. Ever contrary, he
resigned from the Academy in
1935. W B

PROVENANCE By 1930: Leicester
Galleries, London; Charles Jackson
(dealer), Manchester; G. Beatson Blair;
1941: bequeathed by him to the gallery;
1947: received by the gallery
EXHIBITION Summer Exhibition,
London, RA, 1925, no. 17

REFERENCES W. Baron, *Sickert*,
London, 1973, pp. 162–3, 376; *Sickert
Paintings*, exh. cat. by W. Baron and
R. Shone, London, RA, and Amsterdam,
Rijksmuseum Van Gogh, 1992–3,
p. 276, no. 99 (with more complete
exhibition listing and full bibliography)

Christopher Wood
(1901–1930)
Le Phare, 1930

oil on board, 54 × 79 cm
Kettle's Yard, University of
Cambridge, CW8

Christopher Wood was brought
up in modest, middle-class
fashion on the outskirts of
Liverpool before he escaped to
London at the start of the 1920s.
Aided by his looks and legendary
charm, he became the one
English artist of his generation
who was 'found acceptable in the
Paris *monde* of Cocteau and
Picasso', as his contemporary, the
novelist Anthony Powell, put it,
'a convenient bisexuality being
no handicap in that particular
sphere'. *Le Phare* belongs to the
group of pictures that Wood
painted at Tréboul, Brittany,
during the last summer of his
short life. At a glance they are
simple pictures – cheerful scenes
of seaside life with tiny white
cottages clinging to dark-green
hills or, as here, brown-sailed
boats on deep-blue seas – but
they have a lingering, slightly
sinister quality which is
heightened by the knowledge
that Wood killed himself a
month later. *Le Phare* was one of
several pictures owned by
Wood's friend H.S. ('Jim') Ede,
who described it as 'perhaps the
painting of his that I like the
most. The mystery of his life is
in it. His joy of light and
darkness.' RWI

PROVENANCE 1930: H.S. Ede;
bequeathed by him to Kettle's Yard
EXHIBITIONS *Christopher Wood*,
London, The Redfern Gallery, 1938,
no. 142 *Christopher Wood*, Colchester,
Minories, *et al.*, 1979, no. 34; *Christopher
Wood: The Last Years*, Newlyn Orion,
1989, no. 42; *Christopher Wood: A Painter*

Between Two Cornwalls, St Ives, Tate
Gallery, 1996, no. 14

REFERENCES E. Newton, *Christopher
Wood*, London, 1938, no. 376; R. Ingleby,
Christopher Wood: An English Painter,
London, 1995, pp. 65, 245, 248–9, pl. 47

390

L.S. Lowry RA RBA
(1887–1976)

Peel Park, Salford, 1927

oil on board, 35 × 50 cm
inscribed: *L.S. LOWRY 1927*
City of Salford Art Gallery, 1951–14

One of the most distinctive
British painters of the 20th
century, Lowry stood aside from
the tides of fashion and influence
which, during his long career,
preoccupied his contemporaries.
Because he worked full-time in
an office until he was 65, his
painting was accomplished at
nights and at weekends. His
subjects were drawn from his
immediate Lancashire
environment. The seascapes are
set at Lytham St Annes, where
he had enjoyed family holidays as
a child. His landscapes and
townscapes are of Manchester
and Salford, where he lived until
he moved in 1948 to nearby
Mottram, in more genteel
Cheshire. Although at first
glance Lowry's majestic
industrial views peopled with
dark, scurrying figures look like
a naive painter's best attempt at
objective accuracy, the paintings
of his maturity are sophisticated
works of artifice. He mixed fact
with invention to build up
composite designs of great
elegance. His famous matchstick
men are far from childlike and
innocent; their gestures, and
frequently their deformities, are
transcribed with painful clarity.

The lack of shadows is likewise
an artistic device which
reinforces the surreal quality of
Lowry's vision.

Peel Park in Salford was one of
Lowry's favourite subjects. This
relatively early view is
topographically accurate and
shows the Public Library on the
left and looks towards the
present Maxwell Building of
what is now Salford University.
W B

PROVENANCE 1951: purchased by the
museum from the Midday Studios,
Manchester
EXHIBITIONS *Retrospective Exhibition of
the Work of L.S. Lowry, MA, RBA*, Salford
Art Gallery, 1951, no. 50; *L.S. Lowry,
RA*, London, RA, 1976, no. 71;
L.S. Lowry: The Centenary Exhibition,
Middlesborough, Cleveland Art Gallery,
et al., 1987–8, no. 238
REFERENCES M. Levy, *Painters of
Today: L.S. Lowry*, London, 1961, p. 15;
F. Mullineux and S. Shaw, *L.S. Lowry: The
Salford Collection*, Salford, 1977, no. 91;
J. Spalding, *Lowry*, London, 1979, p. 8;
M. Leber and J. Sandling, *L.S. Lowry*,
Oxford, 1987, p. 126

391

Dod Procter RA
(1891–1972)

Clara, c. 1926

oil on canvas, 75 × 59 cm
City Museum and Art Gallery,
Stoke-on-Trent, I.1928

Dod Procter belonged to the
third generation of Newlyn
School artists. Her subject-
matter and style had little in
common with those of earlier
members: she preferred painting
single figures or flowers to the
streets, harbour or fish-market of
the small Cornish port; her
palette was always pure, and her
paintings are built up of a
myriad of small, thinly applied
brushstrokes. In her best figure
compositions one senses an
awareness of Picasso's classical
nudes, as well as of the work of
Aristide Maillol (1861–1944)
and Balthus (born 1908).
Procter's greatest success was
with *Morning* (Tate Gallery,
London) which, when shown at
the Royal Academy in 1927, was
instantly acclaimed and
purchased for the nation by *The
Daily Mail*. If she had followed
up on this triumph she could
have emerged as one of the major
British painters of the 20th
century, but she preferred the
quiet seclusion of family life in
Cornwall and chose to appeal to
her audience through delicate
and beautifully modulated
brushwork rather than through
startling or controversial
subjects. Nevertheless, Procter
became a heroine for those who
championed women painters.

Clara, the second work by
Procter to enter the collection at
Stoke, was bought in 1928 with
the aid of a fund subscribed by
three local ladies. P S

PROVENANCE 1928: bought from the
artist by the gallery with the aid of a fund
subscribed by Lady Joseph, Mrs H.
Johnson and Mrs E.R. Corn

393

Dame Barbara Hepworth
(1903–75)

Kneeling Figure, 1932

rosewood, 67.5 × 28.8 × 32 cm
Wakefield Museums and Arts
(Wakefield Art Gallery)

Barbara Hepworth was brought up in Yorkshire, whose countryside became one of the greatest influences on her work. After attending the Royal College of Art in London, she travelled to Italy, where she learned the art of 'direct carving' in stone. Hepworth concentrated on manipulating form, playing with stillness and movement on the surface of such naturalistic, pared-down works as *Kneeling Figure*, created the year she married Ben Nicholson. Along with her friend Henry Moore, Hepworth advocated 'truth to materials', that is, working with a material's inherent physical properties so as, literally, not to go against the grain of any organic substance.

After meeting the Russian Constructivist Naum Gaubo (1890–1977), Hepworth moved away from naturalism, becoming more interested in revealing the 'essence of natural forms' through the evocation of wind, sea and so forth. However, even at its most abstract, Hepworth's sculpture was always related to the natural environment by way of its organic universalism. D B

PROVENANCE 1944: purchased by the gallery with the help of the Victoria and Albert Museum Purchase Grant Fund, the Wakefield Permanent Art Fund and Wakefield Girls High School
EXHIBITIONS *Barbara Hepworth*, London, Tate Gallery, 1968; *Unit One*, Portsmouth City Museum and Art Gallery, 1978; *A British Vision of World Art*, Leeds City Art Gallery, 1993–4

392

Edward Wadsworth ARA
(1889–1949)

Composition on a Red Ground, 1931

tempera on linen stretched over board, 50.8 × 60.9 cm
inscribed: *E. WADSWORTH 1931*
Leeds Museums and Galleries
(City Art Gallery), 42/37

Wadsworth, as innovative and creative a painter as Britain produced during the first half of this century, was equally at home with abstract and figurative work. The radical abstraction of his Vorticist phase was followed during the 1920s by a period when he constructed panoramic townscapes put together like a jigsaw from disparate elements, each painted with meticulous, if mannered, realism. He also painted lucid arrangements of objects, generally maritime, composed as surreal still-lifes set in deep and empty space. However, in 1929 his objects no longer inhabited perspective space and by 1930 they had lost their identity, to become flat forms reminiscent, to an extent, of Fernand Léger (work by whom Wadsworth owned). Wadsworth joined the movement formed in Paris called Abstraction–Création and his work was illustrated in the first issue of the journal with that name. The *Composition* shown here belongs to this period.

This is another example of a gallery in Leeds benefiting from the discerning eye of Sir Michael Sadler, who presented his purchase to Leeds through the Contemporary Art Society. There is irony in the fact that the painting dates from the year that Wadsworth resigned his membership of the CAS because he felt that the society was failing in its mission to support contemporary art. W B

PROVENANCE 1937: given to the gallery by Sir Michael Sadler through the Contemporary Art Society
EXHIBITIONS Possibly Venice, 18th Biennale, 1932; *A Genius of Industrial England: Edward Wadsworth 1889–1949*, exh. cat. ed. J. Lewison, Bradford, Cartwright Hall, and London, Camden Arts Centre, 1989–90, p. 108, no. 106
REFERENCE B. Wadsworth, *Edward Wadsworth: A Painter's Life*, London, 1989, no. W/A 132

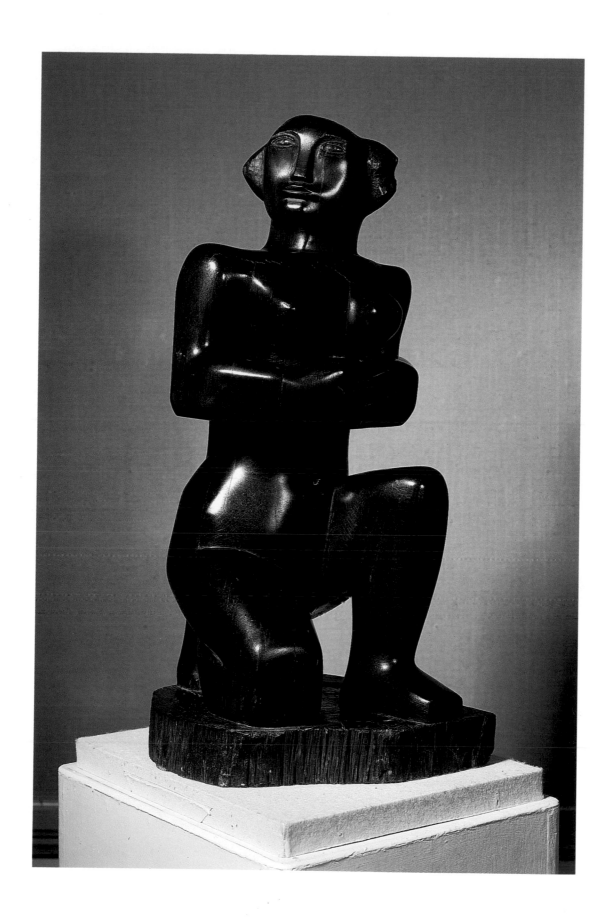

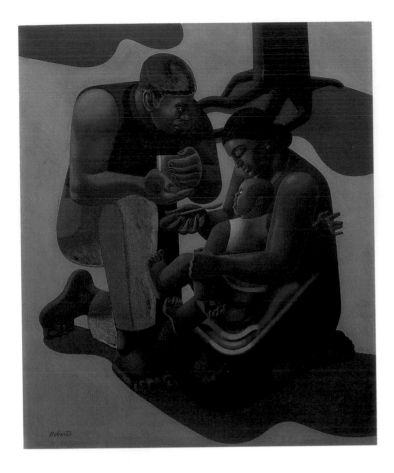

394

William Roberts RA (1895–1980)

The Family, 1935

oil on canvas, 51.4 × 43.8 cm
inscribed: *Roberts*
Leeds Museums and Galleries
(City Art Gallery), 9.2/35

Aged fifteen, Roberts won a
scholarship to the Slade School of
Art, where his contemporaries
included Bomberg, Wadsworth
and Kramer (whose sister Sarah
he was to marry). In 1913 he
became an assistant at the
Omega Workshops, the artists'
cooperative established that year
by Roger Fry, but in 1914 he
joined the breakaway group
headed by Wyndham Lewis
which in 1915 established
Vorticism as a style and artistic

creed. In association with Lewis,
Wadsworth, Bomberg and
others, Roberts developed a
language derived from a blend of
Cubism (the angular abstraction
of form) and Futurism (the
suggestion of mechanistic
movement).

Reference to human figures
underlay even the most radically
abstracted of Roberts's designs.
By the end of the war he had
reaffirmed his lifelong interest in
portraying figures, generally
within an urban environment,
engaged in everyday pursuits. He
developed a personal style in
which he produced complex,
tautly integrated and strongly
coloured designs composed of
schematic figures each built up
from simplified, crisply defined
and often rounded shapes. There
is a hint of Fernand Léger

(1881–1955) in the compact
imagery, but Roberts's colours
are less stark and his subjects
more endearing. Roberts did not
work from models but relied on
his memory to furnish him with
an appropriate stock of postures,
gestures and expressions.

When Roberts reproduced this
painting as *The Peasants* in 1964,
he dated it 1935. However,
according to John Roberts, his
son, it was painted on a visit to
Spain in 1934. Given the artist's
habit of working from drawings,
ranging from preliminary
sketches to finished squared-up
composition studies, it is
probable that the subject was
studied in Spain and painted the
following year. W B

PROVENANCE 1935: bought by the
gallery from Alex, Reid and Lefevre,
London
EXHIBITIONS *New Paintings and
Drawings by William Roberts*, London,
Lefevre Gallery, 1935, no. 8; *William
Roberts ARA*, London, Tate Gallery,
Newcastle, Laing Art Gallery, and
Manchester, Whitworth Art Gallery,
1965–6, no. 51
REFERENCE W. Roberts, *Paintings and
Drawings 1909–1964*, London, 1964,
pl.16 (as *The Peasants*)

395

Sir Stanley Spencer RA (1891–1959)

Sarah Tubb and the Heavenly Visitors, 1933

oil on canvas, 91.5 × 102 cm
Stanley Spencer Gallery, Cookham,
C0055 1995.3.1

*Sarah Tubb and the Heavenly
Visitors*, painted in 1933 and
bought the following year by Sir
Edward Beddington-Behrens,
was among the first pictures that
Spencer conceived for the Church
House, the most ambitious of all

of his serial projects. The
scheme, which was never
realised, but which occupied
Spencer on and off for the rest of
his life, was for an architectural
home in his native village of
Cookham for the pictures that he
felt mattered most: his weave of
biblical and village life that
defined his odd and engaging
vision of the world. *Sarah Tubb
and the Heavenly Visitors* depicts a
story recounted to Spencer by his
father, in which the appearance
of Halley's comet in 1910 so
frightened old Sally Tubb that
she feared the end of the world.
Spencer painted her with the face
of her daughter Sarah, kneeling
on the pavement of Cookham
High Street, surrounded by
angels and village folk. R W I

PROVENANCE 1934: purchased from
Arthur Tooth & Sons by Sir Edward
Beddington-Behrens; to his wife, Barbara
Karmel; 1995: bequeathed by her to the
gallery
EXHIBITIONS *Stanley Spencer*, London,
Leicester Galleries, 1942, no. 17; *Stanley
Spencer: A Retrospective Exhibition*, London,
Tate Gallery, 1955, no. 29; *Stanley Spencer
1891–1959*, London, Arts Council
Gallery, *et al.*, 1976, no. 20; *Stanley
Spencer RA*, London, RA, 1980, no. 142;
Stanley Spencer: A Modern Visionary, New
Haven, Yale Center for British Art, 1981,
no. 30; *Stanley Spencer: Heaven on Earth*,
New York, CDS Gallery, 1983, no. 2
REFERENCE K. Bell, *Stanley Spencer:
A Complete Catalogue of the Paintings*, 1992,
p. 110, no. 151

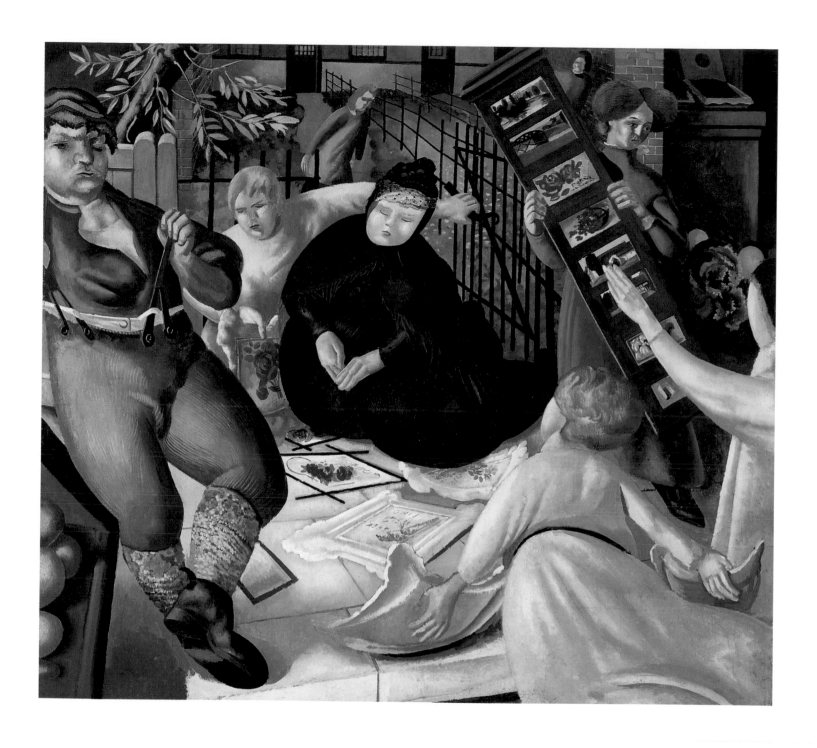

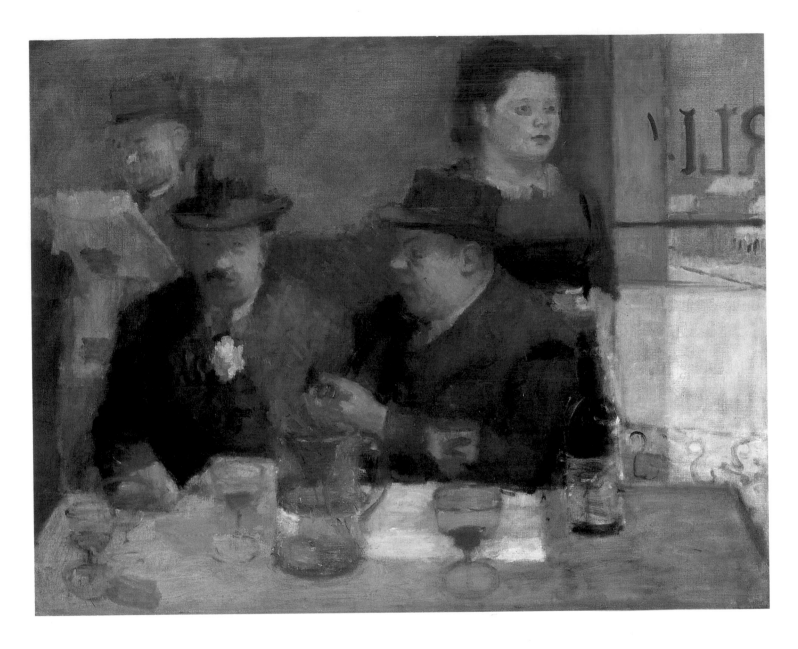

396

Victor Pasmore RA
(born 1908)
Parisian Café, 1936–7

oil on canvas, 71.2 × 91.6 cm
Manchester City Art Galleries,
1941.72

This work began with drawings
made in Paris in 1934–5, but
the painting was done in
Pasmore's London studio using
his friends as models. The
setting was transferred to
Bertorelli's restaurant in
Charlotte Street.

The tradition of painting
neighbourhood cafés with
meticulous objectivity stretched
from Camden Town (best
demonstrated by Ratcliffe's *Coffee
House, East Finchley* of 1914) to
Euston Road (Graham Bell's *The
Café* of 1937–8). Bruce Laughton
reports that Pasmore regards this
painting as exemplary of
Sickert's influence. Pasmore did
indeed emulate Sickert's habit of
creating an artificial construct
from disparate preparatory
documents, as well as from
dedicated sittings from life,
rather than following the more
prosaic objectivity of his Camden
Town colleagues. Like Sickert,
Pasmore has created a painting
which has the appearance, but
not the substance, of objective
reality. As Laughton suggests, in
this, as in the painting's
succulent handling, Pasmore
may also have remembered the
example of Manet's café
paintings. W B

PROVENANCE 1938: bought from the
artist by the Contemporary Art Society;
1941: presented by it to the gallery
EXHIBITION London, Tate Gallery,
1965, no. 11
REFERENCES C. Bell, *Victor Pasmore*,
London, 1945, pl. 2 (as *Parisian Life*);
A. Bowness and L. Lambertini, *Victor
Pasmore: A Catalogue Raisonné of the
Paintings, Constructions and Graphics
1926–1979*, New York, 1980, no. 23;
B. Laughton, *The Euston Road School*,
Aldershot, 1986, pp. 60, 137, 139; *Victor
Pasmore: Nature into Art*, exh. cat. by
N. Lynton, New York, Center for Inter-
national Contemporary Arts, and London,
Serpentine Gallery, 1990–1, p. 15, no. 1

397

Ben Nicholson
(1894–1982)

Still-life (Cerulean), 1946

oil on canvas, 64 × 63 cm
Pallant House Galleries, Chichester,
Kearley Bequest, CHCPH 0596

Although he had little formal
training, Ben Nicholson came to
be one of the foremost British
abstract painters. During the
1920s he painted mostly
landscapes in a subtly *faux-naif*
manner which undermined
traditional notions of perspective.
On visits to France, Nicholson
became interested in the work of
Picasso, Braque, Brancusi and
Mondrian, and began to exploit
the spatial strategies of
'synthetic' Cubism in his own
brand of abstraction. He also met
the sculptress Barbara Hepworth,
who became his wife in 1932. By
the mid-1930s the Russian
Constructivist Naum Gabo had
become a friend and a strong
influence on Nicholson's work:
Nicholson produced a series of
monochromatic 'relief' paintings.

In 1939 Nicholson and
Hepworth moved to St Ives in
Cornwall, which eventually
became the home of a loosely
defined artists' colony, known as
the St Ives School and including
such painters as Peter Lanyon
(cat. 400) and Patrick Heron
(born 1920). By the mid-1940s
Nicholson had returned to a
more humanistic Cubism as seen
though the lens of
Constructivism and hard-edged
abstraction. Works such as *Still-
life (Cerulean)* evince a degree of
spatiality and a vibrancy of
colour previously unknown in
his work. DB

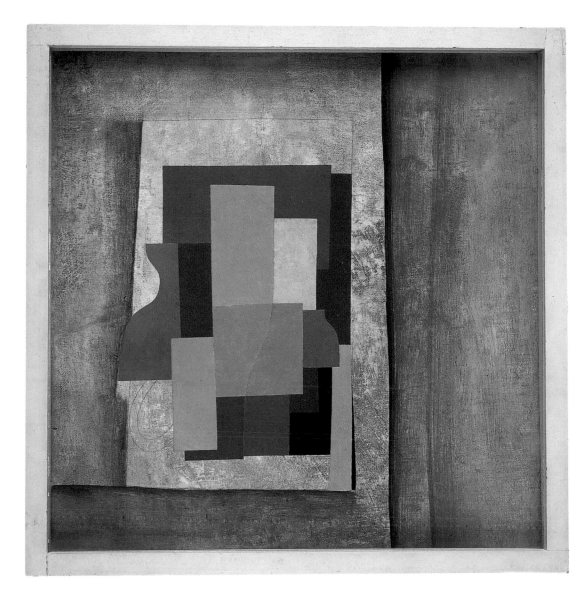

PROVENANCE 1946: Lefevre Gallery,
London, bought by Charles Kearley;
1989: bequeathed to the galleries
EXHIBITIONS Lefevre Gallery, London,
1946, no. 106; *Monet to Freud*, London,
Sotheby's and National Art-Collections
Fund, 1989, no. 167
REFERENCES *The Fine Art Collections:
Pallant House, Chichester*, Chichester,
1990, p. 16 (ill.); J. Lewison, *Ben
Nicholson*, London, 1991

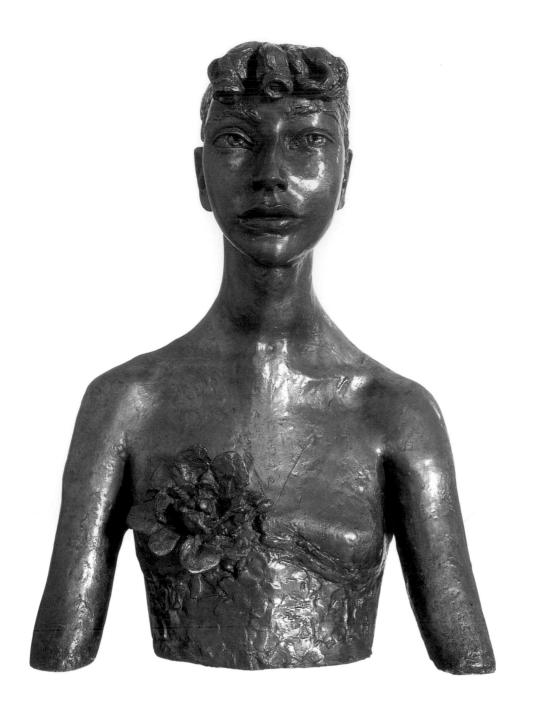

during the early years of this century.

Side by side with commissioned busts of the famous men and women of his age, Epstein made repeated portrait studies of children. This is the third and last portrait of his youngest daughter, Esther (born 1929), by Kathleen Garman, whom the sculptor had met in 1921 and married as his second wife in 1955. The delicacy and elegance of the portrayal looks to masters of Florentine 15th-century sculpture, such as Desiderio da Settignano. The plaster for this sculpture is in the Israel Museum, Jerusalem.

After Epstein's death, his widow, Lady Epstein (Kathleen Garman), and Sally Ryan, the American sculptor and lifelong supporter of Epstein, built up a personal collection of 367 works. The core of this holding consisted of works by Epstein himself, but they also acquired work by many other artists as well as artefacts from all countries and periods. The collection was presented to Walsall in 1972, Lady Epstein having been born and brought up in nearby Wednesbury, where her father had been a doctor. WB

PROVENANCE Garman-Ryan Collection; 1972: given to the museum
EXHIBITIONS A cast first shown in *A New Carving, Lazarus, and Other Recent Work by Jacob Epstein*, London, Leicester Galleries, 1950, no. 5; this cast shown in *Epstein*, London, Tate Gallery, 1952, no. 50. Other casts have been shown at numerous exhibitions since.
REFERENCES J. Epstein, *An Autobiography*, London, 1955, ill. on cover and facing p. 202; R. Buckle, *Jacob Epstein, Sculptor*, London, 1963, pp. 326–9, pl. 509–11; E. Silber, *The Sculpture of Epstein*, Oxford, 1986, pp. 38, 43, 56, no. 407

398
Sir Jacob Epstein
(1880–1959)
Esther with Flower, 1949
bronze, height 62 cm
The Garman-Ryan Collection,
Walsall Museum and Art Gallery,
GR77

From the beginning, Epstein's work aroused controversy. His voracious visual appetite comprehended everything from 'primitive' sculpture to modern machines; his imagination was at ease with the most supreme themes – whether religious, spiritual, primeval or symbolic – and with the most mundane. He worked with equal confidence as

a carver in the tradition of Michelangelo and as a modeller in that of Rodin. Born in New York of Polish parents, he studied art in Paris and settled in London in 1905. He acquired British citizenship in 1910, thus joining the band of immigrant Jewish artists – including Kramer, Gertler and Rothenstein – who enriched the native seam

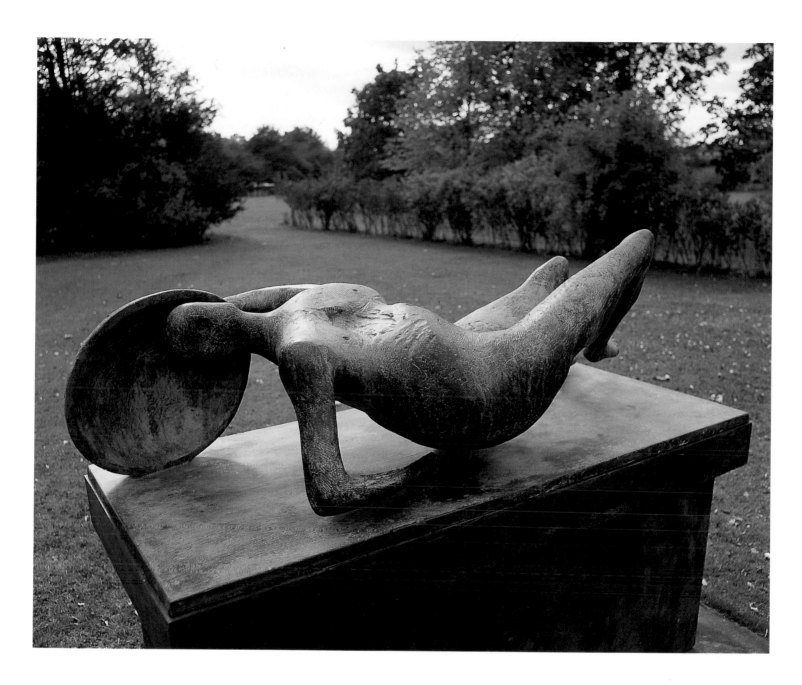

399

Henry Moore (1898–1986)
Falling Warrior, 1956–7

bronze on wooden base covered in
copper sheeting,
60 × 67 × 153 cm (without base)
Kirklees Metropolitan Council,
Huddersfield Art Gallery

Moore said of this work: 'In the
Falling Warrior sculpture, I
wanted a figure that was still
alive. The pose in the first

maquette was that of a
completely dead figure so I
altered it to make the action that
of a figure falling, and the shield
became a support for the warrior,
emphasising the dramatic
moment that precedes death.'

The sculpture, which was cast
in an edition of ten, testifies to
the artist's thorough assimilation
of ancient Greek sculpture, while
its organically inspired forms
reflect Moore's unceasing

engagement with the natural
world: 'The human figure is
what interests me most deeply,
but I have found principles of
form and rhythm from the study
of natural objects such as
pebbles, rocks, bones, trees,
plants, etc.'

It is indicative of attitudes to
contemporary art in Britain in
the late 1950s that, when the
Huddersfield Art Gallery
purchased this cast in 1959, it

was considered a remarkably
bold acquisition for a regional
museum to make. R B

PROVENANCE Marlborough Fine Art,
London; 1959: purchased by the gallery
EXHIBITION *Sculpture 1961*, Cardiff,
National Museum of Wales, *et al.*, 1961
REFERENCES *Henry Moore: Complete
Sculpture*, III, *1955–64*, ed. A. Bowness,
London, 1965, no. 405, pl. 27–30;
R. Melville, *Henry Moore: Sculpture and
Drawings 1921–1969*, London, 1970,
pp. 538–40; D. Mitchinson, *Henry
Moore Sculpture, with Comments by the Artist*,
London, 1981, pp. 138–9

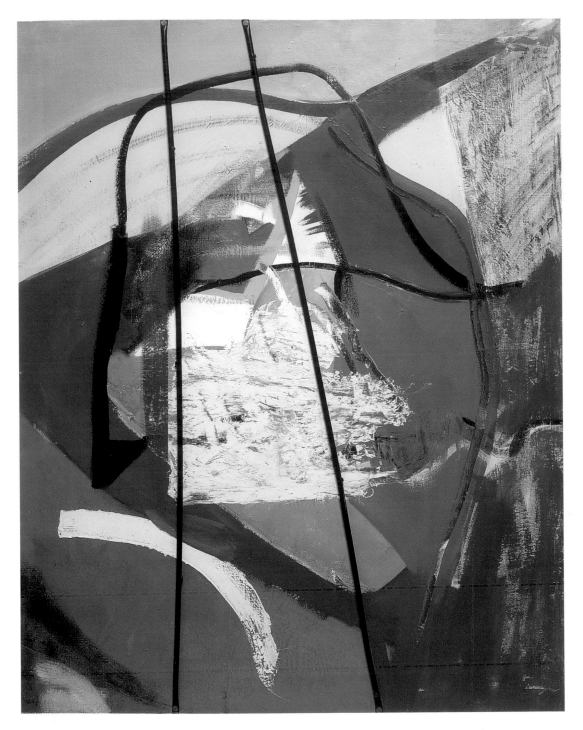

400

Peter Lanyon (1918–64)

Glide Path, 1964

oil and plastic on canvas,
152.5 × 121.7 cm
inscribed: *Lanyon 64*
The Whitworth Art Gallery,
University of Manchester, O.1978.2

Of all the painters associated
with the postwar flourishing of
abstract art in western Cornwall
only Peter Lanyon was born and
bred on native soil. He was born
in St Ives and studied at
Penzance School of Art before
briefly becoming a member of
the Euston Road School in
London. The experience of
America, and his subsequent
travels further afield, stimulated
an interest in collage and
construction and signalled a
move away from earthy tonalites.
His work remained rooted,
however, in the Cornish land-
scape and after he began gliding
in 1959 the sensation of the sky
and air became a component
equal to those of land and sea.
Glide Path has a length of black
plastic hosepipe stretched across
the canvas, suggesting the path
of a plane out over the edge of
the Cornish coast. It was one of
the last works that Lanyon made
before his death following a
gliding accident on 31 August
1964. RWI

PROVENANCE 1964: Sheila Lanyon,
the artist's widow; 1978: sold by her
through Gimpel Fils to the gallery
EXHIBITIONS *Peter Lanyon*, London,
Tate Gallery, *et al.*, 1968, no. 93; *Peter
Lanyon*, Manchester, Whitworth Art
Gallery, 1978, no. 85; *Peter Lanyon: Air,
Land & Sea*, London, Camden Arts
Centre, *et al.*, 1992, no. 43
REFERENCES A. Causey, *Peter Lanyon*,
London, 1971, p. 31, pl. 59; *Peter Lanyon:
Paintings, Drawings and Constructions
1937–1964*, exh. cat., Manchester,
Whitworth Art Gallery, 1978, pp. 46–7,
pl. 35

401

Roger Hilton (1911–75)
March, 1961, 1961

oil on canvas, 132.2 × 139.7 cm
The Whitworth Art Gallery,
University of Manchester, O.1968.1

Roger Hildersheim (his family
changed its name to Hilton in
1916) was born on 23 March
1911 in Northwood, Middlesex.
He studied at the Slade School of
Art in London and then, in the
1930s, under Roger Bissière at
the Académie Ranson in Paris,
where his attention was turned
towards the kind of expressive

abstraction favoured by the
Parisian avant-garde. Like so
many artists of his generation, he
was slow to find his feet after the
war, but an encounter with the
work of Piet Mondrian (1872–
1944) in 1952 guided him to a
simplification of form and
colour. Through his friendships
with Patrick Heron (born 1920),
Terry Frost (born 1915) and
Bryan Wynter (1915–75) he has
been considered central to the St
Ives scene, although he did not
visit the town until 1956 and
maintained a London studio
until 1965.

The title *March, 1961* refers to
the date that the picture was
completed, a deliberate attempt
to distance the image from any
kind of representational
reference, but by March 1961
the landscape and colours of the
Penwith peninsular had in fact
begun to steer Hilton's work
from the path of pure abstraction
towards, as he put it, 'a new sort
of figuration, that is, one which
is more true'. R W I

PROVENANCE 1962: purchased from
Waddington Galleries, London, by the
Contemporary Art Society; 1968:
presented to the gallery by the CAS
EXHIBITIONS *Roger Hilton*, London,
Waddington Galleries, 1962; *Roger
Hilton*, Edinburgh, Scottish Arts Council
Gallery, 1974, no. 33; *St Ives 1939–1964*,
London, Tate Gallery, 1985, no. 207;
British Art in the 20th Century, London,
RA, 1987, no. 216

402

Sir Eduardo Paolozzi RA
(born 1924)

Large Frog, Version II, 1958

bronze, 67.9 × 81.3 × 86.2 cm
Ferens Art Gallery, Kingston upon
Hull City Museums, Art Galleries
and Archives, S.56

Eduardo Paolozzi, together with
Richard Hamilton (cat. 404), is
considered to be one of the
founders of Pop Art in Britain.
After attending Edinburgh
College of Art and the Slade
School of Art, London, Paolozzi
spent time on the Continent,
where he was greatly influenced
by the Surrealists and by Jean
Dubuffet (1901–85) and his
friend Alberto Giacometti
(1901–66). In 1952 Paolozzi,
Hamilton, the critic Lawrence
Alloway and others started the
Independent Group, a coterie of
artists, curators, critics and
designers who were interested in
science, technology and mass
media. From the 1950s on,
Paolozzi has produced two
disparate bodies of work:
sculpture and collage. He has
always collected popular imagery
of all kinds and is profoundly
interested in the idea of America
and in its invention of 'pop'
culture. His collages from the
1950s humorously incorporate a
variety of popular images, raising
the quotidian to the level of fine
art.

Paolozzi's bronze sculptures
are at once whimsical and
apocalyptic. They resemble
robots gone awry, as in the
present example – one of a series
of three bronzes on the theme of
the frog, the third from an
edition of six – an alien animal-
machine coughing up the
detritus of industrial decay.

Made from found materials and
junk, such sculptures bemoan
the loss of self in a postwar age
of mass culture and
consumerism. D B

PROVENANCE 1961: purchased from
the artist by the gallery with assistance
from the Victoria and Albert Museum
Purchase Grant Fund
EXHIBITIONS 30th Biennale, Venice,
1960; *British Sculpture: The 20th Century,
part 2: Symbol and Imagination, 1951–80*,
London, Whitechapel, 1981, no. 56;
British Art in the 20th Century, London,
RA, 1987, no. 223; *Trick or Treat: Art
Since the War*, Hull, Ferens Art Gallery,
1989

403

David Hockney ARA
(born 1937)
Life Painting for Myself,
1962

oil on canvas, 121.9 × 91.4 cm
inscribed: *life painting for myself/life
painting/don't give up yet?*
Ferens Art Gallery, Kingston upon
Hull City Museums, Art Galleries
and Archives, 523

David Hockney graduated from
the Royal College of Art,
London, in 1962 and the
following year visited the USA
for the first time, eventually
settling in Los Angeles. His early
style, as demonstrated by this
painting, consisted of a
combination of scratchy
indeterminate brushstrokes and
scrawled text expressing
Hockney's amorous
preoccupations of the time. From
the very beginning of his long
and celebrated career as a Pop
artist Hockney has been
interested in autobiography and
thus paints only his friends and
surroundings: the Californian
suburban landscape of swimming
pools, ranch houses and
celebrities. He is also openly
homosexual, which profoundly
affects his vision and choice of
subject-matter. D B

PROVENANCE Kasmin Gallery,
London; 1962: purchased by the gallery
through the Ferens Fund
EXHIBITIONS *David Hockney*,
Manchester, Whitworth Art Gallery,
1969; *From Bacon to Now: The Outsider in
British Figuration*, Florence, 1991–2,
no. 74; *David Hockney: Paintings, Prints
and Drawings 1960–1970*, London,
Whitechapel Gallery, 1970

404
Richard Hamilton
(born 1922)
Interior Study (a), 1964
oil and collage on paper,
38.1 × 50.8 cm
Swindon Museum and Art Gallery,
AG176

Richard Hamilton studied at the
Royal Academy Schools and the
Slade School of Art, London. In
1952, along with other artists,
curators and critics, he formed
the Independent Group. Their
exhibition *This is Tomorrow* at the
Whitechapel Gallery, London,
effectively inaugurated the
British Pop Art movement.
Hamilton's interest in popular
culture, in contemporary
mythology and style, and in
modern technology forms the
backbone of his work. His
prescient understanding of the
power of mass media and
advertising is exploited critically
in his paintings and collages.

In *Interior Study (a)* Hamilton
has exploded a bourgeois
domestic space in which a
stereotypical 1950s housewife
gets equal billing with a
television set, already a classic
fixture in the home. Here,
fragmented architectural space is
conflated with the media's
invasion of the domestic realm,
dissolving the borders between
the public and private spheres.
DB

PROVENANCE 1968: given to the
museum by the Contemporary Art Society
EXHIBITION *Richard Hamilton*,
London, Tate Gallery, 1970, no. 72

405

Peter Blake RA
(born 1932)
Got a Girl, 1960–1
enamel on hardboard, photo-collage
and record, 94 × 154.9 cm
The Whitworth Art Gallery,
University of Manchester, O.1976.3

Peter Blake was an early
practitioner of Pop Art. In 1956
he graduated from the Royal
College of Art in London. By the
end of that decade, his interest in
the invention of American
popular culture, its iconography
and language, had become
germane to his work. However,
unlike other Pop artists, such as
Richard Hamilton (cat. 404),
Blake is not critical towards, or
distanced from, his subject-
matter. Indeed, he rejoices in and
fully embraces the popular
imagery that his work re-
presents. Blake's paintings are
emotional rather than intellec-
tual, nostalgic rather than ironic.

Got a Girl employs a row of
squares similar to those in Jasper
Johns's *Target* paintings from the
1950s. The five Pop icons –
Fabian, Frankie Avalon, Ricky
Nelson, Bobby Rydell and Elvis
Presley – are displayed like
heroes over a red, white and blue
triadic chevron design,
memorialising their youthful
pin-up allure. The vinyl disc at
the extreme top left gave the
work its title – that of a song by
the Four Preps, released in 1960,
which bemoans the girlfriend
who can think only of her idols,
not of her real-life sweetheart.

Got a Girl, then, is emblematic
of displaced love, the fantasy Pop
hero eclipsing the physical
reality of the lovelorn beau. D B

PROVENANCE Robert Fraser Gallery,
London; Peter Stuyvesant Foundation
Collection; 1976: purchased by the
gallery with assistance from the Victoria
and Albert Museum Purchase Grant Fund
EXHIBITIONS *Peter Blake*, London, Tate
Gallery, 1983; *British Art in the 20th
Century*, London, RA, 1987, no. 256; *Pop
Art*, London, RA, and Montreal Museum
of Fine Art, 1992–3; *Now We Are 64:
Peter Blake at the National Gallery*,
London, National Gallery, 1996
REFERENCE *The Whitworth Art Gallery:
The First Hundred Years*, Manchester,
1988, p. 120

406
Howard Hodgkin
(born 1932)
Gramophone, 1964–6

oil on canvas, 71 × 90 cm
Swindon Museum and Art Gallery,
AG178

Howard Hodgkin studied at
Camberwell School of Art,
London, and at Bath School of
Art in the early 1950s, then
taught until the early 1970s. His
paintings are situated somewhere
between abstraction and
figuration. These small,
contemplative works are
generally inspired by, and thus
evoke, personal encounters with
people and places at a specific
time in the artist's life.
Hodgkin's exploitation of
vibrant, electric colour engenders
a world of private moods and
emotions. The canvases are
sometimes worked on for
many years until Hodgkin feels
they are finished, until he is
able successfully to rejuvenate
his memory of a particular
day.

The paintings are densely
layered and extend to their
wooden frames, adding an almost
sculptural effect to the works and
enabling the artist further to
enrich his unique painterly
lexicon. *Gramophone* is an early
work which evokes not so much
the mood of an object in a
certain setting as the music
emitted by that object and
Hodgkin's recollection of his
emotional response to it. DB

EXHIBITIONS London, Tooth & Sons,
1967, no. 3; *Howard Hodgkin: Forty-five
Paintings, 1949–75*, Oxford Museum of
Modern Art *et al.*, 1976, no. 17
REFERENCE *The Swindon Collection of
Twentieth Century British Art*, Swindon,
1991, p. 69

407
Lucian Freud (born 1922)
Man's Head (Self-portrait 1),
1963

oil on canvas, 53.3 × 50.8 cm
The Whitworth Art Gallery,
University of Manchester, O.1977.2

Lucian Freud was born in Berlin,
the son of architect Ernst Freud
and the grandson of Sigmund
Freud. He moved to England in
1932 and has remained ever
since. In 1942 he devoted
himself full-time to painting and
is now considered one of the
greatest realist painters of the
20th century. Until the late
1950s, Freud worked in a
Surrealist-Existentialist manner,
using flat forms to portray
people and/or objects in an often
incongruous setting. Since then
he has developed a style in which
the physical presence of his
subjects is stronger, more plastic
and more expressive. His
portraits of friends and family –
whether nude or clothed – are an
intimate collaborational effort
produced over a long period of
time and combine formidable
painterly precision with keen
observation. Freud subscribes to
an ethical position whereby he
paints solely 'what is there',
without adding or subtracting.
 Man's Head (Self-portrait)
investigates the tension between
two types of plasticity, that of
the skin stretched over a network
of bone and muscle and that of
the forearm and hand and the
neck, which bulges like a torso.
The artist's oblique gaze ignores
the viewer. DB

PROVENANCE Colin Tennant, London;
James Kirkman Ltd; 1977: purchased by
the gallery with assistance from the
Victoria and Albert Museum Purchase
Grant Fund
EXHIBITIONS Rome, British Council,
Memmo Foundation, 1991–2; *Lucian
Freud*, Tel Aviv Museum of Art, 1996–7

408

Francis Bacon (1909–92)

Portrait of Henrietta Moraes on a Blue Couch, 1965

oil on canvas, 198 × 147 cm
Manchester City Art Galleries,
1979.603

Henrietta Moraes was a long-time confidante of Bacon whom he met with her husband, the writer Dom Moraes, in a Soho club. This portrait, the second of three Bacon made of her between 1963 and 1969, shows her reclining on a large sofa with a door opened to the right. It was based on photographs Bacon commissioned from the *Vogue* photographer John Deakin. Moraes's contorted face and body lie in what Bacon called an 'elemental state'. Indeed, as the artist averred, the portrait does not represent a distortion of, or violence done to, his subject, but rather a mapping of brushstrokes which will return him to the sitter, and his relationship to her. Through the antagonism of figure to ground, he achieves a kind of 'existential realism' marked by emotionally charged psychological images. DB

PROVENANCE 1979: purchased by the gallery with assistance from the Wilfred Wood Bequest Fund and the Victoria and Albert Museum Purchase Grant Fund
EXHIBITIONS *The English Eye*, New York, Marlborough-Gerson Inc., no. 11; *Francis Bacon, Paintings 1945–1982*, Tokyo and Kyoto, 1983, no. 21; *The Cornerhouse Human Interest: Fifty Years of British Art about People*, Manchester, 1985; *The Pursuit of the Real*, Manchester City Art Galleries, London and Glasgow, 1990, no. 45; *The Outsider: British Figuration Now*, Florence, 1991; *Europe after the Flood, 1945–65*, Barcelona and Vienna, 1995, no. 8; *John Deakin*, London, National Portrait Gallery, 1996

409

Gilbert and George

(born 1943 and 1942)

Four Knights, 1980

16 hand-dyed photographic prints,
241 × 201 cm
inscribed: *FOUR KNIGHTS /
Gilbert & George / 1980*
Southampton City Art Gallery,
17/1981

Gilbert and George have been a
collaborative team since they
first met while attending St
Martin's School of Art, London,
in 1967. Two years later they
presented themselves as 'singing
sculptures', with head and hands
painted as they performed the
song 'Underneath the Arches'.
This work rehearsed their project
of fashioning a single, inter-
changeable identity made
manifest by their 'ordinary',
near-identical looks and suits –
in fact, by declaring their lives to
be a work of art. Since 1971 they
have produced 'photo-pieces' –
all unique black and white or
coloured hand-dyed works –
which have been inspired by
their life together in East
London. Gilbert and George
often incorporate their own
images in these works.

Four Knights consists of two
separate sets of images of four
adolescent youths: one row of
full-length black and white
portraits below a row of colour-
tinted head shots. In the context
of the whole, the colour photos
resemble the jewels on a
metaphoric collective crown, in
an idealised world where 'the
people' both reign and serve. DB

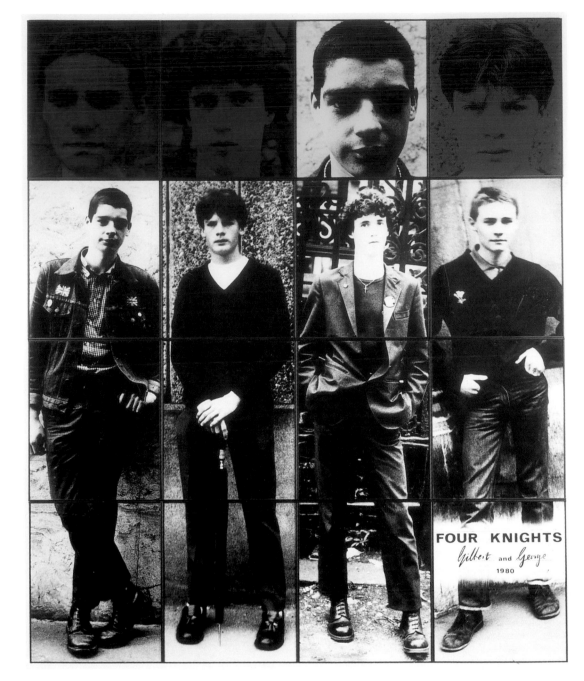

PROVENANCE 1981: purchased by the
gallery with assistance from the Victoria
and Albert Museum Purchase Grant Fund
EXHIBITION *Gilbert and George*, The
Baltimore Museum of Art *et al.*, 1984–5,
no. 29
REFERENCES *Gilbert and George: The
Complete Pictures, 1971–1985*, London,
1976, p. 148; W. Jahn, *The Art of Gilbert
and George*, London, 1989

410

Tony Cragg (born 1949)
Postcard Flag (Union Jack),
1981

blue and red plastic objects,
330 × 440 cm
Leeds Museums and Galleries
(City Art Gallery), 53/82

Tony Cragg's innovative work,
with its distinctive urban
quality, has exerted a decisive
influence on recent British
sculpture. This piece belongs to
a number of works in which
Cragg used the detritus of post-
industrial society to construct

low reliefs, collecting objects and
re-presenting them in a
figurative configuration.

Postcard Flag belongs to a
group of six works, all of which
can be read politically, reflecting
a moment in British history
when jingoistic nationalism was
at a peak and the problems of
economic recession were all-
pervasive. Michael Newman has
written of the present relief: 'the
red and blue plastic forms the
emblematic national image,
white being supplied by the wall
which is also the pictorial
"ground" and physical "support",

so this work elides painting and
sculpture as well as colour and
substance'. R B

PROVENANCE 1982: presented to the
gallery by the Contemporary Art Society
EXHIBITIONS *British Sculpture Now*,
Lucerne, Kunstmuseum, 1982;
Contemporary Choice, London, Serpentine
Gallery, 1982, no. 3; *A Quiet Revolution:
British Sculpture since 1945*, The Art
Institute of Chicago, 1987, no. 2
REFERENCES M. Newman, 'New
Sculpture in Britain', *Art in America*,
LXX/8, September 1982; G. Celant, *Tony
Cragg: Sculpture 1975–1990*, London,
1996, p. 61

411

Richard Deacon
(born 1949)

Let's Not Be Stupid, 1991

stainless steel and painted mild steel,
approx. 5 × 15 m
Collection of the University of
Warwick, WU 409

For this, his first public
commission, Richard Deacon
produced an arresting *tour de
force*. On one side, an upright
form in mild steel undulates
gently within a cage; but the
sense of confinement is broken at
the top, where the form bursts
out of its container. In a
development that gives the work
much of its explosive dynamism,
a horizontal ladder of twisting
stainless steel shoots like an

electrical discharge to the other
side of the sculpture. There, the
voltage seems to surge
unchecked through the entire
length of the second large form.
It threatens to buckle under the
impact of the tremor, but also
appears to be exhilarated by its
freedom from the cage.

At first, the sculpture seems to
set up a straightforward duality
between imprisonment and
liberty. Deacon may have been
thinking of a university student's
desire to leap out of the strait-
jacket imposed by institutional
authority – an urge defined more
clearly in a preliminary drawing,
in which most of the sculpture
erupts from a far smaller cage.
Yet the final work is ambiguous,
and the title Deacon has given
the sculpture sounds a note of

warning. While this might apply
to imprisonment, it could
equally well refer to the dangers
of total freedom. The unconfined
side of the sculpture is, after all,
still connected as if by an
umbilical cord to the other half.
The tension between them is
palpable, and they seem to be
engaged in a tug of war. Even as
the liberated side rejoices in
unshackled space, it remains
dependent on its link with the
caged form. They are evenly
matched, and the sculpture
implies that both sides would
suffer if the bridge between
them were severed. R C

PROVENANCE 1989: commissioned by
the University of Warwick; 1991:
presented to it by the Nyda and Oliver
Prenn Foundation
REFERENCES K. Eustace and
V. Pomery, *The University of Warwick
Collection*, Warwick, 1991, p. 36;
E. Rosenberg and R. Cork, *Architect's
Choice: Art in Architecture in Great Britain
since 1945*, London, 1992; J. Thompson,
P.L. Tazzi and P. Schjeldahl, *Richard
Deacon*, London, 1995

TO · LITERATURE · ARTS · AND · SCIENCES ·

THE GAZETTEER

ACCRINGTON
Haworth Art Gallery
Manchester Road, Accrington

Haworth Art Gallery is housed in an Edwardian neo-Jacobean house on the outskirts of Accrington. The house was designed by the Yorkshire architect Walter Brierley for Anne and William Haworth, children of Thomas Haworth (1819–91), a cotton magnate. It was bequeathed to the town as an art gallery in 1920 by Anne, as her brother, a leading local figure, would have wished. Included in the gift was a modest collection of paintings and watercolours, the grounds and stables, and a sum of money for upkeep. The gallery also contains a remarkable collection of Tiffany glass given to the town in 1933 by Joseph Briggs, Tiffany's Design Director for many years and a native of Accrington.

REFERENCE D. Jackson, *The Haworth Art Gallery*, Accrington, n.d.

CAT. 324

BARNARD CASTLE
The Bowes Museum
Barnard Castle, Co. Durham

The collection was formed and the building created by John (1811–85) and Josephine (1825–74) Bowes. He was the illegitimate son and partial heir of the 10th Earl of Strathmore. From 1830 Bowes, assisted after their marriage in 1852 by his French wife, assembled a major collection of over 1000 Old Master and modern paintings, often bought from dealers in

Paris. It includes a notable group of Spanish 17th-century pictures, together with Italian, Dutch and French paintings from the Early Renaissance to the 18th century. The 'modern' collection numbers works by Courbet and Boudin as well as many by Josephine Bowes.

It was her idea to create a museum. In 1869 the couple commissioned from the French architect Jules Pellechet a monumental building based on the Palais des Tuileries in Paris. It did not open until 1892, but remains one of the most remarkable museum structures in the country, even if incongruous in the County Durham countryside.

The paintings, housed in three picture galleries on the top floor, are complemented by an extensive decorative art collection from across Europe, especially rich in French artefacts and often compared to the Wallace Collection, London.

Set up as a charitable trust, the museum was transferred to the management of Durham County Council in 1956.

REFERENCE C. Hardy, *John Bowes and the Bowes Museum*, Barnard Castle, 1970

CAT. 273, 287, 289, 321, 325, 329, 335, 342

BARNSLEY
Cannon Hall
Cawthorne, Barnsley

Cannon Hall is presented partly as a gallery and partly as a historic house. The 17th-century building, with wings added by John Carr of York in the late 18th century, was bought by the

Borough in 1951. It opened in 1957.

The collection of fine and decorative arts includes the National Loan Collection Trust pictures, assembled by William Harvey of Barnsley (died 1867). Originally intended to tour the country, these pictures, primarily 17th-century Dutch and Flemish, were first housed in Barnsley in 1976 through the National Art-Collections Fund. Cannon Hall also contains the Regimental Museum of the 13th/18th Royal Hussars.

REFERENCE *Cannon Hall Art Gallery*, Barnsley, n.d.

CAT. 301, 309, 315

BARNSLEY
Cooper Art Gallery
Church Street, Barnsley

In 1912 S.J. Cooper entrusted a collection of 275 paintings (including 17th-century Dutch and 18th and 19th-century French and Italian works) to the former Holgate Grammar School and an endowment fund to a group of trustees for the establishment of a gallery. The gallery opened in 1914, after Cooper's death. Further gifts were added, notably a bequest of English drawings and watercolours by Sir Michael Sadler, one of the most enlightened collectors of the 20th century in Britain. The gallery was extended in 1934 to house the Fox collection of 19th-century English paintings.

REFERENCE E. Musgrave, 'Cooper Art Gallery', *Museums Journal*, February 1958, pp. 55–7

CAT. 141

BATH
Holburne Museum and Crafts
Study Centre
Great Pulteney Street, Bath

The collections of Sir William Holburne (1793–1874) are housed in the former Sydney Hotel, a magnificent Georgian building by Charles Harcourt Masters, originally the centre of the Sydney Pleasure Gardens. It was converted into a museum by Sir Reginald Blomfield in 1913.

Holburne was famous in his lifetime for his outstanding collections of silver, porcelain, majolica and bronzes. In painting he favoured the Dutch, Flemish and Italian 17th-century schools. In 1955 the fine-art collections were enhanced by a major bequest from Ernest E. Cook, which included works by Stubbs, Gainsborough, Zoffany, Raeburn and Turner. Recent public appeals have raised funds to purchase works of art of particular local interest, such as Plura's marble group of Diana and Endymion. Since 1977 the museum has shared the building with the internationally famous Crafts Study Centre, which displays collections of work by leading British 20th-century artist-craftspeople.

As a private trust, the Holburne has suffered continuing financial problems. It is now administered by the University of Bath.

REFERENCES *The History and Collections of the Holburne Museum*, Bath, 1993; R. Bayne-Powell, *Miniatures at the Holburne Museum*, Bath, 1995; *Silver at the Holburne Museum*, Bath, 1996

CAT. 34, 43

BATH

Victoria Art Gallery
Bridge Street, Bath

This municipal art gallery, originally paired with a reference library, was founded in 1900 and built by public subscription to celebrate Queen Victoria's Diamond Jubilee.

The building, in the classical style with a rotunda, was designed by James Brydon, who also built a number of ministerial offices in Whitehall. The gallery has recently been extended to encompass both the main floors of the building.

The strength of the collection lies in English art from the 18th century to the present, with a good representation of local artists such as the Barker family.

REFERENCE *Victoria Art Gallery Bath: Concise Catalogue*, Bath, 1991

CAT. 44, 119, 206

BEDFORD

Cecil Higgins Art Gallery and Museum
Castle Close, Bedford

Cecil Higgins (1856–1941) was born in Bedford, the son of a wealthy brewer. He collected glass, ceramics and pictures as the basis for a public museum.

The museum, established in Higgins's former house, was opened in 1949. In 1951 it was decided to concentrate on buying English watercolours, and the gallery now possesses one of the most representative collections of English watercolours and drawings outside London. In 1972 many items were bought from the Handley-Read

collection of 19th and early 20th-century *objets d'art*. The gallery also holds an important collection of modern prints.

A new wing, providing a temporary exhibition space, was added to the museum in 1976, while the original Victorian building was refurbished and includes a room devoted to the architect William Burges.

REFERENCE *Cecil Higgins Art Gallery and Museum*, Bedford, 1987

CAT. 212, 216, 217, 223, 229

BERWICK-ON-TWEED

Berwick-on-Tweed Museum and Art Gallery
Berwick Barracks, Berwick-on-Tweed

The Berwick museum was founded in 1867. It did not acquire an art collection until 1949, when 40 works were donated by Sir William Burrell (1861–1958), founder of the Burrell Collection in Glasgow, who lived nearby at Hutton Castle. Burrell's gift included outstanding works by Degas, Daubigny, Boudin and 19th-century Dutch artists. In 1985 the collection moved to the former Berwick Barracks, where it opened to visitors in 1987.

CAT. 356

BIRKENHEAD

Williamson Art Gallery and Museum
Slatey Road, Birkenhead

The art gallery was financed by a bequest made by a local director of Cunard, John Williamson, and a gift from his son Patrick;

it opened in 1928. The building was designed by the Liverpool architects Leonard Hannaford and Herbert Thearle in a sophisticated neoclassical style influenced by contemporary American architecture, with generous provision of gallery space and carefully planned natural lighting.

The collection contains principally Victorian and 20th-century paintings and a fine collection of British watercolours, along with maritime material appropriate to a port and ship-building town.

CAT. 160, 265

BIRMINGHAM

The Barber Institute of Fine Arts
The University of Birmingham, Edgbaston

The institute, dedicated to 'the study and encouragement of art and music', was founded in 1932 by Lady Barber (1869–1933) in memory of her husband, Sir William Henry Barber (1860–1927). He was born in Handsworth and made his fortune in property development. A building to contain the galleries, the university's music department and a theatre was designed in a clean, modernist style by Robert Atkinson and opened in 1939.

The founder wished the collection to contain 'works of exceptional and outstanding merit', which could encompass furniture, tapestries and manuscripts as well as paintings and drawings. The trustees were instructed to collect paintings only 'of that standard of quality required by the National Gallery

or the Wallace Collection'. Under a succession of distinguished directors, among them Thomas Bodkin and Ellis Waterhouse, the institute has assembled a notable collection of paintings from the Early Renaissance to Impressionism and the early 20th century.

REFERENCE P. Spencer Longhurst, *The Barber Institute of Fine Arts: Handbook*, Birmingham, 1991

CAT. 94, 96, 98, 166, 282, 288, 293, 312, 332, 352, 354, 361

BIRMINGHAM

Birmingham Museum and Art Gallery
Chamberlain Square, Birmingham

Interest in establishing a museum and gallery was apparent in Birmingham in the 1860s, when a number of works were donated to the city. In 1867 the first gallery opened in one room of the Central Library. In its early days the museum was closely associated with the South Kensington Museum in London, which sent a succession of decorative art exhibitions. Work also started on forming a permanent collection, with the establishment in 1870 of an Art Gallery Sub-committee and an acquisition fund. The Birmingham Public Picture Gallery opened the following year.

In 1880 Richard and George Tangye, local collectors, gave money for purchases and an endowment on condition that the city build a new gallery. This building, situated behind the Council House, was designed by H. Yeoville Thomason and

opened in 1885. It was extended in 1900–4, in 1912, when the suite of upstairs galleries was added, and again in 1919. The first curator, appointed in 1885, was Whitworth Wallis, who began acquiring the Pre-Raphaelite paintings for which Birmingham is celebrated. The gallery also owns notable Pre-Raphaelite drawings, a group of which was bought from the collection of Charles Fairfax Murray and presented by local people. Less well known is the Birmingham School, including Joseph Southall and Henry Payne.

The collection expanded after World War II under a succession of talented directors and curators, including John Woodward, Trenchard Cox and Mary Woodall. With generous support from the City Council, the Association of Friends and the Public Picture Gallery Fund, they accumulated an outstanding collection of Old Master and 19th-century paintings and sculpture, with special emphasis on Baroque painting. The notable collection of 20th-century British paintings and sculpture continues to be added to, and foreign 20th-century prints are also a focus of acquisition policy.

The gallery has a large collection of decorative art objects, some of which are shown at Aston Hall, a Jacobean house which has belonged to the city since the 1860s.

The Victorian interiors of the building were restored in the 1980s. The gallery's need for a temporary exhibition space was satisfied by the opening in 1993 of the Gas Hall.

REFERENCE S. Davies, *By the Gains of Industry*, Birmingham, 1985

CAT. 26, 37, 94, 113, 129, 132, 153, 163, 176, 202, 211, 237, 239, 240, 242, 244, 251, 275, 278, 296, 322, 341, 380

BLACKBURN
Blackburn Museum and Art Gallery
Museum Street, Blackburn

The museum was founded in 1862. The art collection, which was added later, is housed in a purpose-built library and museum designed by Woodzell & Collcutt. It is especially rich in 19th-century British watercolours but has other strengths, including Japanese woodcuts (presented in 1944) and Russian and Greek icons. In 1946 Edward Hart, a local entrepreneur with a rope-making business, bequeathed his large collection of manuscripts and early printed books.

REFERENCE Blackburn Corporation, *Catalogue of the Permanent Collection*, Blackburn, 1928

CAT. 159, 241

BOLTON
Bolton Museum and Art Gallery
Le Mans Crescent, Bolton

In 1890 Mere Hall was given to the town as an art gallery. In 1938 it was superseded by a civic centre, built to the designs of Bradshaw, Gass & Hope. This united the museum, gallery and library in a building which also contained the magistrates' court.

Soon afterwards the gallery received an important bequest from a Bolton mill-owner, Frank Hindley Smith (died 1939). Hindley Smith, a member of Maynard Keynes's circle and a collector of modern British art, especially of the Bloomsbury group, was determined that on his death his collection should be used to advance knowledge of art in Britain. He particularly wished to encourage regional galleries which had shown an interest in contemporary art. After his death his possessions were divided between a number of British galleries, including the Tate, London, the Ashmolean, Oxford, and Bolton.

The collection includes some Old Masters, a large group of British watercolours and a sculpture gallery in which the work of Epstein, Moore and Paolozzi is represented.

REFERENCE *A Brief History of Museums in Bolton*, Bolton, 1983

CAT. 308

BOURNEMOUTH
Russell-Cotes Art Gallery and Museum
East Cliff, Bournemouth

The Russell-Cotes Art Gallery and Museum gives a remarkable impression of the residence of a late Victorian art lover. Since the 1980s work has been done to restore the house to its original appearance, while a cleverly designed extension provides modern facilities.

Merton Russell-Cotes (1835–1921) retired from the Scottish Amicable Society in 1876 owing to ill health and, with his wife, bought the Royal Bath Hotel in Bournemouth. He was elected mayor of the town in 1894. East Cliff, the couple's house overlooking the sea, was given to Bournemouth in 1908 and opened to the public in 1922. It includes four purpose-built art galleries as well as domestic accommodation.

The collection contains many notable Victorian works belonging to the donor, whose enthusiasm for art had been kindled by the Manchester Art Treasures exhibition of 1857. He had a particular fondness for the work of Edwin Long, which is shown here extensively. Paintings by Rossetti, Landseer, B.W. Leader and Frith have been added to the collection, as has an interesting selection of work by 20th-century artists. The house contains many of its original furnishings, and the extension, art galleries and gardens include fine examples of specially commissioned late 20th-century craft and sculpture.

REFERENCE S. Olding and S. Garner, *So Fair a House*, Bournemouth, 1997

CAT. 184, 185

BRADFORD
Cartwright Hall Art Gallery
Lister Park, Bradford

The Cartwright Hall Art Gallery was opened to the public in 1904, a result of the generosity of Samuel Cunliffe Lister, later Lord Masham (1815–1906), who had amassed a fortune by developing textile machinery for the mills owned by his family, a major textile manufacturer. The gallery, dedicated to Edmund Cartwright (1743–1823), inventor of the first wool-combing machine, was built on

the site of the former Lister family home.

The building was designed by John Simpson and Edmund Milner Allen in a Baroque style, and was intended for municipal entertaining as well as for the display of paintings. It opened with a large-scale exhibition.

The strength of the collection lies in its holdings of British work from the Victorian period to the present. Since the advent of the Bradford Print Biennale in the late 1960s, the gallery's collecting policy has expanded to include work from abroad, especially from the Indian subcontinent.

REFERENCE N. Pooveya-Smith and C. Hopper, *Cartwright Hall Art Gallery and its Collections*, Bradford, 1997

CAT. 11, 20, 22, 178, 198

BRIGHOUSE
Smith Art Gallery
Halifax Road, Brighouse

The art gallery was founded by Alderman William Smith (1839–1922), a local textile manufacturer, and his wife, Susannah (died 1916). They presented it with their collection of mostly Victorian pictures and, to house it, financed the addition of four galleries to the existing library and museum. The gallery opened in 1907.

Smith offered an additional bequest of pictures on condition that suitable premises were found by the town to house it. Brighouse did not, and the collection was sold.

The founding collection, the greater part of which consists of morally improving Victorian pictures, includes works by Atkinson Grimshaw, Marcus Stone and Thomas Faed. There is also a collection of 20th-century British works.

CAT. 135

BRIGHTON
Brighton Museum and Art Gallery
Church Street, Brighton

Brighton Museum and Art Gallery, which is part of the museums service that includes the Royal Pavilion, opened in 1873. The building, designed by Philip Lockwood, the Borough Surveyor, was erected on the site of the Royal Pavilion's temporary stables.

The original core of the gallery was the collection of paintings and of commemorative pottery assembled by Henry Willett (1823–1905), a friend of John Ruskin and a passionate believer in the cause of education for working people. Although Willett sold many of his paintings shortly before his death, several important Dutch and Flemish works remain in the gallery.

Later bequests and acquisitions have brought a group of 18th-century Italian oil sketches, purchased in the 1960s; Victorian and Camden Town paintings; an excellent representation of works by Sussex artists; and a diverse group of 17th and 18th-century European paintings. The decision, taken in the 1960s, to concentrate on metalwork, furniture and ceramics of the 20th century has resulted in an unusual and alluring collection.

In the Royal Pavilion, bought for the town from Queen Victoria and opened in 1851, successive curators have assembled one of the most important collections of Regency furniture in the country.

REFERENCES *Handbook and Brief Guide to the Art Gallery and Museums*, Brighton, 1975; *The Royal Pavilion and Museums Review*, 1988, 1992

CAT. 373

BRISTOL
Bristol City Museum and Art Gallery
Queen's Road, Bristol

Bristol's first museum collection was part of the Bristol Institution, which opened in 1823. In 1872 the institution moved to a building in the Venetian Gothic style and, some 25 years later, was taken over by the City Council. The art gallery was opened as an addition to the museum in 1905, through the generosity of the Wills family.

The paintings collection is especially strong in the work of the Bristol school. The collection has also benefited from important purchases of foreign paintings, including works by Taddeo Gaddi, Delacroix and Vuillard, made under the post-World War II directorship of Hans Schubart. In the 1960s the Dyer Bequest enabled examples of contemporary abstract painting to be purchased.

REFERENCE K. Walton, *75 Years of Bristol Art Gallery*, Bristol, 1980

CAT. 114, 122, 195, 292, 328, 336, 339

BURNLEY
Towneley Hall Art Gallery and Museums
Burnley

Towneley Hall is a house of remarkable historic and architectural interest, for many years in the possession of the Townley (or Towneley) family. The house and park were bought by Burnley Corporation in 1902, when the house was converted for use as an art gallery and museum.

Towneley Hall's collections include 19th and 20th-century paintings and watercolours, furniture, ceramics and glass with an emphasis on works associated with the house and family. The Whalley Abbey vestments (1415–30) are of particular note. Many works are displayed in period room settings.

REFERENCE *A Guide to Towneley Hall Art Gallery and Museums*, Burnley, 1984

CAT. 6, 8

BURY
Bury Art Gallery and Museum
Moss Street, Bury

Bury Art Gallery was founded by Bury Corporation as a result of a gift by the three children of Thomas Wrigley (1808–80), who donated their father's large collection to the people of Bury in 1887 in commemoration of Queen Victoria's Jubilee. Wrigley had made his fortune in paper, banking and railways.

To secure the gift for the town, a gallery was built to the designs of Woodhouse & Willoughby of Manchester in

what was described as the 'English renaissance style of the 18th century, freely treated'. The collection was transferred there in 1901. Wrigley's highly discriminating collection of 19th-century British paintings, prints and sculptures has been enhanced by works by such 20th-century artists as Edward Burra and Sir Jacob Epstein.

REFERENCE *Bury Art Gallery and Museum: A Souvenir Guide*, Bury, 1996

CAT. 117, 124, 128, 134, 145, 148, 149, 154, 177

BURY ST EDMUNDS
Manor House Museum
Honey Hill, Bury St Edmunds

The historic Manor House was acquired in 1988 by St Edmundsbury Borough Council, which restored and opened it as a museum in 1993. The collections, accumulated since 1900, encompass paintings and *objets d'art*, horology and costume.

The museum is also home to a growing collection of portraits, including fourteen bequeathed in 1993, by the 17th-century artist Mary Beale, who was born locally.

REFERENCE *Mrs Mary Beale. Paintress*, Bury St Edmunds, 1995

CAT. 30

CAMBRIDGE
Fitzwilliam Museum
Trumpington Street, Cambridge

The museum was founded in 1816, with the bequest to the university by Richard, 7th Viscount Fitzwilliam of his paintings, works on paper, books and musical material. The Neoclassical museum building was begun by George Basevi in 1837 and completed by C. R. Cockerell. It opened in 1848.

The museum has benefited from a succession of important bequests and donations. In the 19th century these included the Mesman collection of Dutch and Flemish paintings, given in 1834, John Disney's gift of Classical sculpture in 1850 and Ruskin's donation of 25 Turner watercolours in 1861. Early in the present century, the museum was transformed by Sydney Carlyle Cockerell, its director from 1908 to 1937. He made numerous purchases and persuaded collectors to give works of art, among them donations from the painter and art dealer Charles Fairfax Murray, an associate of Burne-Jones. Cockerell transformed the appearance of the picture galleries by introducing furniture and Oriental carpets in addition to ceramics and sculpture.

In 1924 the Marlay Galleries were opened, considerably extending the building. Numerous further Galleries have been added, including the Courtauld Galleries of 1931, paid for by members of the Courtauld family, and the Adeane Gallery of 1975.

Recent donations have included the Broughton collection of flower paintings, and drawings; the Gow and Tillotsen collections of mostly 19th-century French art; the Hunter collection of 20th-century painting and sculpture; Dr McDonald's European paintings; and the Boscawen collection of mainly Renaissance bronzes.

Since World War II the collection has expanded greatly, notably under the directorship of Michael Jaffé (1973–90). With minimal funding but remarkable knowedge and initiative, one of the world's most distinguished museum collections has been amassed. Among its many strengths are early Italian and Venetian High Renaissance paintings, Baroque works, French 19th-century pictures and on eclectic, unusual representation of British art from the 18th century to the present. There is an outstanding and varied collection of works on paper. The museum has also bought contemporary works, largely by British artists and craftspersons.

REFERENCE W. Goodison, *Fitzwilliam Museum, Cambridge: Catalogue of Paintings*, 3 vols., Cambridge, 1960

CAT. 5, 28, 35, 69, 72, 78, 79, 91, 92, 95, 102, 106, 108, 111, 157, 189, 224, 253, 256, 280, 281, 300, 302, 331, 334, 338, 348, 360, 362

CAMBRIDGE
Kettle's Yard
Castle Street, Cambridge

Kettle's Yard houses the very personal collection of modern art formed by H.S. ('Jim') Ede and given to the University of Cambridge in 1966. Ede began collecting in the 1920s and formed friendships with many of the artists whose works he bought, including Ben and Winifred Nicholson.

Ede travelled widely, meeting artists and visiting collections. On one such visit to America in 1954 he conceived the idea of a 'living space museum', in which visitors would be given the impression that they were visiting a private house reflecting individual taste. In this setting, where works of art would be juxtaposed with furniture, glass, ceramics and *objets trouvés*, an atmosphere of domestic serenity would be created. To this purpose, in 1957 Ede converted four tiny slum dwellings in Kettle's Yard. An extension to the house and an exhibition gallery designed by Sir Leslie Martin were added in 1960.

REFERENCES J. Lewison, *Kettle's Yard*, Cambridge, 1980; J. Ede, *A Way of Life*, Cambridge, 1984

CAT. 260, 267, 389

CANTERBURY
Royal Museum and Art Gallery
High Street, Canterbury

Canterbury's first public museum was opened in 1825 in the city's Philosophical and Literary Institution in Guildhall Street. In 1847 the building and the collection were acquired by the City Council, but it was not until 1899 that the museum moved to the present building in the High Street.

This building is Dr Beaney's Institute, designed by the city surveyor A.H. Campbell in a half-timbered 'Tudorbethan' style and funded in large part by a bequest of £10,000 from Dr J.G. Beaney (1828–91), a flamboyant son of the city who

had made a fortune as a surgeon in Australia.

The art gallery is housed in a 1930s extension, designed by city surveyor H.M. Enderby and funded by the Slater family. The gallery owes its fine holdings of earlier art to the Ingram Godfrey gift of Old Master drawings and prints, the G.F. de Zoete bequest of oil paintings and the T.S. Cooper collection. More active collecting in the last twenty years has added further 18th and 19th-century topographical drawings and a group of paintings which, ranging from the 17th to the 20th century, includes work by John Ward, who lives locally.

REFERENCE C.J. Baker, *Catalogue of Oil Paintings ... in the Permanent Collection at Canterbury,* Canterbury, 1978
CAT. 15, 25, 104, 105, 162, 306

CARLISLE
Tullie House Museum and Art Gallery
Castle Street, Carlisle

The collection has its roots in a museum founded by the Carlisle Philosophical Society in 1836. The future of the museum was secured in 1890 when Charles Ferguson purchased Tullie House, a run-down Jacobean manor house, to house a museum of science and art, an art school and a free library. Tullie House has since been altered and extended (most recently in 1990) to accommodate its growing collection.

In the 1930s the gallery initiated an adventurous acquisitions policy, with a succession of advisers, among

them Sir William Rothenstein and Sir Roger de Grey. It has bought work from numerous living British artists, including Stanley Spencer. Its most significant bequest came in 1949 from Emily and Gorndon Bottomley, who left 600 works by the Pre-Raphaelites and the modern British school.
CAT. 24, 144

CHELTENHAM
Cheltenham Art Gallery and Museum
Clarence Street, Cheltenham

The art gallery was founded in 1898 with a gift of paintings and money from Charles, 3rd Baron de Ferrieres (1823–1908), which included numerous 19th-century foreign (primarily Dutch) paintings. The gallery opened in 1899, and six years later the museum moved to the neighbouring building, vacated by the Schools of Art.

The original art gallery, designed by W.H. Knight, was demolished in 1988 and replaced by a building designed by the Borough Architects in association with Sir Hugh Casson.

The large decorative arts collection includes Oriental wares and furniture of the Arts and Crafts movement, in particular works by members of the Cotswold School.
REFERENCES C. Wright, *Catalogue of Foreign Paintings from the de Ferrieres Collection and other Sources,* Cheltenham, 1988; A. Curruthers and M. Greensted, *Good Citizens' Furniture,* Cheltenham and London, 1994
CAT. 14, 36, 138

CHICHESTER
Pallant House
9 North Pallant, Chichester

Chichester District Council was encouraged by a generous bequest of paintings from Walter Hussey to restore Pallant House, a Queen Anne town house, as a public gallery to show the Hussey Collection. It opened in 1982.

Hussey (1909–85) was an active patron of the arts both in his capacity as Dean of Chichester and as a private collector. He commissioned works from Henry Moore, Marc Chagall, Graham Sutherland, Ceri Richards and others, and accumulated a highly distinctive personal collection.

Charles Kearley (1904–89), variously a builder, farmer and hotelier with a keen interest in buying modern British art, was attracted to Hussey's collection at Pallant House and bequeathed his complementary collection of 60 pictures to the gallery in 1989. Since then the Pallant House collection has grown considerably as a result of several other gifts and acquisitions.
REFERENCE *The Fine Art Collections, Pallant House,* Chichester, 1990
CAT. 82, 365, 397

COOKHAM
Stanley Spencer Gallery
King's Hall, High Street, Cookham

Sir Stanley Spencer (1891–1959) was born and worked for most of his life in Cookham, and the village forms the background to many of his paintings. The

Stanley Spencer Gallery, founded in 1962, is devoted solely to his work and is housed in the former Wesleyan Methodist Chapel, where he worshipped as a child.

The gallery's collection includes a fine group of early religious paintings and an extensive selection of drawings, as well as a recent major bequest of paintings and drawings from the late Barbara Karmel. Biannual exhibitions include loans of important Spencer pictures from galleries and private owners in the UK.
REFERENCE *Stanley Spencer Gallery: 25th Anniversary Exhibition,* Cookham, 1987
CAT. 395

COVENTRY
Herbert Art Gallery and Museum
Jordan Well, Coventry

The Herbert Art Gallery and Museum was founded with a donation in 1938 from Sir Alfred Herbert (1866–1957). The present, purpose-built structure, designed by Herbert, Son and Sawday, opened in 1960.

Donations have included that by Lord Kenilworth of British 19th-century works (1954) and Lord Iliffe's of most of Graham Sutherland's studies for the Coventry Cathedral tapestry (1964). The gallery has a large collection of British watercolours.
REFERENCE Herbert Art Gallery, *Visual Arts: A Brief Handlist of the Permanent Collection,* Coventry, 1997
CAT. 60

COVENTRY
Mead Gallery
Warwick Arts Centre, University
of Warwick, Coventry

On its foundation in 1966 the
University of Warwick allocated
£6000 for the acquisition of
works of art to complement the
new university buildings and
park. Purchasing was undertaken
by Eugene Rosenberg, senior
partner of the university's
architects, who bought modern
British works, by Hoyland,
Pasmore, Frost, Heron and
Freud, from the main London
dealers. In 1986 the Mead
Gallery was opened, primarily
for temporary exhibitions, but
purchases of contemporary
British art continue to be made.
REFERENCE K. Estace and
V. Pomery, *The University of
Warwick Collection*, Nuneaton,
1991
CAT. 263, 411

DEDHAM
The Sir Alfred Munnings Art
Museum
Castle House, Dedham, Essex

Sir Alfred Munnings
(1878–1959) became extremely
famous as a sporting painter and
was elected President of the
Royal Academy in 1944.

Castle House, where Sir Alfred
lived from 1920 until his death,
was established by his widow,
Lady Violet, as an art museum
and as a memorial to her
husband. The building, a
mixture of the Tudor and
Georgian periods, has been
restored and two galleries have
been added, but the essential
character of the house, as lived in

by the Munnings family, has
been retained.

The museum holds a
representative collection of
Munnings's paintings, sketches
and sculpture which is shown in
the house and studio.
REFERENCE S. Booth, *The
Munnings' Collection,* Colchester,
1976
CAT. 205

DERBY
Derby Museum and Art Gallery
The Strand, Derby

In 1883 an art gallery was
provided for Derby (which had a
long-established library and
museum) by Michael Bass,
brewer and MP for the town.
The building, designed by R.K.
Freeman, was extended in 1916
and 1964.

The principal strength of the
art collection lies in the
remarkable (and expanding)
group of works by Joseph
Wright of Derby. The gallery
also contains a large
topographical collection, given
by Alfred Goodey in 1936, and
over 3000 pieces of Derby
porcelain.
REFERENCE D. Fraser, *Guide to
Derby Museum and Art Gallery,*
Derby, 1979
CAT. 51

DONCASTER
Doncaster Museum and Art
Gallery
Chequer Road, Doncaster

The museum and art gallery
were set up in 1909 in a
Victorian town house. They
moved to new purpose-built

premises, designed by the
Borough Architect, L.J. Tucker,
in 1964. The collection contains
19th and 20th-century paintings
and works on paper, with an
emphasis on the British school
and on horse-racing images.
Numerous items, including
works by Nina Harnett, Frank
Dobson and Edward Wolf, were
acquired from the collection of
Sir Edward Marsh, writer,
secretary to Winston Churchill
and distinguished patron of the
arts.
CAT. 67

EASTBOURNE
Towner Art Gallery and Local
Museum
High Street, Old Town,
Eastbourne

The gallery opened in 1923
following a bequest by local
businessman John Chisholm
Towner, which included a group
of Victorian narrative paintings.

After World War II the
collection broadened to include
work by Sickert, Sylvia Gosse
and Picasso. Under the
curatorship of William Gear, a
group of British abstract
paintings was added in the
1960s, and the acquisition of
contemporary art has been
maintained to the present. The
work of Eric Ravilious is
especially well represented.
REFERENCE *Look Here upon this
picture . . . and on this . . .,*
Eastbourne, 1989
CAT. 266

EGHAM
Royal Holloway, University of
London
Egham Hill, Egham, Surrey

Royal Holloway College was
founded in 1873 by Thomas
Holloway (1800–83), who had
made his fortune selling patent
medicines. The college had been
his wife's idea and was originally
dedicated to the education of
middle and upper middle-class
women. The powerful neo-
Renaissance building was
designed by the otherwise little
known W.H. Crossland (a pupil
of Sir George Gilbert Scott) and
modelled on the Château de
Chambord.

The 77 paintings Holloway
donated to the college were
bought expressly for it, in a short
time and at considerable cost.
The college had no purpose-built
picture gallery, so the works
were hung in the students'
recreation hall. The collection
included paintings by
Gainsborough, Turner and
Constable as well as a
representative selection of High
Victorian pictures. Holloway
appears not to have cared for Pre-
Raphaelite paintings, but bought
notable Social Realist works by
Fildes and Holl.
REFERENCE J. Chapel,
Victorian Taste, London, 1982
CAT. 121, 151, 155, 171

EXETER
Royal Albert Memorial Museum
Queen Street, Exeter

The museum, founded in 1861,
along with an art school and
public library, was designed in
the Gothic style by John

Hayward. It opened to the public in 1868 – one of the earliest purpose-built art galleries in the country.

In 1892 Kent and Jane Kingdon bequeathed an endowment fund for the purchase of modern paintings. In 1924 the museum received a large collection of pictures from Sir Harry Veitch, but by the 1950s the Victorian pictures in his collection were considered of little interest and some 150 were sold to form a purchase fund. The Veitch fund was used to acquire works by local Devon artists. The museum holds an important group of works by other 18th-century and Victorian artists and a fine collection of portrait and topographical prints.

Since 1968 the collecting policy has been widened to include works from the Camden Town and St Ives schools as well as prints by living local artists.
REFERENCE *Guide to the Royal Albert Memorial Museum*, Exeter, 1978
CAT. 66, 175, 188

FALMOUTH
Falmouth Art Gallery
Municipal Buildings, The Moor, Falmouth

The gallery is housed in a building paid for by the distinguished philanthropist J. Passmore Edwards (1823–1911). Most of the paintings came to the town from Alfred de Pass, who presented his drawings to the Royal Institution of Cornwall in Truro. The collection contains a number of Victorian and Edwardian works, with several paintings by H.S. Tuke, who lived and worked locally.

The gallery was renovated and extended in 1976, to the designs of Poynton, Bradbury & Wynter. It now houses mainly temporary exhibitions, with an emphasis on contemporary work.
CAT. 191

GATESHEAD
Shipley Art Gallery
Prince Consort Road, Gateshead

The gallery is named after J.A.D. Shipley (1822–1909), a solicitor who was born in Newcastle but lived across the Tyne at Saltwell Towers in Gateshead, where he displayed his collection of 2500 paintings: 18th and 19th-century British and Italian (including Tintoretto), German, Dutch and Flemish of the 16th to the 19th century. The collection was bequeathed to Newcastle and a building was to have been constructed for it next to the newly opened Laing Art Gallery. However, influential people in Newcastle opposed the acceptance of Shipley's collection and the opportunity to fulfil the terms of the bequest passed to the Corporation of Gateshead. A total of 504 paintings was selected for the permanent collection and a classical gallery (designed by A. Stockwell of Newcastle) was erected to house it.
REFERENCE C. Wright, *Dutch and Flemish 16th & 17th century Paintings from the Shipley Collection*, London, 1979
CAT. 118

GLOUCESTER
Gloucester City Museum and Art Gallery
Brunswick Road, Gloucester

In 1901 the Gloucester museum moved to its present location, a hall built by Mrs Margaret Price. Early help was given to the museum by Sir William Rothenstein, who was a co-opted member of the Art Sub-committee. A number of extensions were added, notably a first floor (1958) and a new art gallery (1965).

These extensions were built largely to house the significant bequest of Mr Stanley Marley of Amberley in 1963. This included the ceramics, furniture, watches and paintings which are still the mainstay of the art gallery's display.
CAT. 65

GRASMERE
Dove Cottage and Wordsworth Museum
Town End, Grasmere

Wordsworth lived in Dove Cottage from 1799 to 1808. It was set up as a museum in 1890. In addition to Wordsworth memorabilia, the collection, most of which is on show in a building next to the cottage, possesses a growing number of watercolours and other works associated with the Lake District.
CAT. 209

HALIFAX
Bankfield Museum
Boothtown Road, Halifax

Bankfield House is a large mid-19th-century Italianate villa, formerly the house of a leading textile manufacturer. In 1897 it was converted for use as a museum, specialising in textiles (from which Halifax gained its prosperity). The museum also possesses collections of British 19th and 20th-century works of art (notably from the bequest in 1940 by R.E. Nicholson, a Halifax businessman and founder of the Halifax Art Society), Old Master drawings, 19th-century British watercolours and 20th-century paintings.

The applied art collection was initiated in the 1930s and now contains textiles, basketry, pottery and glassware.
CAT. 232

HARROGATE
Mercer Art Gallery
Swan Road, Harrogate

The collection, established in 1930, was housed above the library in Victoria Avenue until 1991, when it moved to the spa town's newly restored Promenade Room, built in 1806.

The gallery's strength lies in British art of the 19th and 20th centuries, from Turner, Frith and Burne-Jones to Edward Wadsworth, Andy Goldsworthy and David Mach. It is also home to the Kent Collection of antiquities.
REFERENCE *Yorkshire's Best*, Harrogate, 1994
CAT. 248

HEREFORD

Hereford City Museum and Art Gallery
Broad Street, Hereford

Museum collections at Hereford go back to the Woolhope Naturalists' Field Club, which was founded in 1852. In co-operation with the town council, the club later purchased the site in Broad Street and financed the building of the public library and museum, which opened in 1874.

In 1912 an art gallery was added and in 1928 the curator initiated a policy of acquiring depictions of the Hereford area and work by local artists. The gallery also possesses other types of work, ranging from the 18th to the 20th century and including paintings by Cox (who lived in Hereford for a time), Girtin, Turner, John Ward and Dame Laura Knight.
CAT. 225

HUDDERSFIELD

Huddersfield Art Gallery
Princess Alexandra Walk, Huddersfield

A library and art gallery was established at Huddersfield in 1898; the present accommodation, designed by E. H. Ashburner, opened in 1946. In 1974 it absorbed the collections from Batley and Dewsbury art galleries, closed following local government reorganisation.

The gallery concentrates on the work of British artists including 18th-century watercolours and an important group of Camden Town paintings. It has been vigorous in collecting 20th-century and contemporary British art, including works by Bacon, Auerbach, Riley, Moore and Epstein. The collection has benefited from over 50 years of membership of the Contemporary Art Society.
CAT. 54, 150, 375, 399

HULL

Ferens Art Gallery
Queen Victoria Square, Hull

In 1910 Thomas Robinson Ferens (1847–1930) was invited to open the Victoria Gallery in recognition of his generosity in establishing a fine-art collection in Hull. A local industrialist and philanthropist, Ferens continued his support, eventually providing funds for a new gallery. The Ferens Art Gallery opened in 1927 to show the growing collection originally displayed in the Victoria Gallery. In the late 1980s a programme of refurbishment and extension was initiated that has resulted in a doubling of the gallery's display space.

Thanks to Ferens's generous endowment and the work of committed curators, the gallery has assembled an impressive collection of Old Master paintings which, with particular strengths in Dutch 17th-century art, includes works by Hals and Ruisdael. The holdings of 20th-century British art are also notable, with special emphasis placed on the development of portraiture in this country.
REFERENCE *The Ferens Art Gallery*, Hull, 1989
CAT. 297, 305, 311, 320, 330, 384, 402, 403

HULL

University of Hull Art Collection
Middleton Hall, Cottingham Road, Hull

Thomas Robinson Ferens (1847–1930) bequeathed a fund to the University of Hull for the encouragement of the fine arts. In 1963 it was decided to devote this to buying works of art produced in Britain between 1890 and 1940. An impressive group of paintings, drawings and sculpture has been acquired which, since 1967, has been housed in galleries designed by Sir Leslie Martin.
REFERENCE M. Easton, *Art in Britain 1890–1940 from the Collection of the University of Hull*, Hull, 1967
CAT. 374, 383, 386

IPSWICH

Christchurch Mansion
Christchurch Park, Ipswich

Christchurch Mansion was presented to the people of Ipswich in 1895 by a local MP, Felix Thornley Cobbold (1841–1909). The Tudor mansion was converted to house the archaeological museum, the picture gallery and the schools of Science and Art. It opened to the public in 1896. Cobbold also provided an endowment fund for the purchase of works of art, particularly those by local artists. Two galleries have been added to the house, the Wolsey Art Gallery in 1932 (funded by the Wolsey Pageant, 1930) and the Suffolk Artists Gallery in 1991.

The collections concentrate on Suffolk, a county rich in artists, and include fine works by Gainsborough and Constable; but Dutch 17th-century painting and more recent British work are also represented.
REFERENCES C. Bennett, *Christchurch Mansion & Park*, Ipswich, 1989; *idem, Suffolk Artists 1750–1930*, Ipswich, 1991
CAT. 29, 40, 41, 61, 62, 369

KENDAL

Abbot Hall Art Gallery
Kendal, Cumbria

Abbot Hall was built in 1759 as a private house. The house and garden were bought by Kendal Corporation in 1897. While the grounds became a public park, the house remained empty and by the 1950s was threatened with demolition. Following a successful campaign by local people and the Georgian Group to save the building, it opened as an art gallery in 1962.

Abbot Hall now has a distinctive collection, combining earlier works of art of local origin with 20th-century objects. Romney is represented by a number of important works, as are landscape artists who travelled in the Lake District, such as de Loutherbourg, Constable and Lear. The 20th-century collections include works by Kurt Schwitters (who lived locally at the end of his life), Ben Nicholson and the Scottish 'Colourists'. Collecting in both the historical and the contemporary areas continues to be actively pursued.
REFERENCE *Treasures from Abbott Hall*, Kendal, 1989
CAT. 31, 52, 57, 221, 234, 366

KENT

Kent Master Collection
Kent County Council, Arts and Libraries

In 1924 Mrs Amy Master (died 1950) gave her collection of 400 Old Master and 19th-century British drawings to the Folkestone Museum and Art Gallery. The collection was formed by Mrs Master's ancestor, Thomas Man Bridge (c. 1809–83), while travelling on the Continent in the 1830s and at the London salerooms of the 1860s.

The collection, which was originally much larger, includes works by the Carracci, Guercino, Boucher, Ribera, Kauffman, Prout and Clarkson Stanfield. It was originally exhibited on an occasional basis at the Folkestone Museum and Art Gallery, but care of the collection passed to Kent County Council in 1974. The drawings are not on permanent display, but are exhibited regularly at venues throughout Britain.
REFERENCE H. Chapman, *Kent Master Collection*, Kent County Council, 1991
CAT. 74, 83, 88, 89

KETTERING

Alfred East Art Gallery
Sheep Street, Kettering

Founded in 1913, the gallery is named after the Kettering-born painter Sir Alfred East (1849–1913), whose work is well represented in the collection. The gallery also includes a group of British 19th- and 20th-century paintings and watercolours.
CAT. 200

LEAMINGTON SPA

Warwick District Council Art Gallery and Museum
Avenue Road, Leamington Spa

The art gallery, opened in 1928, was accommodated in a building designed by A.C. Bunch, the Warwickshire County Council Architect. The paintings collection consists of a group of 16th and 17th-century Dutch and Flemish works, as well as pictures by 20th-century British artists, including Lowry, Spencer, Duncan Grant, Terry Frost and the local painter Thomas Barker.
REFERENCE M. Slater, 'A Small Municipal Art Gallery and Museum', *Phoenix*, 1981, p. 15
CAT. 313

LEEDS

Leeds City Art Gallery
The Headrow, Leeds

The gallery was built with money raised during Queen Victoria's Golden Jubilee and opened in 1888. The impetus came from Councillor Colonel T.W. Harding, who chaired the relevant committee, endowed a purchase fund and gave works of art. The gallery was erected close to the town hall, to the designs of W.H. Thorp. At first it concentrated on annual exhibitions, often including works from Royal Academy exhibitions. Occasional grants were made by the City Council but the gallery was primarily dependent on donations, such as the Alfred Bilborough bequest of funds to purchase works on paper and the bequest, in 1918, by the Leeds industrialist Sam Wilson of his collection of early 20th-century British works.

Frank Rutter, Curator from 1912 to 1917, introduced an innovative approach, against opposition by a conservative and penurious Council. He organised a Post-Impressionist exhibition but failed to persuade councillors to buy affordable works by Cézanne, Matisse and Kandinsky. His purchases were assisted by the foundation in 1912 of the Leeds Art-Collections Fund. Rutter was supported by Sir Michael Sadler, Vice-Chancellor of Leeds University and a major collector, who gave works of art to the gallery.

In the 1920s collecting focused more traditionally on British watercolours, enhanced by the 1938 bequest by the architect Sydney Kitson. The Directorship of Philip Hendy (1935–45) transformed the collecting policy of the gallery. During World War II, Hendy organised a pioneering series of exhibitions of contemporary British artists at Temple Newsam House, a grand early 17th-century house on the outskirts of the city which has since been restored. (Temple Newsam House now displays many of the city's Old Masters as well as housing a remarkable collection of English furniture, porcelain and silver, largely of the 18th century.)

The reopening of the City Art Gallery in 1950 was boosted by the building of the New Print Room to house the Kitson collection of Cotman drawings and the Lupton collection of English watercolours.

In 1982 the Henry Moore Foundation supported the creation of the Henry Moore Sculpture Study Centre, which was accommodated, with new sculpture galleries, in an adjacent building designed by John Thorp and Neville Conder. The Centre, an independent institution in partnership with the gallery, accommodates a growing collection of sculpture with particular strengths in 20th-century British work, notably Moore. A new exhibition gallery, designed by Jeremy Dixon and Edward Jones, was added to the Centre in 1993.

The gallery is active in its acquisitions of contemporary British art, recently having purchased work by Stephen Campbell, Anish Kapoor, Leon Kossoff, Richard Long and Alison Wilding.
REFERENCES *The Leeds Art Calendar* (biannual publication by members of the Leeds Art-Collections Fund), nos. 102 and 103, 1988; *Leeds City Art Gallery: Concise Catalogue*, Leeds, 1976 and 1982; *Temple Newsam: A Guide*, Leeds, 1984
CAT. 18, 131, 203, 222, 333, 344, 349, 370, 382, 385, 392, 394, 410

LEEDS

University of Leeds Gallery
Parkinson Building, Woodhouse Lane, Leeds

In 1923 Sir Michael Sadler presented a collection of drawings to the university; the artist Joseph Kramer added to them, and these core gifts provided the impetus for developing a collection. In 1960 it was decided to form a collection of English art from 1910 to 1945, especially of the

Camden Town and Bloomsbury groups. The gallery now houses work by Gaudier-Brzeska, Gilman, Spencer, Robert Bevan, Malcolm Drummond, Roger Fry and Nina Hamnett.

A new display area, dedicated to showing works from the permanent collection, will be opened in 1998.

REFERENCE H. Diaper, *The University of Leeds Art Collection and Gallery: A Short History*, Leeds, 1995

CAT. 378

LEICESTER
Leicestershire Museum and Art Gallery
New Walk, Leicester

In 1876 a lecture hall and School of Art were added to the existing Leicester Museum (opened in 1849) which contained geological and botanical specimens and an ethnographical collection. Not until 1881 was a fine-art department established and purpose-built rooms were later added for the display of paintings during the rebuilding of the museum from 1900 to 1930. Most early acquisitions were of Victorian paintings. Substantial internal modifications in 1976 in a functional, modernist spirit have to some extent been improved upon by more sympathetic refurbishments since 1992.

In 1934 an acquisitions policy was decided on: the gallery would concentrate on British pictures but not to the exclusion of foreign works. This enabled the director, Trevor Thomas, to make a controversial purchase in 1944 of three German

Expressionist works, by Marc, Nolde and Feininger. Another such work, by Pechstein, was presented to the gallery at the same time and purchases in this area have continued to this day, resulting in one of the most individual collections in the country.

Since the 1930s, though especially after World War II, the gallery has also bought Old Masters and now has a varied collection, particularly strong in Dutch 17th-century painting. Early to mid-20th-century painting and sculpture are also well represented.

CAT. 126, 261, 286, 304, 363, 364, 377

LINCOLN
The Usher Gallery
Lindum Road, Lincoln

The gallery was founded by J.W. Usher (1845–1921), a local jeweller and clockmaker. He established a collection of clocks, porcelain, silver and coins, which he often displayed in his shop window. In 1900 and 1916 he published details of his collection, which became increasingly famous, in two catalogues printed for private circulation only. Usher left his collection to the City of Lincoln, along with a large sum of money to build an art gallery: the elegant Beaux-Arts-style building by Sir Reginald Blomfield was opened in 1927.

The gallery has concentrated on purchasing works of art with local associations. It has accumulated an outstanding collection of work by Peter de Wint and has also acquired

many contemporary works, since 1933 with the support of the Contemporary Art Society. Purchases are often supported by the Friends of Lincoln Museums and Art Gallery and by the Heslam and Usher Gallery trusts.

REFERENCE *The Heslam Trust,* Lincoln, 1996

CAT. 46, 50, 64

LIVERPOOL
Liverpool Museum
William Brown Street, Liverpool

In 1851 the 13th Earl of Derby bequeathed his substantial collection of natural history specimens to the City of Liverpool, galvanising the Council into buying premises to house it and into passing the Liverpool Museum and Library Act in 1852. The Derby Museum, housed in two rooms, received 150,000 visitors in the first seven months. A wealthy local businessman and MP for South Lancashire, William Brown, offered a large plot of land and the money to build a new museum. Designed in the classical style, it opened in 1860.

Foremost among early benefactors was Joseph Mayer, who in 1867 donated 15,000 items, ranging from Egyptian and Classical antiquities to medieval manuscripts and Wedgwood china.

The Liverpool Museum collections reflect the wealth derived from worldwide trade: the African collection is one of the finest in the country. Notable acquisitions include the Ince Blundell collection of Classical sculpture and a wide

range of material transferred from Liverpool University. The museum now holds encyclopaedic collections of archaeology, ethnology, natural history, geology and physical sciences.

Under the administration of the Merseyside County Council from 1974, the Liverpool Museum was established as one of the National Museums and Galleries on Merseyside in 1986 under a Board of Trustees.

REFERENCE M. Gibson, ed., *Joseph Mayer of Liverpool 1803–1886*, London, 1986

CAT. 7

LIVERPOOL
Sudley House
Mossley Hill Road, Liverpool

Sudley House still gives an impression of the art collections created by Liverpool ship-owners in the late 19th century. The building, dating from the 1820s, was the house of the Holts, a wealthy ship-owning family, and was bequeathed to the city by Emma Holt in 1944. She also left 148 works from her father's collection which, with purchasing policy much influenced by Agnew's, concentrated on 18th and 19th-century British works. In recent years some restoration of the historic interiors has been undertaken.

Sudley House is now administered by the National Museums and Galleries on Merseyside.

REFERENCE A. Kidson, *Sudley: The Emma Holt Bequest – A Guide to the Collection*, Liverpool, 1992

CAT. 147, 197

LIVERPOOL
Walker Art Gallery
William Brown Street, Liverpool

In 1873 the Mayor of Liverpool, Andrew Barclay Walker, announced his intention of giving an art gallery to the city. The building, designed by Cornelius Sherlock and Henry Hill Vale, opened in 1877. At first it functioned primarily as the venue for the Liverpool Autumn Exhibition of contemporary arts, which had a national brief. The Council soon set about creating a permanent collection with the profits from the Autumn Exhibition. P.H. Rathbone, Chairman of the Arts and Exhibitions Sub-committee from 1878 to 1895, acquired major works by promising young artists; the gallery thus accumulated an outstanding collection of Victorian art of various schools. In the 1930s an active programme of acquiring British 18th and 19th-century art was initiated by a new Chairman, Colonel Cotton, and the Director, Frank Lambert.

The collection of Continental art is also of great significance. William Roscoe's paintings from the Liverpool Royal Institution were lent to the gallery from the 1890s and given to it in 1948. After World War II, and especially since the 1960s, further Old Masters have been acquired, forming a remarkably comprehensive collection. The sculpture holdings, with an emphasis on the work of Liverpool artists, especially John Gibson, and on late 19th-century 'New Sculpture', are also notable. Contemporary British art is also collected, encouraged by the biennial John Moores exhibition.

In 1986 the Walker, with Liverpool's other municipal museums, was transferred to the ownership of nationally appointed trustees. It is now one of the National Museums and Galleries on Merseyside.

REFERENCE E. Morris, *Victorian and Edwardian Paintings in the Walker Art Gallery and at Sudley House*, London, 1996
CAT. 9, 12, 49, 86, 90, 169, 187, 204, 207, 270, 276, 283, 284, 291, 298, 310

MAIDSTONE
Maidstone Museum and Art Gallery
St Faith's Street, Maidstone

The museum and gallery are housed in Chillington Manor, an extended Elizabethan house. Resident surgeon-antiquary Thomas Charles (1777–1855) bequeathed his varied art and archaeological collections to the town, forming an early municipal museum in 1858.

Several bequests have followed: in the 1870s from Julius Brenchley (ethnography, decorative and fine art), in the 1890s from the Bentliff brothers (over 200 19th-century watercolours and 17th-century Continental oils) and in the 1960s watercolours by the Maidstone-born Albert Goodwin (1845–1932) from his daughters.

REFERENCES S. Legouix, *Maidstone Museum and Art Gallery: Foreign Paintings Catalogue*, Maidstone, 1976; V. Tonge, *Albert Goodwin (1845–1932): A Maidstone Artist*, Maidstone, 1990
CAT. 21, 227, 243

MANCHESTER
Manchester City Art Gallery
Mosely Street, Manchester

The building, designed by Charles Barry and finished in 1834, is considerably older than the art gallery. The original building accommodated a School of Design as well as the Royal Manchester Institution, an establishment run by local merchants and industrialists for the promotion of literature, science and the arts. It housed annual exhibitions of work by local artists and had amassed an impressive, cosmopolitan collection by the 1860s.

Having established the city's support for the fine and applied arts through the 1857 Art Treasures Exhibition, the Corporation of Manchester took over the ailing Institution in 1883 and converted the building into the City Art Gallery, transforming the first floor into a suite of galleries. It was one of the first major collections to purchase Pre-Raphaelite paintings and now has an outstanding collection in this field as well as in High Victorian painting. The industrial 'potentates' of 19th-century Manchester were impressed by the modernity and innovation found in the work of such painters as Rossetti, Burne-Jones and Ford Madox Brown.

The gallery attracted important gifts and bequests (at least one every decade over the past 100 years), sometimes of historical collections, such as the Assheton-Bennett collection of Dutch paintings, donated in 1979, and sometimes of a more radical kind: for example, Charles Rutherston's collection, given in 1925, was intended to be a loan collection used by schools. Manchester has also accumulated decorative art collections of international importance, including the Greg collection of Early English Pottery and an 'Industrial Art' collection from the 1920s.

The gallery has continued the adventurous collecting policy begun in the last century, concentrating on British art. With the acquisition in 1970 of *Cheetah and Stag with Two Indians,* perhaps Stubbs's greatest painting, the gallery confirmed its international standing.

In 1997 the gallery was awarded a large grant by the Heritage Lottery Fund, allowing it to make a major addition to the building, designed by Michael Hopkins & Partners.

REFERENCE *A Century of Collecting 1882–1982*, Manchester, 1983
CAT. 13, 47, 58, 59, 115, 120, 130, 133, 161, 174, 182, 295, 307, 326, 343, 446, 447, 581, 588, 596, 408

MANCHESTER
Whitworth Art Gallery
University of Manchester, Oxford Road, Manchester

The gallery was founded in memory of Joseph Whitworth (1803–87). Son of a Stockport schoolmaster, he became a leading industrial engineer, developing a machine for preparing clean plane surfaces and devising a uniform and internationally recognised standard for screw threads. He became extremely rich and divided his bequeathed fortune

between engineering scholarships and the Whitworth Institute, founded in 1889, which was to combine a School of Technology and Art with an art gallery.

After Whitworth's death his friends, who included the art dealer Sir William Agnew, pursued the idea of an art gallery dedicated to him. Intended to be a teaching institution, the gallery acquired many reproductions, including casts. The first painting to enter the collection was the most important version of *Love and Death* by G.F. Watts.

The present gallery, designed by J.W. Beaumont & Sons, opened in 1897. From 1963 to 1968, it was remodelled by John Bickerdike, who eliminated many of the original features in favour of a clean modernist interior.

From the first, the gallery has specialised in watercolours. Sir William Agnew and John Edward Taylor, Manchester newspaper editor, art connoisseur and a passionate believer in universal education, made notable gifts. Other Manchester families, whose fortunes were based on the textile industry, notably the Haworths and the Broadhursts, bequeathed works from their collections to the gallery. Because the Whitworth was to be prominent as a teaching institution for industry, textiles were collected as early as 1888, before the official foundation of the gallery, with J.C. Robinson (of the South Kensington Museum in London) contributing a selection of historic textiles. The gallery also has a large collection of historic wallpapers and of prints. In recent years the holdings of both watercolours and contemporary British art have been substantially enlarged.

Founded as a private trust, the Whitworth fell into financial difficulties and was forced to sell a number of its paintings in the 1930s; the watercolour collection, however, remained virtually intact. The gallery was handed over to the University of Manchester in 1958.

REFERENCE *Guide to the Whitworth Art Gallery*, Manchester, 1979

CAT. 10, 210, 213, 214, 219, 233, 246, 255, 257, 367, 376, 400, 401, 405, 407

MIDDLESBOROUGH
Middlesborough Art Gallery
Linthorpe Road, Middlesborough

The gallery was founded in 1937 and occupies a Victorian house, converted in 1958 for the purpose.

As a result of local government reorganisation in 1996, the Cleveland County Fine Art Collection of contemporary art and works bought from the Cleveland International Drawing Biennale were integrated into the collection.

The strengths of the collection include British Surrealism, Neo-Romanticism, art of the 1950s and Scottish artists (William Gear to Mario Rossi). The tendency has been to collect figurative work.

The current acquisitions policy concentrates on contemporary art of national and international importance, with no bias towards local artists.

CAT. 258

NEWCASTLE UPON TYNE
Hatton Gallery
The University, Newcastle upon Tyne

The gallery was founded in 1926 and named after Richard Hatton (died 1925), the first Professor of Fine Art in Newcastle. From the 1950s, under the direction of Lawrence Gowing, work began on establishing a teaching collection, which was to include both historical and contemporary British works, the latter acquired with help from the Contemporary Art Society. The most recent extension, in 1984, was undertaken to provide space for the Uhlman collection of African sculpture. Installed in the building is Kurt Schwitters's last *Merzbau* construction.

The gallery is now used primarily for temporary exhibitions.

CAT. 340

NEWCASTLE UPON TYNE
Laing Art Gallery
New Bridge Street, Newcastle upon Tyne

The gallery, which is named after Alexander Laing (1828–1905), a Newcastle wine and spirit merchant who provided funds for the building but was not himself a collector, opened to the public in 1904 with a large loan exhibition of British art. The success of this encouraged the City Council to form a permanent collection, which grew rapidly and continues to develop.

The collection of British art is large and rich. Apart from a fine selection of work by the Newcastle wood-engraver Thomas Bewick (1753–1828), it includes a significant group of 19th-century pictures, notably by John Martin, who was born in Northumberland, and by Sir Edwin Landseer. There are also masterpieces of Pre-Raphaelite art by Burne-Jones and Holman Hunt. Later artists represented include Stanley Spencer, R.B. Kitaj and Gillian Ayres. There is a major collection of British watercolours, as well as decorative art holdings that include glass, ceramics and Newcastle silver.

In 1996 the gallery began a major programme of improvements which, it is hoped, will culminate in the construction of a substantial extension and the refurbishment of the original building.

REFERENCE *The History of the Laing Art Gallery*, Newcastle, 1954

CAT. 23, 38, 112, 165, 192, 220, 358

NORTHAMPTON
Northampton Museum and Art Gallery
Guildhall Road, Northampton

The museum was established in 1865 in the Town Hall and moved to its present building, previously the county gaol, in 1884. The museum has been extended on several occasions, most recently in 1987, when four galleries were added. The varied collection includes 16th to 18th-century Italian paintings, and British paintings and sculpture from the early 19th to the late 20th century.

Northampton also owns British and Oriental ceramics, as

476

well as the world's largest collection of footwear (shoemaking is the main industry of the town).

REFERENCE W.N. Terry, *100 Years in Guildhall Road*, Northampton, 1984

CAT. 279

NORWICH
Castle Museum, Norfolk Museums Service
Norwich

The museum and art gallery are housed in the Norman castle, a royal palace which is one of the most important surviving medieval buildings in the country. The castle, its keep and its later prison buildings were converted and opened for their present use in 1894.

The museum has rich historical collections devoted to East Anglia, and its acquisitions policy has concentrated on this region. The Norwich School is especially well represented by both oils and watercolours, thanks in particular to two handsome donations, by J.J. Colman and his son R.J. Colman, members of the local family of 'mustard princes'. The region's ties with the Netherlands are reflected in a group of Dutch paintings and in a major collection of Rembrandt etchings. Portraiture and topographical painting relating to East Anglia also feature prominently, as do the applied arts of the area, especially Norwich silver and Lowestoft porcelain. There is also a growing representation of 20th-century British art.

Following a successful application to the Heritage Lottery, the Castle Museum is currently embarking upon a major redevelopment of its buildings and facilities.

REFERENCES *Guide to the Castle Museum*, Norwich, 1993; A. Moore, *The Norwich School of Artists*, London, 1995

CAT. 1, 55, 63, 142, 186

NOTTINGHAM
Castle Museum and Art Gallery
The Castle, Nottingham

Founded in 1878, this is among the oldest municipal art museums in England. The 17th-century mansion was built by the Dukes of Newcastle on the site of the medieval fortress. Burnt out during Nottingham's Reform Bill riots of 1831, it was converted into an imposing art gallery by the local architect T.C. Hine, who retained the character of the older building. In its early days it had almost no collection and was used for temporary exhibitions, drawing substantially on the loan service provided by London's South Kensington Museum, and was intended to play an educational role for the local manufacturing classes.

A number of important bequests have resulted in large painting and decorative art collections, with fine examples of medieval alabaster and British ceramics. Bonington, Paul Sandby and Dame Laura Knight are among the artists born in the environs of the city who are represented here.

REFERENCE *Nottingham Castle Guide*, Nottingham, 1984

CAT. 33, 48, 215, 228, 230

OLDHAM
Oldham Art Gallery
Union Street, Oldham

The gallery was founded in 1883 as a venue for temporary exhibitions of work by local artists and it provided temporary employment for them in framing and conservation. It owes the basis of its collection to Charles Edward Lees (1840–94), grandson of a wealthy Oldham manufacturer. Lees, who started collecting art in the 1860s and was a friend of the Agnew family, gave a large group of watercolours to the gallery, including works by Turner, Cotman, Cox and Paul Sandby. He saw it as an important organ of public education and insisted that admission should be free and possible outside ordinary working hours. The gallery now has a large collection of British 19th and 20th-century works with an emphasis on local artists, for example William Stott.

REFERENCE T. Coombs, *Watercolours from the Charles Lees Collection*, Oldham, 1989

CAT. 196, 201, 231, 247

OXFORD
The Ashmolean Museum
Beaumont Street, Oxford

The Ashmolean is the oldest public museum in Britain and one of the oldest in Europe. It takes its name from Elias Ashmole (1617–92), historian, collector and herald, but the greater part of its founding collections came from the Tradescant family. John Tradescant senior (died 1638) was a professional gardener, botanist and traveller who built up remarkable collections of exotic curiosities and plants. These collections were enhanced by his son, also John (1608–62), and shown to visitors in the family's museum, The Ark, in Lambeth. They were bequeathed to Tradescant's friend Ashmole. The core collection was presented to the University of Oxford by Ashmole in 1678 and a specially designed building (now the Museum of the History of Science) was completed in 1683.

The university's holdings of scientific and artistic objects were enhanced in the 18th century by the donation of the Arundel Marbles and of various other works of art. In the 1830s it was decided to build the University Galleries to house the art collections, which were to be separated from the other objects. A new gallery was erected in Beaumont Street to the designs of C.R. Cockerell and opened to members of the university and a limited public in 1845. In the 19th century, the University Galleries purchased mainly drawings.

In the 20th century, K.T. Parker developed the collection in all fields. He concentrated on drawings, assembling a remarkably comprehensive printroom on the basis of the 19th-century acquisitions. It now contains examples of most major European draughtsmen, including a great series of Raphael and Michelangelo drawings and outstanding works by Dürer, Holbein, Rembrandt and Samuel Palmer.

The museum holds a large group of paintings, assembled from numerous gifts and purchases. They range from the

early Italian Renaissance to Dutch still-life paintings (Daisy Ward Collection) and the Pre-Raphaelites, in which the collection is particularly strong. The museum also contains the university's collections of antiquities, Oriental art, and coins and medals.

REFERENCES A. Macgregor, ed., *Tradescant's Rarities*, Oxford, 1983; R.F. Ovenell, *The Ashmolean Museum 1683–1894*, Oxford, 1986

CAT. 2, 4, 75–7, 81, 87, 97, 107, 109, 226, 250, 252, 303, 327, 337, 350

OXFORD

Christ Church Picture Gallery
Christ Church, Oxford

The Christ Church collection is probably the most distinguished of those art collections which belong to individual colleges rather than to universities. Founded with the bequest of General John Guise in 1765, it was expanded by a number of later gifts, notably the group of Italian 'primitives' given in 1828 by the Hon. W.H. T. Fox-Strangways (1795–1865). In 1897 two great-nieces of the writer Walter Savage Landor donated a group of works from his collection.

The paintings were at first hung in the college library. In the 1960s, with a gift of money from Sir Charles Forte, a new gallery was built to the designs of Powell & Moya.

REFERENCES J. Byam Shaw, *Paintings by Old Masters at Christ Church,* Oxford, 1967; *idem, Drawings by Old Masters Christ Church,* Oxford, 2 vols., 1976

CAT. 3, 68, 70, 71, 73, 80, 323

PENZANCE

Penlee House Gallery and Museum
Morrab Road, Penzance

The fine-art collections belonging to Penzance were moved to Penlee House, a Victorian building, in 1984. They centre on work by the Newlyn School of artists, particularly since the transfer of the Newlyn Art Gallery collection to Penzance in the late 1980s.

REFERENCE J.C. Laity, *The Penzance Art Collection*, Penzance, 1986

CAT. 193

PETERBOROUGH

Peterborough City Museum and Art Gallery
Priestgate, Peterborough

Founded in 1880, the museum has been housed since 1931 in a former family residence, built in 1816, which from 1856 to 1928 was the home of Peterborough Infirmary.

The art gallery was founded in 1951. The fine-art collections range from the 17th century to the present day and include 17th and 18th-century portraiture (mostly of local families), topographical works and Dutch paintings. The 20th-century British collection contains work by Sickert, Fry and Therese Oulton, as well as the Ealand Warwick Bequest with works by Heron, Frink and others.

CAT. 317, 318

PLYMOUTH

Plymouth City Museum and Art Gallery
Drake Circus, Plymouth

The museum was founded in 1898 and, with financial help from Andrew Carnegie, moved in 1910 to its present purpose-built premises, designed by Thornely and Rooke. It has twice been extended. The art collections are large and varied. They include representation of Devon artists, notably early works by Sir Joshua Reynolds, who was born close to Plymouth, as well as paintings by Benjamin Haydon. The gift in 1915 of the Cottonian Collection of drawings, prints and books brought an interesting early 19th-century collection intact to the gallery: it is still shown as a unit. A further gift, of Italian 'primitive' paintings and of Old Master and 18th-century drawings, was made by Alfred de Pass (see Falmouth and Truro).

The gallery also has a good representation of Camden Town paintings and some fine examples of the Newlyn School. Postwar British paintings have also been acquired.

CAT. 42, 99, 101, 103, 168, 194

PORT SUNLIGHT

Lady Lever Art Gallery
Port Sunlight Village, Bebington

The Lady Lever Art Gallery was established by the first Viscount Leverhulme (1851–1925) in memory of his wife, who died in 1913. Opened in 1922, it contained his collections of paintings, sculpture and 'the fine types of industrial arts'.

The gallery was designed in a classical style by William and Segar Owen of Warrington. It stands at the centre of Port Sunlight, the model village which Leverhulme created for the workers at his soap factory. He wished to share his pleasure in the visual arts with his employees.

Leverhulme was an enthusiastic supporter of British art, and believed that it was especially suited to the decoration of the home. Among the interiors are some with a particularly domestic quality and a number of period rooms. The collections contain notable 18th and 19th-century British paintings, including both academic and Pre-Raphaelite works. Some of the paintings were used by Leverhulme for advertising his soap. The furniture is primarily of the 18th century – a reaction against Victorian design.

Set up as a private trust, the gallery encountered financial difficulties after World War II and passed into the ownership of Merseyside County Council in 1978. It is now part of the National Museums and Galleries on Merseyside.

REFERENCE *Lady Lever Art Gallery: Catalogue of Foreign Paintings ... Sculpture and Prints*, Liverpool, 1983

CAT. 143, 164

PRESTON

Harris Museum and Art Gallery
Market Square, Preston

Edmund Harris (1804–82) bequeathed a large sum to the town in memory of his father,

Vicar of Preston, of which a third was to be spent on building a museum and art gallery. The architect was an otherwise little known alderman, James Hibbert, who created an impressive, if anachronistic, classical pile containing a museum, gallery and library. This opened fully in 1895. The spectacular central hall, lit by a huge lantern, depicts the progress of Western art, represented by works (mostly reproductions) from Assyria, Egypt, ancient Greece and Rome, and culminating in modern British art.

Soon after building began, the museum benefited from a large bequest of 19th-century British paintings from a local banker, Richard Newsham. Purchases were influenced greatly in the 1930s by the curator, Sidney Paviere, who set about acquiring pictures by the Preston artist Arthur Devis. French and British sculpture c. 1900 are also well represented.

Extensive work in the late 1980s restored the galleries to their original appearance.
REFERENCE *Polite Society by Arthur Devis,* Preston, 1983
CAT. 39, 125, 158, 236, 245

READING
Reading Museum and Art Gallery
Town Hall, Reading

The original museum opened in 1883 with ethnographical, natural history and antiquities collections. In 1897 three new galleries opened to accommodate paintings given by William Palmer, the Liberal Quaker and brother of the founder of Huntley & Palmer.

In 1957 it was decided to focus collecting policy on art produced between the two world wars, on works of local topography and on art produced locally. The collection benefited from a large donation of sculpture by John Tweed, given by his daughter in 1963.

In 1975 the Council vacated the Town Hall, which with the help of the Heritage Lottery Fund has now been converted, to designs by the Architects Design Partnership, into a purpose-built museum and gallery and concert hall.
REFERENCE *A Brief History of Reading Museum Service,* Reading, n.d.
CAT. 357

ROCHDALE
Rochdale Art Gallery
Esplanade, Rochdale

The gallery opened to the public in 1903 in a building, designed by Jesse Horsfall, next to the public library. It received many donations from the Heape family of Healey Hall, including works by Frederick Holl and David Roberts. The collection was enlarged by a gift from the collection of Thomas Kay (1841–1914), a Stockport man who had made a fortune in patent medicines and who was strongly interested in popular education and local causes. In 1912 Kay had given Old Master paintings and watercolours to be displayed in the Heywood Reference Library, but lack of space obliged the library to hand them over to the gallery. The collection also includes 20th-century British works, by Stanley Spencer and Anthony Green.
CAT. 268, 274

SALFORD
Salford Museum and Art Gallery
Peel Park, The Crescent, Salford

It was a proposal from a Salford MP to Gladstone that resulted in the Museums Act of 1845. In 1846 the town's Lark Hill estate was bought by public subscription and its house converted into a Free Library and Museum, which opened in 1850–1. In the 1870s the building was extended with a wing paid for by E.R. Langworthy, a former mayor. After many extensions the house was demolished in 1938 and replaced by a gallery designed by W.A. Walker, City Engineer.

In 1941 the Committee Chairman decided to concentrate on assembling a collection of L.S. Lowry's work and organised an exhibition of it. In the course of a long relationship between artist and gallery, Lowry gave many works to Salford. In 1974, following local government reorganisation, Salford absorbed the collections belonging to the towns of Eccles and Swinton.

The gallery also has a collection of Victorian paintings as well as of work by Bloomsbury group and other 20th-century artists.
REFERENCE *L.S. Lowry: The Salford Collection,* Salford, n.d.
CAT. 183, 390

SCARBOROUGH
Scarborough Art Gallery
The Crescent, Scarborough

The gallery opened in 1947 in an 1830s Italianate villa. A local hotelier, Tom Laughton (brother of the actor Charles Laughton), presented a group of British paintings dating from the 17th to the 20th century. Collecting has otherwise focused on artists with local connections, notably Atkinson Grimshaw and Lord Leighton, as well as on early tourism posters and prints by living artists.
CAT. 170

SHEFFIELD
Graves Art Gallery
Surrey Street, Sheffield

The gallery was established by J.G. Graves (1866–1945), the founding father of mail order catalogues and hire purchase, and a philanthropist who gave several parks to Sheffield. He paid for a new city library with a separate floor for a gallery. This opened in 1934 with a collection of almost 700 paintings, over half of which came from Graves and had been selected by John Rothenstein, the first curator. The founder concentrated on 19th and early 20th-century British art.

Graves was keen that the collection should be attractive to a wide public. The gallery therefore regularly stayed open late and, in contrast to the Mappin, temporary exhibitions and loans were encouraged. In 1936 the Sheffield Art-Collections Fund was set up to assist Rothenstein with

purchases. There is an interesting group of Old Master paintings, mostly acquired from the 1940s onwards.

The distinguished line of directors initiated by Rothenstein has continued. The most notable postwar incumbent was Frank Constantine, under whose enlightened leadership and unerring eye the education and exhibition departments developed and flourished. The collections received some of their most significant additions during his directorship.

REFERENCE J. Barnes, *J.G. Graves, Sheffield Businessman, Art Collector and Benefactor*, Sheffield, 1984
CAT. 190, 351

SHEFFIELD
Mappin Art Gallery
Weston Park, Sheffield

The Mappin Art Gallery derives from the activities of a local philanthropist, J.N. Mappin (1800–83), a brewer who made a considerable fortune. He assembled his extensive collection of mostly small contemporary British works from 1865 onwards, usually at the Royal Academy and studio sales. He bequeathed the paintings to Sheffield on condition that a gallery be erected to house them. When the gallery opened in 1887, his nephew F.T. Mappin presented 48 paintings, primarily large Victorian works considered suitable for public display.

The gallery building was sensitively designed in the Greek Revival style by the Sheffield firm of Flockton & Gibbs. It was much admired by contemporaries for the handling of light in the display galleries. Damaged in World War II, it reopened in modified form in the early 1960s. The building now displays some of the original collection, but also contains temporary exhibition spaces.

REFERENCE M. Tooby, *In Perpetuity and without Change*, Sheffield, 1987
CAT. 140, 173, 314

SHEFFIELD
Ruskin Gallery, Collection of the Guild of St George
Norfolk Street, Sheffield

John Ruskin (1819–1900) founded the Guild of St George in 1871 as an instrument for the implementation of at least some of his ideas and theories. Ruskin's abhorrence of many effects of industrialisation led to his plans for alternative self-sufficient communities, which would include schools and museums. Though no such communities were established, a museum was opened in 1875. The St George's Museum was a small cottage containing books, pictures, crystals and stones, carefully arranged by Ruskin to provide instruction.

In 1890 an enlarged version of the museum opened at Meersbrook Park in Sheffield. This remained the home of the collection until 1950, when the Ruskin Museum, as it was known, closed. For a period the collection remained in store, though a number of touring exhibitions were arranged. In 1985 a home was finally found for the collection and it reopened at the Ruskin Gallery in the heart of Sheffield.
CAT. 17, 249

SOUTHAMPTON
Southampton City Art Gallery
Civic Centre, Southampton

The gallery was founded with a bequest from a councillor, Robert Chipperfield JP (1817–1911). This provided for the building of an art gallery and art school and included an endowment for buying works of art. Chipperfield stipulated that the Council should consult the Director of the National Gallery (then Kenneth Clark) for advice on purchases, which have consisted of Old Masters, 19th-century oils, watercolours and drawings, and 20th-century oil paintings. Another bequest, by Councillor Frederick Smith (1861–1925), provided further acquisition funds.

The gallery, designed by B. Webber, opened in 1939 as part of the new Civic Centre. It was bombed within a year and the rebuilt galleries did not open until 1960.

In 1963 Arthur Jeffress, a London art dealer who had often loaned pictures to the gallery, bequeathed to it the pick of his collection. Ninety-nine works were chosen, including 20th-century Continental paintings and views of Venice dating from the 18th to the 20th century.

Largely since World War II, the gallery, assisted by its substantial acquisition funds and by perceptive advisers, has assembled an important collection of Old Master and 19th-century paintings as well as an excellent group of Camden Town works. It has also been active in buying the work of promising British artists, often before they have become widely known, and thus boasts one of the first pieces by Rachel Whiteread to have entered a public collection, as well as works by Flanagan, Auerbach and Gormley.

REFERENCE *Southampton Art Gallery: Catalogue of the Collection*, Southampton, 1980
CAT. 27, 316, 345, 353, 355, 359, 368, 371, 379, 387, 409

SOUTHPORT
Atkinson Art Gallery
Lord Street, Southport

A gift of £6000 from William Atkinson, a JP who had made his money in cotton, allowed Southport Corporation to build an art gallery and library. The building was designed in an eclectic Baroque style by Waddington & Son of Burnley and opened in 1878. The inaugural exhibition consisted of around 1000 pictures lent by local people and hung five deep.

Following the 1879 gift from Miss Ball of British watercolours and oils, the gallery received various donations, including that of 1923 by Frank Hindley Smith of works by Cotman, Cox and Ford Madox Brown. Three galleries were added to accommodate this collection. A further, and particularly important, bequest in 1929 by J.H. Bell added more early 19th-century British paintings. There is also a sculpture collection including work by Epstein, Moore and Frink.

REFERENCE *Centenary Catalogue: A Selection of Victorian Oil Paintings*, Southport, 1978
CAT. 179, 372

STALYBRIDGE
Astley Cheetham Art Gallery
Trinity Street, Stalybridge

The gallery was founded by John Frederick Cheetham (1835–1916), MP for Stalybridge and a local mill-owner, and his wife, Beatrice Astley. They paid for the building of the gallery and library, designed by J. Medland Taylor, which opened in 1901. The collection, which was handed over to the gallery in 1932, on the death of Cheetham's sister, contains early Italian paintings bought by Cheetham's father, who had travelled in Europe in the mid-19th century, as well as 19th-century British works. There is also a collection of 20th-century British work.

CAT. 255, 271, 272

STOCKTON-ON-TEES
Preston Hall Museum
Yarm Road, Stockton-on-Tees

Preston Hall, an early 19th-century house, was bought by the Council in 1948 and opened as a museum in 1953. It contains a varied collection of decorative and fine arts, including the Clephan bequest (1930) of British watercolours and a group of paintings. The Hall also shows a series of Victorian period rooms and 'Period Street', in which reconstructed shops and other buildings illustrate the changing face of local history over the past two centuries.

CAT. 299

STOKE-ON-TRENT
Stoke-on-Trent City Museum and Art Gallery
Bethesda Street, Hanley, Stoke-on-Trent

Four of the six towns known as The Potteries had small museums, the first being opened in Hanley in 1846 by the Mechanics' Institute. After the towns were joined in 1910, the museums pooled their collections and displayed them in Hanley. A new gallery was built in Broad Street in 1956 and was extended in the 1970s by the City Architects' Department. The new complex opened in 1981.

The great strength of the museum is its internationally important collection of ceramics. It also has large holdings of primarily British paintings and works on paper of the 19th and 20th centuries, with a particularly noteworthy selection of work by the Camden Town group.

REFERENCE *The City Museum and Art Gallery, Hanley, Stoke-on-Trent*, Derby, 1982
CAT. 391

SUDBURY
Gainsborough's House
Gainsborough's Street, Sudbury

Thomas Gainsborough (1727–88) was born in this house. Sold four years after his death, it was bought in 1958 by the Gainsborough's House Society, which opened it as a museum in 1961. It is run by an independent charitable trust with help from local authorities and the regional arts board.

On display are drawings and paintings by Gainsborough. These include loans but, by means of a generous designation donation, adventurous purchases of works by him and by related artists have been made in recent years.

REFERENCES *Gainsborough's House*, Sudbury, 1977; H. Belsey, 'The Gainsborough's House Collection', *Apollo*, August 1991, pp. 112–15, and August 1997, pp. 55–9
CAT. 53, 208

SUNDERLAND
Sunderland Museum and Art Gallery
Borough Road, Sunderland

This is one of the oldest municipal museums in the country, established in 1846. The present building, erected to the designs of J. and T. Tillman, opened in 1879. It was extended in 1962–4 and, following a major grant from the Heritage Lottery Fund, is currently being further extended and modernised.

The fine-art holdings include primarily British 19th and 20th-century paintings and watercolours as well as a large topographical collection. There is a strong representation of Sunderland-made pottery and glass.

REFERENCE L. Jessop and N. Sinclair, *Sunderland Museum*, Sunderland, 1996
CAT. 19

SWINDON
Swindon Museum and Art Gallery
Bath Road, Swindon

The museum, founded in 1912, originally contained mostly items relating to the geology, archaeology and social history of the area, as well as a few paintings by local artists. In 1944 the Borough Council decided to establish an art collection. A gift by H.J.P. Bomford of some twenty works, including major items by Ben Nicholson, Graham Sutherland, Henry Moore and others, immediately set the standard for the collection.

In 1964 a new art gallery was opened and shortly afterwards Swindon began its policy of using a professional adviser when buying for the collection. With the guidance of Richard Morphet of the Tate Gallery, and also through a long and fruitful relationship with the Contemporary Art Society, Swindon has built up a major collection of 20th-century British art. This now comprises some 250 items and includes work by artists as diverse as Le Brun, Wadsworth, Bomberg, Hilton, Kitaj, Ayres and Craig-Martin. The paintings are complemented by a collection of studio pottery, which contains pieces by Pleydell-Bouverie, Coper, Rie and Britton.

REFERENCE *The Swindon Collection of Twentieth Century British Art*, Swindon, 1991
CAT. 404, 406

TORQUAY
Torre Abbey
The King's Drive, Torquay

Torre Abbey is a building of considerable historical importance. Founded in 1196 for the Premonstratensian Order, it was converted for domestic use after the dissolution of the monasteries and was for many years the home of the Cary family. It was sold to the town in 1929. A small area of the building was opened as an art gallery in 1930, although further development was curtailed by a period of military use during World War II. Many more rooms have been opened to the public since restoration was undertaken during the 1980s.

The abbey contains a number of interesting historic interiors and is partly furnished as a historic house. Its collections include a large group of British watercolours; sculpture by Frederick Thrupp, who died in Torquay in 1895; a number of Victorian paintings; and a collection of books by, and memorabilia relating to, Agatha Christie, a local. The varied collection of decorative arts objects is shown to advantage in this historic domestic setting.
REFERENCE *Torre Abbey: Torbay's oldest and most historic Building*, Torquay, 1991
CAT. 123, 146, 199, 238

TRURO
The Royal Cornwall Museum
River Street, Truro

The museum is owned and operated by the Royal Institution of Cornwall (founded in 1818)
and moved to its present site in 1919. It houses rich collections devoted to mineralogy, archaeology and local history as well as to the fine and decorative arts.

The paintings collection has a strong local bias, focusing on the Newlyn School in particular, but the department's strength lies in the large collection of English and Old Master drawings donated between 1914 and 1935 by Alfred de Pass (1861–1953). This includes works by Rembrandt, Rubens, Van Dyck, Constable and Géricault, many of them bought specifically for the museum to fulfil Pass's ambition of creating a smaller version of London's Victoria and Albert Museum in Cornwall.
REFERENCE *The Royal Cornwall Museum: Guide to the Collection*, Falmouth, n.d.
CAT. 56, 84, 85, 93, 100, 110, 180

TUNBRIDGE WELLS
Tunbridge Wells Museum and Art Gallery
Civic Centre, Mount Pleasant, Tunbridge Wells

The museum was taken over from the Natural History and Philosophical Society in 1918 and is now housed in the Civic Centre, designed in the 1930s by Percy Thomas and Ernest Prestwich and completed after World War II. It has a notable holding of Tunbridge ware.

The gallery's most important donation was the Ashton Bequest (1952) of Victorian narrative paintings.
CAT. 136, 137, 152

WAKEFIELD
Wakefield Art Gallery
Wentworth Terrace, Wakefield

Wakefield's municipal museum and art gallery opened in 1923 in Holmefield House but owing to the rapid growth of the collection, the art gallery was moved in 1934 to a converted Victorian town house in Wentworth Terrace.

The gallery possesses works from the European schools and has benefited from an adventurous policy of acquiring 20th-century British art, especially sculpture. Sculptors included in the collection are Reg Butler, William Pye and Anthony Caro, and there are important groups of work by Henry Moore and Barbara Hepworth, both of whom were born locally. Contemporary painting and printmaking are also well represented, with works by Roger Hilton, David Hockney and Maggi Hambling.
CAT. 139, 262, 393

WALSALL
Walsall Museum and Art Gallery
Lichfield Street, Walsall

The gallery was founded in 1906, with a typical collection of Victorian and Edwardian painting. In 1973 Kathleen Epstein, widow of the sculptor, gave to it the Garman-Ryan Collection, which she had formed (her maiden name was Garman) with the help of the American sculptress Sally Ryan. It includes, in addition to numerous works by Epstein, oils, watercolours, prints, drawings
and bronzes by artists ranging from ancient Greece and Egypt, via Dürer and Rembrandt, to the French 19th century (Degas and Monet) and the early 20th century (Picasso and Braque).

For many years the gallery has been housed above the public library. Supported by a major grant from the Heritage Lottery Fund, a new and extremely innovative gallery is currently being built to the designs of Caruso St John. It is scheduled to open in 1999.
CAT. 254, 259, 264, 398

WARRINGTON
Warrington Museum and Art Gallery
Bold Street, Warrington

Warrington was one of the first towns to found a museum, in 1855. The present purpose-built museum – an adaptation of the designs of John Dobson of Newcastle and a remarkable survival of an early public museum – opened in 1857. An art gallery was added in 1877 to accommodate the work of a local sculptor, John Warrington Wood. The collection now contains work by a number of artists with local associations, including James Charles and Luke Fildes, as well as a group of Old Master paintings.
CAT. 181, 218, 319

WATFORD
Watford Museum
High Street, Watford

The foundation of the museum was prompted by the bequest of 47 paintings by E.T. Burr

(1843–1930), a local solicitor who left a group of North European works, mostly bought at auction in the 1880s. These were housed in the Public Library. A further bequest was made in 1967 by A.D. Blackley (1891–1965), director of the picture restorers and shippers James Bourlet & Sons.

The new museum was opened in 1981 by the Borough Council. The gallery specialises in the work of Sir Hubert von Herkomer, who lived nearby at Lululand, Bushey. It also documents the work of Dr Thomas Munro's art academy in Bushey.
REFERENCE L. B. Harwood, *Paintings and Watercolour Drawings in the Watford Museum,* Watford, 1992
CAT. 172

WOLVERHAMPTON
Wolverhampton Art Gallery and Museum
Lichfield Street, Wolverhampton

The gallery opened in 1884, following the donation by Alderman Jones of a sum towards the purchase of works of 'Art Manufacture' on condition that the Council provide a place to display them. The opening of the gallery was part of the Fine Arts and Industrial Exhibition for Wolverhampton and South Staffordshire. The building, donated by Philip Horsman, was designed by J.A. Chatwin in a classical style and displayed the work of local craftsmen in its construction. A number of important bequests have been made, including the Cartwright Bequest of nearly 300 works.

Early purchases concentrated on paintings of the late 19th century, but 18th-century works were added and the collecting of 20th-century art has been actively pursued. A collection of Pop Art was begun in the 1960s and recent acquisitions, assisted by the Contemporary Art Society and the Arts Council, have concentrated on 'figurative art with a social message', with works by Ana Maria Pacheco, Callum Colvin, John Keane and others.
REFERENCE V. Griffiths and D. Rodgers, *Catalogue of Oil Paintings in the Permanent Collection,* Wolverhampton, 1974
CAT. 294

WORTHING
Worthing Museum and Art Gallery
Chapel Road, Worthing

The museum was founded in 1908 in a building designed by H.A. Crouch and given to the town by its first mayor, Alfred Cortis. Having concentrated in its early years on works by Sussex artists, the art collection contains 19th and 20th-century British paintings and watercolours, with a strong representation of the Camden Town group.
REFERENCE *Worthing Museum and Art Gallery: Catalogue of Paintings and Drawings,* Worthing, 1988
CAT. 167

YORK
York City Art Gallery
Exhibition Square, York

In 1866 the first Yorkshire Fine Art and Industrial Exhibition was held in a temporary building in York. Its success, and profits, encouraged the organising committee to plan a second exhibition, which opened in 1879 in a building intended, at least in part, to be permanent; this became the City Art Gallery in due course. The exhibition building was designed by Edward Taylor with a façade in the Italian Renaissance style, though funding difficulties prevented the completion of its elaborate decorative scheme. From 1880 the building was known as the Yorkshire Fine Art and Industrial Institution and housed annual art exhibitions. An important bequest by a local entrepreneur, John Burton, of Victorian narrative paintings initiated a permanent collection in 1882. The building and paintings were taken over by the City in 1892.

The gallery has been fortunate in its supporters in the 20th century. They include Eric Milner-White, Dean of York, who gave a group of late 19th and early 20th-century British paintings (as well as most of his collection of studio ceramics) in the period 1948–63, and F.D. Lycett Green, a member of a wealthy local family who, in 1955, presented more than 100 Old Master paintings, which provide a remarkably wide-ranging survey of art in Continental Europe. The Curator after World War II was the German-born Hans Hess, who restored the galleries and worked to make the collection more representative; the acquisition of the Lycett Green pictures was his greatest success. A group of paintings by the York-born artist William Etty has been assembled over the years, as has an extensive holding of works on paper, mostly relating to York. A series of purchases in the 1980s and 1990s has further enriched the collection.
REFERENCE R. Green, *York City Art Gallery: An Illustrated Guide,* York, 1991
CAT. 32, 45, 116, 156, 269, 277, 285, 290